EMBATTLED AVANT-GARDES

The publisher gratefully acknowledges the generous contribution to this book provided by the Richard and Harriett Gold Endowment Fund in Arts and Humanities of the University of California Press Foundation.

Embattled Avant-Gardes

Modernism's Resistance

to Commodity Culture in Europe

WALTER L. ADAMSON

UNIVERSITY OF CALIFORNIA PRESS Berkeley Los Angeles London

University of California Press, one of the most distinguished university presses in the United States, enriches lives around the world by advancing scholarship in the humanities, social sciences, and natural sciences. Its activities are supported by the UC Press Foundation and by philanthropic contributions from individuals and institutions. For more information, visit www.ucpress.edu.

University of California Press
Berkeley and Los Angeles, California

University of California Press, Ltd.
London, England

Library of Congress Cataloging-in-Publication Data

Adamson, Walter L.
 Embattled avant-gardes : modernism's resistance to commodity culture in Europe / Walter L. Adamson.
 p. cm.
 Includes bibliographical references and index.
 ISBN-13: 978-0-520-25270-7 (cloth : alk. paper)
 1. Arts, European—20th century. 2. Avante garde (Aesthetics)—Europe—History—20th century. 3. Modernism (Aesthetics)—Europe—History—20th century. I. Title.
NX542.A32 2007
709.04—dc22 2007014869

Manufactured in the United States of America

16 15 14 13 12 11 10 09 08 07
10 9 8 7 6 5 4 3 2 1

This book is printed on New Leaf EcoBook 50, a 100% recycled fiber of which 50% is de-inked post-consumer waste, processed chlorine-free. EcoBook 50 is acid-free and meets the minimum requirements of ANSI/ASTM D5634-01 (*Permanence of Paper*).

For Lauren, who lived it with me

Contents

Preface

Like those of many others, my intellectual journey has involved trying to understand the present—hence the recent past. For me, the recent past means the twentieth century—the four and a half decades before my birth as well as the five and a half I lived through. It is those decades and not September 11, which has transformed the immediate present, that have most shaped my concerns. In my early work, I wanted to try to think with the Marxist tradition in ways that would help liberate it from ideology. I hoped that working through the insights of some of its best thinkers—Gramsci, Adorno, Benjamin, and Habermas—would contribute to developing a political and cultural outlook adequate to our current world. To my eyes, this is a world of abundance but also of great and increasing economic inequality; of advancing democracy but also of the failure to realize democratic potentials in countries where it is most fully established; of formidable scientific, technological, and cultural creativity but also of dismaying cultural vulgarity and pervasive man-made ugliness; of economic and technological power but also of environmental degradation and anxiety-provoking environmental change. Yet I have never been comfortable thinking about these problems by means of large and abstract

ideas separated from the experiences of particular people. Hence my preference for intellectual history over philosophy and political theory, as well as for a biographically rooted approach to intellectual history. From this point of view, if I wanted to understand the twentieth-century experiential world, I should look carefully at the reactions of perceptive and thoughtful people who lived through its early decades. I did this in one way in my book on a group of Italian intellectuals born in the 1880s. I have tried to do it in another, broader but also more thematically focused way in this book, which, for the most part, considers people born into that same 1880s generation.

Behind my choice of the present topic lies one of the great twentieth-century puzzles which, although the subject of many examinations, has proved difficult to approach convincingly because of its intensely emotional nature. To put the matter plainly: in the late nineteenth century and the first half of the twentieth, large numbers of intellectuals in a wide variety of Western nations became dismayed with what they regarded as the cultural cheapening and creative decline of their era. We may refer to them in the usual way as "modernists." Since 1960, however, these modernists have come to be forcefully attacked, typically on the basis of what is perceived as their blinding elitism. The problem, it is now frequently assumed, lay as much within modernist avant-gardes as in what they sought to combat. Modernism, or "high modernism" as its detractors often call it, was the last stand of a Eurocentric, male-dominated, elitist culture that has stood in the doorway of advancing cultural democracy and that deserves to be forgotten. In this book, I rise to the defense of the modernists, although I do not pretend to have solved the larger puzzle of what a properly democratic culture ought to look like. Instead, I have tried to understand the experience of avant-garde modernism and then address the more manageable question of whether we have something to gain from it and, if so, what?

Over the many years I have spent working through the modernist experience in search of greater understanding, there have been many who have been of great help to me, even if they were often unaware of it. Christopher Butler, David Cottington, Christopher Green, Martin Jay, Peter Jelavich, Lawrence Rainey, Claudia Salaris, Michael Saler, and Robert Wohl have all written books or articles on modernism or on a particular modernist movement that have greatly stimulated me and from which I hope I have profited.

The specific conception of this book was first suggested to me by Emilio Gentile, to whom I am deeply grateful for the many fruitful intel-

lectual exchanges we have had over the years. I am also indebted to Jonathan Eburne, Clark Poling, and Mike Saler, each of whom read chapter drafts and offered useful comments. Ivan Bargna offered many stimulating suggestions about how to approach modernism from his own perspective as a historian of African art when he commented on a paper of mine at the International Society for Intellectual History conference in Istanbul in 2003. Many of those who participated in the Association for the Study of Modern Italy's annual meeting in London in 1999 asked probing questions about an early version of chapter 6 that I am still trying to answer. Among them, I especially thank Richard Bellamy. Of the many other friends who have helped me over the years on issues close to this book, I would especially like to thank Liz Goodstein, David Roberts, and Erdmann Waniek. Finally, still others have helped through conversations about larger issues of historical theory and method, some of them in seminars we co-taught. Here I am especially grateful to Bill Beik, Jamie Melton, Judith Miller, Matt Payne, and Sharon Strocchia, each of whom helped further my appreciation of history as a discipline of self-reflection through which we seek to better understand ourselves.

I would also like to thank the editors and publishers of the journals and volumes in which earlier versions of several chapters or parts of chapters appeared. Parts of the introduction are revised from "Modernism in Art, Literature, and Political Theory," in *The Cambridge History of Twentieth-Century Political Thought,* ed. Terence Ball and Richard Bellamy (Cambridge, 2003), reprinted with the kind permission of Cambridge University Press. Parts of chapter 2 are revised from "Futurism, Mass Culture, and Women: The Reshaping of the Artistic Vocation, 1909–1920," in *Modernism/Modernity* 4, 1 (1997); and parts of chapter 3 are revised from "Apollinaire's Politics: Modernism, Nationalism, and Public Sphere in Avant-Garde Paris," in *Modernism/Modernity* 6, 3 (1999). Both are copyrighted by The Johns Hopkins University Press and reprinted with its kind permission. Parts of chapter 6 are revised from "The Culture of Italian Fascism and the Fascist Crisis of Modernity: The Case of *Il Selvaggio,*" *Journal of Contemporary History* 30, 3 (1995), and "Avant-Garde Modernism and Italian Fascism: Cultural Politics in the Era of Mussolini," *Journal of Modern Italian Studies* 6, 2 (2001). They are reprinted with the kind permission of Sage Publications, Ltd., and Taylor & Francis, Ltd. (www.tandf.co.uk/journals), respectively.

Much of the revision and extension of this work as well as the writing of new chapters took place during sabbatical leaves awarded by Emory University during 2001–2002 and in the fall of 2005. My warmest

thanks go to this institution, which has provided my intellectual home for nearly thirty years.

Finally, I happily thank Robert Wohl and another anonymous reader for the University of California Press, whose comments on the entire manuscript helped me see it in new ways as I prepared it for publication. I am also indebted, once again, to the editorial staff at California and especially to Niels Hooper, who guided the publication process with a sure hand and unfailing good cheer.

As always, it is a pleasure to acknowledge that my greatest debts are owed to those who sustain my everyday life: to Lauren, my most engaging critic and generous provider of love, support, and encouragement; to my parents, who likewise have provided incalculable love and support over the years and who have always been there when I needed them; to Daniel, whose ability to think about political action concretely has been a source of continual astonishment to me; and to Thomas Nash, whose budding interests in art and aesthetic philosophy have been far more stimulating to me than he would ever guess.

Introduction

In a book published two years before the outbreak of the Great War, the painter Wassily Kandinsky cast his eyes back upon a battle of a different sort, a battle for the European soul that had already been raging for several decades, a battle for culture and art. His Flanders' fields were already a place where "a weak light glimmers, like a tiny point in an enormous circle of blackness." Although the light pointed forward and was brightening, no one could doubt that European culture had been ravaged by a "long reign of materialism" such that its "souls, when one succeeds in touching them, give out a hollow ring, like a beautiful vase discovered cracked in the depths of the earth." Moreover, those who had wreaked the devastation were still everywhere visible. Calling themselves Jews, Catholics, and Protestants, they were in fact atheists who had declared "heaven empty" and "god dead." In politics these enemies of culture were devotees of parliamentarism; in economic matters they were often socialist; and, in scientific ones, they were "positivist." Most dishearteningly of all, they had invaded art as "naturalists." The world of European culture and art had become a "degraded life . . . used exclusively for materialistic ends."[1]

Kandinsky was a man of extraordinary passion, political as well as artistic, yet his views were broadly those of many of the early twentieth

century's activist, arts-oriented intellectuals. They saw themselves not simply as aesthetic explorers freer than ever before to roam the seas of pure art, but also as carriers of European culture who were uniquely situated to determine whether the public life of the emerging modern world would be based upon aesthetic imagination, creativity, and spiritual depth; or upon functionalism, utility, and the recycling of traditional forms; or upon a vulgarized commodity culture in which "art" was compromised by entertainment and marketplace values. They shared a perception of vast cultural crisis and a dedication to do battle for culture. They were not agreed in their political views or attitudes toward tradition, but most of them believed that a modern culture should be forward-looking and democratically inclusive. Above all, they were convinced that art was fundamental to overcoming cultural crisis because in it inhered the qualitative dimensions of life so besieged by nineteenth-century materialism and its allied institutions of industry, science, and market economy.

These artist-intellectuals were the vanguard of the "modernists," about whom there has grown up an enormous literature in recent years. Their assumptions were not shared by every artist or intellectual of the generation that fought the Great War or the one that emerged from it, but they were prominent enough in those generations to ensure that these years are now universally hailed as the years of "modernism." Modernist intellectuals worked in every art from traditional ones such as literature, painting, sculpture, architecture, music, dance, and drama, to newer ones such as photography and film, and they also participated in the emerging professions of cultural criticism and journalism that so expanded after 1900. Yet the visual arts enjoyed particular prominence in modernist discourse and practice since, consciously or unconsciously, nearly every modernist recognized the importance of the visual image for the emerging culture and politics of modernity. Looking back, it seems clear that the culture of Enlightenment which had prevailed since the 1730s— a literary culture for a lettered, leisured public at home in a tradition grounded in classical texts—had begun to give way after 1880 to a more mass-oriented cultural world in which the steady bombardment of "information" from newspapers, advertising, and incipient entertainment industries became the only shared experience.[2] In this new, culturally more democratic world, where the pace of life quickened amid compressions of time and space, where audiences fragmented as they expanded, and where a common cultural vocabulary could no longer be assumed, the visual image was perhaps predestined to become the favored means of cultural and political communication.[3]

In the present book, I do not aim to write an intellectual history of modernism. We have such histories written from a variety of perspectives that together provide a reasonably full picture of its main aspects.[4] We also have good studies of each of the avant-garde modernist movements taken on its own, as well as some fine country studies that approach the intellectual cultures of the modernist era, usually from the perspective either of the fine arts or of literature.[5] What we are only beginning to get is a critical and interpretative literature that assesses the history of modernism in relation to changes in society, politics, and culture after 1880, and that attempts to understand modernism as a field of contesting positions within an "institution of art"—a set of norms, expectations, and values that determines what counts as "art," that mediates between works of art and the publics for whom they are intended, and that thereby structures and confers priority on practices concerning the production, distribution, consumption, and evaluation of art within a specific historical setting.[6] This book aims to understand how modernism challenged the emerging modern institution of art by investigating the avant-garde practices of a number of influential modernists, from the prewar futurist F. T. Marinetti, to the interwar surrealist André Breton and his more academic, less angry, but no less ambitious contemporary, the English critic Herbert Read. The themes that it considers are the ones that concerned them: the fragmentation, commodification, and democratization of culture; the potential for good and evil of a public sphere transformed by mass politics and nationalism; the relation of "high art" and new manufactured cultures of entertainment; and, above all, the effort to press art into the center of modern cultural life while resisting those tendencies that would reduce it to a commodity defined ultimately by its exchange value.

We will look closely in this book at the men and, occasionally, women who devoted their lives to waging the battle for culture by articulating what they believed modern culture needed and what they hoped it could become. We will consider how they sought to gain an audience for art through writing manifestos and engaging in a variety of other avant-garde practices, often linked to the creation and development of cultural movements. In this way, I hope to bring to light how various related, often rival modernisms operated as sets of convictions, modes of life, and political strategies for cultural transformation. Yet while the biographical approach that underlies most of the chapters is intended to lend concreteness to our picture of how modernism challenged the modern institution of art, I have chosen the figures who appear in them less for their

interest as individuals or for their contributions as artists than for the way they illustrate a diversity of "positions" in a discursive "field" that is itself never fixed but continuously evolving under the pressure of events and new positions generated by them.[7] An allied goal of the book is to further our appreciation for how the field of modernist positions developed in Europe from about 1900 through the interwar and into the postwar era.

Many years of reflection on modernist movements have convinced me that modernism as a whole cannot be understood unless careful attention is paid to its historical development, especially in relation to World War I and its aftermath. What this study calls "avant-garde modernism"—by which is meant a strategy aimed at maximizing the influence of modernist intellectuals over the production, distribution, and evaluation of art and culture—had its heyday in the prewar period, when it flirted with the illusion of autonomous control over culture by intellectuals and had little sense for the magnitude of the forces with which it was competing. During the war and postwar years, however, newly powerful political movements such as Bolshevism and fascism, the expanding might of capitalist industries, the increasingly hegemonic cultural conservatism of the "return to order," and the increasing concern of nation-states with aesthetic matters, all forced modernists to reassess the strategy of "autonomous" or "pure" avant-garde modernism. Under such pressures, the commitment to autonomy was often surrendered in favor of developing the basis for tactical alliances in which modernist aesthetics would function either as design concepts for institutions that modernists hoped to influence but could not control or as revolutionary conceptions intended to enrich political movements and regimes. This transition from an era of pure avant-garde modernism to one in which alternative alliance-oriented strategies emerge is a major preoccupation of this book. The further evolution of avant-garde modernism after the decline of both its autonomous and alliance-oriented variants becomes a focal point in its closing chapters.

To understand any of modernism's varieties, however, we must first consider the questions raised for them by the "long reign of materialism" to which Kandinsky referred. Modernists certainly differed in their interpretations of what had precipitated the fin de siècle crisis and how they should react to it, but the historical concerns that underlay their reflections were largely the same as those that preoccupied their rough contemporaries who founded modern sociology and that continue to preoccupy historical sociologists today. Central among these concerns were the unprecedented development and expansion over the two or three

previous centuries of all those institutions and processes—the modern state, capital markets, industrialization, science and technology—with which we have come to associate the rationalization and increasing scale of life in modern societies. Equally fundamental was the larger normative shift from the vertical principles of social organization associated with traditional religious, metaphysical, and monarchical understandings of the world to the more horizontal notions that we think of in relation to increasingly democratic and scientifically legitimated forms of economics, culture, and politics.[8] Philosophically, the most important expression of this shift was the Kantian critique of metaphysics which, as Jean-Marie Schaeffer has recently shown, spawned a romantic and objective idealist reaction in which art came to be privileged as a locus of meanings otherwise unavailable in secularized modernity and, in that sense, as the sacred other to modern disenchantment.[9] Finally, another, perhaps lesser but still important concern was the aestheticization of capitalism itself and the resulting tendency of industries and governments to understand their national competitiveness in aesthetic terms. Modernists certainly became aware of the aesthetic underpinnings of national competition and, as we will see, frequently linked their own aesthetic preoccupations with questions of nationalism.

All these ways of posing the issue of modernity raised critical questions about how a modern democratic cultural life was possible. From where, for example, would spiritual authority derive in a culture legitimated by democracy and science? In what ways were the traditions and artistic works of more vertically oriented past societies still relevant? Was cultural creativity dependent upon rootedness in local cultures of long duration, or was cultural tradition rather a burden that should be swept away and buried in order to open up the potential of a modern, more democratic inventiveness? How would the social roles responsible for the creation and judging of art be preserved or transformed in a world in which nearly everything was becoming a commodity, an article produced for (or at least potentially available for) sale on an impersonal market? Would not consumers rather than producers have the upper hand in determining taste and value in such societies? Should modernists seek to neutralize or overthrow the new commodity culture, or should they try to bend it to their own ends? And how could the high standards associated with the European tradition in art be maintained as the transition was negotiated from a hierarchical, mostly rural society of limited literacy and cultural participation, to one that was increasingly democratic, urban, literate, and inclusive?

If one looks at how recent historians have assessed post-1880 cultural development in terms of questions such as these, at least two distinct and seemingly contradictory views emerge. Those historians, such as Eugen Weber, who have considered this development in terms of a longer view extending back to about 1650, have tended to see the years after 1880 as ones in which "popular and elite culture came together again" after a long separation between a "culture of the literate" and an illiterate population clinging to the "old ways."[10] Yet those historians who have put on half-century lenses rather than three-century ones have tended to see a sharpening and stiffening of cultural hierarchies, as the upper and middle bourgeoisie sought safe or "sacralized" cultural forms that would differentiate them from the surging masses. Unlike the world of the 1840s or early 1850s in which all classes enjoyed Shakespeare and intellectuals extolled popular cultural tastes, the post-1880 world was one of fearful withdrawal from "common culture" by the upper classes generally and intellectuals in particular.[11] My suggestion is that both views may have a measure of truth. For it is precisely the long-term democratizing trend which Weber accents that offers the most fundamental explanation for the fin de siècle anxieties and regressions toward hierarchy stressed by others.

Fear among intellectuals there certainly was, as work on fin de siècle gender anxieties perhaps best illustrates.[12] Yet it is important to be clear about the nature of this fear. Within the modernist generations at least, the fear was not of anything so global as "modernity." Modernists generally recognized the fact that any simple retreat was no solution. Moreover, while many varieties of a "religion of art" developed in the nineteenth century as modes of compensating for modern disenchantment, they did not play a major legitimating role for modernism, as has recently been claimed.[13] Rather, as we will see, the modernist challenge to the modern institution of art typically involved a break with religion-of-art movements, and especially with their idea of withdrawing into an "aesthetic caste," even if religiously infused understandings of art did not disappear in modernist culture. Much of the fear modernists expressed was no doubt bound up with the emerging mass culture of consumption, which recent scholars have rightly understood to have been gendered as female.[14] Even here, however, the fear registered in the works of modernists was less a general one associated with consumption or mass taste than a specific one having to do with their own self-interest as cultural producers. What modernists feared most was a loss of control over cultural creation because of the vast expansion of for-profit cultural media

that were arising to cater to a mass public. Their fears were that the traditional function of art in society would be lost; or that, insofar as art remained, they would no longer control its production and evaluation; or that art would become vulgarized, with entertainment replacing art in the traditional sense and standardized products replacing individual creations. Above all, they feared that the life of an artist would be rendered illegitimate by the new world of politics and society and superfluous by the new economy—in short, that it would become impossible.

A central argument in this book is that what modernists feared, in a word, was commodification. I further argue that their reaction to the post-1880 world may be aptly characterized as "resistance to commodification." The argument is not new.[15] Its roots lie squarely in the classic interpretation of modernism developed by Theodor W. Adorno. His view, reduced to essentials, rested on the paradox that art in the modern world had become autonomous as a sphere of value only through its commodification, and yet that the conditions for the subversion of this autonomy were also bound up with the process of commodification since, over time, exchange value would come more and more to predominate over use value.[16] In this view, then, modernists were both enabled by commodification and increasingly resistant to it as its full nature become ever clearer. Subsequent scholarly work in this tradition has mostly accented the latter point.[17] But some have reacted against it by claiming that modernists did not so much resist commodification as make the work of art into "a commodity of a special sort, one that is temporarily exempted from the exigencies of immediate consumption . . . and . . . integrated into a different economic circuit of patronage, collecting, speculation, and investment."[18] Others have gone still further to argue that modernists simply adopted an anticommodity pose while actually carving out for themselves an elite niche within commodity culture to enhance their own status and wealth.[19]

No doubt, commodification—and its intensification into the late nineteenth-century "commodity culture" we will consider in chapter 1—presented modernists with real opportunities. As Christopher Green has argued with regard to French visual art, "the dynamism of the dealers was the engine of modernism" and a fundamental reason why modernist painters and sculptors prevailed over their more traditionalist rivals.[20] Ironically, modernists often did quite well on the market whose larger cultural consequences they so feared. Moreover, it is certainly true that manifestos celebrating some new "ism" can be an excellent self-promotion strategy, as the experiences of Marinetti and his countless avant-garde

successors not infrequently showed. Indeed, as we will see in chapter 2, Marinetti went so far as to appropriate self-consciously many of the values and marketing strategies of commodity culture in an effort to beat the rising entertainment industries at their own game. Nonetheless, the notion that modernists self-consciously embraced commodification by seeking to make their work into a commodity of a special sort or the basis of an exclusive market niche seems to me not quite acceptable even in Marinetti's case, because one point around which he and all other modernists stood united was their refusal to allow exchange value to become the standard for judging art. They insisted that only artists, individually or as part of a profession, were fit to assess aesthetic value. They never doubted that artists were capable of developing such standards, and they consistently aimed to wrest control of the judgment process away from critics, audiences, and others they perceived as servants of the bottom line. Where they differed was in how precisely to respond to the threat of commodity culture. Some modernists such as Kandinsky remained intent upon preserving what the futurists called Art with a capital A from control by market forces, while others including Marinetti and the futurists sought rather to take control of these new cultural seas themselves.[21] By appropriating some of the techniques of commodity culture, and using them to build a large democratic audience for art, prewar futurists hoped to assimilate new mass-entertainment industries to futurism rather than the other way around. Indeed, even those avant-garde modernists most hostile to commodity culture generally aspired to develop an art for a democratic culture, one that would have wide appeal, even if they did not always agree about how participatory such a culture would be in terms of the production and consumption of art.

In this respect, modernists were participating in a tradition that went back at least to the Enlightenment. As Thomas Crow has shown, artists began to think in terms of an expanded audience for art within the increasingly commercialized society of eighteenth-century France, where the ideal of a public sphere with art at its center was first developed as a "republic of taste."[22] They too were responding to anxiety. Joshua Reynolds, for example, feared that art was threatened in modern commercial society because such societies promoted divisive private appetites rather than common, community-sustaining values. He and his contemporaries therefore sought to counter this tendency. Their dream of art as the focus of an ideal public sphere persisted through the nineteenth century and, according to Crow, right up to the modernist criticism of Clement Greenberg. As would become especially clear with the modernists, however, this effort was

marked by a contradiction between a democratizing tendency in which "art" became available to an audience of steadily increasing size and a refusal by artists to grant that audience any role in generating the standards by which the value of their work would be judged.

· · ·

Before attempting to elaborate further the approach to modernism to be deployed here, it will be helpful to review the history of the concept at least briefly. Modernism is a term of Anglo-American provenance with both literary-critical and art-historical variants. It arose in the 1920s, but it did not become popular until the two decades after 1945, when formalist criticism held sway.[23] Such "new critics" thought of modernism as an approach to literature and the arts, emerging just before World War I and dominant in the interwar period, that emphasized aesthetic autonomy and formalism, detachment and irony, mythic themes, and self-reflective attention to acts of creation and composition. The novels of James Joyce and Virginia Woolf, the plays of Luigi Pirandello and W. B. Yeats, the music of Arnold Schönberg and Igor Stravinsky, and the abstract art of Piet Mondrian and Wassily Kandinsky were paradigmatic. The term was then appropriated by Western Marxists debating the properly revolutionary approach to aesthetics and cultural critique. In both of these critical traditions, the understanding of modernism was disproportionately aesthetic, not only in the sense of the critical methods that were brought to bear upon it, but also, and most crucially, because the political aims of the avant-garde modernists were not taken seriously. Either they were ignored, as in the case of the "new critics," or they were chastised as reactionary by antimodernist Marxists such as Georg Lukács. Even Marxist defenders of modernism, such as Ernst Bloch, Walter Benjamin, and Theodor Adorno, generally considered them utopian and often misguided.

It is crucial to recognize that the intellectual environment in which modernism was first discussed arose as part of the evolution of modernism itself. As Matei Calinescu has rightly argued, modernism was not so much a new reality, mental structure, or worldview as it was a mode of historical questioning.[24] Yet these questions changed over time, albeit in ways not always clear to the participants. The avant-garde modernism of the prewar years aggressively questioned the commodification of culture and asked itself how the audience for art might be expanded while retaining the hegemony of intellectuals in its production. During the war

and early postwar years, however, the quest for modernist hegemony over culture appeared increasingly chimerical. Moreover, the apparent implication of at least some prewar avant-garde modernisms in bringing about the current catastrophe made them suspect, even among many of their erstwhile stalwarts and supporters. In this atmosphere, the central question for politically oriented modernists became how they might reposition themselves in relation to more powerful elites from industry, commerce, and politics in order to maximize their influence upon, if not actually control, postwar culture.

In nations such as Russia and Italy, where new, apparently revolutionary governments came to power, the answer was simply for modernists to politicize themselves through an alliance whereby they would provide the aesthetics for the new regime. In other nations, where revolutionary movements were weak or in which they failed to come to power, the answer often turned around what this book calls "design modernism." This avant-garde strategy—exemplified by German Bauhaus, Dutch De Stijl, and French purism—aimed to reorient modernism as an objective, often "scientifically" justified design aesthetic through which modernists might forge partnerships with industrial, commercial, and governmental elites. Of course, there remained many modernist groups for whom design-modernist strategies provoked only ire or contempt. Foremost among these were Breton's surrealists, who saw in French purism a set of functionalist, utilitarian, and commercial compromises no less insidious and malevolent than the culture industries they were ostensibly seeking to escape. In such a context, the surrealists preferred to hold their noses and attempt an alliance with socialist groups and communist parties, however remote their likelihood of success. In their defense, it can only be said that none of the other political-alliance or design-modernist strategies were ultimately any more successful than they were.

Thus, in the later years of the interwar period in which the critical discussion of modernism took shape—the years of Hitler, of a surrealism in retreat from revolutionary alliances, and of generalized hostility to "degenerate art" on both left and right—there no longer existed any avant-garde strategy which seemed to offer much hope for a democratic culture according a central place to modernists and their values. In such circumstances, the less avant-garde, more privatistic side of modernism reasserted itself. To the extent that modernism retained a political agenda, it was mostly associated with independent critics such as Adorno, Greenberg, and Read, who held on to the long-term goal of pre-

serving art against commodification while surrendering short-term political objectives. With these developments came increased skepticism about the aesthetic consequences of cultural democratization, such as eroding standards of taste. These tendencies were compounded by the political darkness that prevailed in the war years, although they did not abate in the relative sunniness of the early postwar period, in which the further ascendance of culture industries based on film, radio, and television expanded the cultural supply more dramatically than ever, while also making still plainer the popularity of every species of cultural vulgarity.

In recent decades, as the early critical discourse on modernism has itself passed into history, the term has come to be used in a bewildering variety of ways, and no similarly dominant usage has emerged. Probably the most common usage is as an umbrella term for a group of intellectuals and cultural movements that dominated the European and American scene between 1890 and 1940. Beyond the individuals mentioned above, now mostly considered "high modernists" in their relative isolation, movements such as German expressionism, French cubism, and English vorticism and imagism are generally included. I follow this usage but also include movements such as Italian and Russian futurism, Russian constructivism, Dutch De Stijl, Zurich dada and its successors, German Bauhaus, and French purism and surrealism, which are sometimes separated out as "avant-garde" in contrast to modernism. For reasons we will turn to shortly, I regard any sharp separation of this sort as an impediment, rather than an aid, to understanding.

In comparison with its original usage, then, the concept of modernism has been extended beyond individuals to the cultural movements they created, and beyond stylistics and other formal devices to the responses modernists made to developments in their environment, such as the growth of the modern metropolis, the democratization and industrialization of culture and art, the experience of fin de siècle cultural crisis, the rise of feminism and concepts of the "new woman," and the "space-time compression" that resulted from new technologies of communication and transportation. Despite this contextual enrichment, however, the word continues to be used primarily in a narrow aesthetic sense, with either that adjective or "artistic" or "literary" frequently preceding it. Modernism is, from this perspective, an aesthetic or, at most, a cultural outlook to which a set of political aims might be attached. Moreover, even insofar as such aims are seen to have been attached, they continue to be construed primarily in a defensive way in which "retreat" rather than active confrontation is the operative image.[25]

The persistence of this disproportionately aesthetic and passive understanding of modernism may be attributed in part to the continuing shadow cast over the discussion by the "new critics," but it probably also has to do with the tendency among those who do raise the question of a modernist politics to see it as something that is "added on" to an aesthetic foundation rather than something intrinsic to that foundation. Typically too, this approach to modernist politics tends to understand it as a single position on an ideological spectrum. Some recent studies have tried, for example, to place modernist movements securely on the political left—as anarchists or "left-Nietzscheans"—despite the many examples of individuals and movements that fail to fit.[26] Yet the problem with such ideological approaches is not simply that modernists could adopt quite a variety of political positions, including the extremes of left and right. More profoundly, the problem is that the ideological spectrum only partly reflects the political issues that excited modernist concern. Given that the forces modernists sought to influence and sometimes counteract were some of the most powerful and ubiquitous in modern life, one can certainly understand why there was no unanimity in their choices about which parties deserved their political allegiances, or even whether any political party or ideology deserved them. Despite these variations, however, my argument in this book is that modernists were, on the whole, intensely political in their "aesthetic" activities, seeking to renew modern culture and engaging in avant-garde practices to this end. At the same time, I readily concede that modernists were often unclear about whether and how these activities might be related to the world of parties and ideologies.

The most successful, recent attempts to understand the political dimensions of modernism have therefore tended to focus not on ideology by itself but on practices as inflected by ideology. Thus Crow has stressed the interest many modernists showed in appropriating "low culture" in order to throw existing cultural understandings and practices into question.[27] Others, such as Peter Jelavich and Jeffrey Weiss, have gone still further in this direction by arguing that the modernist appropriation of low culture was aimed at doing active combat with emerging culture industries or mass entertainment for popular allegiance.[28] Yet while these approaches are helpful in understanding the acts of provocation and self-performance pursued by some avant-garde modernists, they are much less helpful in understanding the more serious and constructive politics of many other avant-garde modernists, especially those who continued to take "high art" seriously and those operating in the postwar era, when

design modernism and alliances with industry or political parties came to the fore.

Another political dimension of modernism that has received less attention than the appropriation of low culture but which is equally if not more important is nationalism. Nationalism is often thought to have become bound up with modernism only during and after World War I, but prewar modernist discourse and avant-garde practices contained nationalist inflections of many sorts. Indeed, the affinity between nationalism and all forms of modernism has roots that lie deep in the nineteenth century. As George Mosse has shown for Germany, nationalist thinking was often intensely aesthetic—and aesthetic thinking bound up with national concerns—because they shared the aims of restoring meaning to a fragmented experiential life and of mobilizing mass participation in public life.[29] The ideal of many nineteenth-century nationalisms, like that of many romanticisms and post-Kantian idealisms, was a retotalized world in which separations between the divine and human, the rational and emotional, and the public and private sides of life would be overcome. Art would play a leading role in this overcoming for reasons classically formulated in Friedrich Schiller's *Letters on the Aesthetic Education of Mankind*. After 1880, the sense of art's importance for nationalist goals intensified amid a political climate of imperialist competition, government policies that increasingly recognized the import of aesthetic design for national prestige, and a new era of mass politics in which aesthetic considerations became integral to populist appeals. Although artistic intellectuals in this period tended to pursue an ideal of autonomous art that made them wary of reconciling art and culture with economy and state, they preserved much of the animus behind the earlier thinking in their image of a public sphere reinvigorated by art. It should not be surprising, then, that their modes of addressing the modern crisis brought them close to nationalist aesthetic politics, as such fin de siècle figures as Maurice Barrès and Jean Moréas remind us. Indeed, as we will see, even cosmopolitans such as Rémy de Gourmont found it necessary to address nationalist questions in the 1890s. Likewise, the modernist generations often found it attractive and sometimes necessary to promote nationalist sentiments of their own, even as they also explored the universalist cosmopolitan logic of their creative pursuits and their own personal relationships with one another. Indeed, the cosmopolitan associations that modernism had for rabidly nationalist movements, as well as the public at large, often served to intensify nationalist sentiments among modernists.

The relation between modernism and nationalism figures prominently in this book, and it may be helpful here to outline briefly four of the most common modernist practices in which nationalism is typically inflected. First, modernists often sought to justify and illustrate their appeals to the qualitative by linking them to a claim about the national roots of "genuine culture." In contrast to commodity cultures which are industrially produced, genuine cultures, they would suggest, create art that is strongly marked by and linked to local traditions of artisanship as well as to deep cultural and religious understandings. Second, modernists often sought to understand and project their own identities in national terms. In part, this practice reflected nothing more than the typical experience of individuals living in modern conditions of space-time compression, in which personal identity becomes a precarious project of continuous negotiation rather than a received form that is lived out. Yet, for modernists, this condition was often complicated as well by the fact that they were émigrés, or had personal backgrounds that rendered them suspect in some way to ethnic nationalists. For them especially, questions of nationalism cut very close to the bone. Third, as modernists sought to appeal to a wider and more popular audience, they were quick to sense the power of nationalist motifs. As Eric Hobsbawm has pointed out, the music hall or vaudeville was a prime spawning ground for chauvinist and jingoist sentiments, an association that reminds us how much nationalism uses fetishistic symbols (not unlike the brand names of commodity culture) such as flags, uniforms, anthems, maps, national cuisines and architectures, as well as collective spectacles such as sporting events, military parades, mass rallies, and, as Marinetti would show, futurist "evenings" [serate].[30] In short, nationalism lent itself beautifully to modernist performative practices aimed at audience expansion. Fourth, modernists sometimes used instrumental-rational appeals to nationalism to justify their political affiliations, especially in the interwar period, when they sought to ingratiate themselves with this or that regime. Finally, these practices were often combined, although the first and third of them were sometimes treated as alternatives and the fourth came mostly later.

The approach taken in this book to the relation of modernism and nationalism involves close attention to specific practices. Likewise, my general approach to modernism and politics emphasizes practices—and especially political rather than aesthetic or even what might be called aesthetic-political practices. For example, with respect to Marinetti's prewar futurism, we will consider its attack on "Art with a capital A," its conception of organization and leadership, its deployment of manifestos and

other modes of media manipulation, and its use of performances in its effort to "change life." Of course, I do recognize that such political practices led as well to the advocacy of certain politicized practices at the aesthetic level such as "*parole in libertà*" [words-in-freedom] or, in modernism more generally, to such aesthetic-political practices as readymades, collages, assemblages, grid formations, monochrome painting, photomontage, and the like. To these, however, I will give very little attention in this book, not because they are unimportant but because they have already received extensive study and because I must set some boundaries to my investigation. Since my fundamental aim is to show how modernism can be understood not just as an aesthetic or a literary movement but as a political one, my focus is on the level of movement politics.

One other anticipatory clarification in my approach might be entered at this point. This book is not an effort to deny that we have much excellent work on modernism that approaches it in a narrowly aesthetic way. My suggestion rather is that the formalist understanding of modernism unfolded as part of its history and that we need to remember that an emphasis on formalist or aesthetic modernism came only in the wake of modernists' disillusion with their political projects. Moreover, I believe that formalist and narrowly aesthetic approaches to modernism have been overdone and that they result in certain blindnesses, which it is my object to correct here. One such blindness is the idea that it was because modernism lacked a politics that "postmodern" movements after 1970 came to reject it. In my view, many of the so-called postmodern movements are better understood as efforts to recoup the political dimensions of early modernism—however unacknowledged this link may be—than as radical breaks with later modernism.[31]

The related notion of avant-garde, with its self-evidently political resonances, also figures importantly in my approach and, I would argue, ought to preoccupy anyone concerned with modernism. Unfortunately, however, despite the pioneering work of Renato Poggioli, which treated avant-gardes as integral to a political understanding of modernism, most recent scholarship seems to rely more on the alternative "classic" account of Peter Bürger, which, while certainly superior to Poggioli in many respects, is highly misleading on the relationship of modernism and the "historical avant-garde."[32]

Although Bürger's approach—and its defects on this score—are now well understood (the German original appeared more than thirty years ago), a few words of summation and critical assessment are in order.[33] Bürger treats the "historical avant-garde" (in contrast to the post–World

War II "neo-avant-gardes") as both chronologically and institutionally distinct from modernism, which is understood as having formalist preoccupations that link it closely with aestheticism. Indeed, Bürger uses the concept of modernism very sparingly (despite his debts to Adorno), apparently because it remains bound up for him with aestheticism, autonomous art, and art-for-art's-sake—all ways of describing the "bourgeois institution of art" from which avant-garde movements sought to break. These movements, which Bürger most closely associates with dadaism, early surrealism, and Russian constructivism (but not with Russian or Italian futurism), are defined for him by their aim of destroying the bourgeois institution of art, including modernism, and then reintegrating the hitherto separate spheres of art and life. In short, for Bürger, modernism represented a withdrawal from politics and the public realm, which the avant-garde then sought to reverse through the formation of a new politicized institution of art merged with life.[34]

In seeking to distinguish modernism as the culmination of a bourgeois institution of art from which the avant-garde represents a radical break, this account runs into a number of conceptual and historical problems. First of all, and most simply, if one reviews all the individuals and movements usually associated with modernism and avant-gardism, it becomes evident that most of them involved different combinations of what we might think of as modernist and avant-garde impulses. Consider Kandinsky, for example, at whom we will look closely in chapter 4. Frequently seen as a paradigmatic modernist for his championing of "high art" and for his formalist preoccupations (as well as an aestheticist for his inclination toward a "religion of art"), he was also, through most of his artistic life, an active avant-gardist by any of the common usages of that term, including the notion of reintegrating art and life. Indeed, as each of the figures considered in this book illustrates in a distinctive way, modernism in the sense of the pursuit of an autonomous logic of art, and avant-gardism in the sense of an effort to have art impact life, typically went together, however unlikely that may seem. Of course, the fact that there is considerable overlap between modernist (even aestheticist) and avant-garde impulses does not mean that one impulse or the other might not predominate in a certain period. So it might still be, as Bürger suggests, that avant-gardism comes to predominate during the war and early postwar years, when the need and opportunity for political reconstruction was the greatest. Yet if we think of avant-gardism, as we will in this study, primarily in terms of political practices aimed at moving art into the center of public life—practices that are developed and instituted by

self-determining, politically independent individuals or groups—then the heyday of avant-garde modernism lies before the war not after it. For, as already indicated, during and after the war, avant-gardes (with some notable exceptions such as dada and Italian *strapaese*) tended to surrender their political independence and to pursue their politics by means of one form or another of alliance strategy. It was precisely because the political challenges of those years were so great that avant-garde modernism in its pure form was rendered suspect as utopian and strategically inadequate.[35]

Another problem with Bürger's effort to distinguish modernism and avant-gardes as institutions of art is his claim that the latter sought to destroy the autonomous work of art. It is true that the dada movement, drawing on futurism, created an "anti-art" and that surrealism later joined in the project of desanctifying the idea of the autonomous work, yet they did so by creating de-aestheticized works, which, however divested of the celebratory and reconciling qualities associated with sacralized "high art," nonetheless achieved notable success in that milieu, as their continued display in museums around the world reminds us.[36] This is why recent work on surrealist visual art has carefully distinguished between the movement's goals of superseding art and realizing it in a more generalized creativity on the one hand *and* its actual implementation of such avant-garde goals on the other.[37] Moreover, even to the extent that Bürger's avant-gardes did seek to destroy the autonomous work, they sometimes worked in diametrically opposite ways. Thus, as we will see in chapter 4, the productivists whom Kandinsky encountered in the Moscow of 1918–1921 wanted art to have use-value, while the later surrealists that we take up in chapter 7 were radically opposed to use-value. For all these reasons, Bürger's avant-gardes simply cannot be separated from the larger modernist movement in which they took part. Nor can Bürger's related notion that aestheticist withdrawal first came under attack by the historical avant-garde be accepted. We need instead a larger picture in which aestheticism comes under attack by modernism (hence much earlier than Bürger believes), while modernism incorporates what he calls avant-garde and cannot be detached from it.

Let me now turn directly to how the terms *avant-garde* and *modernism* are understood in this book. I use *avant-garde* to represent the set of practices that artists, individually or in groups, develop to challenge the "bourgeois" institutionalization of art; to gain the attention of, and potentially expand, not only the audience for art but those who create it; to establish a greater presence for art within the public sphere and in the

projects of other elites; to define artistic value in ways that promote their own art as well as helping them maximize their control over it; and to make specific claims about what art is or has been, as well as about what sort of culture a particular nation, or modernity in general, should cultivate.[38] This usage builds upon but is distinct from three other usages, all valuable, that are prominent in the scholarly literature: a formalist usage in which *avant-garde* refers to art that challenges the status of the autonomous artwork; a cultural one in which it is identified with a certain animus or "spirit"; and an institutional one in which it is identified with the launching of a collective movement with certain stated goals.[39] My approach is closest to the last of these, but I want to complicate it with the recognition that establishing a movement is not always the foundational avant-garde practice. As we will see, Marinetti began by publishing a manifesto and only then turned to assembling the group to which "futurism" would eventually correspond. My approach allows us to leave open the question of which practices will be utilized in seeking to achieve avant-garde goals. There is no doubt, for example, that the manifesto is the signature avant-garde practice, yet we will see that Kandinsky intentionally avoided the manifesto form when he launched Blaue Reiter as an avant-garde movement.

Modernism, as used in this book, refers first of all to a discourse and set of attitudes with three central features: the perception of a civilizational crisis in which the expansion of commodity culture loomed large; the belief that this crisis could be resolved by reconfiguring modernity rather than retreating to some premodern state; and the conviction that a self-consciously modern art is fundamental to resolving the crisis because of its potential to reshape the public sphere in a way that would give new life to the qualitative dimensions of human experience. Given these convictions, many modernists engaged in avant-garde practices in order to further them, although there were certainly also many modernists who did not.[40] Typically, such non-avant-garde modernists pursued a "high" art with less regard for the interests and needs of their audience. There were also probably some avant-gardists in the modernist period who did not have modernist convictions. Some cultural movements under Italian fascism, such as the circle around the Florentine journal *Il Bargello* in the early 1930s, seem to fit this description.[41] In any case, a concept of nonmodernist avant-garde is useful in approaching certain limit cases, such as the positivistic and in some ways antidemocratic "modernism" of Charles Jeanneret (Le Corbusier) considered in chapter 5 or the elitist and aesthetically classicist Italian Novecento movement discussed in chapter 6. In

general, this book treats as pure cases of avant-garde modernism those that take political and organizational autonomy as a central value, refuse to compromise it through any form of alliance, and use it to resist commodification. In so doing, my argument is not that modernism can be fully "explained" on the basis of "resistance to commodification," but rather that such a notion is fundamental to understanding the interaction of modernist convictions and avant-garde practices.

Once we come to see modernism in this way—as a set of ultimately political convictions which are, therefore, often allied with avant-garde practices—I believe that we can go further to grasp its place within a reformulated version of Bürger's "bourgeois"—or, as I call it in more neutral descriptive terms—"modern, marketplace" (or simply "modern") "institution of art." Bürger has convincingly shown that this modern, marketplace institution of art is the historical successor to the patronage-based "courtly" as well as the church-based "sacral" institutions of art. Yet I believe that his concept of an institution of art, while of great value in properly contextualizing aesthetic-political positions and individual works of art, tends to be too deterministic, too controlling of the realm of aesthetic creation subordinate to it. I also regard his account of the historical unfolding of the bourgeois institution of art as too wedded to a Marxist teleology in which the avant-garde plays the role of the proletariat in relation to the modernist bourgeoisie. Avant-garde art is never a complete break with autonomous art, however much it may experiment with alternatives to it, and aestheticism and modernism are more than just styles or harmless aesthetic variants of whatever we may take as the bourgeois mainstream. Rather we should see the modern institution of art as (or in relation to) a dynamic field of constantly evolving, aesthetic-political "positions." Such positions often represent forms of contestation, which are carried out not only through works of art themselves but through avant-garde political practices of various types, including those that sustain the project of creating alternatives to conventional artworks. Yet even the most contestatory positions will not be wholly antagonistic to the modern institution of art, since those engaged in them are necessarily also self-interested (and often actively self-promoting) players within the mainstream practices of the institution, which of course include the production for sale of works of art. In short, avant-garde practices always involve ambivalence. We will encounter many examples of this ambivalence in this book, but nowhere more so than in chapter 7, which takes up what is arguably the most radical challenge of all to the modern institution of art, Breton's surrealism.

The field of positions within the modern institution of art can be studied synchronically, but it also develops dynamically over time. As the chapters to follow will suggest, I believe that the postromantic world of European art can be usefully approached as a constantly shifting field of positions which nonetheless underwent two especially fundamental reorientations—one around 1900, the other around 1960—which correspond to widely influential changes in perspective on how the art world should deal with the interrelated advance of commodity culture and cultural democracy. Before 1900, positions prevailing in the field were generally one variety or another of aestheticism—or what I refer to as the "religions of art" spawned largely by the romantic and objective-idealist critiques of Kant. After 1900, in contrast, the field becomes increasingly populated by modernist positions that, while never representing a clean break with aestheticism, nonetheless become much more democratic and therefore resistant to its notion of an "aesthetic caste." Then, in the two decades between 1950 and 1970, the modernist positions in turn lose momentum and are no longer persuasive to younger generations oriented to a more activist as well as a more "pop" culture. Again there is no clean break in the field, and many modernist attitudes no doubt continue to persist even up to the present, even as the overall field fragments and becomes more difficult to characterize in terms of any single prevailing orientation.

While I do not seek to "explain" these reorientations in the book, I do believe that an understanding of processes of commodification and democratization will be integral to any satisfactory explanation of these cultural moments. For the modern institution of art, the central questions these processes posed were these: what is art and for whom is it produced? To speak very generally, in the aestheticist field of positions, what counted as art was decided largely by artists, and while artists did sometimes seek to reach a broad public, they ultimately judged as failures their efforts to do so. The notion that typically followed was either that capitalist societies would have to be wholly redesigned to blunt commodity culture and make possible the reestablishment of genuine art *or* that the community toward which genuine art might be directed would have to be limited to an "aesthetic caste" of practitioners and connoisseurs. Such aesthetic-political positions were possible because it was still assumed either that commodity culture could simply be reversed or that "art" could be neatly separated from the public sphere and constituted as a distinct world outside and in opposition to it. By the end of the nine-

teenth century, however, these assumptions ceased to be plausible and the relationship between art and the public sphere underwent renegotiation.

Again, speaking in very general terms, we can say that in the modernist field of positions that succeeded aestheticism, arts-intellectuals thought it neither possible nor desirable to withdraw into themselves. Nor in general did they believe that it would be possible to suppress commodity culture entirely by redesigning capitalist societies.[42] Commodity culture would have to be actively confronted, yet in a realistic way that did not preclude learning from it or even embracing some of its strategies. Modernists therefore pursued the aim of reaching a broad public much more stead-fastly than the aestheticists had, even as they retained the notion that they alone could properly define and judge art. Whether they conceived their aim as gaining control of and redirecting commodity culture or position-ing their art as a bulwark against its unchallenged advance, modernists in-sisted on remaining the sole arbiters of artistic value, thereby rejecting any notion that measures based on exchange value such as "popularity" might need to be taken into account. In this sense, modernism aimed at a democratic audience modeled on a universalizing of an aesthetically informed elite. However, for reasons that we will explore in the case of Great Britain, this model no longer seemed compelling to arts-intellectuals coming of age after the Second World War.

Regarding the field of positions after the retreat of modernism in the 1950s and 1960s, I am quite frankly less than fully clear. It may even be too early to assess them accurately. Suffice it to say that the model of the universalized elite undergoes massive critique and seems to be largely abandoned in favor of a postmetaphysical understanding of what counts as "art." For most members of the postwar generations, what counted as art could no longer be decided in advance by artists, allied taste profes-sionals, or some "avant-garde," but could only be determined in relation to the active intervention of the community of readers and viewers who represented its audience. Art from this point of view was no longer a spe-cific kind of object displaying certain formal properties but became whatever the community of observers (including such "avant-gardes" as remained) decided it was. Within this framework of convictions, societies were understood as producing a wide variety of things that counted as art irrespective of whether their origins lay in "pop" or "commodity culture," or whether they happened to enjoy great "popularity" or "box office." Indeed, the latter measures were now often treated as reasonable considerations within a descriptively based evaluation process, although

many contestations on this point continued to be evident. A professionally minded arts community remained central for this aesthetic-political field, but it no longer saw itself functioning as an arbiter of taste set above or against the larger community. Moreover, the conviction that "art" could or ought to be placed outside commodity culture or popular entertainment was now mostly rejected in favor of the view that it necessarily included all forms of cultural expression and that there was no intrinsic hierarchy among them.

To explore modernism as a field of positions within the modern institution of art and in relation to the fields that came before and after it, this book turns first to the nineteenth-century intellectual milieu out of which modernism emerged. Here my focus is on the rise of commodity culture and the way intellectuals reacted to it by creating "religions of art." I then consider the practices of avant-garde modernism by focusing on ten exemplary figures who are sometimes treated in chapters devoted to them alone, sometimes more thematically in relation to others who made similar choices or shared the same national context. Obviously, no such method of selecting exemplars can claim to be perfectly representative, but I have made my selections with an eye toward having them be as representative as possible of the positions in the avant-garde modernist field. Thus, for example, Marinetti, Apollinaire, and Kandinsky all represent major prewar avant-garde modernist positions that arise in different national contexts and are quite different in their nature and implications. Moreover, as we will see, the latter two positions were in some ways reactions against the first; treating them together therefore helps to illuminate them. In chapter 5, which considers the emergence of design modernism, I focus again on three individuals—Walter Gropius, Theo van Doesburg, and Le Corbusier—who represent differing approaches that grew out of distinct national contexts. Chapter 6 then considers the postwar Marinetti in relation to his revised avant-garde practices as well as those of the other modernist movements during the fascist period that competed with futurism for the favor of Mussolini's regime. Chapter 7 is devoted to Breton's surrealism in relation to rival positions such as purism and futurism, its stance toward commodity culture, its efforts at an alliance politics, and its attempts to cope with the failure of those politics. Chapter 8 then takes a look, through the prism of Read's criticism, at how modernism adapted to the increasing fragility of its pure avant-garde, design-modernist, and alliance variants, as well as at a leading intellectual from the European nation in which modernism had the longest and fullest evolution.

In short, this is a book about the politics of modernism that attempts to represent as fully as possible the evolving field of modernist positions. It is not directly a book about art: although many of its protagonists were of course artists, often exemplary artists, readers can readily turn elsewhere to increase their appreciation of Apollinaire's poetry, or Kandinsky's painting, or Le Corbusier's architecture. Moreover, I have not let my selection of protagonists be governed by their artistic excellence. The art and poetry of Herbert Read, for example, are today almost forgotten, but his avant-garde involvements are brilliantly illustrative of the way in which the activist side of modernism lost momentum and ultimately exhausted itself amid the political turmoil of the interwar and postwar years. The one external factor that does influence my choices is my desire to deal in some way with each of the most important national contexts. Considerations of national balance have also affected my presentation of the nineteenth-century background to avant-garde modernism in chapter 1, although the reader will find that I share the usual assumption about France's overwhelming importance in that history. Avant-garde modernism was strongest in national contexts where the sense of cultural crisis was most pronounced and where the political environment was liberal enough to allow oppositional expression to exist. In general, none of the European nations was wholly inhospitable to avant-garde modernism in the prewar period, although the specific character of the political environments in Italy, France, and Germany certainly left marks on the movements that arose in their midst. Moreover, the sense of crisis was certainly stronger in Italy and Russia than in Britain or the Netherlands, which may partly explain why avant-garde movements were relatively less strong (and relatively late when they did come) in the latter nations. One nation that receives less attention in this book than it deserves is Russia, which would doubtless have received more had I been a reader of the Russian language. In the postwar period, those modernist movements most able to endure were those operating in political environments where at least some traces of liberalism remained. While they therefore flourished briefly in both Germany and the Soviet Union, they were unable to survive the age of Hitler and Stalin, and they were able to survive in Italy only because Mussolini's regime was less efficiently brutal than those of the other interwar dictators. The focus on postwar Germany is therefore relatively early, and it is certainly not an accident that the final two chapters focus on France and Great Britain.

EARLY AVANT-GARDE MODERNISM

1

Intellectuals, Commodity Culture, and Religions of Art in the Nineteenth Century

In one of his earliest reflections, Walter Benjamin wrote that "color is something spiritual, something whose clarity is spiritual, so that when colors are mixed they produce nuances of color, not a blur." He gave as an example the rainbow, which is "a pure childlike image. In it color is wholly contour; for the person who sees with a child's eyes, it marks boundaries, is not a layer of something superimposed on matter, as it is for adults. The latter abstract from color, regarding it as a deceptive cloak for individual objects existing in time and space." As the child views it, color allows for the creation of an "interrelated totality of the world of the imagination." Unlike most adults, artists continue to participate in this world, which is why they are able to lead us to a kind of imaginative experience in which life presents itself as just such an interrelated totality. "The order of art is paradisiacal," Benjamin concluded, "because there is no thought of the dissolution of boundaries—from excitement—in the object of experience. Instead the world is full of color in a state of identity, innocence, and harmony."[1]

Just a year before, a forty-seven-year-old Kandinsky had opened some autobiographical reflections by describing the colors that had made the most powerful impression upon him as a child. Among them was the "juicy green" that was exposed as the second layer of bark that "the

coachman used to strip from thin branches for me to create a spiral pattern." Such primal experiences, he tells us, had provided him with the spiritual resources that had in turn made possible all of his art, an activity that he compared to "hunting for a particular hour, which always was and remains the most beautiful hour of the Moscow day. . . . To paint this hour, I thought, must be for the artist the most impossible, the greatest joy."[2]

Despite great differences in age, background, and vocation, Benjamin and Kandinsky shared a sense that our experience of color offered special access to a kind of prereflective immediacy, that this access gave art unique value as a conduit to an absolute realm beyond finite experience, and that in such a linkage of art and spirituality lay the highest sort of happiness. For the young Benjamin, such insights quickened his sense that a new, genuinely post-Kantian epistemology was possible, one that would overcome the splits between subject and object, reason and understanding, forms of intuition and linguistic categories—splits that shut us off from spiritual experience and leave us with a desiccated conception of human existence.[3] Because works of art were free to treat color not as "superimposed on matter" but as a medium of intuition that came prior to spatio-temporal intuitions of form, they were able to restore to us a form of experience prior to the "adult" Kantian world and, in doing so, promised a possibility of peering through the cracks and distortions in the patterns and rhythms of everyday finitude, thereby relocating lost traces of the absolute.

The dream of drawing upon prerational, "childlike" resources in order to reintegrate the modern experiential world and reestablish our access to the absolute did not of course begin with the modernist generations. Romantic, Hegelian, and a variety of postromantic attacks on Kantianism and the Newtonian worldview that underlay it were a staple of nineteenth-century intellectual life in Europe, the dialectical twin of the positivism and materialism that such critiques rightly saw as dominating the age. Yet the fact that such attacks, despite their frequent vigor, appeared to be peripheral to the main currents of nineteenth-century European thought until its closing decade suggests that the influence exerted by the Kantian worldview, and the hegemony of scientific inquiry that it sanctioned, derived from more than just Kant's own formidable intellectual powers. As Jürgen Habermas has argued in his presentation of Max Weber, the categorical separation of truth, morality, and beauty deriving from Kant's philosophy expressed the irrevocable transition away from a society based on a hierarchical, religiously sanctioned

worldview linked to a single monolithic value system, a transition that is constitutive of the epistemological and experiential conditions of "modernity."[4] Kant's conception of experience legitimated an approach to knowledge that treated natural science, morality, and aesthetics as separate domains, each with its own inner logic, each requiring a specialized form of inquiry that was autonomous from the others. In this view, truth is associated primarily with the scientific understanding of nature, but each of the spheres is rationalized in the sense that its truths no longer depend upon any relationship to some prior cosmological or metaphysical system but rather follow from inquiry proper to that sphere. The way thereby opens for science to pursue ever more specialized inquiries, which become institutionalized as distinct disciplines and professions, and whose results do not need to be coordinated with morality, aesthetic truths, or any general metaphysical understandings. Indeed, scientific truths become wholly inaccessible to everyday consciousness. As Hannah Arendt would later write, "though they can be demonstrated in mathematical formulas and proved technologically, [the truths of the modern scientific worldview] will no longer lend themselves to normal expression in speech and thought."[5] In such a world, immediate experience—like a whittled branch or a Moscow sunset—becomes obsolete and probably illusory as any sort of knowledge.

It is hardly a surprise that intellectuals primarily oriented to aesthetic and spiritual experience would feel uncomfortable in a world where knowledge had not only been sundered into incommunicable bits but in which the forms of it they privileged had been rendered secondary, if not altogether suspect. Yet their sense of a sundered or fragmented experience was by no means confined to epistemology. The stripping away of recognizable and expressible qualities that Arendt had noted in the world of modern scientific understanding was paralleled in the world of nineteenth-century labor. As G. W. F. Hegel was already suggesting in his early Jena lectures, the concrete labor of peasant agriculture or artisanal crafts had given way to an abstract world of factory production in which the laborer no longer brought forth a completed product and in which the "labor of the bourgeois class" had become an "abstract trade with an individualist mindset based on uprightness."[6] Moreover, the enormous increase in goods produced for the market, whose circulation was made possible by the abstraction of the money form, had produced a dizzying world of exchange no longer linked to concrete human needs or continuous face-to-face relationships. The world of things had ceased to manifest a space-time continuum and now appeared as a jumble of isolated moments whose

connections were not immediately apparent. In the rapidly expanding urban settings in which such manufacture and commerce took place, life took on an abstraction and depersonalization that threatened a sense of enduring subjectivity, as well as a rapidity of movement and increase in scale that redefined it.

Yet there was also a more positive way to construe the changes becoming manifest in nineteenth-century urban life. One of Hegel's great insights, which philosophically informed sociologists such as Weber and Habermas would later pursue, was that the fragmentation of experience that the Kantian worldview and the material organization of modern life both implied were two sides of a single process: that of the decline of a hierarchical, religious, and metaphysical mode of organizing and legitimating a cultural order. Although the nature of the new regime of modernity that would come to replace this hierarchical cultural order was not yet fully evident, Hegel understood that the modern fragmentation of experience was at the same time the cultural democratization of experience—a process he sought to moderate in antidemocratic ways. Such efforts, however, were ultimately futile. As another of Hegel's twentieth-century students recognized in a classic essay, in the modern world "a democratizing trend is our predestined fate, not only in politics, but also in intellectual and cultural life as a whole."[7]

Looking back upon the nineteenth century from our vantage point in the twenty-first, I would suggest that with the democratic revolutions of the end of the eighteenth century came a collapse of social hierarchies whose consequences may be summarized in four points. First, the normative basis of social structure and organization moved in the nineteenth century from the vertical to the horizontal, from a social order based on rank and honor to one based on human dignity and rights in which the "essential equality of all human beings" is affirmed as a "fundamental principle."[8] This new normative foundation obviously did not mean that actual relationships of wealth and power were equalized or that hierarchies of class, gender, race, or nation were erased. Indeed, to many observers of modernity the opposite has seemed truer: relationships of wealth and power tend toward greater inequality, and empirical hierarchies intensify as democratization advances and system capacities expand. Still, the normative change involved in the requirement that all persons, regardless of class, status, or wealth, be addressed as Mr. or Mrs. and be entitled to equal rights under the law has had profound implications for every aspect of life—political, social, economic, and cultural. Second, the repository of the rights and dignity inherent in this

new, more horizontal culture is the human individual who is conceived as a unique being—as a person with "individuality" who can be "true" to himself or herself, who demands recognition as much for his or her uniqueness as for his or her universality as a bearer of dignity and rights, and who desires to be able to express that uniqueness through creative activity. Third, in such a democratizing culture, value judgments about persons assume increasingly objective forms. Although race, class, gender, and other forms of bias continue to inform these judgments, such intrinsic or ascribed criteria come under relentless pressure, and value judgments about persons are increasingly granted legitimacy only when based on the merit of individual achievements extrinsically measured. Finally, this new democratizing culture becomes linked to the development of public spheres, which, however imperfectly realized in institutional terms, tend normatively to regard all individuals as equally legitimate participants. Similarly, this culture becomes linked to an economic marketplace in which individuals are formally free to enter into contracts that will be legally enforced without regard to the social status or economic standing of the participants; to representative political institutions based on ever-increasing (ultimately universal) rights of suffrage; and to institutions of popular culture such as film and newspapers in which "an increasing number of readers become writers" as "everyone becomes something of an expert."[9]

Sketched in such broad strokes, modern democratic culture may seem utterly familiar, yet it contains one anomaly important for grasping the cultural life of the nineteenth and twentieth centuries that is easily missed. While the normative equality bound up with the collapse of social hierarchies implied a process of homogenization that nineteenth-century intellectuals often referred to dismissively as "leveling," the romantic sense for the "individuality" and even uniqueness of individuals that began to be asserted by writers such as J. J. Rousseau and J. G. Herder opened up a space for heterogeneity that was no less palpable. Thus, even as claims to privilege on the basis of inherited status became normatively less valid, claims to recognition on the basis of individual uniqueness often took their place. Moreover, as Herder was perhaps the first to see, claims to recognition on the basis of uniqueness could apply not just to single persons but to the cultural groups from which they took their identities (nationalities, religions, ethnicities, linguistic groups, professions, and, ultimately, genders and sexual orientations). Indeed, as one student of multiculturalism points out, claims to recognition in our world generally have far more to do with allegiances to cultural groups

than with the inner voices of pure individuality.[10] In the intellectual world of modern art, efforts to assert control over the production, distribution, and evaluation of art by artists seeking special recognition as a group (e.g., futurists) were common. And even where such group claims were absent, it was arguably their sense of themselves as special persons which explains why modernists invariably tied their support of democratic culture to the idea that they would retain control over artistic standards and that art would not be reduced to a commodity.

But let us return to the nineteenth century. With his project on the Paris arcades, the mature Benjamin launched perhaps the most ambitious effort to comprehend the changing dimensions of nineteenth-century urban experience that has ever been conceived. From a mass of notes that would ultimately amount to over eight hundred printed pages, he wrote a synoptic essay in 1935 responding to a request from Theodor Adorno and the Institute for Social Research in New York. Here, in six short kaleidoscopic sections, he argued that four new phenomena had converged to produce a fundamentally changed urban world by the early 1850s: a culture of commodification; an allied entertainment industry based on exhibitions, amusement parks, newspapers, and advertising; visual imaging technologies such as panoramas, daguerreotypes, and photography; and a public architecture based on iron and glass. As he explained in a central section dedicated to the Parisian caricaturist and illustrator Jean-Ignace-Isidore Gérard (Grandville):

> World exhibitions glorify the exchange value of the commodity. They create a framework in which its use value recedes into the background. They open a phantasmagoria in which a person enters in order to be distracted. The entertainment industry makes this easier by elevating the person to the level of the commodity. He surrenders to its manipulations while enjoying his alienation from himself and others. The enthronement of the commodity, with its luster of distraction, is the secret theme of Grandville's art. . . . Its ingenuity in representing inanimate objects corresponds to what Marx calls the "theological niceties" of the commodity. They are manifest clearly in the *spécialité*—a category of goods which appears at this time in the luxuries industry. Under Grandville's pencil, the whole of nature is transformed into specialties. He presents them in the same spirit in which the advertisement (the term *réclame* also originates at this point) begins to present its articles. He ends in madness.[11]

Grandville's accommodation to the new commodity culture represented one artistic response to the new convergence of commodity and visuality in mid-nineteenth-century Europe. But Benjamin was keen to show that another such response in those years had been no less fervent.

In the penultimate section of his essay, devoted to the intellectual as *flâneur,* he crystallized the two interconnected responses:

> The art that begins to doubt its task and ceases to be "inseparable from . . . utility" (Baudelaire) must make novelty its highest value. The *arbiter novarum rerum* for such an art becomes the snob. He is to art what the dandy is to fashion. . . . Newspapers flourish, along with *magasins de nouveautés.* The press organizes the market in spiritual values, in which at first there is a boom. Nonconformists rebel against consigning art to the marketplace. They rally round the banner of *l'art pour l'art.* From this watchword derives the conception of the "total work of art"—the *Gesamtkunstwerk*— which would seal art off from the developments in technology. The solemn rite with which it is celebrated is the pendant to the distraction that transfigures the commodity. Both abstract from the social existence of human beings. Baudelaire succumbs to the rage for Wagner.[12]

Interestingly, however, market-oriented opportunism and autonomous art do not exhaust the routes that Benjamin saw for intellectuals in this new commodity culture.

In the final section of the essay, Benjamin reflected upon the development of the forces of production which, in the nineteenth century, had been so powerful as to "emancipate the forms of construction from art." Yet the artistic possibilities that inhered in the new glass and steel architecture, photography, commercial art, and literary montage are not fully realized and "linger on the threshold." Nineteenth-century artistic intellectuals, he suggested, might have asserted their support for the democratization of culture by exploiting the artistic potentials of newly available technologies, but, in the end, they only "dreamed" an epoch to follow.[13]

The vista that Benjamin's project opens on to the nineteenth-century cultural and intellectual world suggests, convincingly to my eyes, that the development of a commodity culture was the decisive element in the reconstitution of experience that Europe's populations underwent with increasing rapidity as the nineteenth century unfolded. He does not suggest, nor do I want to imply here, that the sources of this reconstitution can be reduced to commodification, even when it is understood in the broader context of technological change and urban development that he provides.[14] Yet the central importance of commodification becomes clear when one recognizes its nodal position as a process in which both the fragmentation and the democratization of experience are deeply implicated. Commodification is a necessary condition for the division of labor that in turn makes possible the impersonality and vast scale of modern

economic life, even as it also makes possible the mechanisms of free market exchange that, in some significant measure, all democratic cultures must possess.

Benjamin's 1935 essay seems to me particularly suggestive in the way it evinces the turns in nineteenth-century intellectual life from the coming of commodity culture. Joining forces with the "market in spiritual values," mobilizing autonomous art as a mode of self-defense, and working to develop new potentials for a democratic art out of advances in modern technical and social organization: these were the major options confronting artistic intellectuals in the period.[15] And important forms of avant-garde modernism would develop not only from the last of these but from democratized versions of the others as well. Therefore, in the remaining sections of this chapter, we need first to look more closely at what the historical process of commodification entailed and then to consider briefly several of the key figures and movements that, during the second half of the nineteenth century, responded to commodification with new "religions of art." As we will see, avant-garde modernism marked a break with these "religions" in the sense that the undemocratic and antimodern elements they often mixed into their transforming conceptions of the place of art in modern life appeared out of touch with an increasingly entrenched commodity culture by the early twentieth century. Nonetheless, the persistent effort among some modernists—Kandinsky and the early Benjamin foremost among them—to locate in art the possibility of a kind of ontological revelation cannot be understood independently of this tradition.

COMMODIFICATION AND COMMODITY CULTURE

Few theorists are so inextricably connected with a topic as is Karl Marx with commodification. Certainly no writer of his era reflected more deeply upon the nature and cultural implications of the commodity form, or upon the historical development of the bourgeois class and the market society which the commodity form made possible. It is true, as many recent critiques of Marx on the commodity form have shown, that his conception remained firmly grounded in the sort of productivism that also characterized the understandings of such contemporaries as John Ruskin and William Morris.[16] No one writing in the mid-nineteenth century could have understood the semiotic and consumerist dimensions of the commodity form in the way that more recent developments have brought them to light. Yet the canonical status enjoyed by such passages

as *Capital*'s presentation of commodity fetishism and the *Communist Manifesto*'s bitingly condensed history of bourgeois market society are well deserved.

Marx understood that the commodity form excited a strange fascination. For him, this fascination was mostly rather dry, having to do with the "theological niceties" to which Benjamin referred, but the famous passage from *Capital* does also characterize it as "grotesque" and "wonderful," suggesting some connection to the aesthetic and to desire.[17] Marx saw that the commodity has a "transcendent" aspect lacking in those "common everyday things" produced for use out of "material furnished by nature." He understood that the commodity was alien, in that it was produced for impersonal exchange, but also magical in the way it thereby transcended immediate use, transformed social labor into an "objective" feature "stamped upon the product," became as much image as object, and thereby offered a kind of "promise of immortality."[18] Commodities, he understood, simply "appear" on the market, both because of the discontinuities in production to which Hegel had called attention, as well as because of the way the capitalist marketplace separates production and exchange. Capitalism gives products a "two-fold character" as both "a useful thing and a value." Fetishism arises "only when exchange has acquired such an extension that useful articles are produced for the purpose of being exchanged."[19] Yet Marx did not then go on to ask how the consumer's participation in buying the impersonally produced image-object complicates fetishism. Despite his alignment of commodities with exchange rather than use, consumption for him remains unproblematically identified with "use" rather than with meaning-giving symbols.[20]

Nonetheless, Marx did understand that in a culture dominated by the buying and selling of commodities, exchange value becomes the dominant way of understanding all value. Not only is use value denigrated, but all other modes of determining value, such as those that inhere in personal life, politics, religion, education, or culture and art, come to be reshaped by, if not reduced to, exchange. Here his enormously funny disquisition on money is perhaps the central text.[21] While it probably escaped him that his own theoretical unmasking of commodification might itself become, paradoxically, a fashionable commodity, he surely recognized that critical theorists or artists will have their motives strongly suspected when financial gain accrues to them (a circumstance he himself was not fortunate enough to enjoy). He also appreciated how social and personal relationships are potentially poisoned by their con-

nections to economic exchange, which is why his descriptions of ideal friendship and the utopian social settings in which they occur are invariably decommodified.[22]

Perhaps most important, Marx understood commodification as a long historical process involving many economic, social, and cultural complexities. In both the *Communist Manifesto* and the commodity fetishism passage of *Capital,* his contrast system is European feudalism, although the contrast operates in nearly opposite ways in the two texts. Commodities, he argued, had appeared "at an early date in history," and some of the social features that we associate with them—such as a class of "free" laborers that is bought and sold as "labor power"—had begun to appear then as well, but commodities did not then impose themselves "in the same predominating and characteristic manner as nowadays."[23] Moreover, this developmental process involved a recasting of social relations and of basic cultural understandings, such as the relationship of sacred and profane, that was so gradual and subtle as to be beyond the consciousness of all but the most perspicacious observers. All societies, he understood, create boundaries between a profane realm in which market relations are permitted and a sacred realm in which they are not.[24] Typically, religion, education, art, and the human body itself are withdrawn from market relations, yet societies vary in precisely what and how much are so withdrawn. Marx saw that capitalist societies not only tended to shrink the sacred realm in comparison with precapitalist ones, but that the process of commodification in capitalist societies involved an unrelenting onslaught on nonmarket realms. In the capitalist societies of his own day, "all that is holy" had become "profaned," and "the most heavenly ecstasies of religious fervor" were drowning "in the icy water of egotistical calculation."[25]

It is with the nearly simultaneous appearance of two novels in Paris in the early 1880s that we first encounter a view of the commodity form that clearly comprehends what I am calling its semiotic dimensions.[26] By the semiotic dimensions of consumption, I mean, following Pierre Bourdieu, the ways in which consumption becomes bound up with "acts of cognition" and a "process of communication" which together allow a social code of available meanings to be deciphered and publicly transmitted as symbolic self-representations.[27] In the first of these novels, Émile Zola's *Au bonheur des dames* (1883), the phantasmagoric, machinelike flow of goods and female shoppers fills the cavernous spaces of one of the city's new *grands magasins,* a "cathedral of modern commerce, light but solid, made for a nation of customers." In portraying Au

Bonheur des Dames in all of its overblown grandeur, Zola attends to every detail of retailing and advertising from the Haussmann-engineered boulevards that lead to its shop windows, to the opulent lighting of the interior with its mounds of goods, many of them reflecting their colonial origins, to the inexorability of their early-morning flow on to the displays "like rain from some upper stream," and finally to the thousands of posters, catalogs, and newspaper advertisements that celebrate this new religion, reveal the social codes embedded within it, and offer related dreams of personal fulfillment.[28] The novel's characters are like so many playthings of these huge new "forces of consumption." Indeed, it is the store itself that plays the novel's leading role, boldly stalking the neighborhood like some huge beast, devouring the family-based competitors that had survived from an earlier era, and seducing its young women to become the shoppers and salesgirls that its relentless motion requires.

With the other novel, Joris-Karl Huysmans's *À rebours* (1884), we move from the public side of the new Parisian commodity culture to its private interior, a villa which a scion of one of France's leading families, the dandy Duc Jean Floressas des Esseintes, painstakingly decorates in celebration of his withdrawal from the frightful mass taste that threatens to engulf him. If Zola's *magasin* is consumerism's cathedral, then des Esseintes's abode is an ornate chapel, each of its carefully selected objects displayed with close attention to both its synesthetic effects and its social meanings. Notable among them is a tortoise glazed in gold and studded, not with diamonds ("terribly vulgar now that every businessman wears one on his little finger") or emeralds and rubies ("too reminiscent of the green and red eyes of certain Paris buses fitted with headlamps in the selfsame colors"), but with sapphires (as yet "unsullied by contact with commercial and financial stupidity").[29] In this animal-become-ornament, Huysmans offers us an apt metaphor for the way in which the people of this new consumerist society had themselves become dyads mimicking the commodity form: both themselves and representations of themselves, both physical beings and sets of associations, both functioning bodies and embodiments of meaning.

The world of des Esseintes is one in which nature is turned into "specialties" as surely as in Grandville. It is a world in which visuality functions unceasingly to bring on appetite and desire, in which consumerism is a compensatory system offering solace, supportive illusion, and relief from cosmic boredom, and in which personal identities are constructed and reconstructed in constant interplay with changing fashions and as

publicly identifiable "lifestyles," themselves the creations of marketers and advertisers. In this world, consumption is far from being the mere ingestion of utilities, far even from status-seeking. Consumption is now firmly grasped as symbolic self-representation, and this opportunity is understood to be built into the commodity form itself as surely as are the sapphires in the tortoise's shell.

By the 1880s, then, it had become recognized as it had not been thirty years before that the commodity, as an object produced primarily for exchange, has two aspects: its functionality (to endure on the market, it must do what its manufacturers purport that it does) and its attractiveness (to endure it must sell and, in order to sell, its manufacturers must seek to imbue it with a radiance, mystique, image, aura, and set of symbolic associations that attract buyers and that will continue to attract them). Commodities, we might say, are both themselves and representations of themselves, and this representation is not a realistic reproduction but a magical idealization. Moreover, this second side of the commodity form becomes increasingly dominant over time as institutions designed to exploit it become increasingly central to the functioning of the marketplace. We might say, in fact, that capitalism as a whole becomes increasingly aesthetic, as commodities become more and more bound up with images, logos, trademarks, and other visual references.[30] In present-day economies this trend reaches an apparent limit in those commodities, like a music video, for which their self-advertisement quality is the product itself. Yet the connection of the aesthetic with the commodity form had already been forged in the world of Grandville, Zola, and Huysmans.

Both Zola and Huysmans approached the new commodity culture of their day with an awareness that manufactured goods were, among other things, projected images that related to one another as words in a language. They understood that each commodity projects associations (a "look"), which will come to be associated with other products of its company of origin and thus with the "brand name" and "trademark" of the company itself.[31] They understood that each product was created to be recognized as distinctive, to arouse in the consumer a sense of personal discovery as well as possibilities of personal fulfillment and social advance. They understood that product images had come to form a cultural iconography of consumption, one that was in turn associated with a myth of abundance and with variety of social types and possible "lifestyles." They recognized that this new cultural iconography had brought with it a gendering of the consuming subject as well as a related notion

that consumer institutions structure human action and create human meaning rather than the other way around. Finally, they understood that commodity culture as a whole was part and parcel of a modernizing world that was bent on destroying traditional institutions and values, especially any of them brazen enough to stand in the way of its relentless advance.

Although recent scholarship seems to have settled upon the concept of a commodity culture to refer to the new world that Zola and Huysmans portrayed, it is rarely defined in relation to the larger historical process of commodification.[32] In this book, I want to associate the concept of commodity culture with four basic features. First, a commodity culture is one in which the semiotic dimensions of consumption are solidly entrenched in social experience and in which goods become meaningful and acquire value primarily through the practices and social institutions associated with consumption rather than production.[33] Consumption, in other words, becomes understood as symbolic self-representation and as the main locus of cultural taste and value, while production, which had played this role in forms of capitalist society prior to commodity culture, becomes a more narrowly technical enterprise.

Second, in a commodity culture the world of consumption will be structurally differentiated from the world of production. Practices corresponding to design, wholesale distribution, and retail sale, which in earlier capitalist and precapitalist societies operated primarily through the sphere of production, will now be autonomously organized and institutionalized. Moreover, because the separation of the institutions of production from those of consumption means that the knowledge base associated with the former is in danger of being unavailable to the consumer, new intermediary professions will arise that aim to "educate" consumers as well as to inform producers about consumer tastes and desires. These "taste professionals," as Leora Auslander has aptly called them, will become active in a variety of occupations, including journalism, advertising, interior decoration, architecture, and commercial exhibiting, as well as in the marketing divisions of businesses themselves.[34] In these capacities, they become the central cogs in a feedback mechanism between producers and buyers. When this mechanism is fully operational, producers become able to reshape production based on the tastes and desires of their target audiences, which in turn permits them to identify, stimulate, and exploit different "market segments" within the overall population.

Third, a commodity culture is one in which the historical tendency for

commodifying practices to extend themselves into such "sacred" realms as art, education, and religion is well advanced. Even mature commodity cultures, for example, will still have at least some residues of craft production and artisanship operating outside the sphere of commodity production, but these sectors will be under enormous pressure to become integrated into the commodity sphere. Similarly, artists working in every field of creative endeavor, educators at all levels, and even clergy and other religious leaders will come under pressure to participate in commodity culture by attuning their own goals and procedures to its imperatives. Ultimately, these institutions will themselves be understood as bringing forth special sorts of commodities—works of art, university degrees, spiritual experiences. The advance of visual technologies based on photography, cinema, and ultimately television and computerization will play a critical, strategic role in this extension of the commodification process.

Finally, however, at least in the early commodity culture with which this book is concerned, resistance to the profanation of formerly sacred spheres is still likely to be intense. Some of this resistance will be based on efforts to decommodify a form of production by moving it back into the sacred realm where buying and selling is considered inappropriate. But a great deal of it will also involve what might be called style and evaluation control.[35] By this I mean efforts by producers to seize control over the process of determining the style and value of a product even while accepting the notion that such products are appropriate for market exchange.

For France, there seems to be rough agreement that the arrival of commodity culture should be located during the three decades that follow the Universal Exhibition of 1855 in Paris, although some scholars might push its advent back into the July Monarchy.[36] For Great Britain, the parallel event was the Crystal Palace Exhibition, which took place in 1851 in London and was attended by over 6 million people drawn by cheap transport not only from London but from every corner of Britain and much of the wider world as well.[37] In other European countries, the arrival of commodity culture was no doubt somewhat later, and in some places in the world it has yet to arrive, although awareness of it is now global. Some historians would distinguish between a bourgeois form of commodity culture in which access remains restricted to moneyed classes and a later "mass" version in which all classes are included, pressures exist not only to buy goods but to replace them frequently, popular entertainments become fully industrialized (as in Hollywood cinema),

and consumerist behaviors of all sorts become a major leisure and iden-
tity-forming activity.[38] For this study, the point that truly matters is that
by the end of the nineteenth century, there is effectively no way for
European artists and other cultural intellectuals to opt out of commod-
ity culture. The most use-value-oriented artifacts will circulate as com-
modities—despite or even because of their origins. Indeed, those objects
that appear to be the least commodified in origin may become the most
valuable precisely because they are viewed as genuine or uncorrupted.
Similarly, as Bourdieu has argued, intellectuals who withdraw from com-
modity culture and forgo "economic capital" may actually increase their
"symbolic capital" by doing so; whatever their intentions, they come to
inhabit a kind of "economic world turned upside down" in which they
have an "interest in disinterest."[39]

Two implications of this relation between commodity culture and
intellectuals deserve emphasis. One is that we must distinguish between
commodification and commercialization. To decide to produce art for a
commercial market or to refuse to participate in it is largely a matter of
personal intent, but whether or not one's art becomes a commodity oper-
ates quite independently of intent. The Picasso painting or the novel by
Kafka may become—almost certainly will become—a commodity irre-
spective of its creator's intentions, and it will continue to be a commod-
ity long after its creator is dead. Second, we will see that the modernists
dealt with commodity culture in various ways, some seeking to bend it
to their own designs rather than rejecting it outright, others opposing it
straightforwardly and often vehemently. Yet the former always showed
ambivalences, particularly on the questions of style and evaluation con-
trol, while the latter inevitably allowed commodification to creep into
their practices however much they rejected it in principle. The reason for
such lapses is quite simple: since all modernists lived in a commodity cul-
ture, and since many of them were intent on expanding the audience for
art while nearly all of them wished at least to have a good audience for
their own art, they could hardly avoid some sort of self-promotion (hir-
ing an editor, contracting with an art dealer) and thus some implication
in commodifying practices.[40]

The arrival of commodity culture with its popular newspapers, adver-
tising, international exhibitions, department stores, dealer-critic system
in art, and other institutions that promote the semiotic dimensions of
consumption is a culminating event in a process of commodification that
stretches back, by most accounts, to about 1400.[41] As such, it represents
more an intensification of a long-standing historical process than a

sharply defined qualitative shift.[42] This process is sufficiently complex that even a brief historical summation will not be attempted here. Suffice it to say that it involves the establishment of a set of conditions for impersonal and expanding exchange over large territories; for production governed by a system of wage labor and capital investment that maximizes profit; for the holding of land and other resources as private property; and for the private rather than collective production and appropriation of goods. Thus the classical narrative of the rise of capitalism focuses on the commodification of land and labor with the wage system, the gradual demise of serfdom, and the increased use of money on regional, national, and international levels.[43] This narrative tends to stress the progressive extension of the commodity form to ever-widening social and cultural spheres as well as the legal concomitants of that extension.[44] As this system of commodified production and exchange grows, older forms based on local and subsistence production are displaced. This displacement is a very gradual one, however, and the actual history of commodification involves a coexistence of commodity and artifact forms, with artifacts coming to circulate as commodities even as they decline in overall quantity relative to commodities. The newer literature on the history of consumption also focuses on the ways in which commodification develops and becomes extended, but it attends as well to such questions as the dating of various consumer practices, the degree to which demand should be treated as a causal agent in industrialization and consumerism, the relation of consumption to class formation, and, most important, the changing institutionalization of consumption as the commodity system becomes increasingly differentiated as well as extended.[45]

There is also a large and variegated literature on the ways in which cultural forms such as theater, painting, literature, music, and popular entertainment were affected by the process of commodification prior to commodity culture as well as during and after its triumph.[46] Here again the fundamental point is that commodification is a gradual process involving many distinct moments over several centuries. Popular entertainment, for example, had been associated since the fall of the Roman Empire with the traveling showman whose spectacle was tightly bound up with the retailing of commodities. Yet, as Asa Briggs has shown, this form of entertainment, which reached local populations on an intermittent basis, gives way in the Britain of 1850 to an urban-based, organized, and ultimately industrialized successor, first through the music hall, then through the rise of professional sports, and finally, after 1895, through cinema—all institu-

tions in which large populations avail themselves of cheap transport and increasing leisure time to go to the entertainment rather than the other way around.[47] Moreover, as Habermas has argued in his study of the bourgeois public sphere, insofar as cultural goods were already being marketed to urban consumers in eighteenth-century Europe, these goods were "in principle excluded from the exchange relationships of the market." Although one paid an entry fee for theater, concert, and museum, and directly for books and art, "exchange value still failed to influence the quality of the goods themselves" and a sense for the "incompatibility between these kinds of products and the commodity form" still pertained. In contrast to the world of this earlier, "culture-debating public," that of the post-1850 "culture-consuming public" is one in which "the laws of the market have . . . penetrated into the substance of the works themselves" as the "consciousness that once characterized the art business as a whole continues to be maintained only in specific preserves."[48]

Before we turn in more detail to these "specific preserves" and the responses to commodity culture of the cultural intellectuals who dwelled in them, it should be noted that these intellectuals, far from merely "responding" to a set of conditions from which they were removed, were actually constituted as a social stratum by these very conditions. As Christophe Charle has shown in greatest detail, the term *intellectual* comes to be used in a new and distinct way after 1880 to refer to an aspiring elite of the well educated who sought to use their access to the press and other forms of publicity to exercise "symbolic power" and thus compete for influence with other elites more firmly in control of the traditional sources of economic and political power.[49] In this period, the intellectual field, which had produced a succession of types from the eighteenth-century "man of letters" to the scientific *savants* with whom the naturalist movement had allied, entered into a crisis provoked both by its great expansion, as the numbers of those liberally educated rose precipitously, and by contestations over what sort of moral, social, and political roles such individuals ought to play. As Habermas put the point, basing himself on the older work of Arnold Hauser: "only then [after naturalism] did there arise a stratum of 'intellectuals' that explains to itself its progressive isolation from, at first, the public of the educated bourgeoisie as an—illusory—emancipation from social locations altogether and interprets itself as 'free-floating intellectuals.'"[50]

The precarious social position in which these intellectuals found themselves reflected a complex set of circumstances connected not only with the arrival of commodity culture but also with contradictory cultural

pressures for both democracy and hierarchy, the general expansion of industrializing capitalism, imperialism, and mass politics, and an educational system overburdened by, and ill equipped to deal with, the demands that all these forces placed upon it. Yet none of these forces contributed more directly to the construction of the intellectuals and the manner in which they would enact their new role than did commodity culture. In mass-oriented newspapers as well as in their own "small reviews," the intellectuals not only found their social voice but learned how to gain attention for themselves by provoking scandals and otherwise developing their capacities for notoriety-enhancing self-performance. Indeed, their sense of being trapped in a commodity culture from which they could not escape could sometimes stimulate the development of these capacities in quite creative ways. As F. T. Marinetti illustrates, there proved to be no surer way for an avant-garde intellectual to gain notoriety than by refusing to pander to an audience, indeed to heap insults upon it as part of a strategic gesture of outrageousness. Yet, having gained attention for themselves through commodity culture, it was also commodity culture that provided these intellectuals with their most fundamental agendas. Could intellectual powers and sensitivities be brought to bear on a redesign, or even an overthrow, of commodity culture? Or might it make more sense to try to renegotiate the sacred-profane divide by recasting the world of art as a kind of religious realm that would at least provide a "specific preserve" for the aesthetically sensitive and might even respiritualize society and neutralize, or even overturn, the excesses of commodity culture? These were two of the questions that already preoccupied their mid-nineteenth-century forebears.

REDESIGNING THE WORLD AGAINST COMMODITY CULTURE

The "bourgeois" society that began to emerge in the first half of the nineteenth century provided for a freedom of artistic creation far greater than in earlier societies where art was more tightly controlled by political, religious, and social mechanisms. Art was becoming emancipated in the sense that experience no longer had to be forced into a priori genres and period styles but was allowed to give birth to artistic form rather than the other way around. Artists became increasingly able to devise their own codes of meaning and to project their visions independent of traditions, preordained social usages, and requirements imposed by patrons. Freed from commissions to decorate the churches, public buildings, and homes of the dominant classes, artists were also progressively

freed from the obligation to express the dominant values of society, often choosing instead to advance critical values of their own. As Adorno argued in *Aesthetic Theory,* art had always stood in opposition to society, but because it was unaware of itself as such, a fundamentally oppositional art had been inconceivable prior to the French Revolution.[51] In the postrevolutionary nineteenth-century world of rising bourgeoisie, industrial transformation, and organized working-class movements, not only did an artistic opposition become conceivable, but especially after 1850, it became the artist's dominant image in society.

As this chapter has been suggesting, the sources of this critical attitude and oppositional stance were complex and various. The newfound freedoms that artists enjoyed no doubt emboldened them, sometimes even leading them into the "dream of transforming pen, brush, fiddler's bow, or maestro's baton into . . . a spiritual power, a moral prestige, and a social authority such as scepter, sword, and crosier had attained."[52] Yet theirs was an ambiguous and ambivalent freedom no less frequently wedded in their minds to a sense of having been discarded by society and, in still more profound ways, to an experience of existential rootlessness. Notoriously, romantic art and literature convey a sense of homelessness at once social and cosmic. Anxieties associated with the postmetaphysical world of Kantian epistemology and its sundering of experience help to explain this sense, but of equal or greater importance for many artists were the more mundane inadequacies of their new social position, which left them prey to the wiles of an impersonal market whether as writers or musicians seeking gainful employment or as painters needing to appeal to an anonymous buyer.[53] Then too, artists could not but be sensitive to the dramatic changes that the forces of industrialization, urbanization, and cultural and political democratization were beginning to wreak on the larger society, changes that frequently provoked in them an aesthetic revulsion against modern life and a corresponding sense of alienation.

Out of this emotional cauldron was born the notion of a new "religion of art," one that might overcome the Kantian fragmentation of experience, restore art to its rightful spiritual place beyond the reach of the commodity world, and make possible a new, harmonious, creative, human community, or at least preserve the conditions for a vibrant world of art.[54] Historians of romanticism have typically located such a notion at the center of that movement. Another well-known and influential variant is the philosophy of Arthur Schopenhauer. What deserves greater emphasis, however, is the remarkable irony with which this

notion presents us. No sooner had intellectuals been freed from the obligation to provide aesthetic support for the hierarchical world of traditional religious faith than did they seek a new spiritual shelter of their own, under the banner of romanticism, in a quasi-secularized religion of art, one that not infrequently served as a temporary station on the way to a full reunion with the world they had lost.

Despite such defections, however, the tradition of the religion of art endured throughout the nineteenth century and into the modernist era.[55] Indeed, it is often seen as having intensified in the climate of aestheticism, symbolism, and decadence that prevailed during the century's last decade and a half.[56] Certainly it was in the shape given the religion of art by these latter movements that modernists encountered it, sometimes with an embrace, more often with a negative reaction, even while remaining half-consciously under its spell. Yet the idea of a religion of art took on various forms in the postromantic era, not all of them insisting as resolutely as did symbolism on the transcendent status of art. One such form was the medievalizing aesthetic associated with John Ruskin, William Morris, and the English Arts and Crafts movement they inspired, a movement as steeped in religious language as any in its era.[57] It too aroused considerable interest in the era of prewar modernism, and it would become a still greater force for inspiration as design modernism developed after World War I.[58]

More a sensibility and a vision than a unified movement, the intellectual tradition that produced English Arts and Crafts shared romanticism's dream of a reintegrated experiential world with full access to the absolute, but its conception of art was very different from the transcendent realm envisioned by most romantics.[59] For Ruskin and Morris, as well as for the other progenitor of the movement, the Catholic architect A. W. N. Pugin, the most fundamental index of a civilization's greatness was the aesthetic quality of the objects and edifices it created for use in everyday life. In this broad sense, art for them was identical with artisanship and craft, and the preeminent value for judging art was the quality of the aesthetic pleasure evident in the laboring activity that stood behind it. Thus, while each of them manifested a distinct religious sensibility that made him want to gain access to the absolute by means of an experience of beauty that celebrated it, the path to it that they envisioned did not involve regaining some sort of prereflective immediacy, as Benjamin and Kandinsky would later seek to do, but rather involved reestablishing the connection between art and the good society, one that the domain separations associated with Kant occluded from view. In

Kant's terms, their aim was to reconnect the aesthetic with the practical realm of moral and social value, using Hegel's world of labor as their point of departure. Of course they recognized, however dimly, that the modern division of labor had now been complicated by a dizzying new world of exchange. Their hope was to redesign this world against the shape it was assuming in commodity culture by reuniting the imagination of the artist with the skill of the medieval artisan, "master of his work and his time," who built a world of beauty as a natural extension of his desire to create. Properly guided by simple machines and "little or no division of labor," these artisans had engaged in an anonymous collective activity that, at once, fulfilled them as individuals and enhanced the beauty of their communal environment.[60] For Ruskin and Morris, to return to this medieval ideal was, however paradoxically, to embark on Benjamin's road toward the democratization of art, even though they rejected the technological advances he quite properly thought of as critical to such a choice. Like Hegel's, their solution to the problem of modernity relied on reintegrating certain features of the static, closed community of European feudalism.

With its cities and celebrated countryside made ugly by industrialism and the social irresponsibility of capitalism, Britain is no surprise as the setting for a religion-of-art movement with a social reading of redemption. The question of the proper response to industrialism and forces of political and cultural democratization had preoccupied its intelligentsia since Edmund Burke.[61] The Great Exhibition of 1851, with its vast array of ostentatious commodities radiantly illuminated by glass and iron architecture, offered fresh symbolic evidence of the emerging direction of modern civilization. Ruskin and Morris both despised it and feared the future it seemed to represent.[62] In the same year, one of the directors of the exhibition, Henry Cole, was authorized by the British government to set up national schools of art that would promote industry by providing training in the design of mass-produced products. Indeed, the most famous of these schools would soon be built as part of the museum complex on the South Kensington site where the Crystal Palace had stood. This initiative's effect was to separate "fine art," as taught at the Royal Academy, from "applied art," as taught at the new schools, a division that Ruskin would vehemently attack in *The Two Paths* (1859) and against which the Arts and Crafts movement would later revolt.

The profound antagonism that both Ruskin and Morris expressed toward every sign of an emerging commodity culture bore many affinities with romanticism, but it was not any simple romantic reaction or

medievalizing reflex. As with the romantics, their disenchantment with modern life provoked in them a totalizing response aimed at transforming what they perceived as a chaotic and fragmented industrial disorder into a new sort of organic society that, inspired by the ideal of the medieval artisan, would reshape the human environment through the creative reinvention of art. With this totalizing approach they distinguished themselves from later modernist generations who, for the most part, pursued a more modest goal of a reconstructed public sphere with art at its center rather than taking on the capitalist order as a whole. Yet, despite their somewhat differing political commitments, neither Ruskin nor Morris was blindly antimodern or even antimachine. Their medievalism represented their belief in the intrinsic cultural value of having production and design determined by workers, a system they viewed as more practical, better organized, more congenial to human nature, and more conducive to human happiness than one in which these determinations were made by an impersonal marketplace. Their intentions were not so much to return to a bygone age as to overcome the disaggregating effects of modernity, which, in splitting off art from science and morality, had also split up art into high versus low, fine versus applied, or art versus craft, splits that reflected larger diremptions between mental and manual, urban and rural, individual and community, work and play.

Ruskin made his reputation primarily as an art and social critic rather than as a visual artist or creative writer. His influence was nonetheless enormous, most famously through his chapter "On the Nature of Gothic" in the second volume of *The Stones of Venice,* which became a kind of Arts and Crafts manifesto and which Herbert Read later called "the greatest essay in art criticism in our language."[63] In his lectures of 1858–1859 on the theory and practice of art, Ruskin utilized a comparative social framework to set forth and justify his view of proper aesthetic standards.[64] Societies that "rejoiced in art," such as India, did not necessarily produce better art than those, such as Scotland, which were "careless of art." "Wherever art is practiced for its own sake," he argued, it results in the "destruction of both intellectual power and moral principle." To be "helpful and beneficent to mankind," art must begin by recording the "facts of the universe" and only then make manifest "human design and authority in the way the fact is told." Practiced according to this standard of "truth to nature," art will become a source of "comfort, strength, and salvation."[65] From this fundamental standard, Ruskin derived a subordinate notion of "truth to materials."

Artistic form should always be determined according to the intrinsic qualities of the materials being used. Such qualities will suggest how materials ought to be worked, and in a properly shaped object artistry and the intrinsic qualities of the material will be mutually reinforcing. Good art will, in turn, reflect the creative input of its producers, since they will not only understand but find joy in these truths.

The great problem, of course, was that unless producers were free to pursue their work as they saw fit, both art and society would be brought to ruin no less surely than in the debased societies of pure art. Yet while Ruskin clearly judged the capitalist society of his own day to be incompatible with his ideals, he nonetheless implored its manufacturers to refrain from "corrupting public taste and encouraging public extravagance" and, by observing high artistic standards, "to form the market, as much as to supply it." In them he saw hope for a society that, forgoing the "pomp and grace" of earlier aristocratic cultures, would devote itself to "the loftier and lovelier privilege of bringing the power and charm of art within the reach of the humble and the poor; and as the magnificence of past ages failed by its narrowness and its pride, ours may prevail and continue, by its universality and its lowliness."[66]

Unlike Ruskin, Morris was not simply a writer with an aesthetic and moral vision but "a Victorian version of the Renaissance man," who, after beginning in poetry, worked in architecture and painting, and then decided to master as many crafts as he could, while also establishing a business and becoming active in socialist politics, historic preservation, and book publishing.[67] In 1861, he opened the firm of Morris, Marshall and Faulkner, Fine Art Workmen in Painting, Carving, Furniture, and the Metals, which aimed to produce a wide variety of high-quality craft products for sale as commodities. These products sold well for several decades and influenced affluent taste. But this sort of success was a disappointment to Morris, and by the end of the decade, "the holy crusader against the ugliness of his age seemed to be seeking refuge in art rather than in transforming his world by means of it."[68] In the 1870s, he turned to socialism.

Morris was faithfully devoted to Ruskin's notion of truth to nature. For him design innovations were to come from practice, through working with materials and as solutions to functional design issues, not from stylistic experiment. He was harshly critical of contemporary artists who devoted themselves to "noble works of art, which only a few rich people even pretend to understand or be moved by."[69] Likewise, he could not

abide those "new aristocrats of intellect," such as Matthew Arnold, who, although committed to a democratization of culture through education, were too consumed by fear of the working classes to lead them.[70] Their path was that of a culture of the wealthy that "cultivates art intellectually" while living "happily, apart from other men."[71] Yet, as many historians have recognized, Morris's own business experience left him hoist on his own petard.[72] The handicrafts his firm produced—costly and designed for a refined taste—inevitably reached only a luxury-market niche rather than the popular audience he so passionately sought.

Despite Morris's intentions and multidirectional energies, his legacy, like that of Ruskin before him, is most profound in his popular lectures, which he delivered over the last two decades of his life. Nowhere is this more true than in his lecture entitled "The Socialist Ideal in Art" (1891), which offers one of the nineteenth century's most provocative arguments for why modern societies need to rethink the aesthetic implications of the commodification process.[73] Morris begins by drawing a line in the sand: every man-made object—"a house, a knife, a teacup, a steam engine"— "must either be a work of art or destructive of art." The contrary idea of "the commercialist," that art is confined to those objects which are "prepensely works of art" and "offered for sale in the market as such," implies that art can be enjoyed only by the rich man and that even he, "as soon as he steps out into the streets . . . is again in the midst of ugliness to which he must blunt his senses, or be miserable if he really cares about art." The link between art and society could not be clearer: unless you have a society based on the "harmonious cooperation of neighbors," art will be, at best, a minoritarian enclave in a vast expanse of ugliness. Such social cooperation does not require a Luddite retreat into an age before machines, but it does mean that the "spirit of the handicraftsman" must prevail in the sense that "the instinct for looking at the wares in themselves and their essential use as the object of his work" is what governs economic life. When a worker creates through such a spirit, he is precisely not making commodities for sale, but rather "he is making the goods for himself; for his own pleasure in making and using them." A society in which art flourishes requires a new kind of market. Instead of the "present gambling-market and its bond-slave, the modern factory system," such a society will be based on a "market of neighbors." Such a society will not only be harmonious, human, and happiness-producing, but will be one in which people, in order to have artistic perceptions, will not have to be "born blind." It will also be one that does not "condemn a vast population to live in South Lancashire while art and education are

being furthered in decent places," which is "like feasting within earshot of a patient on the rack."

If we recall the main features of commodity culture as earlier discussed, it becomes evident that Ruskin and Morris rejected all of them. They saw production rather than consumption as the main locus of cultural taste and value. They resisted any structural differentiation between the worlds of production and consumption, preferring the unified ideal of a community of producers meeting common needs through mutual cooperation. They certainly perceived the extension of commodification into society's more sacred realms, and they adopted a wide variety of tactics to resist commodification including an ideal of decommodified artifact-based production, the development of aesthetically based standards such as truth to materials to replace or at least complement exchange value, the rejection of any notion of a fashion system, and the establishment of themselves as arbiters of taste within the actually existing system of commodity exchange. All of these views marked Ruskin and Morris as members of generations which still believed that a politics of resistance to commodification could be based on a simple "just say no."

Yet the influence they exerted on later modernisms—in Britain, Germany, and elsewhere—was considerable, despite the datedness of their perspectives. In Nikolaus Pevsner's classic interpretation, Morris is "the true prophet of the twentieth century," to whom we owe whatever sense we have that "a chair, a wallpaper, or a vase [is] a worthy object of the artist's imagination."[74] Moreover, the influence of Morris and the Arts and Crafts movement was transmitted directly to the continent in the person of Hermann Muthesius, who was deeply impressed by English architecture and design after studying it under a commission from the German government from 1896 to 1903. Through Muthesius, who was among the founders of the German Werkbund in 1907, Pevsner was able to draw a straight line from Morris to Walter Gropius and the Bauhaus. While this view serves to remind us that the Bauhaus sense for the intimate connection between art and the good society, as well as the corresponding need to integrate art and artisanship, did not emerge full blown in 1919, we should also not forget how much loftier the ambitions of Morris and his movement were as compared with what the Bauhaus would quickly become. Morris was never fundamentally concerned with industrial design, nor did he ever contemplate an alliance of art and industry. His aim, like Ruskin's before him, was the total moral and social reconstruction of modernity around the notion that "art is man's expression of his joy in labor."[75]

RECASTING ART IN BAUDELAIRE'S PARIS

"Let us imagine a beautiful expanse of nature," wrote a twenty-five-year-old Charles Baudelaire, "where the prevailing tones are greens and reds, melting into each other, shimmering in the chaotic freedom where all things, diversely colored as their molecular structure dictates, changing every second through the interplay of light and shade, and stimulated inwardly by latent heat, vibrate perpetually, imparting movement to all the lines and confirming the law of perpetual and universal motion."[76] So begins a discussion of color that is usually treated as one of Baudelaire's first formulations of his doctrine of correspondences—a complex view in which the interrelation of colors with sounds, feelings, tastes, and scents is seen as one of mutual reinforcement tending toward unity and, thereby, toward the transcendent. And so it is. Baudelaire insists that "in color," no less than in music, "we find harmony, melody, and counterpoint." Just as the composer "knows by instinct the scale of tones, the tone-value, the results of mixing, and the whole science of counterpoint," so too the visual artist can "create a harmony of twenty different reds." Yet we should not miss the fact that Baudelaire's passage, almost as strongly as the one from Benjamin with which the chapter began, reveals a sense for color as itself a kind of primal world, which, although tied to matter at the molecular level, still "shimmers in chaotic freedom," thereby offering itself as a powerful medium of intuition.

Baudelaire did not approach the question of color with the same Kantian issues as did Benjamin. Indeed, his aesthetics operated within a Kantian framework of autonomous art that sought to revitalize experience by intensifying its aesthetic dimensions rather than reintegrating them with truth and morality. Yet, remarkably, he would later make the same connection as did Benjamin between the world of the colorist and that of the child. In his famous essay "The Painter of Modern Life," Baudelaire claimed that "nothing is more like what we call inspiration than the joy the child feels in drinking in shape and color." The child's "vividly colored impressions" are perhaps most closely approximated in adult experience, he suggested, by those we take in during our days of convalescence "after a physical illness."[77] It comes as no surprise, then, that Gérard Constantin Guys, the popular illustrator whom the essay used to exemplify the "painter of modern life," is portrayed as both a "man-child" and an "eternal convalescent." For the child, this mode of perception, in which a vibrating, fluid world takes on an exceptional vividness, comes naturally; for the artist it requires an act of will. "But

genius is no more than childhood recaptured at will, childhood equipped now with man's physical means to express itself, and with the analytical mind that enables it to bring order into the sum of experience, involuntarily amassed."[78]

For Baudelaire, the creative artist or "genius" depends upon a "surnatural" experience of intuition in which the world comes into view as in the eyes of a child, a convalescent, or someone who has become intoxicated, but in which it remains subject to the careful investigation of "the analytical mind."[79] The artist is not irrational. As he wrote in his essay on Richard Wagner, "genius" must not be deprived of "its rationality" and reduced "to a purely instinctive and, so to speak, vegetable function."[80] Yet the extraordinary power that a creative artist such as Wagner wields does not come through his ability to render the everyday world more rationally intelligible but to render it differently intelligible as both luminous and transcendent. Great art leads us to an experience of transcendence, but not so much one that stands above or outside the world as one that uses a state of aroused awareness to fix upon it more intently.

Unlike those of Ruskin and Morris, Baudelaire's conception of art does not seek to reunify the world. One might better say that it becomes the world for its devotee: life is to be lived for art. As Baudelaire explained in an article on the writer Théophile Gautier, who was well known for his celebration of *l'art pour l'art* in the preface to *Mademoiselle de Maupin* (1834), "the loudly-trumpeted doctrine of the indissoluble union between beauty, truth and goodness is an invention of modern philosophical nonsense." Against intrusions "from Geneva or Boston," Baudelaire aimed to defend the beautiful as a realm autonomous from claims of goodness ("the basis and aim of ethical inquiry") and truth ("the basis and aim of the sciences"). Although he conceded that "the novel is one of those complex art forms in which a greater or lesser share derives, now from the true, now from the beautiful," he insisted that the pursuit of truth has nothing to do with poetry and that "if a poet has pursued a moral aim, he will have diminished his poetic power; nor will it be incautious to bet that his work will be bad."[81] Likewise, in his review of the Salon of 1859, he declared that the depressing mediocrity of its paintings owed much to "our exclusive taste for the true," which "oppresses and smothers the taste for the beautiful."[82]

In rejecting a moral art, as well as every form of aesthetic utilitarianism, Baudelaire was naturally contemptuous of all notions of art as craft. He dismissed Victor Hugo as "a craftsman, much more adroit than

inventive, a worker, much more formalist than creative" in whose writing "nothing is left to the imagination"—which, in Baudelaire's hierarchy of values, is almost to say that it was not art at all. To Hugo, Baudelaire contrasted Eugène Delacroix, whose great virtue was his "naïveté," which implied "technical mastery . . . but a technical mastery that is humble and leaves the big part to temperament."[83] Not surprisingly, then, any notion of connecting art and industry was an even greater anathema to Baudelaire, since "when industry erupts into the sphere of art, it becomes the latter's mortal enemy."[84] Unlike Ruskin and Morris, he would have no truck with implicating art in any redesign or overthrow of the industrial world of commodities. His commitment instead was to recasting the world of art as a secular-religious realm that might or might not neutralize the rampant materialism of the age and respiritualize society, but that would at least make possible a realm of beauty for those who knew how to find it. As his view of color and his doctrine of correspondences suggest, the fragmentation of experience was no less a problem for Baudelaire than it was for Ruskin and Morris. Yet for him the solution lay not in a reintegrated totality but in an enhanced spirituality of the aesthetic.[85]

The great investment Baudelaire made in autonomous art, however, did not mean that he embraced a narrow formalism of the sort that seems to be implied by Gautier when he famously wrote that "nothing is really beautiful unless it is useless, everything useful is ugly," and "nothing beautiful is indispensable to life."[86] The young Baudelaire condemned "the puerile utopia of the school of art for art's sake . . . [as] inevitably sterile."[87] To the question of whether art was useful, Baudelaire replied affirmatively in 1851, declaring in Nietzschean fashion that a "pernicious art" is one that "distorts the underlying conditions of life."[88] Baudelaire wanted an art that was passionately committed to life, and it was in that sense that he embraced art as a spiritual refuge. In the vocabulary of the day, his affirmation of art's "usefulness" implied some sympathy for leftist and bohemian "social art," as Pierre Bourdieu explains in his penetrating analysis of mid-nineteenth-century French aesthetic-political positions.[89] Yet social art's materialism and its gross insensitivity toward issues of spirituality pushed Baudelaire closer to Gautier's camp than to the "realism" of Jules Champfleury, although he could be found at both the Brasserie Divan Le Peletier and the Brasserie Andler, where Gautier and Champfleury respectively held court.[90] For Baudelaire, a proper opposition to bourgeois civilization meant overcoming every trace of materialism and utilitarianism in a kind of aesthetic out-

flanking of the political field in general, which is why, in 1848, "he does not fight for the republic, but for the revolution, one he loves as a sort of art for the sake of revolt and transgression."[91]

Baudelaire was also contemptuous of those attitudes and practices of the social art camp which he saw as a kind of pandering to the proletariat and which he particularly identified with George Sand.[92] His highest allegiance was to a cult of art composed of "people who, like me, want artistic matters to be treated only between aristocrats, and who believe that the small number of elect is what makes Paradise."[93] However painful his alienation from society, he was prepared to accept it in return for a world of art vibrant enough to support a flourishing of that "constructive imagination which . . . , inasmuch as man is made in the likeness of God, bears a distant relation to that sublime power by which the creator projects, and upholds his universe."[94] The social prerequisite of such constructive imagination was a new sort of cultural aristocracy for whom art would not be devoted to the lowly objects depicted in the realism of Gustave Courbet or Champfleury, but to a kind of divinely inspired transmutation of natural forms that would affirm the triumphant powers of human imagination, as in the art of Delacroix.

Baudelaire died in 1867—before the commodity culture of the department store and of a generally aestheticizing capitalism was fully evident in France, and before the Franco-Prussian War and the resulting Third-Republic politics of *revanche* that made nationalism so prominent in French political culture after 1885. Yet he was certainly attentive to some aspects of the commodification and democratization of French culture, especially as they had emerged in the much-expanded and privatized art market of the Second Empire. Although the Salon was not removed from state control until 1881, a new system based on private galleries, dealers, and marketing practices was moving aggressively to the center of the Paris art world during Baudelaire's last years.[95] The prestige associated with the Académie des Beaux-Arts and the Salon had also clearly lessened, and the ambitions of at least the major visual artists no longer had much to do with state honors and commissions. As late as 1847, a depressed Courbet, whose three submissions had all been refused in the Salon of that year, lamented that "to make a name for oneself one must exhibit and, unfortunately, that [the Salon] is the only exhibition there is."[96] Yet less than a decade later, he had succeeded in organizing a one-man show of his works not far from the state-sponsored Universal Exhibition, a defiant act that Baudelaire saw as a "remarkable début" that had "produced something like an insurrection."[97] This new ability

of artists to promote themselves outside official institutions unsettled these institutions profoundly, sometimes creating rifts within them, as when Napoleon III famously authorized a Salon des Refusés in 1863. Yet no amount of state intervention was capable of curtailing the erosion of the classical system of categories through which state-sponsored art elites had earlier imposed their preference for huge canvases depicting historical and mythological scenes. While even in the eighteenth century a few successful French painters such as J.-B. Chardin and J.-H. Fragonard had managed to free themselves from such constraints by garnering private commissions, the freedom to explore subjective and intimate worlds through landscapes, still lifes, and portraits had remained institutionally compromised through the romantic generation and up to the realists.

After 1851, pressures undermining state hegemony over art became overwhelming because they did not derive solely from the emerging private market system that so emboldened French artists, important as that was, but also from new technologies. As Beatrice Farwell has argued, when Baudelaire referred to a "cult of images" in his *Mon coeur mis à nu,* he was not referring to salon paintings or literary images but to the new prominence, in mass-circulation journals, of lithographs by artists such as Achille Devéria, Nicolas Maurin, and Grandville.[98] Benjamin also pointed to lithography as the essential development that had allowed "the technology of reproduction" to reach "a fundamentally new stage" in the nineteenth century.[99] The mass-printing industry exploded between 1820 and 1860, in large part because it learned to use lithography to illustrate journals such as *La Caricature, Le Charivari,* and *L'Artiste,* much in the way the photo-mechanical half-tone would be put into service after 1890.[100] In particular, this technology fueled the growth of the *roman feuilleton,* or installment novel, which became enormously popular in the 1830s and 1840s. By the 1850s, some talented artists such as Honoré Daumier were able to support themselves by their sales in this domain and thereby to mock the upper classes in their drawings without fear of economic or political reprisal.[101]

Baudelaire himself felt the sting of declining state hegemony over the arts when, in 1857, he and the publisher of *Les Fleurs du mal* were prosecuted for, and found guilty of, offending public morality. Six of its poems were banned and Baudelaire received a hefty fine. Yet he was also quite aware of the potential benefits of scandal, even if, for him, they never materialized. As his biographer remarks, "Baudelaire himself understood the significance of his prosecution" and "begged his mother 'only to consider this scandal . . . as the real foundation of my for-

tune.'"[102] Likewise, his theoretical writing showed a keen awareness of intensifying commodification and some of its ramifications for art, even if he failed to appreciate the coming aestheticization of capitalism and the potential for an activist response to it by artists.

If we look at an old engraving, Baudelaire suggests at the outset of "The Painter of Modern Life," we encounter a "double kind of charm, artistic and historical." As art, it will display universal elements like beauty and wit, but it will also show us the "moral attitude and the aesthetic value" of the epoch in which it was created. This latter aspect has its own sort of beauty, which "is always and inevitably compounded of two elements." Yet individual artists often choose to serve primarily one or the other: either the eternal and variable, as with some religious painters, or, as with Daumier's drawings, the "relative circumstantial element, which we may like to call . . . contemporaneity, fashion, morality, passion." Baudelaire does not fail to note that the recent invention of lithography has much enhanced the potential of this latter sort of art. Yet he also makes clear that an art adequate to modern experience cannot rest content with merely documenting it, since that would turn art into a mere reflection of fashion. When Baudelaire turns to "Monsieur C. G.," through whom he projects his sense of how the activity of modern art is properly conceived, we discover a painter who observes as sharply as a Daumier but whose works are all "signed with his dazzling soul." [103] As Michel Foucault has rightly reminded us, Guys is not "a mere *flâneur*" but someone who "makes it his business to extract from fashion whatever element it may contain of poetry within history."[104] For Baudelaire, Guys represents the dialectical synthesis of beauty's two moments, one that does not merely present the ephemeral world of fashionable commodities but transfigures it by means of the aesthetic imagination into the eternal as it appears in the passing moment. The result is a spiritual art—one that is "natural and more than natural, beautiful and better than beautiful"—that is achieved not by escaping the profane world of commodities but by fixing intently upon it.

Yet the double nature of Baudelaire's beauty is not so different from the two sides of the commodity form distinguished earlier. When Baudelaire's painter of modern life acts so that "materials, stored higgledy-piggledy by memory, are classified, ordered, harmonized, and undergo that deliberate idealization, which is a product of a childlike perceptiveness," we are reminded that commodities too are both material objects and magical representations of them.[105] And so we may well be led to ask: how did Baudelaire think the art he championed was to be distin-

guished from advertisement? The question becomes still more provoking when we consider that Guys is often paired with Grandville as two of the epoch's most appealing popular illustrators.[106] If, as we have seen Benjamin write of Grandville, the latter transforms nature into "specialties" that are presented "in the same spirit in which the advertisement" operates, what are we to say about Guys?

Although such questions probably did not occur to Baudelaire, he did show great sensitivity to the way commodifying processes like fashion had intensified the self-representing dimensions of the modern self. "The idea of beauty that man creates for himself affects his whole attire, ruffles or stiffens his coat, gives curves or straight lines to his gestures and even, in the process of time, subtly penetrates the very features of his face," declares "The Painter of Modern Life." "Man comes in the end to look like his ideal image of himself."[107] Or as Foucault puts the point: "Modern man, for Baudelaire, is not the man who goes off to discover himself, his secrets and his hidden truth; he is the man who tries to invent himself," who takes himself "as object of a complex and difficult elaboration."[108] Yet if such self-fashioning is so central to modern man; if, like the dandy, he has a "burning desire to create a personal form of originality" and engages in a "kind of cult of the ego," then the question of the relation of advertisement to the sort of art best suited to modernity would seem to become still more acute.

For Baudelaire, however, the dandy is a historically endangered species who thrives best in "periods of transition when democracy has not yet become all-powerful."[109] He operates as a prescriptive ideal representing, in Foucault's words, "an indispensable aestheticism," and one that Bourdieu connects with the professionalization of the artist whose quest for a pure aesthetic forces upon him the self-discipline of the "scientist or the scholar."[110] But, in Baudelaire's pessimistic view, he is a magnificent "setting sun" because the democratization of culture, far from being an aestheticizing force, actually de-aestheticizes. It would seem to follow, then, that the activities of a painter of modern life such as Guys, however great the power they derive from the profane world of commodities, are ultimately divorced from anything like advertising because, popular illustrator or not, he and his world of art were destined to remain a spiritual refuge for a few privileged devotees rather than one connected with the larger forces of modern life.

Yet why did Baudelaire settle so firmly on the idea that the democratization of culture implied a de-aestheticizing of life? The answer appears to emerge in his review of the Salon of 1859, particularly in that essay's

remarks on photography. As bitter as any Baudelaire ever wrote, this essay recoiled from the "mediocrity" of the latest salon and the "discrediting of the imagination" in contemporary culture that it seemed to represent.[111] Ironically, it was "progress" in the sense of "the progressive domination of matter" and its link to "our exclusive taste for the true" that Baudelaire located as the main sources of art's current crisis. Not only were contemporary artists becoming more and more like mechanical technicians—painters not of what they dream but what they see—but visual technologies like photography were also threatening "the impoverishment of French artistic genius." Photography was a domain infringement, an effort by the world of scientific truth to destroy the aesthetic imagination.[112]

The larger problem was that modern industrial technology, when coupled with "the stupidity of the masses, its natural ally," was producing a tasteless culture of profane literalness. Far from providing new opportunities for art within the commodity culture of a democratizing and aestheticizing capitalism, as Benjamin hoped visual technologies like photography would do, Baudelaire saw them as a scientistic profanity that could be tolerated only if they returned to their "true duty" as documenting devices "like printing and shorthand."[113] Thus, even though he did show more awareness of the semiotic dimensions of commodity culture than had Marx, Ruskin, or Morris, Baudelaire still did not fully appreciate the linkage between commodity culture and the aestheticization of capitalism. For him, self-fashioning was less aided by, than in conflict with, the democratization of culture because the forces of industrial modernization that were advancing the latter were also rendering all of life literal, flat, and meaningless, even art. In a world in which democratization and such aesthetic potential as existed in commodity culture cut in opposite directions, the only hope was that artists might somehow preserve themselves from the corrupting influence of industrialization and democratization, even as they sifted through an increasingly commodified world for elements of aesthetic transfiguration.

Yet the consequences Baudelaire drew from his analysis of a democratizing modernity had not always been as pessimistic as the image of monastic withdrawal that seems to be implied by the 1859 essay. Prior to 1848 especially, he seemed to hold out serious hope that the public might be educated for art. In reviewing the 1845 Salon, he explicitly accepted the traditional role of the critic to orient the public in its potential purchases, and he organized his discussion using painting categories as would a tour guide, even following "the order and rating assigned them

[paintings] by public favor."[114] Yet he was equally clear that the primary standard of judgment he would utilize was originality, rather than the technical skill so admired by the public, and that the key to originality lay in the faculty of imagination. "Every public," he tells us, "possesses a conscience and a fund of good will which urge it towards the true, but a public has to be put on a slope and given a push," clearly a job for the "taste professional" who has the aesthetic sensibility the public lacks.[115]

The political implications of Baudelaire's remarks at the outset of the 1846 Salon have been much disputed.[116] Yet while their ironic tone may render uncertain the essay's attitude toward the French bourgeoisie, there is no doubt that he singles out for special opprobrium those "monopolists [*accapareurs*] of spiritual things" who, as shapers of critical opinion through newspapers and other media that treat knowledge like something from "a counter and a shop [*boutique*]," actively mislead the public for their personal gain.[117] When the subtitle of the essay's first main section announces the question "what is the good of criticism?" there again seems little doubt that Baudelaire means both to disparage the commercialist criticism of "pharisees" and to underline his own disinterest as someone who, because he is an artist himself, adheres to the rigorously internal standards of the professional.[118] Years later, in his essay on Richard Wagner, Baudelaire would make the argument that "the poet is the best of all critics," since great poets are inevitably led to criticism as part of a spiritual life of self-examination. By the same token, he thought that "for a critic to become a poet would be miraculous . . . , a wholly new event in the history of the arts."[119]

As Richard D. E. Burton has argued, however, even in the pre-1848 writings in which Baudelaire's hope for educating the bourgeoisie for art seems greatest, he was "fully aware that he is arguing from a position of very real weakness."[120] His attachment to the bourgeoisie was always fundamentally based on what Clement Greenberg once called "the umbilical cord of gold."[121] For he believed that, even if genuine art critics like himself were able to make the bourgeoisie understand the superiority of a Delacroix over a Grandville, artists would always need the bourgeoisie more than the reverse and that, short of a revolutionary transformation, aesthetic and spiritual values would remain subordinate to economic and material ones, recognitions that could not but provoke feelings of resentment. After 1851, however, when his lingering hopes for revolutionary change collapsed before the reality of the Bonapartist coup d'état and the subsequent constitutional plebiscite that legitimated it, Baudelaire's resentment was transmuted into political cynicism and rabid

hatred of everything bourgeois, feelings that effectively ensured that his religion of art would thenceforth serve only as a spiritual refuge for the already converted rather than as an instrument of democratizing evangelism as well.

Ultimately, Baudelaire rejected the notion that modern society as a whole could be repaired in any way that would make it a comfortable dwelling place for artists like himself, but he did not lose hope that it would tolerate an autonomous high culture offering spiritual sanctuary for the few. In this sense, although the aspiration of Ruskin and Morris to reforge an organic society through art was completely foreign to him, he believed no less than they that resistance to commodification could still be a matter of simple rejection. Or, rather, he arrived at that conviction after becoming disillusioned with his efforts at shaping a new role as a democratically oriented "taste professional" engaged in style and evaluation control, one that later modernists such as Apollinaire and Kandinsky would pursue more steadfastly. Yet the difference between their steadfastness and his disillusionment was not an issue of psychology. What they could see that he did not was that modern society was not an anti-aesthetic industrializing wasteland from which all that passed for art and culture could be clearly distinguished. For the modernists, art and culture could not be neatly separated from the public sphere and reconstructed as a world outside of, and in opposition to, a democratizing culture and society. For them, either avant-garde efforts to reconstruct the public sphere with art at its center would succeed, or art, as a sphere of value autonomous from the commodity form, would simply be lost.

WAGNER AND THE POLITICS OF SYMBOLISM IN FIN DE SIÈCLE PARIS

Like Baudelaire, Wagner was part of a generation for whom 1848 was the defining moment. His presence on the Dresden barricades during the spring of 1849 became legendary, earning him such monikers as "the Red Composer" and the "Marat of Music," and the prose writings that emerged from the experience "made his name all over Europe with a breadth and an intensity that his music had not effected."[122] The power of this rhetoric reflected his passionate conviction that the new age of revolutions would sweep away the degraded culture of capitalism and usher in the sort of community life that, as in ancient Athens, was genuine because it was sustained by a public realm in which citizenship and humanity were undivided and culture and politics, indissolubly fused. So strong was Wagner's sense of the imminence of this ideal's realization

that, even as late as mid-November 1851, he wrote to a friend that his own cultural creativity was entirely dependent upon revolutionary success. "A *performance* is something I can conceive of only *after the Revolution;* only the Revolution can offer me the artists and listeners I need. . . . *This audience* will understand me; present-day audiences cannot."[123] A month later, he confessed to the same friend that he had "now completely abandoned every attempt to combat the prevailing mood of stupidity, dullness of mind and utter wretchedness," which had left the world with only "the corpse of European civilization. I intend only to live, to enjoy life, i.e. as an artist—to create and see my works performed: but not for the critical shit-heads of today's populations."[124]

As this formulation suggests, Wagner would work to sustain himself artistically after 1851 by distinguishing between his present audience and an ideal public of a now much more distant "future," one that would have to be forged by the power of his art. Yet the commercialized cultural depravity depicted in his prose writings of the revolutionary period certainly suggests that such a task would require the Herculean capacities and energies that perhaps he alone enjoyed. In "Art and Revolution" (1849), Wagner condemned "modern art" with a single dismissive stroke: "its true essence is industry; its ethical aim, the gaining of gold; its aesthetic purpose, the entertainment of those who are bored."[125] Positioned as it is by modern society, art "sucks forth its life juice . . . from the golden calf of wholesale speculation," and the result is "prurient vanity, claptrap and, at times, the unseemly haste for fortune-making."[126] Yet "art remains in essence what it always has been," which he characterized in "The Art-Work of the Future" (1849) "as the living presence of religion, which springs not from the artist's brain but from the *Volk*."[127]

Like Ruskin and Morris, Wagner sought to restore the vitality of art by underscoring its noncommodified "sacred" status and reviving its connection with popular folkways.[128] The artist of the future could be identified with the *Volk* because all genuine art expresses its sentiments, ideas, and aspirations and therefore has popular appeal virtually by definition.[129] Some scholars have gone so far as to see in such ideas a commitment to a democratizing of art.[130] Yet Wagner's conception of the public sphere was based on the profoundly antimodern distinction between polis and household, which implied that only those free from the chains of economic necessity could participate in cultural and political life. For him, therefore, any notion of reinvigorating modern art by strengthening artisanship and its connection to art would only make the problem worse.[131] Art could return to its essence under modern condi-

tions only if it were rigorously separated from everything utilitarian and restored to its position as the central religious rite in society, one responsible for community-formation on the model of classical Athens.

Once it was clear that history had refused to cooperate—at least in the near term—with Wagner's cultural design, he was forced to rely more heavily upon the notion, also developed in the writings of 1849, of art as rooted in the fellowship of, and cooperation among, a community of artists, a *Genossenschaft aller Künstler*.[132] Thus the famous Festival of Bayreuth, which opened in 1876 with the premiere performance of Wagner's "Ring of the Nibelungen" cycle, was initially conceived as a community of artists whose work would collectively articulate what remained of an uncorrupted folk spirit. Not surprisingly, however, given Wagner's grandiose designs for this modern Dionysian festival and its lavish temples of art, in practice the free community of artists soon became the free gathering of patrons, which in turn became a festival of paying customers no different from any other entertainment venue.[133] While it must be said in fairness that this trajectory left Wagner himself rather despondent, its end-state—production for a high-cultural niche market—might have been predicted given that it was precisely the same fate as that suffered a decade before by Morris's company when it tried to forge the basis for a counter-commodity culture.

Yet how we ought to understand Wagner's later work generally, and Bayreuth in particular, in relation to commodity culture is a matter of some doubt. On the one hand, Wagner has been treated as the foremost artistic exemplar of nineteenth-century "musical idealism," a culture of listening based on pious seriousness and deep suspicion of fashion and entertainment values.[134] Even based on the limited evidence presented here, the reasons for this alignment should be self-evident. Yet, on the other hand, Wagner has also been understood—and with equal plausibility—as a kind of mass-entertainment virtuoso who pioneered in the creation of "phantasmagoric" effects. In staging his works at Bayreuth, Wagner used specific techniques of intensifying them as spectacle (hiding the orchestra, dimming the lights) in ways which, according to Adorno, showed his deep estrangement from the public, which was reduced to a "reified object of calculation by the artist." Wagner's art thus took on a "commodity function, rather like that of an advertisement: anticipating the universal practice of mass culture later on, the music is designed to be remembered, it is intended for the forgetful."[135]

However we may wish to balance these perspectives in assessing Wagner's overall relation to the rising world of commercial entertain-

ment, what is clear is that he continued to be venerated by several generations of artists, including the modernists, and that this veneration primarily reflected the prestige of a single ideal of Wagner's, that of the *Gesamtkunstwerk,* or total work of art. Such an ideal was not original to Wagner, although the degree to which Wagner's conception carried forward earlier romantic concepts is a matter of dispute.[136] For Wagner, the concept of *Gesamtkunstwerk* referred to efforts to restore art to the position it had enjoyed in the ancient Greek world before poetry, music, and dance were separated from one another. As the young Nietzsche, inspired by Wagner, famously argued, Greek tragedy was a *Gesamtkunstwerk* in the way it unified the Apollinian and the Dionysian, plastic expression and ecstatic music, a synthesis that overcame Kantian divisions and offered access to unified experience and a tragic wisdom embodying the absolute.[137] For Wagner, the ideal of restored unity implied the need to conceive specifically modern forms of artistic synthesis and, in the wider sense, a modern form of community in which politics and art would be reintegrated.[138] Although the reality of Bayreuth was hopelessly distant from any such utopia, the subsequent prestige of the *Gesamtkunstwerk* ideal derived not so much from Wagner's practice or even conception of it, but from the inspiration it provided for a variety of aesthetic-political programs. The futurists, for example, were drawn to it because of their experimental efforts to invent new forms of performance, while an artist like Kandinsky perceived it more as Nietzsche did: as a way of overcoming modern divisions and specializations and restoring a world of spiritual vitality.[139] Benjamin, as we have seen, regarded it as a defensive stratagem for sealing art off from developments in modern visual technologies, while Apollinaire, in stark contrast, saw it as an ideal that technological innovations in graphic design and typography might finally help realize. Other artists saw it in still other ways, partly dependent on their specific vantage points, for the ideal inspired all the arts including architecture and even city planning.[140]

In France, a cult of Wagner set the intellectual fashion for a half decade after the composer's death in 1883 and the appearance during the following year of Huysmans' *À rebours,* which almost single-handedly defined a decadent style to which Wagner was assimilated.[141] Although Wagner's death inspired many national movements with quite different aims and characteristics, *wagnérisme* was the first movement to name itself as such (the term precedes Wagnerism and *Wagnerismus*) and was much more avant-garde than its relatively dour Bayreuth counterpart.[142] Its center of gravity was the circle around the symbolist poet Stéphane

Mallarmé, which helped to create and sustain the *Revue wagnérienne* (1885–1888) during its short life.[143] Paradoxically, however, as Huysmans' novel explained, the patriotic fervor that had swept France after its defeat by the Prussian armies in 1870 "made it impossible for any theater in the country to put on a Wagner opera," and these *wagnéristes* were actually quite ignorant of his work.[144] Indeed, to some extent they shared the ultrapatriotism of the broader public, and their interest in Wagner, according to one scholar, was as much in finding a "French response" to him as in Wagner himself.[145] Other scholars have gone still further to argue that "Wagner's reputation throve on the absence rather than on the presence of his works in France" and that "what was wanted in the *Revue wagnérienne* was less Wagner's doctrines set out accurately, than arguments to reinforce symbolist tendencies with the prestige of his name."[146]

What is certain is that Mallarmé himself, although intrigued by Wagner's *Gesamtkunstwerk* ideal, which bore affinities with his own utopian musings on "*Le Livre*," took a rather skeptical view of the German composer in an article published in the *revue*.[147] Part of this skepticism, as private notes by a member of his Tuesday Circle demonstrate, was that Wagner "gave music an obvious predominance, such that poetry was subsumed into music . . . , whereas for Mallarmé the role of poetry was on the contrary the preponderant one."[148] Such a privileging of music was indeed inherent in the late Wagner's ideal of *Gesamtkunstwerk,* and not merely because of his bias as a composer, but also because of the strong influence upon him, after 1854, of Schopenhauer, whose philosophy treated music not merely as the highest form of art but as the only humanly available mode of access to the ultimate reality behind phenomena, that of the metaphysical will.[149] Yet Mallarmé's skepticism also had a definite political dimension having to do with Wagner's unwarranted appeal to "legend."

The starting point of Mallarmé's article is "the theater-goer of today [who] scorns imagination but . . . is skilled in making use of the arts . . . to transport him to a place where a special power of illusion will be released." This theatergoer rejects the "intellectual despotism" of past theater, with its devotion to "the sacred pages of the book," favoring instead the accessibility and suggestive "atmosphere of reverie" associated with music. With a perfect comprehension of his audience, Wagner evokes the "sacred feelings" associated with the ancient past and brings them "face to face with myth," thereby leaving them enthralled by "some strange, new primitive happiness." Yet such an appeal to "ori-

gins" is dangerous in the way it closes us off from "invention" and everything "imaginative, abstract, and therefore poetic." Here Mallarmé explicitly turned his critique in a nationalist direction by claiming that the "French mind," unlike those of ancient Greeks and present-day Germans, "shrinks back from legend" and demands an art that is open to "individuality" and "embraces the many aspects of human life."[150] The implication is that "legend" stymies the creative imagination necessary for a life of freedom because it is so affirmative, concrete, and therefore so potentially manipulative. In contrast, an art based more firmly on poetic symbols, and thus on the allusive potentials in language, will open up the human imagination and encourage creative invention rather than dogmatic repetition.

As this summation suggests, Mallarmé's response to Wagner involved deep issues not just about the relation of music and poetry in a synthesis of the arts, but about the nature of language and the politics of art as a mode of communication. While the intricacies of Mallarmé's complex view of language cannot detain us here, a brief consideration of a few of its key aspects will help to clarify those issues.[151] By the late 1860s, the young Mallarmé had already come to the view that nothing exists beyond visible reality but that, within it, lie perfect forms (akin to Platonic ideas), which it was the poet's task to try to capture. True poets were not mere describers of the empirical world but, as he put it in a well-known late essay, visionaries who evoked for their readers "the flower which is absent from all bouquets."[152] In doing so, however, as this same essay makes clear, poets were the model for a larger politics of language that rejected "speech," which is "no more than a commercial approach to reality," in favor of "literature" where "allusion is sufficient" given its goal of evoking an essence. Like literature, music too became an "impalpable joy" when it was freed from the material and utilitarian constraints of the everyday commercial world. The arts in general offered the possibility of "pure works" in which the voice of their creators was stilled in favor of yielding the initiative to the work itself, thereby permitting its recipients to experience and interpret it independently of controlling authorial imperatives.

This goal of freeing reader-spectators to do with works of art what they will is also illustrated by what Mallarmé suggested in the essay regarding a synthesis of literature and music, for which his model was "transposition" rather than hierarchical "structure." In an earlier essay, to which he alluded here with a paragraph-long extract, Mallarmé had argued that neither literature nor music could be stabilized by connect-

ing it with a reference point in "nature" but ought rather be subjected to "quakes and slippings, unlimited and unerring trajectories, rich reverie in sudden flight, delightful unfulfillment, some special lunge or synthesis, but . . . no sonorous tumult which could be reabsorbed in dreams." Just as each art form should be free to push away from natural origins to that "beyond" which is our primary source of spiritual pleasure, so too works of artistic synthesis must be playfully "transpositional" such that "one bends toward the other, submerges, then returns to the surface with its treasure; another dive, another fluctuation and the entire cycle is created to perfection."[153] So conceived, art becomes a religious experience that is also a vehicle of individual liberation and cultural democratization, rather than one in which reader-spectators are offered revelation as willfully preconceived by the poet-composer.

This startlingly innovative view of language, which Mallarmé deployed in his critique of Wagner and which became the fundamental basis of the symbolist movement, had profound implications for the way that movement was able to reconceive its relation to the public sphere. Rather than promulgating a self-contained religion of art from outside that sphere, which the public could either accept or (more likely) reject, the symbolists hoped that the pursuit of "pure works" of art might open up a space of contestation in which "language" confronted "speech," a space that would encourage immanent critiques by citizens rather than nonnegotiable demands from artists. Precisely for this reason, Adorno pointed to Mallarmé as the epitome of a politically emancipatory program for autonomous art.[154] Yet, in both Mallarmé and most later symbolists, the potential for cultural democratization built into poetic language was only partially realized, for it coexisted uneasily with a view of artists as a Baudelairean cultural aristocracy or aesthetic caste, which retreated from public life even as it discovered the tools with which to transform it. Thus the early Mallarmé dedicated himself to Baudelaire's project of creating art as a "mystery accessible only to the very few," a commitment that is not only continually reiterated in subsequent writings but justified, in a well-known autobiographical letter to Paul Verlaine, on the grounds that the present age was only a "form of interregnum for the poet," who ought not to get involved with it except "now and again [to] send a visiting card to the living, in the form of stanzas or a sonnet, so that they don't stone him, suspecting him of knowing that they do not exist."[155]

What made Mallarmé's posture of ironic retreat all the more remarkable was that, quite unlike Baudelaire, he had an early comprehension of,

and even sympathy for, a rising commodity culture. He wagged no fin-ger of moralistic reproach against photography, and he seemed to have a positive attitude toward its artistic dimension, even once comparing Félix Nadar's work favorably with Baudelaire's poetry in a letter to Verlaine.[156] Moreover, a decade before the appearance of *À rebours,* he had single-handedly written and produced eight issues of a Paris fashion magazine called *La Dernière Mode.* Although recent investigators of this enterprise differ with respect to how much irony we should read into it and what Mallarmé's purposes in it were, there is little doubt that he regarded the new commodity world with genuine fascination.[157] For the magazine did not simply present women's fashion but enveloped it in a wider discus-sion of many aspects of emerging consumerism, including the perform-ing arts, exhibitions, menus for home entertainment, interior decoration, and tourism. Indeed, even before this episode, Mallarmé had written four articles on the London Exhibitions of 1871–1874 in which one recent historian finds "a complete absence of Ruskinian censoriousness of manufactured shoddiness or any nostalgia for artisanal craft."[158] In one of these articles, Mallarmé wrote that "the fusion of art and indus-try [is] truly an effort of the entire modern age," which is defined by a "double-sidedness" in which "art decorates the products our immediate needs require, at the same time as industry multiplies with its hasty and economical methods those objects made beautiful in past times only by their rarity and uniqueness."[159] It was an acute observation, far in advance of French government policy. Finally, in the autobiographical letter to Verlaine, Mallarmé confessed that the several issues of *La Dernière Mode* "still serve, when I blow the dust off them, to make me dream at length."[160]

Mallarmé's combination of a novel theory of language opening its contestatory potential and his avid interest in the newly emerging com-modity culture suggests a very different kind of religion of art from any we have previously encountered in the nineteenth century. While the poet for him remained a high priest, much in the manner of Baudelaire, Wagner, and even Ruskin and Morris, he did not regard contemporary life as aesthetically flat; nor did he aim to remake it as an aesthetically enhanced organic society. Despite his great personal reserve, he played with the toys that the new commodity culture presented, anticipating in this respect some of the later antics of Alfred Jarry and Apollinaire. At the same time, his search for a new poetic language—one that should be "seen" on the printed page as a visual form, even as it alludes and evokes—shared much with the emerging practices of commercial adver-

tising.[161] Benjamin saw him in fact as "the first [poet] to incorporate the graphic tensions of the advertisement in the printed page" and, in this respect, to have recognized that the literary culture of the book was being replaced by the "prompt language" of "leaflets, brochures, articles, and placards."[162]

Mallarmé's radicalism, then, was not a matter of overthrowing society or even of making the world safe for his religion of art, but of advancing the artistic cutting-edge, a stance that represented one of the first signs of an emerging professionalism in the French art world.[163] With this stance, Mallarmé opened up the possibility of a new sort of resistance to commodification, not one that posed an alternative to which the world must conform, but one that could complicate and contest the existing cultural world, foster the public expression of individuality, and even in some ways democratize poetic language. Moreover, Mallarmé developed his cultural politics without appealing to a utopia, without being afraid to engage with commodity culture or to express nationalist sentiments, without blinding himself to the interests that art might share with the state, and most importantly, while recognizing the need for art to find its own way forward, whatever the society and politics of the moment. In all of these ways, Mallarmé clearly prepared the way for modernism. Yet the democratizing potential in his ideas could not be realized so long as artists remained loyal, as he did, to a concept of art as a mystery accessible only to the few.

One of Mallarmé's followers, who did much to carry forward and extend his aesthetic-political perspective, as well as to democratize it further during the post-1895 period in which symbolist aesthetics began to lose their luster, was the poet, novelist, essayist, and critic Rémy de Gourmont. Largely forgotten after his death in 1915, Gourmont was one of the most celebrated intellectuals of his day: editor of the most prominent symbolist journal, the *Mercure de France,* and responsible according to André Gide for giving symbolism its "philosophical significance"; author of some forty books; a deeply learned man and something of a polymath; an important influence on the Anglo-Saxon modernism of T. S. Eliot, Ezra Pound, Kenneth Burke, and Herbert Read; and last but not least, a good friend of Apollinaire.[164] What will concern us here, however, has less to do with his works and with the influence they exerted than with the ways in which his intellectual trajectory and stance as an avant-garde spokesman reflected some of the larger currents through which a new stratum of "intellectuals" came to be constituted after 1890, a phenomenon to which he himself called attention.[165]

The intensification of French nationalism after 1870 reached new levels with the meteoric, political ascendance of the charismatic General Georges Boulanger, who, after being appointed minister of war in 1886, mustered a cross-class coalition of the disaffected in a *revanche* movement against the German occupation of Alsace-Lorraine. After a series of stunning electoral victories, in which "Général Victoire" gained the support of many intellectuals including Mallarmé, his supporters nearly succeeded in fomenting a coup in January 1889 that would have ended the Third Republic.[166] Although the government was soon able to restore stability and Boulanger became discredited, the political passions he ignited remained strong throughout the 1890s. These passions were expressed in many different radical forms including anarchism, socialism, royalism, anti-Semitism, Catholicism, and in "leagues" both nationalist and antinationalist. Boulanger himself was perceived as having failed in part because he lacked a doctrine, and nationalists of many stripes—most prominently Maurice Barrès and Charles Maurras—now sought to articulate one, lacing their prose with emotional references to "France for the French," the need to combat the universalism that "uproots" people from their local soil, and the equally important need to cast a wary eye on the "*métèques*," or foreign residents, a neologism derived from the metics of ancient Greece but carrying strong racist overtones in their usage. In the early 1890s, such sentiments were proclaimed amid public images of a parliament dragged down by financial scandals and anarchist bombs exploding in Paris cafés, some of them planted by leading symbolists such as Félix Fénéon.[167] By the end of the decade, the true *cause célèbre* of the age arrived in the form of the Dreyfus Affair, regarding which hardly anyone, and certainly no intellectual, could avoid taking sides.[168] Under its impact the broadly accepting, if not wholly cosmopolitan environment in which the symbolist movement had thrived (the author of its founding manifesto, Jean Moréas, was of Greek origin) gave way to bitter partisan rancor.

Gourmont too was an anarchist in the 1890s, although the bombs he planted came entirely in the form of his hermetic writing. The first of these, which cost him his job as a thirty-three-year-old librarian at the Bibliothèque Nationale, was an 1891 article in the *Mercure* in which he heaped scorn on the "deafening yelps" of the *revanchistes* and claimed to prefer the "placid Germans."[169] Four years later, in a more reflective mood, he wrote that "since the discovery of patriotism, since men have begun to quench their thirst with that sour milk, one might say that the tissues of universal life have tightened, folded in upon themselves, impris-

oning the essential cells in a strict and jealous jail. For a Frenchman, to be French comes before everything, even genius, despite the fact that the French are one of the most obviously hybridized of all the peoples waving their guns across the ancient land of Europe."[170] Yet, in a more circumspect and erudite way, Gourmont had himself participated in national mythmaking when, in 1892, he had published *Le Latin mystique,* a book which followed by only a few months an inflammatory article by Maurras that raised the theme of "Latinity" and the "Latin aesthetic" in ways that created a particular stir among the symbolists, already reeling from the defection of Moréas, who had, with Maurras, created the École Romane during the previous year.[171] Whatever his precise intentions, Gourmont was not as far above the fray as he pretended to be.

In 1890, Gourmont had published a florid and arcane novel, *Sixtine,* whose ambience and male protagonist are often compared to those of *À rebours.* In 1894, he collaborated with Jarry on a sumptuous but short-lived journal tantalizingly titled *L'Ymagier* [The Image Maker]. Yet, by late 1895 when he commenced a series of short pieces in the *Mercure* that would continue until his death and that would be republished in book form as *Épilogues: Réflexions sur la vie,* Gourmont became dedicated to portraying everyday scenes and subjects in ways that were wholly accessible, thereby calling out to a much wider readership. Soon he was also taking up, sometimes in quite lengthy studies, a startling variety of subjects from psychology and biology to philology and the historical investigation of language. By the end of the decade he had moved firmly away from "the dreamy opacity of symbolist poetry" to "a conception of style based on the creation of striking visual metaphors," one that would influence the later poetics of British imagism.[172] Yet what is ultimately most striking about this shift is the way it coincided with a broader turn in French intellectual life, away from both symbolist abstruseness and militant social art, and toward professionalism, reconciliation with mainstream culture, national solidarity, and even, as one historian has put it, "the domestication of the artistic élite."[173] This turn, which many scholars have dated from about 1895, did not necessarily imply any waning in the public expression of political passion, but it did rechannel that passion in a more culturally democratic and less exclusionary direction.[174]

In his post-1895 writing, Gourmont projected himself as a consummate taste professional, a critic of art, literature, and society devoted to developing a knowledge-based expertise and disseminating it to a broad reading public. Yet, at the same time, he continued to cultivate his image

as a representative of the radical avant-garde political gesture, above all through a critical practice he called "dissociation."[175] At first glance, "dissociation" seems to mean simply a skepticism that refuses to accept "current ideas and associations of ideas, just as they are," and insists upon breaking them apart and reworking them in "an infinite number of new couplings which a new operation will disunite once again until new ties, always fragile and equivocal, are formed." Yet two of its aspects mark Gourmont's practice as distinctive. First, he made a point of aligning this view of language with its implications for the public sphere: "associations" were linked with utility, interest, and pleasure, and for that alone they required contestation.[176] By the same token, "dissociations" implied the disruption of prejudices and commonplaces, and for that alone required relentless pursuit. Second, Gourmont took dissociation as an endless process that refuses to arrive at anything more than provisional "truths," and certainly not at any firm philosophical position. In this regard, he allied himself with Nietzsche's concept of a "lie in the extra-moral sense," claiming that all "true language begins with the lie" and that "science is the only truth and it is the great lie."[177] As he wrote in one of his *épilogues* at the time of Nietzsche's death: "we have learned from Nietzsche to deconstruct the old metaphysical edifices built upon a foundation of abstractions. All the ancient cornerstones have crumbled into dust, and the whole house has collapsed. What is liberty? A word. Let us have no more morality unless it be aesthetic or social; no more absolute system of morals, but as many general moralities as there are races and castes, and as many particular ones as there are individual intelligences. What is truth? Nothing but what appears true to us, what flatters our logic. As Stirner said, there is *my* truth—and yours, my brother."[178]

In embracing "lies" as preferable to "truths" that corresponded to nothing deeper than human agreement, itself always provisional and therefore ephemeral, and, typically, to nothing firmer than utility, interest, and pleasure, Gourmont was giving voice to an anxiety widespread among prewar intellectuals, although it was not always so closely linked to its Nietzschean origin.[179] The core insight—that there is no foundation for knowledge or value outside the meanings and purposes humans construct—could of course be taken in many directions. While the positivistically minded responded by seeking to delimit potential knowledge more rigorously, many artistic modernists were encouraged to redouble their Baudelairean preference for the beautiful over the true and the moral, and for creativity and performance over rationality and science.

Yet the insight could have sobering consequences for modernists as well. Within the context of this study, the most important one was to provide yet another reinforcement for the turn away from religions of art that would remake society as a whole, and in favor of the more modest goal of using art to challenge and reinvigorate the existing public sphere. For if knowledge is a continuous human construction and reconstruction, then the idea of a cultural order properly designed once and for all was only an enticing mirage.

Gourmont's Nietzschean outlook also propelled him toward an intense, aesthetically oriented individualism, which again was broadly echoed. For if the world is nothing but my representation of it, then it follows that each individual perceives the world in a unique way and that the "value" of each person's outlook ultimately rests on its being unique and original. Gourmont delighted in declaring that humans are distinguished from animals in their ability to lie and that "an artist is one who lies in a superior fashion, better than other men."[180] In addition to its sheer bravado and asocial irreverence, this notion could be tactically deployed against those like Max Nordau, who attacked modern art as "degenerate" and "nonconformist." "We are of a violently different opinion," wrote Gourmont. "The capital crime for a writer is conformism, imitativeness, submission to rules and teachings. The work of a writer must be not only the reflection, but the enlarged reflection, of his personality. The only excuse a man has for writing is to write himself— to reveal to others the kind of world reflected in his individual mirror. His only excuse is to be original."[181]

Hard as he may have tried to hold together the role of the professional critic disseminating knowledge to the public with the more radical political gestures prompted by his social alienation and anxieties, Gourmont was ultimately unable to resist a greater attraction to the latter. Like Mallarmé, Wagner, Baudelaire, as well as Nietzsche, he insisted in the end that the individualism he embraced and the art it permitted would never be practiced or even appreciated by more than the few. Indeed, despite his skepticism about truth, he naturalized the division by speaking of "races and castes." For him, the art world was an "aesthetic caste" composed of those who "are qualified to judge the beauty of works" because they do not deploy extrinsic standards like what is pleasurable or what enjoys "success," but are able to say of a work that "it pleases me and nevertheless it is not beautiful; or, it displeases me and nevertheless it is beautiful."[182] This attitude did not mean that he turned his back on the aesthetic dimensions of everyday life. Like Mallarmé he was inter-

ested in decorative art, and he recalled with pleasure the episode of *La Dernière Mode*; indeed, he was largely responsible for restoring its memory to the next generation.[183] He also was responsible for the "first extended discussion of cinema as a medium in the 1 October 1907 issue of the *Mercure de France*," yet "he felt free to praise these [lifelike] qualities of the mimetic cinema precisely because the cinema was not Art."[184] Although he understood that the modern world and the new commodity culture it was bringing to life were too dynamic—too heterogeneous in their manifestations and effects, too continuously innovative, too unpredictable—to be programmatically reconstructed as a fixed hierarchical order, he was unable to accept the implications of this insight for the world of art. Like many others of his generation, he was able to extend the implications of Mallarmé's strategy for resisting the commodification of art only up to the point at which a surrendering of the notion of an aesthetic caste would have been required.

· · ·

Although few nineteenth-century European intellectuals were fully self-conscious about the fragmentation, democratization, and commodification of their experience, these phenomena help us to explain their tendency to create "religions of art." As we have seen, these "religions" in turn were quite variously formulated. Some treated art as artisanship, others as a realm of antiutility. Some put community first and wished to reconstruct all of modern life as a reintegrated cultural totality; others put the individual first and believed that the goal of cultural contestation should be focused on reinvigorating the public sphere to allow for fuller expressions of individuality. Some who opted for community and total rebuilding appeared to assume that their vision was broadly compatible with a democratizing culture; others who thought in this way were openly antidemocratic. But whether democratic or antidemocratic in spirit, those who created religions of art based on fixed visions of a cultural totality were out of step with the dynamism exhibited in the actual unfolding of democratizing cultures. On the other hand, although they were more keenly appreciative of the dynamism of the process of democratization, those who thought in terms of the individual and cultural contestation almost invariably fell back into defending a hierarchical notion of cultural aristocracy.

There were and are a number of problems with notions like cultural aristocracy or aesthetic caste. But let us leave aside the normative and

political issues they raise and approach these notions pragmatically. Is cultural aristocracy a viable concept in the late nineteenth century, whatever one may think of its legitimacy or desirability? One of its presuppositions is that there is a more or less autonomous world of culture that can be indulged in by some privileged group of connoisseurs or spiritualistic aesthetes while the rest of society not only lives without culture but may even be oblivious to its very existence. Culture in this sense is a refuge more or less in the way a monastery functions for monks. Yet while artist colonies may presumably be created in any free society, the notion that such colonies could incorporate all of "culture" and its appreciation was a problematic notion even in the nineteenth century, when commodity culture and processes of cultural democratization were not yet very advanced. Commodity culture was, after all, in large part an expression of capitalism's tendency to aestheticize itself, given the dual nature of the commodity form. Industry too, as it incorporated new technologies, was developing its own modern aesthetic, as some art-and-industry organizations would soon perceive. Moreover, by the late nineteenth century a significant segment of capitalism was openly moving in the direction of entertainment industries that were manufacturing and marketing "culture" like soap or tobacco. Finally, just as commodification and industrialization were rendering "culture" increasingly complex and diffuse, so too the intensification of the more general process of cultural democratization was making any hierarchical claim about culture increasingly problematic.

Of course, the concept of a cultural aristocracy or aesthetic caste was intimately bound up with the notion that art was transcendent in the sense of providing a form of ontological and spiritual revelation for those capable of following its path. From this point of view, the fact that capitalism and industrialism were becoming more aesthetic or producing culture industries might be viewed as having nothing to do with art. Yet such a view of art came to be increasingly at odds with the way nineteenth-century artists were coming to perceive themselves and their work. Modern artists, like creative people in modern societies generally, tend to see their work as a wholly secular matter of pursuing individual designs and, thus, as capable of being appreciated by all those who open themselves to it. As we will see, even those modernists like Kandinsky, who continued to believe in art as a unique pathway to spirituality, typically jettisoned the notion that this was not a pathway potentially open to everyone.

In the late nineteenth century, the model that was developing for

accommodating specialized claims of knowledge—and in that sense, for legitimating an elite—was that of the profession. From this point of view, to say that an aesthetic caste of artists should preside over art was like saying doctors should preside over medicine. (The fact that the commodification of medicine is increasingly making the latter idea suspect is a matter I will leave aside here.) Assuming that it makes sense to speak of artist-intellectuals as a profession, what might the claim that they should preside over art mean in practice in the turn-of-the-century European world? What it came to mean increasingly, I submit, was that the specialized knowledge of artist-intellectuals gave them the right to be the sole arbiters of the value of whatever this profession judged art to be. This way of understanding the claims of artist-intellectuals implicitly recognized the wide dissemination of what might be thought of as "culture" in modern society, and it did not require the cordoning off of culture as some spiritually privileged domain. Moreover, claims to cultural aristocracy could be abandoned and the related terminology of privilege discarded, even as artist-intellectuals conferred upon themselves the exclusive right to make judgments about artistic value. This is the stance adopted by the group of artist-intellectuals that I am calling avant-garde modernist, and it is the basis for the shift to what I am calling the modernist field of positions. Avant-garde modernists abandon claims to cultural aristocracy, reject the allied notion that they can retreat from the public world into their own private enjoyment of art, and commit themselves to resisting the idea that the aesthetics of production and consumption in a democratizing culture can appropriately be guided by the market alone. These modernists see themselves as an elite of taste professionals, one that is uniquely positioned as the legitimate guide to the production and evaluation of art and culture in modern society and that has the power, at least potentially, to universalize its aesthetic understanding and, perhaps, even creativity itself. Yet in so casting themselves, they continue—like Gourmont—to project the deep anxieties and ambivalences that arise from being would-be emperors over such an embattled territory.

2
F. T. Marinetti

No one living in early twentieth-century Europe did as much to shape the emerging role of the avant-garde modernist intellectual as did F. T. Marinetti. One looks in vain through the annals of nineteenth-century art for anyone quite like him. Initially a poet writing in French, he soon added theater and a novel to his opus, but it was as a cultural visionary, organizer, and personality that he made his mark. With a sense of intellectual role modeled upon Gourmont and Moréas, combined with a sense of persona akin to Oscar Wilde or to a publicly oriented Des Esseintes, Marinetti sought and soon achieved a new and unique mode of fusing cultural creativity with political action. By manipulating press and publicity in an effort to marshal "symbolic capital" on an international scale, he aimed not merely to advance himself, or some "school" of art, but to confront a civilizational crisis and to contribute to its resolution by competing for influence in the public sphere with traditional elites whose capital was economic and political. Hostile to the snobbish sacralized culture of the upper bourgeoisie, into which he himself had been born, he nonetheless rejected an oppositional politics based on class and ideology in favor of an original political strategy in which cultural entrepreneurship and image-making were harnessed to the economic and technological forces that were creating "modernity."

Unlike Ruskin and Morris, for whom the machine, however powerful, was merely an extension of the human hand, Marinetti saw in machine power a dynamic experience of life, a new world of unprecedented energy and excitement which, although clearly celebrating human creative capacities, had cultural ramifications that were not yet understood. For him, trains, cars, airplanes, telephones, and cameras were not simply technical devices extending human abilities to move and communicate, but vital, cultural, even spiritual forces through which time and space were being compressed, cities reawakened, visuality enhanced, and print culture transformed and partly superseded. These technologies had also propelled the commodity form into the center of modern life, making possible a world of objects and fashions that was perpetually transforming and at ever-increasing speed. To Marinetti, this commodified world of urbanism and technology did not represent a crisis, which lay rather in the tendency to retreat from this new world into small-minded nostalgia. To him, modernity represented an unprecedented opportunity for art, one with ramifications that were both creative and more broadly political. Rather than scorning modernity or recoiling from it in fear, art should seize upon it as an opportunity to break with the contemplative and safe cultural modes associated with highbrow institutions such as museums, concert halls, theaters, academies, and literary bookshops, and to rededicate itself to shaping the cultural values that were exploding willy-nilly into everyday urban experience.[1] By the time prewar futurism had reached its apogee in 1914, Marinetti had made of it a kind of Wagnerian *Gesamtkunstwerk* applied not just to stage performance but to urban life generally such that fashion, design, architecture, sport, entertainment, cuisine, sexuality, and other cultural forms became integrated into a vision of modernity that he and his movement aimed to realize.[2]

How did this Marinetti—a man of unexceptional artistic talent and without any foothold in mainstream institutions of power or their popular political alternatives—manage to develop such an ambitious vision and thrust it so forcefully into the public eye? The details of his life in prewar Europe cannot preoccupy us here, but a quick review of some of its highlights will provide initial orientation toward an answer.[3] Born in Alexandria, Egypt, in 1876, the son of a provincial Lombard lawyer working in the Suez trade, Emilio Angelo Carlo Marinetti (known as Tommaso or Tom within the family) began writing poetry, immersed himself in French symbolist reviews, and even started his first journal (*Le Papyrus*) before moving to Paris in 1894 to complete his *baccalauréat*.[4]

To please his father, he then took up the study of law, first at Pavia and then at Genoa, where he received his *laurea* in 1899. Yet, at the same time, he was publishing poetry in, and had become "Italian secretary" for the *Anthologie-Revue de France et d'Italie,* a bilingual journal published in Milan and Paris and dedicated to symbolism, naturism, and other avant-gardisms of the day.[5] Indeed, his poem "Les vieux marins" [The Old Mariners] won a competition in 1899 judged by Gustave Kahn and Catulle Mendès, and he convinced his father to allow him to visit Paris, where he heard it declaimed at one of the *samedis populaires* [popular Saturdays] that Kahn had organized at the Théatre Sarah Bernhardt. During the visit, he established important contacts with Kahn and others in the symbolist world and, perhaps even more significantly, established the basis for a myth he invented, still prevalent in the critical literature today, that his poem had been read by Sarah Bernhardt herself.[6]

By the first years of the new century, Marinetti had returned to Paris and moved decisively into its literary world, contributing to *La Plume, Revue blanche,* and other small reviews. He was publishing reams of poetry: an epic poem, *La Conquète des étoiles* [Conquest of the Stars] appeared in 1902; another, *La Momie sanglante* [The Bloody Mummy], came out in 1904; and, in the same year, Marinetti produced his first volume of lyrics, *Destruction.* He also wrote a first play, *Le Roi Bombance* [King Feast] (1905), which was a farce on the model of Alfred Jarry's infamous *Ubu Roi.* Jarry, whom Marinetti had come to know through the *Revue blanche,* would soon become a contributor to *Poesia,* the sumptuous review that Marinetti would publish in Milan from 1905 to 1909. In this period, Marinetti published another collection of poetry, *La Ville charnelle* [Carnal City] (1908), which pursued the theme of urban experience along lines similar to Émile Verhaeren's *Les Villes tentaculaires* [Sprawling Cities]; a book of criticism, *Les Dieux s'en vont, D'Annunzio reste* [The Gods Have Departed, D'Annunzio Remains] (1908), which challenged the *poeta vate*'s cultural hegemony in Italy; a second play, *Poupées électriques* [Electric Dolls] (1909), which established Marinetti's bent for social criticism with a devastating onslaught against bourgeois marriage; and *Mafarka le futuriste* (1909), a first novel so outrageous to prevailing sensibilities that, when it was translated into Italian in 1910, its author was indicted for obscenity. Ultimately convicted, Marinetti was able to use a substantial inheritance from his father's death in 1907 to buy his way out of prison time, but the conviction would come back to haunt him when he sought to become an officer in World War I.

Notwithstanding such consequences, Marinetti clearly relished the public relations bonanza represented by his obscenity trial, since his principal aim in all of his frenetic literary activity was always to make an impact on the public sphere, both in Italy and elsewhere. The world of politics was never far from his purview, yet his political perspective was by no means conventional. Beginning in the late 1890s in Milan, he had dabbled in the leftist circles that included Anna Kuliscioff, Filippo Turati, Claudio Treves, Arturo Labriola, and Margherita Sarfatti, but he had little patience for the logistics of socialist and syndicalist organizing.[7] The sort of politics that appealed to him is better exemplified by his 1908 pilgrimage to Trieste, where he carried a wreath at the funeral of the mother of Guglielmo Oberdan—a young Italian who had been executed in 1882 by the Austrians for a murder plot against the emperor Franz Josef and who had then become a martyr to the irredentist cause. While there, Marinetti was arrested for an anti-Austrian speech.[8] These were the politics of the photo opportunity and the symbol-infused mass demonstration, a politics for the age of mass media, and in terms of Marinetti's overall activities, they figured as just part of the performance mix, however important, rather than as an activity of independent significance.

Fundamentally, Marinetti's strategy for a remaking of Italian culture in the years leading up to futurism remained the seemingly preposterous one of forging a public image and gaining notoriety by publishing a poetry review. As his friend Carlo Linati later recalled, when Marinetti first presented the idea of launching a review based exclusively on poetry, Linati had objected that "it is crazy to start such an enterprise in Italy in this age of commercialism!" Marinetti's reply was that only such a review would satisfy him because "I want to shock [épater] senile, Carduccian Italy with this gesture of craziness."[9] What he understood better than Linati did was that it was precisely the "gesture of craziness," rather than the content behind it, that made his strategy perfectly suited to the world of commodity culture. Such a gesture of (calculated) craziness stood behind every facet of his public persona, which another contemporary described as "a bit the Gascon braggart and a bit the Don Giovanni— simple in his material needs and yet refined in its tastes and pleasures . . . , carefree and yet hardworking . . . , Italian in his versatility, French in his gift for conversation, Turkish by the tobacco and coffee he consumes, more rebellious and wittily anarchic than conservative . . . , [and yet] a young *arbiter elegantiarum,* a *charmeur* in his mode of speech, his smile, and his dress."[10] Most notoriously of all, such a gesture stood behind the decoration of his Milanese abode, the notorious "Casina Rossa," which

astonished the painter Ardengo Soffici in 1913 with its "appalling taste," furnished as it was "more or less in a Turkish style, with rugs (whether genuine or fake) in shrieking colors; similarly covered sofas; wild animal skins; hexagonal *tabourets* of ebony inlaid with ivory and mother-of-pearl; low round tables, small but with extravagant contours; and with vases, metal goblets, and knick-knacks strewn everywhere."[11]

More than any other intellectual personality of his era, Marinetti sensed how the commodity form had remade human identity and human relations. He shaped and continuously reshaped his persona for the mystique, aura, and symbolic associations he wanted to project, in precisely the same way as the manufacturer of a product does to attract buyers. Marinetti was himself and a representation of himself, a mediatized self-idealization, a kind of walking (or galloping) trademark—the "caffeine of Europe."[12] For he understood that it was his ability to project a unique and captivating public image, and, ultimately, a movement of avant-garde art related to it, that offered his main hope of raising the level of symbolic capital that would allow him to thrust his agenda of technological modernity and cultural revitalization successfully into the public sphere.

COMMODITY CULTURE IN MARINETTI'S MILAN

By the early twentieth century, the commodity culture that had so fascinated Huysmans and Zola was fast developing, as one of its principal features, a complex of technologically sophisticated and increasingly international media and entertainment industries involving newspapers, popular magazines, best sellers, films, professional sports, and fashion, all of them interconnected by advertising.[13] While Marinetti's recognition of, and interest in, these new industries is now increasingly understood, thanks to the efforts of scholars such as Claudia Salaris, until recently the more common understanding of his early public life focused on the way he and his futurist movement had anticipated fascism, shaped its ideals of war, virility, and misogyny, and become bound up with it in the early postwar period.[14] Although few would dispute the importance of Marinetti and the futurist movement for the understanding of early fascism, this focus has tended to relegate futurism to the status of an independent variable, thereby leading to serious distortions. Few would deny, for example, that futurism strongly appealed to masculinist ideals and frequently asserted a misogyny later appropriated by fascism. Yet from the beginning, futurism also sought to attract, and held a strong attrac-

tion for, women anxious to escape the confines of traditional roles, an interest that further increased during World War I as the rapid social changes it imposed created new opportunities and expectations for women. That attraction, as we shall see, had much to do with futurism's erotic and mass-entertainment dimensions.

To comprehend this side of the futurist movement, it is crucial to understand its Milanese setting. Although best known as the apex of the industrial triangle that grew up in northern Italy after 1895, and for the socialist and trade union movements that accompanied this industrialization, Marinetti's Milan was also undergoing a major cultural transformation that included the development of significant culture industries.[15] These were the years of major expositions, the largest of which—at eighty-four thousand square meters of enclosed space—was the International Exposition of 1906, which celebrated the opening of the Simplon railway tunnel that, crossing Mont Blanc from Switzerland into Italy, was the longest such tunnel then in existence. The exposition featured a building devoted to automotive engineering, probably the first at a world's fair, as well as other industrial-commodity pavilions, fine arts exhibits, and cultural events.[16] Grand department stores also appeared, and professional sports took off. The Touring Club of Italy, based in Milan, organized its first automotive "*giro d'Italia*" in 1901, and in 1907 two Italians, Scipione Borghese and the journalist Luigi Barzini, won the first Peking-Paris eleven-thousand-kilometer race. The year 1901 also saw the first International Automobile Exhibition in Milan, which honored Ettore Bugatti, a man who would become famous as a builder of luxury cars, race cars, and motorcycles. The first Milanese soccer team, the "Milan Cricket and Football Club," was formed in 1899. Bicycle racing became popular with the first Milan–San Remo race coming in 1907. Clubs for mountain-climbing, skiing, and rowing all formed in the late nineteenth century became more active (the first "*coppa Milano*" in rowing dates from 1904), and ice-skating, roller-skating, marksmanship, tennis, fencing, wrestling, boxing, motorcycle racing, and aviation all began to find enthusiastic participants and spectators.

Theatergoing remained a major focus of cultural life—these were the Arturo Toscanini years at La Scala—but its audiences became less aristocratic as private boxes were sold off and ticket prices were standardized; and, increasingly, operas produced, such as Giacomo Puccini's *Madama Butterfly* (1904) or *La fanciulla del West* [Maiden of the West] (1910), aimed at a popular audience.[17] Part of what made this possible was the growing acceptance of repertory opera, which meant that the

opera season could be based, year in and year out, on the same fifteen or twenty "classic" operas. Alongside traditional theater, audiences grew for operettas, variety theater, circuses, and above all, for the silent cinema, which had its golden age in the Italy of the immediate prewar years. Cinema prices were low, and huge audiences were drawn to the Centrale, an elegant theater constructed in Milan's Galleria next to its northern portico. The first cinema production company in Italy was formed in Turin in 1908, but by 1914 Milan had three. The new films they produced presented longer narratives, and by 1913 blockbuster shows such as Mario Caserini's *Last Days of Pompei,* Enrico Guazzoni's *Quo Vadis,* and Giovanni Pastrone's *Cabiria* were creating great excitement.

These years also witnessed the emergence of mass journalism under the leadership of Luigi Albertini, editor of Milan's *Corriere della Sera* from 1900 to 1921.[18] During these two decades its print run increased from about seventy-five thousand to over six hundred thousand, as major Lombard firms gave it their financial backing. The *Corriere* became the model, not only for other city newspapers, but also for more partisan ones such as the Socialist *Avanti!* which had a daily circulation of four hundred thousand in 1914.

What fueled all these developments, in addition to the growth of industrial capitalism, was an enormous increase in urban population. In the hundred years up to 1914, Milan's population nearly quintupled from about 140,000 to 655,000. Much of the increase reflected a pattern of migration into the city from nearby farms. The influx produced major problems such as a housing crisis, but also stimulated many modern infrastructural changes, such as new buildings and road widenings downtown, the development of public transportation (trams were electrified in 1899), and the expansion of telephone service (lines went underground beginning in 1901, and the first calls to Paris were put through in 1902). From the perspective of the new culture industries, however, the main point was the vast increase in the size of potential audiences and their changed character with the swelling tide of recent rural immigrants.

How should artists respond to the rise of these entertainment industries, and what sort of offerings should they make to the new audience to which those industries were catering, apparently with great success? One answer, which in the terms of this book we might trace back to Grandville, would be simply to join the mass-entertainment frenzy, even if that meant debasing art to the level of kitsch. A second answer—that of the late Baudelaire and to which the symbolist movement still largely conformed—would be to split the world of art such that the masses would

be entertained by the new industries, while genuine art would continue to prevail in a separate, small elite-cultural refuge. To Marinetti both of these answers were unacceptable: the first because it would mean surrendering artistic autonomy and creativity, the second because it would simply perpetuate the emerging division between popular entertainment and the sacralized high culture he so detested. Marinetti's answer went in a third direction: to raise kitsch to art or, perhaps more accurately, to blend kitsch and art in a way that satisfied both the recent rural immigrants and other workers, as well as the artistic intellectuals who would continue to create it.[19] In this way, the standards associated with artistic autonomy would be preserved even as the masses were entertained and their entertainers thrust into the center of the public spotlight. Moreover, this strategy had the additional advantage of continuing to appeal to the taste for exoticism among the aristocratic elements in his audience (elegant ladies not infrequently attended futurist *serate*), while simultaneously bypassing the need to cater to the bourgeoisie, or even of allowing for a combination of the two elements, as in his manifesto "Down with the Tango and Parsifal."[20] In short, Marinetti saw himself as both a new taste professional specializing in mass-cultural entrepreneurship, who knew how to retain control of the artistic product *and* as the leader of a pocket of resistance to the bourgeoisie and its sacralized culture. For a brief period at the end of World War I, he even believed that this resistance was about to galvanize the masses sufficiently to become the basis of a new society.

Reflecting upon the funeral of Giuseppe Verdi in the Milan of 1901, Marinetti had still been enough of a symbolist to think that "the Italian artist finds himself exiled" and no longer at home in a Milan where "electricity and steam engines reign amidst ringing bells, screeching sirens, aggressive bicycles, smoke, and hubbub."[21] But he soon reversed himself, as he came to recognize the aesthetic potentials in modern technology, commodity culture, and mass entertainment. By 1905, when he wrote his first ode to the automobile and launched *Poesia*, he had dedicated himself to a rethinking of artistic practices in relation to these new phenomena, and he was beginning to show signs of the obsession that would pervade the rest of his artistic life: the obsession with audience.[22] In this respect he was not unlike Wagner. Yet whereas Wagner shrank from cultural democracy despite his quest for audience, or perhaps better, sought to remake his audience in an ideal mode and to divorce it from what he saw as the current cultural degradation, Marinetti would

come to embrace cultural democracy, accepting entertainment values and adamantly rejecting any revived connection with artistic traditions and popular folkways. In this latter regard, he would vehemently denounce Ruskin, and he even regarded Nietzsche as too much the backward-looking elitist to embrace wholeheartedly.[23]

Marinetti spent the *Poesia* years developing the ideals and associated images which he would single-handedly foist upon the world as the founding manifesto of futurism. Only then did he begin to recruit the group of card-carrying futurists to which the manifesto had referred when it declared that "the oldest of us is thirty."[24] In fact, when these words appeared in *Le Figaro* on 20 February 1909, Marinetti himself was already thirty-three, but he had decided that part of the movement's image was to be its youthful vigor. Marinetti had lavished his inheritance on *Poesia,* and it had returned the favor by achieving a circulation of perhaps forty thousand copies by its final issue.[25] Its issues sold for the then astronomical price of ten lire, but this was more a reflection of Marinetti's image of the journal than of any aim at making a profit. Indeed, Marinetti thought nothing of giving away copies to people he wished to influence. Moreover, through *Poesia* he became an accomplished devotee of the press release, and he launched a variety of lectures, conferences, competitions, and "inquests" designed both to make it visible and to bring into its orbit those who might be of help in advancing his aims.

In the fall of 1908, Marinetti had a dramatic traffic accident which, while not quite a near-death experience, seems to have inspired the rambling prologue that accompanied his founding manifesto when it appeared in *Le Figaro.*[26] The manifesto itself—in eleven provocatively phrased points—had already been circulated throughout Italy in leaflet form when, in the last days of January 1909, Marinetti wrote the prologue in a room at the Grand Hôtel de Paris. He then used an old crony of his father's—"the Pashah Mohammed el Rachi, a former minister in Egypt, now a seventyish Parisianized epicurean and *Le Figaro* shareholder," as Marinetti later described him—to get the two-part document published in the Paris newspaper which had earlier published Moréas's symbolist and Saint-Georges de Bouhélier's naturist manifestos but which had more recently become known as the "Jockey Club's daily."[27] As a direct spin-off of this publication, Marinetti got press coverage in many other European dailies, and he further fanned the flames by writing literally hundreds of letters to prominent European intellectuals promising to reprint their evaluations of futurism in *Poesia.*[28] A few

months later he managed to get his play *Roi Bombance* produced by the posh Marigny Theater. Meanwhile, he punched out critics, and even fought one duel, to create yet more scandal.

Although Marinetti was an indefatigable and cunning self-promoter, he was not unparalleled among Italian avant-garde intellectuals in his use of such methods. One of them, from whom he certainly learned a trick or two, was his close friend Umberto Notari.[29] Originally from working-class Bologna, where he was born in 1878, Notari had come to Milan at age twenty with some journalist experience but nearly penniless, had gone to work as a journalist, and then, at the time of Verdi's death, had become a press agent for the hotel where Verdi had lived his last years. His earnings soon allowed him to create the newspaper *Verde e Azzurro,* which became notable as the first Italian daily to take an active interest in sports.[30] He also established a press of the same name, which published two of Marinetti's first books.[31] What truly made his name, however, was his publication in 1904 of *Quelle signore* [Those Women], a novel set in a bordello that had sold eighty thousand copies in six months.[32] Two years later, it was his good fortune to be accused of obscenity by a court in Parma. Marinetti, who attended and clearly relished the trial, wrote a detailed account of it for the Parisian readers of *Gil Blas* and then translated his account into Italian, appending a brief, self-congratulatory introduction. It reads in part:

> Notwithstanding the triumphant Americanism of his journalistic career, it would have been difficult for Notari to have gained the resounding success that he has with his novel, even to this day, had the Attorney for the King of Parma, during the provincial festivals, not had an idea worthy of a sublime Barnum: that of denouncing the pornographic immoralism of the book, which, by his order, was seized and prosecuted. . . . It is impossible to imagine such an atmosphere when one has, right and left, seductive journalists who put their feet up on the table, promising you voluptuous publicity, and when you have before you orators who take such dangerous gambits. . . . The sentence of the Parma Tribunal was proclaimed immediately through every publicity channel, and this gave an extraordinary boost to the book's sales such that, today, one finds it in all the elegant parlors, in all the bedrooms, under the virginal bed linens of all the convent-school girls and inside the prayer benches of all the new brides.[33]

Four years later, as we have already noted, Marinetti would succeed in getting *Mafarka il futurista* tried for obscenity, although his effort at high pornography never produced the sales volume that his friend achieved.

Like Marinetti, Notari too had strong political convictions which,

however, were so seamlessly woven into his public relations style that the motives behind them were not always easy to assess.[34] In 1910, for example, he attempted to form his own "Italian Association of the Avant-garde," in connection with which he published a long manifesto called *"Noi"* [Us]. Here he discussed a number of the political causes he favored, above all a campaign, also supported by Marinetti, to expel the Vatican from Italy.[35] Yet, in a self-advertisement on the first page, Notari listed ten other books he had already authored, including four novels, two of which, he noted, had been "tried for obscenity"; three books of politics and sociology; two of journalism; and one play (a staged version of two of his novels). His ad also noted that *"Noi"* was a volume of 150 pages; in fact, the reader can easily see that it has only 119 very small pages with very large print and very wide spacings. In this context, the claims the manifesto makes about imminent formation of the "association," Notari's draft of its constitution, and his plans for its "convention" in San Marino appear suspect as serious political projects.

Despite their many similarities, however, there are at least three important differences between the self-promotional styles of Marinetti and Notari which are instructive in clarifying Marinetti's distinctive orientation. The first is that Notari's approach to the new sphere of mass entertainment was always much more that of a conventional businessman than Marinetti's. Perhaps because of his working-class background and his lack of both Marinetti's wealth and the independence that went with it, Notari was more driven by profit-making motives and more prone to give his mass audience precisely what it demanded. Thus, for example, *Verde e Azzurro* is brimming with English words reflecting the new world of consumerism and mass entertainment—"amusements," "five-o'clocks," "garden party," "bookmakers," "sports," "sportsman," "turf," "greatest day," "dead-heat"—which would have made literary-minded readers cringe. Although his work does use gentle ironies to provoke its audience, the gap between the artist's autonomous taste and that of the masses, which Marinetti never ceased to exploit, is completely absent in Notari. While Marinetti's intense opposition to *"passatismo"* [passéism] was an implicit criticism of his audience and of Italy's museum and tourist culture, Notari actually used *Verde e Azzurro* to help promote Italy as a land of tourism.[36] Moreover, while Notari explicitly invoked a modernist aesthetic and published many articles on literature, art, and theater, he had less passion for such topics than for mass sport, which he approached with the mind of an ardent fan.[37] Indeed, Marinetti later recalled that *Verde e Azzurro* "had provided the impetus for the

first marathons of twenty thousand young men, bare-chested in the sun, racing competitively through the streets of Milan."[38] The other promotion for which Notari became known in the prewar period was an international traveling fair of Italian commercial products. After the war he developed *L'Ambrosiano,* the Milanese daily best known for its coverage of sports. By 1926 he had also founded and was editing a business daily, *La Finanza d'Italia,* and his books in the postwar period are mostly economic discourses done in a humorous vein, a genre that Massimo Bontempelli dubbed "novelistic economics" [*economia romanzata*].[39] While the avant-gardist impulse that gave rise to *"Noi"* never entirely died out—another of his dailies, edited during the war years, was *Gli Avvenimenti,* the "third page" of which was first overseen by the futurist poet Paolo Buzzi and later by Margherita Sarfatti—it gradually diminished, and by the fascist era it had been reduced to a stylistic flourish within a mainstream publishing business.

A second difference in their self-promotional styles is that, while both men demonstrated enormous energies, Marinetti played to a much wider audience and lived his life—and especially the half-dozen years after the first futurist manifesto—in a perpetual international whirlwind. Carlo Linati, who initially coedited *Verde e Azzurro* with Notari and who also knew Marinetti well, credited the latter after his death in 1944 with "having presented us with a totally new human type: a kind of model of the 'man in a hurry' [*affrettatore*], an agitator of the spirit which the times probably called for and of which, up to now, we have had no more historical examples."[40] During the first futurist years, Marinetti never ceased being on the run, giving "conferences," exhibitions, and *serate* in two dozen Italian cities and a dozen countries and managing most of the details himself. As two of his young futurist disciples marveled, "Marinetti spends half of his life on the train: war correspondent and soldier in Tripoli and Bengasi and in the Bulgarian trenches of Adrianopolis; futurist propagandist in Paris, Bruxelles, Madrid, Moscow, Petersburg, Milan, Palermo. His home is not the Casa Rossa of Milan nor the Excelsior Hotel in Rome but the railroad car."[41] All told, between 1909 and 1915 he paid four extended visits to London, seven to Paris, four to Berlin, two to Brussels, and one each to Russia, Libya, and Bulgaria, and he did roughly twenty-five *serate* from Trieste to Palermo and Turin to Catanzaro. At the same time, he was producing literally hundreds of poems, articles, and manifestos.

Finally, although Notari certainly appreciated how consumerism and the new technologies of communication and transportation had revolu-

tionized the conditions of cultural production, Marinetti was more acute in his theoretical understanding of these developments.[42] As he boasted to a female admirer just after the publication of the founding manifesto:

> I also enjoy a lucid knowledge of my epoch. I believe that the methods of action and intellectual propulsion today cannot be those of fifty years ago. I believe that the most fertile and reinvigorating ideas cannot be propagated by the book. Ideas in books are hopelessly bewildering to people, given the flood of industrial and commercial forces, and the sickness and tiredness of the human brain, shaken by the incessant racket of economic interests in a life that has become, for almost everyone, more cinematographic and anxious than ever. We must therefore adapt the movement of ideas to the frenetic movement of our acts. In this regard, isn't it absurd how the *Giornale d'Italia* these days makes accusations against me, asking ironically if Alessandro Manzoni would have proclaimed his romanticism by designing huge billboards, with bright red lettering on a white background, declaring "Romanticism—Manzoni"? Does it make sense to you, dear friend, that there might be something in common between our life today and the one our grandparents led? . . . Let's conclude: I think that today one can propagate an idea perfectly by splashing two-color posters on the walls of our great cities.[43]

That this was a conception Marinetti took literally became clear to his fellow futurists when, entering Paris on the Boulevard des Italiens for their February 1912 show at the Galerie Bernheim-Jeune, they saw their names boldly emblazoned on huge billboards.[44]

THE POLITICS OF SELF-PERFORMANCE

In an essay of the early 1970s, George Steiner suggested that the great age of the book had run from the era of Montesquieu to that of Mallarmé.[45] This period of about a century and a half had sustained a reading culture because of the privacy and leisure enjoyed by a middle-class lettered public; the existence of a corpus of conventional references—to classical mythology, theology, history, and philosophy—that did not have to be "explained"; the belief in a common set of philosophical and social values connected to this corpus; a deep trust in the power of language to inform; and a convention of mimesis through which it was assumed that language and world were intrinsically related and mutually sustaining. But, as the social underpinnings of this culture eroded in the 1880s, the world of European poetry had moved in two contrasting directions: toward a hermeticism in which difficulty served to keep the philistines out and to preserve a self-selected aesthetic caste; and toward a dramat-

ically external, often collaborative crying out to the public with "the voice of the megaphone and the read-in."

It was precisely this voice that Marinetti discovered in 1909, and he did so on the basis of an analysis of the decline of the literary and its displacement by the slogan and the visual image that was remarkably similar to the one Steiner would later offer. For Marinetti, the problem with the older generation of writers, such as D'Annunzio, was that they had failed to understand how the book had been superseded and how, to have any practical effect on popular behavior, they would have had to avoid verbal complexity, literariness, and other elements that create distance between writer and reader.[46]

This point is worth bearing in mind as one considers the attitude toward the masses inscribed in Marinetti's public performances. He certainly derided the audiences of his *serate* for their stupidity, credulity, and docility, yet he also knew that his ability to provoke them with the long-winded readings of the poets on stage derived from the new mode of cultural production he had discerned in contemporary society. Moreover, he fully recognized that this new mode was linked to a rising society of consumerism, which was in turn predicated on mass appeal. In this sense, he understood that he was wholly dependent upon his audiences, that the spectacle of a *serata* was nothing without them. He was quick to exploit their power in order to create a new more spontaneous and participatory style of performance. In this performance the audience becomes the power of the city crowd into which the poet-*flâneurs* have wandered; the excitement of the spontaneous unforeseeable turns in the event depend on it, not them. The notoriety of the performance, and the possibility of yet bigger, more spectacular, more turbulent, raucous, and violent *serate* in the future likewise depend on it, not them.

Thus, while each *serata* unfolded as a unique event, there were a number of carefully orchestrated stages through which they typically proceeded.[47] First, days before the event itself, groups of futurists would display themselves—like the goods in a department store window—at a local chic café. Or, to the same effect, they would stage their arrival at the local railway station with absurdist ceremony. Soon enticement would be supplemented by printed advertisement: leaflets handed out on street corners, posters tacked up on walls. Then, on the day of the event, but hours before its announced starting time, crowds would begin milling about in a carnival atmosphere in some *piazza* near the rented theater, which would be as grand as available. Gradually they would enter the theater, becoming steadily rowdier as their numbers increased, and

would begin to pelt the empty stage with whatever they had brought along for this purpose. The futurists would deliberately delay their own arrival perhaps two or three hours, the better to overheat the atmosphere. Then, dressed formally in "smoking jackets" to accent their aristocratic difference, they would alight on stage and, one by one in the spotlight, declaim their verse or manifesto, often to the accompaniment of intensified pelting. Finally, to prove that the violence had left them unfazed and to reemphasize the ultimate separateness that their genius required, they would troop off in a postperformance procession to the local café for late-night private merriment.

The performance, in this wide sense, staged the separateness, absence, and difference of the futurists at every turn, even while it sought to provoke the audience into a leading role in making the event spontaneous. It played with the ambiguity of dependence (we are the goods that you are buying) and domination (we declaim regardless of what you throw). You are the *passatisti,* and we, the *futuristi.* You buy our tickets, honor us with your presence, make us famous, yet we remain futurist geniuses autonomously pursuing our own pure art. The result is theater, but it is variety theater, not the mainstream "contemporary theater (verse, prose, and musical) . . . [which] vacillates stupidly between historical reconstruction (pastiche or plagiarism) and photographic reproduction of our daily life."[48] In the *serata,* as in the variety theater, there is a flight from mimesis, an acting out of the desire to present rather than represent so characteristic of every modernist aesthetic. The *serata* appears to declaim, to remain wedded to the printed book of poetry, yet this declaiming is never didactic or educational, never an end in itself; it has become a vehicle designed to elicit the main performance as a spontaneous act of audience and futurists together. D'Annunzio's plays, however grandly staged, remained representations rather than true theatrical presentations. Only in the variety theater and the *serata*—only, that is, in the theater appropriate to the new commodity culture—was an avant-garde modernist performance possible.

To the futurists, then, modernism and commodity culture were not merely compatible but mutually reinforcing: only through performances that combined art with the entertainment values of mass spectacle was it possible to realize the modernist value of a pure nonmimetic art. For Marinetti it was traditional theater that had become mere entertainment, while variety theater was the only available staging ground for genuine dramatic art. In essence, this art was built upon a provocative staging of difference, through which, it was hoped, sufficient friction would be gen-

erated to ignite its potential for the spontaneous and dynamic interaction of artists and audience. While, as performance, this aesthetic strategy was arguably new, its staging of difference traded on a very old structure within modernist art. As Peter Nicholls has demonstrated, Baudelaire constructed an ironically antisocial position for the poet by inserting two voices within the poem. In one voice, Baudelaire sympathized with a young girl of the lower classes (or the faces of a crowd or some other figuration of the masses); in the other, the girl or the crowd or the masses became simply the occasion for the poem, and the reader was forced to confront the irony that the poem's subjects were nothing without the poet who commemorated them. With the first voice he made clear that the poet was as poor as the girl; with the second, that he did not wish to become close to her, that there was a gap between them he did not wish to cross.[49]

As we saw in chapter 1, however, while Baudelaire may have understood this dialectic of identity and difference as a literary structure, he refrained from deploying it as public performance or otherwise developing it as a form of politics. In contrast, not only did Marinetti and his futurists learn to stage difference in a way that drew upon nineteenth-century notions of the separation of artistic caste from mass while using that difference, paradoxically, as a way to gain audience share; they also staged it in the theater of world politics. During World War I, for example, they strongly identified with the Italian people, first inciting them to intervene in the conflict and then celebrating them for having done so. Yet they also insisted upon setting themselves apart in their "futurist squads," which were usually devoted to the most technologically exciting and ostensibly daring activities, such as the armored-car division or the aviation unit. When, in June 1917, the Italian High Command created the elite units known as *arditi* in order to try to break the stalemate with the Austrians, futurists flocked to them as if to further institutionalize their sense of difference from ordinary soldiers. The resulting alliance of futurists and *arditi* lasted into the postwar period and provided an important source of early fascism.

The war certainly intensified Marinetti's political passions, but politics had always played an important role in futurist *serate,* especially in the earliest ones before the stable of artists he was then recruiting had joined the show. The very first one took place on 12 January 1910 in Trieste, a city gripped by irredentism because it was still ruled from Vienna while being more than half Italian. In his speech for the occasion, Marinetti incited the crowd by pressing all the hot buttons that were fast becom-

ing identified as the core of futurist politics: in favor of the nation, militarism, and war ("the world's only hygiene") and against internationalist and "antipatriotic" socialism, "timid and clerical conservatism," materialism, "economic opportunism," and the "tyranny of love." Confrontations ensued between the Italian audience and the few Austrians who had dared attend.[50] At the next *serata* of 15 February at the Teatro Lirico in Milan, an even more intense irredentist demonstration erupted, probably because of the media attention that the first one had received.[51] The legacy of that event was that actual violence, or the threat of it, was never far from a futurist performance, even when political themes were not explicitly invoked.

Marinetti also developed a series of political manifestos in the prewar years, designed to coincide with national elections.[52] Here again the major themes, all turning on an intense nationalism with modernizing and expansionist overtones, were reduced to slogans based on a single word (irredentism, pan-Italianism, anticlericalism, antisocialism, *antipassatismo*) or a mantralike phrase ("the word ITALY must dominate over the word LIBERTY" or "every liberty, except being cowardly, pacifist, anti-Italian"). Indeed, not only did everything come in short telegraphic phrases, but the political values asserted were linked to the world of mass entertainment and the overcoming of literary culture: "cult of progress and speed, sports, physical force, reckless courage and danger"; "against the obsession with culture, classical education, the museum, the library, and ancient ruins"; and "for the predominance of gymnastics over the book."[53] Nationalism, in Marinetti's view, was bound up with the same social dynamics that had brought modern technology and commodity culture.

This connection in Marinetti's mind between nationalism and modernity helps to explain why nationalism was not incompatible for him with a certain kind of internationalism. Futurism was a movement directed at the whole world, and its animating vision of a modern culture celebrating the technological triumphs of the present was unabashedly universalist. Certainly Marinetti spent much time and energy as a barnstorming promoter of it across Europe. He did so, presumably, because the virtues and values he hoped Italians would uphold were also very much for export to the Spanish and the English, as the speeches he made in those countries suggested.[54] Each nation, in his view, needed to break free from the fetters of the past and forge its own future based on futurist virtues and values.

There may even have been something deeper in the way Marinetti was

so intensely nationalist and yet also so concerned with imagining other nationalisms. As someone who had been born in Egypt and educated in French schools and who continued to write almost exclusively in French until 1912, Marinetti could hardly have escaped questions about his own national identity, even if his lineage guaranteed his cultural rootedness in a way, as we will see, that Apollinaire's did not. Questions about Marinetti's national identity were certainly raised by others, sometimes even in print. As Enrico Corradini, founder of the Italian Nationalist Association in 1910, wrote of him in *Il Marzocco,* a Florentine review: "F. T. Marinetti is a young Italian who lives in Milan and writes in French. As a writer therefore he is twice *déraciné: déraciné* in so far as he is an Italian writing in French, and *déraciné* in so far as he writes in French and lives in Milan. And that is why this young man, who belongs by half to two countries and to none fully, and yet who shows much cleverness in both orbits, has always occupied my attention as an object of study regarding the road one can take in literature and art under these undoubtedly unique circumstances."[55] One can only wonder whether Marinetti's enthusiasm for Italian wars and for serving in Italian armies (which continued right up to his participation in World War II at the age of sixty-six) may have had something to do with his knowledge that sentiments such as these were in the minds of other Italian nationalists.

Even if issues of identity did inform Marinetti's politics in the prewar period, however, the overwhelming impression left by his manner of political expression in these years is that politics for him was subordinate to performance. There is no reason to read his prewar politics teleologically as a prologue to fascism. It was only in the early postwar context that Marinetti revolutionized his political objectives and began to fantasize a counterbourgeois political order with the futurists installed as the new political class. "I believe that parliamentarism, a fallacious and short-lived institution, is destined to perish," he wrote in May 1919. "I believe that Italian politics will inevitably see its death throes hastened, unless it shows its flexibility by substituting the artists—geniuses at creation—for the class of lawyers—geniuses at dissolution and excuse-making—that have monopolized it up to now. . . . It is above all from the lawyerly spirit that we want to liberate Italian politics."[56] The new non-lawyerly, nonparliamentary order would abolish prisons and police, reduce government to the minimum, dissolve the family for free love, and, most important in light of the present discussion, promote a new free artistic sphere. Six months later, Marinetti spelled out the details of this new sphere, which, since it would be "lavished upon everyone,"

would "multiply the number of creative artists." Life would "no longer be simply one of bread and labor, nor one of idleness, but one of *life as a work of art [vita-opera d'arte]*."[57] As such images suggest, however, the spirit of these writings is festively anarchic, and they leave unclear just how participatory this new sphere would be (Marinetti's category *"gli artisti"* appears castelike throughout) or how the commodity culture of mass entertainment that had emerged before the war might or might not be reinstitutionalized.

FUTURISM AND JUDGMENTS OF TASTE

Marinetti's futurism was the first artistic movement to respond aggressively to commodity culture rather than to retreat from it, as French symbolism largely had. And this response was brilliant in many ways. The futurist reduction of modernity to the phenomenon of speed [*velocità*] probably communicated the basic rationale for a modernist art more effectively than did any other modernist movement. The range of interconnections that Marinetti made between his futurism and the conditions of modern life is also quite startling. He understood the emerging power of the press and publicity and, thus, the need for the artist/intellectual to use these means for his own ends—a task he himself undertook on virtually a daily basis with every media tool he could devise. He understood that the power of modern commercial advertising should inspire a rethinking of his poetry and even the forging of a new theory of poetic language.[58] He understood that modern civilization is based on the dominance of vision and that visual images would not only increasingly replace written forms but also reorient print media by heightening the visual dimensions of their typography.[59] He understood that the world of capitalism was becoming more aesthetic as it became more consumerist. He understood how the commodified image implied the need to reconstruct one's own personality as a set of masks and poses. He understood that the spectacle of modern life was rooted in a marketplace whose dimensions were not bounded by the local community, the city, or even the nation, but were genuinely global. He understood that modern society as a "mass" society was inevitably bound up with a democratizing culture.[60] Finally, Marinetti understood that the future of art lay in adapting it to newer mass-entertainment venues such as variety theater and cabaret, in which it might enjoy a large and variegated audience. For only through such an audience could art have a significant impact on the public sphere, which, as futurist practices made clear, was always his fundamental concern.

Of course, a reorientation of art toward the world of mass entertainment could not by itself guarantee commercial success, and there were undoubtedly occasions when the futurists failed to exploit the full potential of the new media and venues in which they were working.[61] The difficult question to answer in this regard is whether such failures resulted primarily from an inability to achieve commercial success or whether futurist art and performance were sometimes complicated by other motives. Or, to put matters more generally: does sensing the potential power of mass-entertainment industries and the corresponding necessity of participating in them mean that one is endorsing the commodity status of art and reducing the test for artistic excellence to box office receipts? Did Marinetti believe that art had become simply a commodity, an exchange value to be determined by the marketplace, that is, by the demand it could generate, rather than by the intrinsic worth of the art object as determined by the traditional means of evaluation by professional critics and other artists? Did he hitch his star to the consumer society wherever that might lead in terms of the definition of art, the standards to which it was beholden, and control over its production?

One recent critic has answered these questions in the affirmative: "the deeper rationale of its [futurism's] apparently irrational metaphysic was quite simply that of the market"; "the logic of consumerism . . . [was] welcomed [by the futurists] as the perfect antidote to a decadent economy of accumulation and repression"; and "art would no longer be fetishized for its aloofness but would be thoroughly integrated into the fast-moving circuit of commodities."[62] As we have seen, however, while there is no question that the futurists aimed at mass appeal, there are several senses in which they were less than fully adapted to marketplace logic. Marinetti insisted, for instance, on an antagonistic self-presentation before his audiences—the famous "pleasure in being booed" so much in evidence at futurist *serate*. This "pleasure" certainly contributed to the futurists' notoriety, but it also evidenced an elitist view of themselves as above the masses for whom they performed and, thus, as the final arbiter of the value of their art. Moreover, as we saw in the comparison with Notari, Marinetti upheld values such as the antipathy to tourism that ran counter to "the logic of consumerism," and by no means were all futurist enterprises aimed at the mass audience that such a logic suggests. The "*edizioni futuristi di Poesia*"—books that Marinetti continued to edit for many years after the last issue of the journal *Poesia* appeared in October 1909—were aimed at an audience of no more than a thousand (as their publication runs attested), and their quality was uncompromising.[63]

Finally, in those few texts in which futurists directly discussed the concept of value, they did not reduce it to market exchange.

Before turning to one such text, however, we need to say more about Marinetti's conception of audience. In his manifesto entitled "The Variety Theater" (1913), he commended this theater on a number of points that suggested its close connection with industries of mass entertainment: it "distracts and amuses," it continually invents "new elements of astonishment," it "uses cinema," and it "generates what I call 'the futurist marvelous.'" Indeed, it inaugurates a new mode of art which "destroys the solemn, the sacred, the serious, and the sublime in Art with a capital A" and thereby "cooperates in the futurist destruction of immortal masterpieces." One of the main reasons it is able to succeed in these ways, he continued, is that the variety theater "is alone in seeking the audience's collaboration. It doesn't remain static like a stupid *voyeur*, but joins noisily in the action, in the singing, accompanying the orchestra, communicating with the actors in surprising actions and bizarre dialogues. And the actors bicker clownishly with the musicians. The variety theater uses the smoke of cigars and cigarettes to join the atmosphere of the theater to that of the stage. And because the audience cooperates in this way with the actors' fantasy, the action develops simultaneously on the stage, in the boxes, and in the orchestra." Yet, while audiences in the variety theater clearly shape the work of art as it is performed, it is noteworthy that Marinetti nowhere suggests that they are fit to judge it. Indeed, the tenor of the essay is quite the opposite: artists, he thinks, would do well to recruit an audience that is "notoriously unbalanced, irritable, or eccentric," and he ends his essay with a reference to the "world's futurist brain." [64] It should therefore come as no surprise to find that two of Marinetti's junior lieutenants would uphold the view, in a manifesto that appeared the following year, that artistic judgment must remain the prerogative of the artists themselves.

"Weights, Measures, and Prices of Artistic Genius" was coauthored by Bruno Corradini and Emilio Settimelli, two of the young cohort of Florentine futurists who would edit *L'Italia futurista* during the war.[65] In the manifesto, they are unabashed in their enthusiasm for the idea that "the producer of artistic creativity must join the commercial organization which is the muscle of modern life." They pooh-pooh "criticism" as "passéist pseudo-criticism" and claim it has "no right to make judgments." Instead they invoke the more positivist sounding terms *measurer* and *measurement*. "Measurers" should judge art the way all human activities are judged: by the raw amount of nervous energy put into

them. Such traditional critical standards as beauty and inspiration should be rejected, and something called "value," which is based on "natural rarity," should be put in their place. In the "intellectual field," they claim, "rarity" is a direct function of the "cerebral energy" needed for production. "The futurist measurement of a work of art means an exact scientific determination expressed in formulae of the quality of cerebral energy represented by the work itself, independently of the good, bad or non-existent impression which people may have of the work."

Despite the appeal to science and objectivity, then, artistic value for these futurists is strictly a function of the artist's "cerebral energy" and has nothing to do with external reception in the marketplace. Moreover, the "measurer" is not some external authority but the futurist himself. It is the "futurist measurer" who "will . . . analyze the work of art into the individual discoveries of relationships of which it consists, determine by means of calculations the rarity of each discovery, that is the quantity of energy necessary to produce them, fix on the basis of this rarity a fixed price for each one of them, add up the individual values, and give the overall price of the work." Yet, why any of this should be done by the producer rather than by simply allowing the market to determine price and value is left undiscussed. Indeed, the authors' assertion that the evaluative standards for art are objective would seem to contradict their claim that the futurists must be the "measurers." As we will see in chapter 4, Kandinsky can claim that the artist must determine value because only the artist understands the "content" that must determine the form, but Corra and Settimelli cannot tell us why the futurist alone can weigh "rarity." What is clear from their account is only that, "because all that matters is the quantity of energy manifested, the artist will be permitted all forms of eccentricity, lunacy or illogicality." True "genius" invariably manifests such qualities. Of course, some purported geniuses are "frauds" (D'Annunzio and Puccini are cited as examples). Far from trusting the market to eliminate them, these futurists ask "the state to create a body of law for the purpose of guarding and regulating the sale of genius."

Futurism operates in venues that are frequented by the masses, but like all other modernisms, it clings to a qualitative mode of establishing artistic value and refuses to accept the masses as the arbiter of taste. In their amalgam of avant-gardism, modernism, and a commodity culture of mass entertainment, futurists seek to exploit the gap between their own autonomous "calculation" of artistic taste and that of the masses, both as a means of creating notoriety for themselves and of exerting crit-

ical leverage against features of the actually existing, sacralized bourgeois culture they oppose. In short, the futurists want to have matters both ways. They know they have to play to a mass audience, using technologies and media it will appreciate and catering to its short attention span, but they also seek to remain firmly in control of their own product. Neither the masses nor culture-industry capitalists are to have any say about what ought to be produced or how. In this respect they remain as firmly elitist as any nineteenth-century artist. Faced with industries of mass entertainment that threatened to negate them, the futurists, like other avant-garde modernists, understand that there is no possibility of retreat. Modern forces have to be faced, and since that is so, they may as well be embraced. Indeed, for the futurists the end of "Art with a capital A" was a precondition of present creativity rather than its death. By the same token, to accept exchange value as the determinant of artistic worth and, thus, to allow it to determine the kind of art produced, would threaten the extinction of the artistic enterprise. The futurists therefore sought to reshape artistic practices within an entertainment industry that they would control, and they were brazen (or foolhardy) enough to believe that they would succeed.

Whatever the historical prospects for their vision, however, it suffered from one major difficulty that Marinetti and his friends probably sensed but were loath to admit: they did not want simply to excel in the sense of producing art that was of "rare" quality; they also wanted to affect an audience in order that they would make a strong impact on the public sphere—even to change society. For this reason, they lacked the luxury enjoyed by those non-avant-garde modernists who can produce art based on autonomous standards because they do not care whether it achieves big box office. In contrast, the futurists could not be indifferent to the size or the judgments of their audience. Despite their claims that they alone could judge art, they were therefore always seeking to ensure that their audiences judged their art positively, which is precisely why they never tired of issuing press releases, coaxing art dealers and critics, and even acting on their own as putative taste professionals. This tension between autonomous creation and market reception ran deep within futurism, and it helps to explain the movement's often confused selfpresentation.

THE GENDERING OF MARINETTI'S AUDIENCE

One of the deepest and most notorious of these confusions involved the futurist relation to women: to women as part of their audience and as

potential futurist creators. As is well known, Marinetti gave careful attention in his postwar political writings to the question of the emancipation of women, toward which he was quite favorable.[66] At least in part, this sympathy probably reflected the changed position of women in Italian society generally, and in the futurist movement in particular, during the war. While Marinetti never felt bound to a politics of realism, he no doubt understood that women were half the population, were likely to be an emerging cultural force given modernity's culturally democratic direction, and needed to be included in social and cultural relations if these were to be transformed in the activist directions futurism sought to promote. Still, his postwar political writings were not the first place he had communicated the view that women ought to be granted the same social and political rights and opportunities as men. His notorious expression of a "scorn for woman" in his founding manifesto has tended to obscure not only the enthusiasm many women felt for futurism but also the nature of Marinetti's "scorn."

From the beginning Marinetti's persona, style, and ideas appealed to many women, especially poets, and he was receptive enough to their creative efforts to make a substantial place for them in *Poesia*. Indeed, one of the most notable aspects of that journal was just how many female contributors it had. At a time when women were almost completely excluded both from mainstream journalism and from avant-garde reviews, *Poesia* published the poetry of roughly fifty women, or about 15 percent of the journal's total contributors.[67] Many of these women, such as Ada Negri, remained loyal friends of Marinetti to the end of their lives.

In comparison with their presence in the *Poesia* years, women were relatively absent from early futurism, a fact which the declaration of a "scorn for woman" might appear to explain. Certainly, given his hopes of transforming Italy in an anticlerical, antiliberal, and intensely individualist direction, Marinetti was intent upon attracting a very aggressive male to futurism. In this regard, the "scorn for woman" was part and parcel of the futurist cult of speed, sport, force, courage, danger, and risk and the futurist hatred of quietism, the academic, the classical, the traditional, the nostalgic, and the sentimental. As such, the phrase reflected the sort of militarist male bonding that the futurists exhibited during the war. It may even have reflected a certain unacknowledged homoeroticism.[68] Yet, it is also clear that Marinetti intended the phrase not literally as a sexist denigration of women (though he undoubtedly would not have minded had some men been drawn to futurism because they misunderstood it in that way) but, more subtly, as a denigration of the qui-

etist and sentimental virtues traditionally associated with women. Or, to put the point another way, Marinetti's "scorn for woman" was a rejection, not of women as a biological category, but of the discursive position that the feminine had assumed in fin de siècle life.

In a preface to the 1910 Italian translation of *Mafarka le futuriste,* for example, Marinetti wrote that "when I said to them, 'scorn woman,' everyone threw vulgar insults at me, like so many whores enraged by a police dragnet. And yet, I wasn't talking about the worth of women as biological entities but of the sentimental importance that is generally attributed to them. . . . I want to conquer the tyranny of love, the obsession with the one and only woman, the romantic moonshine that bathes the facade of the bordello!"[69] This point is then reiterated in what is perhaps Marinetti's most famous declaration on women during the prewar era, "Against *Love* and Parliamentarism."[70] "We scorn woman conceived as the unique ideal, the divine reservoir of love, the voluptuous lure, the tragic bibelot, the fragile, obsessing and fatal woman whose voice, laden with destiny, and whose fairylike hair, reach out and become entangled with the foliage of the moonlit forests. . . . In this struggle of ours for liberation, our best allies are the suffragettes, because the more power and rights they attain for women, the more woman will cease being a mere provider of love and hotbed of sentimental passion and luxury. . . . If women dream today of winning their political rights, it is indisputably because they feel deep inside, unconsciously, that as mothers, wives or lovers they are pent up in a narrow circle, purely animal and devoid of all usefulness."

Still more telling is the parallel interpretation of the "scorn woman" injunction by early futurist women such as Eva Kühn Amendola, wife of the philosopher and later antifascist Giovanni Amendola. Writing under the pen name Magamal, in an essay of 1913, she read futurism's scorn for woman as a very positive "indication that futurism spells the end of the reign of the eternal feminine. . . . The future century will speak with disgust and contempt of an age where men were allowed to exploit the feminine and in which she was his slave."[71] The reign of the "eternal feminine," with all its Puccinian perfumes and softness, with woman as symbolic of mere species regeneration and motherhood, is coming to an end, and futurism is the first political movement to have understood this and to have set as a goal the hastening of this development.

Besides Magamal, the most famous *femme futuriste* of the early years was Valentine Saint-Point, grand-niece of the French poet Alphonse de Lamartine and a consummate artist in her own right.[72] Like Magamal,

Saint-Point directly confronted the phrase "scorn for woman" and read it as a criticism of what women had been, that is, of what men had encouraged women to be in the past, but also of what women had allowed themselves to be. Following Nietzsche, she argued that the success of that campaign had produced an overly feminized age and, thus, the need for a masculine corrective. "What is most lacking in women and men alike is masculinity," she wrote in 1912. "That is why futurism, with all its exaggerations, is right."[73] Women must cease to be fearful of war, nurses who encourage weakness or mothers who are "octopuses of the hearth, whose tentacles bleed men dry and make their children anemic." They are the equals of men but have been waylaid by sentimentalism and deprived of their sensuous instincts. They must return to their instincts, become as strong as men, and lead men and themselves to a new heroic age.

Magamal and Saint-Point were exceptional women who cultivated their sense of being exceptional and were attracted to futurism on that basis. Another such woman was Margherita Sarfatti, whom we will consider in chapter 6. Yet, considering Marinetti's many letters from "*amiche*" and the many women who attended his trial and *serate* (which were not all-male homoerotic events as has sometimes been claimed), it is clear that futurism appealed to many creative women tired of the limited and familiar options with which bourgeois life presented them and anxious to forge pathways of their own. Nowhere was this demonstrated more clearly than in the fifty-one issues of *L'Italia futurista,* the Florentine journal inspired by Marinetti that appeared from June 1916 to February 1918.

The editorial collective that produced *L'Italia futurista* numbered seven, of whom one, Maria Ginanni, was a woman. Ginanni was regarded as its leading poetic talent, but as the war dragged on into 1917, she became the journal's leading editorial writer as well. From the beginning, she was charged with the administration of its publishing house, the Edizioni di *L'Italia futurista*. The journal's short life was tumultuous, and three distinct phases can be identified. In the first, running from June 1916 to the end of the year (about twelve biweekly issues), the emphasis is on poetry and prose poems with little overt political content. The journal's effort to cultivate its evidently large female readership is, however, already quite apparent. In the second phase—roughly, the seventeen weekly issues of the first half of 1917—the poetry is supplemented by a spirited cheerleading for the war, mostly in articles written by Ginanni. Finally, in the most interesting phase—the twenty-two issues from mid-1917 to early 1918, the cheerleading diminishes, and in its place arises a

debate about women which was clearly provoked by a sense of how much the war had altered their lot and by hopes and anxieties regarding the postwar world. Here female writers in addition to Ginanni—above all Enif Robert, a poet and novelist, and Rosa Rosà, a graphic artist and novelist—step to the fore. In addition, there were occasional contributions from a number of other women, including Magamal, Fanny Dini, Irma Valeria, Fulvia Giuliani, Marj Carbonaro, Emma Marpillero, and Shara Marini.

Though consistently avoiding a feminist label as too intellectualist, these women gave no quarter in the fierceness with which they defended women's interests. By July 1917, Rosà was already predicting that the war had so toughened women that they will "supersede by a good deal all that for which the most feminist feminists have hoped." When the soldiers return home they will find "strong women . . . women who the war has shaken up just as much as it has shaken up men."[74] In effect, her argument was that Saint-Point's desire for a masculinized woman, which had become canonical among futurist women, was being transformed into historical reality. Because of the war, the masculine/feminine split had been trumped by one along *futurista/passatista* lines: we should no longer divide humanity into men and women but "should begin to divide it into superior, strong, intelligent, healthy, able-bodied individuals as against the deficient, cretinous, crippled, and soft."[75]

Such rhetoric was not left unchallenged by futurist men, some of whom were strongly antagonistic to it.[76] But such challenges merely provoked Enif Robert to reply with a sociological categorization of men—there are the vulgar sexist brutes, the intellectualist eunuchs, and those rare men who combine equal quantities of physical and mental potency—and she was fully confident that women could and would choose intelligently among them. Unlike Rosà, who championed "women who work, study, earn money and create . . . , who have learned to appropriate for themselves a clean and clear vision of the world on their own, independent of men," Robert sought a new male-female partnership that redefined love as "an intelligent cooperation between two beings who together, with equal rights and equal will," work for common solutions to common problems.[77] In 1919 she and Marinetti would coauthor a novel, *Un ventre di donna* [A Woman's Belly].

The fundamental point, then, that arises from the late issues of *L'Italia futurista* is that women who counted themselves futurist played an important role in the journal, forced a debate about the "new woman" and Italian society, and demanded a postwar world based on full equal-

ity between the sexes. Whether or not futurist men welcomed their ideas, futurist women were now sufficient in number to demand inclusion in the world of futurism. For them, futurism represented a vision of social equality that transcended the narrow sphere of political rights and promised the possibility of a new public sphere based on the avant-garde's transformative role within commodity culture, altogether a most exciting alternative to the suffocating constrictions of bourgeois society.

That women would assert themselves in this way within the futurist movement was probably never anticipated by Marinetti. As we have seen, when he first asserted his "scorn for woman," he inserted it in a list of value commitments that were doubtless designed to appeal above all, if not exclusively, to men. Yet the logic of his enterprise required the building of a large audience, and as we have also seen, he had relentlessly devoted himself to mastering the techniques that would do just that. Thus, whatever his original intentions regarding "scorn for woman," when the appeal turned out to attract women as well as men, he had every reason not only to accept them into the movement but to accept them wholeheartedly. From this point of view, it made perfect sense that he would champion the emancipation of women even as he also championed male virility; each was the central passion for one wing of his audience. Nor was it a coincidence that he chose the last two issues of *L'Italia futurista* as the place to begin to make this case for female emancipation.[78] There, in the midst of an acrimonious debate between futurist men and women, Marinetti positioned his futurism in a way favorable toward progressive women and the democratizing forces of modernity—and against what he regarded as the failed romanticism and sexism of the past.

Yet the story of how women demanded inclusion in the world of futurism would not be complete without mention of a curious *serata* which took place in Paris in 1926.[79] That spring, Marinetti was asked to speak at the weekly gathering of a French women's group. At first he demurred, claiming that their proposed topic—"whether war toys excite or do not excite violent instincts in children"—was too dependent upon the specific culture in question, and that he was Italian and they, French. But, after more pressure, he agreed, a decision he would regret when, on the appointed day, he entered the elegant lecture hall to find about two thousand Parisian women awaiting him. Hesitantly, he tried to express his views by means of a rambling story about how puppies, when they emerge still blind from their mother's womb, cruelly battle each other for milk and, in so doing, establish a natural hierarchy of strength which is

far more important for their development as warriors than any toy would ever be. Before he could finish, however, his words were "drowned out by a deafening burst of feminine shrieks with insulting whistles and ironic smiles." They shouted that the *patria* was dead and that he was a *passatista*, to which he replied that "the supreme civilization is the perfected, gigantic patria." And so it went, back and forth, until he exited "the hail of virulent insults" and headed for the local café. It may not have been Marinetti's last *serata*, but it was very likely one of his most memorable.

FUTURISM, AUDIENCE, AND CULTURAL DEMOCRACY

This story is more than merely amusing. It offers an excellent illustration of a contradiction that had always loomed over futurist practices. Futurist performance depended upon a calculated scorn for the audience, which the futurists adopted precisely in order to ignite spontaneous energy and to break down the division between the audience and the stage. Whether the audience appreciated being put in this position was not at issue, at least for the futurists, who nonetheless hoped to make themselves popular at the same time as they were building a more democratic culture. Yet this complex amalgam of commitments—to entertainment as well as art, to a self-presentation at once elitist and democratic— represented a problematic halfway house. Audiences in a democratic culture want not simply to participate in culture and to be entertained but, ultimately, to participate and to be entertained on their terms rather than those of some self-appointed genius or geniuses above them. Or, to state the point in a slightly different way: audiences in a democratic culture will accept "stars," indeed they will often worship them, but these stars must be the ones they have selected or think they have selected.

Futurism's view of women was part and parcel of its more general assessment of, and attempt to alter, the state of contemporary European mores, degraded as it believed they had become by the feminization of manners in the nineteenth century. The futurist gospel owed much to Nietzsche's lament about world-weariness, and the futurist solution to civilizational crisis, like his, turned in part upon a remasculinizing of society that would restore to humanity its heroic virtues and capacity for greatness. Although his focus was therefore primarily on men, Marinetti at least recognized that the demand of futurist women for inclusion in the modern world on equal terms with men was both consistent with the democratic ethos of modernity and desirable in promoting futurism. Indeed, the hail of invective thrust upon him by the Parisian women in

1926, however painful, could be welcomed as yet another proof that futurist performance was enjoying a broadly popular success.

The question nonetheless remained regarding what "success" gained in this way actually meant. Marinetti believed that modern civilization faced a crisis because its cultural mores and modes of communication were obsolete in relation to the dynamics of modern industrial and commercial life. He had therefore crafted a strategy of influence that not only sought to transform cultural values appropriately but did so through styles and tactics that themselves reflected the intended transformation. This strategy was also intended to show that a cultural elite could be powerful enough to compete for influence with political and economic elites, the traditional wielders of power. Modernity, Marinetti believed, represented an unprecedented opportunity for art and not, as for many other modernists, a set of conditions that art would need to fight against in order to survive. Properly reconceived, art could be deployed to build a large and constantly expanding audience for the futurist agenda. Yet precisely here lay the fundamental problem. How could Marinetti know if his audiences were appropriating his values or only enjoying *him*? Was he truly advancing a futurist agenda or just gaining notoriety in the manner of a uniquely clever buffoon? His staging of difference certainly helped him gain notoriety, but did it not also run the serious risk of alienating his audiences from any values they might associate with him— as it had with the French women who challenged his devotion to patriotic values?

Marinetti's halfway house also suffered from problems connected with the larger environment to which he was so enthusiastically committed. Among the assumptions in his early concept of futurism were that art must be inflected with mass-entertainment styles and values in order to be in tune with the inherent democracy of modern everyday life; that twentieth-century art and culture were only now in the process of being invented and so were fully capable of being creatively reshaped; and that so long as that reshaping remained in tune with modern conditions, futurists could fuse modernism with mass entertainment in a way that would allow them to retain control over their artistic product. Although these assumptions may have been plausible in 1909, the last of them would eventually prove to be the futurist Achilles' heel, and for two distinct reasons.

First, while Marinetti may have been right to think that mass entertainment offered fertile ground for developing a modernist culture, he was wrong to imagine that he could eradicate the distinction between art

and entertainment and still have artists retain control over their products. As his confrontation with the French women suggests, once an artist becomes merely a provider of entertainment, audiences will demand that they be entertained on their own terms. Artists need not submit to audience control in order to champion a democratic culture. Democratic cultures need constant provocation and contestation in order to keep themselves vibrant and forward-looking. For this reason, a culture that is entirely spectator-driven is unlikely to uphold the highest democratic ideals. Yet artists who choose to pursue entertainment values in democratic cultures while holding their audiences in contempt are likely to discover either that they have been dismissed as irrelevant or that their styles and products have been appropriated by others who are willing to cater more straightforwardly to what the audience wants.

Second, Marinetti was wrong to imagine that his synthesis of a democratic audience with futurist control could possibly prevail against fully commercialized competition. That many later artistic movements, such as the French and Italian avant-garde cinemas of the 1950s and 1960s, made something like the same mistake may lead us to excuse his naïveté. Yet the chutzpah revealed in his attitude toward his competitors would reappear—with similarly unfortunate results—in futurism's concerted effort after 1923 to be recognized as official fascist art. As we will see in chapter 6, even as Marinetti was attempting to seduce the fascist regime, it was seducing him.

As the futurist Fortunato Depero sighed wistfully in 1931, after a two-year sojourn in New York, "the shop windows along the most luxurious avenue in the world, in other words New York's Fifth Avenue, are for the most part futurist. . . . At every street corner, in every space reserved for advertising, I see myself more or less plagiarized or robbed, with more or less intelligence, with more or less taste; my vibrant colors, my crystalline and mechanical style, my metallic vegetation, fauna and humanity, geometric and fantastic, is greatly imitated and exploited." But then, regaining his composure, he added: "This pleases me very much; even though I have dedicated myself to advertising only for a limited time, I recognize and do not hesitate to say that I have been influential."[80]

In contrast, although Marinetti certainly had to compromise futurism's autonomy during the fascist years, he was never willing to see it surrender control over its artistic destiny in return for influence. And this brings us to another problem in the perplexing, if also innovative, way he had of pursuing the ideal of cultural democracy. We have seen that he was obsessed with audience. No doubt this obsession was ultimately

governed by his desire for success in the conventional sense of popular-
ity and acclaim. Yet he also believed that gaining a large audience for
futurism would help to engage the masses in public life and make them
energetic and dynamic participants in modernity, and this is the sense in
which Marinetti's practices were aimed at advancing cultural democ-
racy. Yet this aim was made problematic by his elitist pose, which, as we
have seen, involved appealing to a democratic audience by cultivating the
outrageous and bizarre as a way of marking out difference. What was
problematic here, however, lay not only in the pose but also in the fact
that the pose was not merely a pose: Marinetti's elitism also reflected his
deep commitment to the futurist movement, which he did not want to
see melt into society in the way that Depero had seen his art dissolve into
the advertising displays along Fifth Avenue. These elitist convictions
were manifest above all in the futurist mode of participating in World
War I, in which they functioned to support group solidarity at whatever
cost to general camaraderie. However, as we will see in chapter 6, after
the war and especially under fascism, Marinetti became a victim of his
own success, and the difference between his attitude and Depero's would
cease to be a matter of any practical import. Especially in the 1930s,
futurism would multiply into a number of autonomously operating
movements in many Italian cities, and while this successful democratiza-
tion of the movement must in some ways have been gratifying for
Marinetti, he rarely reached out to the public in the manner of the pre-
war years and chose instead to turn inward to his close associates, cling-
ing tenaciously to his role as movement leader. Thus, while his ambiva-
lence about the democratization of futurism may not have been as
extreme as that of Breton's surrealism, which we will consider in chapter
7, it nonetheless never ceased to be evident in the late Marinetti's public
self-presentation.

In the end, however, what remains compelling about Marinetti's early
futurism has little to do either with practical inconsistencies or with the
successes and failures it achieved in the culture and politics of his own
day. Marinetti's greatest significance lay rather in his prescient intuition,
unique among avant-garde modernists, that the future of modern art
and culture lay in some creative fusion of artistic talent and imagination
with the popular energies and forms of expression bound up with the
dynamism of modern urban life. Modern art and culture, he understood,
could not hope to preserve itself as a tradition or professional practice
independent of the world of newspapers, films, cameras, telephones, rail-
roads, and machine technologies more generally, but would have to take

full advantage of what modern industrial, technological, and commercial institutions and practices had created—and would continue to create at ever-increasing speed. Art would have to abandon its pretension to be "Art with a capital A," attune itself to the intensified visuality and clipped syntax of modern life, and make itself anew. Through this vision, Marinetti's futurism left an indelible mark on the modern culture that it helped to build and that has succeeded it, probably more so than any other avant-garde modernist movement.

3

Guillaume Apollinaire

One of the leading and most distinctive voices in twentieth-century French poetry, Guillaume Apollinaire was always centrally preoccupied with his own art. In *Alcools* (1913) and subsequent volumes, he sought continuous innovation in his perpetual quest for a poetics adequate to the experience of modern life. Unlike Marinetti, then, he could not devote himself so single-mindedly to building an orientation to the public through art. Yet he was no less attuned to the role of the intelligentsia in contemporary cultural and political life, and he was equally compelling in the way he defined the role of the avant-garde modernist. Indeed, he probably did as much to create the specifically avant-garde type of cultural intellectual as anyone of his generation in France.

Himself a member of Picasso's "Bateau-Lavoir" circle, Apollinaire championed the cubists, yet he became increasingly cool to cubist art and cannot be said to have launched a movement as Marinetti did with futurism. He saw the work of art as a performance, but not so radically as to break with the traditional notion of Art with a capital A. He was strongly committed to artistic experiment but also to classical values in art, to which he was attracted in part because they helped to secure his precarious identity as a Frenchman. Rather than creating a movement around a particular vision of modernity, Apollinaire redefined and ex-

panded the role of the avant-garde taste professional, using it to promote and defend the plastic arts as the royal road to a public life at once spiritually reinvigorated and democratic. In this role, he saw himself as a promoter not of this or that avant-garde tendency but of avant-garde art as a whole. In cultural politics, Apollinaire was less a visionary than a reconciler. At the height of his powers in the immediate prewar years, he was working to reconcile the differences between futurism and cubism, between the Puteaux cubists and those in Picasso's band, between cubism and Robert Delaunay's orphism, and between the avant-garde worlds of Paris and Berlin. He was also devoting himself to an independent avant-garde journal, *Les Soirées de Paris,* as well as to supporting its principal competitor, Ricciotto Canudo's *Montjoie!*[1] Little wonder that his portrait was painted by so many different artists, including Maurice de Vlaminck, Henri Rousseau, Jean Metzinger, Giorgio de Chirico, Amedeo Modigliani, Mikhail Larionov, Marie Laurencin, and Pablo Picasso.[2]

When Apollinaire arrived in the French capital in October 1899, in flight from a sizable hotel bill his mother had left unpaid in Stavelot, Belgium, he was already steeped in the aesthetics and politics of the symbolist movement and such postsymbolist movements as Jean Moréas's École Romane and the *naturisme* of Saint-Georges de Bouhélier and Maurice Le Blond.[3] In general, Apollinaire took a more skeptical and materialist view of language than did Stéphane Mallarmé, whose long reign as the *maître* of symbolism had come to an end in 1898, but as an avant-garde critic Apollinaire was deeply indebted to him. As we have seen, Mallarmé advocated an art and an art-critical practice aimed at opening the public's imagination rather than reconnecting it dogmatically with tradition or foisting upon it some authorial imperative. He also advocated a transpositional art, a politics of contestation that eschewed utopian designs, an openness to commodity culture, and above all, a belief that art must find its own way forward whatever the social and political trends of the moment. Apollinaire followed Mallarmé in each of these respects and, like him, developed a critical practice that sought, by allusion and suggestion, to open up the qualitative dimensions of experience for the reader or viewer without "explaining" how they ought to be understood.

Yet the position of the critic in what would soon come to be Apollinaire's Paris was quite different than it had been in Mallarmé's. Newspaper circulation had skyrocketed in the two decades before 1914, and with it the power of the press and the culture of advertising, to which newspapers were closely linked.[4] The art market had also changed sub-

stantially, not least through the rise of independent salons that gave new opinion-shaping powers to avant-garde critics. Apollinaire took full advantage of the new context, advancing the aesthetic ideal of the artist with a distinctive and original voice, naming styles, and suggesting to the public which artists were doing distinctive and original work. Especially in the years from 1910 to 1914, when he had access to the mainstream press through his column entitled *"la vie artistique"* for the Paris daily *L'Intransigeant,* he gained a broad readership for his views, expressing them in an accessible prose not unlike that of his friend Rémy de Gourmont. Like Gourmont too, he sought to combine the expert knowledge of the taste professional with the avoidance of "commercial speech," a Nietzschean skepticism toward truth and utopian ideals, and a jocular style delighting in the provocative lie. Yet, unlike Gourmont, he fully embraced a democratic cultural ideal, declaring the legitimacy of any and all means that might bring the masses into the orbit of art—from inexpensive reproductions of "great works" to gossip columns about artists.[5]

Apollinaire's conception of a democratic culture suited to modernity was quite complex however. Unlike Marinetti, he believed in a historical culture and in an art firmly rooted in local and national traditions. As many commentators on his poetry have remarked, he was continually trying to anchor the modern in tradition.[6] Yet he was not backward-looking. He rejected rural utopianism of the sort embraced by the artists who established the Abbaye de Créteil commune in 1906.[7] Like Marinetti, he was committed to an inventive modernist, even future-oriented art that was unafraid to take risks in search of a mass audience. Apollinaire was a master of the practical joke—what the French call *blague*—and he assumed fake expertise, delighted in the published hoax, told tall tales, and otherwise pursued entertainment values both to express his sense of himself and, undoubtedly, to increase his notoriety and thereby his audience.[8] Remarkably, Apollinaire sought to enlist the entertainment values of popular culture even as he also insisted upon the deep seriousness of avant-garde art and the classical French traditions he thought it extended. How could even he manage to reconcile such antitheses? Without claiming that he was always successful, the answer proposed here is that Apollinaire embraced entertainment values in order to promote great art and even accepted the idea that entertainment values might be incorporated into that art itself (as reference material, as stimuli to new artistic forms), so long as they did not undermine, as in Marinetti's *serate,* the seriousness of art as an intellectual enterprise. Despite his jocular style, Apollinaire valued other artists as he did his own work—for their seri-

ousness of purpose as well as their distinctiveness and inventiveness—and he was never willing to break down the wall between art and entertainment, even if his ability to locate it was sometimes unsure.

In his last year of life, Apollinaire succinctly summarized his view of the avant-garde enterprise in a letter to the author of a new volume on cubism: "one must stimulate the curiosity of the public and offer them the rich reflections that will move their spirits little by little to the point where they are charmed, but without making them understand, above all, without understanding."[9] For Apollinaire, the problem facing the avant-garde critic ran deeper than any simple failure on the part of the public to "understand" art. Although he was probably unaware of the educational efforts in art criticism made by the young Charles Baudelaire, he would certainly have rejected their Enlightenment orientation. The problem facing the avant-garde critic, as he understood it, was that the mode of understanding currently available to the public, rooted as it was in consumerism, fashion, and the utilitarianism of the workaday material world, deafened it to the spirituality in art and encouraged it to demand of art that it be something other than what it necessarily is. As part of the same mode of life, mainstream critics were all too eager to satisfy the public by reinforcing the prevailing "understanding" and telling it what it wants to hear. Yet in this process art is degraded: the public in effect asks the critics to declare what is new, exciting, and satisfying; the critic responds by doing precisely that; and the artist is thereby instructed as to what will sell. For Apollinaire, as for other avant-garde modernists, the proper direction is precisely the reverse. The avant-garde critic must seek to transmit the voice of the artist rather than be the echo of the public. Art may be promoted as new and exciting, but that promotion must respect the visions and designs of art's creators. Of course, sometimes a particularly astute critic may help to clarify those visions and designs in the minds of the artists themselves. In the public side of this process, however, art must never be "explained" or rendered readily comprehensible, for that would tend to predigest the experience of reception by codifying it in all-too-familiar terms. Rather the wise critic makes clear to the public which works of art are worthy of attention, provokes the public to attend to those works, and then gets out of the way.

POLITICS, MASS ENTERTAINMENT, AND ART IN APOLLINAIRE'S PARIS

Poet, art critic and promoter, literary critic, journalist, editor and publisher, novelist, dramatist, movie-script writer, prankster, pornographer,

and impresario of the Parisian avant-garde, Guillaume Apollinaire is re-
garded as everything except a political man.[10] He himself promoted this
view. Writing to the editor of *La Plume* in 1902, he claimed to have noth-
ing to say about politics, a subject that is "detestable, deceitful, sterile,
and injurious."[11] In thousands of pages of prewar writing, he signed only
one article that might be considered political thought.[12] The fact that he
turned to political subjects during World War I might be explained con-
tingently in terms of his enthusiasm for the war experience and his recog-
nition of its historical import. Yet, paradoxically, never was there so pub-
lic a life as Apollinaire's, and no one has ever dedicated more energy to
the promotion of art as an answer to the spiritual malaise of modern life.
In that sense, his indefatigable production of criticism as well as his
unending public performance of self were nothing if not political both in
intent and in effect. Moreover, the public environment in which he lived
was so overheated with nationalist frenzies that he could hardly have
avoided politics even had he so wished.

When we look closely at his one published piece of political philoso-
phy, the paradox begins to unravel. Based on premises drawn explicitly
from Spinoza's *Ethics* but also from Nietzsche, Apollinaire argued that
politics in the sense of government is nothing but the pursuit of power by
politicians and that any notion that it might promote social improvement
misunderstands the human condition. Humans may express genuine
sympathy for their fellows, but this sentiment is always subordinate to a
primary egotism. While an individual may be gratified by helping
another individual, acts of so-called charity which minister to the collec-
tive serve only to salve the consciences of the rich and powerful.
Similarly, "politics does have the often forgotten aim of aiding others *en
bloc*," but government is too blunt an instrument to succeed in any such
endeavor, excepting perhaps that of allowing politicians to imagine
themselves virtuous.[13] Is there, then, no genuinely collective mode of
social redemption? Although the question is not addressed here, it is
notable that, less than a month later, Apollinaire would see in Picasso's
early painting precisely the force capable of reawakening "the profound
self-knowledge that humanity had of itself" and giving us back the
"eyes" necessary for entering into the social world of children, mothers,
beggars, and forlorn old men.[14] It was an argument for the socially
redemptive power of avant-garde art, to which he would return on many
subsequent occasions.

Like Mallarmé and Gourmont, Apollinaire had no faith in any polit-
ical remaking of society as a whole, and he likewise refused to pose an

alternative to which the world must conform. Yet the apparent apoliticism to which his grim realism led was actually just a mask for his deepest conviction, one to which he dedicated his life: that only through the visionary power of avant-garde art could men and women living in modern mass societies regain their human capacity for the concrete experience of life, a capacity that had withered amid the abstractions of commodified urban existence. Far from representing a solution to this modern crisis, the issue-oriented, materialistically self-interested politics shaped by newspapers and propelled by the wheeler-dealing of the democratic electoral process only compounded it. This public sphere merely reinforced the mechanical, quantitative, and ultimately nihilistic modes of thought underlying modern industry and science. A revitalized public sphere would depend crucially upon the elevation of aesthetic vision, language, and performance to a position of genuine centrality in modern political life. In a properly aesthetic public sphere, art would reconnect with daily life and with concrete national traditions, thus reviving the national spirit and reconsecrating civic energies.

In this sense, Apollinaire's avant-gardism was based less on antiutopianism than on a transference of utopian aspirations from the political to the cultural spheres, certainly a comprehensible turn, given the darkening of the French political landscape under the impact of the events of 1905–1906.[15] Heeding a call from the Second International, which was dominated by German intransigence, the French parliamentary socialists had withdrawn in 1905 from the *Bloc des Gauches* of anticlerical radicals, socialists, and republicans that had controlled parliament since 1899. The significance of this withdrawal was substantial, since it effectively ended not just an era of reform that culminated late in 1905 with the passage of a parliamentary act formally separating church and state, but also a spirit of activism, class collaboration, and intellectual engagement with politics that had grown up in the Dreyfus years and, as we have suggested, forged the "intellectuals" in the modern sense. In addition to a robust mainstream politics, the Dreyfus years had produced a huge extraparliamentary public sphere of independent movements favoring syndicalism, feminism, cooperatives, communal living, and popular education, and also including a variety of interest groups, professional societies, and journals and magazines associated with them. The collapse of the left bloc did not end this activity, but it thrust it on the defensive such that, when Captain Dreyfus himself was finally exonerated in July 1906, the event appeared somewhat paradoxical.

Against the ruling left bloc and the broad array of social movements

allied with it were the parties of the right, which drew upon loyalties to the church, the army, and a variety of sentiments connected with tradition, including monarchism, anti-Semitism, and anti-German revanche. These parties may have been mostly on the political defensive since Émile Zola's letter to the president of the Republic was published under the headline "*J'accuse*" in the 13 January 1898 edition of *L'Aurore*, but they received a major, unexpected boost when the German kaiser Wilhelm II sailed into Tangier on the last day of March 1905 and challenged the French by declaring his support for Moroccan independence. Although the move failed diplomatically in the short term—Germany's hope of creating a breach between Britain and France was disappointed by the 1906 Algeciras Conference, at which Germany was forced to accept continued French control of Morocco—it caused a sea change for the French right. In another of those crises that had punctuated French political life since 1871, the right was again thrust into the limelight, and the nationalist and Catholic ideals for which it stood became de rigueur among intellectuals as never before.[16] Perhaps nothing indicated this shift more clearly than the change of heart by Charles Péguy, who, as editor of the idiosyncratic *Cahiers de la Quinzaine* since 1900, had championed Dreyfus and associated himself generally with positions on the left but who, reeling from recent events, declared himself an unalloyed French nationalist as well as an ardent if undogmatic Catholic at the end of 1905.[17]

During the half decade that separated the First Moroccan Crisis from its 1911 sequel, nationalist passions intensified to the point where everyone in France, except for syndicalists and some socialists, embraced some form of them, and the practice of tarring one's political opponents with xenophobic innuendos became widespread. In this climate, Charles Maurras's Action Française, which had arisen in the last years of the nineteenth century, widened its attacks on all the "enemies" of France: from Protestants and freemasons to Jews and "*métèques.*" While Action Française remained small in terms of membership, it gained the sympathy of many middle-class professionals and intellectuals, and by 1908, Maurras was emboldened enough to begin a newspaper.[18] The classical aesthetic values he championed there and elsewhere came to be taken seriously by many avant-garde modernists, sometimes in self-defense but often from genuine sympathy or (as with Apollinaire) from a complex amalgam of these motives.

Yet if the ascendance of a politics of resentment and viciousness in France helps to explain Apollinaire's skepticism toward the sphere of politics as conventionally defined, the vitality of its cultural sphere

should remind us that there were "pull" as well as "push" factors involved in his mind-set. Both in its institutions and ethos, this culture has been thoughtfully studied by others, and it will suffice here to recall a few of its more salient aspects.[19] As in Milan, so too even more dramatically in Paris: the nineteenth-century rise of institutions of commodity culture such as newspapers, advertising, mass merchandising, and department stores provided the foundation for industries of mass entertainment, which expanded in variety and reach up to the outbreak of war. Always famous for its cabarets and cafés—the latter alone numbered twenty-seven thousand by 1900—Paris by the early twentieth century had become consumed by an astonishing variety of entertainments, from the time-tested, like opera and theater; to the outdoorsy, like horseracing, ice-skating rinks, circuses, amusement parks, and professional sports such as bicycle racing; to indoor spectacles like wax museums, dance halls, panoramas and, after 1905, movie theaters (cinema having earlier appeared at fairs, department stores, music halls, and café-concerts). Many of the venues where these entertainments were held had been newly created by culture moguls such as Joseph Oller, who after arriving in Paris from Catalonia, founded the Nouveau Cirque (1886), the Moulin Rouge dance hall (1889), and the Olympia music hall (1893), the latter a lavish facility built in a safe and elegant quarter of Paris. Such entertainment entrepreneurs, often foreign-born like Oller, catered to the well-to-do, but for those who could not afford their venues, there were over two hundred café-concerts in Paris, the most famous being the Folies-Bergère, which mostly charged no admission and offered programs based on English-style music halls. Other cheap sources of entertainment were dance halls like the Moulin de la Galette or the racetrack at Longchamp, which, because of its system of pari-mutuel betting, typically saw Sunday crowds of forty thousand by 1900 (including, not infrequently, Apollinaire's mother).

In the latter decades of the nineteenth century, Paris had become known for entertainment districts such as Montmartre and Place Pigalle, which, trading on the symbiotic relationship between artists and their bourgeois audiences, offered antibourgeois entertainments for the bourgeoisie—and in bohemian or otherwise racy settings that allowed patrons to imagine themselves as participants in a lower world of salacious irresponsibility. Yet, as mass entertainment became more and more controlled by big capital, especially after 1900, the gap between worker-oriented café-concerts and the new music halls widened considerably, the latter seeking to distinguish themselves as havens of sacralized bourgeois

culture that offered bounteous excitement without the seediness and danger that lurked in their more populist alternatives. Yet, no less than in those alternatives, music halls made copious use of low-cultural forms, inserting their songs into a larger spectacle replete with juggling, magic and animal acts, circus acrobats, and athletic performances. As entertainments, what distinguished them were the lavish costumes and spectacular lighting, which could be used to create an extremely fast-paced performance often perceived as "American" in style. After 1905, music halls moved further and further in this direction as they were forced to compete with the first movie theaters built specifically as such.

Among the sources of the so-called American style in mass entertainment were the world fairs hosted by Paris in 1889 and 1900. As part of the first of these, both Buffalo Bill's Wild West Show and the Barnum and Bailey Circus had performed, astonishing their audiences with quantities of personnel, animals, and equipment that were hitherto unimaginable. Not to be outdone, the 1900 Exposition had featured a Swiss village based on roughly five acres of artificial mountains, forests, pastures, chalets, and other buildings, and involving over three hundred "Swiss peasants." The village was only the most dramatic example of the advertising and public relations onslaught connected with the exposition, which amazed at least one contemporary observer not only with its quantity but also with the degree to which it played upon imaginative desires, dreams, and private fantasies.[20]

Advertising in the form of posters had proliferated in fin de siècle Paris, thanks both to technological advances such as mechanically produced color lithographs and to the legal system, above all an 1881 law offering very liberal rules about posting. As a result, the advertising posters of Jules Chéret became the emblem of the era. Yet it was only in 1903 that France greeted its first professional journal on advertising, *La Publicité*.[21] Moreover, newspapers had been slow to expand their pages to incorporate ads, and even slower to mix them with news and features as well as to publicize mass entertainment. As a result, entertainment venues had tended to publish their own newspapers, and weekly journals specializing in the presentation of the full range of available entertainment emerged. Gradually, however, the limits mainstream newspapers had imposed on themselves diminished, and their changed practices had major impact since, by 1914, those in Paris alone were publishing 4.5 million copies a day, more than double what they had done three decades before. At the same time, as street traffic in the city soared—one estimate is that it increased tenfold from 1891 to 1910—billboards (such as the

one announcing the arrival of the futurists in 1912) became so ubiquitous that, as of 1912, they became subject to special taxation.[22]

What, then, did this sort of cultural vitality have to do with avant-gardists like Apollinaire? Apart from the fact that they too were citizens of Paris, and therefore deluged by the appeals and effects of mass entertainment, avant-gardists may be seen to have been affected by these developments in several more specific ways. First, at the level of narrative self-understanding, it was undoubtedly significant for avant-garde art that the main principle of the music hall was a rapid cutting and splicing without regard for traditional narrative continuities, not unlike the way newspapers threw together the most diverse articles on their pages, or the way the most innovative new filmmakers, such as Georges Méliès, were crafting their productions.[23] A magician by trade, Méliès built France's first movie studio in 1897, and he used his wizardry at special effects (especially those involving the disassembling and reassembling of human bodies) to make a number of fantasy films that explored the antinaturalistic potentials of the medium while also incorporating the latest dance crazes and using celebrities from elsewhere in the entertainment world as his stars. Although innovative, independent filmmakers like Méliès fell into economic difficulty after 1912, his example certainly lent concrete plausibility to the notion that the public sphere might be revitalized through modernist aesthetic vision and performance.

Second, at the level of political atmospherics, mass entertainment presented the social world in a harsh, often satirical light, as the historian Charles Rearick has emphasized.[24] While the purveyors of this culture sought to imbue it with the glamour and aura of "gay Paris," its material traded upon a deep-seated social anger and an ethic of ressentiment that mocked governmental authority, the hypocrisy of the bourgeoisie, and social pretensions of every kind. Satirical periodicals such as the *Courrier française* were a huge industry; music hall productions were their staged equivalents. Méliès's films were an exception to this trend. But, as the film industry rapidly expanded (by 1914 there were 260 movie theaters in Paris alone), and as it became increasingly reliant upon extravaganzas that appealed to a less educated audience, it is not surprising that more violent and vulgar subject matter came to predominate, particularly in 1913–1914. In such a cultural and political environment, it should also not surprise us that avant-gardists came to understand successful performance in terms of strident tones, derisive humor, and overheated rhetoric, rather than as dispassionate, enlightenment-oriented education.

Nonetheless, avant-garde modernists did devote serious attention to

the new entertainments, both in terms of the world they reflected and their relation to art. This was particularly true of cinema. Ricciotto Canudo was a pioneering film critic whose idea, first articulated in a 1911 essay, that film represented the "seventh art," served as a kind of manifesto for film as art and is today hailed for its prescience.[25] Apollinaire's attention to film came even earlier. A few weeks after Gourmont's début as a *Mercure de France* film critic, he wrote a short spoof about the founder of the "Cinematographic International Company" (English in the original), a bit of fun that has provoked one scholar to speculate that it "may have been a specific parodic response to Méliès film of the preceding year, and its advertising premise."[26] Later, as editor of *Les Soirées de Paris,* he continued to show an avid interest in mass entertainment, even publishing an article about American baseball.[27] The journal also featured a regular column on film by Maurice Raynal.[28]

But the strongest interconnection between the larger Parisian cultural world and its avant-garde undoubtedly came through its art market. This market, of course, can hardly be seen as part of a mass-entertainment industry, yet, like the latter and the wider commodity culture of which they both were a part, its scope was fast accelerating, and it had become more democratic both in production and in consumption since its privatization in the late nineteenth century.[29] Between 1872 and 1906, the number of self-described artists increased by over 50 percent in Paris to about 35,600, and art buyers likewise became more numerous and diverse, with more and more private galleries opening each year to serve them.[30] Moreover, after the privatization of the official Salon, a number of alternative salons emerged: the Indépendants in 1884, the Société Nationale in 1890, and the Automne in 1903, each of them championing the innovative over the academic. By 1910, the Indépendants and the Automne were exhibiting about nine thousand works a year from several thousand artists, and many more works were displayed at the so-called salonettes, or satellite exhibitions held just prior to the salons themselves.[31] The number of private galleries, already over a hundred in 1860, increased apace in subsequent decades, but, as in mass entertainment, there was also a trend toward oligopoly through which big firms such as Durand-Ruel and Bernheim-Jeune (which did the 1912 futurism show) gained increasing control over major artists and events. Yet, because such firms were generally reluctant to take risks, there was plenty of room for lower-capital dealers to speculate on budding talent, including avant-garde innovators esteemed by the artistic community but not yet widely known or appreciated.

In this increasingly complex world, there were two main promotional strategies open to avant-garde artists, in addition to simply opening one's own studio to visitors. One involved contracting with a dealer who then gained exclusive rights to promote and exhibit the work. In practice, this strategy was mostly available to artists who were already recognized talents, and its leading example was Picasso's relationship with Daniel-Henry Kahnweiler. The other involved exhibiting in the independent salons (the official one did not show avant-garde art), in which case an important supporting tactic was to work closely with avant-garde critics to gain the publicity required to sell at the salon. No critic was better able to exploit and benefit from this tactic than Apollinaire.

THE INTELLECTUAL FORMATION OF A "NON-POLITICAL MAN"

When Apollinaire published his first major book of poetry in 1913, the reviewer for the *Mercure de France,* Georges Duhamel, greeted it in the following terms:

> Nothing makes one think more of a secondhand furniture dealer than this collection of verse published by M. Guillaume Apollinaire under the title, at once simple and mysterious, of *Alcools.* I say secondhand furniture dealer because a litter of incongruous objects have been discarded into this slum, some of which have value but none of which is the product of the merchant's own industry. Precisely there is one of the characteristics of the secondhand trade: it resells but does not manufacture. . . . In the massing of objects a colorful and dizzy variety takes the place of art. With difficulty one can perceive, through the holes of a shabby chasuble, the ironic and ingenuous look of the dealer, which is at once that of the Levantine Jew, the South American, the Polish gentleman, and the *facchino* [porter].[32]

The attack, whose motives are now obscure, must have seemed to Apollinaire like the flashing forth of a nightmare he had been living since coming to Paris at the age of eighteen. There it all was: the wandering life of his Polish mother, who had taken him from birth in Rome to Monaco, then Cannes, Nice, Aix-les-Bains, Lyon, Paris, Stavelot in Belgium, and back to Paris; his own economic struggles to survive in the French capital as a bohemian writer; the fact that his mother lived for years out of wedlock with a Jewish man, Jules Weil; that he himself was often mistaken for a Jew, since "the anti-Semites cannot imagine a Pole not being a Jew";[33] that he was uncomfortable enough with his apparently immigrant, Jewish, and "southern" background to drop his foreign-sounding surname; that he had famously been arrested and humiliatingly incar-

cerated on suspicion of stealing the *Mona Lisa* from the Louvre; that his life had been full of expediencies and shady dealings; that he was, in short, as French xenophobes of the time called them, a *métèque,* and an illegitimate one at that.

Painful as his vulnerability to such scurrilousness must have been, Apollinaire was hardly unfamiliar with it. From the beginning of his literary career, he had been made aware of his ethnic otherness by editors who, for example, refused to allow him to replace Kostrowitzky with a pseudonym.[34] Still, he never retreated into a defensive cosmopolitanism but rather, as one critic has put it, deployed a "poetic counter-ideology," peopling his essays and verse with a "mythology of Tziganes, Bohemians, Germans, Jews, Cossacks, etc., into which he integrated his own genealogical fantasies."[35] In the clear light of day, however, he always regarded himself as a Frenchman. Indeed, for his adopted homeland he had the passion of a religious convert. His friends were émigrés or visitors from every corner of Europe, and he reveled in their company, but even the Italians he did not regard as in any way fellow countrymen. At the height of the cubist-futurist controversy, he wrote to Ardengo Soffici, his most faithful correspondent, who had himself lived seven years in Paris: "But *you Italians,* don't be unfair toward the French who have created nearly all of intellectual modernism."[36] Moreover, he nearly always wrote in French and, when he did deploy his Italian, showed that it had atrophied from disuse and come to function mostly as a reminder that his early childhood had been spent in a country to which he had never returned, not even for a brief visit.

If the firmness of his national identity reflected its objective precariousness, it was also rooted in an intellectual formation which was typically and self-consciously French. Admittedly, we do not know as much as we would like about this formation.[37] Yet when Apollinaire himself reflected back on it in 1908, he singled out for attention an avant-garde movement of the previous decade that had already nearly been forgotten: "The most important poetic current which, striking the spirit of the youth of my generation, sought to oppose symbolism, which it succeeded, was called naturism. It had its day and charmed many new poets. At that time, because of symbolism, they were still weighed down by the cumbersome baggage of accessories bequeathed by the Parnassians who took them from the romantics. The naturists swept all that away. Then, prodded by civic enthusiasm, they wanted to mingle with the crowd."[38]

Naturism was quickly forgotten because it was unable to translate its ideas into distinguished verse, but the ideas themselves, as communi-

cated in a variety of manifestos, were one of the most potent cultural reflections of the increasingly democratic spirit of the early Dreyfus years. Promulgated primarily by the two young poets, Bouhélier and Le Blond, naturism embodied an intense desire to find new ways for a young generation of artists to have an impact on French politics in the aftermath of the French police clampdown on anarchism in 1894. Like Moréas, the naturists saw symbolism as having a disdain for the national literary tradition, as well as cultivating a recherché language far removed from that of the street and the practical problems of life. Unlike him, however, they did not want to create just another *"cénacle,"* nor to return to traditional verse, but to set a resolutely modernist, aesthetic-political direction for their generation as a whole. It was a vision that appealed to some slightly older French intellectuals as well, such as André Gide, who, in an 1896 letter to Bouhélier, declared his "very lively sympathy" for naturism and signed it as "your *coreligionaire.*"[39]

If we turn to naturism's inaugural manifesto, published by Bouhélier in *Le Figaro* in January 1897, we cannot but be struck by the intensely nationalistic rhetoric in which its largely political purposes are set. It calls for the "resurrection of national cults." It opposes the "northern poets" and wants "regional ceremonies in honor of the 'heroes who died for their country.'" It champions "civic activity," "glory," and "exploits." It claims that "the next art will be heroic" and aims "to create a new conception of the world." While some of the language about "moral enslavement" and the "spirit of the race" sounds vaguely Nietzschean, non-French writers and artists such as Nietzsche, Ibsen, and Wagner are held up as "foreigners" who have triumphed over properly "ethnic literature." Bouhélier concludes: "Revival of the national spirit, a cult of the earth and of heroes, the consecration of civic energies, these are the sentiments that give to contemporary youth such a unique, unexpected and admirable character."[40]

The argument was deepened in essays written for a special issue of *La Plume* on naturism that appeared in November 1897. It included contributions from Eugène Montfort, Albert Fleury, and the Belgian naturist Camille Lemonnier, as well as from Bouhélier and Le Blond. Striking a revolutionary chord, Bouhélier likened the task of his generation to that of Mirabeau, Robespierre, and Desmoulins and claimed that "we are at a turning point between epochs. The world's equilibrium is being reconstituted. . . . God has disappeared from the world," but naturism has adopted the "mission" of helping "a new world free itself from the chaos of our times."[41] In his essay, Le Blond connected naturism's nationalist

program to the failings of the recent French poetic tradition, including the École Romane. For him, the symbolist poets "preferred to be the solitary pontiffs of their interior cathedral" rather than "the interpreters of a place, region, or people." They cultivated a "special jargon" that was little known. Moreover, many of them followed in a romantic tradition that was still a "Christian art." Naturists, in contrast, cultivate the "ethnic idea." While others before us, such as the École Romane, have done likewise, we are forward-looking modernists while they are "reactionary" devotees of "archaism." Finally, "Moréas, who is of Greek origin, may have his reasons for celebrating the reeds of the river Eurotas and the snows of Mount Olympus. These traditions are not ours. In our view, to the Madeleine or the Bourse, monuments based on a pastiche of antique styles, we always prefer Notre-Dame of Paris."[42]

Le Blond's chauvinism, with which he here tarred Moréas, may remind us of Duhamel's later tactics. Yet Le Blond and other naturists understood their commitment to nationality not as an end in itself but as a necessary condition for freeing modern art from poetic formalism in order to engage it in the revitalization of modern life. They were committed to enlarging the concept of art in an inclusive direction, overcoming distinctions between high and low art, reconnecting art with daily life, and restoring to the intellectual his human face ("Mallarmé is an artist, Verlaine is a man").[43] While they believed that rootedness in concrete ways of life was crucial to this endeavor, such concreteness could be Belgian (as with Lemonnier), or that of another "border nation," or that of a particular French region. Indeed, an important part of what was at stake for naturism was the cultural hegemony of Paris. Naturist writers in Provence, for example, sometimes referred to the "tyrannical yoke of Paris."[44] The *Revue naturiste,* which Bouhélier and Le Blond edited from Paris, in effect agreed with them, proposing in 1898 to decentralize itself with three regionally tailored editions in order to increase the provinces' sense of dignity.[45]

Among other naturist projects was a Collège d'Esthétique Moderne, which during the 1900–1901 academic year offered a series of lecture courses by Bouhélier, Le Blond, and Montfort and which attracted the participation of Apollinaire.[46] For Apollinaire, these would be years of great economic uncertainty but also of intellectual apprenticeship in the postsymbolist intellectual free-for-all that was Paris in the time of Dreyfus. He wrote for a variety of little reviews including *La Revue blanche, L'Européen, Tabarin, La Grande France, La Plume,* and *L'Europe artiste.* He attended the "soirées de *La Plume*" that its editor, Karl Boès, gave at

the Caveau du Soleil d'Or on the Place Saint-Michel. There he met all the naturists as well as other young poets such as André Salmon, Paul Fort, Alfred Jarry, and Mécislas Golberg, a Jewish anarchist from Poland, and more established figures such as Moréas and Gourmont. He entered the polemics on new poetic schools, such as Fernand Gregh's "humanism," declaring that "poets no longer want to be ecclesiastics, scholastics, scholars, students, disciples, or, in a word, slaves."[47] He began his own journal, *Le Festin d'Ésope,* which produced nine issues in 1903–1904 that included poetry, stories, criticism, philosophical articles, and an occasional political article and naturist manifesto, but also practical information on medicine and financial investments. It was succeeded in April 1905 by *La Revue immoraliste,* which, however, lasted but a single issue after its patron bailed out. Thereafter, Apollinaire wrote for a variety of journals, large and small, mainstream and esoteric, but gave up his efforts at being an editor until he established *Les Soirées de Paris* (1912–1914).

Despite his naturism, Apollinaire wrote some early poems in a symbolist vein, and he took a lively interest in the neosymbolist initiative of Paul Fort's *Vers et Prose* when it was launched in 1905.[48] Yet, when he made the discovery of Picasso's painting and began to write about it in that same year, the road toward cultural regeneration through nonmimetic modes of expression increasingly appeared to him to run through the plastic arts. In contrast, the symbolist way beyond mimesis focused upon Dionysian music, which symbolists found suggestive of the impalpable powers associated with an ideal language. While they were not uninterested in the visual and plastic arts, they tended to believe that such arts imposed too great a mimetic constraint. As we will see with Kandinsky, those modernist painters who continued to take the symbolist tradition seriously moved in an antimimetic direction and showed strong interest in discovering a pure language of the arts that exposed underlying links between music and the plastic arts. Although exposed to Kandinsky's ideas in 1912–1913 through Delaunay, Apollinaire continued to be far more captivated by the visual than the musical, a taste that certainly reflected his high estimation of Picasso, but with the advent of advertising and film may also have reflected a more Marinettian sense for the heightened status of visuality within the modern cultural world.[49]

What Picasso and other new painters inspired Apollinaire to believe was that the creative artist can best think through the possibilities of an autonomous, nonmimetic art by confronting external appearances, not by attempting somehow to get above or within them. This is precisely

what he saw Picasso doing: accepting the irreducible difference represented by the object but then investigating that difference in a playful, creative way that allowed him to express his own world rather than duplicate an external one. Through play with the object, Picasso was able to investigate the relation between seeing, remembering, and artistic presentation, and thereby "reenchant" a disenchanted world.[50] Apollinaire collected the most important of his Picasso-inspired reflections on cultural regeneration, revised them, and then published them as *Méditations esthétiques: Les peintres cubistes* in 1913. As we will see, they represent the theoretical foundation not only of his own poetic art but of his approach to the public sphere and the larger political hopes so beautifully encapsulated in the lines from his "Poème lu au mariage d'André Salmon": "Nor does one renew the world by taking the Bastille again / I know that the only people who will renew it are those grounded in poetry."[51]

However, the vision of a socially redemptive art that the *Méditations* articulate was always complicated for Apollinaire by two factors, the first of which was the naturist legacy. Apollinaire consistently placed his vision of a socially redemptive art within a nationalistic frame, even as he sometimes softened the ethnic-nationalist understanding of that frame which one finds in a Bouhélier, Le Blond, or Barrès.[52] As he put the point in an essay on the decorative arts: "The artisan who chisels, shapes, or carves out an object meant for everyday usage ought to remain anonymous. The taste of which the object is a manifestation, like the decorations that adorn it, belongs to a given period, nation, and environment."[53] Genuine art is always rooted in the concrete national conditions of a people—a conviction, as we will see, that Apollinaire shared with Kandinsky. Yet far more than Kandinsky, he worried about how even mere exposure to foreign art might sow "confusion . . . in the minds of our artisans" and do them "commercial harm."[54] Still, for obvious reasons, Apollinaire was more reluctant than a Bouhélier to dismiss "foreigners" as irrelevant to French art. He thought, for example, that when employed as the judge of an art exhibition, "a foreigner, who is outside the Parisian coteries and free of the influence of critics who are often submissive and rarely disinterested, will be naturally drawn to the most important works."[55] Moreover, by *foreigner,* Apollinaire generally did not mean someone who falls outside the French "race." Rather he most often operated with an inclusive definition of Frenchness that was civic rather than ethnic. He was not, however, entirely consistent in this regard and occasionally utilized a concept of "Latinity" which, from its associ-

ation with Maurras and Edouard Drumont, could have ethnic-nationalist as well as anti-Semitic overtones.[56] All that is certain was that, in Apollinaire's mind, the naturist view that art and its capacity for social redemption must always be connected with the concrete national conditions of a people remained fundamental.

The second complicating factor concerns the danger represented by processes of industrialization and commercialization for the eclipse of avant-garde art. Apollinaire was more nervous about the survivability of avant-garde art than the discussion of the *Méditations* would suggest. In an article for the "solidarist" journal *La Démocratie sociale,* for example, he argued that "mechanical processes threaten every form of art that involves the physical capacities of the artist." Art was becoming "industrialized." Yet while orchestras, theaters, and "painters who content themselves with copying nature" might give way to the phonograph, the cinematographer, and the photographer, Apollinaire here argued that "great painters" who "express the sublime plastically" cannot be replaced.[57] Still, the level of anxiety in the article is sufficient that one is not surprised to read elsewhere in Apollinaire that "today's young painters" are succumbing to the dangers of "industrialization" and artistic overproduction far more than established avant-gardists such as Picasso, Braque, Derain, and de Chirico.[58] The evident implication, which he chose not to make explicit, was that the days of avant-garde art might well be numbered. Partly because of this fear, Apollinaire was deeply concerned in the immediate prewar years with holding the avant-garde together against larger industrializing forces.

APOLLINAIRE AND THE PUBLIC SPHERE

Apollinaire's idea that the socially redemptive role of avant-garde art was best conceived in terms of the "plastic virtues" that symbolism had largely neglected emerged only after his reflection upon the painting of Picasso and Matisse.[59] Yet some of his earliest poems already evince an interest in language very different from the symbolist quest for an ideality merging concrete world and poetic imagination. As Timothy Mathews has persuasively argued, poems such as "L'Adieu," which Apollinaire published in *Le Festin d'Ésope* in December 1903, aim primarily to undermine any stable sense of the relation between words and sensations or experiences.[60] In such poems, language is presented as a form of purely human expression, as a set of word-constructs that recognizes its own artificiality and that defies ready reference to any frame-

work outside the poem itself. If symbolism sought to transcend difference and merge with nature, Apollinaire emphasized the failure to merge, the unbridgeable gap between language and experience that derives from language's own materiality.[61] For him, poetry did not spring from a muse but represented a confrontation with difference in which the intellect struggles to understand not the image itself but what it means to perceive an image and to register that perception in language.

In his early poetry, then, Apollinaire was already pursuing a relation to the natural object which artists like Picasso would teach him so much more about, one in which the object is not represented and yet also does not disappear entirely from view. Pursued at the highest levels where they become self-conscious activities, both poetic language and pictorial art reflect an indeterminacy from which artistic creativity springs. Yet if Picasso's painting is not about revealing the object in nature but about revealing material that allows for the creative search for the object, about *his own* interconnected processes of perception, memory, and presentation, then what can it mean to say that "it is the social function of great poets and artists to renew continually the appearance nature has for the eyes of men"?[62] If creative works do not share common objects or subjects, if our language is fully enclosed within our own experiences, memories, and creative acts, which are sui generis, how is social communication of any sort possible? A Picasso painting may be likened to a statement, but it is difficult to see how it could be clarified by a counterstatement or opened to dialogue. This is precisely the sense in which Apollinaire regarded avant-garde works of art as performances: they were efforts to influence that the audience could accept or reject and that, if accepted, would ultimately awaken self-knowledge, but only if given the opportunity to disclose their inner worlds rather than being initially subjected to external questioning.

Because avant-garde works of art are performances in this sense, the public sphere in which they are presented is one of agonistic exchange rather than mutual dialogue. This idea ought not to sound strange. In our own world of sound bites and thirty-second television spots, a performance politics based on analogous logic reigns supreme and, indeed, testifies to Apollinaire's historical perspicacity. Yet the difference between the two worlds is at least as important as what they share. Our performance politics is quantitative and commodified, linked to a conception of value in exchange, while Apollinaire imagined a performance politics informed by art and governed by claims of taste through which the audience would be led to a greater appreciation of the qualitative dimensions of life.

Through the notion of avant-garde performance, Apollinaire breaks with the Enlightenment metanarrative of emancipation via public learning modeled on scientific advance, but such performance, far from being a retreat from the public sphere, offers precisely the mode of knowledge that will best inform public life in commodified societies.

Apollinaire's fullest articulation of his concept of avant-garde performance is found in the *Méditations esthétiques*. Here he argued that, unlike the traditional artist who finds inspiration in a purposive natural world which he then mimics, the avant-garde artist recognizes the world, in both its natural and social dimensions, as fundamentally without purpose: "The rainbow is bent, the seasons quiver, the crowds push on to death, science undoes and remakes what already exists, whole worlds disappear forever from our understanding, our mobile images repeat themselves, or revive their vagueness, and the colors, the odors, and the sounds to which we are sensitive astonish us, then disappear from nature—all to no purpose."[63] Yet, for avant-garde artists, the fact that no divine order inheres in the world as given, that "no muse inspires them," is no impediment to art but rather its source. Like Nietzsche's "active nihilist" or the Gourmontian critic who practices dissociation, Apollinaire's avant-garde artist responds to a meaningless world by forging "his own divinity."[64] This "divinity" makes him "master" of the creative process, freeing him from any subservience to the creative acts of forces outside himself. But it also has two more specific effects. As Apollinaire writes of Picasso: "A new man, the world is his new representation. He enumerates the elements, the details, with a brutality which is also able to be gracious. New-born, *he orders the universe in accordance with his personal requirements, and so as to facilitate his relations with his fellows.*"[65] In its freedom to deal with "elements" and "details" in terms of the "personal requirements" of the artist, avant-garde performance presents a world that is unique, that discloses a personality, that is therefore qualitative, concerned with the status of the unreproducible particular, and completely foreign to what is merely "fashionable."[66] Yet, in Apollinaire's view, the best avant-garde performance is able not only to reconnect with the concrete experience of life but also to be suggestive about that experience for others. Art "facilitates his relation with his fellows" in the sense that "the picture which he offers to the admiration of men will confer upon them, likewise, the glory of exercising their divinity—if only for a moment."[67]

In speaking of divinity, then, Apollinaire appears to refer to the absolute freedom to create, which in turn implies the presentation of a per-

sonal world powerful enough to reconnect modern individuals with the qualitative dimension otherwise missing from their existences. By becoming divine in this sense, the avant-garde artist rescues modern society from nihilism and meaningless repetition. "Without poets, without artists, men would soon weary of nature's monotony. The sublime idea men have of the universe would collapse with dizzying speed. The order which we find in nature, and which is only an effect of art, would at once vanish. Everything would break up in chaos. There would be no seasons, no civilization, no thought, no humanity; even life would give way, and the impotent void would reign everywhere."[68] With such artists, on the other hand, the experience of the qualitative reawakens: thought, humanity, order, and the sublime all once again become possible.

However, for anyone who studies Apollinaire's avant-garde activity or who reads his day-to-day art criticism, this happy vision of avant-garde and public marching hand-in-hand toward a respiritualization of the world must appear problematic in two important respects. First, in the turbulent political atmosphere prevailing in Paris, the avant-garde was itself divided internally and not infrequently torn apart by rancorous disputes, as the attack on Apollinaire by Duhamel illustrates. For Duhamel was not some mainstream critic antagonistic to the avant-garde but an artist and avant-gardist himself. He had been associated with the Abbaye de Créteil group, those rivals to Picasso and his band who had later transmuted themselves into the Puteaux cubists. Moreover, his attack came in the *Mercure de France,* with which Apollinaire was also closely associated. Indeed, it was the *Mercure* that had published *Alcools* in the first place. No doubt Duhamel's motives for the attack were personal as well as group-related, yet he was hardly the only avant-garde critic to attack Apollinaire.[69] Especially in the immediate aftermath of the *Mona Lisa* incident, which itself occurred just after the explosion of the Second Moroccan Crisis, Apollinaire was subjected to a great many chauvinist onslaughts.[70]

Although Apollinaire was surely angered by such attacks, and some scholars have suggested that his rapprochement with futurism may have been an acting-out of his frustration with the conservatism they represented, what is more noteworthy is that Duhamel's at least came after two years of avant-garde activity in which Apollinaire had tried hard to reconcile himself with the Puteaux group and thereby bring the whole Paris avant-garde together.[71] The group of artists of which Puteaux was the latest incarnation had tended to be much more salon- (as against gallery-) oriented, more nationalist, and more natively French than the

cubist group around Picasso with which Apollinaire had mainly been associated.[72] In 1911, he had attended the meetings of the Puteaux cubists at the studio of one of their members, Jacques Villon. He championed their efforts to gain control of a specific part of the 1911 Salon des Indépendants, which they succeeding in doing as "Room 41," a move that mainstream critics had either ridiculed or ignored. In 1912, he gave important publicity to the salon they organized, known as the Section d'Or, which was funded by Francis Picabia and ran concurrently with the Salon d'Automne of that year as an odd hybrid of salon and private gallery. Indeed, Apollinaire may even himself been involved in organizing it.[73] What is certain is that he gave a lecture at the opening, wrote the cover article for its "bulletin," and gave it a hilarious review in his regular column for *L'Intransigeant*.[74] That, after all this effort, Apollinaire was still so savagely attacked testifies to the magnitude of the problem of intra-avant-garde relations he faced.

The other way in which the capacity of avant-garde art to respiritualize the world was problematic lay in the hostility and incomprehension of the public. Certainly the challenge before the avant-garde critic like Apollinaire who would try to present himself as a kind of taste professional worthy of a broad and sympathetic readership was at least as great as that of smoothing out avant-garde factionalism. It was a challenge to which he rose in a manner equally steadfast and no less responsive to the mood and needs of those he aimed to serve. The many hundreds of pages he wrote encouraging the public to pay attention to this or that painter or show testify to his steadfastness, and their spirit of teasing provocation—almost always gentle and rarely adopting the shrill tones of the manifesto—seems to have been quite effective. His preferred presentational modes were the exhibit review and the brief programmatic treatise for the exhibit catalog, and in them, as in his other characteristic forms of critical writing—art news, freestanding interpretations of individual artists, promotional and self-promotional blurbs, and polemics against rival critics—he was never without his own distinctive, critical voice.

Apollinaire viewed the public sphere as a complex field of positions including, most saliently for him, artists, critics and the press, salon juries and judges, artist organizations, dealers and gallery owners, and the public at large. His critical practice took each of them into account, now chastising a gallery owner for "deliberately under-representing" Cézanne or being overly preoccupied with the "taste of the moment," then needling the "gentlemen of the (judging) committee" for their "intellec-

tual poverty," or supporting "young painters" against the "venomous spirit in our art critics," or commending the Société des Indépendants for the growth in its membership.[75] Yet, in every encounter, his unwavering goal seems to have been to reduce the distance between the most talented and sophisticated artists and their potential public, and to do so in clear language accessible to as broad a public as possible. "Henri Matisse, whom so many uninformed viewers find disconcerting, is an extremely appealing painter."[76] Or: "People will also admire Albert Gleizes's *Fishing Boats.*"[77] Or: "M. Eug. Blot invites us to visit an exhibition of sculptures, wood carvings, and potteries done by Gauguin while he was in Tahiti. This artist, whose religious sentiment was vague but profound, and who felt so strongly the need to live in a state of nature at the antipodes, was an artisan full of skill and charm."[78] Such formulations are typical of a practice in which Apollinaire approached the public alternately as tour guide, investment adviser, or technical expert and connoisseur, but always with the aim of quickening its interest in the performance at hand while trying hard to refrain from proclaiming directly what it ought to see.

Apollinaire conceived his mission as defending the art he considered most meritorious and tasteful; thus he advocated cubism even though he was not particularly excited by it. In this limited sense, his criticism sought to be educational as well as promotional, and he sometimes appeared almost professorial, doling out grades to some artists ("Mme. Lewitska's landscapes of Roussillon are solid and full of poetry. . . . Lhote, who is improving markedly. . . . Frank Burty who is also improving. . . . Delaunay is one of the most gifted and most audacious artists of his generation"), while scolding others for being beholden to motives (like "profit") inappropriate in the pursuit of pure art.[79] Despite his high regard for the French, he treated France as a country in which philistinism predominated, but of which he was the self-appointed eradicator. He hoped particularly to interest the younger generations in art: "It seems to me a must to visit the Salon d'Automne; fathers will do well to take their sons there, both from a pedagogical and humanitarian point of view."[80]

Yet, despite Apollinaire's evident seriousness of purpose, the jocular spirit for which he was so renowned constantly broke through, and he became known as a critic who was at least as attached to humorism as he was to serious forms of persuasion. Thus, to promote "women's writing," he wrote a year's worth of columns for Montfort's *Les Marges* under the signature of "Louise Lalanne" before first having Montfort announce that Louise had been abducted by a cavalry officer and then

finally revealing her true identity.[81] Later, during the war, when he was assigned to translate news reports from the English press for *Paris-Journal,* he seems to have "translated" entirely from his own imagination, pointing out that "there is no better way to influence events."[82] Such playfulness carried over as well into some of his attitudes about art. Thus, he commended plagiarism as an activity in which "so many great men have engaged" and shrugged aside the idea that there was anything to be concerned about in artistic "fakes." Here he commended the attitude of the German curators who, he claimed, "instead of lamenting the fact [of a fake] and transporting the work to the attic . . . simply place the little word '*nach*' ('in the manner of') before the artist's name."[83]

Apollinaire's tricksterism, however, was not merely a matter of personal style. It also reflected his awareness that humorist appeals, so commonly exploited by the rising industries of mass entertainment, would help to provide him with the widest possible audience. He was never content with limiting the reach of avant-garde art to an elite public, for he knew that the capacity of avant-garde art to make an impact on the problems of modern life—commodification, industrialization, uglification—depended upon its ability to address a broad public. Moreover, he knew that to address a broad public, neither avant-garde performance itself nor the critics who mediated it could afford to isolate themselves from the sort of appeals that mass entertainment deployed. In practice, the three components of his model of the public sphere—agonistic performance by an avant-garde, its mediation by professional critics, and its reception by a broadly democratic public—were all mutually interdependent.

In Apollinaire's estimation, the modern world had become a place where we are "surrounded by ugliness on every side. We allow horrible buses to disfigure the streets of Paris without protest, and our houses are the ugliest possible." [84] Whatever can be done to enhance the beauty of the lived environment is of benefit, whether that means the paintings of a Matisse hanging in a left-bank gallery or the advertising posters of a Jules Cherét which have so "ennobled the art of street decoration."[85] Apollinaire wrote frequently on the decorative arts, and he could appreciate an electric chandelier with bulbs made to look like sea urchins as much as a new avant-garde talent.[86] He thought inventive commercial applications of the arts not only beautified the environment but provided the masses with a taste of art, one that might lead them closer to avant-garde works. Thus a cheap reproduction of Seurat's *Circus* had its place, and popularized books on the designs of the "great masters" might even encourage their readers to find their way to a museum.[87]

Apollinaire's attitude toward the mixing of art and commerce was often playful and without a sense of threat, as when he amused himself with imaginary conversations about dress shops exhibiting at the next Salon d'Automne.[88] Avant-garde painting needs a "great marketplace," and whatever stimulates art generally will help provide it.[89] A frequenter of the Médrano Circus all his life, Apollinaire foresaw a future rapprochement between circus and theater in an interview during the war.[90]

Yet Apollinaire's enthusiasm for mass entertainment was not blind. He approved of it so long as it contributed to the dissemination of a taste for art to a wider audience, but his attitude became disapproving when standards of taste were greatly weakened or lost. He was particularly harsh when he thought avant-gardists were surrendering to popular appeal rather than excellence as the ultimate arbiter of their success. The futurists, for example, sometimes succumbed to a "popular, flashy art," and he thought Marinetti's ideas on variety theater courted "the danger. . . of falling into that refined half-heartedness, poor and pretentious, half-Munich and half-Salon-de-Automne, which is the most obnoxious kitsch [*pompier*] there is today."[91] Such avant-garde performances were no longer primarily governed by claims of taste but had, despite their own intentions, subordinated themselves to the principle of exchange value.

There is, then, in Apollinaire's conception of a modern public sphere, a delicate and precarious balance. As the fullest expression of the search for art's autonomous essence, avant-garde performance is modernity's best hope for getting back in touch with the qualitative dimensions of existence that lie beyond exchange. Such performance is itself quintessentially modern, growing out of the same ingenuity and imagination that have produced modern industry and technology. In this sense, avant-garde art and mass entertainment are continuous with one another, each an expression of the aesthetic potentials of modern life, which are very great. "Modern style," Apollinaire wrote in 1912, lies above all in "its iron constructions, machines, automobiles, bicycles, and airplanes," and he who sees in the Eiffel Tower a "lack of style" is quite mistaken.[92] Two decades before Walter Benjamin and Siegfried Kracauer, Apollinaire was calling attention to the democratic potential of the work of art in an age of "mechanical processes," even while also expressing the fear that the "industrialization" of art might ultimately distract the avant-garde from its pursuit of a pure art.[93] That was of course the other side of the balance. Market forces pressured younger painters to produce too much and too soon, and a market-stimulated "art of the boulevards" was

threatening to undermine the avant-garde from within.[94] His anger at this potential even led Apollinaire into the occasional anti-Semitic remark, as when he wrote of Heinrich Heine as "a Jew who tried to gallicize himself, and unfortunately it is this caustic Jewish spirit that has managed in large measure to replace the simplicity of the French spirit; the art of the boulevards is Jewish to the point of excess."[95]

Embedded within this unfortunate display of rancor, however, lies an important point, one that will play a central role in "The New Spirit and the Poets," his most important late essay. For Apollinaire, the main antidote to the collapse of avant-garde values before the demons of exchange was the naturist principle that genuine art must be rooted in the concrete national conditions of a people. So long as avant-garde art remained connected to folk traditions, customs, specific locales, and the life circumstances of a particular people, its anchoring in the qualitative appeared secure. But when, as with many of the futurists, it lost touch with its roots in a vain quest for an avant-garde internationalism or notoriety for its own sake, it was prone to seduction by the quantitative and abstract, despite its own best intentions.

FUTURISM, WORLD WAR I, AND A "NEW SPIRIT"

There is one notable exception to Apollinaire's lack of interest in writing manifestos: the brief futurist manifesto he wrote in the spring of 1913 that appeared in the Florentine journal *Lacerba* that September.[96] Yet even this is not quite the exception that it initially appears to be. Beginning with the first Parisian exhibit of the futurist painters in February 1912, Apollinaire had been lukewarm toward the Milanese movement, claiming that its participants were "nothing but imitators . . . of the avant-garde French schools."[97] Although this view provoked the hostility of some futurists, especially Umberto Boccioni, Marinetti himself recognized the immense value of having Apollinaire in his corner and reacted more strategically. Through pressure on Soffici, a Florentine futurist who had known Apollinaire from a long sojourn in Paris, Marinetti seems to have teased Apollinaire into writing a futurist manifesto.[98] Yet, according to the later recollections of Carlo Carrà, when Marinetti received the manuscript, he judged it interesting but not yet written in manifesto form. The elaborate font and typeface variations of the version that appeared in *Lacerba* were Marinetti's work, although they met with Apollinaire's approval.[99]

Ironically, the one futurist influence upon Apollinaire that seems

incontrovertible are Marinetti's ideas about typography, punctuation, and visuality in poetry. On more substantive matters, however, Apollinaire was critical of futurism, both before and after the brief parenthesis represented by his manifesto. The reasons for this attitude are not hard to discern. As already indicated, Apollinaire feared that futurism was insufficiently serious about artistic values and too given to the fashionable. Futurism also seems to have provoked his anxieties about being French; nearly all of his articles on the movement treat it in the context of a Franco-Italian avant-garde rivalry. Apollinaire clearly reacted against Marinetti's autocratic leadership style, as would the Florentine futurists in the spring of 1914.[100] Yet Apollinaire also had deeper reasons for being cool toward futurism, reasons connected with his ideas about an avant-garde strategy adequate to modern innovations in culture and communication.

For Marinetti, as we have seen, the modern world was veering away from written persuasion, especially in extended forms such as the book, and toward the visual, cinematic, and verbal-performative. Accordingly, the fundamental form of his avant-garde practice was the futurist *serata,* in which written poetry became only a means within a staged performance that drew its energy from a calculatedly hostile relation with its audience. Although Apollinaire was also impressed by the power of the visual in modern life, he jealously guarded the specificity of the literary, defending the written page and the book against obsolescence and against being reduced to its present performative value, even as he sought to make poetry more attentive to the speed of modern life. This attitude was linked with a view of language which, as we have seen, remained analytical and intellectualistic in its insistence upon its own artificiality and separation from experience. Language for Apollinaire was a critical instrument for investigating the difference and otherness of the confronted object rather than, as in Marinetti, a medium through which human bodies and the world were to be ecstatically merged. To follow Marinetti's irrationalist and apparently world-transforming understanding of language, Apollinaire feared, was actually to return art to a traditional-mimetic understanding rather than a modernist-autonomous one. As he wrote in the *Soirées,* "Marinetti's words-in-freedom [*mots en liberté*] bring about a renewal of description and as such they have their importance, but they also imply an offensive return of description and are in this sense didactic and anti-lyrical."[101]

According to some critics, however, Apollinaire's enthusiastic, sometimes ecstatic response to the war represented a movement back toward

futurism.[102] This is a view we will consider—after we have briefly enumerated the essentials of that experience. As a foreign-born resident of France, Apollinaire was under no obligation to enlist. He could have gone to Switzerland, as some friends suggested, or to New York with artists such as Francis Picabia, Marcel Duchamp, and Albert Gleizes, or he could simply have stayed in Paris as Picasso did. For reasons that should by now be evident, however, Apollinaire made immediate efforts to join the French army. Initially, these efforts failed because of his Polish name, his mother's Russian birth, his own Roman birth, and the fact that, despite his French nationalism, he had not troubled to apply to become a naturalized citizen until just a few months before the outbreak of conflict. Ultimately, however, the army's need for manpower prevailed. By December he had joined the thirty-eighth regiment of field artillery at Nîmes, and by April 1915 he was at the front. There he mostly remained until a shell splinter penetrated his tin helmet on 17 March 1916, eight days after finally being granted French citizenship. Apparently superficial at first, his head wound soon proved otherwise, temporarily paralyzing his left hand and forearm and putting so much pressure on his brain that the army doctors ordered him to be trepanned.

During his months of combat, Apollinaire wrote a number of poems—notably "Merveille de la guerre" [Wonder of War], "La petite auto" [The Little Car], "Fusée" [Flare], and "A l'Italie" [To Italy]—that appear to celebrate the butchery of war and to aestheticize the experience of it in a manner not unlike Marinetti's. *"Ah, Dieu, que la guerre est jolie"* is the most often cited line of his war poetry and, not infrequently, it serves to end as well as to begin discussion.[103] Yet even the most thoughtful interpreters have tended to agree that Apollinaire celebrated the war rather crudely. As Mathews argues, "certainly it is impossible to ignore that Apollinaire poems exist that are difficult to read other than as attempts to establish dominance, whether real or imaginary," that are "expressions of a desire for power, for a willful suppression of difference," and that "move at will from concrete to imaginary, experience to creativity, image to myth."[104] I regard this as a harsh assessment, but I have no reason to quarrel with it. That the war may have caused Apollinaire to lose touch with his critical faculties temporarily, as Mathews intimates, seems readily explicable in view of his experience in it as well as his intense desire to prove himself fully French. As Kenneth Silver has argued, pressures on everyone living in France to be accounted fully loyal to the war effort were the decisive feature of cultural experience in these years.[105]

But was Apollinaire's reveling in war a function of a renewed futur-

ism? Here Mathews's answer seems ultimately uncertain, but that of
Raymond Jean is not. Jean argues that the shock of the war threw
Apollinaire into a crisis of identity so deep that he lost all rational con-
trol over his faculties. In his view, the "counter-ideology" of ethnic fan-
tasy and exile that had permeated Apollinaire's poetry from the begin-
ning was an escape, a refusal to confront the likes of Duhamel in rational
argument, and an unconscious flight into myth that marked a profound
alienation. The shock of the war so intensified this alienation that he was
no longer able to accept the involvement of individual existence in his-
tory, a primal refusal that Jean finds expressed in Apollinaire's futurist
"antimanifesto" where it speaks of a "suppression of history." Yet why
should the fantasies of ethnicity and exile that inhabit Apollinaire's
poetry be treated as an escape from historical responsibility? Jean
appears to assume that the only appropriate response to Duhamel's racist
xenophobia would have been an assertion of cosmopolitanism and that
any counternationalism must be an irrational escape. As has been argued
here, however, Apollinaire was a French nationalist from the beginning
for reasons very much bound up with his attraction to naturism. From
this point of view, his enthusiasm for the war is explicable as the full
blossoming of attitudes he had always held. To believe that his attitude
toward the war requires some special explanation is to fail to recognize
the depth both of his own prewar nationalism and of the nationalist ten-
dencies of the prewar French avant-garde as a whole.

That Apollinaire's hearty embrace of the war was not a function of
any return to futurism is also evident from the argument of "The New
Spirit and the Poets," which he delivered as a lecture in November 1917
and which was published posthumously in the *Mercure de France* of 1
December 1918. The crisply written essay is a brilliant, if less than fully
coherent, synthesis of his value commitments, his view of public life, his
sense of the coming transformations in culture and technology that will
affect that life, and his understanding of the historical role avant-gardes
must continue to enact.

From its opening sentence, which touts France as the world's cultural
center, the essay rings with nationalist rhetoric. "The strong intellectual
discipline which the French have always imposed on themselves" will
save them from the "excesses of the Italian and Russian futurists." Yet
Apollinaire's argument for the importance of national rootedness per-
tains to every nationality, not just the French. "Truth," he claims, must
be explored "as much in the ethnic domain . . . as in that of the imagi-
nation." He also proclaims his confidence that "social developments will

[never] go so far that one will not be able to speak of national literature," a formulation that seems driven as much by his fear of global cultural forces as by his dispassionate analysis of the present. Indeed, he goes so far as to say that "art *increasingly* has a country"; he explicitly rejects cosmopolitanism; and he emphasizes the old naturist principle that "poets must always express a milieu, a nation," that artists are always the "expression of a race, of one given environment. Art will only cease being national the day that the whole universe, living in the same climate, in houses built in the same style, speaks the same language with the same accent—that is to say never."[106]

Apollinaire knows full well that the "old regime" has expired on the battlefield and that "the new spirit" whose outlines he is trying to discern is linked to rising forces of cultural democratization, globalism, and technology. Yet the effect of these realizations is mostly to excite his desire for a "return to order."[107] Indeed, it has been suggested that the phrase "new spirit," as deployed by French intellectuals in this period, including both Apollinaire and Le Corbusier, traded upon its usage in French wartime propaganda, where it referred precisely to "France's 'reawakening' after August 1914—her new sense of strength, control, and equilibrium."[108] Certainly the values Apollinaire declares are rational and orderly: "The new spirit which is making itself heard strives above all to inherit from the classics a good sound sense, a sure critical spirit, perspectives on the universe and on the soul of man, and the sense of duty which lays bare our feelings and limits or rather contains their manifestations." The trick will be to integrate these values with the modern technical prowess that the futurists so celebrate and the importance of which he certainly acknowledges too. "Typographical artifices," for example, "have the advantage of bringing to life a visual lyricism which was almost unknown before our age." They may even make possible a kind of Wagnerian "synthesis of the arts, of music, painting, and literature," although such a synthesis would be wholly modernist and devoid of that composer's "mighty romanticism." Ours is the "era of the telephone, the wireless, and aviation," and the "popular art *par excellence*" is the cinema. The old literary culture of a leisured, lettered readership is gone; "rapidity and simplicity" of communication has become the order of the day.[109] Poets will respond with enthusiasm. "They want to be the first to provide a totally new lyricism for these new means of expression which are giving impetus to art—the phonograph and the cinema." Yet the exciting potential of these modern technical triumphs is sharply distinguished from the moral values the futurists associate with them.

The essay prefers to speak of "new spirit" and "poets" rather than avant-gardism and avant-garde, but it is clear that, despite its return-to-order tenor and opposition to futurist values, Apollinaire remains committed to an agonistic public sphere based on avant-garde performance. "Poets and artists," he writes, "daily increase the patrimony of civilization; and through the truth and joy they spread, they will make this civilization, if not adaptable to any nation whatsoever, at least supremely agreeable to all." And: "since men must live in the end by truths in spite of the falsehoods with which they pad them, the poet alone sustains the life whereby humanity finds these truths." There are signs, however, that Apollinaire is moving toward a more broadly democratic conception of who might be expected to be engaged in avant-garde creative activity. Like Antonio Gramsci, who responded to the postwar era by declaring that everyone is an intellectual, Apollinaire declares that "one can be a poet in any field: it is enough that one be adventuresome and pursue any new discovery." Poets are all those who "undertake discoveries." They "are not simply men devoted to the beautiful. They are also and especially devoted to truth, insofar as the unknown can be penetrated, so much that the unexpected, the surprising, is one of the principal sources of poetry today." These are words whose implications will be seized upon by André Breton in the 1920s, as he sought to revolutionize the notion of who might be expected to be an artistic creator.

In the nearly three years between his head wound and his death from influenza, Apollinaire lived his life in tune with this same tenuous balance of values. He wrote the program notes for Paris's major avant-garde performance of 1917, *Parade*, a kind of *Gesamtkunstwerk* featuring set designs by Picasso, music by Erik Satie, and a libretto by Jean Cocteau. In these notes, the word *surrealism* appeared for the first time. A month later, his own hilariously farcical play, *Les Mamelles de Tirésias* [The Teats of Tiresias], which he also called surrealist, had its début in Montmartre with Breton and Jacques Vaché in attendance.[110] Moreover, he paid close attention to new avant-garde developments like dada, and gave early enthusiastic support to Tristan Tzara.[111] Yet, at the same time, the values he articulated shifted sharply to the conservative side. Not only did he begin to write more explicitly political articles and to show new enthusiasm for Maurras and Action Française, but even avant-garde work like *Les Mamelles de Tirésias* can plausibly be read as endorsing extreme pro-natalist values.[112] Although he had left the battlefield, he continued his military career, working first as a censor for the press relations bureau of the Ministry of War, where he was responsible for excis-

ing passages that might be considered defeatist or useful to the enemy. After holding that position for nearly a year, he was transferred to the Ministry for Colonies in April 1918.[113] Not surprisingly, when Tzara approached him at this time regarding his journal *Dada 2*, Apollinaire coldly responded that "it would be compromising for me . . . to collaborate on a review . . . that has Germans for collaborators, even if they should favor the Entente."[114] Such Germanophobia had not prevented him from lecturing at the *Der Sturm* gallery in Berlin in 1913, but the devastation of war, his military service both at the front and in Paris, and the uncertainties of the new era that loomed before him strongly reinforced the nationalist instincts that had always undergirded his thinking about the nature and political potential of avant-garde modernism.

In the period when he was working for government ministries, Apollinaire became quite close to a young medical student employed by a nearby psychiatric hospital. Just twenty-two when Apollinaire died, the young Breton became so enthralled with the poetry and personality of the avant-garde's elder statesman that he later confessed: "It seemed to me that I was not so much talking to a man, even with a man I admired more than anyone, as with an intermediary power, someone capable of reconciling the world of natural necessity with the human world."[115] Nonetheless, Breton's reaction to the "New Spirit" lecture, which he had helped organize, was deeply ambivalent: "While [my friends and I] were pleased to have him confirm that in poetry and art 'surprise is our greatest new resource,' and to see him demand 'freedom of unimaginable opulence,' we were worried about the importance he placed on reviving the 'critical spirit' of the classics, which to us seemed terribly limiting, as well as on their 'sense of duty,' which we considered debatable, in any case outmoded, and, regardless, out of the question. The will to situate the debate on a national, even nationalistic, level ('France,' said Apollinaire, 'keeper of the entire secret of civilization') seemed still more unacceptable to us."[116]

Far from marking a return to futurism, the spirit of Apollinaire's wartime writing and thinking was an intensification of his long-standing attachment to the French classical tradition. Indeed, in several of his late letters, he went so far as to assert that the cubism of Picasso and "Second Lieutenant Georges Braque" was a "reaction in favor of tradition carried out against impressionism" and an expression of "Latinity."[117] As Breton sensed, Apollinaire's late intellectual outlook, viewed in relation to those in the interwar period most influenced by him, went in at least three different, partly opposed directions. If one of them was the surrealist world

of unconscious fantasy, the occult, and the aesthetics of "surprise," another was the seemingly opposite world of rational, technology-based order that we find in the problem-solving "new spirit" of Le Corbusier. Still a third was the hypernationalist rejection of globalizing culture—or "Americanism" as it came to be called increasingly during the interwar years—that is perhaps best illustrated by Apollinaire's followers in the Italian *strapaese* movement. Never a man whose visions could be easily contained, Apollinaire embodied modernism at its most protean.

4

Wassily Kandinsky

n *Aesthetic Theory*, Theodor Adorno cast Wassily Kandinsky as his foremost exemplar of how a modernist strategy of "spiritualization" goes wrong:

> The aesthetic concept of spirit has been severely compromised not only by idealism but also by writings dating from the nascence of radical modernism, among them those of Kandinsky. In his justified revolt against sensualism, . . . Kandinsky abstractly isolated the contrary of this principle and reified it. . . . Art's crisis is accelerated by spiritualization, which opposes selling artworks off as objects of sensuous gratification. Spiritualization becomes a counterforce to the gypsy wagon of wandering actors and musicians, the socially outcast. Yet however deep the compulsion may lie that art divest itself of every trace of being a show, of its ancient deceitfulness in society, art no longer exists when that element has been totally eradicated and yet it is unable to provide any protected arena for that element. No sublimation succeeds that does not guard itself in what it sublimates.[1]

For Adorno, the effort to respond to the loss of the auratic in art by resurrecting its spiritual or religious possibilities in a secularized world actually hastens the deauratization it seeks to combat because it overly rationalizes its own approach to art and forgets art's origins in sensuousness, in the imitation of natural beauty. So anxious are the "radical

modernists" to save "pure art" from contamination by the commodity form that they fail to "guard themselves in what they sublimate."

Confronting a world in which industry and capitalism are rapidly advancing into the domain of culture, and in which art is thereby threatened with being incorporated into a world of entertainment, radical modernists seek to make art autonomous, or in Kandinsky's vocabulary, which we will soon explore, to make it obey the dictates of "internal necessity." With this move Adorno has no quarrel. Yet how is art based on internal necessity to find an audience sufficiently wide to counter the effect of the emerging culture industry? Adorno's reply is that any avant-garde effort to promote art or a respiritualized culture in which non-commodity values lie at the center subjects it to a dialectic in which autonomous art inevitably mimics the commodity form it seeks to escape. "The absolute art-work converges with the absolute commodity" because, following a rationally self-conscious program toward a goal it cannot foresee, it is condemned, like capital, to an endless quest for "the new," and thus to becoming evanescent fashion. Avant-garde strategies are thus self-defeating. The only viable strategy for modernism is the passive, non-avant-garde one he associates above all with Samuel Beckett, in which modernist art succeeds in reflecting "the truth of the new" but at the price of becoming "intentionless." Refusing to interpret his works and eschewing any effort to connect them with the "socially useful," Beckett is politically charged precisely because his art seeks nothing—because "it criticizes society by merely existing"—and thereby acts out the role of a placeholder for a truth beyond exchange.[2]

Kandinsky was no doubt a good choice for the role in which Adorno cast him. In seeking to respiritualize society through avant-garde art, he offered a philosophical analysis of its nature that is fuller than that of any other avant-garde modernist of his era. Moreover, he was vehement in his rejection of nineteenth-century materialism and its enduring legacy, as well as unusually scrupulous in eschewing entertainment values in his pursuit of autonomous art and a wider audience for it. He rejected futurist grandstanding and refused in all other ways to collapse the distinction between popular culture and high art—the latter denigrated by the futurists as "Art with a capital A." Yet in doing so, Kandinsky did not eradicate the sensuous element in art. Indeed, it was the sensuousness in his use of color and his theorization about the basis of that sensuousness that would seem to make him vulnerable to the charge of having advanced deauratization and thereby served the culture industry. Certainly his ideas would be a useful primer for anyone seeking to use color to

influence perception and excite desire. Yet, despite its shortcomings, the great virtue of Adorno's account is that he at least recognizes that Kandinsky did pursue an active avant-garde strategy based on what might be called a respiritualization of the cultural world.

Such a recognition has not been particularly evident in Kandinsky scholarship, large as that body of work now is. Its primary focus has always been on Kandinsky's path toward abstraction, which, even when culturally contextualized, tends to turn inward toward the man and his art rather than examining the ways in which he sought to make his art (and avant-garde art more generally) communicate with a larger public.[3] Recent work, however, has given growing attention to how Kandinsky operated in relation to the larger cultural world including the art market, as well as to the nature of his political interests. On the former point, he has been understood variously as a good organizer with an even keener eye for others who might excel at cultural entrepreneurship more than he; as a cynical player in the world of exchange value, his spiritualizing theory to the contrary notwithstanding; and as an artist with a sharp-eyed "strategy for success" who nonetheless managed for the most part not to compromise his antimaterialist values.[4] In his politics, Kandinsky has likewise been characterized as an anarchist, a Slavophile nationalist, a conservative member of the "rear-guard" rather than any avant-garde, and a Russian liberal.[5] Yet only rarely does the literature raise the Adornian question of the social role of avant-garde art in relation to the spiritual regeneration of the public.[6] This is the issue that the present chapter will address. Specifically, we will consider how Kandinsky understood avant-garde art and its cultural context, how he distinguished it from the commodity form, how he hoped to educate the public to appreciate it, how he understood his public, and what it meant for him to address the public in the very different worlds of prewar Munich and wartime and postwar Moscow and Weimar.

Kandinsky epitomized the individual artist who, with great seriousness over many years, develops his own distinctive approach to painting. Indeed, he went a step further than most in this respect, developing what he saw as the "color-language" of painting and showing the relation of its elements to music and other arts.[7] Yet he also believed deeply in the moral and social function that the artist had traditionally performed: that of expressing the spirituality of his epoch's culture and closing any gaps between that spirituality and contemporary society. This view led him to understandings, statements, and actions that, in my view, had left-liberal and sometimes anarchist and nationalist resonances. That he was

"apolitical," as much of the older Kandinsky scholarship holds, and as he himself affirmed to his future biographer, has some truth only if politics is taken in the narrowest of senses having to do with "current events" and parliamentary machinations.[8] Certainly it is not true if one takes into account a visionary politics of social and cultural regeneration. Like Wagner, whose art he greatly admired, Kandinsky was profoundly critical of the materialism of his age, but unlike Wagner his avant-gardism was quite unapocalyptic and concretely focused, even though that focus would change over time. We will see that he continuously devoted himself to such an avant-garde politics through both practical and theoretical efforts, not least among the latter being an articulation of the immanent criteria by which art might be judged in contrast to the external "bottom-line" orientation being imposed willy-nilly by commodity culture.

AVANT-GARDE AND PUBLIC IN PREWAR MUNICH

Kandinsky's apparently precipitous decision as a thirty-year-old in 1896 to put aside a legal career and a teaching position at the University of Dorpat in Estonia in order to study art in Munich contains some hidden complexities. Although he had never formally studied art in Russia, he had a rich set of experiences in the budding world of Moscow modernism, including work as artistic director of a printing shop and connections with the Russian art intelligentsia that he would exploit throughout the Munich years. Perhaps even more important, he had received funding from the Russian Ethnographic Society to spend the summer of 1889 studying the art and customs of the Zyrians living in the Vologna region east of Moscow, an experience that he recalled with great passion in his autobiographical reminiscences of 1913 and which Peg Weiss has recently argued is the foundation of his entire artistic enterprise.[9] Yet just as these experiences should lessen our sense of abruptness in his choice of an artistic career, so too we should recognize that the choice did not represent an abandonment of the larger motive that had stood behind his pursuit of the law. In 1912, he would tell the German avant-garde art world that he had felt in those early days that "art was an impermissible luxury for a Russian," yet he did not throw his strong sense of social responsibility to the winds in 1896 but rather learned over time how to realize it within the world of avant-garde art.[10]

The Munich he encountered as an art student was fertile ground for maintaining his sense of social responsibility through art. It had a vibrant

bohemian life in Schwabing. Indeed, by one estimate more than twenty thousand artists and students were living in a city with a total population of just forty thousand.[11] There was an established Russian émigré community in Munich, and during his student years Kandinsky made a number of friends among Russian artists who would soon become active with him in organizing a Munich avant-garde. It had the combustible mix of a lingering traditional popular culture—including peasant arts and crafts as well as fairground and puppet theaters—and a fast-developing mass-entertainment industry involving commercial stages, cabarets, and vaudeville acts.[12] It had an arts and crafts tradition going back to the 1850s, and it had become the center of German Jugendstil, whose roots lay in the social activism of John Ruskin, William Morris, and the English Arts and Crafts movement. Even as Jugendstil itself began to fade from fashion after 1902, the decorative arts movement in Munich continued to flourish and even took a new direction with the 1907 founding in Munich of the German Werkbund, an organization dedicated to bridging the gulf between art and industry.[13] Munich was also the scene of a dynamic symbolist movement encompassing poetry, painting, and theater, all based on the same politics of respiritualization that Adorno identified in Kandinsky. Finally, however, Munich might also have stimulated Kandinsky's social consciousness because it was turning increasingly conservative. After 1903, as in many other European cities including Paris, Munich's liberalism was declining and Catholicism was asserting itself both politically and culturally.[14] Although when Kandinsky first arrived he had been quite impressed by Munich's cultural vitality, by 1909 he was dismissing the city as a cultural "fairy kingdom in which pictures sleep on the walls."[15]

While the forces at work in moving Munich to the right far transcended its avant-garde art scene, the intermixing of Jugendstil decorative arts with symbolist high art made for a radical brew that provoked strong reaction. If Jugendstil drew upon the critique of industrialism and commodification in the English tradition of Ruskin and Morris, German symbolism offered up a Wagnerism that used theater to combat the corrosive effects of industrial capitalism. Although like its French counterpart, the German symbolist milieu as a whole reflected an aestheticism that withdrew from present social problems into an ethereal world of myth and fantasy, it did cultivate a notion of *Gesamtkunstwerk* through which all the arts would be integrated in a musical drama. The ideal of *Gesamtkunstwerk*, also present in Jugendstil, was no less influential than the latter's commitment to reinvigorating the beauty of everyday life.

Together they represented two of the most important avant-garde ideals of social engagement available in prewar Europe.

Among the leaders of Munich Jugendstil was Peter Behrens, who after 1900 moved away from painting for architecture, designed a theater explicitly for *Gesamtkunstwerk,* became active in the Werkbund, and was a formative influence on young architects such as Walter Gropius and Le Corbusier. Kandinsky worked with him through Phalanx, the avant-garde exhibition society and art school Kandinsky helped found in 1900, soon becoming its chairman, and in which Behrens twice exhibited.[16] Yet even as he immersed himself in the Munich art scene, Kandinsky remained in touch with the parallel world of Russian symbolism, in whose sumptuous (and snobbish) journals much of his early art criticism would appear. Two of them were *Mir Iskusstva* [World of Art], published in St. Petersburg (1898–1904) by the group of the same name which included Aleksandr Benois and Sergei Diaghilev, and its successor *Apollon* (1909–1917), a more literary journal that offered poems and essays by symbolists such as Valery Bryusov. Formed by men of Kandinsky's generation, their cultural world, like that of Western symbolists, was resolutely dedicated to high art for a refined public, but their political yearnings for a "new man" who would be the basis for a respiritualized society of the future were much more developed than among their more retiring Western counterparts.[17] However, unlike the Russian futurists who broke with them in the years just before World War I, these symbolists refused to profane their own art with even the semblance of mass-cultural accretions. They insisted upon a respiritualized world built to their own specifications which, whatever else it might contain, would place Art with a capital A at its center.

Interpreters of Kandinsky's painting differ regarding how strongly he was influenced by Jugendstil and how to apportion that influence in relation to Russian symbolism.[18] Yet at least three points in this context seem indisputable. First, Kandinsky in this period did design and create a great deal of decorative art, ranging from appliqué and jewelry to ceramics, furniture, and even dresses for Gabriele Münter. Moreover, this interest in applied art was shared by many of his friends, including those of the Blaue-Reiter period, such as August Macke, Paul Klee, and Franz Marc. Second, like the Russian symbolists, he combined a passion for the respiritualization of society with an equally steadfast commitment to preserving the institution of high art in separation from the applied or decorative arts. Most of their tastes were also his: for the art of Arnold Böcklin, Maurice Maeterlinck, and Wagner; for the Christian, aesthetic,

and erotically infused utopianism of Vladimir Solovev; for expressive rather than documentary readings of reality; for an association of life with movement and history with apocalypse.[19] Finally, in his work with Phalanx he certainly included Jugendstil along with all other new antia-cademic trends in art, whether or not they influenced his own painting. Indeed, everything about his work with Phalanx during its short life (1900–1904) suggests that he sought to strengthen the avant-garde by defining it far more expansively than the influences he admitted into his painting. Its twelve exhibits over three years involved subject matter ranging from the integration of life and dramatic expression in cabaret, to the decorative arts of the Darmstadt Artists' Colony, the lyrical can-vases of the German symbolists, the naturalist paintings of Claude Monet and French neoimpressionism, the graphic arts of Heinrich Wolff, and the humorism of Carl Strathman, whose unique art playfully engaged the boundaries between the high and the decorative.

The name *Phalanx* referred, in its Greek root, to a group of armed infantry and, in its utopian-socialist usage by Charles Fourier, to a har-monious unit of society.[20] Both meanings are suggestive of the sense of social responsibility and commitment to finding a public for avant-garde art that so engaged Kandinsky in the Phalanx years. While his success in these terms was modest at best, he provoked a strong, often hostile reac-tion from journalists, whose own aspirations to becoming the arbiters of public taste were increasing no less rapidly than the skyrocketing circu-lations of the newspapers and magazines for which they wrote. It should not surprise us to learn, then, that Kandinsky's own counterthrust was no less passionate. More important for us, a careful reading of Kandin-sky's early art criticism shows very clearly how he understood the rela-tion of public, criticism, avant-garde art, and the respiritualization of modern society.

Kandinsky wrote at least eight such articles, all for a Russian audi-ence. Five of them appeared in *Apollon* between the fall of 1909 and the end of 1910, a particularly fertile period in the development of his paint-ing and in which he was also engaged in the writing of *On the Spiritual in Art*. The fact that he did so much art criticism in itself testifies to the seriousness with which he took the relation of art to the public. Also notable is the very accessible, often polemical style in which these articles were written.

Already in the first of them, which appeared in a Moscow journal in the spring of 1901, Kandinsky makes abundantly clear how he under-stands the cultural situation in which modern art finds itself.[21] Modern

culture is one of specialists, he writes, except in the area of art, where any "Tom, Dick, or Harry" is allowed to proclaim his views. Lacking any true knowledge of art, these "critics" nonetheless are allowed to perform the crucial mediating role between the artist and the public. Two problems inhere in this situation, which is understood in terms very similar to those we found in Apollinaire. First, the gap in sensitivity and knowledge between the artist and the contemporary public is very wide: "artists devote the greater part of their lives to something that the public patronizes for a couple of hours at leisure." Moreover, while the lives of most artists remain integral, the life of the public, divided as it is between working for a living and "leisure," has become "alien to art." The inevitable misunderstanding between public and artists runs deep, not only because the public is uninformed about art but also because its mode of life partakes of the materialism and utilitarian rationalism that inheres in urban industrialism. Second, critics are themselves part of this alien mode of life. Their writing need not be truly informed because it is aimed at introducing "diversity and excitement" into the life of the public, at providing entertainment. The operative principle of newspapers, Kandinsky would observe in *On the Spiritual in Art,* is simply one of "giving the people what they want."[22] Art critics need only write what the public wants to hear, "reproducing what they term the 'loud exclamations of the public' in the press." Instead of a cultural world in which communication runs from artist to critic to public, we have one with the direction reversed, or perhaps one in which there are two conversations, a false one between critic and public and a true one between artist and public that is rarely able to take place.

Kandinsky, then, is explicit from the beginning that the cultural situation for modern art is one driven by commodification. Art shows, he writes in *Apollon,* have become "covered markets" in which critics and the public together search out the "big hits."[23] The public descends upon these markets "like autumn mosquitoes, avidly reading the catalogue and casting an occasional glance at the pictures." Most of them will therefore fail to understand and, feeling themselves the objects of a hoax, will "jab the pictures with their fingers . . . [and] employ the most forceful and impolite expressions; some even . . . spit."[24] Even when the reception is not so angry, when, as Kandinsky puts it in *On the Spiritual in Art,* "the great masses wander through the rooms [and] find the canvases 'nice' or 'great,'" the atmosphere may have negative consequences for the artist. Feeling denigrated, he or she will be tempted to join in this new "evil, purposeless game" and to pursue "the satisfaction of his own

ambition and greed."[25] Public, critics, and artists will then be united in conversation—to the great loss of art.

In the present materialist world, only a small fraction of the public is able to sense what the artist knows in every fiber of his being: that viewers properly appreciate art only when they approach it intuitively, opening themselves to a direct experience with the artist's interiority as translated into form.[26] It was Kandinsky's insistence upon this point that moved him, like Apollinaire, beyond the more Enlightenment-oriented criticism of Baudelaire. Yet artists cannot expect the public to approach art in this intuitive fashion. Kandinsky is strongly democratic in his sense of the public for art: "there is no man who cannot receive art. Every work of art and every one of the individual means belonging to that work produces in every man without exception a vibration that is at bottom identical to that of the artist."[27] His confidence is based on his sense that the nature of art and an appreciation for it are instinctive, as children's art, folk art, and "primitive" art remind us. Yet in the current materialist environment, and with the interference that the journalistic critics represent, the only hope is for artists themselves to take the lead in educating the public through a critical discourse that supplements their art. Unlike that of the journalists, this discourse should not be based on the false premise that the public appreciates art when it possesses "knowledge" about it. Rather the artists' discourse will be a kind of antidiscourse which lulls the viewer back into a spiritual mind-set that allows the "vibrations" from artist to viewer to be transmitted.[28] "Art is spiritual bread. The artist-chef has to 'understand it,' but the 'public' should bare their souls to it and apprehend it."[29] Such is the fundamental teaching of Kandinsky's religion of art, in which the aesthetic caste has been widened, in modernist fashion, to include everyone.

ON THE SPIRITUAL IN ART

The premises about art that implicitly underlie Kandinsky's art criticism are developed in *On the Spiritual in Art,* which appeared at the end of 1911. Here the work of art takes on a dual character, as both an act of creation and of communication ("every individual artist has his own message to communicate").[30] Or, perhaps better put, the work of art is an act of creation mediating a stream of communication from the world to the spectator. The image that emerges from Kandinsky's text is of an artist in a world that is both material and spiritual. The world has external objects that have internal sounds.[31] It has also more purely spiritual

things like colors. The artist, in turn, has internal psychic dispositions, background experiences, a level of maturity, a culture including in the modern world a nationality, and so forth. Like all other human beings, the artist is striving for a harmonious relationship with the world. What distinguishes the artist is just that the work through which he or she pursues this harmony is art. The artist hears, feels, sees, touches, smells— experiences—the world, mixing his or her sense of it with internal states to produce external forms. These forms may appear like objects in the world or they may not. That is up to the artist, although at this point Kandinsky still expresses some reservations about a completely non-representational art.[32] In 1913, he will sketch a set of historical stages corresponding to the move away from representationalism.[33] Whatever the forms deployed, however, the foundation of the work of art lies in a communication from the world to the artist, who then responds by translating inner "content" into external "form," an act of externalization that allows a further communication with the spectator. The spectator's reception is possible because he or she has the same internal spirit as the artist and the world. In short, the world sounds, the artist creates in relation to that sound, and the spectator understands by virtue of the vibrations coming to him from artist and world.[34]

However, as we have seen, this communication process will be corrupted in a materialistic world operating according to what Kandinsky now calls the principle of "external necessity," that is, of "ambition and greed."[35] External necessity governs the production of art in commodified societies, where value is reduced to what sells the most or garners the greatest critical acclaim, that is, to exchange value. All modernists reject the notion that value can be reduced to exchange value. Kandinsky's distinctive merit is to have articulated a modernist alternative for determining value that does not simply substitute the whim of the artist for the tyranny of the box office. This modernist standard of judgment is what Kandinsky calls "internal necessity." In his first published reference to internal necessity, Kandinsky articulated it as a critical standard in the following terms: "In art, form is invariably determined by content. And only that form is correct which expresses, materializes its corresponding content. . . . Thus, only its author can fully assess the caliber of a work of art; only he is capable of seeing whether and to what extent the form he has devised corresponds to that content which imperiously demands embodiment. The greater or lesser degree of this correspondence is the criterion by which the 'beauty' of the work of art may be judged. . . . Thus in essence, the form of a work of art is determined

according to internal necessity."[36] Yet, in *On the Spiritual in Art,* the concept of internal necessity as a standard for judging art is embedded in a larger discussion in which it plays at least two other key roles. To grasp how internal necessity operates as a counter to exchange value, we must reconstruct this wider context.

In the first place, internal necessity offers Kandinsky a way of understanding the genesis and composition of a work of art. The genesis of every true work of art can be accounted for in terms of three levels of "spirit." Such works express the creative personality of the artist or individual spirit; the spirit of the age and the particular nation in which the artist lives; and, finally, spirit as a whole—"the pure and eternally artistic, which pervades every individual, every people, every age."[37] All genuine art will be based on the first two sorts of spirit, while the last will be present in every "great" work of art. Yet, how exactly can even an artist know if his art truly responds to spirit, that is, if "the form he has devised corresponds to that content which imperiously demands embodiment"? The answer lies in a careful reading of the art work, which will show whether its pictorial elements such as color, line, and other forms are a true reflection of internal necessity. For Kandinsky, such elements each have an objective "inner value" which gives them a unique "sound." This value, or sound, is an internal necessity that remains fixed so long as the element is used by itself. A color, for example radiates enormous psychic power, which is why the artist can use it to influence the soul of the viewer in a certain way. As such, the particular color has an internal necessity: it necessarily radiates this kind of emotional charge rather than that one. Likewise, every form "says something" intrinsically. The true artist will not even have to choose form. Forms, he tells us in his 1913 autobiography, arrive "of their own accord."[38] The artist simply learns to guide their arrival in such a way that they "sound" like the effect he or she seeks to achieve. As elements of color and form are combined, however, each interacts with the others in a dynamic way. Resulting tensions must be patiently coordinated so that an overall composition that harmonizes is reached. It is in this coordination of elements that the creativity of the artist is above all expressed. For the composition that is "free from the accidental" will not be easy to achieve. It will lack the "unfounded willfulness" of a "meaningless formal game" that those who are "deaf to the inner sound of form" will see in it. But this means it will embody a "founded willfulness"—a communication of the artist's inner content in terms of external form that is internally necessary. It will be a system of harmonized internal necessities.[39]

From the internal necessities of color, form, and their interrelations in composition, Kandinsky argues that a "grammar of painting" should ultimately be attainable, although he does not claim to have it as yet. What is certain is only that the laws by which such a grammar operates will not be physical or external but internal and, as such, a set of relations with which artists work that nonetheless leaves them free. The grammar of art does not control what art is any more than the grammar of a spoken and written language controls what poetry is. It is simply, to use a phrase from J. W. Goethe of which Kandinsky was very fond, a "knowledge of the thorough bass [which] in painting . . . has been missing for a long time."[40]

Kandinsky argues that, even without a full knowledge of art's grammar, the internal necessities of artistic composition can be grasped well enough to be able to differentiate works that are based entirely on internal necessity from those that are not. Moreover, he claims that any artist can know this about his or her own work. Here we arrive at the second aspect of internal necessity, its role as a standard of judging art. Consider, for example, Kandinsky's appraisal of Henri Matisse: "Guided by his purely personal qualities, with his particularly French chromatic gift, Matisse stresses and exaggerates color. Like Debussy, he is unable to free himself for long from conventional beauty: impressionism is in his blood. And so with Matisse, among pictures possessing great inner life, one finds other pictures that, owing their origin principally to external causes, to external stimuli (how often this makes one think of Manet!), possess principally or exclusively a merely external life."[41] Guided by his individual spirit as well as by his Frenchness, Matisse sometimes produces an art based on internal necessity. In other cases, however, he allows his fondness for impressionism to exert an "external" influence upon him in the sense that he is composing on the basis of nostalgia and convention rather than following the dictates of internal necessity. Pablo Picasso, says Kandinsky, "never succumbs to this kind of [external] beauty." However, while he is "led on always by the need for self-expression," the cubist style at which he has arrived is in its own way too "external" because it "seeks to achieve the constructive element through numerical relations" and "physical laws" rather than "the laws of internal necessity, which may . . . be described as spiritual."[42]

It is worth noticing here that an art based on internal necessity is no less (and no more) sensual than one based on external necessity. Kandinsky is careful to distinguish between the question of how sensuous art is and the conditions under which art becomes a commodity. The idea that

making art obey internal dictates might render it less sensual never crosses his mind. Indeed, the Matisse example suggests that his "exaggeration of color" derives from his personal qualities and his Frenchness, that is, from the two primary sources of internal necessity rather than from his devotion to impressionism.

Just as artists and their works can be judged by the standard of internal necessity, so too can spectators. Materialistic cultures produce a spectator who is "all too often accustomed to seeking a 'meaning,' . . . who is unable simply to relate to the picture . . . , to experience for himself the inner life of the picture, to let the picture affect him directly." "Connoisseurs," he adds, are particularly prone to these tendencies. "Dazzled by external devices," they forget that "the beautiful is that which is inwardly beautiful." Indeed, according to Kandinsky, art created in accordance with internal necessity is not only beautiful but moral ("all means are moral if they are internally necessary"). Unlike Baudelaire, Kandinsky holds that there is no immoral art which is also aesthetically good, and when he speaks of "what is right artistically," we must understand him in both aesthetic and moral terms. From the spectator's point of view, to follow internal necessity is to seek to intuit the psychic and spiritual content behind the visible form, a content which seems to be something like the objectification of Arthur Schopenhauer's notion of will as the deepest (noumenal) reality.[43] External necessity engages phenomena; only an art based on internal necessity can find the essential or absolute within objectified will.

The third aspect of internal necessity for Kandinsky, and perhaps the most interesting, is its historical dynamism. Although he understands internal necessity as an "ineluctable will for expression of the objective," this force "requires from the subjective today one general form, tomorrow another." Art is always changing, as the artists themselves and their social circumstances change. Kandinsky's modernist faith is that this movement is a "forward" one, although he puts the word in quotes. But whether or not the progress of spirit is truly forward is less important than the implication that "today's inner laws of harmony are tomorrow's external laws, which in their further application continue to have life only by virtue of this same necessity, which has become externalized."[44] It follows that what is traditional or conventional can never be internally necessary today, even though it once may have been. Consider again Matisse. In its own day, impressionism may well have been an art based on internal necessity. But, having now become conventional, it will become an external force when Matisse deploys it.

It is this historical dynamism in Kandinsky's concept of internal necessity that marks perhaps his most decisive advance over nineteenth-century efforts to develop intrinsic standards for art, such as Ruskin's "truth to nature" and "truth to materials." Ruskin's standards share with Kandinsky's a qualitative and aesthetic character, but in their unalloyed objectivism they remain a static benchmark without any means for recognizing, and taking into account, those changing historical circumstances that affect artistic creation. The brilliance of Kandinsky's formulation is that it is able to incorporate this flexibility while also building in an objectivist "truth to nature" criterion at the level of the primary elements of artistic form.

This point also needs to be recognized by those who would accuse Kandinsky of being conservative, or "rear-guard."[45] Kandinsky often expresses a fondness for the art of the past. He writes, for example, that "it is perhaps with envy, or with a sad feeling of sympathy, that we listen to the works of Mozart. They create a welcome pause amidst the storms of our inner life." Yet precisely because Mozart's cultural world is no longer ours, a composer who wrote in Mozart's style today would be creating a merely external art. Indeed, thinking about his own age, Kandinsky writes memorably: "Clashing discords, loss of equilibrium, 'principles' overthrown, unexpected drumbeats, great questionings, apparently purposeless strivings, stress and longing (apparently torn apart), chains and fetters broken (which had united many), opposites and contradictions—this is our harmony."[46] In Mozart's day, harmony may have implied the harmonious; today it necessarily involves dissonance. While we can still appreciate Mozart's art, it can no longer be ours because our society is no longer his. Likewise, the art of today will not be that of tomorrow.

Adorno may well be justified in maintaining that Kandinsky rationalizes his approach to art, and his concept of internal necessity with its Schopenhauerian resonances would seem to be exhibit A for such a claim. Moreover, Adorno may also be correct to suggest that, in pursuing a respiritualized art based on internal necessity, Kandinsky condemns art to a perpetual quest for "the new." Yet despite the superficial similarity of this outcome with the world of commodities and fashion, avant-garde art for Kandinsky evolves neither because, like the commodity, it drifts aimlessly without a sense for the permanence of the needs to which it responds, nor because it is obeying some rationally self-conscious program, but because of its very rootedness, as a conjunction of internally necessary elements, in the concrete conditions of a particular age. Indeed,

we will soon see how, with Blaue Reiter, he is able to connect avant-garde art with tradition in a dynamic way that avoids the opposite pitfalls of rationalism and blind conservatism.

Even if Kandinsky is able to decouple avant-garde art from the commodity form, however, the problem of widening the audience for it remains acute. Kandinsky concedes that a modernist art with its inevitable commitment to dissonance, as well as with its movement toward abstraction, does imply an increasing level of "difficulty." And while he sometimes suggests that the public will rise to the occasion by developing a "greater and more refined sensitivity," at other times he opines that "man is generally not willing to plumb the depths, but prefers to remain on the surface, because this demands less effort."[47] In the final analysis, Kandinsky's quest for an avant-garde art with an audience sufficiently large to justify his hope that it will respiritualize humanity depends on two further points. One is simply his faith that after the materialistic epoch of the nineteenth century that continues to his own day will come "the epoch of the great spiritual," the phrase with which *On the Spiritual in Art* concludes.[48] The other is his willingness to expend effort to create the avant-garde that can educate the public to this end.

DER BLAUE REITER

In the spring of 1911, Carl Vinnen published a virulent xenophobic manifesto against the German art establishment.[49] Provoked by the Kunsthalle Bremen's recent purchase of a Van Gogh, Vinnen took aim generally at the activities of German museum directors, as well as the critics he thought were allied with them, all of whom he supposed to be ignoring German creativity because of the exaggerated fashion for recent French painting. Although such views were not uncommon in the chauvinistic atmosphere prevailing then in Germany, Vinnen's attack was distinguished by the fact that he was himself a painter associated with the Worpswede artist colony north of Bremen that had been dedicated for two decades to a German regionalist art based on romantic and sentimental landscapes.[50] As such, his manifesto quickly became notorious and provoked an immediate response from Kandinsky and Marc, who were, at just this point, beginning to think through the avant-garde project that would become known as the Blaue Reiter.

The origins of the two art exhibitions and the almanac associated with Blaue Reiter are usually treated in relation to the rift in the Neue Künstler-Vereinigung München, an avant-garde exhibition society founded by

Kandinsky and friends in early 1909.[51] Certainly that rift, which may have had some nationalistic overtones of its own, provided the immediate stimulus to the creation of Blaue Reiter.[52] Yet it took place nearly six months after plans for Blaue Reiter were under way, and the more fundamental source for the latter project was undoubtedly the Vinnen affair. It is notable, in this regard, that the almanac was dedicated to Hugo von Tschudi, a civil servant whose befriending of avant-garde modernists in Germany had cost him his job as director of the National Gallery in Berlin in 1909 and who had then died in the fall of 1911.[53] But well before the almanac itself, which appeared in May 1912, Vinnen had been answered by a volume entitled *The Battle for Art,* which contained the responses of some seventy-five gallery directors, writers, art dealers, and artists, including both Kandinsky and Marc.[54]

Not least among the anxieties that had provoked Vinnen was the declining appeal of Worpswede art on the German market, against which he thought that a policy of nationalist protectionism was warranted. Although he conceded that French impressionist and postimpressionist art had helped to reinvigorate German artists, he argued that critics and museum directors had made of French avant-garde art a fashion having no relation to real merit. Moreover, he argued that German art should be promoted because it was necessarily grounded in the native folkways it celebrated and would help to preserve. Interestingly, however, several of the more prominent writers who answered Vinnen—including Wilhelm Worringer, Artur Moeller van den Bruck, Karl Ernst Osthaus, and Wilhelm Niemeyer—were also associated, here and elsewhere, with nationalist arguments privileging German art. They agreed with Vinnen that a vital art was rooted in national folkways, that such folkways deserved preservation, and that the folkways underlying German art were deeper spiritually than those of many other nations. Where they differed with him was in their more modernist taste, as well as in their belief that, if German artists wanted greater critical acclaim, then they would have to create better art.

Kandinsky's reply to Vinnen could easily have assumed similar form. We have seen that he associated a moment inherent in every true work of art with the spirit of the age and the particular nation in which the artist lived. This aspect of internal necessity led him to declare straightforwardly in the almanac that just "as every individual artist has to express himself, so each people has to express itself, including the people to which the artist belongs. This connection is reflected in the form and is described as the national element."[55] The almanac assembled some 140

works of art, many of which illustrated the folkways of a wide variety of peoples—most richly those of Bavaria (through glass and mirror paintings) and Russia (through prints), but also of China, Japan, the South Pacific, Malaya, Egypt, sub-Saharan Africa, Brazil, Mexico, and Alaska. We also have abundant evidence of the significance of Russian folk art and folk-cultural traditions for Kandinsky, who would refer to them in his 1913 autobiography as his spiritual "tuning fork."[56] We even have some evidence that his feelings for Russia led him into pan-Slavist sympathies in the heady atmosphere just prior to World War I.[57]

While Vinnen and Kandinsky certainly had sharply different political sensibilities, they shared a sensitivity to the national and folk-cultural basis of artistic creation. Like Vinnen, Kandinsky believed that the materialism brought on by commercial and industrial modernization had undercut aesthetic experience such that a renewal of national cultures was necessary to get artists and audiences back in touch with their own spiritual natures. Moreover, that shared sensitivity led them to other shared commitments that have been insufficiently appreciated. Vinnen's main target was the new world of journalists and critics, which he blamed for turning art into mere fashion. Although this may have been a "typical populist charge against modernism," as one historian has called it, it is the same sort of charge that dominates Kandinsky's early articles.[58] Clearly, Vinnen, Kandinsky, and many other artists—modernist and antimodernist alike, and of all political persuasions—were deeply concerned with the consequences for art that flowed from the commodification of culture and the institutions associated with it. In contrast to the forces of commodification, they saw the nation as a source of the spirituality of art and, in that sense, as a source of cultural regeneration. They believed that cultural regeneration would be possible only if the environment for art's reception could somehow be decoupled from commodifying institutions and respiritualized. In short, the idea of the nation as a carrier of cultural regeneration was not simply a critical weapon against modernism but was bound up in complex ways with modernism itself.

None of this changes the fact that Kandinsky would have judged Vinnen's own art to be hopelessly "external." What is remarkable, however, is that, in his reply, Kandinsky did not refer to Vinnen, to his art, or even, directly, to the question of nationality and art. Set forth in numerous short paragraphs with a complex set of parallelisms and pervaded by deductive logic, Kandinsky's reply summarized his view of the relation of external and internal forces in the world and in human creation, under-

lined the historical dynamism that comes through new artistry and new cultural epochs, and then prophesied about the new spiritual era the world was entering, declaring in conclusion that "every contemporary artist must inevitably make his creation conform to this necessity."[59] It is as if he was saying that the best answer to Vinnen is the inexorable historical movement toward the "epoch of the great spiritual."

Interpretations of Kandinsky's text must remain uncertain, given its laconic and somewhat enigmatic quality. Caution may have played a role in it. As a foreign national living in Germany, Kandinsky faced pressures not unlike those of Apollinaire in France, and it is understandable that he might have preferred not to engage directly with German chauvinists. Yet, his emphasis on the external-internal dichotomy makes perfect sense as the basis for a reply to Vinnen. Like his art, Vinnen's nationalism was external in at least three senses: in its simple return to the traditional and conventional as a basis for culture, in its privileging of a particular national tradition, and in its demand that government act top-down with a policy of protectionism to ensure the conditions for its development. For Kandinsky, in contrast, each national tradition plays an important cultural role as part of the second moment of internal necessity, but each is also participating in a larger spirit of human creativity that is universal—what Kandinsky called "the pure and eternally artistic."[60] Universalism without rootedness in local conditions of time and space would be false, and this may well represent a danger lurking in the new manufactured cultures of entertainment. But nationally based creation without a sense for the universal elements of culture is also false. Kandinsky's approach to culture stresses the local basis of genuine artistic creation, but in a dynamic way that does not merely reproduce tradition and convention. Likewise, the fact that genuine cultural creation requires a local basis—*Sittlichkeit,* or "ethical life" in the Hegelian sense—in no way privileges any particular such context. Finally, Kandinsky conceived national cultural creation in a bottom-up way that linked it closely with the first moment of creation, that of individual artistry. His interest in the nation had to do with the beauty of Moscow at sunset, not with any desire for protectionist policies from governments.

These concerns about nationality as a basis for culture and in relation to the art market reappear in the organization and spirit of Blaue Reiter, especially in the almanac. Yet it would be wrong to think of Blaue Reiter as merely a reactive enterprise. To understand its character, we must distinguish a number of its aims and aspects. When Kandinsky himself looked back upon the almanac in 1930, he recalled his "desire to compile

a book ... to which exclusively artists should contribute as authors."[61] The need to separate the critical enterprise from critics and return it to artists themselves was, as we have seen, a central notion in Kandinsky's avant-garde practice from the beginning. The fundamental basis of the concept of internal necessity lay precisely in this idea that only artists can fully understand, interpret, and assess the value of works of art. In the almanac, this idea is expressed through a quotation from Delacroix, which is given its own page: "Most writing on art is by people who are not artists; thus all the misconceptions."[62] And, it is reflected in the actual contributors, only one of whom—Roger Allard—was a critic (as well as a poet and writer) by profession.

Closely associated in Kandinsky's mind with the return of artists to the center of the critical dialogue on culture was the idea of an interarts dialogue, above all between painters and composers. During the latter half of 1911, Kandinsky was indefatigable in his pursuit of a Blaue-Reiter contribution from Arnold Schoenberg.[63] In the end, not only did he succeed, but he managed to garner three other articles on music (from a total of eight that the original plan for the volume had called for). For Kandinsky, the separation of the arts was mutually "harmful," not only from the point of view of each art's development but, perhaps even more importantly, because of the need for the arts to contribute together to a regeneration of culture.[64] Here his largest hope was for the development of forms of artistic synthesis, or *Gesamtkunstwerke,* and his own contributions to the almanac reflected that ideal not only in their variety—critical essays, reproductions of paintings, and a work of theater—but in the character of the latter work, "The Yellow Sound," which he termed a "stage composition" and which integrated drama with painting as well as with a musical score by Thomas von Hartmann.

Kandinsky also associated the cultural regeneration that Blaue Reiter might advance with a broadening of the notion of painting from works produced by professional painters to works of children's art, folk art, and paintings by other sorts of artists (his interest in Schoenberg's painting stemmed from this source). Blaue Reiter was to demonstrate that works created by professional painters, as well as by other creative artists, were not narrow technical exercises but the leading edge of the creative human spirit advancing as a whole. At the same time, for reasons already indicated, Kandinsky did not want in any way to compromise the integrity of the role of the individual artist in this advance. Individual artists producing their own avant-garde works in accord with internal necessity would always remain the centerpiece of his conception

of art and culture. Moreover, just as he always opposed notions of cultural reorganization in which the integrity of the individual artist might be lost, so too he rejected any notion of Blaue Reiter as a collective movement or "school" imposing an identity on its members. Movements were "justified" and even "essential," but "complete freedom" for the individual artist was their most fundamental requirement.[65]

Kandinsky's attitude in this respect follows directly from his concept of internal necessity: commitments to a collectivist orientation would threaten to render external the work of individual creators. This is why, as one historian has aptly put it, Blaue Reiter "was never a movement nor, strictly speaking, an exhibiting society" but only "a fraternity of artists sharing a common ideal."[66] Yet Kandinsky's attitude almost certainly derived as well from his acquaintance with Marinetti's futurists, whose art show opened at Herwarth Walden's Tiergartenstrasse Gallery in Berlin within a few days of the almanac's appearance in Munich. Fast emerging as the very embodiment of avant-garde art merged with entertainment values, Marinetti's futurism would certainly have been anathema to Kandinsky.[67] We know, for example, how his friendship with the Russian artist David Burliuk, who wrote an essay on Russian avant-garde for the almanac, rapidly deteriorated after Burliuk and Vladimir Mayakovsky published the first important manifesto of Russian futurism, "A Slap in the Face of Public Taste," at the end of 1912. Its irreverent style, as announced by the title, drew the following public reaction from Kandinsky: "I have the greatest sympathy for all honest and creative experiments, and I am even ready to excuse some rashness and immaturity in young authors. . . . Under no circumstances, however, do I go along with the tone in which the prospect is written and I categorically condemn this tone, whoever the author may be."[68] Of course, his appraisal was not sweetened by the fact that Burliuk had included some of Kandinsky's poems in the book without his knowledge or consent.

Yet Kandinsky's objection was not simply to the raucous and ribald quality of futurist manifestos but to the very idea of a manifesto. In his 1913 "Reminiscences," he noted that both the almanac and *On the Spiritual in Art* had been "misunderstood" as "manifestos," but that nothing had been "further from my mind." The "principal aim" of both of them, he added, had been "to conjure up in people who still did not possess it this rewarding talent . . . , this capacity for experiencing the spiritual in material and in abstract phenomena, which will be indispensable in the future." The aim of the almanac is not to entertain or amuse but to educate: to educate not through an "appeal to the understanding, to

reason" but by stimulating the capacity for experiencing the spiritual vibrations of art.[69] A future spiritual age was surely coming, but Kandinsky was unwilling to settle for the comforts of a blind determinism. He saw "art-understanding" as an "evil" against which artists had to fight back.[70] He wanted to advance the public through the pedagogical program which, as he had long felt, reflected art as artists rather than critics understood it. Accordingly, the almanac seeks to show its readers what art is rather than telling them how to experience it.

An important part of this showing, as has been emphasized, turns on the relation of the national and universal elements in art. The almanac shows this relation to be dialectical: artists from a remarkable variety of national backgrounds and epochs have produced works that, enabled in large measure by those particularities, nonetheless speak with a common voice about the human spiritual condition. Thus, while any severing of art from its roots in artisanship and in its sustenance by local traditions would be to deprive it of life, those connections must be appreciated as dynamic ones that imply both the continual renewal of art and a renewal in which no single national tradition, or set of such traditions, is privileged over others. For Kandinsky, the Russian tradition held pride of place, and the Russianness of the almanac is not uncommonly noted, but the book is nonetheless a celebration of the common aims and ideals of a variety of nationalities, ancient and modern, Western and non-Western, and it never offers the slightest hint of any exclusionist spirit. Similarly, while it may be fair to characterize Blaue Reiter as "a battle to be waged in defense of a cultural legacy," its objective is not a return to the past.[71] The almanac offers a number of illustrations of what might be best described as artifacts as well as a number of works of art. They share the fact that they are not commodities, but they are "non-commodities" in different ways. Artifacts are defined by their production as objects for use rather than sale, while works of art are produced in accord with the principle of internal necessity, even if the artist has an eye toward sale. Nothing in the almanac suggests a return to a world of preindustrial artifacts. Rather its aim is a world respiritualized by the widening reception for works of art. In such a world, art would be genuine, hence decommodified, but nowhere does Kandinsky call for decommodifying the world. He may sometimes have hoped for such an outcome, but he did not actively seek it.

This point brings us to the charge sometimes made about Kandinsky and Blaue Reiter that their primary motive was commercial gain, a motive disguised beneath a rhetoric of love of art.[72] That Kandinsky was

attuned to the need to sell paintings as well as to promote himself and his endeavors with commercial acumen is incontrovertible. As is well known, he sought out appropriate editors and art promoters, such as Reinhard Piper and Herwarth Walden, who, in turn, offered the almanac in deluxe as well as regular editions, promoted it and the related exhibitions with a press release composed by Kandinsky, and pursued any avenue they could think of that might produce success, commercial as well as artistic. Yet, if this point is incontrovertible, it is also unremarkable. For reasons we have considered that have nothing to do with making money, Kandinsky sought to attract a mass audience around which a democratic culture might be built. In the modern world, attracting mass audiences for culture means doing so by producing for a market, yet Kandinsky was unwilling to cede to the masses or the critics the authority to judge value. He wanted to be popular and hence "to sell," but he never connected the value of his art or any other art with whether its popularity was great or its selling successful. Indeed, the argument that Kandinsky was driven primarily by externalities such as "ambition and greed" makes little sense, even from the point of view of his own material self-interest. Because he did truly love art and committed his life to it, as anyone who studies his life can easily see, it was hardly in his self-interest to allow the critical standard for art to become market-based.

Indeed, it is not too much to say that just as internal necessity was his standard for the creation of art, so too was it the fundamental principle underlying his avant-gardism. Kandinsky hoped for a large audience for avant-garde art, but he refused to pursue it by catering to it, dumbing art down, or otherwise breaking with internal necessity as a standard. For the same reason, he refused the futurist gesture, defended the traditional role of the individual painter, and embraced a complex outlook that we might call nationalist universalism. Above all, he believed that Blaue Reiter had shown how avant-garde art could remain true to the demands of internal necessity while also reconnecting with cultural traditions and stimulating an aesthetic sensibility within a mass public living in a commodified world.

Yet Kandinsky never intended to end the collaboration of Blaue Reiter after the publication of just a single almanac. While World War I intervened to prevent its continuation, his ideas for a second volume had been undergoing rapid development in the two years between the appearance of the first one and the outbreak of the conflict. Discussions between Kandinsky and Marc involved many new ideas for widening the group of participants and for new themes. Among the latter were some

surprises. In one letter, Kandinsky raised the possibility of including illustrations of "old business posters and advertising signs, among which could be paintings from booths at fairs. I'd like to reach the limits of kitsch (or even overstep them)."[73] At the same time, allied projects were discussed, including a Bible in which Kandinsky, Marc, Klee, and others would each illustrate one of the Old Testament books.[74] In 1914, the group also became involved with the Munich Künstlertheater, whose animating spirit was the dadaist-to-be Hugo Ball.[75] Their project, which included a book on theater as well as *Gesamtkunstwerk* productions, went unrealized until some of the latter were staged in wartime Zurich, by which time Marc had perished and Kandinsky had fled to Russia.

These years also saw dramatic developments in Kandinsky's conception of art. He tells us in his 1913 autobiography that he had only then come "to experience . . . the province of art and the province of nature . . . as completely independent realms."[76] The discovery led him to develop the concept of "pure art" in a new way—not simply to refer to art based on internal necessity, as it had in 1911, but to refer to an art of construction in which all traces of nature are eliminated.[77] These ideas and their implications were further articulated in a January 1914 lecture prepared for a gathering in Cologne but never delivered. In the lecture, which was Kandinsky's last piece of serious writing before the outbreak of the war, the new separation of art from nature seemed to throw into doubt some aspects of the compositional elements of internal necessity, such as the "objective element which could justify the [choice of] colors." Certainly he did say that he had "wrongly" conceived of color, since he had neglected to consider how "the innate, inner character of a color can be redefined *ad infinitum* by its different uses." However, he backed away from any implication that his faith in internal necessity as an objective criterion for art had been shaken, continuing to insist that "form . . . must . . . enter into the work of art of its own accord." Indeed, the essay closes with a stirring reaffirmation that the artist must "obey that categorically imperative voice, which is the voice of the Lord, before whom he must humble himself and whose servant he is."[78]

The Cologne lecture did not explore the implications of Kandinsky's aesthetic reformulations for avant-garde practice and, generally, for the relation of art to the public. But there is no reason to think that they would have led Kandinsky to alter his approach. For art to communicate between artist and public, it would not seem to matter whether the content of the message is something objective or something that the artist simply develops, through his own godlike creativity, and then transmits

from one human being to another. What ultimately forces Kandinsky to amend, if not to alter, his concepts of avant-gardism and art as communication are changes in the external political world. Yet we might note that these changes did not entirely hinge on World War I but were anticipated already in 1914 in another Cologne gathering—one that, in contrast to Kandinsky's lecture, actually did take place. This was the Werkbund's convention of early July, which featured a spirited debate between those whose concepts of art and industrial design continued to privilege the creativity of the individual artist and those who stressed the need to raise the general level of artistic quality within industry, even if that meant "standardization" and a new, more collective role for the artist.[79] It was a debate that Kandinsky never participated in, perhaps never even knew about, but that would affect his life immensely over the next decade.

MOSCOW AND WEIMAR, IZO AND BAUHAUS

Amid the growing international tensions, Kandinsky had been plotting the logistics of how he might return to Russia, if necessary, since late 1912, but in July 1914, as his departure began to appear imminent, he allowed himself to express his feelings about the prospect. "Since last winter I have experienced a strange, never-waning longing for Moscow," he wrote to the peace activist Erich Gutkind. "Moscow is the soil out of which I derive my strength and where I can live inwardly in the way my work requires."[80] Yet little about the Moscow to which he returned, or the larger European world in which it was situated, would turn out as he imagined. The war would sweep away the Romanov dynasty, as it would the Habsburgs, the Hohenzollerns, and (very soon thereafter) the Ottomans, as well as the hierarchical cultural world they all represented. It would give birth to the Russian Revolution and, with it, a context for Kandinsky's avant-gardism completely different from any he might have foreseen in the Blaue Reiter years. Not surprisingly, as Kandinsky scrambled to adapt to the fast-changing circumstances, he produced little art—not a single oil painting, for example, in the year and a half after the October Revolution.

While subsequent chapters will deal in a fuller way with the consequences of the war for avant-garde modernism, a few remarks here will help set the context specifically for Kandinsky. First of all, the kind of international travel, communication, and collaboration that had made possible a project like Blaue Reiter were now impossible. Kandinsky was able to travel to a neutral country like Sweden for a few months of 1916,

but otherwise he was confined to Russia, just as other artists were mostly confined to their countries. Correspondence was very difficult, as it had to go via neutral countries. Second, the passions of wartime also tended to turn intellectual and cultural life inward and to provoke reactions against prewar avant-gardism, its utopian spirit, and the notion of the artist as a spiritually inspired, individual creator—all seen as part of the cultural chaos out of which the war had emerged rather than any remedy for it. These reactions took a variety of forms, from nationalist and classicist "return-to-order" sentiments on the right, to the destructive "anti-art" poses of the dadaists on the left, who sought to galvanize a public by drawing upon images from the mass media and by thinking of themselves as engaged in utilitarian activity without special knowledge or materials. Third, the world came to appear more and more as a stage upon which only large-scale forces played—armies in battle and the destruction and disease they spawned; emerging political movements such as communism and, soon thereafter, fascism; giant industrial firms and the technological developments for which they and their government allies were responsible. In such an environment, not only did the projects of individual artists and small avant-garde groups seem hopelessly out of scale, but the very idea of art as a sphere separate from society, and thereby functioning independently from the need to reconstruct all of life aesthetically, appeared outmoded. As a postwar world finally began to emerge at the end of 1918, avant-garde groups tended either to ally themselves with larger political movements or to refashion themselves in more utilitarian ways as artistic styles which might serve industry and government in the rebuilding of a postwar world.

This sense of a shifted life scale, and a need to reconstruct modern culture as a whole in its terms, endured far beyond the war itself. Kandinsky would never again launch a self-sufficient avant-garde modernist enterprise like Blaue Reiter, and although he would continue to create his own individual art, his avant-garde quest for a spiritually reinvigorated culture based on avant-garde art would be carried out entirely as a participant in new formal institutions: the Svomas (later Vkhutemas) art school, the Museum for Artistic Culture, Inkhuk (Institute of Artistic Culture), and RAKhN (Russian Academy of the Science of Art) in Moscow; and the Staatliches Bauhaus in Weimar, Dessau, and Berlin.

Already in 1916, Kandinsky seems to have sensed something of these emerging developments. In a draft for a brochure published in connection with a Gabriele Münter show in Stockholm, he expressed some sentiments that were strikingly continuous with his prewar outlook.

Münter's talent, he wrote, "is of a pronouncedly national character—an unmistakable sign of individuality, personality, i.e. artistic, creative personality." He further characterized her as "among those rare artists" who deserve to be thought of as "creative" respondents to internal necessity rather than mere "virtuosi" whose art remains "external."[81] Yet, in the published brochure, all references to Münter herself were dropped, and the distinction between creative and virtuoso artists was developed in far greater detail than he ever had before.[82] What is most striking about this discussion is the extraordinary praise heaped upon virtuosi— they have "brilliant, versatile talent that is extremely sensitive to every impression, reacts very strongly to everything beautiful, and with the greatest skill and ease develops in many directions"—despite the fact that their "art" belongs entirely to the "material world" and shows neither "inner development" nor "spiritual content." Such virtuosi, who do copies of great works as well as every sort of applied art, form "schools" and, in general, practice their art in ways Kandinsky found inimical. Yet they were treated here as worthy of the honored title of artist, and the implication that derives from their prominence in the discussion is that they will play an increasingly important role in the modern world of art. In short, we are very close to the suggestion that for creative artists to survive in this world, they will need to work closely with their counterparts among the virtuosi.

Kandinsky's varied activities in the early Soviet art world are well known and need only brief summary here.[83] Narkompros, the government agency responsible for the arts, had a number of subsections, including Visual Arts (IZO) and Theater and Music, which together involved most of Russia's modernist avant-garde. Kandinsky was initially associated with the latter, then moved to IZO, where he taught in its art school, Svomas, beginning in 1918. He also edited IZO's successive newsletters, *Iskusstvo* [Art] and *Khudozhestvennaia Zhizn* [Artistic Life], in 1919–20; worked with its international bureau, through which he had contact with Walter Gropius and the Bauhaus in early 1920; involved himself in its never-realized plans for an encyclopedia of the fine arts; and, perhaps most important, founded its Museum of Artistic Culture in 1919, through which he developed, and (with Aleksandr Rodchenko) handled European acquisitions for, a Moscow art museum and twenty-two provincial museums over the next three years.

In an article of 1920 for *Khudozhestvennaia Zhizn,* Kandinsky clearly set forth both the context for this museum work and the special assumptions he brought to it.[84] Because of "the burning desire of our age to

democratize generally every aspect of life," he wrote, the museums will be organized "unconventionally," to focus not simply on artistic invention but also on the element of "craft" in art. It was a move he welcomed because it should help to expand the audience for art by demystifying the artist, who is simply a "working man" who should "take equal place among the ranks of the working population," thereby overcoming his unwarranted, all-too-common image as "pampered by fortune" or "habitually living in luxury." In the West, Kandinsky added, the state had generally failed to use its own institutions to expand that audience, despite valiant efforts by men such as Hugo von Tschudi, the former director of Bavarian state museums to whom the *Blaue Reiter Almanac* had been dedicated. Seeing himself very much in the role of a Tschudi for revolutionary Russia, Kandinsky vowed to use his new office to advance all new movements in art as well as their comprehension by "the broad masses." Although it is unlikely that this idea of democratizing proletarian Russia by importing the works of van Gogh, Cézanne, Picasso, and other modernists was shared by many Bolsheviks, he pursued his museum work steadfastly and with great energy.

Despite the materialist standpoint of the Bolsheviks, Kandinsky not only continued to believe in a coming age of spirituality but in the role of avant-garde art in bringing about that new age.[85] Accordingly, he adapted his avant-gardism to the new scene, working hard to develop a strategy for art that would relegitimate the role of the autonomous "creative" artist before his easel, while also underlining still more vigorously art's democratic commitments. Yet, even as he did so, the artistic ground was shaking under his feet, as the world of van Gogh and Picasso gave way to the constructivism of Vladimir Tatlin and the still more radical productivism of Osip Brik, tendencies that rejected the traditional role of the artist as well as the notion of creativity based on intuition or spiritual inspiration to which it was allied in Kandinsky's mind. In 1920, as the first director of Inkhuk, Kandinsky would propose and promote a program based on his avant-garde values, one that would ultimately be rejected in favor of an alternative written by Rodchenko. The defeat, which forced Kandinsky's resignation as director in early 1921, occurred despite the fact that he had written his program in a scientistic and objective spirit that is without parallel in other periods of his writing.[86]

The core notion in Russian constructivism, as pioneered by Tatlin, was that of the work of art as a self-contained constructed object, a notion he had developed in part from his acquaintance with Picasso and cubist Paris in 1913–1914.[87] From this perspective, artworks were under-

stood to be objects composed of various material elements, ordered by specific techniques, and without necessary reference to any external reality. It was but a small step from this conception to viewing art as just another form of laboring activity, and constructivists were strongly inclined to conceive their works as parallel to the relationship of craftsmen with their products, although without necessarily deeming them to have a utilitarian function. Productivists such as Brik took the further steps of insisting upon the utilitarian dimension and assimilating art to industrial (rather than craft) production, which in the early Soviet Union implied a strongly Marxist proletarian dimension to art. By 1920, when Kandinsky put forward his Inkhuk program, the USSR was dominated by a cult of technology allied with constructivist and productivist thought and strongly biased toward producing practical objects for everyday use.

Somewhat ironically, Kandinsky had made important early contributions to the intellectual environment out of which both Russian and Western constructivist movements would arise. In letters to Schoenberg from 1911–1912, he had embraced the concept of art as construction, taking care, however, to avoid reducing it to a matter of geometry or otherwise separating it from the artist's inner vision.[88] In 1913, as we have seen, he revised his concept of pure art around the notion of the constructed object. His still more fundamental concept of internal necessity influenced many early constructivists, including Theo van Doesburg, founder of Dutch De Stijl.[89] Moreover, as we have also seen, Kandinsky had never been anything but supportive of applied art, although his approach to it was decorative rather than constructivist in the sense of fusing the artistic element directly into utilitarian design. Just after the revolution, he had designed factory-produced teacups, yet another small aspect of his effort to advance the democratization of art in his native land. Toward that end, he was willing to compromise much in terms of his vocabulary and approach in the analysis of art, but he drew a sharp line before what he was unwilling ever to surrender: his symbolist concept of the individual artist guided by creative intuition as the art world's vital center.

In a candid interview with a French journalist in July 1921, Kandinsky spoke of "young painters who push the materialistic viewpoint to absurdity . . . , purists of a revolutionary viewpoint who believe that the purpose of painting is a public one, that any art object without use is bourgeois, that the epoch of pure art is finished."[90] The irony that his own theorization of pure art as construction had led to an outcome in which pure art was dying at the hands of utilitarianism must have been

very painful. Certainly, his decision to leave Russia for Germany a few months later and never to return owed much to his perception of the strength and short-term irreversibility of this development.[91] Yet, while the Bauhaus milieu he would soon enter was much more congenial to him, it too was alien in not dissimilar ways. As he would lament to his future biographer late in 1923, "in the Bauhaus, which in many respects I esteem very much, I am quite superfluous; I can go only to certain limits in my teaching here, since all that goes further does not fit within the limitations of the Bauhaus."[92]

Some historians have emphasized the continuities between Bauhaus and Blaue Reiter.[93] It is true that when Kandinsky arrived in Weimar in June 1922, he joined a faculty with both Klee and Lyonel Feininger, the two other major figures from Blaue Reiter who had survived the war. The program of the early Bauhaus also had utopian elements that recall Blaue Reiter, chief among them the notion of a synthesis in the arts. Yet, as Kandinsky's exchange with Gropius in early 1920 revealed, their conceptions of *Gesamtkunstwerk* were fundamentally different.[94] As the contributions to Blaue Reiter had demonstrated, Kandinsky's notion of synthesis involved painting, music, dance, and theater—forms suited to conveying inner states—and ignored forms such as architecture, and even sculpture, that were less suited to this purpose. Sensing such a bias in a "Russian artists' program" (written in fact by Kandinsky) that had been forwarded to him from Moscow, Gropius called attention in his reply to "one point that has not been fully developed in the Russian program and that we consider especially important, i.e. 'the association of all forms of art under the cloak of "great" architecture.'"[95]

In early 1919, Weimar's School of Arts and Crafts, which had flourished in the prewar era under the Jugendstil artist and Werkbund operative Henry van de Velde, was amalgamated with its School of Fine Arts and rechristened the Staatliches Bauhaus. Gropius, who might have succeeded van de Velde as Arts and Crafts director in 1915 had the school not closed because of the war, had proposed the merger and now became the first Bauhaus director. The merger took place in an atmosphere of socialist revolution in which initiatives such as the "Novembergruppe" and "Workers Councils for Art and Art Education" sought to bring the joy of art into the lives of the toiling masses. Partaking of the same spirit, the Bauhaus aimed to unify the arts under the aegis of architecture and design as part of a total reform of social life, although the more specific dedication of the school to an alliance of art and industry took several years to develop. To this basic goal a number of other aims were attached

that were very much like those with which Kandinsky had grown familiar in revolutionary Russia: the breaking down of barriers between pure and applied art while eradicating the former as an independent activity; a resulting practice of art in which there was no distinction between structure and decoration; and a resulting theory of art based on a utilitarian conception of beauty as good practical form. Thus, despite its dual origins, the Bauhaus was not only never an art academy privileging creative art in Kandinsky's sense, but strongly biased against such art from the beginning.

What Kandinsky seemed to have been preparing himself for in his 1916 discussion of creative and virtuosi artists now came alive for him at Bauhaus: his job was to distill the knowledge from years of activity as a creative artist for the benefit of budding virtuosi. To be sure, his great eminence as a painter lent the Bauhaus increased prestige, yet it was not to advance painting as such that he was hired but, rather, to elevate the crafts by providing a deeper basis for their practice. The Bauhaus concept was that students of design should receive a broad and unified training by take courses with both a "master of form" and a "master of design." Kandinsky joined the faculty as a "master of form" and taught courses in basic design, color theory, and eventually, analytical drawing. The understanding of his role as a facilitator to students who would never themselves become "pure" artists was so strict that it was only after the Bauhaus moved to Dessau in 1925 that he was he able to offer a course in painting. Although the primary subject matter of the courses he did teach amounted to the grammar of art he had been working to achieve since the days of *On the Spiritual in Art,* communicating such pathbreaking ideas to students was certainly challenging work. At the same time, he also struggled to defend his perspective on art before the public.

Much of this defense involved reiterating long-held positions in the context of new conditions. He argued that the advance of materialist outlooks and a "down with art" mentality had resulted in a purely external understanding of artistic form in which it is forgotten that harmonious results are possible only when form derives from inner "content."[96] Such attitudes, he implied, could only be overcome through patient teaching over the long term. Yet much of Kandinsky's writing in the Bauhaus years displayed the palpable fear that the role of the individual artist might be destroyed in the meantime. To defend it, he sometimes defined "pure art" in terms of this role ("easel painting") rather than, as previously, in terms of the nature of the art created.[97] His strategy also involved conceding what had only been implicit in 1916: that "the talent

of an artist of 'pure' art and that of an artist of 'applied' art are 'equal in value although different in their specifics.'" Acknowledging the "burning question of 'production art,'" he was now prepared to offer it a certain primacy. He simply argued that "however substantial the role" we give it, "free art" should not be "rejected." He also made clear his understanding that "the interests of the state" had come to include art, in the sense that national industries, to be competitive, must take advantage of all available means, including aesthetic ones. [98] None of this did he claim to want to overturn. His aim was just to maintain the conditions under which "free art" was still a theoretical possibility.

Turning to the Bauhaus itself, Kandinsky expressed his recognition that "the basis on which painting is taught" at the school is one which treats it not as "an aim in itself" but as a "co-organizatory force." He went so far as to articulate the view, unimaginable in the Blaue Reiter years, that "even 'pure' art needs today a more precise, consistent scientific basis," one which avoids any "one-sided emphasis upon the intuitive element."[99] As to modern society, he had begun to see "the collapse of the wall between art and technology," a development he seemed prepared to accept, even though it was leading the "'general public' [to] the perhaps not altogether conscious view that market prices and the affairs of political parties constitute the spiritual basis of human life . . . , that anything that exists outside these interests can have no essential value."[100] To that view, the only answer that appeared to convince him was the one he had offered to Carl Vinnen fifteen years before, when Vinnen had raised the question of how contemporary nation-state policies were deforming art: the coming "epoch of the great spiritual."

Kandinsky continued to write in this spirit for the rest of his life. After the demise of the Bauhaus in 1933 and his subsequent move to France, where he would live until his death in 1944, his life again became focused more narrowly around his own efforts at pure art. He lent his name to the occasional avant-garde movement, such as Michel Seuphor's Cercle et Carré, but without ever participating wholeheartedly. To the end, he remained a forward-looking cultural democrat, but his last years were in Nazi-occupied Paris, a diabolical caricature of the spiritually regenerated modern world of his dreams.

· · ·

Adorno believed that the fundamental problem with the strategy of "spiritualization" was internal. By making art so serious, rationalized,

and programmatic, art had been deprived of precisely what made it art: its sensuousness and playful subversiveness as a "gypsy wagon" offering a "show." While I believe Adorno had his finger on an important point here, Kandinsky avant-gardism does not seem to me to be its best illustration. Kandinsky did pursue a strategy of spiritualization, yet he did not repress the sensuous element in art. Ironically, in fact, the materialism and utilitarianism of many of the Russian constructivists inspired by his prewar work on construction was far more coldheartedly antisensuous than his work ever had been or ever would be. And this was prophetic, for Russian constructivism was not an isolated movement in terms of the larger cultural and intellectual assumptions with which it operated. In this sense, the deepest problems for Kandinsky's avant-garde strategy of spiritualization were not internal but external: they lay in the assumptions about what art should mean and what its place in modern society should be, assumptions that were being nurtured by the larger historical environment in which constructivism and related tendencies of "design modernism" were rooted.

As Kandinsky would have been the first to acknowledge, his strategy depended upon a general historical movement toward a respiritualizing of culture, a movement he aimed to foster but which he could hardly bring about single-handedly. He continued to declare his faith in this coming epoch, as we have seen, throughout the postwar period. Yet such declarations became increasingly empty, not merely because of the ever-intensifying impersonal processes of commodification and rationalization, but also, and most painfully, because they came under attack from within the community of artists upon which his avant-gardism obviously depended. In the prewar period, Kandinsky attacked journalistic "critics" for their failure to appreciate the spiritual elements in art and, thus, to educate the public appropriately. Even at moments like the Vinnen affair or the breakup of the Neue Künstler-Vereinigung München, however, it probably would never have occurred to him to think of his fellow artists as potential adversaries in the very conception of what art is. In the postwar period, in contrast, Kandinsky was so busy defending his conception of art against the antagonistic ideas of his fellow artists that he completely abandoned his polemic against journalistic critics.

In both revolutionary Russia and Weimar Germany, artists moved quickly toward the assumption that modernist avant-gardes, operating in the autonomous way they had in the prewar period, were no longer viable. As we have seen, Kandinsky adapted quite creatively to this assumption, even though it cut strongly against his prewar experience.

He also adapted, with somewhat greater difficulty, to a number of other assumptions that increasingly dominated his environment: that applied art would have new prominence as a spearhead for the effort toward a full-scale redesign of modernity; that artists needed to accept a new status for art as a "co-organizatory force" in material production; and that the interests of art would best be advanced by an art-industry alliance in which artists would train designers to serve industry. Yet there were also assumptions in this new environment that he could not accept: that art should be redefined in utilitarian terms; that the "free" individual artist was a bourgeois and outmoded role; and that genuine art was something other than the outgrowth of individual artistic creativity as defined at a subjective level by internal necessity. These were the assumptions that thrust him on the defensive and that spelled the demise of his strategy of spiritualization.

Yet Adorno's argument needs reformulation in another way as well. Those avant-garde modernists such as Marinetti who sought to maintain or even to rev up the "gypsy wagon" of art through a creative merger with popular culture and its entertainment values suffered the same fate as Kandinsky did. We will see how this was the case for Marinetti's futurism in chapter 6. Suffice it to say here that the very notion of the autonomous artistic avant-garde capable of carrying modernist culture to an audience in the public sphere without the need of alliance partners of some sort did not survive the Great War, except in the nihilistic and destructive forms of Zurich and Paris dada as well as, more uncertainly, in early surrealism, some later surrealist offshoots, and the idiosyncratic Italian movement *strapaese*. Before we turn to the postwar world of alliance-oriented modernisms, then, it may be worth reflecting briefly upon some of the features common to "pure" avant-garde modernism as suggested by the three figures we have considered.

Experiencing themselves as an embattled minority within a rising tide of philistinism, the early avant-garde modernists began by defining a cultural orientation for themselves that could be integrated with their political concerns and thereby anchor their public identities. This orientation might be relatively tight or loose—coordinated around an "ism" that becomes a group identity or simply defined by a common association that does not require bending individual free expression to group demands. Marinetti's futurism exemplified the tighter orientation; Kandinsky's Blaue Reiter, the looser one. Apollinaire's efforts to orchestrate an avant-garde Paris, primarily by reconciling the various factions of cubism, fell somewhere in between.

The cultural orientation then served as a basis for defining social and political issues to be addressed. The early avant-garde modernists believed that modern, increasingly commodified cultures had become corrupted in one of several ways—by their sacralization as bourgeois domains of status or material self-seeking, by their materialism and scientism, by their loss of rootedness in local traditions of art and artisanship, or by their *"passatismo"*—and they sought as a group to regain control over the production of art and to redirect it toward their cultural ideals. This regaining of control was seen as a means by which avant-garde art could reorient the broader public toward a concrete qualitative experience of life, and it was frequently believed that some sort of nationalism had a fundamental role to play in such a reorientation. Both Kandinsky and Apollinaire believed strongly in the national rootedness of qualitative cultural experience and differed only in the political consequences they drew: Kandinsky was a lifelong cosmopolitan, while Apollinaire moved away from cosmopolitanism in the heat of World War I. Marinetti's nationalism, in contrast, reacted strongly against any notion of reconnecting with cultural depths. For him, Italy had become a museum culture whose national resurrection depended precisely on a break with the nation's glorious past. Like Kandinsky, he believed in a "nationalist universalism" in the sense that nationalist expression was deemed important for the health of every national culture, yet unlike either Kandinsky or Apollinaire, he saw nationalism as bound up with the same forces as was commodity culture rather than as a respiritualizing counterthrust to it.

To sustain their attack on existing corrupted cultures, "pure" avant-garde modernists made strong claims for the control of art by artists, hence for art as a self-determining (in that sense, professional) enterprise that must be evaluated by internal standards rather than external ones like exchange value. Kandinsky was the most systematic and aggressive among these three (and, to my knowledge, all other) modernists in defining an internal standard for the understanding and judgment of art, a notable achievement that was nonetheless eased for him by his sharp separation of art from entertainment.

To advance an alternative modernist culture, the early avant-garde modernists sought to develop a broad democratic audience for art. If they organized themselves tightly around an "ism," then they might also seek to expand by encouraging the development of other groups with their cultural orientation. All of the early avant-garde modernists, however, shared the notion that for art to survive it would have to be

extended to encompass everyone as a potential participant, at least as a spectator. To this end, they cast themselves as taste professionals educating the public for art, but they tended to seek alternatives to Enlightenment modes of emancipation via rational understanding. For them, such understanding was bound up with the material, merely quantitative, commercially corrupted world of journalism, parliamentarism, science, and industry. Their appeals, in contrast, were based on something more primal, like Henri Bergson's concept of intuition or Nietzsche's performative notion of the agon.

In line with this mode of seeking a democratizing of culture, the early avant-garde modernists declined to use political strategies that would ally them with political movements, involve them in parliamentary politics, or otherwise bring them into contact either with mainstream social and political elites or with "revolutionary" vanguards. They preferred to rely instead on a direct approach to the public by means of which they hoped to build a new public sphere oriented around the value of art. Their differences in this regard mostly lay in their approach to commodity culture. Marinetti saw a rising culture of materialism and consumerism and sought to counter it by promoting his own version of such a culture, while Kandinsky refused to believe that a modern democratic culture had to be materialist or consumerist and never lost faith in a coming respiritualized world, even after his paragon of spiritual culture—his native Russia—was seized by the Bolsheviks. Apollinaire again emerges as the intermediate case: close to Marinetti in his flirtation with entertainment values and rejection of a symbolist concept of art, yet also close to Kandinsky in his ultimate separation of art and entertainment as well as his faith in art's capacity to forge a modern spirituality.

Finally, the early avant-garde modernists differed on the question of whether art should be preserved as an independent enterprise—what we have referred to here with the futurist phrase Art with a capital A. But even when they sought to reorient art through some sort of fusion with commodity culture (or with mass-entertainment industries within it), they hoped to keep it under their control. Their differences in this regard turned fundamentally on the question of whether such an incorporation of entertainment values was necessary to achieve an expanded audience for art and cultural democracy. Kandinsky believed that Art with a capital A and an expanded audience for it were perfectly compatible ends, and he was therefore unwilling to incorporate entertainment values to achieve his ends. While he understood the emerging power of the press and of advertising, he was cautious in utilizing that power even to

advance avant-garde aims. Similarly, he rejected any notion of a performative politics of self and its jocular spirit, so brilliantly deployed by both Marinetti and Apollinaire. In this regard, he remained attached to the symbolist generation, into which he had been born, that generally retreated from commodity culture and mass entertainment rather than responding to them proactively, as did those such as Marinetti and Apollinaire, who broke with symbolism as rebellious young men.

All of the early avant-garde modernists, however, believed deeply in the need to preserve the absolute freedom of individual artists, both to create art and to evaluate its merits. It was in order to preserve this freedom that they sought to maintain their self-sufficiency by refusing to advance their political objectives in alliance with any party, group, or individuals that might compromise it. After the war, such a conception of "pure" avant-garde modernism—without necessarily losing its allure—came to appear as the epitome of Belle Époque innocence, even to its greatest champions like Kandinsky.

VARIETIES OF INTERWAR MODERNISM

5

The Rise and Fall of Design Modernism

Bauhaus, De Stijl, and Purism

n June 1928, one of the leading voices in the German art world, G. F. Hartlaub, wrote a despairing assessment of the current prospects for art.[1] The "'free' fine arts," he lamented, had become "commercially hopeless" and culturally irrelevant since they had ceased to reach a significant audience. Today's "one true public art" is commercial advertising because it alone "reaches the nameless urban masses, whose enthusiasm no longer belongs to the church or to municipal authorities but rather to sports, fashion, and especially such 'enterprises' as football, boxing matches, and bicycle races." To survive in such a "crisis" atmosphere, artists must join the forces of capitalist industry that will otherwise defeat them, which in turn means persuading those forces that they are needed. "Why should the businessman bother with such a synthesis [of artistic quality and commercial effectiveness]? Why should he choose the true artist in place of the reliable *routinier*?" If "aesthetically worthwhile posters" could alone guarantee the excellence of advertised items, an art of quality might pay, "but this is currently the case only with some products aimed toward elite user groups." Although the only viable future for artists lay in their ability to smuggle beauty into effective consumer advertising, they would retain even that opportunity only

if they could make the case for their business relevance by means of "commercial, not idealistic, principles."

The crisis of art that Hartlaub perceived had several dimensions. In part it was self-imposed. Prewar expressionism "went too far" in its "revolutionary" aesthetics, which were too "bold" to be acceptable to the "patron class" and "too artistic" to engage the broader public. The social isolation of artists was then deepened by the war, which produced a new generation "antagonistic toward all romantic tendencies" and "determined to affirm all technical, standardized, and 'Americanized' habits of life." Yet the importance Hartlaub granted such contingent factors was secondary. According to the main thrust of his analysis, art in the European world had always been under the control of an alien master, which was why, as his opening sentence declared, "All art is advertising." In the early modern era, church and crown had patronized art as part of a continuous campaign to convince believers and subjects of their right to rule and to inculcate in them an appropriately "reverent astonishment." While processes of secularization and democratization appeared to free art from such subservience, in fact such freedom had proved illusory because the business tycoon had stepped in where the churchman and the monarch once were. Arguably, in fact, this substitution had made matters worse. For while artistically engineered beauty was undeniably important as a way of honoring God and his earthly representatives, Hartlaub thought it quite uncertain whether the value art might add to the industrial product would ultimately serve the business firm's bottom line. In contemporary society, artists must not only do the bidding of their master but convince the master of the value of that bidding.

Hartlaub was a gallery director, art critic, and visual artist who had coined the phrase "*Neue Sachlichkeit*" when he promoted an exhibit of "high" art under that name at the Kunsthalle Mannheim in 1925.[2] In his brochure copy for the exhibit, he claimed to be interested not in "new catchwords" but in "showing . . . *that art is still there, . . . that it is alive,* despite a cultural situation that seems hostile to the essence of art as other epochs have rarely been."[3] Yet, despite the great success of the show, which involved 124 canvases by thirty-two artists and traveled to Dresden, Dessau, and other German cities after its Mannheim debut, the nightmare that Hartlaub dimly foresaw in 1925 seemed to have come true only three years later. The commodification of culture was bringing about the end of art in the classical sense, and the only remaining hope was to ride the bandwagon of the aesthetics of capitalism to save whatever might still be salvageable in art.

Hartlaub's article appeared just three months after the resignation of Walter Gropius as director of the Bauhaus, and as we will see, the two events were among those that signaled the sense of defeat that came after a decade dominated by the avant-garde practices of "design modernism."[4] Yet the fears Hartlaub expressed were not new. In the early years of the century, leaders of the German Werkbund had struggled with the question of how art might be rescued from the advancing forces of commercialized vulgarity.[5] Their answer was that art should be enlisted as an ally of industry in the general project of creating a style adequate to modernity, one through which a sense of integrated social experience might be regained without falling off into romantic nostalgia or capitulating to consumer-driven fashion.[6] According to an understanding widespread at the time, which derived from the pioneering investigations into "late Roman art industry" by the art historian Alois Riegl, every civilization had a *Kunstwollen* [will to art]—an unconscious, essentially spiritual source of creativity through which it strove to express itself.[7] Such expression was particularly apparent in a civilization's applied arts and crafts, which Riegl studied under the concept of *Kunstindustrien* [art industries]. By allowing its *Kunstwollen* to flow naturally into its *Kunstindustrien* and material life more generally, a civilization expressed its true sense of style as a kind of Zeitgeist, or *Zeitstil*. True culture displayed a unity of conception, but this unity could not be imposed but had to grow unself-consciously from the activities of daily life. That is why genuine style had as much or more to do with the way a society met its practical needs than with "art" as a separate domain, and certainly any attempt to create style self-consciously as a particular "look" was doomed to deteriorate into imitation, analytical representation, and, all-too-often, mere fashion. True style was in an important sense "style-less" in that it was most likely to emerge when the solution to practical problems was pursued apart from self-consciously aesthetic considerations. The problem for the Werkbund was how to promote a creative alliance of artists and industrialists that would lead to the expression of a German *Kunstwollen* and, thereby, to "good form" and "quality" in German products as well as, more generally, a genuine modern style whose emergence would sweep away the mere imitations and passing enthusiasms of the new consumer-driven commercial world.

Although the Werkbund had very few artists as members, its makeup was otherwise quite varied, and it was constantly splitting into factions based on both political and strategic issues. In its early years, the dominant faction was oriented toward an arts-and-crafts individualism, but

problems of control by artists over their productions as well as the inability to secure that control by means of copyright law reform led some, including its main leader, Hermann Muthesius, to develop an alternative strategy based on the notion of *Typisierung* [standardized types] by 1910.[8] In this view, which Muthesius pressed aggressively at the 1914 Cologne convention, a high level of artistic taste consistent with the development of a genuine style could be maintained only through a top-down aesthetic control in which the form of the finished products of German industry would be subject to mandated conventions.[9] Against this view, "individualists" at the convention such as Henry van de Velde protested that "by his innermost essence the artist is a fervent individualist, a freely spontaneous creator" who would be utterly negated by any such bureaucratic machinations. Yet, no less than Muthesius, van de Velde was committed to the pursuit of a "new style" based on the German *Kunstwollen*. Indeed, while Muthesius was ready to trust an art-industrial elite to divine the *Kunstwollen*, van de Velde argued that it could emerge only as the result of artistic experimentation and not from preemptive legislation. Yet once it did emerge it would be perfectly proper to translate it into such "standards and standardization" as would be necessary to ensure that the new style was appropriately elevated.[10]

Despite their tactical differences, then, Muthesius, van de Velde, and fellow Werkbund leaders shared an optimistic conviction that the crisis of art in modern commercial society could be overcome through an art-industry alliance that would not only make sense from the point of view of German national interests as economically and politically defined but that would also offer the hope of cultural revival through a new style appropriate to modernity. Although at least some of them recognized the precariousness of this production-based strategy for art given the increasing ascendancy of the world of consumption in the determination of aesthetic form, they remained persuaded that an alliance of powerful elites could educate, reshape, or otherwise control the inchoate aesthetic impulses bubbling up from below. Moreover, they were sustained by a faith in the aesthetic purity of modern industrial engineering and, hence, by a sense that the cultural interests of art and industry ultimately converged—and in a way that put them both into active opposition to the fashions of commodity culture. These hopes and convictions, as we will see, would continue to sustain the design modernism of Gropius and the Bauhaus in Germany and, in a general way, the design modernisms that developed elsewhere in the war and early postwar years.

What separated prewar Werkbund views from those Hartlaub ex-

pressed in 1928, then, was not the analysis of the problem but the sense for the viability of the solution. For Hartlaub, the idea that artists and industrialists might participate as anything close to coequals in an enterprise that would impose quality, good taste, and genuine style upon the modern material world had become a chimera. Art was simply beholden to the economic marketplace, and all that was left of it was "advertising art" in the narrow sense, that is, properly speaking not art at all but, as he put it, "art in the service of business."[11] If art were to be kept alive in any sense, it would have to learn to accept its utter subservience to exchange value, for the current world was one in which, like the post-Gropius Bauhaus of Hannes Meyer, nothing associated with beauty or style was believed to have independent value.

In contrast to such unmitigated pessimism, the cultural outlook that prevailed during the war and postwar years in which design modernism came to the forefront was a complex amalgam in which the utter destruction of the world of the past seemed to be linked to unprecedented creative possibilities in the present. To be sure, there were those—most notoriously, in some of the dada movements—for whom the destruction led straight to an unalloyed nihilism, even as little fondness was expressed for what had been destroyed.[12] Yet those cultural historians who have taken a broad view of this period have rightly characterized the overall cultural mood among modernist intellectuals as one of "constructive vision" and "new sobriety," "return to order" and "serious rigor," and a "sense of renewed life" able to perceive "the bright side of the darkest cloud."[13] These historians have also studied the ways in which the new mood delegitimated the practices associated with the avant-garde modernism of the prewar period and, at least in a general way, have shown how an alternative form of such practices could emerge out of the war and flourish in the early postwar era. Yet to appreciate the novelty and coherence of such practices, as well as the range of variation in them, the cultural history of the postwar era needs to be brought more fully into dialogue with the historical literatures on industrial design, architectural design, and the merging of art and design in constructivism.[14]

My argument in this chapter is that, when these various historiographies are read together, it becomes apparent that the dominant form of avant-garde modernist practice shifted during the war years from the pure or autonomous types associated with prewar futurism, cubism, and expressionism to the notion of an art-industry alliance or, more exactly, to a reorientation of art and artistic work that would prepare the way for the future possibility of such an alliance. In historical reality, this shift

could be a messy affair, and it is well known, for example, that expressivist tendencies persisted well into the early Bauhaus. Yet, in the main, such a reorientation occurred because the prewar modernist celebration of individualist originality linked to autonomous avant-garde movements aimed at winning over a democratic audience for art now appeared out of touch with the conservatism of mainstream society and the power of its elites. Not surprisingly, then, the avant-garde modernist movements that dominated the European scene in the postwar years—German Bauhaus, Dutch De Stijl, and French purism—all adopted avant-garde practices that at least implicitly surrendered autonomy and direct appeals to a mass audience in favor of moving art to a position from which it would be able to engage in conversation with the industrial and governmental elites who were rebuilding the postwar world.[15] This is the strategy I am calling design modernism. Nonetheless, as we will see, each of the three major movements that developed it had a quite different character.

Of course, as I have been suggesting, design modernism did have its roots in the prewar world. Yet those roots lay not so much in the major art movements of the era as in the minor decorative arts as well as in those art-industry organizations, such as the German Werkbund, whose participants were largely made up of industrialists, architects, and others concerned with the applied arts who were sometimes, but not typically, artists themselves. In the prewar period, modernist artists, when they were politically engaged, tended to be associated with one of the major avant-garde movements. In the postwar period, in contrast, many of the most important avant-garde artists turned their political attention toward the strategic ideas associated with prewar art-industry groups, even as they also frequently attacked the organizations, such as the Werkbund, that had given rise to those ideas as staid, bourgeois, and insufficiently art-oriented.[16] Such attacks were particularly prevalent in the heady days of 1919, when the character of political elites seemed very much in transition.

What then were some of the more specific characteristics of design modernism as an avant-garde strategy? While a full answer to this question can only emerge from a discussion of the three cases that make up the bulk of this chapter, it may be helpful to offer a few more preliminary generalizations here before turning to those cases. To the end of gaining influence over social and political elites, design modernists worked out a variety of specific strategies. Some of these were more practical, like educating artists for industry; others were more theoretical, like working out

a broad aesthetic vocabulary that could serve as a basis for building art into everyday life. Design modernists also gave new prominence to architecture and to reworking the idea of *Gesamtkunstwerk* in a more architecture-centric form. They tended to repudiate individualism in art, not only because they saw prewar modernism as having been ineffective, but also because they hoped that a more institutional approach, allied with the goal of a unified style, would offer a better chance of avoiding mere "fashion." Furthermore, they tended to follow organizations such as the prewar Werkbund in opposing fashion and in exalting ideals of industrial engineering and machine technology as the basis of a style that would resist fashion. Yet, as we will see, design modernists in the West, unlike the revolutionary constructivists that Kandinsky confronted in the Russia of 1921, mostly continued to believe in "free art," even as they also emphasized art's character as pure construction. In short, they believed in design as the work of a collectively oriented artist seeking after the *Kunstwollen* or style-less style of modern culture as a whole through careful research into basic aesthetic relationships, especially as they might grow from and be reflected in industry and technology. And they also hoped to find some kind of practical vehicle by which the artist-designer might extend modern aesthetic values into the public sphere.

WALTER GROPIUS AND THE BAUHAUS

Although well known as a pioneer of modernist architecture who founded and led the Bauhaus in its first decade, Walter Gropius is in some respects an unlikely candidate for inclusion in a book about avant-garde modernism.[17] Unlike every other figure discussed in this book, Gropius did not work in either the fine arts or literature. Nor did he even consider himself to have had great talent as an architect, in part because of a manual difficulty in doing architectural drawing. Yet, even in the prewar years, he showed a strong interest in the fine arts and in the spiritual culture he believed they fostered, ideas that led him toward a conception of an art-industry alliance that was perhaps unique within the Werkbund for its combination of hard-headed *Sachlichkeit* [matter-of-fact-ness] and a modernist commitment to the centrality of the arts in envisioning social regeneration. Gropius was never interested in an art-industry alliance in the sense of subordinating art to engineering, which the Werkbund concept of *Sachlichkeit* suggested and which was even more strongly implicated in the later functionalism for which art did not even exist except as utility.[18] Gropius always sought after some artistic-

spiritual "more," however intangible, even as he showed himself to be a consummate pragmatist in his feel for politics as the art of the possible.

Despite the fact that he managed to qualify as an architect on the basis of only five semesters of formal training, Gropius was uninterested in his architectural education, which he regarded as boring and lifeless, and which he interrupted in 1904 for a year of military service in an elite regiment filled with Junker officers. When he returned to civilian life, he gained his first architectural commissions, but then, having inherited money from the death of a great aunt, he traveled for a year in Spain, during which he became enthralled with its art world, spending days in the Prado and at antiquarian shops and even briefly venturing into the export of Spanish art for sale in Germany. While in Spain, the young Gropius met Karl Ernst Osthaus, the wealthy scion of an industrial and banking family who had become an art collector and the founder and director of the Folkwang Museum in Hagen. Impressed with Gropius, Osthaus referred him to Peter Behrens, who by 1908 had become a prominent architect in Berlin. Gropius would work with Behrens from 1908 until 1910, traveling with him to England and Austria and adopting his classicist preference for an architecture based on values of regularity, proportionality, and precisely executed material forms and structures symbolic of modern life.[19] Confident enough to establish an independent firm in 1910, Gropius made his name within a year by his daring use of glass and steel in place of conventional wall structures in the Fagus shoe factory at Hildesheim. The "social ethic" and sense of "common social responsibility" that Hans Wingler would later see as the heart of Bauhaus also became evident in 1910, when Gropius sent his proposal for a company dedicated to constructing low-cost worker housing to the Berlin industrialists, Emil and Walther Rathenau, the latter of whom he had met through Behrens.[20] His social concern for workers was also evident in his work on the housing issue within the Werkbund, which he joined in 1912. In addition to participating in Werkbund debates, he did an office building for the exhibition at their 1914 convention and a number of designs—of railway locomotives and passenger compartments, furniture, and even wallpaper—that manifested their ethos of art-industry collaboration. Yet, as he recalled in a letter from 1963, he took special pride in bringing sculptors and painters into his architectural work in this period, a very different sort of collaborative spirit than was typical of Werkbund architects and designers.[21]

When the war broke out in August 1914, Gropius was called to the front, at which he served with only a few interruptions for the entire

length of the war and for which he would receive numerous citations. Not surprisingly, he suffered many near-death experiences in these years, including one in June 1918, when he was buried for two days in the rubble of a collapsed French town hall before being rescued by German troops. When the war's end finally came, Gropius was drained, embittered, and yearning for a German spiritual renewal, feelings complicated by a marriage to Alma Mahler in 1915 that would effectively dissolve by 1918. Yet the more material roots of the Bauhaus also lay in these years. In 1915, Henry van de Velde had written to him asking if he might be interested in taking over as director of Weimar's School of Arts and Crafts, a school van de Velde had founded but that would soon be closed by the war.[22] Stimulated by his correspondence with van de Velde and with Fritz Mackensen, who headed the rival Weimar School of Fine Arts, Gropius outlined his own vision of art education and an art-industry partnership in a long memo of early 1916 to the Grand-Ducal Saxon State Ministry in Weimar.[23] In 1918–1919, while he was deeply involved with the radical postwar politics of the Arbeitsrat für Kunst and the Novembergruppe, Gropius reopened the negotiations with Mackensen and, in this environment, succeeded in gaining approval for the progressive concept he envisioned.[24] On 21 March 1919, the Staatliches Bauhaus opened its doors to about 150 students, although neither they nor Mackensen and his colleagues from the old School of Fine Arts nor the residents of Weimar were at all prepared for what Gropius's innovative spirit would soon come to mean.

The politics of the Bauhaus, which have been well studied in terms of both the inner dynamics of the school and its relationship with its external environment, must be put largely outside the bounds of the present discussion, as must the long-standing scholarly debate regarding the degree of continuity between the 1919–1922 period and subsequent evolution of the Bauhaus in which it became more fully oriented toward the commercial world under the slogan of "art and technology, the new unity." Rather, the focus here is the origin and development of Gropius's design modernism and the avant-garde practices with which he sought to advance it. I will try to tease out the distinctive character of Gropius's vision both from his pre-Bauhaus writing and from his writing and practice during the Bauhaus years. Nonetheless, a few orienting observations regarding the politics of Bauhaus are necessary, since especially after 1918 Gropius's ideas can only be understood in relation to his practices, and his practices were deeply affected by the political context in which they unfolded.

Although "the fortuitous course of events favored Gropius" in the establishment of Bauhaus, the new institution began with very little funding.[25] Potential sources were the state government of Thuringia, the national government (whose politics were at antipodes from what prevailed in Weimar and Thuringia), private contributions, and such income as might be generated from workshop manufactures (which did not really begin until the Dessau period) or through joint ventures with industry. Not only did each potential source require a different political strategy, but no strategy could be pursued without potentially alienating one of the Bauhaus's constituency groups. In addition to those suggested by funding, these included the town of Weimar's craft industries and associated guilds, which were hostile to Bauhaus from the beginning; the local population generally, which was heavily monarchist and conservative, and thus also hostile; Mackensen and his colleagues, four of whom were hired as Bauhaus faculty and who were united in their desire to see Bauhaus remain a traditional studio-based art school; the new painters Gropius hired as "masters of form," who, except for László Moholy-Nagy, held attitudes not very different from the art faculty he inherited; the students, who were critical of Gropius for ignoring them and whose attitudes were mostly similar to those of the painters; and radical-art groups at the national level, pressures from which went in the opposite direction and were particularly strong in 1919.

Especially in the Weimar years up to April 1925, the Bauhaus was a fierce arena of factional contention. Moreover, although Gropius was viewed by many as autocratic, the truth is that he continually struggled for institutional control with powerful faculty such as Johannes Itten, an expressionist hostile to any collaboration with industry whom Gropius ultimately dismissed in 1922 to make way for Moholy-Nagy. Every statement Gropius made, especially in the early years, must therefore be read as much for its political meaning as for what it revealed about Gropius's own attitudes.[26] To compete for national funding, for example, it behooved him to replace conservative painters with radical ones, yet to do so meant running the risk that the conservatives would reestablish a traditional art academy that would compete for funding and deprive Bauhaus of its unique character as a union of the arts and crafts. Indeed, such a rival academy opened its doors in April 1921, thereby providing a new incentive for Gropius to move to the left. Meanwhile, the questions that had always divided Bauhaus—the relationships between painting and the crafts, between the arts and architecture, between the crafts and modern machine production and technology, between art in general

and commerce—persisted and could not be resolved without alienating some important constituency. Thus, if looking back to the pre-Bauhaus years for the development of Gropius's ideas and convictions would seem to make sense regardless of Bauhaus politics, that politics reinforces the need, for without some sense of what Gropius stood for before he became so deeply implicated in this political world, we cannot hope to make sense of his strategies within it.

In his 1910 proposal on worker housing, which is the first statement of his views we possess, Gropius offered a typically Werkbund analysis and solution based on an art-industry alliance.[27] Craft labor was dying out and was, in any case, too expensive to be applied to low-cost housing. Industrial methods made sense economically but offered only an inferior product. The solution could only be to upgrade the industrial product by using high-quality architects to create first-class models, which would be designed "down to the minutest detail by responsible designers" and then industrially reproduced. With this solution "art and technology would be happily united," and not only at the level of the individual residence but at that of society as a whole, which might soon be blessed with a genuinely modern style [*Zeitstil*]. Although Gropius's problem here was limited, it is noteworthy that both the solution and the analysis based on the art-craft-industry triangle that would inspire the Bauhaus were already in place.

In a Werkbund-sponsored lecture at Osthaus's Folkwang Museum the following year, Gropius advanced a very similar analytical framework but added the important acknowledgment that the sources for his concept of the *Zeitstil* lay in Riegl and Wilhelm Worringer, who had himself drawn extensively on Riegl in his well-known book *Abstraction and Empathy* (1908).[28] In the lecture, Riegl is invoked to argue "that the beauty of a work of art is founded upon an invisible lawfulness inherent in the creative will, not upon the natural beauty of the material; and that all material things are only subordinate mediating factors with whose help a higher spiritual state—precisely a *Kunstwollen*—can be given sensuous expression."[29] Yet the lecture's reference to Worringer is perhaps even more significant, since, while the notion of the *Kunstwollen* had become something of a Werkbund commonplace, Worringer's influence was much less evident there but was perhaps the major critical source for German expressionism. His influence helps to explain why, when Gropius drew out the implications of his *Zeitstil* concept in this text, the modernist resonances are such that we may almost feel ourselves to be in the world of Kandinsky. For not only does Gropius tell us

that "our great technical and scientific epoch will be followed by a time of spiritualization" [*eine Zeit der Verinnerlichung*] in which "civilization is succeeded by culture," but he makes absolutely central the role of the "artistic genius" in bringing about a "culture" based on a "great common idea." He claims that "the genesis of the work of art requires personality, the power of genius" and that "only the genius creates truly monumental works of art that have the power to shape all other artistic expressions as they extend down into daily life." Indeed, he goes so far as to tell us that "the value of a work of art lies above all in the spiritual satisfaction of an inner need for redemption, rather than in the quality of its materials. For creator and spectator alike, the work of art means a rest from the confusion of worldviews" (or, in Kandinsky's language, "harmony"). Thus does Gropius express a criterion for artistic value that is remarkably close to Kandinsky's notion of "inner necessity," and in the very same year no less. At the same time, his analysis is distinctive in the way it accents the importance of "artistic genius" not for individualist but for collectivist ends. Pure art can transform daily life and inspire a "great common idea."

The point here is not to claim that the young Gropius was an expressionist, which is certainly not the case. He could in fact be quite critical of what he saw as the "false romanticism," excessive individualism, and "the eternal search for the novel" to which the artists of his day too often succumbed.[30] But it is to suggest that a modernist conception of how art should be judged and valued and a modernist commitment to the cultural value of the artist were part of Gropius's intellectual makeup from the beginning. As he put the point in outlining his conception of an art-industry alliance for the 1913 Werkbund yearbook, "the artist has the power to give the lifeless machine-made product a soul; his creative force lives on, actively embodied in outward form," which is why "his collaboration is not a luxury, not a bonus added out of good will, but an indispensable element of the *Gesamtwerk* that is the modern industrial process."[31] Far-sighted industrial firms had indeed begun to recognize that "it pays in the long run to give thought to the artistic worth of a product as well as to its technical perfection and price-worthiness." At the same time, great modern artists understand that they can make their most heroic contributions, not by pursuing some "novel" idea or purely individualist end, but by using their individual visions and resources to engage technical demands with such close attention to the fundamentals of aesthetic form that the *Kunstwollen* implicit in modern functionality is able to spring forth. As the aesthetic magnificence of recent American

grain silos suggests, great modern art can be produced even in the absence of great artists so long as there prevails an "artistic naïveté" that preserves "a natural feeling for large compact forms that are pure and sound." Yet only the involvement of the artistic genius can ensure that aesthetic values will be realized at a high level and for the benefit of a common culture.

The key to grasping Gropius's prewar views on art is to recognize their nearly contradictory insistence upon the importance of the individual artistic genius in cultural creation, which alone can give "soul" to modern material life, and the nature of that creative will as a disciplined inquiry into the aesthetic qualities of modern industrial and technical forms. It is these forms that are "style-creating," as Gropius put it in the title of his essay for the 1914 Werkbund yearbook, and yet it is the individual artist who must exercise the creative "will to form" that alone can ensure the realization of "the true value determinations of the art work."[32] Much ink has been spilled on the vexed question of whether Gropius sided with Muthesius or with van de Velde in the 1914 Werkbund debate at Cologne. Without attempting here to resolve that question, which had personal and organizational as well as ideological dimensions, it should simply be noted that Gropius's views were a kind of forced resolution of the debate's two sides, yet in a way that was not simply additive.[33] Although he agreed with Muthesius that a style appropriate to modernity was embedded in industrial forms and that, as he had himself first proposed in 1910, the aesthetic potential of those forms could be realized through a creative collaboration between the artist-designer and the industrialist, he also believed that the artistic input was one of "genius" and could not be short-circuited. As he later put the point in a letter to his biographer, Muthesius's "main error was his belief that one can establish and fix a style by organizational methods from above. . . . [But] a type develops only by slowly growing connections, i.e. by the preference of the free wills of many individuals."[34] Finally, however, while van de Velde was right to underline the fundamental importance of individual artistic vision in the achievement of a modern style, his conception of this vision remained too subjectivistic and socially ungrounded for it to be able to contribute to "the spiritual coherence of the age."[35]

During the war years and into 1919, Gropius's perspective grew in several directions. First, as we begin to see in his 1916 proposal to the state ministry, his thinking necessarily took a pedagogical turn as he focused on specific educational initiatives, which in turn forced him to rethink the

relationships among art, industry, and craft on an educational as well as a societal level.[36] Second, the war itself had an enormous effect upon him, which is evident not only in the way he now brought the largest questions of revolutionary social transformation and spirituality to the center but also in the intensified emotionality of his rhetoric.[37] Finally, as already noted, Gropius became involved in 1919 with a number of revolutionary art and architecture organizations through which his exposure to, and sympathy for, socialistic and expressionist thinking expanded significantly, and these involvements, too, certainly colored his rhetoric. Indeed, some historians have drawn upon these developments to argue that they led to an early Bauhaus which is more nostalgic, even medievalist, and less Werkbund-oriented than the fundamentally different Bauhaus that followed the 1922 turn toward "art and technology, a new unity."[38] Without entering into that controversy here, I want to suggest that Gropius's design modernism at the Bauhaus is fundamentally continuous with his prewar thinking and unified in its aims as it develops in and after 1919. Moreover, I contend that even his practices were largely unified; what changed were the external circumstances and pressures that encouraged him now to push in one direction, now in another.

The manifesto with which Gropius launched the Bauhaus in 1919 used the familiar form of ebullient and impassioned prologue followed by a listing of principles and particulars that Marinetti had inaugurated a decade before, although it added a title-page woodcut, "Cathedral," by the expressionist Lyonel Feininger.[39] The manifesto's central concept, which Feininger's woodcut reflected, is that of the total work of art—here referred to as an *Einheitskunstwerk,* no doubt to emphasize the stylistic unity that can arise from the cooperation of a "working community" of artists and craftsmen, as against the more modest collaboration of the various separate arts in a *Gesamtkunstwerk.* Nonetheless, the principle of integration remains educationally and socially based rather than intellectually grounded as the outcome of a commonly developed and rigorously scientific vocabulary of form, like that which one encounters in De Stijl. Indeed, one could argue that what mainly distinguishes Gropius's *Einheitskunstwerk* from its prewar cousin is the greater unity afforded by its foundation in architecture, in contrast with the theatrical basis that typified prewar concepts of *Gesamtkunstwerk* such as those of Behrens or Kandinsky. In any case, the vision accords places to "art," "craft," "industry," and their interconnections in ways that are continuous with his thinking since 1910, even if both the concepts themselves and their interrelationships have become more complex.

Gropius's understanding of art here, as in the Bauhaus years generally, is that of an independent, self-defining value that will be negated if made subservient to extrinsic purposes but that must discipline itself to resist tendencies to self-isolation. Gropius condemns "salon art," the educational model of the art academy, and the current social "isolation" of art that they have produced. These conceptions raise an "arrogant barrier" between art and artisanship that impoverishes both activities and society as a whole. When art is divided from artisanship, art becomes sterile and artisanship withers (and may even die) from lack of creative engagement with art. The solution, however, is not simply to merge art and artisanship or in any other way to compromise art's independence. Unlike artisanship or craft, "art cannot be taught," but artists, who have somehow acquired the capacities and inspiration that make art possible, should be at the center of Bauhaus both because they can be used to elevate the teaching of craft and because their pure research by means of free art will inspire, inform, and help sustain the designs of the community as a whole. The presence of truly great artists can be expected to raise the level of every kind of cultural production, thereby enriching the actualization of the *Kunstwollen*. Thus, when Gropius wrote to a friend about Bauhaus early in April, he suggested that for our "art institute, . . . the most important task is to invite strong, vital personalities to join us; we must not meddle with mediocrities, but must do everything within our means to attract significant, well-known personages, even if down deep we do not as yet fully comprehend them."[40] No doubt, hiring such "stars" had advantages for publicity as well as for teaching and research. Yet whatever the priority of his motives, Gropius certainly carried through with this aim: almost all of his early "masters of form" were painters and sculptors, and most of them were absolutely top rank. Thus, while the "free arts" had no place in the early Bauhaus curriculum, the participation of free artists in that curriculum and in pure research was central to Gropius's design.

In his prewar writing, Gropius was somewhat dismissive of craft, but as he became more oriented toward pedagogical questions as well as upon the need to focus on the reconstruction of society as a whole, the strategic importance of craft moved into the foreground. Within the 1919 manifesto, its position is central. Since art cannot be taught and, yet, since industry and society generally need artists who help to realize a cultural style adequate to modernity, one has to decide upon the educational orientation most likely to produce them. Gropius's rejection of the art academy and studio model itself implied an alternative based on craft

and workshop. Although the Bauhaus took several years to develop craft workshops, the pedagogical strategy upon which they were based was in place from the beginning. After passing a mandatory introductory course on basic principles of art and design, students were to move on to workshops which were initially cotaught by a distinguished artist as "master of form" and a "master of craft."[41] The arrangement was somewhat awkward because masters of craft had no vote in Bauhaus policy matters and were generally accorded a second-class status. By 1925, the system was discarded in favor of utilizing recent Bauhaus graduates ("junior masters") to teach the workshops either as single instructors or as fully equal coinstructors. Thus, while Gropius regarded craft as a secondary value in comparison with either art or industry, it was of strategic importance because it lay at their intersection. Craft training stimulated art even if it could not produce it; crafts pursued at a high level were important as a social and aesthetic foundation for quality industrial production; and the creative genius of the painters could be helpful both indirectly—by stimulating craft—and directly by participating in industry. Moreover, having masters of craft was the only guarantee that the Bauhaus would not lapse back into the academy model that Gropius so detested.

The idea that Bauhaus would produce artists who would cooperate with industry was mentioned, although not elaborated upon, in the 1919 manifesto. The fact that the point was left so underdeveloped in 1919 and then suddenly deployed in a major way in 1922 has led some scholars to find a shift in Gropius's orientation from craft to industry. Yet there were many practical reasons that explain the delay, including the need to develop the workshops first in their own terms, to allow Bauhaus research to develop before attempting perhaps premature applications, and to give German industry time to recover the degree of organization, the stability of outlook, and the confidence necessary to make it a proper Bauhaus partner. Indeed, as Gropius himself argued early in 1922, "contact with industry and with the practical work of the world can only be established gradually."[42] Moreover, Gropius's conception of an art-industry alliance for the Bauhaus was less a matter of creating direct partnerships than of developing Bauhaus as a kind of "laboratory" that could provide industry with what we now call research and development.[43] In that sense, Gropius's relative lack of discussion of industry during the early Bauhaus did not signify its lack of ultimate importance for him.

In any case, it is true that Gropius undertook a major reassessment of

the Bauhaus generally, and its relation to commerce and industry in particular, in 1922–1923. This reassessment involved an economic evaluation of the Bauhaus by a local businessman, a heightened emphasis on commerce and industry in Gropius's public statements, and two Bauhaus exhibitions in these years, the second of which was focused on the theme of "art and industry, a new unity." [44] It did not involve a reorientation in Gropius's concept of art, which had always been collective in orientation.[45] Rather, the factors that led him to the reassessment grew out of immediate circumstances. First of all, Theo van Doesburg, the De Stijl artist and avant-garde activist to whom we will be turning shortly, visited Weimar in 1921–1922, and his aggressive strategy for positioning a constructivist art in relation to the modern public sphere had a major impact on the community that certainly caught Gropius's attention, even if he distrusted van Doesburg and refused to hire him for the Bauhaus faculty.[46] Second, it had become apparent that expressionism, although temporarily reinvigorated in the early postwar period, was now moribund. This shift undermined the position of those such as Itten who most vigorously opposed constructivist and art-industry thinking. Third, by 1922 the Bauhaus was no longer beholden to the former School of Fine Arts faculty and had numerous workshops, a firmer sense of itself, and a more regularized internal life that positioned it for a more active relationship with industry. Finally, and perhaps most important, the Bauhaus, like every German institution, found itself in exceedingly precarious economic straits in 1922, which, for a rational leader like Gropius, could not but encourage a reconsideration of its business side and its relationships with industry.[47] This shift caused consternation among the leading Bauhaus artists, even as at least some of them such as Feininger understood that Gropius was operating out of economic necessity as well as conviction.[48]

Despite the political turmoil in Weimar that forced Bauhaus to move to Dessau in April 1925, the years between 1923 and 1928 are typically—and rightly—treated as the "consolidation phase" that preceded a post-1928 "disintegration."[49] Nonetheless, consolidation had paradoxical effects that generally pushed the Bauhaus further from, rather than closer to, its founding ideal of an *Einheitskunstwerk*. The increasingly practical orientation of the workshops as well as the instructional shift toward "junior masters" tended to marginalize the painters both organizationally and psychologically. Although their freedom from teaching in the workshops made it possible for them to teach pure art as they had not before, this work was increasingly remote from the institution's defining

mission. For it marked a turn toward specialization, the foremost expression of which was the establishment in 1927 of a department of architecture at the Bauhaus under the direction of the newly arrived Hannes Meyer. Ironically, the full arrival of architecture as a subject of study at the Bauhaus probably did more than anything else to upset its founding notion that the unity of the arts should be achieved in "the complete building."[50]

Still, it was the wider economic and political environment that most undermined the Bauhaus enterprise as a whole, as well as its targeted effort at relations with industry. Even in the safe haven of Dessau, under the initially sympathetic stewardship of its mayor, Fritz Hesse, the school was unable to escape from its precarious financial position. Although contracts with industry increased, companies were frequently delinquent in their payments, most workshops were less than profitable, sometimes even draining resources, and Hesse was in no position to offer the school monetary support. In 1926 Gropius took the desperate step of asking faculty to forgo 10 percent of their salaries, even as the painters among them were becoming increasingly frustrated with the enterprise.[51] Meanwhile, the school became the focus of bitter satire in local newspapers, just as the 1927 local elections brought a rightist majority to power. Although the budgetary picture improved in 1927, a controversy with a leftist publisher over a project for low-cost housing that Gropius had developed prompted his resignation in February 1928. The issue that had first inspired Gropius to conceive his design for a new relationship of art and industry had come full circle, but by 1928 it was clear from Gropius's position of increasing isolation from both Bauhaus artists and German elites that the design itself had ultimately failed to inspire those for whom it had been created.

THEO VAN DOESBURG AND DE STIJL

Like Gropius, Theo van Doesburg was born in 1883 into comfortable bourgeois circumstances, but while Gropius seems always to have been intent upon moving up within the German establishment, van Doesburg ran away from home at eighteen to enter the Dutch bohemian world as a painter, actor, poet, writer, and self-educated critic.[52] We know very little about his life until 1908, when he held his first solo exhibition in the Hague and published some short stories.[53] Two years later, he produced a portfolio of color caricatures, *De maskers af* [The Masks Removed], for which his publisher arranged to have his future De Stijl colleague Piet

Mondrian write the introduction. By 1912 he was doing regular art criticism and essays for *Eenheid* [Unity], a weekly best known for its devotion to various spiritualist tendencies from Rosicrucianism and Eastern religious thought to theosophy and the "Christosophy" of Mathieu H. J. Schoenmaekers.[54] In his articles, van Doesburg showed himself to be conversant with the international art currents of the day, including futurism, Blaue Reiter, Japanese art, and the writings of Worringer and the Dutch architect H. P. Berlage, whose important work *Over stijl in bouw — en meubelkunst* [On Style in Construction and Furniture Design] had appeared in 1904.[55] Meanwhile, his painting, although not especially innovative, was becoming more accomplished, and in the spring of 1914 he sent three works to the Salon des Indépendants in Paris. Within a few weeks, however, the steady evolution of his intellectual and artistic life was rudely interrupted as he was called into the Dutch army and posted near the Belgian border to guard against a possible German invasion.

There van Doesburg met the poet Antony Kok and, after being demobilized in 1916, the architects J. J .P. Oud and Jan Wils in Leiden, as well as the painters Mondrian, Bart van der Leck, and the Hungarian expatriate Vilmos Huszár. Together they would establish *De Stijl* [The Style], the journal that gave rise to the movement and which was published under van Doesburg's editorship from October 1917 until 1928, with a final number appearing after his premature death in 1931. Although the Netherlands saw no fighting during the war, De Stijl's founders were united by the conviction that the prewar world and its culture of "individualism" lay in ruins and that only the recent dramatic innovations in the arts—especially developments in abstract painting—could provide a proper foundation for European reconstruction. In particular, they shared the utopian belief that a rigorous, scientifically valid set of design principles could be articulated in a manner that would permit social and aesthetic experience to be harmoniously reintegrated without compromising the integrity of the separate arts from which the principles would be derived. To this end they were prepared to devote enormous intellectual and artistic energy, although they were too wary of potential compromises to engage directly with economic and political elites in the actual reconstruction of European societies.

Mondrian was the great artistic genius within De Stijl, and his intellectual formulations dominated the early issues of the journal, but it was van Doesburg who brought the group together and, although it never had the sort of camaraderie associated with the futurists, he alone was responsible for keeping alive the collectivist aspirations for which the

movement stood. A volatile personality not unlike Marinetti, van Does-
burg alienated as many people as he attracted, but as Oud later wrote,
within De Stijl he was the only "good 'manager' and 'promoter' . . . who
understood the art of 'selling' his ideas."[56] Moreover, while Mondrian
was preoccupied with the "reality" of his own painting and Oud devoted
himself to architecture and townscapes in the manner of a professional,
it was the avant-garde van Doesburg whose tireless advocacy of an inter-
arts synthesis oriented toward social reconstruction gave De Stijl its
international prominence within the emerging world of design modern-
ism.[57] Indeed, van Doesburg's personality and artistic vision were too
protean to be confined within the limits of De Stijl's decidedly Calvinist
seriousness, and by the early 1920s at least two "other" avant-garde van
Doesburgs (I. K. Bonset, Aldo Camini) had emerged who allowed him to
play the dadaist and other lightheartedly subversive roles without the
knowledge of his De Stijl colleagues.[58]

For the van Doesburg of 1916, however, creating "the style" was a
powerful idea with apparently unlimited aesthetic and social potential.
The encounter with Oud seems to have been particularly stimulating for
him, since it introduced him to a notion Oud was just then developing:
that architecture could serve as the binding element in a new "monu-
mental" art that would transcend the isolation of the various "individu-
alist" arts and provide modernity with an aesthetic unity akin to what
the Gothic cathedral had provided for the medieval era.[59] Within weeks
of meeting Oud, van Doesburg was writing excitedly about "a monu-
mental-collaborative art . . . wherein the different spiritual means of
expression (architecture, sculpture, painting, music, and the Word) in
harmony—that is, each individual one gaining by collaboration with
another one—shall come to the realization of unity."[60] Later, he wrote to
Oud that "my aim is indeed to achieve what Berlage proclaimed in the-
ory: an *integrated unity* of house and components, right down to the
writing-paper."[61] Yet while Oud's writing was secular in tone, van Does-
burg's use of the word *spiritual* in his 1916 text signaled a larger preoc-
cupation which brought him remarkably close to both the spirit and the
letter of the concept of *Einheitskunstwerk* that Gropius would articulate
almost three years later.

An abiding feature of his early writing, van Doesburg's spiritual
yearnings are well expressed in an essay of June 1916, in which he de-
ployed a quasi-Hegelian historical analysis to position "abstract" paint-
ing as the spiritual force that makes "contact with the universe through

the peace of its mathematical planning" and thereby makes possible the "intimacy" that will pervade "the modern temple to be established in the future."[62] Early societies, he argued, had designed their buildings with purely practical ends in view, but over time "aesthetic senses were aroused" and "decoration was introduced." Finally, as "more profound beauty was perceived" and nature appeared as the reflection of "God the Father or the Universe (all names for one and the same concept)," painting moved toward abstraction, and now for the first time, it has become possible to imagine a properly painted architectural environment that will allow modern everyday life to blossom as the embodiment of a transcendent ideal.

The influence of Worringer is almost certainly present here, as it was in the young Gropius, but these views—with their symbolist and "religion of art" resonances—were most forcefully influenced by Kandinsky, as van Doesburg made clear in other texts of this period.[63] Indeed, in an essay written late in 1915, van Doesburg attributed to Kandinsky the three-part historical schema he was then deploying, and he named Kandinsky as the painter with whom "the third great period" of art (abstraction) had begun.[64] A few months later, he argued that Kandinsky was the originator of the constructive idea in art and cited the final sentences from *On the Spiritual in Art* in which Kandinsky foresees the advent of "a conscious, reasoned system of composition" that will allow the painter "to explain his works in constructional terms" and thereby participate in an "age of purposeful creation."[65] In yet another contemporaneous essay, he depicted Kandinsky as a kind of Russian Messiah, who had brought forth "the artwork of the future, the abstract, clean, pure painted work of art, . . . without accidental elements" and guided by "the feelings of our time."[66] One of those feelings, as van Doesburg expressed it in 1919, was "inwardness" [*innerlijkheid*], which offers the basis for an art that is both "original" and "decided, definite, and therefore strong," in contrast to an art of "externality" [*uiterlijkheid*], which will be "unoriginal" as well as "arbitrary, capricious and therefore weak."[67]

Yet, for all his innovativeness, Kandinsky was in the end too much the old-school individualist and his own design practices were too "decorative" to appeal as an avant-garde model to this budding design modernist. Soon Mondrian, with his dedication to developing a rational-scientific artistic vocabulary that could be collectively appropriated, became a more important guide to van Doesburg's emerging concept of artistic practice.[68] Both Kandinsky and Mondrian opened up the possi-

bility of an art of construction that might become the basis for a "universal stylistic idea" and thereby guide the respiritualization of European culture, but Mondrian's approach was far more compatible with the notion of an aesthetic reconstruction of the modern lifeworld through an alliance of art with the forces of modern industry and technology.[69] As we saw in chapter 4, Kandinsky shied away from what Willy Rotzler has called a "geometric, constructive non-objectivity" in favor of a "free, organic or expressive non-objectivity."[70] In the latter approach, one begins with natural form and then abstracts from it such that traces of the external world are never wholly lost; in the former, one begins and ends with forms as they appear to the mind without reference to the external world.[71] From the point of view of a design-modernist practice, what is most significant about this difference is that only the geometric constructive approach fully lends itself to art conceived as a "universal language" of form which, once identified and understood, can be collectively appropriated and applied to the reconstruction of modern life as a whole.

In a manifesto that appeared as the lead article of De Stijl's first issue, van Doesburg appealed, in a manner familiar from prewar German aesthetic discourses such as those appropriated by the Werkbund, to the need to overcome the current "archaistic confusion—the modern Baroque" by creating "the logical principles of a ripening style based upon a clear proportion of the spirit of the age and the means of expression."[72] Such, he declared, was "the object of this little magazine." To carry it out, he argued, the "really modern, i.e. conscious artist" must adopt a "two-fold vocation": first, "to create the purely visual work of art" and, then, "to awaken the layman's sense of beauty" by educating the public to understand and appreciate "purely visual art." To do the former, this artist would have to "sacrifice his ambitious individuality" and, while continuing to operate within a specific branch of the plastic arts, strive to "speak the common language" that "serves the universal principle" and that can thereby lead to "an organic style." To do the latter, artists would have to take seriously their obligation to "contribute towards the reform of the aesthetic sense" by speaking directly to the public as "experts" and, he implied, displacing the false expertise of mere art critics.[73] The stakes in this enterprise were high. As he argued a few issues later, the "realization" of culture in the Hegelian sense of the actuality of the idea must initially take place through the plastic arts (above all, painting) because they embody the idea in its purest form. Only then can the "political, juridical, philosophical or religious" realizations of the idea appear.[74]

In his early work, then, van Doesburg developed two closely related but nonetheless quite distinguishable concepts of a collective project for modern art: that of architecture as the binding element in a new monumental art (in Bauhaus terms, an *Einheitskunstwerk*) and that of a universal or common language of art that the various arts would pursue independently before ultimately merging their results. Of the two visions, the second is certainly the more ambitious. In its terms, each of the plastic arts would have to pursue a rigorous self-analysis aiming to identify the fundamental means of expression in that medium and then, reducing or distilling these means into a select minimum of elements, experiment both independently and with representatives of the other arts regarding potential ways of recombining the elements into an indivisible nonhierarchical whole of "purely visual art."[75] Such an art would be integrated in a stronger sense than even that of an *Einheitskunstwerk,* since here elements from painting, architecture, and possibly sculpture would not only work together in a common design but do so on the basis of ultimately shared principles that would allow the arts to participate together according to a rational design and without any being privileged. Ultimately, this double process of elementarization and recombination would produce a new world—new both in the sense of its constituent parts (from furniture to interior design to architecture and town planning) and in the sense of the relationships among these parts with the world as a whole.

In principle, the project of a universal language of art arising from the cooperation of painting and architecture should have allowed van Doesburg to produce a more potent aesthetic basis for an art-industry alliance than was available to Gropius at Bauhaus. For such a project raises the hope of a kind of science of design, which, once developed, might be applied to specific endeavors by those without any special aesthetic sensibility or training. Moreover, van Doesburg enjoyed other tactical advantages over his rivals in Weimar. From the beginning he had *De Stijl* as a magazine, which offered a forum for discussion as well as a means of reaching a broader public. With the De Stijl group he also had a rough parity of architects and painters in contrast to the Bauhaus, which always relied almost entirely on painters to develop its artistic ideas. For, in addition to Oud and Wils, architect Robert van't Hoff, architect and furniture designer Gerrit Thomas Rietveld, and constructivist sculptor Georges Vantongerloo all participated in the early De Stijl. In practice, this apparent advantage may actually have been a disadvantage, since the architects and painters of De Stijl found it difficult to

avoid mutual suspicion, the architects fearing that their designs would be corrupted by painterly influence and the painters, that their experiments would be compromised by a premature integration with architecture.[76] Still, in the early years at least, van Doesburg had an extremely capable group of collaborators who shared, to varying degrees, the project of a universal language of art, and one of them—Mondrian—was a brilliant painter with parallel goals, even if he and van Doesburg disagreed about many specific issues within a theory and practice of abstract art.

Why, then, did van Doesburg fail to develop a more adequate institutional basis for the De Stijl movement in support of his goal of reorienting the public sphere through art? An answer begins to emerge when we consider the matter of a Dutch Werkbond.[77] Such an institution never developed in the prewar Netherlands, but interest in the German Werkbund as well as in Muthesius's ideas about an art-industry alliance were both strong. Dutch translations of some of Muthesius's works became available after 1910, and a contingent from the Netherlands, including Berlage, attended the 1914 Cologne convention. Immediately afterward, there was substantial enthusiasm for a Dutch Werkbond, but it collapsed when the advent of the war led to a conflation of the idea with German cultural imperialism, and it was not until 1917, in the context of thinking about postwar reconstruction, that the question again arose for intellectual debate. Yet not only did van Doesburg fail to participate in that debate, but not a word about it appeared in the pages of De Stijl. Why should this have been so? Allan Doig has speculated that while van Doesburg sympathized with Muthesius's ideas, he was sufficiently distressed by the sharp clashes at Cologne to conclude that "the ideological purity which he demanded of his colleagues was impossible in such a large, official framework."[78] However this may be, Doig is surely right to suggest that van Doesburg would have had great difficulty in participating in the ideological give-and-take that inevitably occurs within a large political organization, and he certainly lacked the diplomatic qualities that allowed Gropius to sustain the Bauhaus for ten years amid political perils of every description.

A firmer basis for understanding van Doesburg's attitude toward the practice of an art-industry alliance emerges only much later in 1925, when he did some articles on recent German developments for *Het Bouwbedrijf* [The Building Trade], a journal aimed at an audience of industrial manufacturers, contractors, and architects.[79] Commenting upon the prewar architectural work of Behrens and Gropius, he argued that to design at the behest of industry "necessarily restricts architects in

their romanticism and aesthetic speculation," which explains why they had succumbed to such a "sober functionalism."[80] Working with industry necessarily meant compromise: not a compromise of one's "individuality," which he thought Behrens and Gropius (unfortunately) retained, but compromise regarding the possibility of thinking "constructively out of an architectural instinct." Such compromise meant that architecture remained a matter of working creatively to purify old forms rather than beginning with the internal logic of the material and applying to it a rational vocabulary of forms without regard to conventions or traditions. To put van Doesburg's point in terms of the 1914 Cologne debate, one could say that the top-down aesthetic control that the "individualists" there had feared because of its potential to truncate the aesthetic experimentation required to create a genuine new style was here rejected as well, but not in the name of van de Velde's "fervent individualist" but rather in the name of his exact opposite. According to van Doesburg's ideal, artists should indulge their romantic imaginations in order to carry out truly pathbreaking experiments with aesthetic forms, but they must then accept unequivocally whatever results their experiments (or those of other investigators) produce and apply them in an unfettered way to whatever concrete problems are presented. In this light, van Doesburg saw his ideal as an anti-individualism, and at least until the logic of art has been fully worked out, he rejected collaboration with industry from this anti-individualist point of view.[81]

In another article for *Het Bouwbedrijf,* van Doesburg brought the same outlook to bear on a critique of the educational practice of Bauhaus Weimar. Gropius and his colleagues were correct, in his view, to retain a commitment to the "free arts," which "always have been trailblazers for the so-called great innovations in the arts." Then, referring to the Bauhaus ideal of an *Einheitskunstwerk,* he argued that "globally seen, the goal was—at least in theory—a *consistent elementarization* of architecture, realized as a standard—or normal type, which can be industrially reproduced." With this goal, van Doesburg expressed no quarrel. The problem, however, was that the Bauhaus had failed to live up to it in its pedagogical practice. The rigorous experiment that would have been required to achieve "elementarization" was nowhere evident in the Bauhaus's "so-called prerequisite course," in which the student "was suddenly left to his own personal whims." Nor was it evident elsewhere because "nobody knew where to start with the discipline." Indeed, van Doesburg reported that when he had confronted Gropius with this issue in 1920, "I was greatly surprised to learn that he absolutely

rejected the notion of collective building and 'left everybody free to work in whatever way he fancied.'" Lack of discipline, in his judgment, had caused Bauhaus to squander the most significant "official opportunity" for "a radical innovation of the education in architecture and the arts" that Europe had seen in the postwar period.[82]

What then about De Stijl? Had it made optimal use of its own potential for fomenting a radical revolution in the arts that could serve to reconstruct the public sphere with the "idea" of art at its center? Van Doesburg's reflections on the German experience suggest that the "two-fold vocation" he had articulated for De Stijl in 1917 was based on a paradox. To actively pursue the second aspect of this vocation—reawakening the public's sense of beauty by reforming their aesthetic sense—the De Stijl artist would have to become engaged with modern public life, and thereby with the reality of industrial society, and yet to do so risked corrupting the primary objective of a purification of art through elementarization and collaborative recombination. Thus, it should come as no surprise that during the first three years of the journal—its heyday in terms of both intellectual innovation and group participation—the only real effort at public outreach was its First Manifesto of 1918, which, in contrast to much of what appeared in De Stijl, was written in simple nontechnical language and offered up an easily assimilable view of the world based on binaries of old/new, individual/universal, external/internal, and natural form/new plastic art.[83] Virtually all of the De Stijl group's effort in this period went, instead, into theoretical considerations about the nature of painting, the relationship of painting and architecture, and the general design issue of how it might be possible for the constructed object to achieve a stylistic unity without "decoration," without anything resulting from "individualist" reflection or added from "the outside." Practical illustrations of the potential fruitfulness of the theory did appear—De Stijl presented a Rietveld armchair, for example, already in 1919—but how precisely the movement might lead to the reconstruction of the social world remained obscure.

Radical change of a sort came in 1920. Bored perhaps with Dutch conservatism, or dispirited by his inability to marshal the De Stijl troops, or simply excited by the prospect of an internationalization of De Stijl ideas, van Doesburg turned his attention to the wider world, visiting Mondrian in Paris in March (his first trip outside the Netherlands); spending two intense December weeks in Berlin, where he met a number of German modernists, including Gropius, Bruno Taut, and Hans Richter; and then, in 1921, setting out on a journey to Belgium, France,

and Italy (where he met Marinetti); and finally settling in Weimar, where he lived for the most part until the end of 1922.[84] In 1923, he moved on to Paris, where he spent the rest of his life, although he continued to travel widely in Europe, promoting the (now increasingly moribund) De Stijl experience.

Van Doesburg also shifted his artistic focus in 1920. Over the next half decade he did very little painting, choosing instead to devote himself to exploring architecture, especially the role of color within it. In part, this change was a response to his encounter with El Lissitzky, whom he met in early 1922 and through whom he became more fully aware of the experimentation with three-dimensional art objects that international constructivists such as Lissitzky were carrying out.[85] In part, too, it reflected a renewed interest in the new possibilities of literary expression as he pondered, in futurist fashion, how "books" based on "length and duration" were giving way to a poetry based on "depth and intensity" that uses "all means at our disposal [including] syntax, prosody, typography, arithmetic, orthography" and that will result in a "spiritual renewal of the word."[86] So he expressed the matter in the Second De Stijl Manifesto of April 1920, cosigned by Mondrian and Kok, and so he increasingly explored it both in the poetry of "I. K. Bonset" and "Aldo Camini," and in dada performances with Tristan Tzara and Hans Arp. In 1922, he launched *Mécano* [Mechanic], a dadaist journal that not only permitted a spoofing of Bauhaus practices and all notions of art reduced to utility but brought together a wide variety of contributions from Tzara, Arp, Kurt Schwitters, Raoul Hausmann, Max Ernst, Francis Picabia, and Georges Ribemont-Dessaignes, among others.[87] Moreover, the journal delighted in playing with its self-presentation, not only in familiar ways via typography but also through color (each of its four issues was a different primary color) and form (each of the first three issues came folded such that they had to be unfolded and then rotated to be read).[88]

Van Doesburg brought these two apparently contradictory currents together by inviting his dadaist friends to join the Russian constructivists from Berlin and the Hungarian émigré circle around the journal *Ma* [Today] at the first International Congress of Progressive Artists held in Düsseldorf at the end of May 1922.[89] Not surprisingly, the congress, which was as much a playful slap at Bauhaus as a serious effort at organization, soon became mired in political argument, the details of which are explored in its final declaration.[90] The congress raised great hopes regarding the place of art in a new world order, and a Constructivist

International was established in Weimar the following September, but its main result was the impetus it gave to Richter, who established the important international constructivist journal *G* in 1923.[91] Van Doesburg himself used the occasions to attack the expressionism still associated with the Bauhaus and the commercialism associated with art exhibitions, as well as to publicize the De Stijl idea.[92] On a personal level, the most important result of the Düsseldorf experience was that it cemented his relationship with Cornelis van Eesteren, a celebrated young architect who had come to Weimar earlier that month to take the counter-Bauhaus course van Doesburg was offering and with whom he would enter the Paris art world in 1923, when they jointly exhibited at Léonce Rosenberg's Galerie de l'Effort Moderne.[93] That exhibit, which opened in mid-October, featured architectural drawings and painted architectural models of three "ideal" houses intended to illustrate the possibilities projected by De Stijl for a new collectively produced monumental art.

By 1923, then, the De Stijl movement had moved away from its original participants and base in the Netherlands toward an eclectic mix centered around an internationalized van Doesburg. But to what extent did it have fresh ideas? Certainly there were some. After his exposure to Lissitzky's ideas, van Doesburg developed a more rigorous concept of construction (a "fitting together"), which he contrasted with composition (a mere "putting together"). In an unpublished constructivist manifesto of 1923, he declared: "composition is a matter of arbitrary combination, of subjective taste, of cookery; construction is the object of ordered synthesis, each element being defined in a precise order and fully adapted to the whole."[94] The contrast appears in other essays of 1923, including one for Richter's *G*, and it informs his discussion of what he and van Eesteren had accomplished at the Rosenberg gallery.[95] Second, van Doesburg now became a champion of "machine art" in a way he had not earlier been, although the point seems to have been mostly bound up with his critique of Bauhaus in 1922, and he had no compunctions about withdrawing the idea a year later when it suited his purposes.[96] Third, he now became less fearful of discussing his differences with Mondrian openly and thus explored time as an active element in architecture more fully than he previously had.[97] Finally, he now offered more explicit discussions of his notion of artistic value and the way it functioned in opposition to commercialism. In an article expressing his affinities with dada, for example, van Doesburg argued that the contemporary world had become a "pseudo-culture" in which all cultural symbols had become reducible to mere "advertisements"—"religion to a

cross, Odol toothpaste to a curved bottle, Nietzsche to his big mous-
tache, Oscar Wilde to his homosexuality, Tolstoy to his caftan and san-
dals."[98] The only response that made sense in such an environment is the
one dada had adopted: no longer seeking "to convert." However, unlike
most dadaists and more like early futurism, van Doesburg also claimed
that objective values could be determined in culture and art: genuine
"created works" were those in which "the builder has allowed the force
of energy a maximum of expression," and constructions were "good" to
the extent that they were "organized and unified" through a "maximum
of energetic force."[99]

Yet, even if van Doesburg's ideas moved forward in some respects,
after the Rosenberg gallery exhibit in 1923, both the De Stijl movement
and his personal efforts to embody the De Stijl idea in practical forms
available for public appropriation steadily declined. He had a painful
falling out with van Eesteren in mid-1924 for reasons that ran parallel to
his problems with the original De Stijl architects: they were unable to
establish a mode of collaboration that satisfied their mutual sense of
intellectual property rights and a proper recognition of each man's con-
tribution to the artistic results.[100] Then, in the same year, van Doesburg
suffered the disappointment of having his proposed contribution to the
Dutch pavilion at the Paris "Exposition Internationale des Arts Décora-
tifs et Industriels Modernes" of 1925 rejected by a Dutch selection com-
mittee.[101] Meanwhile, his off-again-on-again relations with Mondrian
were also deteriorating at the end of 1924 and had fully collapsed by
June 1925.[102] Not surprisingly under such circumstances, the *De Stijl*
magazine became shorter, more irregular in appearance, and as van
Eesteren put it in a letter, "a totally personal expression of van Does-
burg, . . . a kind of private correspondence between yourself and your
readers."[103] Finally, in 1928, van Doesburg suffered the profoundly disil-
lusioning experience of seeing the color scheme for his Café Aubette in
Strasbourg, a project on which he had worked with Jean and Sophie
Taeuber-Arp for over two years, scrapped by the owners in response to
public criticism and replaced within days of the project's inauguration.
The experience led him to renounce his De Stijl ideal of artistic creation
for the public: "Let the architect create for the public," he wrote; "the
artist creates beyond the public and demands new conditions diametri-
cally opposed to old conventions."[104]

Whatever its original prospects, then, van Doesburg's twofold project
for a De Stijl movement had become unrealizable by 1928 at the very lat-
est, since it was clear by then not only that the De Stijl artists would be

unable to agree upon a common language of art but also that any hope of public acceptance of the movement's ideas had become remote. Nonetheless, De Stijl continued to function as a critical force until van Doesburg's death, and in this respect its fundamental positioning was not unlike that of the institution that had so excited his love-hate in 1921–1922: Gropius's Bauhaus. For, like Gropius, van Doesburg increasingly sought to differentiate his views from those of utilitarian functionalism, which excluded any consideration of aesthetics from architecture and design, and which both Gropius and he saw as increasingly influential. This effort, evident already by 1923, is especially strong in his writing of 1930–1931.[105] In an article that appeared a month before he died, van Doesburg defended "the machine" as the path to "social freedom," but only if its usage is "guided by the artistic spirit."[106] At the same time, the article maintained his faith that the artistic forms and style appropriate to modernity cannot be drawn from nature or from recognizable objects in any sense. In this respect, he continued to combat an alternative modernist aesthetic, also antifunctionalist but more conservative than his own, of which he had become aware after its creators attacked his Galerie de l'Effort Moderne show in 1923. That aesthetic was of course the purism associated with Amédée Ozenfant and Charles-Edouard Jeanneret, more commonly known by his recently adopted name of Le Corbusier.

LE CORBUSIER AND PURISM

The man who would become the most famous architect of the twentieth century attended an arts and crafts school at La Chaux-de-Fonds in the Swiss Jura, where he had been born in 1887 (four years after both Gropius and van Doesburg).[107] Initially, he studied the art of engraving watches practiced for generations in his family. His teacher, Charles L'Eplattenier, was mad about John Ruskin, and young Edouard got caught up in a medievalism against which he would later rebel. L'Eplattenier also decided that his very promising student should be an architect but, since he could not provide him the training, sent him off for inspiration in Italy and Vienna in the fall of 1907. In Vienna, Le Corbusier met the famous architect Josef Hoffmann and had the opportunity to work with him, but he was disappointed by the city's recent architecture, which he accused of pursuing originality at the cost of honesty and beauty of materials.[108] So he moved on to Paris, where by July 1908 he managed to gain an apprenticeship with Auguste Perret, an

architectural rationalist known for his innovative use of reinforced concrete. After nearly a year and a half in Paris working with Perret and in its decorative arts industry, he spent a few months back in La Chaux-de-Fonds with L'Eplattenier and then went on to Germany, where, after half a year in Munich, he gained a position under Peter Behrens in Berlin. Gropius had recently resigned from that office, and Le Corbusier did not make his acquaintance during his five months with Behrens, but by then he had already met a number of other important Werkbund figures, including Muthesius. He had even attended their June 1910 convention—and not merely out of intellectual curiosity: just days before he had received a letter from the art school at La Chaux-de-Fonds commissioning him to study the strategy and organization of the decorative arts in Germany.

Le Corbusier's research on the German decorative arts resulted in his first book, published in early 1912, after he returned from six months of travel in southeastern Europe. That was the trip that he always referred to as his *"voyage d'Orient,"* even though it was the European classical past with which Behrens was so enthralled that he in turn so passionately pursued.[109] In any case, the *Étude sur le mouvement d'art décoratif en Allemagne* is an extremely interesting document, in part because of what it tells us about Le Corbusier's prewar attitudes and enthusiasms, but also, as Nancy Troy has argued, because he would use the book to establish his credentials as a participant within the debates then raging in France regarding how the country might respond to the perceived German ascendance in the newly industrialized world of art and design.[110] Especially notable in the present context is the way Le Corbusier's interest in avant-garde art practices emerges from the book's detailed accounting of the Werkbund's "propagandistic and avant-garde initiatives," Osthaus's Folkwang Museum in Hagen, van de Velde's School of Arts and Crafts in Weimar, and a wide variety of other German cultural institutions and practices, even including those involved in the nation's new department stores. Indeed, the book is full of admiration for Germany's ability to incorporate a well-institutionalized aesthetic dimension into its economic development. Yet Le Corbusier was also careful to conclude that if "Germany remains the center of industrial production, Paris is the home [*foyer*] of art," and all she needs to do to assert herself again is "to abandon her lethargy in the domain of the applied arts."[111]

Le Corbusier was exposed to the ideal of an alliance of art and industry already at La Chaux-de-Fonds, albeit in a Ruskinian mode accenting artisanship, craft production, and decorative-ornamental design. But it

was his early experience in Germany that led him to a fuller appreciation of the possibilities inherent in design modernism as it was then emerging as an avant-garde strategy in the Werkbund. There he learned about some of the concepts and ideals central to the prewar German intellectual environment, including that of a *Kunstwollen,* or styleless style, an architecture inspired by classicism in its devotion to expressing social unity and a common social goal, and the notion of urbanism, of planning for whole environments rather than unrelated individual buildings. He was also very likely inspired by the idea, discussed by Gropius and others, of using architecturally standardized elements in prefabricated housing for the working class. One of his major projects during the four years he spent back at La Chaux-de-Fonds after his German experience was that of developing his so-called dom-ino system of worker housing. Although never realized, this system was an important practical step in Le Corbusier's emerging notion of a constructional language for art and architecture that might serve to cement an alliance of art and industry. As its association with the popular game implied, dom-ino was based on the idea of producing standardized elements whose design required the cooperation of architects and engineers and that could then be manipulated by the former as a language for building.[112]

Unfortunately, the Swiss Jura was hardly ready for such ideas, and with its building industry slumping in any case during the early war years, Le Corbusier was increasingly frustrated. Although credentialed as an architect, he was forced to work mostly in interior design, and he developed an intense loathing for his occupational environment. "Business," he wrote to a friend. "What a dilemma! If you try to please people, you become corrupt and sell yourself; if you do what you feel you must do, you cause displeasure and create a void around yourself."[113] To escape this world, he visited Paris as often as he could, and he also managed to attend the Cologne Werkbund Congress of July 1914. Moreover, he devoted most of his intellectual energies in 1915–1916 to a book manuscript tentatively entitled *France ou Allemagne,* which further pursued the theme of French-German competition and its implications for a politics of avant-garde art.[114] But it was only in early 1917 that he summoned the courage to break definitively with his hometown and to make his grand entrance into the Parisian art world.

Very shortly after his arrival, Le Corbusier attended a performance of the Ballets Russes and kept the program booklet, which contained Apollinaire's essay "'Parade' et l'esprit nouveau," praising Picasso's stage sets and the "new spirit" of Paris's wartime art world.[115] The event fore-

shadowed his own development of the journal *L'Esprit nouveau* with Ozenfant, a painter, and Paul Dermée, a dramatist and journalist. Ozenfant was already deeply involved in the wartime avant-garde scene as a member of the "classical" or "crystal cubists," who had come together under the slogan of a *"rappel à l'ordre"* and who showed their work at Rosenberg's Galerie de l'Effort Moderne.[116] He also edited *L'Élan* (1915– 1916), a journal which likewise aimed to dispel the dark clouds that had descended over prewar avant-garde culture by shrouding its own cubism with patriotic fervor.[117] In fact, both Ozenfant and Perret, with whom the former had once sought architectural training before turning his full attention to painting, were involved with Art et Liberté, a political organization that defended artists from nationalist attacks in part by mounting a counternationalism of its own. Quite possibly, it was Le Corbusier's work *France ou Allemagne* that led Perret to arrange to have him meet Ozenfant, a potential publisher for the manuscript, over lunch at Art et Liberté.

In *L'Élan*'s farewell issue, Ozenfant offered an important appraisal of the contemporary politics of art. On the one hand, he defended cubism on the grounds that "cubism is a movement of purism," which offers the prospect of "cleansing the language of the plastic arts of parasitic expressions, just as Mallarmé tried to do in verbal language."[118] But on the other hand, he argued that cubism was in "crisis" because "certain major artists" had turned it into a "commodity" by "ossifying its forms into 'decorative' formulae." The implication was that the cubist movement had descended to the level of *art nouveau* or *art munichois* by pursuing the false idols of artistic and consumerist "fashion," instead of recognizing that artists should "know as much as possible about the [scientific] laws that govern them" and that art's "value does not depend upon the absence of representation but upon the beauty of harmony." To be saved from its own excesses, the world of cubism required an "intervention" of "the intelligence." To restore a world of harmony and order, it would not be enough simply to "cleanse the language." Art would also have to cleanse itself of its commodity-culture incrustations by learning from science and devoting itself to research such that it too could become scientific.

Le Corbusier's new friendship with Ozenfant stimulated him to take up painting, a passion to which he is supposed to have devoted himself every day for the rest of his life.[119] In September 1918, he visited Ozenfant near Bordeaux, where the two painted landscapes and, drawing upon complementary areas of expertise and shared intellectual and

political values, formulated the principles of "purism," which appeared as the book *Après le cubisme* just days after the death of Apollinaire and the end of the war.[120] Concurrent with the book's release, the two artists held the first exhibit of purist painting at a Paris gallery, where the book's concluding manifesto could also be readily distributed. Thus, a maximum of publicity was generated for a new aesthetic of "purism," of which the Paris art world became aware simultaneously as a theory and a painterly practice.

Like Ozenfant's article for *L'Élan,* the book argued that the cubist movement was right to have "become newly conscious of its means" by seeking out the "language" of art, but wrong to have done so in an idiosyncratic, haphazard mode that was bound to result in a merely "ornamental art." There were actually two problems here: like other prewar avant-garde movements, cubism was imbued with the ideals of "originality" and "individualism" as well as a suspicion of science, all of which were bound to lead it astray. But more than most other avant-garde modernist movements, cubism also went astray because its experiments in abstract art ultimately led it to abandon representation. As the authors explained, because its paintings were "composed like carpets," cubism was fated to remain at the "level" of the merely decorative. Here we see the source of the criticism that Ozenfant and Le Corbusier will make when they became aware of van Doesburg and the abstract art of De Stijl in the early 1920s.[121] In 1918–1919, however, the significance of their claim lay above all in the concept of level, which was linked to one of their two most important new theoretical arguments: that a hierarchy of the arts exists which leads from lower decorative forms based on "pure sensation" to higher forms in which "raw sensations—pure colors and forms"—are "organized" by the intellectual analysis of the artist. Pure or "superior arts," then, are to be distinguished from lower forms and will never be completely nonrepresentational, as the latter may well be. Indeed, at the apex of the organized forms of high art are those devoted to depicting the human body, which is "organized with the laws of symmetry as legible as those that determine the construction of the violin" but which, given its intricacy, "exceeds the beauty" of any other "single thing."[122]

The other theoretical argument made by the authors of *Après le cubisme*—in this case, one that van Doesburg would have shared—is that contemporary art must draw its inspiration from the "modern spirit," which lay above all in the styleless style of the new world of industrial machinery but that was also linked to the classical past

through common metastylistic values such as monumentality, precision, and opposition to the variable and accidental. "The constructions of a new spirit rise everywhere . . . bridges, factories, dams, and so many gigantic works carry within them . . . something of a Roman grandeur," a grandeur that derives ultimately from the scientific knowledge that makes the constructions possible.[123] "Science advances only by dint of rigor. Today's spirit is a tendency toward rigor, toward precision . . . in sum a tendency toward purity. This is also the definition of Art." Hence, the choice for art was quite stark: "either art will align itself with the scientific era, in which case it cannot remain in its present state; or it will not align itself with the scientific era and it will cease to be."[124] Painting, for example, must be researched scientifically: "the habit of painting without preliminary research, under the sway of emotions . . . is too pervasive. We believe, by contrast, that a work should be completely set in the mind; in which case technical realization is merely the rigorous materialization of the conception, almost a matter of fabrication."[125] This "setting in the mind" still involved the creative freedom of the artist, but that freedom could not simply run wild under the banner of "imagination" or "originality." Rather it had to be disciplined by a technical mastery governed by a meticulous application of formal harmonies and other scientifically derived and mathematically based rules of composition. Correctly constructed, such an art would be appealing because it would have used scientific methods to discover the aesthetic basis of human affect and would thereby correspond to human needs. Foremost among these needs was the need for order, one that classicism had appreciated and that was being rediscovered by modern scientific civilization. An art that understood human affect scientifically would be one that is effective aesthetically.

Such were some of the key points in purism's aesthetic program. Yet *Après le cubisme* did more than lay out the theoretical rationale for a new and improved successor to cubism. Its authors were clearly pushing toward a new vision of the French public sphere in which art would regain a paramount role: "What is most characteristic of our era, as we said, is the industrial, mechanical, scientific spirit. The solidarity of art with this spirit need not lead to a machine-made art, nor to depictions of machines. The deduction is different: the state of mind that results from a knowledge of machines affords profound insights into matter, and consequently into nature. In parallel with a science, with an industrial society, we should have an art conceived according to the same plan. As the means of science and art are different, what links them is a community of

spirit [*communauté d'esprit*]."[126] Although the authors did not specify a practical vehicle for advancing this culture of modern scientific rationalism, they clearly hoped to build a constituency for it by educating the public to appreciate its clean lines and pure forms, as well as to promote it through strategic alliances among elites. For just as science and modern industrial design should be of great interest to artists, so too properly conceived art should be of great interest to scientists and industrialists.

France had a long and vigorous tradition of thinking about the relation between the decorative and high arts, as well as of their potential unification for the benefit of industry and society, even if it had never established an organization analogous to the German Werkbund. Much of it was associated with Roger Marx, a senior civil servant who had played a major organization role in the Paris Exhibition of 1900 and whose widely read manifesto on "social art" had appeared just a few months after Le Corbusier's study of decorative art in Germany.[127] However, the ideal central to this movement of allying decorative artists with manufacturers in an effort to improve product aesthetics is one that aroused Le Corbusier's suspicions and that would soon engage his active contempt.[128] Although he had long been concerned with the issues raised by "social art," he distrusted most existing efforts to ally industry and art as reducing the latter to a subservient, inferior, and merely commercial status. As he wrote in his 1912 book, schools of applied art such as van de Velde's can be successful only when they "ally theoretical instruction with practice, or better yet, when they make practice into a pretext for theoretical considerations. The inverse tendency marks the regression toward the 'school' . . . that resurrects clichés, the farce [*mascarade*] of styles, and routine."[129]

A better clue to the sort of art-industry alliance that Le Corbusier probably had in mind comes when we remember that, as he himself was cofounding the purism movement and beginning his exploration of painting (still under the name of Jeanneret), he was also earning his living as the manager of a brickwork and building materials factory at Alfortville, a position he held until he began an architectural firm with his cousin Pierre Jeanneret in 1922. He also had a number of other business involvements in these years, which brought him into association with many leading industrialists and bankers in France and Switzerland, contacts that would prove valuable when he launched *L'Esprit nouveau*.[130] Yet, just as Le Corbusier developed his painting, architecture, and business skills under different names and as separate compartments of a very full life, he seems to have believed that art would be compro-

mised if it entered into an alliance with industry prematurely. Indeed, art must preserve its autonomy as a theoretical domain in order to be able to maintain itself as an equal partner within any such alliance. Industry too should cultivate its autonomy. Modern industries were already designing at a high level and did not need practical help; indeed art would do well to study industrial design and the sciences that informed it. Likewise, industry would learn most from art if art sustained itself as pure research.

Such ideas were probably just beginning to percolate in Le Corbusier's mind in 1920, when *L'Esprit nouveau* was conceived, but alliance strategies were deployed in very concrete ways to make possible the lavishly illustrated and often quite hefty journal. Not only did Le Corbusier call upon his contacts in the business world for immediate financial support, but he seems to have gained a government subvention for the journal as well.[131] In addition, advertising support from major industrial concerns was solicited aggressively, and readers of *L'Esprit nouveau*'s early issues saw images of Ford automobiles and Le Thermidor electric heaters alongside promotional material for *Valori plastici* and the *Nouvelle Revue française*.[132] Moreover, while its articles were intellectually demanding, its broad mix of writing on politics and economics, science, industrial innovation, city planning, and sports, in addition to painting, literature, theater, cinema, and photography was clearly intended not only to promote the creative interplay of science and art but also, more broadly, as a kind of advertisement for modern life. Interestingly, while the first three issues of the journal carried the subtitle *"Revue internationale d'esthétique,"* in the fourth issue it became the *"Revue internationale illustrée de l'activité contemporaine."* By construing its intellectual domain so widely, *L'Esprit nouveau* also increased its capacity to build credibility for art as a source of innovative ideas that industry and government should take seriously.

Was an ideal of "synthesis" or a *Gesamtkunstwerk* implied by their commitment to a "common effort" or "community of spirit" among art, science, and industry, as well as to the allied advances in "contemporary activity" they made possible?[133] The well-known opening line of *L'Esprit nouveau*'s first issue reads: "There is a new spirit, a spirit of construction and synthesis guided by a clear conception."[134] And, in their article on purism in the journal's fourth issue, Le Corbusier and Ozenfant pursued the ideal of synthesis in terms of their conception of a "universal transmittable language" in the plastic arts.[135] This language, they claimed, is made possible by the existence of "primary sensations deter-

mined in all human beings by the simple play of forms and colors," which in turn permits us to set out universal "laws of composition," the most important of which were those of proportion. Such laws were seen as both pictorial and architectural, for example, in the "golden section ratio" which permitted composition integrating the golden section triangle with the picture format.

Yet, for reasons we can only touch on here, Le Corbusier did not push such integrative possibilities very far. As already indicated, he insisted upon a notion of hierarchy in which the high arts—art with a capital A that is absolutely without utility—are sharply distinguished from the world of useful objects, however designed and decorated. Among the high arts were "architecture, painting, and sculpture—works of no immediate utility, disinterested, exceptional, works that are plastic creations invested with passion."[136] Like Gropius and van Doesburg, Le Corbusier understood the importance for research of maintaining the "free arts," but more emphatically than they, he refused to treat their existence as a means to an end. For this reason, architecture—itself a high art but one that also incorporates the world of useful objects within its created environments—takes on the strategic role of a unifier of opposites. As one scholar puts the point, Le Corbusier and Ozenfant "never actually advocated the *unification* of even painting, sculpture and architecture, but only their *cooperation*."[137] Thus, as Le Corbusier's Pavillon de l'Esprit Nouveau for the 1925 Paris Exposition famously illustrates, the stylistic unity based on modern engineering that gives it the appearance of a *Gesamtkunstwerk* is belied by the seemingly haphazard inclusion of purist paintings on its walls. Unlike van Doesburg and van Eesteren, whose integrated environment of painted architecture had been presented two years before at the Rosenberg gallery, Le Corbusier appeared to delight in creating an architecture through which he could explore the contradictions between the technologically generated lived environment and pure art. For him, the architectural object could not be reduced to a universal matrix, as in De Stijl, but must be accepted as an environment in which there coexist different rules for construction—rules reflecting the laws of science and engineering, the nature of plastic form, and the diversity of human needs—all of which the artist-architect must struggle to reconcile.

Despite its commitments to "synthesis" and a "universal plastic language," then, *L'Esprit nouveau* had much less to do with advancing the integration of the arts than either *De Stijl* or Gropius's efforts at an *Ein-*

heitskunstwerk through the Bauhaus. Rather, to judge by the journal's actual thematic focus, its fundamental purpose was to advance the prospects for an aesthetic modernization of France by exploring the nature of human persuasion in both its visual and linguistic forms. Perhaps because the cultural environment in postwar France was so much more nostalgic—hence, tradition-oriented and regionalist—than in Germany or the Netherlands, Le Corbusier lacked confidence that his own vision of modernity would win the day there.[138] Thus, as Marjorie Beale has argued, *L'Esprit nouveau* sought above all to understand "the mechanisms underlying suggestibility, aesthetic influence, and the formation of sensibility" and then to persuade artists that they become the "technicians of visual communication" by using the results of these studies in their own work.[139] Indeed, even the interest of Le Corbusier and Ozenfant in a universal plastic language might be understood from this point of view. For if a grammar of forms could be identified and correlated with specific psychological states, then it might be possible to create a kind of science of images through which their psychic effect on viewers could be predicted in advance and then manipulated. Artists would then be capable of becoming, in Beale's words, "technicians of visual communication, a goal which closely resembled the aims of their colleagues in advertising."

However, for Le Corbusier, artists should not take on this role independently but only as part of a professional collaboration among elites. Unlike Apollinaire and other prewar avant-gardists, he had little faith in the idea of repositioning art as a central value within the modern public sphere by having artists educate the public directly. "Art is not something for the people," he wrote in *L'Esprit nouveau*'s eighth number. "Art is only necessary sustenance for elites who must commune with themselves in order to lead. Art is in essence lofty."[140] Art for Le Corbusier becomes the vehicle for enlisting "scientific, artistic, and industrial elites" in a "common effort" toward the aesthetic modernization of French public life. As he put the point a few issues later, "a review like *L'Esprit nouveau* seeks to allow the various elites, who are not yet aware of the general mechanism that moves the contemporary world, to become better acquainted with it and to have it take hold of them."[141]

Are we then to understand the purposes of *L'Esprit nouveau* as not only akin to advertising but literally as advancing "advertising art" in Hartlaub's sense? There seem to me to be several reasons for resisting such a conclusion.[142] First, although Le Corbusier's interest in advertising

was so intense that he apparently sometimes even faked ads in order to increase the journal's attractiveness to potential advertisers, neither he nor any other participant in *L'Esprit nouveau* truly worked in advertising or wrote articles about advertising for the journal.[143] Second, Le Corbusier's theoretical commitments to the autonomy and "uselessness" of high art as well as to hierarchy in the arts separated him from those involved in advertising art. Third, his use of *L'Esprit nouveau* to pursue a "universal transmittable language" of plastic art, although geared toward unraveling the secrets of mass psychology, was not aimed at a science of commercial marketing but at teaching elites to appreciate the modern designs they were already creating in order, ultimately, to influence the public. Fourth, not only did Le Corbusier lack interest in the consumer culture that advertising art supported; he was literally horrified by it, as his polemics against decorative art and especially its representatives at the 1925 Paris Exposition vividly show. Finally, and most important, he did fervently believe, no less than did Kandinsky, Gropius, and van Doesburg, that art had a spiritual mission that would be utterly negated by reducing it to a commercial form.

In the opening argument of *L'Art décoratif d'aujourd'hui*, Le Corbusier refers to the "great emptiness of the machine age" for which some people attempt to compensate by "resurrecting" the "local cultures" or "folk culture of the past." Yet, however much art was once rooted in such cultures, any attempt to overcome the current "crisis" of spiritual meaning by reconnecting contemporary art with these lost worlds will only make art "idle and sterile," turning it into "decoration." We must "rid ourselves of the romantic and Ruskinian baggage that formed our education." (Le Corbusier does not mention prewar avant-garde modernist defenders of the local origins of all genuine art, such as Kandinsky and Apollinaire, but there is no doubt that he would relegate their analyses to the same utopian bin in which he puts Ruskin's). Local cultures are going or gone, and we must instead look forward, taking our inspiration from the machine, which "is bringing about a reformation of the spirit across the world." The machine awakens us to "the intense joy of geometry" and bids us enter the "Salon de L'Aéronautique as opposed to the Salon d'Automne." This does not mean that we should collapse art into technology. "Art has no business resembling a machine (the error of constructivism)," and its legitimate creators are those who are "enthralled by pure forms." Art is not a calling for the many. "The classes too have their classification: those who struggle for their crust of bread have the simple ideal of a decent lodging." But through the architecture that creates such lodging, the masses

can learn to appreciate a deeper form of beauty and gain spiritual eleva-
tion from it, even if they do not participate in creating it.[144]

The hopes embedded within the analysis of *L'Art décoratif* must, how-
ever, be balanced against the sense of bitter disappointment it conveys
regarding the state of art in contemporary France, above all as expressed
in the 1925 Exposition. That story has already been well told and need
not be repeated here.[145] Suffice it to say that for Le Corbusier the expo-
sition was a commercially driven, incoherent medley of "styles" aimed at
a luxury market-niche, instead of the scientifically conceived set of design
solutions to the problems of modern French society as a whole that it
should have been. Not only were the best sites given to pavilions erected
by Paris's four main department stores, while Le Corbusier's was located
in a remote corner; but the commercial pavilions treated designers as
hired guns to provide what the department store owners believed the
public would buy, while Le Corbusier insisted on the designer as a pro-
fessional who collaborated with industrial, business, and governmental
elites but who exercised ultimate control over the aesthetics of his work
without regard to current public fashion. Moreover, his pavilion stood
for the principle of standardized design and was conceived as a single res-
idential unit in a city of 3 million people. As he saw it, his elitism pro-
vided aesthetic excellence in the service of the public at large, while theirs
simply responded to the untutored whims of the privileged classes.[146] As
most other observers saw it, Le Corbusier's intervention at the exposition
was merely an unwelcome gesture of protest.

As its recent historians have emphasized, the 1925 Exposition wit-
nessed the confrontation of two rival conceptions of an art-industry
alliance. In one, art and industry would collaborate on terms basically set
by industry, which implied a role for art corresponding to the "genteel
notion of limited serial manufacture and modest stylistic renewal of basi-
cally traditional forms."[147] In the other, art would play a leading role in
the research of design solutions for modern problems, while fully respect-
ing the styleless style inherent in modern industrial (as against commer-
cial) products. Indeed, in Le Corbusier's own version of the second con-
ception, respect for the aesthetics inherent in industrial production meant
that artists should not even be directly employed in industry. This was
why he did not approve of the Bauhaus program for educating artists for
industry, even though *L'Esprit nouveau* did offer its moral support for
Gropius during the crisis of 1924–1925 that forced Bauhaus to leave
Weimar.[148] Yet, as Le Corbusier's fate at the exposition made painfully
evident, his differences with Gropius were ultimately a moot point: nei-

ther man's version of design modernism would prove capable of standing firm against the political and economic forces arrayed against them.

Even before the exposition itself, both Le Corbusier and Ozenfant had become sufficiently disillusioned by their difficulties in sustaining elite support for *L'Esprit nouveau* to abandon the journal and end purism as a collaborative enterprise.[149] After their coauthored book *La Peinture moderne* appeared in 1925, they went their separate ways, with Le Corbusier turning more toward his work as an architect, which had been faring increasingly well since the establishment of the partnership with his cousin. From this perspective, leading a movement of artists toward an art-industry alliance mattered less than making the individual alliances with political parties, movements, and specific politicians that enhanced his own ability to gain important architectural commissions. Yet Le Corbusier was far from abandoning his effort to reinvigorate the French public sphere both aesthetically and politically. Although he was not a cultural democrat in the sense of believing that everyone can or will appreciate art, his elitism was diametrically opposed to the nineteenth-century conception of an aesthetic caste devoted to building its own private spiritual sanctuary. Such a retreat was impossible for someone so committed to the idea that the most valid aesthetic expressions of modernity come from the world of industry and technology. He therefore continued to work toward improving the responsiveness of the French government toward his visions of art, industrial design, and urbanism. In this regard, he favored reformist groups with rightist technocratic orientations. In 1927, he made overtures to the French fascist movement, founded in 1925 by Georges Valois. Its journal, *Nouveau Siècle,* had celebrated Le Corbusier's urban designs and architecture as prototypes of a fascist future. In 1928, Le Corbusier became a technical adviser to Ernest Mercier's organization Redressement Français, which, although short-lived, made manifest the interest of some of France's more influential industrialists (Mercier was a leader in its power and oil industries) in pushing the Third Republic toward a technocratic overhaul of the state.[150] Although these efforts involved obvious continuities with the politics of *L'Esprit Nouveau,* they reflected far less confidence in France's mainstream elites. If the world of consumerist capitalism so dominant at the 1925 Exposition had rejected his purist movement and its vision of an art-industry alliance, perhaps politics could be used to reorient capitalism in a more amenable direction. As we will see in chapter 7, this counterestablishment politicization of modernism after 1925 was shared by

André Breton and the surrealist movement, despite the dramatic differences between their aesthetic and political visions and those of Le Corbusier.

· · ·

Practices aimed at bringing artists into conversation with industrial and governmental elites for the advancement of their mutual interests seemed plausible in a world of postwar reconstruction. But as we have seen, the fundamental premise behind this politics of design modernism—that the interests of art and industry ultimately converged in a way that encouraged a common opposition to the fashions of commodity culture—lost its plausibility once it became obvious that the latter would be restored to the position of importance they were already assuming in the prewar period. What is interesting is that the design modernisms we have considered suffered a common demise despite the fact that their orientations were quite different, bearing, as they did, the distinctive marks of their leaders and countries of origin.

The problem that led Gropius to adopt his Bauhaus project and to build the institution in the way he did was how to give artists a meaningful and economically viable role in the creation of a modern state and industrial order that could together rebuild a war-devastated Germany. The brilliance of his design was that it permitted a resolution of the more utilitarian sides of this problem—such as artist training—while also reconceiving "free art" as research appropriate to developing a modern styleless style such that the Bauhaus as a whole assumed the character of a "laboratory" for modern art and design. Yet, in retrospect, it is hardly surprising that the political passions released by Germany's wartime devastation conflicted so sharply with this resourceful, thoughtful, and innovative vision.

In the case of the Netherlands, where the ill effects wreaked by the war were not so dire, van Doesburg and his fellow De Stijl partisans dedicated their energies to the more abstract project of investigating the vocabulary of form that could ultimately be used to create an aesthetically integrated built environment reflecting a modern, rational style. Although De Stijl's focus was always more on the intellectual than on the public side of its program, van Doesburg took pride in what he regarded as practical demonstrations of his theoretical ideas, such as the Rosenberg gallery exhibit and the Aubette project. Unfortunately, however,

such demonstrations not only failed to attract a significant public but, still more importantly, came only after theoretical disagreements had prompted the defection of most of De Stijl's original members.

For Le Corbusier, in his adopted country of France, the problem was how to impose a rationalist modernizing cast upon the generally regionalist and nostalgic orientation of the "return-to-order" mentality in postwar cultural life. For while purism certainly thought of itself as a return-to-order movement, its rationalist, classicist, scientific, and generally modernizing orientation was quite different from the more dominant strains of postwar French return-to-order thinking. Le Corbusier's strategy, manifested in purism, was to create an avant-garde movement that, like De Stijl, would define and develop a language of form but also, like Gropius's Bauhaus, would act as a kind of research laboratory for modern design (albeit without an educational program for artists). Also like Gropius, Le Corbusier hoped, ultimately, to forge an alliance of artistic, industrial, and governmental elites in favor of an aesthetics based on modern engineering and against both the traditionalist orientations of the postwar French return to order and the consumerist and high-style "decorative" orientations that were proving so seductive to the nonartistic elites. Yet he was able to gain neither the adherence of artists nor the sustained support of nonartistic elites, and by 1925 he seems to have concluded that he would have to try to bring about an alternative technocratically oriented politics for France.

Is there a general explanation for the common failure of the public dimensions of these projects, however significant we may judge their aesthetic enrichments to modern life? One might argue, as Kenneth Silver did regarding purism, that design modernism was essentially an "aesthetic of reconstruction" which "lost its *raison d'être*" as the rebuilding of Germany, the Netherlands, and France "drew toward completion."[151] Yet such an argument would beg the question of what it was precisely that looked more complete about these countries in 1925 as against 1918. This chapter has tried to suggest that it was above all the institutions of commodity culture—of the *consumerist* orientation of capitalism— whose existence looked both imposing and assured by the second half of the 1920s in a way that had not been in the case immediately after the war.

But let us be more specific about the direct effects of commodity culture upon the projects of design modernism. In the first place, the imposing nature of mid-1920s commodity culture made it difficult to persuade industrialists that they should pay attention to the political demands of

artists, especially when they came into conflict with those of consumers. If we think about avant-garde modernist art, industry, and commodity culture as a triad in which the first and last were competing for the allegiance of the second, then by 1925 this had proved to be a very uneven contest. Second, consumer capitalism was helping to erode design-modernist movements from within. As Hans Richter perceived in 1924: "What is operating under that name [constructivism] today no longer has anything to do with elementary design [*Gestaltung*]. . . . Meanwhile the art market and oil painters have adopted the name, and the individualists, the deal-makers, the oil painters, the decorativists, and the speculators all now march under the name constructivism—as long as the slogan is fashionable."[152] Third, given the difficulty of sustaining modernist movements, the temptation to surrender ideals of collaborative building in favor of the narrower professional pursuit of architecture apart from painters, sculptors, and other artists naturally grew stronger. That Le Corbusier and van Doesburg both moved more toward their work as architects just as the Bauhaus was establishing its first department of architecture is probably no coincidence. Yet this "victory of the new building style," as one prominent modernist architect of the period called it, masked the deeper failure of the design-modernist program in the wide and totalizing sense of an *Einheitskunstwerk*.[153]

Finally, however, we need to be clear that the obstacles facing design modernism did not come only from business, industrial, governmental, and even artistic elites. There were also perfectly good reasons for its demise that grew directly from the increasingly ascendant forces of cultural democracy. Just as Marinetti in 1926 had to face the wrath of French women demanding that they be entertained on their terms rather than his, so too the denizens of Strasbourg's Café Aubette demanded an environment to their liking rather than one imposed by van Doesburg. Similarly, Le Corbusier's fate at the 1925 Exposition and even that of Gropius's Bauhaus turned in part upon the problem of a democratic public that did not approve of what artist-designers were attempting to create for them. In the case of the Bauhaus, although its most tangible and immediate problems were political, the deeper issue it faced was that training artists for industry cannot succeed in giving them a meaningful social role if production is primarily determined by advertising and marketing (consumer desires, however manipulated) rather than the other way around.

Given all of these difficulties, it is no wonder that many avant-garde modernist movements in the interwar period, rather than devoting them-

selves primarily to design modernism, thought instead in terms of political alliances with regimes and movements that either opposed capitalism or promised to take it in a less consumerist, more technocratic direction. It is to the story of three such movements in fascist Italy that we now turn.

6

Futurism and Its Modernist Rivals in Fascist Italy

The oldest of us is thirty; so we have at least a decade for finishing our work. When we are forty, other younger and stronger men will probably throw us in the wastebasket like useless manuscripts—we want it to happen![1]

F. T. Marinetti, 1909

Before the First World War, futurism was certainly the major movement of avant-garde modernism in Italy and arguably in all of Europe. Marinetti's brainchild, it would always remain fundamentally under his control, but even by 1913 tensions were becoming evident between his leadership, an expanding avant-garde membership, and the aim of building a popular audience. Rivalries emerged between Florentine and Milanese futurisms and even among futurist artists themselves.[2] By 1914, the base of the movement was beginning to shift from Milan to the Rome of Giacomo Balla and Giuseppe Sprovieri's Galleria Permanente Futurista, a process that intensified during the campaign for Italian intervention in World War I and during the war and postwar years.[3] Geographic dispersion also meant increasing stylistic eclecticism and new aesthetic orientations for futurism. Balla, for example, the only member of the futurist inner circle older than Marinetti, brought to the leadership of Roman futurism an already distinguished artistic career which included pioneering work in Italian divisionism during the 1890s; exhibits after 1900 at the Venice Biennale, the salon in Odessa, and the Salon d'Automne; and, perhaps most important, decorative arts work in Düsseldorf in 1912 that exposed him to Jugendstil and reinforced the

geometric-decorative tendencies in his own art. By 1915, in his manifesto with Fortunato Depero on the "futurist reconstruction of the universe," he inaugurated a unifying tendency that Enrico Crispolti has termed "second futurism," but which, from the perspective of this book, might be thought of as a futurist design modernism.[4]

By the early postwar years, the Italian cultural scene had become much more complex, and futurism was even more fragmented. Some of its most talented stalwarts, such as Umberto Boccioni and Antonio Sant'Elia, died in the war. Some who survived it, like Carlo Carrà, had grown more conservative and joined earlier defectors from futurism like Ardengo Soffici in calling for a "return to order." Others such as Mario Carli, Emilio Settimelli, and Giuseppe Bottai would split with Marinetti over political questions, the first two launching one of the many independent futurist movements that dotted the Italian cultural landscape in the early 1920s, while Bottai abandoned futurism for a straightforward embrace of fascism. The creative energies of the movement were increasingly in the hands of a younger generation that had not participated in the prewar movement, such as the Florentine circle around *L'Italia futurista,* or who pursued futurist art and design without being Marinetti loyalists. In Rome in 1917, for example, Enrico Prampolini, who had joined the futurists as an eighteen-year-old in 1912 and had written several important futurist manifestos before the war, launched *Noi,* an independent self-declared "avant-garde" review with close ties to the Zurich dada of Tristan Tzara. In its second series (1923–1925), the journal would move closer to Marinetti, but this liaison was short-lived as Prampolini moved to Paris in the wake of the crisis precipitated by the murder of the socialist Giacomo Matteotti in June 1924. By 1930, the only remaining prewar futurist still loyal to Marinetti was Balla, and he too would desert by 1933.[5] Moreover, by then, futurism was no longer just identified with major artists working in cultural capitals but was dispersed into more than a dozen cities and towns from Sicily to the Veneto.[6]

Some general version of this outcome had been foreseen in the founding manifesto of 1909, as the epigraph to this chapter suggests. Indeed, the decade Marinetti had given futurism for "finishing our work" ended uncannily just a few days before the launching of fascism in Milan's Piazza San Sepolcro. Yet by 1919 he had evidently forgotten his original prophecy. His success in leading *L'Italia futurista* no doubt contributed to his belief that he could maintain the movement's original aims as well as his own personal control over it. In fact, in 1919 Marinetti even raised his

ambitions as he succumbed to the illusion of a futurist-fascist alliance as the basis for a major political role for futurism in Italy, an illusion which, once exposed, threw his movement into a total disarray from which it partially recovered, in 1923, only by settling for a purely "aesthetic" definition of futurism's public role. In effect, if in the heady days of 1919 he had imagined that the autonomous futurist movement of the prewar years might actually lead a futurist-fascist alliance into power, by 1923 he was embracing an alliance strategy in which futurism wholly subordinated itself to fascism and reconceived its resistance to commodification entirely in terms of a successful fascist regime.

Meanwhile, the fissure within futurism between those who continued to have political aspirations for it and those who accepted its aesthetic compartmentalization within fascism had become mirrored within Italian avant-garde modernism as a whole. In addition to Carli and Settimelli with their journal *L'Impero* and Bottai with *Critica fascista,* those avant-garde modernists making the turn toward political activism included Curzio Malaparte with *Conquista dello Stato* and Mino Maccari with the first series of *Il Selvaggio.* More typical, however, were those who reasserted classical aesthetic values and sharply circumscribed the activist dimensions of their avant-gardisms, even if classicism in this environment did carry certain political resonances.[7] The writers for *La Ronda,* the artists of *Valori plastici,* and the artists who, in 1922, launched the Novecento movement in Milan all fit this description. Indeed, of all the Italian cultural movements of the postwar and fascist periods, only one succeeded in producing a unified aesthetic-political vision of the avant-garde modernist variety that prewar futurism had pioneered. And that movement—the mostly Tuscan *strapaese* [super-country] that arose within *Il Selvaggio* in 1926—rooted its identity, paradoxically, in a complete rejection of prewar avant-garde modernism.

After fascism's seizure of power in October 1922, there emerged a further complexity in the Italian cultural scene: the recognition by astute and ambitious cultural impresarios that fascism might well be complemented by an official state art. In fact, despite its much-vaunted aesthetic proclivities, fascism did not move in this direction, seemingly preferring the broader legitimation that might be gained through a policy that one historian has dubbed "aesthetic pluralism."[8] Yet both Marinetti, with what was left of his futurist movement, and his main emerging rival, Margherita Sarfatti, from her position as press agent and chief organizer for the Novecento artists, devoted themselves to making their movements into an official state art, until they were derailed by Roberto

Farinacci and others within the fascist regime of the 1930s who advocated a Hitlerite critique of modernism as "degenerate art."

A final complexity in the postwar Italian cultural scene derives from the fact that Italian modernism was part of the same milieu that we considered in the chapter 5, one that, despite differing national political settings, presented common challenges with respect to the politicization of cultural life during the war and the rapid acceleration of culture industries and pressures for cultural democratization after the war. Thus, it should come as no surprise that at least some futurists would move toward design modernism in this period, even if capitalist industry was not nearly so entrenched in Italy as it was in Germany, France, and the Netherlands. In Italy, however, given the salience of a socialist-communist alternative between 1919 and 1921, as well as the domination of a fascist alternative to liberal democracy after 1922, design modernism tended to be less autonomous from political ideologies and movements than in northern Europe. Or, to put the point another way, design modernism in Italy was almost completely subordinate to a strategy of resisting commodity culture by allying with a political movement or alternative state-political form that might vanquish it and thereby create an environment more conducive to art. In general, avant-garde modernists in postwar Italy found themselves confronted with the need to choose between art and politics (and, within politics, between left and right extremes) rather than holding them together as they had been able to do in the prewar period. Choosing either art or an independent politics meant running the risk of having no impact in the public realm, while choosing a politics of alliance entailed a dangerous bet: that the freedom for artistic experiment, which had undergirded prewar modernism, as well as its romantic, realist, and naturalist ancestors, could be maintained in a world in which liberal values and practices had been abandoned.

Despite the difficulties of the choice, the reality of fascist Italy ultimately presented a permissive environment for avant-garde modernism, at least as compared with Russia and Germany, the other two European nation-states in which political alternatives to liberal democracy triumphed in this period. Why this was so is easy to speculate about but difficult to pin down. It has been argued, for example, that "fascism required an aesthetic *overproduction*—a surfeit of fascist signs, images, slogans, books, and buildings—to compensate for, fill in, and cover up its forever unstable ideological core."[9] Yet, if this is so, it becomes harder to understand why the regime never adopted a monolithic, specifically

fascist aesthetics and never sought to establish and enforce coherent fascist aesthetic principles as the Reich Chamber of the Arts did in Hitler's Germany. As Marla Stone has argued in greatest detail, fascism never allowed any school or movement to define an official art; "rather the official culture of Italian fascism is best defined by its diversities, contradictions, and ambiguities."[10] At the same time, however, fascism did pay close attention to cultural movements and gave them sufficient support to prevent the forging of any artistic underground. One might speculate, then, that it feared undermining popular "consent" by favoring any single style. Yet it is just as plausible to believe it had no such conscious policy, that its aesthetic incoherence simply reflected regime incoherence.

Was Mussolini's aesthetic policy incoherent, then, or incoherent like a fox? No definitive answer seems possible. What is clear is that, in the wake of the Matteotti Crisis and Mussolini's assumption of dictatorial power, Mussolini was thrust on the defensive toward intellectuals and responded with a number of initiatives, such as the Enciclopedia Italiana, the Reale Accademia d'Italia, and the Istituto Nazionale Fascista della Cultura, aimed at co-opting them. Then, as regime confidence grew in the late 1920s, it gradually established a corporative system under the Ministry of Corporations, which, especially during Bottai's leadership from 1929 to 1932, did exercise a mildly coercive, intimidating control over cultural production. Yet the regime always preferred the carrot of officially sponsored exhibitions over Nazi-style bludgeons. And it not only permitted but even sanctioned modernist expressions within those exhibitions. While the upsurge of fascist hard-liners such as Farinacci and Giuseppe Pensabene in the 1930s ultimately meant the defeat of modernist efforts to gain official recognition of their principles, even after the anti-Semitic laws of 1938 and the alliance with Hitler, artistic freedom was never entirely stamped out in Italy, as Bottai's efforts as minister of national education (1936–1943) remind us.[11]

How, then, might we conceive the overall field of aesthetic positions in the muddled and contradictory environment that fascist Italy presents? Simplifying, one might begin with a triangle representing the three basic positions of avant-garde modernism, conservative traditionalism, and fascist intransigence. By fascist intransigence, I mean the view that art should be made subservient to the needs of the fascist regime and that all those art movements, especially modernist ones, that failed to so subordinate themselves should be condemned. Each position had well-known advocates. For the modernists, Marinetti's futurism remained the purest example, even if, as I have been suggesting, the postwar variety was more

fragmented, less dynamic aesthetically, and more compromised both culturally and politically than its heroic forebear. For the conservative position, the clearest and most influential exemplar was probably Ugo Ojetti, who, as culture critic for *Il Corriere della Sera* and as a wealthy establishment fixture on art and literary prize committees, staunchly opposed modernist initiatives, even (and perhaps especially) those of the relatively tame Novecento movement. For the fascist-intransigent position, the most prominent proponents, besides Farinacci and Pensabene, were other prominent *gerarchi* such as Achille Starace, Fascist Party national secretary from 1931 to 1939; the anti-Semite Giovanni Preziosi, who was made a minister of state in 1938; and Alessandro Pavolini, who was the founding editor of the rabidly fascist *Il Bargello* in Florence and who became minister of popular culture in 1939. Coming to prominence after 1930, these men condemned all independent art movements and favored the sort of idealizing, naturalizing, monumental, and celebratory art generally associated with totalitarian regimes.[12]

This picture must, however, be complicated in several ways. First, there were at least four influential players whose cultural position lay somewhere between Marinetti's futurist modernism and Ojetti's conservative traditionalism. These were Sarfatti and her Novecento movement; Massimo Bontempelli's identically named and loosely related literary movement, which championed European modernist writers but within a self-consciously moderate discourse designed to appeal to a wide middlebrow audience; Bottai's varied but always influential activities on behalf of a "liberal," urban, and urbane fascism; and the architectural rationalism of the Milanese "Gruppo 7" movement which, despite being Italy's version of the avant-garde architecture known elsewhere in Europe as the Modern movement or International Style, compromised itself with conservatism in the 1930s in order to gain regime favor.[13] Second, there was the group around the Roman daily *L'Impero* (1923–1933), which, although futurist by background and sensibility, championed a "revolutionary" fascism of the first hour that brought them close to fascist intransigence, even if their stance toward regime policy was often critical.[14] Carli, for example, was a friend and follower of Farinacci, and another member of the group, Telesio Interlandi, held views similar to those of the most intransigent *gerarchi*. Finally, and most important, there was the *strapaese* movement around Maccari's *Il Selvaggio* and Leo Longanesi's *L'Italiano* which, as we shall see, offered a unique blend of avant-garde modernism and political reaction.

MARINETTI AND FUTURISM IN A POSTWAR WORLD

During futurism's first six heroic years, Marinetti was furiously driven by two passions: to be acclaimed as the leader of an international avant-garde headed by Italian futurism and to reshape an emerging commodity culture in a futurist mode, one committed to art's autonomy in the sense of creative control by artists and yet utilizing elements associated with both high and low culture in order to appeal to a cross-class, cross-gender audience, thereby upsetting the sacralized bourgeois culture of the day. Part maestro and part entrepreneur, Marinetti took politics seriously in this period, but whatever revolutionary dreams he had were not very concrete. Moreover, he neither said nor did anything to suggest that he aimed to challenge capitalism or even the hegemony of the bourgeoisie within it.

It is this prewar Marinetti who is mostly encountered in scholarly studies even today, but especially in the classic historiography that predates 1980.[15] The primary exception is Crispolti, whose work on "second futurism," beginning in 1960, widened the futurist panorama to the entire period up to Marinetti's death in 1944. By the time of the Turin exhibition he organized in 1980 on the futurist "reconstruction of the universe," many new questions on the political and aesthetic objectives of the interwar movement and the relationships among different regional futurisms, as well as between Marinetti and independent futurisms, were in the air.[16] And when, in 1986, a comprehensive exhibit on futurism was held at the Palazzo Grassi in Venice, it was appropriately entitled "Futurism and Futurisms."[17] Yet, while the acknowledgment of futurism's multiplicity was an important step, it hardly resolved the larger question of how to understand the fundamental relationships among the various chronologically and geographically based parts. One proposed solution would have us distinguish futurism as avant-garde from futurism as style and then maintain that, while both were present in the heroic period, the former dies with Boccioni in 1916 and the latter ascends to full prominence and develops in multiple new ways thereafter.[18] Another argument widely found in the historiography of futurism is a simple continuity thesis based on some fundamental characteristic or essence of the movement.[19]

Neither of these solutions seems to me to be optimal. Against the first, it must be said that futurism continues as an avant-garde—indeed, its avant-garde orientation intensifies in the 1917–1920 period—even as

futurism as style begins to blossom. Against the second, it must be said that the apparent continuities in futurist goals and styles mask important variations in futurist avant-garde practices. At least five general varieties of futurist practice may be distinguished. First, there was the prewar practice of an autonomous avant-garde using public performance (above all, the *serata*) in an effort to build a mass audience for a unified aesthetic-political movement of cultural renewal. While audience-building techniques continued into the fascist era, *serate* became virtually nonexistent under the new regime. Second, in 1915 and thereafter, a design-modernist practice developed in which the aim was to develop a total style suited to aesthetic applications in every facet of the modern everyday lifeworld. Third, between 1918 and 1920, Marinetti conceived and sought to actualize futurism as a political party leading a futurist-fascist alliance (or, at least, acting as a coequal member of such an alliance) aimed at taking power. Fourth, after 1923, Marinetti pursued a practice in which futurism sought to ally with fascism as its aesthetic complement by serving as its official state art. Finally, in the 1930s, Marinetti prevailed over a dispersed and somewhat chaotic mass movement, which, while clearly still subordinate to fascism, sometimes acted independently of the regime and maintained an independent identity and appeal. We have said or will say something about all of these, but given that only the second operated in relative independence from Marinetti, we shall begin with it.

With the International Exposition of Modern Decorative Art, held in Turin in 1902, the Italian public had been exposed to the Art Nouveau design concepts of northern European luminaries such as van de Velde, Behrens, and Charles Rennie Mackintosh.[20] Balla had attended because he was exhibiting at the allied Turinese Quadriennale.[21] Yet subsequent expositions such as the one held in Milan in 1906 were relatively provincial, and it was only in 1912, after working on the Lowenstein house in Düsseldorf and under the stimulus of futurism, that Balla established a research program on artistic constructions and their implications for the potential redesign of everyday life. Much of his painting, 1912–1914, explored the complex geometries and "rhythms" of the automobile as well as purely abstract "iridescent compenetrations," both of which made use of vivid color. In 1915, at the time of the manifesto on the "futurist reconstruction of the universe," he did three-dimensional "plastic complexes"—actually mixed plastic-pictorial complexes articulating a formal vocabulary for the constructed object by means of dynamic outlines and fields of color that together could produce "an explosive art, an art of surprise."[22] Together with Depero, he then explored the

implications of artistic construction for "every possible aspect of reality: the image of a city and its architecture, stage sets, artificial nature, exhibition installations, . . . furniture, clothes, everyday objects and appliances, advertising, typography, books, aesthetic objects, narrative prose, works for the theater, poetry, . . . photography and photomontage, cine films, mass communications (radio), postal art."[23] Perhaps most famously, in the spring of 1914 he wrote a manifesto in French on "the futurist men's suit," which Marinetti then surreptitiously transmuted into Italian as "the anti-neutral suit" manifesto of September, the better to serve the incipient intervention campaign.[24]

At both abstract and concrete levels, then, Balla began an exploration of design modernism in advance of his northern European counterparts, and he led his protégés Prampolini and Depero into the enterprise as well. Yet the mood of this work was one of playful inventiveness—a pursuit of "art-life-entertainment aiming precisely at the ephemeral and the banal."[25] Thus the reconstruction manifesto conceived the "futurist toy" as the fundamental fruit of the exploration of plastic complexes, one that would "accustom the child to spontaneous laughter" and "be of great use to adults too, since it will keep them young, agile, jubilant, spontaneous, ready for anything, inexhaustible, instinctive, and intuitive."[26] In this sense, the work shared much more with the world of the *serata* than with the sobrieties of De Stijl, Bauhaus, and purism. Not surprisingly, then, Balla was never willing to make the move from craft to industry, and the tradition of design modernism he spawned would remain domestic and artisanal in orientation, coming to fruition in the *"case d'arte futurista"* [futurist art centers] movement of the late 1920s and 1930s, in which applied art remained far more rooted in the *atelier* than in the factory. Moreover, by the 1930s this design modernism as expressed through the *case d'arte* had become shamelessly commercial and, thus, dubiously modernist in the sense of presenting any real resistance to commodity culture.

Other futurists within Italy's design-modernist world seemed to go in a more genuinely industrial direction. In their 1923 manifesto on "mechanical art," Prampolini and his friends Ivo Pannaggi and Vinicio Paladini cited a rich futurist tradition of exploring machine aesthetics, including Marinetti's use of motors when he declaimed his *parole in libertà* at a March 1914 *serata* in Rome, Prampolini's 1915 manifesto entitled the "Absolute Construction of Motor Noises," and Gino Severini's 1916 article for the *Mercure de France* on "machinism in art."[27] Yet the truth is that even their interest in the machine was more metaphorical

than concrete. While they celebrated modern technology in the abstract for the speed and dynamism it brought with it, they were less than fully engaged with the technical, economic, or even aesthetic realities of industrial production. Even Prampolini's journal *Noi,* which in its second series served as the primary futurist bridge to the northern and eastern European world of constructivism, purism, and production art, did not succeed in articulating a design-modernist program with anything like the rigor found in those movements. Not surprisingly, then, the latter tended to regard Italian futurism as quaint and outmoded, as Marinetti learned when he nearly came to blows with Lajos Kassák, leader of the Hungarian *Ma* group, at a Vienna hotel in October 1924.[28]

In those parts of Europe where it was strongest, design modernism tended to be associated with the political left. French purism was the exception in this regard, yet its technocratic orientation made it no less fully aware than constructivist and productivist tendencies elsewhere of the aesthetic dimensions of industrial production and the corresponding need to rethink the artistic vocation in relation to the industrial process. In Italy too, there was an avant-garde left that included some futurists. It was especially strong in 1921–1922, when it operated through Proletkult, a cultural organization established by Antonio Gramsci in Turin, and the futurist circle around Paladini's journal *Avanguardia* in Rome.[29] Yet in neither case was there a serious discussion of the integration of art into industrial production. Paladini used his writings in this period mostly to explore the need for a communist revolution in Italy, one to which futurism would contribute by providing the "spiritual" side of a revolutionary "synthesis" leading to "complete renewal."[30] His friend Prampolini did attend the Düsseldorf congress of May 1922, and he contributed a piece on machine aesthetics for the July issue of *De Stijl.*[31] Yet by the time the manifesto cosigned by Prampolini, Pannaggi, and Paladini appeared in spring 1923, the movement to which it was connected was fading fast, given Mussolini's assumption of power the previous October. And for reasons that will become apparent shortly, Paladini and Pannaggi would soon become less comfortable with futurism, especially in its Marinettian version.

Given the political polarization of postwar Italy, apparently "Bolshevik" ideas such as design modernism or production art were difficult to discuss except on the left. A university for the decorative arts, which one historian has dubbed an "Italian Bauhaus," was founded in 1921 at Monza near Milan, but both the school and the "triennial" exhibitions to which it was linked soon came under fascist control and were bent in

an aesthetically conservative direction.[32] Likewise, after fascism came to power, futurist rhetoric regarding machine art declined markedly and futurist design modernism became ever more domesticated and commercial. Thus, the final issue of *Noi* in 1925, which according to the cover was dedicated to the futurist participation at the Paris Exposition, reproduced the paintings that Prampolini, Balla, and Depero had shown there, but limited its written texts to a reprinting of the 1923 manifesto on mechanical art and of Antonio Sant'Elia's 1914 manifesto on futurist architecture, both in French translation.[33] Subsequent relations between futurism and Italian industry were perhaps best typified by Depero's 1927 "Manifesto to the Industrialists," which offered to do *"architettura pubblicitaria"* [advertising-oriented architecture] for Italian industry so that its streamlined automobiles would not have to be displayed in baroque palaces.[34]

But let us return to the grander days of 1919, when everything seemed possible. In that year, Marinetti "organized in Milan the first *Grande Esposizione Nazionale Futurista* . . . featuring over 460 works of painting, sculpture, freewording, decorative arts, and architecture."[35] Yet his own greatest work of art was his newly established Futurist Political Party, through which he seduced himself into the fantasy of a counter-bourgeois political order with futurists as its new political class. In his vision, the Futurist Party would soon abolish prisons and police, reduce government to a minimum, dissolve the family for free love, and promote a new artistic sphere that would vastly multiply the number of creative artists and make life itself into a "work of art" [*in cui la vita sarà vita-opera d'arte*].[36] The move was akin to the postwar political turn described earlier in relation to Bottai and Malaparte, except that Marinetti imagined politics subordinated to his own world of art rather than the reverse. In this expressly political phase of futurism, avant-garde and party merged, but the uniquely futurist *serata* was abandoned for (or, perhaps, transformed into) the political rally, party congress, and occasional excesses of *squadrismo*.[37]

All of this collapsed abruptly in the middle of 1920, as Mussolini made clear the political irrelevance of the futurists for him and moved sharply to the right. Marinetti was thrust into a period, unique for him, of soul-searching reflection and reassessment. Objects of his earlier scorn, such as love and marriage, were now embraced both in his writings and in his life—he married Benedetta Cappa in 1923. His literary outpourings swelled noticeably, and they featured themes of betrayal, as in the thinly veiled autobiographical play *Il tamburo di fuoco* [Drum of

Fire] (1922), and political disillusionment, as in his novel *Gli indomabili* [The Untameables] (1922). A new emphasis on spiritual matters entered his manifestos. In "Il tattilismo" [Tactilism], which he presented in Paris and Geneva in January 1921, he portrayed the communist left as "materialist," in search of an artificial "paradise" rather than "life," and in favor of the "material appetites" of a "majority" rather than the genuine spiritual needs of the "minority made up of artists and thinkers."[38] Only the new sensory education of an art form he called "tactilism" could possibly save mankind from the loss of all spiritual experience. Likewise, in "Inegualismo e artecrazia" [Inequality and Artistocracy] (1922), he championed individual refinement, originality, exaggeration, and the qualitative while condemning the abstractness of political and collective ideals based on equality, fraternity, justice, and the quantitative.[39] The implication was that unless people were brought back to an awareness of the spiritual depths of their own individuality they would be deluded into seeking artificial paradises rather than true experience. Politics was to be shunned; vital experience depended on aesthetic and spiritual awareness.

By early 1923, however, Marinetti had come to see that a new form of futurist politics was necessary, if only to secure the right to a continued futurist exploration of the aesthetic. Thus he moved to restore some semblance of unity to futurist ranks, joining forces with Prampolini in the second series of *Noi* and with Carli and Settimelli of *L'Impero,* which printed two new futurist manifestos in March and April. In the first of these manifestos, Marinetti directly addressed the "fascist government," appealing to the "enormous influence that futurism has exercised in Italy and the world" in order to claim for the movement a set of "artistic rights"—such rights as a "credit bank for artists," state support for the arts, control by "avant-garde artists" over the content of national and regional festivals, and the like. More important than his demands and the anxieties they revealed, however, was the logic Marinetti put forward to defend them: "the political revolution must sustain the artistic revolution, that is, futurism and all the avant-gardes."[40] Fascism and futurism were now conceived as engaged in a common "revolutionary" enterprise through a strict division of labor. In effect, Marinetti was offering to limit futurism to the artistic and to provide loyal support for fascist politics in return for a kind of state sanction. The latter point was then reinforced in the second manifesto, cosigned by Marinetti, Carli, and Settimelli, which is dedicated "to Benito Mussolini, Leader of the New Italy."[41] As Claudia Salaris has aptly put it, "the global [futurist] utopia gives way to the demand for corporate guarantees."[42]

In 1924, Marinetti gathered the two new manifestos, along with a number of other political pieces from earlier years, into a book, *Futurismo e fascismo,* again dedicated to "*mio caro e grande amico Benito Mussolini,*" that reiterated in more detail the logic of the futurist-fascist alliance in a new introduction.[43] Opening with what over the next decade will become a characteristic appeal to the heroic origins of futurism in 1909 and with many long quotes from others regarding futurism's historical importance, Marinetti declared that "futurism is an artistic and ideological movement. It intervenes in political struggles only in the hours of grave danger for the Nation." Thus the suggestion was that futurism had been politically active because of the communist threat during the "*biennio rosso*" of 1919–1920; now that Mussolini had consolidated his power, it could safely return to its "artistic" mission, especially since "Vittorio Veneto and the advent of fascism in power represent the realization of futurism's minimal program." What this artful charade ignored were not only the far greater political ambitions futurism had declared in 1919–1920 but also the unified aesthetic-political vision it had maintained in its heroic era.

In the early days of the fascist regime before the Matteotti Crisis, Marinetti was already attempting to seduce the fascist master into making his movement the aesthetic basis of the regime. This effort would fail for reasons that historically minded observers were already able to divine. "Italian fascism," wrote Giuseppe Prezzolini in 1923, "cannot accept the destructive program of futurism but must on the contrary, given its *Italian* logic, restore the values that are the opposite of futurism's. Discipline and political hierarchy mean hierarchy and discipline in literature as well."[44] The interesting question, then, is not why Marinetti's effort to reshape futurism as a fascist state art would fail but why he persisted in it for so long.

Part of the answer lies in Marinetti's personal evolution. As we have seen, after 1920 he had begun to make the conservative turn that would ultimately predispose him toward a fascist version of a respiritualized society in a way that would have been far more difficult, if not impossible, from the standpoint of heroic futurism.[45] Indeed, other observers of the Marinetti of these years had begun to perceive that his ideals were no longer necessarily so antithetical to those of the incipient regime as Prezzolini had pictured them.[46] Nonetheless, comfortable or uncomfortable as he may have been with the regime, Marinetti could hardly escape recognizing that his movement and his own freedom as an artist were under threat. He therefore adapted a piece of wisdom usually associated

with the world of sport: the best defense is often a good offense. Evidence for why Marinetti might plausibly have pictured himself in a defensive position is not hard to find. The cultural climate was generally one of a return to order, and in these circumstances modernist movements that explicitly invoked tradition, such as Sarfatti's Novecento, which Mussolini had favored with a speech at its first group show in Milan in the spring of 1923, appeared to have the advantage. Indeed, at the Venice Biennale of 1924, which featured many *novecentisti* as well as works by a number of Russian futurists, their Italian counterparts were not even invited. Moreover, as the fascist police moved to a massive crackdown on the left in 1925–1926, no one who had declared himself a "revolutionary" was safe, and in fact, the police did develop a file on Marinetti which declared his "political coloration" to be "antifascist."[47]

Nor is it hard to find signs of Marinetti's "good-offense" counter-strategy. In November 1924, he had convened what was billed as the First Futurist Congress in Milan. Although Mussolini did not himself favor it with an appearance, as he had the Novecento show of the year before, a telegram from *Il Duce* was solemnly read at the occasion and loudly trumpeted in postcongress publicity.[48] In February 1925, just a few weeks after Mussolini's assumption of dictatorial powers, Marinetti transferred his residence from Milan to Rome and arranged to have a sumptuous banquet given by Roman luminaries at the Cabaret del Diavolo in the Hotel Élite feting his arrival. Again, while Mussolini chose not to appear, his effusive statement of regret was reprinted in Marinetti's ever-present propaganda.[49] Finally, in May and June of 1926, Marinetti made the first of several international trips in which he sought to make himself into a kind of cultural ambassador for Italy, this time in an elaborately staged tour of Brazil and Argentina, which was recounted with equally elaborate fanfare in the futurist press upon his return.[50]

All of this posturing gained Marinetti Mussolini's attention but nothing more. Indeed, the *Duce*'s consistent snubs were making it clear that futurism was not destined to be a new fascist state art, and he was sometimes quite explicit on the point. "It is far from my idea," he wrote in *Il Popolo d'Italia*, "to encourage anything that might be likened to an art of State. Art has to do with the works of individuals."[51] It is true that Mussolini sometimes also called for a "fascist art," even if not for an "art of state."[52] In any case, attentive to such equivocations or not, Marinetti persisted. He curried regime favor by agreeing to join the Accademia in 1929, despite his own lifelong demand for the closing of all academies, which had been reiterated in a manifesto just six years before. When he

found that the polemics between the *"strapaese"* of *Il Selvaggio* and the *"stracittà"* [super-city] of Bontempelli's *Novecento* were deflecting attention away from futurism, he launched his own *"stracielo"* [super-sky] movement with its attendant aesthetics of *aeropittura, aeropoesia, aeromusica,* and the like.[53] At about the same time, he attacked Sarfatti's Novecento, contesting "the right of the *novecentisti* painters to declare their paintings to be the only fascist paintings, which they do with the aim of gaining an ever greater monopoly on state prizes, well-paid jobs, and sales to public agencies."[54] And he enlisted young futurist lieutenants such as Fillia (Luigi Colombo) to back up his claim that "only the futurists, as a group of artists who prepared and collaborated on the fascist revolution, have the right to speak of an Art of State."[55] None of these efforts, however, could disguise the fact that Marinetti was being consistently outmaneuvered by a prewar futurist *amica* who had subsequently become a tenacious and tactically brilliant, independent, cultural *impresaria.*

FUTURISM AND NOVECENTO: THE CONTEST FOR AN ART OF STATE

With its combination of material wealth, cultural marginality, and aesthetic focus, the early life of Margherita Grassini bore some uncanny resemblances to Marinetti's.[56] Born in 1880 into an upwardly mobile Jewish family living on the edge of the Venetian ghetto, she moved in her early teenage years into the Palazzo Bembo on the Grand Canal. Sparing no expense in her education, her family employed private tutors who imbued in her a love of European art and culture as well as a close acquaintance with its nineteenth-century champions: Schopenhauer, Nietzsche, and, above all, Ruskin. From them she gained a confidence that art could play an important public role in shaping and reshaping the spiritual, moral, and political identities of a people, and she firmly rejected art for art's sake in favor of the view that art must express social values.

Unlike Marinetti, however, her early political allegiances were socialist. In 1898 she married Cesare Sarfatti, a young lawyer who was a product of the same small Venetian-Jewish elite, and within a few years they had moved together to Milan to be at the center of Italian socialist politics and its modern cultural life. In eager pursuit of a career in art criticism and journalism, she soon met Ugo Ojetti, then also a socialist, as well as Umberto Notari. When the latter was accused of obscenity for his novel *Quelle signore,* Cesare became his lawyer and Marinetti their constant companion at the Parma trial. Two years later in 1908, she became

an art critic for the socialist *Avanti!*, and in her memoirs she tells us that she was an early devotee of the futurist movement which would be headquartered in the Casina Rossa at Corso Venezia 61, just a few doors down from the Sarfatti flat at number 93.[57] There she would play the gracious hostess at her salon, which was frequented by many futurist painters, especially her favorite, Boccioni. Meanwhile, Cesare became engaged in yet another pornography trial, this time as one of the defense attorneys for their already famous avant-garde neighbor, and Margherita widened her own avant-garde contacts to include the Florentine circle around the review, *La Voce*, to which she made occasional contributions.

By 1912 she had met Mussolini and attached herself to his radical wing of the Italian Socialist Party. Their relations would be close over the next decade and a half, although her biographers maintain that they did not blossom into a full-blown love affair until 1918.[58] When the war came, both Cesare and Margherita moved in nationalist and prointervention directions, although she would find it difficult to break with the Socialist Party and did not do so for more than a year after Mussolini's dramatic separation of October 1914.[59] During the war, she wrote the art column in Notari's journal *Gli Avvenimenti* that Boccioni had done until his death, and she continued with it until the journal itself died in October 1917. In 1918 she took over the art column for Mussolini's *Il Popolo d'Italia*. One of her early articles there was a posthumous appreciation of Apollinaire, whom she held up as an exemplary avant-garde critic, a patriotic soldier, and a champion of the same combination of classicist aesthetic values and modernist forms that she herself advanced.[60]

Among those frequenting her salon in 1919 were the painters Achille Funi, Leonardo Dudreville, and Mario Sironi. Together with Luigi Russolo, they would write a manifesto, "Against All Returns in Painting" (1920), in which they proclaimed their continued adherence to futurism and—ironically, given their impending itinerary—opposition to the current fashion of a "return to order."[61] Given that Russolo and Sironi were especially well known as futurists who had posed with Marinetti in one of the then famous photos from the front, the manifesto appeared to be just another instance of the futurist diaspora of the postwar years.[62] Later memoirs by Funi and Dudreville further suggest that their reaffirmation of futurism was not intended as any sort of new program for futurism, let alone a fresh avant-garde direction, but was mostly just a proclamation of their collective intention to associate with one another.[63] It is thus all the more remarkable that, even before the

manifesto appeared, these four painters were already being shaped into the nucleus of an avant-garde group based on ideals precisely the opposite of those encapsulated in their manifesto's title.

In contrast to Marinetti, Sarfatti wrote only occasional poetry and had not used her prewar salon to launch an avant-garde modernist movement. But in 1919, as she wrote art criticism for Mussolini's newspaper and edited her own allied avant-garde journal, *Ardita,* she seems to have sensed the opportunity for creating such a movement as a kind of cultural arm of an emerging fascist politics. Accordingly, she began to arrange patronage for her stable of artists even before their collective manifesto appeared.[64] Over the next three years, she wrote numerous reviews of their work for *Il Popolo d'Italia, Ardita, Gerarchia,* and other publications, and became a kind of unsolicited press agent for them.[65] In October 1922, when her lover bluffed and blustered his way into power, she saw that the time was ripe to move to fulfill her own ambitions. Although it is not clear whether at that point she already saw her Novecento movement as a potential state art, we do know that once Mussolini took power she exhorted its members to work toward a "collective synthesis," began to organize meetings to plan for the first Novecento exhibition, and clearly aspired to forge a political connection with the regime by arranging to have Mussolini speak at the opening.[66] By 1924, she had scored the first major national success for her movement when she garnered an official invitation to have them exhibit at the Venice Biennale, the first time any organized group had ever exhibited there. In her promotional copy for the exhibit, she acknowledged that "each [of the Novecento painters] has his own artistic vision" and yet, without claiming for them a common style or set of artistic principles, she portrayed them as "inclined toward agreement about some essential unities . . . ideals of concreteness and simplicity that are becoming increasingly clear and defined."[67]

In recreating futurism as an "artistic revolution" allied to the larger "political revolution" of the fascist regime, the Marinetti of 1924 had seen the writing on the wall and lowered his ambitions. In contrast, the Sarfatti of 1924 had utilized the fascist victory to catapult herself to new heights as an avant-garde leader. Yet it would be wrong, in my estimation, to see her as a mere opportunist. No doubt her conception of a radical revision of aesthetic values linked to and upholding a return-to-order politics was opportunistic, but it was also based on real convictions.[68] Her nationalism had intensified during the war, partly in response to the

devastating loss of her teenage son Roberto to an Austrian bullet in January 1918, and while she remained committed to the idea that art should play a leading role in advancing public values, she now embraced the very unsocialist and even undemocratic notion that avant-gardists should become "spiritual guides" who "determine, unawares, the future attitudes of the general populace."[69] Moreover, her art criticism evinced a definite aesthetic orientation that left little doubt as to what those attitudes ought to be and what sort of avant-garde ought to lead.[70] During the war and early postwar years, she had come to understand that the avant-garde rebellions of the prewar era had made valid contributions to a definition of aesthetic modernism but that they were no longer consonant with political realities, which demanded a synthesis of modernism and "classicity." Modern art would necessarily innovate, but it ought to do so within the traditional, formal vocabulary of Western art and its specific national traditions, which required attention to volume, solidity, perspective, and clarity of form as well as to art's ethical and public functions. As she wrote in 1925, the Novecento painters were dedicated to "lucidity in the form and dignity of the conception" of the artwork and to eliminating "the artificial and the eccentric," as well as the "arbitrary and obscure."[71] Or, as she put the point in 1930: the name *Novecento* reflected a "call to order," its painters having "proclaimed themselves Italian, traditionalist, modern." Theirs was an art perhaps best exemplified by the "aristocratic" Sironi, who is "the painter of mechanical urban landscapes as unrelenting as the geometry of the lives enclosed by cube-shaped houses on rectilinear streets." Yet Sironi's art also called forth transfigurative possibilities in the way it played "supplely with grays and yellowish-browns, while outside the velvety shadows and the perspective provided by receding arches, female figures smile austerely, as if encircled by a mysterious halo."[72]

Clear as her own aesthetic and political convictions may have been, Sarfatti was nonetheless in a tactically difficult position because she was promoting a movement whose members did not necessarily see themselves as united, especially regarding the political implications of their common association. Dudreville, in particular, was uncomfortable being as closely associated with the regime as Sarfatti had brought them. Moreover, while all the most important Novecento painters worked with the traditional themes, blocky forms, allegorical figures, and architecturalism associated with a neoclassical style, they did not necessarily share a common sense for the way they should be organized as an avant-garde movement. In Dudreville's view, for example, there was a sharp distinc-

tion between the Novecento movement born in 1922 and its successor, with which he refused to be associated, that emerged after Sarfatti re-christened it Novecento Italiano in early 1925. With this move, which may have been in response to Mussolini's assumption of dictatorial power, Sarfatti sought to reshape Novecento as a more structured and organized enterprise, complete with a governing committee that included the mayor of Milan, an honorary committee headed by Mussolini, and an elaborate set of exhibition rules, all codified in a long "circular letter."[73] Yet there was more to her design than structures, snob appeal, and rules. Through her honorary committee, which included Marinetti and Ojetti as well as close friends such as Notari and Ada Negri, Sarfatti sought to embrace nearly the entire cultural spectrum and, in so doing, signaled the strategic shift upon which Novecento Italiano was based.

In February 1926 came the first official show of Novecento Italiano, again addressed by Mussolini. What was most notable about it, however, was the broad range of artists represented, some 114 in all, including such prominent names as Carrà, Severini, Giorgio de Chirico, and Giorgio Morandi, as well as rivals from the current futurist camp such as Balla, Depero, and Prampolini, and in addition, Soffici and Libero Andreotti from Tuscan *strapaese*. As Sarfatti wrote in the catalog copy, she had invited all "the best forces in the new artistic generations."[74] Yet, while this inclusiveness may have made sense in terms of building a potential "art of state" by mirroring the apparent regime preference for an aesthetic pluralism, it also undercut the possibility of any greater "collective synthesis" among the original *novecentisti* themselves. It is difficult to have common commitments to style and principle while also seeking to represent a whole nation.

Yet, wise or unwise, Sarfatti's effort to build a national avant-garde under the Novecento Italiano umbrella quickly fell apart. Ojetti defected from the honorary committee in 1928 and became the movement's most implacable foe. *Il Selvaggio* increasingly made Sarfatti's movement the target of its satirical thrusts. Most important of all, the regime's establishment of the Confederation of Professionals and Artists in 1928 undercut any hope that an autonomous movement, however well connected, was going to organize artists and set standards and policies for art exhibitions. None of this put Novecento out of business. Although its second official show in 1929 was noticeably less successful than the first— Mussolini refused to speak to the more restricted audience that remained for Novecento in the aftermath of all the defections—Sarfatti would continue to register important successes. In September 1930, for exam-

ple, she organized an impressive exhibit in Buenos Aires which featured forty-five artists and included works by *strapaesani* such as Soffici, who were enticed by the international exposure. And the *novecentisti* played an important role at the 1932 Mostra della Rivoluzione Fascista, mounted in Rome for the tenth anniversary of the regime. Here, of the nineteen main floor rooms that were the heart of the exhibit, Sironi designed four of them and Funi two, while *strapaesani* such as Maccari and Longanesi did only one each, and the futurists did none.[75] Moreover, Sarfatti herself penned the celebratory article that has perhaps most memorably characterized the political meaning of the Mostra for historians today.[76]

Still, by the end of the 1920s, signs that the reassertion of conservative traditionalism in art was intensifying were unmistakable, reflecting as they did the increasing conservatism and traditionalism of regime policies, most notably in the Lateran Pacts signed by Mussolini and the Vatican in February 1929. In this climate, for example, Soffici called for an art animated by Catholic religiosity, demure and traditional in subject matter and form, and "national" in the sense that it explicitly sought to exclude foreign influences, including foreigners themselves from participating in it.[77] Even more provocatively, Marinetti abandoned his rabid, lifelong anticlericalism and publicly declared himself a Catholic.[78] With rivals like these, it is not surprising that Sarfatti should introduce the participants of the 1929 Novecento show as "young fascist artists, that is, revolutionaries of modern restoration, in art as in social and political life."[79] Yet the phrasing is a striking intensification of her earlier, more politically benign rhetoric just the same. And it revealed an accurate sense of what lay ahead, as the polemic against her by the fascist intransigents was only then a year away from being launched.

Thus, if Sarfatti's greater aggressiveness in 1929–1930 provoked Marinetti into a polemical exchange with her, that exchange must be understood against the background of the failure of her inclusiveness efforts of 1926 as well as the fast accumulating evidence of a rising tide for the fascist right. Ironically, it was just at this point when Sarfatti and Marinetti were coming to fight one another more openly that the larger national environment was turning decisively against both of them. Amid a worldwide depression and emerging totalitarianisms in Russia and Germany, the question that now loomed was not which avant-garde would prevail in Italy but whether any of them would survive at all. As attacks mounted by the likes of Farinacci, who used his positions as edi-

tor of the Cremona daily *Il Regime fascista* and, after 1933, as a member of the Fascist Grand Council to conduct a nonstop campaign against avant-garde modernism, Marinetti became less concerned with the nuances of *stracielo* than with defending himself against charges of being degenerate and anti-Italian. In 1934, while in Berlin for an *aeropittura* show, he felt the terror that Hitlerite polemics against degenerate art and "cultural Bolshevism" had produced in the German avant-garde, a phenomenon with which he had already been acquainted indirectly when Kandinsky wrote to him in 1932 regarding the closing of the Bauhaus in Dessau by the Nazis there.[80] Although the Italian situation was less dire, responses to intransigent attacks were nonetheless a main preoccupation of the futurists in the years after 1933.

Yet futurism's fate was one of striking complexity that cannot be captured by the image of suffering the torment of the intransigent right, powerful as that torment was. Two other factors—themselves contradictory—must be introduced to comprehend what happened to it. The first was that futurism took on something of the character of a mass movement in the Italy of the 1930s in a way that was mostly independent of Marinetti, even if he remained its titular head. Throughout the country at the local level, we see futurist groups being formed, journals created, "*case d'arte*" founded, and exhibits held, which suggest a popular surge at the base of the movement.[81] Yet, these groups were far from being a revival of the populist dimensions of Marinetti's prewar project, at least if we think of the *serata* as against one of Notari's marathons through the streets of Milan. For, like the latter, this new "futurist" activity was celebratory and innocuous, completely lacking in critical edge. In the words of one scholar, the everyday futurists of the 1930s looked "just like a sports team" with their "bright-colored ties, futurist hats and various badges."[82] Much of their activity was linked to *aeropittura* and the various other "aero" arts, including even aeroceramics, aerodance, and aero-architecture, a manifesto concerning which was cosigned by Marinetti and two other futurists in 1934.[83] What made the aero-arts so popular was that this was the great age of record-breaking distance aviation, symbolized for Italians by Italo Balbo's transatlantic flight of 1931. And, just as in aviation, so too in aeropoetry, "records" could be set. In 1933, the futurist poet Farfa published a volume whose cover presented the poet's photograph, which was captioned: "Farfa, national record-breaking poet, winner of the first futurist poetry race, being crowned with the aluminum helmet at an altitude of one hundred meters."[84] In short, this

was a pop culture of a would-be consumer society—a futurist culture industry—rather than any sort of resistance to commodification.

Indeed, aeropainting exhibitions were often so large—two hundred in Rome in 1933, perhaps five hundred at the Venice Biennale a year later— that one might well say that they produced not only a pop culture for the masses but a pop culture by the masses.[85] At the same time, futurists led by Depero (but also including Balla and even Pannaggi) contributed without inhibition to what there was of a commodity culture in fascist Italy by creating advertising art for its industrial products. What aeropainting and advertising art had in common was that neither was of much concern to the fascist *gerarchi* and their police. As Mussolini's regime organized itself for empire and war, it focused much attention on reining in avant-garde modernist leaders but apparently very little on their popular offspring. There seems, in fact, to have been much room for maneuver for street-level futurists within the Italian civil society in the half decade leading up to the 1935 invasion of Ethiopia, even as their leadership suffered top-down persecution.

The other factor which must be considered in taking the measure of futurism's fate is Marinetti's own remarkable evolution from antipasseist *enfant terrible* to the fascist man of order who paid obeisance to Mussolini and his regime long after it made any sense to do so from the standpoint of his own self-interest. Beginning with his "spiritual" turn of 1921–1922 and his decision to marry in 1923, through his acceptance of the regime and move to Rome in 1925, and finally to his decision to join the Italian Academy in 1929 and to convert to Catholicism in the 1930s, Marinetti became more and more conservative in his self-presentation. As Marja Härmänmaa has exhaustively documented in a recent study, this evolution saw Marinetti "challenge decadence" by adopting a variety of personal ideals—the "healthy man," patriotic warrior, devoted father, spiritualist and man of faith—that stood in startling contrast to the irreverent, sometimes subversive inventiveness that the futurist movement had represented and that continued to be echoed, albeit in highly domesticated form, in futurism as mass culture.[86] In contrast to the insolent firebrand who presided over prewar *serate,* the Marinetti of the 1930s appears as a dour patriarch with a distant, somewhat goofy aristocratic bearing whose colorfully dressed children are too busy playing harmlessly with their futurist toys to pay him much attention.

If the relationship between futurism and Marinetti became increasingly bizarre and even incoherent, the same could not be said for Novecento and Sarfatti, since little was seen of either of them after 1933.

The Novecento painters did not disappear. Sironi flourished as never before as he abandoned the easel for a fascist-dedicated *pittura murale,* but he no longer associated himself with the Novecento movement.[87] However, for Sarfatti, who went into exile in 1938, these years were nearly unbearable. For reasons that are not entirely clear, but which undoubtedly involved her Jewish background, her womanhood, and her long since concluded relationship with Mussolini, she sustained an even sharper attack from the Italian fascist intransigents than did Marinetti. Already in 1931, in response to one of Farinacci's take-no-prisoner assaults, she was reduced to deploying her patriotism and fascist loyalism into a plea for the right for Novecento Italiano to continue to exist. "This right, besides deriving from general principles, is based upon my own passage from being an interventionist in 1915 to being a fascist in 1919, mother of a volunteer who received a gold medal and fell on the battlefield at seventeen, and mother of young *squadrista* who at sixteen was a comrade of Aldo Sette's. These things are too well known by war combatants and fascists of the first hour for me to have to repeat them." These are words from a letter she wrote to Farinacci, whose chilling response was to declare publicly that his first impulse had been to throw the letter into the wastebasket.[88] Similar letters in 1933 provoked a similar response, except that now Farinacci could also point approvingly to Hitler, "who thinks about artistic degeneration just as we do."[89] Somehow, Sarfatti suffered on for another five years, but with the passage of the racial laws, she fled to Paris, then Barcelona, Montevideo, and Buenos Aires, returning to Italy only in 1947.

For their part, the futurists acquitted themselves rather well in their battles with Farinacci and his henchmen, especially considering the overwhelming firepower arrayed against them. Prampolini, for example, had the courage in 1934 to reply directly to one of Hitler's attacks on modern art, calling it "absurd" and based on "fear."[90] And in the same year, Mino Somenzi, editor of perhaps the most important futurist journal of the period, which was successively named *Futurismo, Sant'Elia,* and *Artecrazia,* artfully defended his enterprise by maintaining that, in three years of publication, his journal had always "insistently laid claim to advancing a fascist art." Implying that the intransigent fascist right was suffering from a failure of nerve, he advised keeping all eyes on the future: "worrying excessively about illuminating the glories of the past implies a lack of courage and above all a lack of faith in the present and future glory that we are creating. . . . The fascist regime, revolutionary as it is, and typically futurist in its Italian, innovating, synthesizing, and

speed-producing essence, ought not to fear battle in the artistic field because, just as in the political one, it will surely win." And then pointing to America as a country regarded by many as a land of the future, Somenzi portrayed fascist intransigence as a shameful reluctance to mount an appropriately forward-looking challenge.[91]

As late as 1937 Marinetti mounted a spirited attack on Hitler's degenerate art movement.[92] When in November 1938, Interlandi published an attack on all of modern art as "Bolshevik and Jewish," Marinetti organized a demonstration at the Teatro delle Arti in Rome for December 3, following it up with another in early January 1939. But the regime then mounted a firm reply, outlawing Somenzi's journal *Artecrazia* and using the Enciclopedia Italiana to rewrite the history of the futurist movement entirely in terms of its nationalist and fascist dimensions.[93] Meanwhile, Marinetti seems to have written a letter to Hitler (probably never mailed) in which he sought to distinguish futurism from the German avant-garde, which he conceded was too full of Jews, communists, sexual deviants, and alcoholics.[94] In the early 1940s, his finances and health deteriorating, Marinetti accepted a dole from the regime, then volunteered for duty at the Russian front in 1942, lent his support to Salò, and lived for six months in Venice, the city his 1910 manifesto had ridiculed for its hopeless *passatismo*.[95] In December 1944, he died in another tourist resort, the Lake Como village of Bellagio.

THE *STRAPAESE* ALTERNATIVE

In contrast to futurism and Novecento, the artists and writers associated with *Il Selvaggio*, which sprang forth in Colle Val d'Elsa near Siena in the wake of the Matteotti Crisis, appeared so dedicated to the pursuit of a fascist culture as a means of ensuring an Italian "return to order" that the regime never questioned their fascist credentials, even though they too championed a species of aesthetic modernism, exemplified for them above all by Morandi's painting.[96] Yet, paradoxically, they also differed from the *futuristi* and *novecentisti* in their resolute determination not to curry favor with the regime, of which, in fact, they would become increasingly critical. Dedicated "fascists of the first hour," they were wary of what they perceived as a widening gap between fascist ideals and the careerism and corruption they had come to associate with the fascist *gerarchi*, and they saw their political role as one of prodding the regime to remain true to itself. Significantly, they anchored themselves in Tuscany and did not move to Rome in the mid-1920s to be near the seat

of power, as did both Marinetti and Sarfatti. In so doing, they were acting upon the sort of nationalism, rooted in the artisan and peasant values of the *paese* [countryside], for which they stood. And while this regionalist nationalism led them to reject both prewar modernism and its war and postwar successors, movements for them associated with a false cosmopolitanism, internationalism, and elitism as well as with political inefficacy, their "*strapaese*" ideology remained truer to the prewar avant-garde modernist project of a cultural and spiritual renewal of modern society than did either interwar futurism or Novecento. For at the heart of their view lay a perception of profound civilizational crisis deriving from the materialism of modern civilization, which had in turn led to the crisis of World War I, the Italian political response of Mussolini's fascism, and most recently, the doubts about the ability of fascism to remain true to its founding vision in the wake of the Matteotti murder. In true modernist form, their answer was to push fascism into being the new regime of modernity that would resolve the crisis by reshaping the public sphere in ways that would renew the concrete local—qualitative—dimensions of Italian life.

Led by Maccari, who edited *Il Selvaggio* from its birth to its death in 1943, the circle included such prominent artists and writers as Soffici, Malaparte, Longanesi, Piero Bargellini, Ottone Rosai, Camillo Pellizzi, and Berto Ricci. All Tuscans except for Longanesi of Bologna, they understood themselves to be perpetuating the avant-garde tradition associated with prewar Florentine journals such as *La Voce* and futurist-oriented *Lacerba*, with which in fact a number of them had been directly involved. Those journals had promoted the myth of a great war as the means to the modernist end of cultural renewal, but their formulations came to appear rather naive and abstract when those who had written them returned from the reality of the war in 1918. By then, the wide-eyed world of the prewar avant-garde seemed eons away, the sense of political crisis in Italy was so great as to create not simply the hope but the expectation of an impending political system change, and the threat of Bolshevism loomed large. In this atmosphere, a turn toward active political commitment seemed not only warranted but necessary. Once fascism appeared, veterans such as Soffici seized upon it as a genuine mass movement that could potentially take political power. Yet this political turn implied an aesthetics of nationalism rather than internationalism, a populism rather than a vision of elite "autonomy," and a reintegration of Italy's classical artistic heritage into modern art rather than unfettered artistic experimentalism. Soffici was especially critical of those who con-

tinued to pursue an undisciplined avant-garde modernism of the pre-war sort, "tumbling among their 'dadas' as we stop to build our own house."[97]

Reeducated in the fire of the trenches, postwar Tuscan avant-gardists parted company with prewar modernism not on the question of its project of spiritual renewal, which they embraced more fervently than ever, but on their assessment of the aesthetic and political means needed to fulfill it. Although their rhetoric called upon apparently traditional conceptions of art and life, their politics were future-oriented and in-clined toward the ideals of sacrifice and public-spiritedness they saw as necessary to achieve that future.[98] Indeed, conservatives such as Ojetti, whom they saw as soft and comfortable, were among the foremost tar-gets of *Il Selvaggio*'s mordantly ironic bite. In their view, the modernist tradition was itself too implicated in the pathologies of modernity to be able to carry out its own project. To secure modernism's aesthetic foun-dations required a thoroughgoing critique of all of modern art's com-promises with science, technology, industrial capitalism, and commodity culture over the past three centuries. Although modern art was not to be rejected, it would have to be submitted to the discipline of a critique based on its history. And to secure its political foundations required a relentless sweeping away of all bourgeois incrustations from political and cultural life. Rosai, Maccari, and Malaparte were avid participants in the Tuscan *squadrismo* of 1920–1922, and all of the other *selvaggi*-to-be favored the spirit of *squadrismo* against the normalizing and bureau-cratizing tendencies that they associated with the fascist party and regime after 1925. For them, *squadrista* violence, was, like the war, an opportu-nity to celebrate the Italian "warrior spirit" and to get back on the path-way to a spiritually replenished nation. Politically, then, their return to "order" was alive with paradox.

The Matteotti murder was the triggering event for the launching of *Il Selvaggio* because the pro-*squadrista* wing of the Fascist Party with which the *selvaggi* were associated, already worried about Mussolini's embrace of the conservative Nationalists and his open courting of the Vatican in 1923, feared that the regime might now be pressured to com-promise further. In its maiden issue, Maccari made an impassioned plea for *squadrismo* as "the most important and the most alive of the various currents of fascism."[99] Writing contemptuously of those who regarded *squadrismo* as one of those "necessary evils" that was no longer needed, Maccari appealed to history. Except for the "Garibaldean parenthesis,"

modern Italy had been corrupted by a tradition of "bourgeois beer-belliedness" and "slipper-wearing" that had produced a politics of "surrenderism" [*rinunciatarismo*]. It was high time to revive the "warrior spirit of our race," which "foreigners do not appreciate," high time to restore the virtues of "force, virility, and will." The prewar Marinetti might well have recognized himself in such a call.

Over the next two years, Maccari and his friends added many details to this picture of the Italian national condition and made clear how they intended to see it renewed. Too much of modern Italian political and cultural life had been shaped by foreign influences. Cavour's politics, for example, were "made in England." His liberalism had corrupted the national character, lending prestige to the commercialism of the urban centers and undercutting the traditional and genuinely Italian ways of life associated with the small provincial towns and countryside. The result was a postwar world in which "the province is healthy and the cities are polluted; the provinces produce and the cities consume; the provinces create and the cities falsify; the provinces have faith in their ideals and the cities don't know what they believe; the provinces love sacrifice in order to make people more noble; the cities love money in order to doll themselves up and enjoy; the one wants men of action and thought, the other wants buffoons and schemers."[100] Cities also bred bureaucrats and fascist "reformists," while the countryside bred "tribes" like the *selvaggi* who cultivated their ruralism and encouraged others to "return to the earth."[101] The path to cultural renewal was made of dirt, not paving stones, and certainly not asphalt.

Yet by March 1926, when Mussolini's dismissal of Farinacci as head of the Fascist Party signaled the apparent end of *squadrismo* as a plausible ideal for fascist party politics, the *selvaggi* were quick to see the need to separate their identity from party politics and political tactics and to refocus it on a broader cultural basis. Moving his headquarters to Florence with Soffici's help, Maccari wrote that the journal had "closed its *squadrista* period and chosen the cultivation of art as the task for its new life." He vowed to deliver a "droll journal, Florentine and Sienese, bizarre and sometimes mysterious," one that would help fascism laugh and, "in the most honorable of senses, amuse Mussolini."[102] Yet, if his turn was toward culture and aesthetics, it was far different from Marinetti's in 1923. However lighthearted their intentions or rhetorically reformed, the *selvaggi* never surrendered their political program for an Italy made in their image. Indeed, the ideology of *strapaese* that was the

outcome of their cultural turn took the stridency of their critique of contemporary Italian cultural and political life to new levels during the Florence years of *Il Selvaggio,* which lasted until early 1929.

Soffici was *strapaese*'s most important theorist.[103] Born in 1879 to a *fattore* [farm manager] and his wife in Bombone, a tiny hamlet east of Florence, he studied at Florence's Accademia di Belle Arti, but it was in Paris, where he lived from 1900 to 1907, that he truly became an artist. His freehand drawings and art nouveau designs graced the covers of the *Revue blanche* and other avant-garde journals, and he participated in the *La Plume* circle through which he met Picasso and Apollinaire. But he always felt that his creativity was dependent upon a Tuscan stimulus, and after a "spiritual crisis" in Paris in 1907, he returned to Poggio a Caiano, the Tuscan town in which, except for his military service in World War I, he would live the rest of his life.

Besides painting, Soffici wrote poetry, novels, and criticism. His book on Arthur Rimbaud (1911) was one of the first in Italian, and his novel *Lemmonio Boreo,* the first part of which was published in 1912, would appear as an uncanny anticipation of fascism when the complete version came out in 1921. His articles on French impressionist and postimpressionist painting for *La Voce* introduced Italians to these movements. He also wrote for some of the later issues of *Leonardo* and joined with Giovanni Papini to edit *Lacerba.* During the war he spent two years at the front and was seriously wounded in 1917. In 1918 he edited an important trench journal, *La Ghirba.* After the war, Soffici had an epiphany in which the artisans of Tuscany appeared to him as genuine artists, and he gave up what he had come to see as the frivolity of futurism.[104] He also married, became more religious, wrote political articles for *Il Popolo d'Italia,* supported D'Annunzio's occupation of Fiume, and welcomed the March on Rome.

Although his willingness to incorporate the Catholic Church into his ruralism put Soffici at the conservative end of *strapaese* politics, he was its most engaged critic as well as the one most inclined to identify a new cultural enemy as the source of Italy's ills. "With increasing dismay and disgust," he wrote in April 1926, "the inhabitants [of Italian cities] are witnessing the multiplication of testimonies to the most shameless architectural barbarism and debasement of the beauty and harmony of its *piazze,* streets, and dear and famous places, sacrifices to the triumph of bad taste, vulgar mercantilism, and garishness [*pacchianeria*]."[105] Why this aesthetic plague should have descended just then would become clear to Soffici six months later when he identified the culprit as that

"Americanism being diffused in Europe, which after having ruined Germany, pushing it to the point of collapse, is now contaminating England, France, and almost every other nation on our continent."[106]

Soffici equivocated somewhat in his characterization of this Americanism. In the article just cited, he first associated it with "the contaminating force of modern plutocracy" that is reducing the European nations to "prostitutes," a characterization that would seem to identify the enemy with the modern American corporation and perhaps the American government. Yet the very next sentence, which likened Americanism to a "plague that spreads, vulgarizing the world, rendering it stupid, bestializing it, humiliating and destroying high, luminous, glorious, millennial civilizations," suggested that a much larger cultural force was at stake. Indeed, Soffici went on to argue for a global identification of money with the Antichrist and for America as "the herald in the process of dissolution whereby the dominion of gold triumphs over every other force of order." America, it turns out, is simply the current standard-bearer for the "Anglo-Saxon nations animated by the pure spirit of Protestantism and democracy."[107]

Americanism, then, is partly associated with the institutions of postwar American economic might and partly with a civilizational principle going back three or four centuries. With the latter association, Soffici recalled an argument made by Malaparte in 1921 with which he was quite familiar: that Italy's fate as a modern nation and culture had been shaped by the domination of the "northern and western" European spirit born out of the Reformation and that had everywhere supplanted the "southern and Eastern" spirit during the second half of the sixteenth century."[108] According to Malaparte, this new cultural spirit was "metaphysical" rather than "physical" (anchored in nature) and produced a sense of unease that was paralyzing to cultural creativity. If contemporary Italy were to bring forth a new kind of modern civilization in which people would regain their sense of spiritual connectedness to the earth, and thus the possibility of cultural creation that would express human power while leaving them at peace with themselves, it would have to integrate its art with the aesthetic principles of the Italian classical tradition. In doing so, it would overcome the hegemony of the northern spirit that had begun in the seventeenth century, a spirit of titanic madness that tried to dispel its unease by accenting the fantastic, unexpected, and monstrous. The implication was that the spirit of romanticism and decadence that had characterized European culture in the nineteenth century, and that unfortunately pervaded many modernist movements right up to

the present, had its origins in the era of Luther and the Baroque culture that followed. Thus the key to a properly modernist cultural renewal was to encourage Italian fascism to recultivate what historically had been Italy's major cultural achievement: an art that expressed spirituality through, and not against, the concreteness of the natural physical world.

Soffici incorporated this argument and drew from it the same conclusion, but he went beyond Malaparte in linking the historical culture of the Protestant north with the new challenge of Americanism that is assaulting all of "old Europe." This challenge was presenting itself in various ways, rather like the symptoms of the disease to which Soffici likened it. At the most basic level, Americanism was a challenge to Italian national autonomy. In Soffici's mind, as in the minds of other *selvaggi,* America's domination of international finance was connected with the aim of "disarming Europe."[109] An even more immediate and palpable worry the *selvaggi* associated with Americanism was its challenge to Italian cultural autonomy, since unfortunately but undeniably it was attractive to the Italian masses. "America descends to the sound of dollars," wrote one *selvaggio,* "with its black idols, the cocktail, jazz, fashion, the imbecility and dazzling glitter of a civilization that is all sea-foam and no land, all machine and no heart." He continued: "Am I American enough? That is the secret question that pushes young people to look fashionable at every moment and occasion of their day."[110]

Yet the problem of Americanism was not confined to youth or to the apolitical; its power and the commodity-culture orientation it epitomized threatened the ranks of fascism itself. American automobiles, for example, had become status symbols for the *gerarchi,* who were buying them despite the fact that doing so undermined a key Italian industry.[111] Under the influence of Americanism, fascism was succumbing to the "corruption and ethical disorder of past regimes." Mussolini was remaining true to fascist principles, but too many of his lieutenants were becoming *affaristi* [profiteers]. Fascism needed to return to the martial virtues that launched it in the first place.[112]

As commodity culture, Americanism also threatened Italian and specifically Tuscan traditions of artisanship. Moreover, its Taylorist and Fordist concepts of labor involved a quantitative approach to production that "standardizes" the product and deadens the spiritual aspects of genuine work.[113] Still more troublingly, its concept of standardization was becoming connected with all aspects of public life—with the notion that Italian cities all need arterial roads, that local ordinances should everywhere be the same, that the Italian countryside should have the same

laws, codes, and norms as the cities, and so forth.[114] And, at a still deeper level, Americanist modes of life were threatening not only the cultural but also the racial identity of Italians. *Il Selvaggio* is full of race talk. Sometimes it takes the confident and ecumenical form assumed in the following reflection of Soffici's: "Italy for me is superior to all other nations also for this reason, that it is the melting-pot of various races, from the German to the Arab, from the Illyrian to the Gallic, from the Norman to the Greek, and it takes the best from each one, in this way forming a synthesis that represents the perfection of the European type."[115] More commonly, however, the group's race talk revealed deep anxieties about the association of Americanism with the alienness of "Jews" and "Judaism" and with a variety of other enemies from Protestants, Anglo-Saxons, and "Europeanists," to blacks, homosexuals, decadents, masons, and democrats.[116] *Strapaese*'s struggle to revive an endangered mode of life was too much on the defensive and too lacking in self-confidence to avoid resorting to a demonization of the other.

For *strapaese*, then, modern culture must be purged of the lure of American money and commodified values, a task that will require a countervailing power of equal historical weight. That countervailing power can only be fascism, which is why they believed that they had to remain loyal to the regime, however maddening its deviations from their fascist ideal. Yet, at the same time, modern culture must also be redefined against the spirit of romanticism, decadentism, and prewar modernism, bound up as it was with the values of northern Europe. It was this task that Soffici addressed in *Periplo dell'arte* (1928), the major statement of *strapaese*'s aesthetic politics.

The book opens with images of civilizational crisis. We live in a world of "pictorial Babel," of the "progressive decay [*decadere*] of Europe" leading inexorably toward "total barbarization." Movements in the arts have become mired in an "opaque atmosphere of muddle [*confusionarismo*]," with "futurist revolutionary extremism" on one end and the "reactionary extremism of would-be neoclassicism" on the other. Courbet's dictum—"*il faut être absolument moderne*"—has become the watchword of every art, which has been reduced to successive fashions "always *retour de Paris*." Yet these were but symptoms. European art had taken a fundamental wrong turn in the sixteenth century, when with "the invention of oil painting the possibility presented itself of an intrusion of the material into the pure spirituality of the artistic act." Although the "best artists" of the day "had only adopted the new technical ingredient with caution," by the seventeenth century the temptation to fall into an

art of opulent sensuality and materialist luxury had proved too great, and by the eighteenth, "critics were taking the material phenomenon of artistic technique almost solely into account."[117]

Although some nineteenth-century artists, such as the Macchiaioli and even a few impressionists, had managed to avoid the technological temptation and to maintain a "pure and healthy conception of art," in recent years their successors had once again been overtaken by the corrupting influences of non-Latin nations, especially Germany. "So-called fauvism, cubism, and futurism presented patent examples of a continually increasing inclination toward that deprecatory and frightening bad taste of the Germans." Fin de siècle Paris had been "invaded by entire legions of foreign painters—Germans, Scandinavians, Swiss, Russians, Poles, Slavs, Armenians, Americans, Japanese, Africans, many of them Jewish—who were ruled by a universalist charlatanism." (Curiously, Soffici failed to mention Italians such as himself). The rootedness of all good art in the "aura" and folkways of a particular region had become utterly lost, and art had fallen prey to theory and abstraction.[118]

On this point rested the nub of Soffici's argument: "every art ought to be from a place," as he wrote in a chapter title.[119] Such was his simple formulation of the claim so deeply embedded in the prewar views of Apollinaire and Kandinsky, that to remain vital art must grow from the folk traditions, customs, specific locales, and life circumstances of a particular people. Yet, unlike Apollinaire, who became increasingly committed to modern technologies, and unlike Kandinsky, who remained a lifelong cosmopolitan, Soffici drew radically antitechnological and anticosmopolitan consequences from the formulation. He had remained close to Apollinaire during the war years but found himself much more drawn to the return-to-order implications of the latter's "New Spirit" lecture than to its material vision of modernity. Now he argued that only by resituating themselves in their native countryside, away from the cities and their technology and materialism, could modern artists hope to restore the genuine "religiosity" characteristic of all great art. Moreover, to situate art in this way meant to reject the cosmopolitan and universalist ideal of a "pure aesthetic, which in other times I myself professed and proclaimed, but which leads inevitably to the decadent cult of formal delicateness and undermines the human and heroic plenitude of the work."[120] Such decadence was characteristic both of Marinetti's futurism and of the *novecentismo* of Sarfatti and Bontempelli, which the *selvaggi* treated as Italian cultural concomitants of *americanismo*.

With its commercial appeals and stylistic linkages to the world of

advertising, futurism had become little more than a vehicle by which "America is emigrating to Italy." Indeed, Marinetti himself should be seen as "the official representative of America in Italy."[121] Although early futurism had been "an effort to massage a tired and sluggish national body," and as such had value, "later futurism" commits all the worst sins of the day—"internationalism, mannerism, conventionalism, democracy, philo-Bolshevism"—and is "absolutely incompatible with fascism which, as everyone knows and sees, is the restoration of secular values such as tradition, hierarchical order, discipline—necessary and indispensable presuppositions for the carrying-out of our revolution and the attainment of its goals, the foremost of which is *a modernity that is ours, an Italian modernity.*"[122] Similarly, *novecentismo,* or *stracittà* in Malaparte's vocabulary, is a movement for those who prefer the fashions of "Paris, London, and New York" over native traditions. By publishing foreign authors and Italian authors in French translation, it cultivates a "literary Europeanism" that contributes to the "standardization of literature" and promotes a "pictorial Esperanto" among avant-garde painters, that is, an art that so steadfastly pursues abstract universals as to negate the particular "subjects, lands, nations, and sentiments" that alone can render painting vital and authentic.[123]

Strapaese's attack on futurism was sufficiently acute to attract a counterattack from Marinetti, who included the *strapaesani* in his 1929 polemic against Novecento. There he referred to Soffici as an ex-futurist who had once written well on futurism but who "has now become a *passatista,* an enemy of futurism, an extoller of the moldiness, plagiarism, banality, and dung of the village." Soffici, like Carrà and other *selvaggi,* had confused "the need for disciplinary order by fascism in power with today's art which, legitimated by the revolution, owes itself an ever increasing creative freedom." Yet, "incapable of being creative, he hates creators; incapable of originality, he hates those who are original."[124]

However appropriate Marinetti's attack for Soffici's own art, which had indeed suffered from a loss of creative energy after the war, it was hardly appropriate for *strapaese,* which, as we have seen, remained dedicated to the modernist project of cultural renewal. Yet, for reasons we have already considered in relation to futurism and Novecento, such polemics ceased to matter much almost as soon as they were delivered. Despite *Il Selvaggio*'s fascist fundamentalism and the similarity of its rhetoric to that of the intransigents, it would suffer the same fate as futurism and *novecentismo.* While it might seem that the rise of the intransigent faction of the Fascist Party after 1930 would give the *stra-*

paesani a new lease on life, the actual effect was quite the opposite, for there was in fact no love lost between the two groups. The *strapaesani* viewed the intransigent *gerarchi* as hopelessly compromised by their associations with the national government, while the latter viewed the renegade Tuscans as oddball provincial artists unworthy of their attention, let alone their support. Spared the sharp attack the intransigents unleashed against Sarfatti's Novecento, the *strapaesani* nonetheless became dispirited and unable to hold together as a group, and Maccari began a peripatetic existence that would take the journal first to Siena, then to Turin in 1931, and finally to Rome in 1932. The ideology of *strapaese,* if never officially abandoned, was increasingly neglected as the journal became more and more Maccari's one-man band.

<p style="text-align:center">• • •</p>

In the winter of 1940, as the world awaited a Nazi-fascist attack to the west, Soffici wrote Marinetti an emotional letter of reconciliation. Referring to a recent encounter they had had in Viareggio, he confessed that he had been "overjoyed that, despite so many differences of temperament and opinion separating us, we were united by one thing of an essential nature: our disinterested passion for Italy, for art, and for poetry."[125] Their aesthetic quarrels of the interwar years, Soffici seemed to be saying, ought to be put to rest in favor of their common commitments to Mussolini, fascism, and Italian nationalism. And in fact there is much evidence to suggest that they were of like minds politically at this juncture. Soffici was more future-oriented in his politics than ever, as he declared in his diary entries for 21 and 25 April that "Mussolini has a clear idea and a plan," and that the "new Europe" would be based on an alliance of "Italy, France, and Germany," with "England diminished and isolated in her sea."[126] And Marinetti had reasserted a resistance to commodity culture by placing himself in opposition to Americanism—with its "'adoration of money,' alcoholism, standardization, obsessive quest after well-being, progress understood merely as 'financial success,' and so forth"— and had moved still further to the right politically.[127]

Such professions of intensified solidarity with the regime and its politics did not of course include any from Sarfatti. Yet even though Novecento may have died earlier than its rivals, what held all three movements together was that, while none of them could be said to have been successful in meeting its objectives, all of them persisted very deeply into a regime whose ostensible aim was a totalitarian culture. Each of

them, in fact, entered into a kind of symbiotic relationship with the regime such that they could neither fully live with it nor without it. They could not live with the regime because it made life miserable for them after 1930, even though the thoroughly inimical Hitlerite notion of modernism as "degenerate art" did not become officially entrenched until the regime's waning days. Yet they also could not live without it, because each required the regime to legitimate itself: futurism and Novecento because the plausibility of their avant-garde modernist strategies had come to rest on a political alliance, *strapaese* because it needed a fascism that might resolve the modern crisis in ways that would make plausible its ruralist vision of an alternative modernity.

In terms of their strengths and weaknesses, however, the three movements were quite different. Although by most measures it remained the strongest movement of the three, futurism, as we have seen, underwent drastic change during the interwar years, which weakened it in very significant ways. Most important, Marinetti lost control over the movement in three different senses: its splintering into rival elite movements, some more political, some (such as Marinetti's own) more aesthetic; Marinetti's ceding of futurism's political dimension to Mussolini in 1923; and his inability to ride herd over a protean mass-oriented futurist movement that became increasingly commercial and, in general, artistically second-rate. While his political alliance strategy still gave some focus to futurism's resistance to commodity culture, at least within Italy Marinetti was no longer in a position to deploy his chief weapon in that regard—the *serata*—and, as a result, the movement became more and more identified with "style"—design modernism, advertising art, and local futurist art shops, the *case d'arte*. The fact that his only means of retaining the hope that futurism might still someday lead a new modernist culture in Italy lay through political alliance probably best explains why he stuck with that strategy for so long. Yet what futurism actually meant became increasingly unclear as Marinetti remained at the movement's center only in a rather vague sense, despite his grand poses as Italian cultural ambassador, distinguished Italian academician, and senior soldier extraordinaire.

In contrast to futurism, Novecento did not preexist fascism and was entirely aimed at being fascism's aesthetic partner, a goal which it pursued steadfastly, enthusiastically, and with some success, especially in the 1920s. Although Sarfatti's aesthetic orientations and commitment to avant-garde art were well established already in the prewar period, it is likely that Sarfatti would never have mounted an avant-garde modernist

movement had fascism not appeared. And while she certainly made the most of this opportunity in a strategic sense, she did not succeed in articulating a compelling avant-garde vision. Was Novecento a movement that would provide fascism with a culture of sufficient vitality and popularity to allow it to counter the commodity culture emanating from capitalist democracies? One looks in vain through her writings of this era for any very clear answer. All one can say is that this former writer for Notari's *Gli Avvenimenti*—a wartime journal that relentlessly pursued entertainment values—now consistently maintained a serious and highbrow engagement with neoclassical art. And while we may agree with Igor Golomshtok that Novecento, in comparison with the pseudo-avant-gardes of Stalinist Russia, never compromised its principled pursuit of autonomous creativity in the manner of some would-be official arts, one feels compelled to add that the aesthetic vitality of Novecento had more to do with the quality of its artists than with the creative vision of its leader.[128] Sarfatti was an Italian nationalist who thought that high art could serve as a spiritual guide for the masses and that Italy could distinguish itself in this field if it returned to classicist values; beyond such principled generalities, she never had that much to offer.

Strapaese certainly did have a distinctive cultural and political vision. Theirs was an idiosyncratic, self-styled vision of a new regionally based Italy that would restore public-mindedness to its citizenry, revive qualitative experience through close proximity to the land and to artisan traditions, and suppress those commercial distractions responsible for the softness and unmitigated materialism of the modern bourgeoisie. These Italian regions would be loosely united through a vibrant fascist public life, the strong spiritual presence of the Catholic Church, and by modernist artists who would perpetually rekindle the nation's artistic heritage with innovative new works from within it. Ultimately, this new Italy would help to reshape modernity itself away from the Protestant, democratic, liberal, individualist, romantic, decadent, anomic, materialist, and Americanist version that had so far prevailed. No avant-garde movement in fascist Italy was clearer than *strapaese* in what it opposed: its resistance to commodity culture was uncompromising, and its critique of those movements such as futurism, which in its view had bowed to this "Americanism," was sharp, if entirely predictable.

There were nonetheless many ambiguities, vagaries, and contradictions in this vision. It attacked urban culture indiscriminately and yet was itself a product of urban cultures. It attacked liberal values yet persisted itself only because of liberal concepts of toleration and press free-

dom inherited from the prewar and early postwar regimes it deplored. It proclaimed belief in a fascist culture yet disparaged actually existing fascism. It pictured artist-intellectuals as having a major role in the new fascist civilization yet complained of the inattention they were receiving in the present one.[129] It claimed to be modern and yet could not explain how the modernity it advocated could avoid the ills associated with cities and commerce and still remain modern. It claimed to be realistic and yet defended a craft ideal that was hopelessly outmoded and even pitiful in its powerlessness to combat the Americanist juggernaut.

Perhaps the best way to see the fundamental problem with the *strapaese* vision is to compare it to one that prevailed in France from Baudelaire to Gourmont: that of artists as an aesthetic caste. On the one hand, the *strapaesani* would certainly have rejected the notion of an aesthetic caste. Artists, they believed, must become involved in the world just to do art; postures of ironic retreat are not an option. Although some of them, such as Soffici, continued to pursue the notion of a religion of art, they unanimously rejected any notion of a withdrawal into a *cénacle*. Indeed, this was the fundamental point in their critique of prewar avant-gardes. They were committed to remaking modern public life according to their interpretation of fascist values, however quirky and unrealistic that interpretation may have been. On the other hand, the people to whom they directed their appeal—the peasants and artisans who carried the regional and local values that *strapaese* so esteemed— paid them no attention, and the limited urban audience they did reach was the object of their contempt. In this sense, *strapaese*'s independence was purchased at the price of playing to a nearly empty concert hall. Indeed, over time not only did the small audience move toward the exits, but even those on stage joined in the exodus, leaving conductor Maccari twirling his baton in near silence. Thus, while in principle the *strapaesani* rejected the nineteenth-century ideal of an aesthetic caste, in actual fact they present us with one of its clearest twentieth-century illustrations.

7

André Breton's Surrealism

In March 1923, after several failed attempts to establish himself as the leader of a new postwar avant-garde, an angry young poet and aspiring critic published a despairing assessment of the "crisis" of the visual arts in a Paris daily.[1] Although he had just turned twenty-seven, Breton focused his analysis on the French institution of art in its heroic years prior to August 1914 as compared with what it had become since. In those days, art critics had condemned "official art" and asserted a "will to modernism" that had successfully secured the reputations of great painters out of favor with the establishment, such as Courbet, Manet, and Cézanne. These critics had been independent, largely free of commercial influence, and seriously engaged with art's intellectual content—like Apollinaire, for example, with whose work the youthful Breton had been quite enamored.[2] But the will to modernism had collapsed during the war. And while this collapse had been necessary and even desirable, neither the painters themselves nor the critics had been able to recover a coherent sense of purpose. The art world had become a "sea of oil" through which critics navigated not by seriously assessing new work as "thought" but only by reducing their judgments to the quality of the "painter's craft." In so doing, they had succumbed to the "Epicurean morality" of sensual pleasure, which the savagery of the war had raised

to new heights of excess and which had led to the hegemony of commercial art markets and the loss of specifically artistic value. "Criticism," Breton declared, "is no longer up to the task. Long jealous of the apparent sanction conferred on its judgments by the noisy announcement of certain sale prices, criticism now seems to be no more than the shifty agent of these transactions, which have nothing whatsoever to do with art but which still threaten to devalue it. . . . I see no way to keep silent about such a grave danger. Art is, I repeat, currently under the sway of dealers, and this is to the great shame of artists."

Yet despite the apocalyptic tone in which the present was portrayed and the sharpness of his contrast with the prewar years, Breton made it clear that the roots of the present commercial degradation extended well into the earlier era. The problem was that prewar modernism had continued to adhere to a "viewpoint of taste" in making aesthetic decisions and judgments, however subversive and innovative its own taste may have been. Taste, Breton argued, was at best a "secondary" criterion for evaluating art. A work of art must rather be judged in terms of whether it takes "our abstract knowledge . . . a step forward," whether it produces "interesting revelations." An aesthetics of taste privileges the material and sensuous, which partly explained why present-day art had been reduced to mere commerce. To restore purpose to art would require developing a proper program of artistic "research" and thereby overcoming the "incomprehensible disdain of everything having to do with thought" characteristic of the prevailing artistic production and reception. Although Breton did not put forward any such program here—the first *Manifesto of Surrealism* was still nineteen months away—he made clear that it would not be that of those "exegetes" from the purist movement whose "formal research" into cubism had degraded that venerable tradition of inquiry into an utterly banal form of decorative art.

The article appeared at a time often referred to as the "*époque floue*"—the "vague years" between the end of dada and the onset of surrealism—when Breton is supposed to have been unsure of his own intellectual direction.[3] Yet it establishes several directions that are decisive for understanding both Breton and the surrealist movement. First, it shows that, already in the early 1920s, Breton was preoccupied with and antagonistic toward commodity culture as a setting for intellectual and artistic life. Like G. F. Hartlaub and others, he saw the inner world of art corroding under the pressure of commodification, yet unlike most such critics, he refused all compromises with commodity culture. Second, the article anticipates the argument of the first *Manifesto of Surrealism* that

postwar cultural degradation reflected a disdain for "thought" that was itself rooted in centuries-old traditions of rationalism, utilitarianism, and positivism. It therefore also foreshadows the way in which the surrealist "research" Breton was already conducting with his avant-garde friends would become the general basis for surrealism's effort to reconceptualize modern art as a form of pure research uncontaminated by rational or utilitarian ends.[4] Finally, and most important, it shows that these two points were clearly linked in his mind: art as research is the solution to the problem presented by the commodification of art. Indeed, as we will see, the contrast between taste, style, and commerce on the one hand with knowledge, research, and science on the other is one of the fundamental underpinnings of Breton's outlook and of the surrealist movement he created.

In an incisive exploration of the nature of Breton's avant-garde engagement, Peter Bürger has argued that it was a "total refusal" motivated by an "existential" sense that the "the absence of justice in the world is inexcusable."[5] No doubt there is much truth in this judgment, and Bürger marshals considerable evidence on its behalf.[6] Yet it represents, I believe, only one side of Breton—one of his many often contradictory stances or moods. Bürger's characterization reflects Breton's embittered response to the war and explains the tone of absolutism so frequent in his pronouncements. It also explains why he so often neglected to present convincing arguments, preferring to use his own "incontestable integrity" as his evidence, especially for his political views.[7] But it fails to grasp the way Breton would forge surrealism as a synthesis of existential, psychological, aesthetic, and political elements, which was aimed at founding another culture and not simply at asserting a particular outlook. Bürger believes that Breton was unable to establish himself on "political terrain" because he refused to write literary works from a distinct political point of view.[8] In my estimation, however, Breton refused political engagement in the usual sense because he was after larger game. His fundamental political hope was to reorient modern culture away from the commodity world and toward new forms of creativity open to everyone and inextricably bound up with everyday life; and he believed that an art alive to expanding our cognitive frontiers beyond the narrow purview of Cartesian rationality was central to such a project. To develop such an art was for him the most important form of political engagement.

Yet if we return to "Distances"—the article with which we began—and consider its context, it becomes clear that the young Breton already

faced "existential" challenges that were bound to complicate, if not fatally compromise, any and all forms of political engagement. Over the two years prior to its appearance, Breton had attempted to organize a broad coalition of French avant-garde groups for a "Congress of Paris" aimed at reinvigorating postwar cultural life.[9] He had also tried to launch a new salon to replace or at least supplement the Salon des Indépendants, which the article depicted as "showing signs of fatigue." In this endeavor Breton had sought to enlist a wide variety of intellectual support, even including Marinetti.[10] Unfortunately, however, both efforts had fallen flat. To make matters worse, these were the same years in which speculation in the French art market had reached new heights, a phenomenon to which Breton caustically referred in the article, but regarding which he was far from an innocent party.

Breton had begun collecting art in the immediate postwar years, and from 1920 until 1924, he worked as the art investment adviser for the wealthy couturier Jacques Doucet. It was the only secure job he ever held, and it took him right to the financial center of the Paris art world beside one of the most important collectors in the period.[11] In response to Breton's advice, for example, Doucet purchased the "Demoiselles d'Avignon" from Picasso in 1923–1924 for twenty-five thousand francs.[12] With him, Breton also attended the auctions of Daniel-Henry Kahnweiler's extensive prewar cubist collection, which had been sequestered as "enemy" property by the French government, and which—hitting the market in several large, closely spaced waves—sold at bargain prices. As Breton's leading biographer comments, "Breton publicly denounced the auction, but it was because of the bargain prices that he was able to acquire some of the works—not all of them on Doucet's behalf." [13] Indeed, Breton bought no fewer than eighteen paintings at the Kahnweiler sales, and he was active enough as a collector in the French art market generally that its leading scholar calls him "almost" a dealer. While most of his purchases were modest (under five hundred francs each), some were surprisingly expensive. In 1925, apparently feeling flush from his job with Doucet, he bought one painting for nineteen hundred francs and another—a Modigliani—for 10,100![14] Strikingly, this was precisely the year in which Breton made his first serious political commitments.

Breton was an avid art collector for his entire adult life and took two brief flings at operating his own gallery—the Galerie Surréaliste (1926–1928) and the Galerie Gradiva (1937–1938). While he always functioned on the economic edge and certainly never got rich from this activity, it was his main source of income except when he drew a salary from

Doucet. In that sense, it was the flourishing of the interwar art market that made possible Breton's life of surrealist research and oppositional politics. In this respect, he was the perfect personification of Theodor Adorno's argument that modernists were not only resistant to commodification but also enabled by it. My point here, however, is not so much to argue that the antimony Breton drew in "Distances" between commodity culture and art as research was less than heartfelt, however serious the compromises he made in his own life. Rather, what I want to suggest is that he never had the slightest clue—not in 1923, not later—as to how the commodity culture he so detested might be replaced. Although the principal reasons for this failing were conceptual and strategic—how to overcome such deeply rooted intellectual and cultural traditions, how to induce social transformations that were so obviously beyond the capacity of surrealism or even of "art" to undertake alone—Breton himself understood that they were not limited to such external factors. For he recognized—explicitly in his article, implicitly in his life—that the materialism (as well as the material needs) of artists themselves was not an insignificant part of the overall problem.

BRETON'S "NEW SPIRIT" OF MODERNITY

Born into a provincial petit-bourgeois family in 1896, Breton endured an unhappy childhood and an education under the Cartesian academic models that prevailed in the Third Republic, the culmination, as he later wrote, of "centuries of the mind's domestication."[15] Both experiences would later prove decisive in the construction of the surrealist project.[16] Meanwhile, the outbreak of the war found him going through the motions as a young medical student in Paris. Although he later claimed to have had no desire to be a writer, he was already involved in the avant-garde scene, having published his first poems the previous March in the neosymbolist review *La Phalange*.[17] Then, as the guns of August sounded, he discovered the poetry of Apollinaire, telling a friend he was "wild about" it and laughing that he would be accused of "snobbism."[18] By the end of the following year, he was sending his own verse to Apollinaire at the front and had received a letter back praising him for his "striking talent."[19] Yet for Breton, as for Apollinaire, the war years were mostly an agonizing spectacle. Drafted early in 1915, he served as a medical orderly treating psychiatric patients at various neurological clinics. This work introduced him to the use of free association and dream interpretation as medical treatments, an experience of obvious

importance for surrealism, especially after it was supplemented by a reading of Freud in the 1920s. Yet it was the horror of dealing with so many thousands of soldiers whose sanity had been destroyed at the front that had the greatest impact on him.[20] The angry and embittered man who emerged from having been, as he later described it, "flung into a cesspool of blood, mud, and idiocy," is the one who gave surrealism its "tenet of total revolt, complete insubordination, of sabotage according to rule" and its cynical expectation that "nothing" is born "save from violence."[21]

Breton met Apollinaire face-to-face only in May 1916, when the latter invited him to the hospital room where he was recovering from his head wound. Breton arrived the day following Apollinaire's trepanning operation to find that this "very great man"—"lyricism in person"—had become "sad and feeble."[22] Apollinaire would of course never fully recover from his wound, and Breton later suggested that the weaknesses he found in the intellectual program set out in Apollinaire's "New Spirit" essay might have resulted from the way his enfeebled condition had "limited his audacity and reduced his field of prospection."[23] As we noted in chapter 3, Breton was repelled by the essay's patriotic stance, its Gallocentrism, and its classicist return-to-order values. He believed that Apollinaire had been hopelessly optimistic regarding modern technologies, and he had nothing but disdain for the notion of technological progress the essay upheld. Far from accepting modernity as it presently existed, a properly formulated "new spirit" would need to reconstruct it in ways that would undo centuries of damage to the human imagination for which the catastrophe of World War I was only the most dramatic evidence. Nonetheless, Breton recognized that this essay had set the terms of the postwar debate in avant-garde Paris, and he was certainly able to locate resources within it that aided him in articulating his own position within that debate.

Although Breton thought the essay had "humiliated" art in relation to science—and it certainly did not draw parallels between or directly interlink artistic and scientific research, as Breton would later do—it had spoken of poets and artists as engaged in "experiments and investigations," as "seekers after truth," and as people who "undertake discoveries."[24] Breton would seize upon the point and portray Apollinaire as a man "we love" above all because he knows how "to make room for discovery."[25] Yet what no doubt appealed most to Breton about Apollinaire's notion of artistic discovery was the way he connected it to the "enormous spaces of the imagination" and divorced it from any utilitarian end. Such were

precisely the premises of the research on automatic writing that Breton and Philippe Soupault would begin carrying out in 1919 and which they would publish as *Les Champs magnétiques* in May 1920.[26]

The main rival of this incipient surrealism was the purism of Ozenfant and Le Corbusier. As we saw in chapter 5, the purists had sought to appropriate Apollinaire's mantle by adopting *L'Esprit nouveau* as the name of their journal, and their rationalist interpretation of the new spirit, which aimed to satisfy both return-to-order and design-modernist imperatives, was both intellectually influential and well financed. Breton acknowledged their preeminent position when he invited Ozenfant to sit on the steering committee for the Congress of Paris and again when, in the wake of its failure, he wrote an article lampooning the purist enterprise as commercially compromised and artistically dependent upon a formerly significant but now exhausted cubism.[27] Two years later he would become embroiled in a caustic polemic with Paul Dermée, another *Esprit nouveau* stalwart, who was contesting Breton's right to reserve the word *surrealism* for his movement alone.[28] At stake in this controversy, however, was not just a matter of controlling an avant-garde label; it was also about what form the "new spirit" of modern culture should take.

It would be hard to think of two arts-oriented French-speaking intellectuals in the early 1920s more different in intellectual outlook, temperament, and personal style than Le Corbusier and Breton, yet the rivalry between their movements probably owed as much or more to what these movements would come to hold in common than to the ways in which they were opposed. Their differences were obvious and have already been well analyzed by other scholars.[29] Suffice it to say here that purism was a formalist project which aimed to discover the nature of human aesthetic emotion and the rules of artistic creativity corresponding to them, while surrealism would reject formalism as leading ultimately to a "style" that can be commercialized and aim instead to supersede autonomous art altogether by recasting it as creative research linked to life. Purists saw art as a vehicle through which well-schooled practitioners could explore the rationality and logical order of the human mind, while surrealists came to believe that art could become a fully egalitarian, radically innovative mode of exploring cognitive and emotional experience beyond the narrow confines of "rationality" as hitherto conceived. Purism stressed technical mastery in art, while surrealism was contemptuous of *métier*. Purism opposed the variable, particular, and accidental, while surrealism's interests lay precisely there. Purists believed in a hierarchy of the arts, while surrealists came to believe that art as gen-

eralized creative action could help destroy all hierarchies, social, political, and intellectual alike. Purists thought modern art should draw inspiration from the styleless style of industrial machinery, while surrealists thought art should reject the concept of style altogether.

But in the context of France in the 1920s, with its booming commercialized art market, intensifying commodity culture, and regionalist ruralizing fashions in art and culture, purism and surrealism also had important commonalities that, from Breton's point of view, might have made them appear uncomfortably similar. Like the purists, Breton revered science and wanted to take taste professionalism to a new level by appropriating the ethos and prestige of science for his movement, even if his conception of science was much more revolutionary, seeking as it did to expand its frontiers well beyond those of reigning positivist paradigms. Likewise, *La Révolution surréaliste,* the maiden journal of Breton's movement, was no less sober and research-oriented than *L'Esprit nouveau* and, like the latter, was modeled on a popular scientific journal, in this case *La Nature.*[30] Moreover, again like the purists, Breton would seek to reorient art as "research," although in his case research meant endeavoring to transform the quality of everyday life directly through individual participation rather than aiming to create technically advanced "works of art" conceived as a kind of "basic research" for industrial design. Like the purists, too, he rejected a nonrepresentational art, even if his justifications for the choice were quite the opposite of purism's—to stimulate revolutionary consciousness through the provocative image rather than to restore proper artistic hierarchies.[31] Yet no less than the purists, Breton would have rejected Apollinaire's naturist notion that art needs local rootedness in favor of a much more universalist conception of art's nature and origins. Finally, as we have seen, Breton shared the purist fear of being engulfed by commodity culture and sought through his movement to reshape the world in ways that would preserve a place for genuine aesthetic experience. And, like Le Corbusier, he would begin to search for a political answer to this problem in 1925, albeit at the opposite end of the ideological spectrum.

Breton's version of the new spirit also sought to distinguish itself from dada and futurism, although, especially in the case of dada, this was a gradual process that did not fully sort itself out until the failure of the Congress of Paris. Initially, Breton had been captivated by Tristan Tzara and dadaism for the same reason that he had been drawn to nineteenth-century poets such as Arthur Rimbaud and Isidore Ducasse, the Comte de Lautréamont, as well as Breton's wartime friend Jacques Vaché: all of

them flaunted an anti-art-for-art's-sake attitude in which an adventure-some life was not only privileged over literary creation but inseparable from it in the sense that the cultivation and expansion of the individual imagination were seen as the only true justification for artistic activity.[32] Breton had also appreciated the way Tzara made creative use of adver-tisement to promote the public and political dimensions of his avant-garde movement. Although Tzara would not come to Paris until January 1920, his "Dada Manifesto 1918," with its proclamation that "advertis-ing and business are also elements of poetry," had arrived by early 1919.[33] Apparently already in search of means by which to make a polit-ical impact, Breton wrote to close friend Louis Aragon in April that "for me, poetry, art, cease being an end and become a means (of advertis-ing)"—a political means in the sense that "this is how I pose a threat to politics. . . . Christianity is an advertisement for heaven."[34] However, the more he witnessed Tzara's antics in the months after his arrival, the more he came to recognize the superficial and unprincipled qualities of this sort of "advertisement." By the time of the congress, he was denouncing Tzara as a "publicity-greedy imposter . . . who no longer corresponds to any current reality."[35]

Breton's early references to Marinetti and futurism were less frequent though generally in the same vein.[36] If what Breton's "new spirit" shared with Le Corbusier's was essentially a commitment to seriousness in en-gaging the social and political world, such a commitment is precisely what he found lacking in Tzara and (generally) in Marinetti.[37] Yet, while dada was out to destroy the bourgeois institution of art simply by ridi-culing it, futurism coupled its *serate* with a positive program, and there have been many scholars, particularly in Italy, who have thought that the young Breton owed debts to Marinetti that he may have wished to con-ceal.[38] For example, futurism arguably anticipated surrealism in its inter-est in exploring the unconscious and the imagination freed from the con-trols of logic and convention, and it has often been suggested that Marinetti's *parole in libertà* were a precursor of automatic writing. Indeed, as we saw in chapter 2, Marinetti had spoken of the "futurist marvelous" [*il meraviglioso futurista*] in his manifesto on variety the-ater.[39] Might then Breton have been hiding something when he declared in his Barcelona lecture of November 1922 that, among the cubist, futur-ist, and dada movements, "futurism is not nearly as interesting as the two others"?[40] Or when he declared four years later that Marinetti's the-ory of words-in-freedom was "infantile," even as he acknowledged that "against this theory . . . we have set automatic writing"?[41]

However we may wish to answer such questions, certain parallels between the two movements even more obvious than those already mentioned should be acknowledged. Both Marinetti and Breton developed antiliterary attitudes in reaction against French symbolism; both attacked the traditional places of culture such as the museum; both wanted their movements to have a political impact in the world; and both forged avant-garde strategies in the 1920s based on political alliances. One might even say that just as futurism sought to become the state art for fascism without surrendering its own independence, so too would Breton seek to make surrealism the revolutionary art for communism. Yet Breton was justified in the fundamental distinction he drew between the two movements in 1926: "For us, the issue is not to revive words and subject them to clever manipulations in the hope of forging a new style [as futurism does], interesting as that might be. . . . What should we care about [an] artistic renaissance. Long live the social Revolution and it alone!"[42] Futurism, he was arguing, still wanted to be a "style," even if a style around which the entire "universe" might be "reconstructed." Breton, in contrast, rejected the idea of constructing an avant-garde style or a school because he believed that journalists would use any such category to pigeonhole and dismiss, that designers would use it to market commercial products, and that, in any case, the notion of creating works of art following a certain style was itself quite meaningless.[43] Art for him was a knowledge-producing activity having to do not with products and styles but with processes and results.

From this difference there followed a larger one regarding the connection between movement and public, one already evident in the first manifesto, although it would be better articulated when Breton set forth his conception of cultural democracy in the early 1930s.[44] In Breton's view, the futurists remained attached to the traditional romantic notion of the artist as a person of special talent or "genius" who communicates with an audience that receives the work. While the *serata,* or variety theater more generally, offered the audience something of a participatory role in the performance, the artists alone create *parole in libertà.* Moreover, since the futurist performance itself was essentially entertainment, Breton might well have agreed that spectators (such as the French women of 1926 who confronted Marinetti) were right to demand being entertained on their terms. In contrast, the surrealist notion of automatic writing, formally similar as it may be to *parole in libertà,* is predicated upon the "total equality of all normal human beings before the subliminal message" and is no longer a "prerogative of the chosen few."[45] Thus,

in the first manifesto, Breton counseled the would-be automatic writer to "forget about your genius, your talents, and the talent of everyone else."[46] Automatic writing is "within the reach" of anyone who is willing to follow a few simple rules.[47] But it is emphatically not entertainment. It is a conduit to a wholly participatory, but also deeply serious, notion of aesthetic experience in which the distinction between artist and audience is overcome and the idea of art as mass entertainment, abandoned.[48]

By the time Breton was writing the first manifesto, then, he had established at least in his own mind a clear alternative to the purist and futurist projects for a "new spirit" or culture of modernity: entertainment values would be eschewed in favor of serious scientific research, as in purism; but the focus of research would lie at the intersection of imagination and language, as in futurism. At the same time, surrealism would transcend purism, futurism, dada, and all other previous modernist movements because it would detach art from the traditional artist-audience relationship and "put [it] within the reach of everyone" as a full participant rather than as a mere consumer. What the manifesto then does is to name and define Breton's alternative project as surrealism, sketch the larger cultural context to which surrealism is a response, articulate how surrealist research produces what Breton calls the "surrealist image" and what the nature of that image is, and, finally, begin to discuss the vexing political issue of "the applications of surrealism to action." Although we cannot be detained here by an attempt at a full analysis of this seminal text, a few comments on some of these matters will help to clarify where Breton stood with his surrealist project in 1924.[49]

The fundamental problem posed by the manifesto was that Western civilization had subordinated the imagination to the "laws of an arbitrary utility" and "imperative practical necessity," thereby reducing "the imagination to a state of slavery." But the "reign of logic" served by such laws helps "only in solving problems of secondary interest." Moreover, like the young Benjamin and Kandinsky before him, Breton believed that a culture devoted so heavily to such functionalist and ultimately materialist values had impoverished spiritual experience and left humankind deprived of the prerational "childlike" resources without which such experience would be permanently lost. Unless the imagination can "reassert itself" and "reclaim its rights," civilization is bound to stagnate, since "the imagination alone offers me some intimation of what *can be*." Creative activities promoting the human imagination were a conduit to an appropriately enlarged sense of the mind's powers, and Breton argued that

we must fear nothing—not even madness—in the quest to restore the imagination to its proper place.[50]

Unfortunately, however, the reign of logic was both historically entrenched and not without literary and artistic allies, foremost among which is the "realistic attitude, inspired by positivism, from Saint Thomas Aquinas to Anatole France . . . [which is] hostile to any intellectual or moral advancement" and reinforces the now widely prevalent "hatred of the marvelous."[51] The manifesto rejects realism because it offers only a straightforward mimesis. It is a "purely informative style" that has been rendered obsolete by technical processes such as photography and that, in any case, "stultifies both science and art by assiduously flattering the lowest of tastes: clarity bordering on stupidity, a dog's life." Moreover, within contemporary commodity culture, its "images" function like those of a "shopper's catalogue." In contrast, surrealism can teach people how to "practice poetry," a practice that might even lead society to "decree the end of money" and, thus, to put an end to the "absurd choices, dreams of dark abyss, [and] rivalries" with which the current social order presents us.[52]

Against the realist image—a simple reproduction of the referent often designed merely to please the eye—Breton put forward his account of the "surrealist image," which cannot be produced by rational design or even by conscious effort and is in no sense merely the mental representation of an external object.[53] Unlike Kandinsky's forms and those of his successors in modernist abstract art, Breton's surrealist images work with representations drawn from empirical reality. Yet, like Kandinsky's forms, surrealist images come to us "spontaneously, despotically" and cannot be willed. They arrive of their own accord when the mind, placed in a "passive or receptive state," such as that which precedes automatic writing, witnesses the "fortuitous juxtaposition of the two terms that a particular light has sprung," a juxtaposition (to cite the most famous example) like that of Lautréamont's chance meeting of an umbrella and a sewing machine on a dissecting table.[54] The "value" of such a surrealist image, Breton then argued in his best scientific language, has nothing to do with faithful mimesis but rather "depends upon the beauty of the spark obtained; it is, consequently, a function of the difference of potential between the two conductors." Reason's role in this process is "limited to taking note of, and appreciating, the luminous phenomenon"; in no sense does it produce the phenomenon. Such images rewrite the given object world in ways that "upset the mind" in potentially productive ways, evoke "the marvelous" and thereby allow us to "relive with glow-

ing excitement the best part of childhood," and connect with desire by attesting "to the fact that the mind is ripe for something more than the benign joys it allows itself in general."[55] In this last sense, the surrealist image might seem to serve the needs of consumer advertising far better than its more mundane realist counterpart (and, arguably, surrealist images have become increasingly prominent in recent consumer advertising), but Breton suppresses any such implication, whether consciously or not.

However, Breton did express great interest in "applications of surrealism to action" or, what he will call in the *Second Manifesto,* "the problem of social action."[56] In the manifesto's concluding passage, he celebrated "the pure surrealist joy of the man who, forewarned that all others before him have failed, refuses to admit defeat, sets off from whatever point he chooses, along any other path save a reasonable one, and arrives wherever he can." The problem is that it is unclear whether the "world in which I endure what I endure . . . , this modern world," is prepared to accept such behavior. And so Breton imagined this man at a "trial of the real world," and asked himself, in a curious long footnote, "how the first punishable [surrealist] offenses . . . will be *judged.*" Will the man be held responsible for surrealist acts, or will "medico-legal considerations" excuse him? Can one be innocent by reason of surrealism as one is innocent by reason of insanity?[57] Breton permitted himself to imagine a positive long-term outcome to this scenario, with a "new morality" forged from surrealist acts substituting for the "prevailing morality." Yet the immediate social and political questions raised for the reader by his speculation about the possible consequences of surrealism's "complete nonconformism" provoke not optimism but anxiety: can the world really be made safe for surrealism and, if so, how?

Breton had no answer to such questions in 1924. Yet it was already clear to him that surrealism's position in modern society was precarious and that to secure it would require resources well beyond what surrealism could supply for itself. Moreover, the manifesto itself is a performative act aiming not just to proclaim surrealism but to draw together the group of stalwarts who will pursue the form of life it advocates and otherwise champion it. Several passages in the text speak about the "friends" involved in the movement, and while Breton indicated little about the nature of their commitment, he did state that "surrealism does not allow those who devote themselves to it to forsake it whenever they like,"[58] words that ring ominously in light of the movement's subsequent history. It may be, then, that he already sensed not only that the world

would have to be made safe for surrealism but also that surrealism would have to be made safe from the world, that is, from the corruptions of commodity culture so much on his mind in "Distances." In any case, if he was not yet aware of this point, he soon would be.

Yet the problems Breton faced as he first contemplated "applying surrealism to action" ran still deeper. Let us imagine Breton, anxious about the prospects of surrealism in a hostile world, beginning to consider the possibility of a political alliance, as he certainly did after July 1925. He has just created an avant-garde movement that deplores the "reign of logic" and seeks to explore imaginative depths beyond it. He has made enormous claims for the imagination's creative capacity, which can be fulfilled only if we wholly free ourselves from "utility." Indeed, this is the very essence of surrealist "action." Yet not only will any potential alliance partner necessarily be involved in instrumental-rational action, but surrealism itself, in order to succeed in whatever strategy it undertakes, will be well advised to think calculatively and adopt a utilitarian logic of its own. The paradox Breton faced is that he needed to make the world safe for surrealism even as surrealism itself prohibited any outlook focused on "making safe" (or any other utilitarian motive). He also needed to make surrealism safe from the world and, in this regard, to insist on "discipline" within the ranks of a movement dedicated to a kind of mental indiscipline. For even if the surrealist image alone shows us what the world "can be" and, in that sense, produces enlightenment, understanding what the world "must be" for the activity of surrealist image-making to be possible requires more of a rationalist than a surrealist mind-set.[59] Nonetheless, Breton's own political mind-set, as we will see, mixed the two frameworks—with predictably chaotic and explosive results.

THE EMERGENCE OF A SURREALIST POLITICS

Breton had always conceived surrealism as political in the sense that it responded to Rimbaud's call of "*changer la vie*" rather than satisfy itself with autonomous works of art. This political focus was initially evident both in what he took from dada and in the circumstances surrounding his break with dada. It was evident both in his critique of commercialized art and in surrealism's democratic commitment to an aesthetic experience "within the reach of everyone." Yet none of this implied a commitment to a specific course or program of political action. For Breton, the decision to so commit seems to have happened slowly and haphazardly

between the end of 1924 and January 1927, when he and four other surrealists signed on with the French Communist Party (PCF). Others have told this tangled story in detail, and I will not try to retell it here.[60] But recalling a few of its episodes will help to clarify how Breton became involved, what his motives in politicizing the surrealist movement were, and what consequences the decision to enter into alliance politics had for the movement.

The death of Anatole France almost exactly at the moment when the first *Manifesto of Surrealism* was published provided a convenient occasion for the surrealists to illustrate how they might apply themselves to action, even if the result—a vitriolic coauthored pamphlet entitled "A Corpse"—may only have resurrected their dadaist taste for scandal.[61] Here was the perfect target: the grand old man of French literary realism, a Nobel laureate and national hero, but in surrealist eyes a "windbag" and "prototype of everything we despised."[62] They attacked with verve, and their vituperations did have political consequences, bringing them more fully to the attention of the procommunist group around the journal *Clarté*, with whom the surrealists would ally the following summer, and providing the occasion for Doucet to halt Breton's gainful employment. Then, as the first issues of *La Révolution surréaliste* began to appear, echoes of the pamphlet's activist purpose reverberated in Breton's publicly stated resolve not to allow his journal to become just another "literary publication."[63]

Yet, except for one somewhat whimsical article by Breton, which ostensibly sympathized with the working class while also chastising it for "cultivating the idea of work in a semi-religious fashion," *La Révolution surréaliste* lacked the sort of political content that might have redeemed Breton's activist claims—until the issue of October 1925, when there suddenly appeared both his own review of Leon Trotsky's biography of Lenin and a political manifesto, "Revolution Now and Forever," cosigned by the surrealists and the Clarté group.[64] How may we explain the hiatus? It is true that Breton, startled by the directionless and overblown quality of the April issue, had taken editorial control of the journal himself beginning in July, chastising the previous editors for operating with a "literary alibi."[65] Yet Breton himself had written nothing political over the first nine months of 1925 and, as he later confessed, had few political ideas in this period beyond a vague sense for the need for "subversion."[66] What changed the situation, pushing Breton to begin to think through his own political strategy and program in a way he pre-

viously had not, was yet another "literary" scandal, this time over the symbolist poet Saint-Pol-Roux.

On the evening of 2 July a banquet in honor of the poet, sponsored by the *Mercure de France,* was held at the Closerie des Lilas on the Boulevard du Montparnasse.[67] For the surrealists, who had long esteemed the poet and were therefore in attendance, the banquet came at the end of a full day of politics. A petition which they had cosigned against France's recent decision to become militarily involved in the Rif War between Spain and Morocco had appeared that morning in *L'Humanité.* Then, in the afternoon, they retrieved from the printer their "Open Letter to Mr. Paul Claudel, French Ambassador to Japan," a conservative Catholic poet and longtime antagonist over such matters as Rimbaud's religiosity, who had depicted the surrealists as "pederasts" in a recent interview.[68] To ensure that the banquet guests were apprised of their letter, the surrealists placed a copy at each place setting. Not surprisingly, the chemical reaction provided by these acts in the context of a formal dinner party set off a riotous explosion that ultimately saw surrealists swinging from chandeliers and brawling with other guests as well as the boulevard crowd. The result was the arrest of the surrealists, their near-universal condemnation by the press and the public, threats of violent reprisals from the French right, including Action Française, and in Breton's later assessment, "surrealism's final break with all the conformist elements of the time."[69] The only words of support they received came from *L'Humanité* and other groups on the revolutionary left.

In one momentous day Breton and his friends had burned all their remaining bridges to the French establishment. Long aware of the need to make the world safe for surrealism, Breton had perhaps contemplated an alliance with the revolutionary left, but he had taken no steps toward one, no doubt at least partly because of what he regarded as their philistinism. Now he had no other choice.[70] Of course, this did not mean that he recognized his predicament immediately, or that he had no hesitations about the alliance over the next many months, or even that he became eager to correct his ignorance about Soviet communism or Marxism. His review of Trotsky on Lenin shows no such effort and defends communism ("good or mediocre in itself, defensible or not from the moral point of view") as an "instrument," as "the most marvelous agent ever for the substitution of one world for another."[71] Communism, for Breton, was a rabbit he pulled (paradoxically) from his antiutilitarian surrealist *chapeau.* As he explained in 1934, the surrealist movement in 1925 had been

"forced to ask itself what were its proper resources and to determine their *limits;* it was forced to adopt a precise attitude, exterior to itself, in order to continue to face whatever exceeded these limits."[72] The notion that "surrealism could be "sufficient unto itself," which Breton later characterized as its "initial position," was no longer an option. But would a communist triumph really mean the end of commodity culture? Would it really make the world safe for surrealism in the sense of allowing people to "practice poetry," to proceed "along any other path save a reasonable one" and to arrive wherever it leads? Would it produce a world in which one could be innocent by reason of surrealism? Breton believed that the roots of commodity culture lay deep within the intellectual traditions of Western rationalism. How then could they be extracted merely by overthrowing capitalism in the name of an ideal no less rational-utilitarian than capitalism was? Yet, unable to escape the utilitarian (and very unsurrealist) logic of events, he decided nonetheless to "gamble on the red card."[73]

Initially, Breton and his friends pursued the logic of alliance in concrete terms mostly through close work with the Clarté group in the winter and spring of 1926. In this effort, they claimed to be subordinating themselves entirely to the Communist International and the PCF and to have no concept of a "surrealist revolution" (despite the name of their journal).[74] Yet their commitment to research beyond the "reign of logic" meant that they would never alter the surrealist program one iota to accommodate their new Marxist colleagues, and Breton even argued in the pages of *Clarté* that the surrealists needed "the strength to wait" before undertaking concrete political action, since it would be quite unrevolutionary for them to give up their "work of the mind" in favor of short-term political gains, however emotionally satisfying those might be.[75] Not surprisingly, then, the major initiative of the two groups—a journal to have been called *La Guerre civile* [Civil War]—never materialized. For the surrealists, an alliance with the communist left may have been satisfying as a formal solution to their problem of how, credibly, to advance a radical "new spirit" of modernity. Yet, since it also entailed the very real danger that making the world safe for surrealism might end up sacrificing surrealism (and even "thought" more generally) to some larger political end, there were tight limits as to how far (and in what ways) the alliance could be pursued.[76]

Breton's most poignant expression of these antimonies came in the fall of 1926 in a pamphlet entitled "In Self-Defense," a response to an attack by Pierre Naville, one of the editors of *La Révolution surréaliste* he had

ousted in the spring of 1925 who had since joined the PCF. Naville had needled Breton with the argument that either "the surrealists believe in a liberation of the spirit prior to the abolition of the bourgeois conditions of material life," in which case they were hopelessly idealist, "or they consider it impossible to create a revolutionary spirit except on the basis of a revolution that has already been accomplished," in which case they were superfluous.[77] Breton certainly did believe in the first proposition, even if he was loath to admit it openly. His main worry was about the legitimacy of the second—for reasons that orthodox communists would never have suspected. His reply therefore reiterated the first manifesto's argument about the crisis of "western culture": "That which is thought (merely for the glory of being thought) has become almost incomprehensible to the masses and is all but untranslatable for them." Yet the even more fundamental problem was that, rather than confront the collapse of the human imagination that this triumph of instrumental-rational "thinking" represented, the communists were showing that they too were quite oblivious to it. *L'Humanité* was "cretinizing" and "unreadable," so focused on "current events" as to leave no room for the "larger picture," and containing nothing about "the true currents of modern thought" or "the life of the mind." Rather than understand that what the crisis demanded was a restored harmony of the spiritual and the material, the PCF believed that "western populations can be saved" through "mechanization" and "electrification." That was why, Breton admitted, surrealism had "reservations" about "completely embracing" the only existing political program that goes beyond "empiricism and daydreams." And that too was why, although the surrealists had embraced the communist program "in principle," the communists still treat us with such suspicion and "constantly and openly denigrate our attitude."[78]

As always, however, Breton's problems ran deeper than he allowed himself to acknowledge in public pronouncements. In confronting the communists, it was easy to treat "materialism" as something external to surrealism, but in fact he understood that its tentacles reached into the movement itself, indeed into his own private involvements with art. Nor was this fact entirely concealed from his communist bedfellows, at least from the most perspicacious among them. Recalling his Clarté days in a postwar memoir, Victor Crastre noted that "at this moment [November 1925], Breton and most of his friends become aware of the precariousness of their position. Their desire to break with the bourgeoisie, even the most 'enlightened,' is always at stake. Between them and the bourgeoisie they raise a wall of sand which the waters pummel unceasingly; in spite

of their efforts to show the harshest brutality, the fawns of snobbism return to lick their hands. They must replace the wall of sand with a wall of concrete; they must get their hands dirty in order to avoid the fawn's caress. Might communism be the scarecrow that keeps the snobs and aesthetes at bay?" [79] The need for a "concrete wall" to separate avant-garde stalwarts from the corrupting influences of snobs, aesthetes, and the marketplace that was never far from them was not something Breton only began to feel in the fall of 1925. He had recognized, at least since he wrote "Distances," that surrealist research required dedication and freedom from the temptation to pursue art in relation to commodity culture. But it seems likely that Crastre was right to think that Breton saw an alliance with the communists as a helpful tool for keeping the surrealist troops in line, focused on their research and on the collective needs of the group.

What is incontrovertible is that Breton did begin to act in 1926 as if making surrealism safe from the corrupting influences of the commodity world was an important priority. On 18 May, he and Aragon protested against what they regarded as the commercial involvement of surrealist artists Joan Miró and Max Ernst in contributing set designs to a lavish Diaghilev production of the ballet *Romeo and Juliet*. "It is not acceptable that thought should follow the orders of money," they wrote in a tract that they and their surrealist comrades, shouting revolutionary slogans and otherwise reviving their old dada selves, would shower upon the audience at the premiere itself.[80] Participating in the Ballets Russes, they argued, contributed to the "degradation [*déclassement*] of the *surrealist* idea."[81] Then, in the aftermath of Breton's response to Naville that fall, as group discussions about whether to join the PCF heated up, Breton orchestrated the first "excommunications" from surrealism involving Soupault and Antonin Artaud. Here again he condemned his comrades for activities smacking of commercial motives or for the "*isolated* pursuit of the stupid literary venture"—writing novels, contributing to "bourgeois reviews" or to conventional theater—which, to his mind, risked surrealism's degradation into a mere style for the consumption of "snobs and aesthetes."[82] These preoccupations were likewise central to Breton's most important work on visual art, *Surrealism and Painting*, the four installments of which appeared in *La Révolution surréaliste* between July 1925 and October 1927.

The double game Breton began to play in these years was to seek communist recognition of surrealism's legitimacy, indeed its preeminent position as revolutionary art, while also solidifying its research side and

blocking any slide into mere style or entertainment. But would surrealism be able to move beyond automatic writing into a larger research program that incorporated the visual arts? In 1925 Breton and his friends had developed a method for the collective production of drawings known as "exquisite corpse" [*cadavre exquis*], which showed, among other things, that everyday people could engage in visual experiment just as they did automatic writing.[83] But he was sensitive about whether something that appeared to be a "parlor game," and whose value might thus be construed as "entertainment or even recreation," should be presented as a leading example of serious surrealist research.[84] From this point of view, anchoring research to the work of individual painters appeared to be a safer bet. But were contemporary painters carrying out research, or were they too just playing games with the likes of Diaghilev? Or, to bring matters still closer to home, was the work being displayed at the Galerie Surréaliste genuine research or merely an income-generating enterprise for the artists and the gallery's director? One historian has noted that advertisements for the Galerie appeared in the sixth issue of *La Révolution surréaliste,* which also contained the second installment of *Surrealism and Painting,* thus inevitably placing Breton's discussion in a "commercial context."[85]

As in "Distances," so too in this text, Breton's argument pivoted around the conflict between research and commerce.[86] No less than poetry, painting was a "language" that, by placing "at my disposal a power of illusion," offers an apparently unlimited play of the imagination and thus a capacity to create worlds that rival "what is vulgarly understood by *the real.*" Historically, painters have often failed to follow this imperative, preferring "to make the magic power of figuration with which certain people are endowed serve the purpose of preserving and reinforcing what would exist without them anyway." Theirs is a "wretched use of that power . . . , an inexcusable abdication" that can be avoided by modeling the image on a "purely internal" rather than an "external world." Painters who pursue this internal model discover in themselves "a *reason* to paint" and then, insulating themselves from the external world, follow the "mysterious path" illuminated for them by an inner light. In this respect, their path is essentially the same as the one Kandinsky outlined in *On the Spiritual in Art:* the creative individual translates the "sound" of the object into artistic "content," which then becomes manifest in an artistic "form" that an audience can receive. Breton simply cast the starting point of this model in more cognitive terms and then depicted the process of imaginative translation visually,

rather than on the musical analogy favored by the symbolist generation. In this way, the "internal model" becomes painting as "research."[87]

But is there some method or protocol for this research that can be sketched, especially for the benefit of those without the "magic power of figuration," in a manner parallel to the "secrets" for "written surrealist composition" presented in the first manifesto?[88] Interestingly, Breton made no effort to do so, preferring to demonstrate the nature of painting as research by analyzing the work of several professional painters whose methods and results he thought especially noteworthy. His foremost example was Picasso. Beginning in 1909, Picasso had used a "powerful searchlight" to "explore" the "enormous significance of that sudden flash of inspiration" that had given birth to cubism, and over the past fifteen years he had built "a laboratory open to the sky" and advanced "deep into unknown territory." Yet precisely because of the enormous power of this "research," Breton was forced to admit that Picasso had proved himself a "genius" [*génie*]. Was painting as research, then, limited to those at or near Picasso's level of talent? Breton was anxious to avoid any such implication. What truly mattered, he insisted, was that "the exploration be continued," and "everyone has the power to accompany an ever more beautiful Alice into Wonderland." Moreover, he praised Picasso not for his genius but for his "steadfastness of purpose," his "will power," and his "admirable perseverance," virtues that less-talented researchers may presumably possess in equal measure. In his accounts of other artists, Breton likewise utilized descriptive terms—Ernst's "methods of procedure," André Masson's "science" and "chemistry of the intellect," Yves Tanguy's "scientific exactitude"—that presented painting as a scientific discipline and underscored its professional investigative character.[89]

Unfortunately, however, much contemporary art was going in the "opposite direction," led astray by the "temptation" to live for "the vile, stinking beast named money" and that "monstrous thing, success," rather than for "a fundamental moral code" that puts "spiritual values" at the center. Henri Matisse, André Derain, and even Georges Braque fall into this group, but it is for Giorgio de Chirico that Breton reserved his most embittered scorn. The metaphysical and dream paintings he had undertaken from 1910 to 1917 were "incomparable"—"for us, the most extraordinary journey ever undertaken"—but "we have spent five years now despairing of de Chirico, forced to admit that he no longer has the slightest idea of what he is doing." Having lost his way intellectually, de Chirico "has put into circulation a large number of palpable fakes,

including slavish copies," and has even reproduced "his own early paintings with his present heavy hand . . . because by cheating on its external appearances he could hope to sell the same picture twice." Yet if de Chirico's devolution reveals the tragedy of what can happen to the artist now that Europe has "degraded the human spirit" by "establishing a market value for works of art," no one, Breton conceded, can stand entirely outside it. "Every work of art today is subject . . . to commercial transactions," and painting has become a "lamentable expedient." At a point of acute despair in his final installment, Breton exclaimed: "What is the use of painting, what is the use of this or that solemn treatise on painting! Let us rather speak cryptically of the alibi with which we provide ourselves to avoid finding ourselves a hundred thousand leagues away from where we are. No rules exist, and examples are simply lifesavers answering the appeals of rules making vain attempts to exist"— examples representing, it appears, those artists who do manage to sustain themselves as researchers, even in a world in which "all" is "irrevocably lost."[90]

Notoriously, Breton's susceptibility to such fits of exasperation seems to have deepened as his double game of the late 1920s proceeded, reaching bottom in the *Second Manifesto of Surrealism,* which appeared in the final issue of *La Révolution surréaliste* (December 1929) and then in a revised deluxe book edition the following June.[91] The text is infamous for its vituperative fervor against many of those in or close to the surrealist movement, so much so that Breton felt the need to apologize for the "sometimes hasty judgments I made about various people" in the new preface that accompanied its postwar republication.[92] Yet, as that preface also noted, in 1929–1930 Breton was still gripped by the hope of building "an association such as had not been seen, as far as its goals and enthusiasm were concerned, at least since Saint-Simonianism." Indeed, the manifesto itself presented surrealism as an inner circle of stalwarts that was "still in its period of preparation." In such a context, the goal that became paramount for Breton was to ensure that this circle observed an "unflagging fidelity to the commitments of surrealism." Thus, although he had no use for the ideals of "family, country, religion," he viewed loyalty as absolutely critical to surrealism's potential success.[93] The problem, however, was that loyalty required "a disinterestedness, a contempt for risk, a refusal to compromise, of which very few men prove, in the long run, to be capable."[94] Even more distressing was the fact that all such virtues were distinctly out of fashion: surrealist success required "conditions of moral asepsis [*asepsie morale*]" which, unfortu-

nately, "very few people in this day and age are interested in hearing about."[95] Thus the anger and despair of the manifesto, as well as the excommunications it effected, were provoked by the tension between Breton's hopes and related ideals on the one hand and his perceptions of the weaknesses of his fellow surrealists on the other—weaknesses that he again related to the temptations of commodity culture.[96]

Were there reasons why Breton should have been especially worried about the collapse of loyalty at this particular moment? The manifesto hints at an affirmative answer in its caustic defensive reaction to the "reception given our critical collaboration in the special number of [the popular Belgian magazine] *Variétés*, 'Le Surréalisme en 1929,'" perhaps the largest public exposure the surrealists had achieved to date.[97] Far from welcoming the wider audience and media attention afforded by this event, Breton seemed troubled by them, concerned that surrealism was becoming fashionable, prestigious, or "consecrated," to use Pierre Bourdieu's term.[98] Thus, while the manifesto continued to defend surrealist research techniques as valuable, in part because they were "available to everyone," Breton also claimed that he did not want to address himself to the general public but only to the "pure young people who refuse to knuckle down." Surrealism valued itself as a movement of outsiders, and it appears that Breton was beginning to fear that a widening audience would contribute to the corruption of the movement, to making it "no more than an intellectual pastime like any other." Surrealists, he declared, must "stop showing off smugly in public and appearing behind the footlights. The approval of the public is to be avoided like the plague. It is absolutely essential to keep the public from entering if one wishes to avoid confusion."[99] Then, too, Breton's expression of such an intensely inward-looking, antipublic attitude may have been connected in his mind with the goal of disciplining his movement for a communist alliance: he would make another major effort at putting "surrealism at the service of the revolution" over the next three years. In any case, we will see that he made his strongest declaration of an opposite attitude—both outward-looking and embracing of the public—precisely at the point when this latter goal collapsed.

MOVEMENT POLITICS, PROFESSIONALISM, AND CULTURAL DEMOCRACY

Walter Benjamin published his well-known essay on surrealism in February 1929, well before the appearance of the *Second Manifesto* with its skepticism about seeking public approval. Centrally concerned with

the possibilities of a surrealist politics, the essay was critical of Breton's political-strategic thinking but argued that surrealism's political appreciation of "the one hundred percent image space" was precisely what the revolution needed.[100] The communist intelligentsia had "failed almost entirely . . . to make contact with the proletarian masses" because this task "can no longer be performed contemplatively." Surrealism, however, understands that "to win the energies of intoxication for the revolution" means to develop a potent image politics, one that deploys images to connect body and mind, affect and intellect, so that "revolutionary tension becomes bodily collective enervation." Although his analysis did not specifically comment on how well the surrealists seemed to be able to translate their image politics into practice, it did conclude by observing that they alone read the *Communist Manifesto* in a manner adequate to the present.[101]

Interestingly, however, by the fall of 1935, when Benjamin was writing his essay "The Work of Art in the Age of Its Technological Reproducibility," he had reached a much more negative conclusion regarding surrealism's capacity for revolutionary politics, one that hinged precisely on its image-making practices.[102] The same people who take "an extremely backward attitude toward a Picasso painting," he argued, will have a "highly progressive reaction to a Chaplin film" because of the way the latter allows "an immediate, intimate fusion of pleasure—pleasure in seeing and experiencing—with an attitude of expert appraisal." In art forms such as painting, which are "viewed primarily by a single person or by a few," conventional presentations will tend to be "uncritically enjoyed, while the truly new is criticized with aversion." But in an art form such as film, which is collectively experienced, even innovation tends to be enjoyed and the "critical and uncritical attitudes of the public coincide." Unfortunately, however, the public attitude toward surrealism will tend to fall into the "backward" rather than the "progressive" category. Even though its attitude toward the image was not contemplative, surrealism, Benjamin implied, still insisted too much on serious research and refused to embrace a truly populist image-making.[103] Even an intoxicating image delivered by means of a Picasso painting is unlikely to be effective in moving the masses to action. In this sense, then, surrealism's repugnance toward any association of art with entertainment had guaranteed the ineffectiveness of its image politics. Indeed, one might go still further to say that it had encouraged precisely the opposite result from the one the surrealists claimed to want: that they would be enjoyed only by those "snobs and aesthetes" for whom the unconventional was a titillation. To

Louis Aragon, writing at the end of 1931, this is exactly what had happened: "we have arrived at a paradoxical result: our thought is considered a luxury item *precisely* because of its revolutionary character."[104]

Benjamin did not ask himself why Breton and his friends had failed to adopt an appropriately populist form of image-making. But the answer emerges clearly if we return to Adorno's critique of the avant-garde strategy of "spiritualization" that we considered in chapter 4. For although that critique missed the mark in the case of Kandinsky, who pursued an art at once spiritual and sensual, it applies perfectly to Breton, whose notion of art as research was precisely an antisensual strategy of spiritualization.[105] In his case, fear of commodity culture caused him to repress the sensuous elements in art and to put the "gypsy wagon" permanently in the garage—from which it follows that Benjamin's analysis presents us with another intriguing paradox: although Breton had sought out a communist alliance because of the resources it offered in the fight against the degradation of art into commerce and entertainment, what he needed for an effective alliance with an overly contemplative communist movement was a greater attention to the entertainment value of the surrealist image.

However, from Breton's point of view in mid-1930, as he launched his new review, *Le Surréalisme au Service de la Révolution,* any such suggestion would have appeared remote from political reality. For him, the pressing question was not what mode of surrealist participation ought to be offered to the communists but whether they would accept any sort of surrealist participation at all. He had joined the PCF in 1927 in an act of collective solidarity in order to prove his good faith and, he hoped, to put an end to uncertainties in the party regarding where he stood politically. Yet because of the party's deep-seated distrust of artistic avant-gardes, their reaction had been quite the opposite: they had questioned his motives and forced him to undergo the relentless interrogation and routine initiation into a cell that he later described in the *Second Manifesto.*[106] As a result, his actual participation in the PCF had lasted no more than a few months.[107] Nonetheless, lacking any real alternative, he had continued to acknowledge the leading role of the Comintern and the PCF in revolutionary politics and to insist on the need for a revolutionary transformation of society in order to sustain the surrealist project. Indeed, in 1930, on the first page of the first issue of *Le Surréalisme au Service de la Révolution,* he had published a telegram sent to Moscow declaring that in the event that "imperialism declares war on the soviets," surrealism would abide by whatever directives the Comintern declared.[108] At the same time, he had continued to hope that surrealism

could mount independent avant-garde activity that would be supportive of the party and that might even, in the right circumstances, gain its approval without having to accept the subordination implied by the usual notion of a politically engaged art.

In the early 1930s, Breton was often encouraged in this last respect by the apparently increased recognition among communist organizations of the need for a vibrant cultural front. The PCF spent much of 1930 engaged in planning tenth-anniversary celebrations for December, and although these were ultimately abandoned because of deepening internal divisions, the surrealists made real efforts to participate in the planning process. This collaboration was extended through coordinated protests against the Colonial Exhibition, held in Paris from May through November of 1931.[109] Meanwhile, the Comintern organized a Congress of Revolutionary Writers, which was held at Kharkov in the Ukraine in November 1930, with Aragon and Georges Sadoul in attendance as surrealism's representatives. One of its results was the creation of an International Union of Revolutionary Writers, with Aragon on the governing board. During the same period, Breton and André Thirion were attempting to create an Association of Revolutionary Artists and Writers (AAER) in France, an organization however that the Comintern rejected because of its independence.[110] Within a year, the PCF would put forward its own substitute organization, the Association of Revolutionary Writers and Artists (AEAR) from which Breton was initially excluded.[111] Many years later, he would speak somberly of the "illusion" he had held "from 1928 to 1932" that communist "distrust" of surrealism's political initiatives "would eventually subside."[112]

Yet, even at the time, Breton understood that were he to overcome this distrust by convincing the communists that he was one of them (unlikely in itself), the probability that they would embrace surrealism as a revolutionary art for the communist movement had become remote. By 1931 it had been four years since he had set himself this goal, and no progress toward it was evident. This fact had dawned on other surrealists as well, which is why the movement became more and more split into two wings, with Breton as the only link between them.[113] On the one side were those primarily interested in alliance politics, their ranks depleted by nearly twenty members from the purges associated with the *Second Manifesto*.[114] Of the figures besides Breton who had played major roles in the early years of the movement (Soupault, Artaud, Aragon, Robert Desnos, Paul Éluard, and Benjamin Péret), only Aragon, Éluard, and Péret were left, and they now became the major political players. For them, the fail-

ure to gain communist recognition of surrealism's political legitimacy meant that the option of giving up surrealist research and devoting themselves exclusively to communist politics demanded reconsideration, and in fact two of them would soon abandon Breton for orthodox communism, Aragon in 1932 and Éluard in 1938.[115] On the other side were those primarily interested in pursuing surrealist research. Except for Tzara and René Crevel, who reconciled with Breton in 1929, this group was entirely composed of younger recruits—"active new elements," as Breton would later call them—such as Luis Buñuel, René Char, and Salvador Dalí.[116] All of them had become surrealists by 1931, and over the next two years they would be joined by Alberto Giacometti, Georges Hugnet, and Roger Caillois. These men—above all, Dalí and Giacometti—brought surrealism a much-needed infusion of innovative ideas and creative energy. Yet, from Breton's point of view, the price paid for such gains was high. In Dalí, for example, surrealism had an artist whose flamboyant style suggested closer associations with the temptations of commodity culture than Breton had ever before tolerated. And although most of the new surrealists expressed at least some interest in leftist politics, if not in a communist alliance, a few declared themselves apolitical or, in the case of Dalí, went so far as to flirt with the fascist right in ways Breton would have immediately condemned just a few years before.[117] But his position was now too weak for him to be legislating the rules of surrealist conduct. Indeed, as in the case of the political wing, most of these surrealist associations were short-lived, with Tzara, Crevel, Char, Caillois, and Giacometti all exiting the movement before the end of 1935.

The research dimension of 1930s surrealism has been actively investigated in recent years, above all in the work of Steven Harris, who has emphasized the synthesis of Hegelian aesthetics, psychoanalysis, and Marxism in its approach to the workings of unconscious thought.[118] Although Harris arguably overstresses the degree to which this research emphasis breaks with the surrealism of the 1920s, there is certainly a much-increased level of ambition evident in its nature and range and, especially, in the investigation and presentation of its theoretical and historical moorings.[119] In an article written to accompany a 1936 exhibition of "surrealist objects," for example, Breton contextualized the research on objects in relation to a briefly sketched "comparative history" of the "parallel development" of scientific and poetic-artistic ideas since the early nineteenth century, and then suggested that surrealist research was furthering the process by which "reason" is today "constantly remolding

its image" through "a continuous assimilation of the irrational." He also argued that surrealism was heralding a "new way of thought" that would help free society from "anxiety," lack of "human brotherhood," and "petrified systems."[120] Surrealism was at the forefront of the reorientation of science away from positivism and its technical interest in control over nature and society toward a "surrationalism" that would, in Habermas's later vocabulary, pursue an "emancipatory cognitive interest" leading to social equality and individual creative self-realization.[121]

Research into topics such as objective chance, black humor, found or created objects, dreams, and automatism was not of course calculated to attract the attention of mainstream science, but Breton was deadly serious about the "professionalism" he thought it implied. In an article, "On the Relations between Intellectual Capital" (1930), he went so far as to argue that all "genuine" intellectual labor (as against that driven by materialist desires for "money, honors, fame, etc.") must be subject to "professional regulation" [*réglementation professionelle*], and yet that such regulation "is and always will be impossible in bourgeois society" because the value of genuine research cannot be quantitatively assessed.[122] In this sense, Breton's notion of professional research rejects the tendency of late symbolism to reconcile with mainstream culture in its pursuit of professionalism yet nonetheless renews the symbolist emphasis on the need for a professional orientation of avant-garde work. Breton did not advocate radical contestation at the expense of systematic, publicly verifiable inquiry but argued instead that the two values were interrelated.[123]

The emphasis on the professionalism of surrealist research had one further characteristic that may remind us of symbolism: it reinforced the inward-looking caste-forming qualities already evident in the language of the *Second Manifesto,* qualities that suggest surrealism's "religious" or "sect-like" character. Many of those who experienced the surrealist movement as participants or close observers have emphasized these qualities.[124] Recent scholars have also stressed the way surrealism functioned as a "religion" or "micro-society" based on the ritualistic nature of group gatherings, their aura of "brotherhood," their initiations and other shared ceremonies, as well as the way they found their "epiphanies in the street."[125] Yet, much as Breton was drawn to ritual and group solidarity, as well as to the possibilities that artistic creativity offered for the reconstitution of spiritual experience, he was not at all interested in "art" as a consolation or distraction from life's woes, or as something to be cultivated by an isolated aristocracy of taste. The whole point of surre-

alism was to overcome Baudelaire's separation of art and dream from action, as well as the more general idea of an "aesthetic caste" and the art-for-art's-sake tradition with which it was associated.[126] If we can connect surrealism to nineteenth-century "religions of art" at all, it would be through its grandiose world-transforming ambitions, which may remind us of William Morris, rather than through its internal dynamics and goals as a movement.

Moreover, the insular quality that both surrealism's "professional" research and sectarian politics tended to encourage was complemented, at least in Breton's rhetoric, by his elaboration on the theme of cultural democracy in an article that appeared in *Minotaure* roughly seven months after the final issue of *Le Surréalisme au Service de la Révolution*.[127] The article's setting is perhaps not irrelevant here. Edited by the wealthy publisher Albert Skira, *Minotaure* was a "sumptuously produced" wide-ranging review dedicated to contemporary visual art and poetry, studies of ethnography and archaeology, music, architecture and "*les spectacles*" (theater, film, dance, and popular culture), and it was clearly intended to attract a broad audience.[128] Avoiding all mention of Marx, Freud, or Hegel in a manner quite unlike most of his other writings in this period, Breton argued that surrealism's "distinctive feature is to have proclaimed the total equality of all normal human beings before the subliminal message, to have constantly maintained that this message constitutes a common patrimony, of which everyone is entitled to a share, and which must very soon, and at all costs, stop being seen as the prerogative of the chosen few." The article then touched on many of the concepts from Breton's earlier writings that supported this goal: the need to "revise" our concept of the artistic "vocation"; the rejection of "artistic talent" as a value; and the need to use artistic practices as a universal form of "education"—or "diseducation," or Rimbaudian "derangement"—of the senses.[129] The only point missing from the discussion was the famous sentence from Lautréamont that the surrealists were so fond of quoting and sometimes misquoting: "poetry ought to be made by everyone, not by one."[130]

Breton's aim in this passage was to democratize the artistic function and then cast it as the fundamental criterion for the good society. His model of the creative act remained the Kandinskyan one he had suggested in *Surrealism and Painting;* here he simply stressed its potentially universal character. Such a conception of cultural democracy certainly has the advantage of avoiding the problem of merely enshrining "box office" that occurs if we simply reverse Kandinsky's chain and move

from what the audience wants to what the artist should then produce. In contrast, Breton's model in effect states: we surrealists create art and, if you want to join us, we will show you how to do it too, not through impossible craft, but through very accessible techniques that our research has tested and made available. As such, it has many affinities with the model of cultural democracy that Benjamin would almost contemporaneously advocate in his article "The Author as Producer" (1934): the "apparatus" of cultural production "is better the more consumers it is able to turn into producers—that is, readers or spectators into collaborators."[131] Nonetheless, in basing his model of cultural democracy on the universalization of artistic practices developed by a professional elite, Breton raised certain practical difficulties for himself that were inevitably less salient for an independent intellectual such as Benjamin. Surrealism was a movement dedicated to art as research, to the work of art as a professional project, which was inevitably linked to a "chosen few," even if a "self-chosen few." Might not making this way of life universal put an end to surrealist research in this sense and thus to the surrealist movement? If art as research is the antidote to the commodification of art, might not a universalized creativity unguided by professional expertise run the risk of falling back into a universalized entertainment, thus provoking once again the outrage of society's rebellious outsiders and causing them to recreate an avant-garde movement? If artists such as de Chirico or even Ernst were too weak to follow the "fundamental moral code" that puts "spiritual values" at its center, what hope can there possibly be that the general public will follow it, even if the means of a universalized creativity are made available to them? On the other hand, if a surrealist movement remains necessary as a regulator of cultural creativity, how exactly have we arrived at cultural democracy?

At the very least, such questions suggest that to make his model of cultural democracy convincing, Breton would have had to pursue its relation to the dynamics of the surrealist movement more deeply than he in fact did. We will return to this point. Yet, however we assess Breton's efforts to articulate a viable concept of cultural democracy, the fact remains that he moved abruptly from an inward-looking antipublic focus on alliance politics and research during the period in which he most wanted the movement to be of "service to the revolution," to at least one key theoretical statement suggesting an outward-looking embrace of the public after its eclipse. To see what had happened that may help explain this shift, we need to return briefly to events and consider the political circumstances Breton faced in 1933.

During the previous year, he had pressed hard to be included in the AEAR, and by year's end he had succeeded; indeed, he managed to get himself placed on its board of directors.[132] Apparently sensing that the moment of shared collective venture he had so long craved might finally have arrived, Breton threw himself into its activities during the first two months of 1933, writing an article protesting conditions at an automobile factory and lecturing on proletarian literature.[133] Yet old differences of style and attitude soon resurfaced, and his enthusiasm dampened. In March he wrote to Éluard: "I believe more and more in the necessity of a noisy rupture with these commies and the resumption of the most intransigent surrealist activity."[134] Then, when a letter to the editor of *Le Surréalisme au Service de la Révolution* denounced "the wind of systematic cretinism blowing from the U.S.S.R.," Breton was asked to repudiate it or be expelled from AEAR.[135] Not surprisingly, he chose the latter, and by the end of June he had been formally expelled.[136] Never again would he work within an organizational structure associated with the communist party.

AN INDEPENDENT ART OF THE LEFT

The consequences for Breton's surrealism of this sudden turn of events would be difficult to overestimate. Committed since mid-1925 to making the world safe for surrealism through a strategy of political alliance, that strategy was now in total disarray. Yet the problem which had provoked the need for it—that of finding a viable mode of organizing modernity through which commodity culture might be replaced—remained as formidable as ever, and there were no other plausible alliance candidates on the horizon besides the communists. Moreover, since this fact could not but dawn on Breton's fellow surrealists, the prospects for "an association such as has not been seen . . . at least since Saint-Simonianism" had never looked dimmer. What was there to keep surrealism politically engaged, to prevent it from becoming just another school or style, or even to hold it together at all? What, in short, was to be done?

One option was to swallow hard and continue to pursue a communist alliance despite the daunting odds against success. Historians of surrealism generally agree that Breton did in fact pursue such a strategy until the summer of 1935, when he abandoned it because of the utterly humiliating treatment he received at the meeting of the Comintern-sponsored Congress of Writers in Paris that June. A second option was to acknowledge the lack of a suitable partner for a revolutionary alliance and to

remake surrealism as an independent art of the left, however utopian that might be. Many historians have argued that this was in fact Breton's choice, although they usually see him adopting it only after the summer of 1935.[137] Finally, Breton had the less palatable but perhaps more realistic option of forging a half-hearted peace with commodity culture by pursuing art as research without any concrete political correlative to its putative goal of "changing life." One historian of surrealism has argued that this was in fact the option Breton chose in 1936, when, in the wake of the collapse of the independent revolutionary movement, Contre-Attaque, he turned his energies more and more to international exhibitions and other forms of retreat "from the street to the salon."[138] Regarding the latter two options, my own view is that Breton's actual choice is better characterized in terms of the first than the second, but I would mix them in the sense that I believe that Breton had always been more oriented to the salon than he was comfortable admitting and that he seems to have understood his increased attention to galleries and exhibitions after 1935 as part of a reaching out to the public that was an integral part of his independent leftism.[139] He certainly claimed that "in the three years before the new war, surrealism reaffirmed its will not to make peace with the entire value system promoted by bourgeois society."[140]

The circumstances Breton faced at the end of 1933 would have been difficult enough even without the crisis of surrealist politics. Although now middle-aged, he still faced constant financial pressures. Moreover, he had recently undergone a wrenching divorce and found himself increasingly alone personally as well as politically. Yet he seems to have been determined nonetheless to meet his political challenges head-on by simultaneously pursuing each of the first two options indicated above. Thus, on the one hand, he reacted to the violent right-wing street demonstrations connected to the Stavisky Affair of February 1934 by joining in the counterdemonstrations organized by the socialists and communists and working with groups such as the Committee of Vigilance of Antifascist Intellectuals that would soon become integral to the Popular Front. In April, when the government, fearing more trouble, deported Trotsky from his temporary exile in France, Breton protested but took care to do so on civil-libertarian grounds rather than because of any "current conceptions" he and Trotsky might share.[141] And in June, lecturing to a group of Belgian surrealists, he made clear both his impeccable antifascist credentials and his desire to continue to work actively within a united front.[142] Yet, on the other hand, Breton's activities in this period already presaged a strategic shift toward an independent leftism. In fact, the event

in Brussels was part of a new pattern in which, abandoning his earlier qualms, he reached out to a broad public through lectures and articles that accessibly explained the aims of his movement. This pattern also included his effort to reinvigorate surrealism's theoretical commitment to cultural democracy, new pledges to internationalize the movement, and the publication of an *International Bulletin of Surrealism*.[143] In 1935, he would write catalog copy for a surrealist exhibition in Copenhagen, pay an extended visit to Prague during an exhibit there, lecturing and granting interviews, and then move on for more of the same in Zurich and the Canary Islands. One not very friendly historian has depicted Breton as a "traveling salesman" for surrealism in this period.[144]

Breton continued to try to have it both ways until the Congress of Writers in Paris, in which he had hoped to participate despite his knowledge that it represented a thinly veiled attempt to muster support for the recently concluded Franco-Soviet Pact. This pact, which shocked everyone on the French left in its precipitousness, was anathema to Breton given the specter it raised of a left-oriented championing of "family, country, religion." But his views did not matter at the congress since he was not allowed to express them. Its leaders did permit the text he had prepared to be read, but by Éluard not Breton, and "only after midnight, when the hall was already emptying out and the lights were being switched off."[145] As Breton wrote in August, when he finally admitted the bankruptcy of his strategy of trying to win party support for surrealism and made public his true feelings about Stalinism and the revival of traditional values of family and nation he saw connected with it: "For the finest victories of socialism to be sent down the drain all that remains to be done is reestablish religion there—why not?—and private property. Even at the cost of arousing the fury of their toadies, we ask if there is any need of drawing up another balance sheet in order to judge a regime by its works—in this case the *present* regime of Soviet Russia and the all-powerful head under whom this regime is turning into the very negation of what it should be and what it has been."[146] Whatever might once have been gained from a communist alliance was now irrelevant, given that Stalin had betrayed the revolution.

Even before the Congress of Writers, however, Breton delivered an address in Prague that seemed to accept the inevitability of a break with communism and aimed to work through both the trauma of it and its consequences. Surrealism, he declared, now faced a "double problem": either it could accept the primacy of politics, in which case its research would have to be surrendered, or it could assert the primacy of research,

in which case it would have to "give up collaborating on the practical plan of action for changing this world." Yet neither alternative was acceptable: "those among the modern poets and artists—the vast majority, I think—who realize that their work confuses and baffles bourgeois society, who very conscientiously aspire to help bring about a new world, a better world, owe it to themselves to swim against the current that is dragging them into passing for mere entertainers." And then he put the rhetorical question: "is there or is there not an art of the left capable of defending itself, and I mean by that one capable of justifying its 'advanced' technique by the very fact that it is in the service of a leftist state of mind?"[147] The issue was clear: since surrealism could not be of service to a revolution that no longer existed, it had to discover how it could be put into the service of developing and sustaining a "leftist state of mind."

But beneath this issue lay a still more fundamental question: even if an independent leftism could somehow keep surrealist research vitally engaged with the world, what would it actually mean since, as Breton implied in this speech and as all his choices since 1925 had suggested, it could not hope to offer a "practical plan of action"? Breton would put forward several different answers over the next four years. Here, in the spring of 1935, he placed the accent on defense, as would the Congress of Writers with its theme of the "defense of culture." They had very different notions of defense, of course. For the Soviets, defense meant rallying a broad spectrum of Western writers and artists around the celebration of traditional values—family and country, if not religion—transmitted through an aesthetic of "socialist realism." For Breton, it meant continuing an active program of surrealist research but in the context of a "united front of poetry and art."[148] Surrealism "still has aggressiveness" and still aims at the "emancipation of man," but in the present context it must also make common cause with all those "whose role is . . . to sharpen human sensibilities," even those like Stephen Spender, whose view that "good artists . . . do not stray off into militant politics" he quoted.[149] Working at least for now with the likes of Spender and the nonsurrealists associated with *Minotaure* was important, because the value of free artistic expression they continued to champion was so clearly threatened. Obviously, however, such a defensive posture left Breton vulnerable to the charge that he had himself fallen back into the autonomous art that surrealism had always claimed to have superseded. Char, for example, saw surrealism headed down "a road that inevitably leads to the retirement home of Belles Lettres."[150]

In the fall of 1935 Breton would thrust independent leftism into a

more offensive mode when Georges Bataille, a former rival with whom he had come to work more closely on the early issues of *Minotaure,* approached him with the idea of jointly leading Contre-Attaque. This "combat union of revolutionary intellectuals," as it styled itself in its inaugural manifesto, proclaimed that it was the genuine revolutionary alternative to the PCF and the Comintern, one which, although open to Marxists and non-Marxists alike, would realize the socialization of the means of production in a way entirely consistent with Marx's writings.[151] The manifesto argued that the Popular Front would fail because it was too quietistic and traditionalist. In contrast, Contre-Attaque, in Bataille's words, was a "Popular Front in the street" aiming to incite a "real revolution" that would "provoke the passionate rapprochement of the popular masses from all countries."[152] It would succeed where communism had failed because it knew how to appropriate the mode of appeal that Hitler and Mussolini had used for their causes: just as "nationalist reactionaries in various countries have been able to take advantage of the political weapons created by the working-class movement, we intend in turn to make use of the weapons created by fascism, which knows how to manipulate man's fundamental aspiration toward emotional exaltation and fanaticism."[153]

Despite such excess, of which it is virtually certain that Breton disapproved, he entered the group with great hope, thankful to have allies who at least shared the same enemies and some of the same ideals. Over the winter of 1935–1936, the group distributed numerous leaflets, organized meetings, held at least one public rally, and otherwise sought to mobilize "a vast assembly of forces—disciplined, fanatical, and capable, when the day comes, of exercising a pitiless authority" that would enable it to outmaneuver the rival Popular Front and preside over the defeat of capitalism.[154] Yet somehow the exalted Jacobin language in which these intellectuals expressed their goals failed to ignite their intended proletarian and peasant troops, and as this failure became sadly apparent by early spring, the coleadership arrangement began to unravel. On 24 March, Breton and the other "surrealist adherents of the group" proclaimed its dissolution, citing "surfascist" tendencies that had become far too "flagrant." Their brief self-certain declaration concluded by "affirming their unwavering attachment to the revolutionary traditions of the international workers' movement."[155] Yet precisely how such an affirmation could be translated into some new strategy of independent leftism was far from clear.

On 6 June, Léon Blum became prime minister of a Popular Front gov-

ernment; five days later an International Exhibition of Surrealism opened at the New Burlington Galleries in London. This was fitting symbolism: surrealism's political hopes had been quashed, at least for the moment, and it found itself in exile as mere "art." Not surprisingly, then, Breton was himself focused on the connections between politics and art when he published his thoughts on the exhibition several months later. However, despite the debacle represented for him by Blum's assumption of power, he gamely sought to construe these connections in a positive light by accenting the worker unrest that had accompanied it.[156] The exhibition, he noted, "opened and was enjoying its success at the very moment when the French workers . . . were forcibly occupying the factories," and he implied that the two events should both be subsumed under Trotsky's recent dramatic prediction that "the French Revolution has begun."[157] Breton then went on to note that "counter-revolution beyond the Pyrenees" had begun by the time the exhibition concluded on 4 July and that the events in France and Spain were "in essence but one revolution at two different stages . . . [a] resolution of the social crisis in the only place where it can be resolved—*in the street.*" Likewise, surrealism was becoming one revolution because of its internationalization: it "now tends to unify in one name the aspirations of the inventive writers and artists of all countries . . . [a] unification [that] far from being simply a unification of style, corresponds to a new consciousness of life *common to all.*" Surrealism's internationalization, and not the "twenty thousand visitors" it had attracted to the exhibition, was the true measure of its current influence, "which has risen with ever increasing rapidity during recent years."[158]

The contrast between the dire straits into which Breton's political aspirations for surrealism seemed to have fallen and his strenuous efforts at denial raise the obvious question of interpretation. In the view of Susan Suleiman, Breton is here masking "the gradual, reluctant, perhaps totally unwilling but nevertheless indubitable movement of surrealism during the 1930s from the street to the salon." In particular, she argues that, in view of the break-up of Contre-Attaque, for which, as we have seen, "the street" was symbolic of true revolution and a mode of contesting the Popular Front, Breton's reference to the street in this text can hardly be more than a "rhetorical flourish." Moreover, his "parenthetical dismissal of the factory" as a privileged site for surrealist politics and his failure to name an alternative reinforce her sense that a "displacement" has occurred.[159] I would agree that Breton's reference to the street recalls Contre-Attaque and that he certainly understood that movement

as well as the larger aggressive strategy it represented to be dead, at least for the immediate future. Yet I do not believe that Breton was refusing to name the site of surrealist politics in this text and, thus, that he had in effect lost his political bearings, "however totally unwillingly." On the contrary, Breton invoked the street because he continued to believe that all genuine revolutions (including, ultimately, the surrealist revolution) must take place there, but he also understood—even if he could not bring himself to admit—his own inability to help bring about such a revolution anytime soon. Whatever might happen because of worker agitation such as that of the June Days, he knew that from a strategic point of view the revolution must be postponed, just as he was now coming to accept a "postponement" on the larger question of the "reconciliation of art and life."[160] The deep problem for Breton in 1936 was not that he had retreated to the salon but that he continued to believe that revolutions could be expected to bring about world-transforming social change instead of grasping, as did one of his more rightward-leaning intellectual contemporaries, that they are better regarded simply as transfers of power that "give to Power a new vigor and poise."[161]

Because he grudgingly accepted "postponements," and because his emotions engaged him in this direction anyway, Breton now openly embraced Trotsky, whose political views he had long admired but which implied accepting a utopian posture rather than a "practical plan of action." Indeed, Trotsky became almost a crusade for him in the fall of 1936, as the Moscow Trials cast their macabre shadow over the West.[162] Then, in April 1938, Breton went to Mexico on a grant from the French Ministry of Foreign Affairs, got to know Trotsky, wrote a political manifesto with him entitled "For an Independent Revolutionary Art," and upon returning to France, established the International Federation of Independent Revolutionary Art, with branches in Paris, London, and New York, as well as Mexico. These activities would mean little in a world now on the brink of a second world war. But the manifesto did make clear than an "independent revolutionary art" was neither a "so-called 'pure' art, which generally serves the extremely impure ends of reaction," nor an art that could be integrated with revolutionary action, except in some indefinite future. Indeed the manifesto imagined that, even in a postrevolutionary society, the most likely initial scenario would be a "socialist regime with centralized control" separated from an already established "anarchist regime of individual liberty" promoting "intellectual creation."[163] Thus, while an independent revolutionary art would help to keep alive the prospect of revolution over the long run, it

could not expect an immediate harmonization with social life even in the event of revolutionary success.

Paris in 1938 witnessed perhaps the most successful surrealist exhibition ever held, but with the coming of the war and thus the impossibility of sustaining either the momentum it generated or the new Trotskyite politics of surrealism, the end of the movement was at hand.[164] Such at least is the view of most scholars.[165] Yet even those who insist on following surrealism's trail into the postwar era and up to Breton's death in 1966 would likely concede that the fundamental fate of the movement had been decided by 1936: the success that Breton had achieved was not the ultimately political success he so longed for but rather the commercial and "artistic" success he had so desperately hoped to avoid. Perhaps because of this fact, he remained in his heart a Trotskyite engaged in a personal, permanent revolution for the rest of his life, never allowing himself to accept official honors or to become a "mere" critic like Adorno, Greenberg, or Read. Indeed, he remained into old age very much the angry young man, as we recognize when we read of an incident in 1953 in which he seems to have deliberately smudged a prehistoric cave painting with his hand to spite a local official.[166] Nor did Breton ever lose his contempt for commodity culture in general or the commercialization of art in particular. As he wrote at the dawn of the postwar consumer society, seemingly recalling his days with Doucet: "the gravest consequence of this [present] situation is that in art the relationship between production and consumption is entirely distorted: the work of art, with rare exceptions, escapes those who carry for it a disinterested love, and offers to the indifferent and cynical a simple pretext for the investment of capital. From the emancipating value that it should be, it is transformed into an instrument of oppression to the extent that it contributes . . . to the growth of private property."[167] Nonetheless, what he *had* lost—probably by the middle of 1933 and definitely by the fall of 1936—was any real hope that a social, economic, and political alternative to commodity culture could be achieved within his lifetime.

· · ·

Breton was nothing if not ambitious in the way he crafted and then led the surrealist movement. From the beginning, it was far more than just an existential response to the dismal landscape left by the carnage of World War I. Surrealism was an idiosyncratic but also genuine effort to expand the human imagination through new modes of creative activity

that could serve as prototypes for a kind of culture beyond commodity culture, while also reorienting the larger "reign of logic" that supported commodity culture. As such, it was far more ambitious than dada, which attacked art but proposed no alternative; or revolutionary constructivism, which proposed an alternative but one that applied only to the new social order in which it existed, and for which it arguably ended up becoming as one-sidedly affirmative as the forms of culture against which it had reacted. Among all the avant-garde modernist movements, only Marinetti's futurism evidenced comparable levels of ambition, albeit in the opposite direction of fusing art and entertainment rather than reconceiving art as a realm of knowledge strictly separate from anything so lowly as popular entertainment. Yet, through its concept of art as research, Breton's surrealism showed brilliantly how the work of art could be reconceived as a potentially universalizable act of imagination that at once embodied both a critique of the desiccated, overly rationalized, and instrumentalized culture of modern capitalism and a way beyond it.

Nonetheless, the concept was problematic because of the multiple faces it took on when put into practice. Was art as research the activity of a professional elite of painters and poets, a theoretical model for universalized creativity that would put an end to artistic elites, a program for one or the other of these things that should be put into play within existing commodity culture, or a program to be harnessed to a revolutionary political movement that might ultimately produce an alternative to commodity culture? The problem was that Breton's art as research was all of these things. Because it was supposed to provide an alternative to the present and yet lacked the political resources to guarantee success, Breton allowed himself to stumble into the politics of revolutionary alliance, gambling on "the red card" rather than carefully thinking through a strategy. Yet that choice hardly obviated the practical necessity for him to continue to negotiate his way within the society of the present—with all the compromises that necessarily entailed. Moreover, the need to present surrealism as an attractive candidate for alliance with international communism meant that its inward-looking nonpublic face tended to be accentuated at the expense of its potential development as a mass-cultural movement. Yet did this trade-off make sense? What were the chances that communism would succeed? And even if it did succeed in establishing itself in power, what reason was there to think that any communist society would tolerate surrealist research or pay the slightest attention to correcting the Western overemphasis on instrumental rationality?[168]

All of this became moot once Breton's eight years of effort to forge an

alliance of surrealism and communism fell to pieces in 1933. Arguably, this collapse presented him with the opportunity to clarify how art as research might be developed as an alternative *within* commodity culture rather than an alternative to it, but fearful as he was of seeing it become indistinguishable from the autonomous art he had sought to escape, he continued to pursue the revolutionary political engagement of the surrealist movement by whatever means remained available. No doubt, this choice satisfied certain of his psychological needs, but it meant that the fundamental dualism between the elitist and populist sides of his concept of art as research was never clarified.

However, before we conclude this chapter, it will serve us well to reflect briefly on this dualism. There is no question that Breton used the surrealist movement to develop the elite potential in research; we see this clearly in his attention to professionalism and the worries he expressed about the public at the time of the *Second Manifesto*. But what besides theoretical pronouncements is there to justify the notion that he was serious about developing the populist side of the concept and thereby actually reaching the people in a way that would realize his extremely ambitious model of cultural democracy? Because he was so fearful of the degeneration of art into mere entertainment, Breton was reluctant to bend art as research in any direction that presented even the hint of such an outcome. We see this attitude in his discussion of the game of "exquisite corpse," regarding which he seems to have felt a certain sense of shame, despite the fact that every such drawing we now remember was done by a "high" artist. I believe this example offers an important clue regarding Breton's mind-set. Despite the apparent antipathy to "high art" embedded in his relentless critique of styles, schools, and other modes of packaging programs for producing artworks that quest after the new— Breton's fundamental allegiances remained in important respects to this world.[169] Even the hope expressed by his model of cultural democracy was not so much that creative activity would become popularized but that the populace, when immersed in new, more imaginative forms of creativity—forms developed by professional researchers—would be raised to the level of the surrealist elite and become something like connoisseurs of the imagination. Surrealism, we might say, was not so much snobbism denied as snobbism universalized. Breton did not need Adorno to tell him that the surrealist project of art as research—which responded to a moral imperative and searched for spiritual values—was not one that "everyman," even if released from material necessity and given his druthers, would be likely to choose. Nor was it probably lost on him that he would

be hard pressed to defend the view that art is what one discovers when one exercises one's imagination according to surrealist precepts and techniques rather than those of some other movement or no movement at all. Himself a fan of Chaplin films, he may even have understood that at least some commercialized entertainment offered a way of reinvigorating the surrealist marvelous. Yet, so far as I can tell, Breton was never challenged on these points in quite the way they would ultimately confront an Englishman very much inspired by him, the poet and critic Herbert Read.

8

The Critical Modernism
of Herbert Read

In an essay entitled "English Art," which appeared in *The Burlington Magazine* in 1933, the man who was soon to be recognized as Britain's leading art critic sought to explain why his nation's visual art had suffered such a steep decline after the glory days of John Constable and J. M. W. Turner. Talent, in his view, was not the issue. The Pre-Raphaelites, for example, had talent, yet they had "shut their minds against the modern consciousness . . . and escaped into odd sanctuaries of pedantry and snobbery." Moreover, the same decline had occurred in poetry: the late William Wordsworth and Alfred Lord Tennyson were no match for what "the freer atmosphere of France" had produced in Baudelaire. "It is, in fact," he concluded, "to something stultifying in the atmosphere of England that we must look for an explanation. And personally I cannot find it in anything else but that final triumph of the puritan spirit—our industrial prosperity. The true explanation of the Pre-Raphaelite movement is the Great Exhibition. Looking, as we may still do, through the pages of the sumptuously illustrated catalogue of the masterpieces of art and craftsmanship then displayed, we are revolted by the ugliness and vulgarity of every single object; but we cannot deny them, in the mass, an astonishing vitality. They are the expression of the taste of the age, and they are appalling and shameful; but granted the economic and moral

ideals of the age, they are inevitable. Before such inevitability, the sensitive soul could only retreat."[1]

When he wrote those words, Herbert Edward Read had just become the editor of Britain's most prestigious art journal. He had done so at the behest of its founder, the Bloomsbury doyen Roger Fry, and it was in fact in the first issue under Read's editorship that his critical assessment of English art appeared. That issue proved to be both a real and a symbolic transfer of power, for when the ailing Fry died several months later, Read assumed his role as the nation's leading proponent of modernist art, even as he also remained one of its more important poets and literary critics. From the perspective of this book, however, what was most significant about Read's first Burlington article was his analysis of the causes of English artistic decline. "Puritan spirit," "industrial prosperity," "Great Exhibition": what were these but elements of the larger framework out of which a British commodity culture both "sumptuous" and "vulgar" had emerged after 1850? In Read's view, it was the allure of mass-produced commodities, their presentation in a "crystal palace," and their visual replication through advertisement that had displaced the dazzling landscapes of Turner. Moreover, this new commodity culture was not a force to be resisted. So powerful as to appear "inevitable," "sensitive souls" could only retreat before it.

Here we shall put aside the question of the nature of British commodity culture, for it is less its nature than its consequences—real and perceived—that were significant for the intellectual tradition, culminating in modernism, that resisted it.[2] In speaking of the retreat of sensitive souls, Read was no doubt referring to the aestheticism of the Pre-Raphaelite Brotherhood and Walter Pater, the Arts and Crafts tradition of Morris and his epigoni, and the Bloomsbury Circle of Fry and Clive Bell—all manifestations of a religion-of-art tradition that was certainly both strong and unusually long-lasting in Britain.[3] He may also have been thinking of the insularity evident in Britain's delayed reception of continental trends in experimental art: famously, the first postimpressionist show in London, arranged by Fry, did not come until 1910. Yet Britain was distinctive in another related way as well, one that helps us situate Read himself: it developed an unusually prominent and forceful tradition of cultural critics, from John Ruskin forward, one that certainly included Morris and Arnold as well as Pater, Fry, Bell, and Read.[4] Although they were by no means identical in their aesthetic views and tastes, these critics all thought a great deal about the social and moral dimensions of art in relation to a society believed to be especially insen-

sitive to art—a nation of philistines, as they commonly put it.[5] As compared with their counterparts on the continent, they were also less likely to work in the arts themselves and thereby more intellectualist, less concerned with specific works and more given to philosophical disquisition, more likely to invoke the values and methods of science, more attentive to connections between art and commerce, more inclined to believe that art should aim to improve society in some way, and more culturally and politically mainstream. Although they mostly situated themselves on the political left and sometimes showed affinities for socialism and anarchism, they also saw themselves as part of an educated British elite, and—at least until Read—their tastes in art were conservative in relation to those of their continental counterparts.

If the power of Britain's commodity culture helps to explain the relative weakness and obscurity of its late nineteenth-century art, as well as its delayed reception of the more adventurous currents of continental art, it also helps to explain the vitality of its intellectual tradition of cultural criticism. British modernism, it has been said, was "more an adopted rather than native child," and this is certainly true if one looks at specific modernist movements—from futurism and expressionism to design modernism and surrealism—in which the British invariably responded rather than initiating.[6] Yet, as a critical practice, British modernism was rooted in, and could draw upon, a vibrant tradition of native theorizing that had arisen in reaction to the country's tumultuous nineteenth-century social and economic history. Here Britain led at least as frequently as it followed, and while the main reason British modernism endured into the 1950s and even 1960s is the nation's unswerving commitment to liberal institutions, its persistence as a philosophically oriented taste professionalism long after other modernist practices were exhausted has as much to do with Ruskin as with Read.

Toward the end of his life, Read reflected upon Ruskin, "who throughout a long lifetime fought with eloquence and passionate clarity for the values I have fought for, and in the end was utterly defeated." And he concluded that his own fate had been the same: "I know I have wasted my energies in this vain and bitter struggle, only to see the black claws of an industrial civilization spread over whatever beauty was left in England when Ruskin died."[7] Whatever one's view of Read's stance within the cultural politics of the early 1960s, his dejection is bound to arouse sympathy, for no one during Read's lifetime in England worked longer or harder on behalf of modernist art than he did. Nor did anyone engage in such a wide variety of modernist practices: from participating

in vorticism and imagism as a young painter and poet, to cofounding an avant-garde magazine in 1917, to organizing the ceramics and glass collections of the Victoria and Albert Museum, to participating in T. S. Eliot's *Criterion* circle, to leading an avant-garde in the Hampstead of the 1930s, to theorizing about and working for several institutions dedicated to an art-industry alliance, to thinking through a political alliance strategy in relation to the surrealist movement—in addition to writing voluminously and in a philosophically lucid and accessible way about art, literature, and politics from the 1920s until his death in 1968.[8] During this period Read wrote more than forty books, some of them just pamphlets, but many of them treatises of substantial length and argumentative complexity. It seems fair to speculate that more English readers are likely to have encountered modernist discourse through Read than through any other author.[9]

Read moved most decisively beyond Ruskin by adding a psychoanalytic dimension to the understanding of the nature and sources of human creativity. Today his appropriation of Freud and Jung may seem overly mechanical and dogmatic, but his view of the creative process as fundamentally rooted in the unconscious and his specific argument for "aesthetic education" as a means for overcoming the one-sided emphasis on analytical and rationalist approaches to the activity of knowing remain provocative. Read always saw his efforts to advance modernist art in relation to larger historical issues regarding how the aesthetic dimension of life might be reintegrated into a civilization that, in his eyes, had become increasingly antagonistic to it. He understood that Britain could not simply establish a Werkbund, or a Bauhaus, or a native surrealist or constructivist movement, or even a more general reversal of public antagonism toward modern art, and be done with the issues Ruskin had raised so passionately. Modernist engagement for Read meant starting at the roots with what he saw as the atrophy of the pre-logical modes of cognition he associated with the aesthetic sense. "You cannot impose a culture from the top," he wrote; "it must come from under. It grows out of the soil, out of the people, out of their daily life and work."[10] Like Apollinaire, he believed that promoting the "understanding" of modern art would backfire if the social and scientific processes which had led to its misunderstanding were not at least appropriately counterbalanced. Far more than Apollinaire, however, Read linked the role of modernist critic to a programmatically developed political and educational philosophy aimed at nothing less than the reconstitution of modern civilization "from under."

THE MODERNIST CRITIC AS CULTURAL NATIONALIST

Read has left us a resplendent memoir of his early childhood on the north Yorkshire farm of Muscoates Grange, where he was born in 1893.[11] It was an idyllic world he would lose abruptly when his father died in 1903 and the family was forced to move to the grim industrial cities of Halifax and Leeds.[12] At the University of Leeds, which young Herbert entered in 1912 with money borrowed from an uncle, he became friends with a number of aesthetes, including Michael Sadler, son of the vice-chancellor, who met Kandinsky in 1912 and translated *On the Spiritual in Art* into English in 1914; Frank Rutter, the young curator of the Leeds Art Gallery, with whom Read would begin the avant-garde journal *Art and Letters* during the war; and perhaps most important of all, Alfred Orage, twenty years his senior, cofounder of the Leeds Art Club in 1903, author of two subsequent books on Nietzsche, and beginning in 1907, editor of *The New Age,* a guild-socialist publication for which Read did a regular column on literature after the war.[13] Through the Arts Club, the young Read became captivated by Nietzsche and participated in lively debates regarding Fry's Paris-oriented postimpressionism, the many other varieties of new experimental art including Kandinsky's expressionism and Wyndham Lewis's vorticism, as well as the politics of anarchism and guild socialism. Then personal tragedy struck again as Read's mother died in December 1914. The following month he entered the British army as a second lieutenant.

Except for brief periods when recovering from a 1916 war wound or on leave, Read spent the last four years of the war on the front lines.[14] Yet his intellectual development did not pause but may even have intensified. Long interested in poetry, he published his first volume, *Songs of Chaos,* in 1915 and also wrote two plays in North Riding dialect, which were subsequently lost.[15] When T. E. Hulme's translation of Georges Sorel's *Reflections on Violence* appeared in 1916, Read was immensely impressed, drawing from it a vision of postwar social regeneration, the logic of which he outlined in a letter to the *Yorkshire Post.*[16] In 1917, he launched *Art and Letters* with Rutter, and it was there that his first effort to pose a theory of modern poetry appeared in January 1918.[17] Weeks before, while on leave, he took a first plunge into London literary life, meeting Eliot and entering into an ultimately unsuccessful collaboration with Lewis.[18] Meanwhile, he spent his evenings reading Sorel's philosophical mentor, Henri Bergson, whose contrast between intellect and intuition would prove to be enormously influential on his later aesthetics.[19]

After the war, Read's hopes for the social renewal of Britain led him to accept a position in the civil service, first at Labour, then at Treasury, but the work made him miserable and left no time for poetry and criticism, so it came as a great relief when he succeeded in being transferred to another civil service post at the Victoria and Albert Museum in 1922. Through this position, which he held for the rest of the decade, Read developed his extraordinary knowledge of the history of all the arts from ancient civilizations forward that would provide such a strong foundation for his art criticism. In the meantime, he devoted his after hours to collaborating with Eliot on *The Criterion,* writing poetry (a new volume, *Mutations of the Phoenix,* appeared from Virginia and Leonard Woolf's Hogarth Press in 1923), and writing longer books of criticism through which he explored the contrast between classical and romantic principles of art and made his first efforts to articulate a psychoanalytic approach to the study of art. Read was also persuaded to edit the manuscripts of Hulme, who had died at the front in 1917. Among the essays which appeared as *Speculations* in 1924 was one on Bergson and another which used Worringer's distinction between "abstraction" and "empathy" to develop the thesis that modernist art represented a break with a cultural and artistic tradition that had prevailed in the West since the Renaissance. For Read, this essay and, even more, Worringer's distinction would prove fundamental in opening the way to a serious examination of the relation between modern culture and the English tradition in art.[20]

In 1926, both Fry and Read published books dealing with the theme of art and modern capitalism. Curiously, the dimensions of each book were inversely proportional to the fame of its author. A pamphlet of twenty-two pages, *Art and Commerce* was written by the only English art critic with continent-wide fame, a status he had enjoyed at least since Apollinaire had listed him among the "roses" in his futurist "antimanifesto" of 1913. In contrast, the author of the 260 folio-sized pages which appeared as *English Stained Glass* was largely unknown even in England, no doubt because it was only his second book-length publication outside poetry, the other having appeared in 1926 as well.[21] Yet those who actually read the books would have discovered something much more significant: although both took a historical approach to the question of how art could survive in a world of commodities, their answers—and the philosophical presuppositions that underlay them—were miles apart. It will be useful to consider Fry's argument briefly before we take a somewhat fuller look at Read's.

Fry began by distinguishing an object produced to satisfy a material

need, which he called an artifact, from an object produced to satisfy something other than a material need, for which he invented the term *opifact*.[22] Acknowledging a debt to Thorstein Veblen, he made clear that the primary needs satisfied by opifacts had to do with prestige and social status. In this sense, "the opifact is primarily an advertisement." Fry then defined works of art as that subcategory of opifacts whose producers operate with a "special inspiration and uncompromising conviction," which those opificers who are not true artists lack. Artists also tend to be "intolerant individualists" and "disturbers of the established harmony," in contrast to opificers, who tend to be "fairly good members of society." With these definitions and generalizations in mind, Fry then turned to a historical overview of art and opifact production. Briefly put, his argument was that what varies historically is the volume of opifact production, which rises with commercial development and organization. The ratio of artworks to opifacts also tends to be lower when overall opifact production is high, which means that, in general, strong commercial development is bad for true artists. While the Italian Renaissance was exceptional in combining a high ratio with high overall opifact production, the same is unfortunately not true of nineteenth-century England and France. Yet they prove exceptional in another way. For whatever reason, artists in these societies "refused to be suppressed" despite the high volume of opifact production. This refusal represented a challenge to social order, which these societies met through various self-protective strategies. Yet, for Fry, the main force tending in the long run to reconcile this artistic refusal with modern commercial development was the nineteenth-century discovery of "the enormous power of the trade advertisement" through which industrialists are able to vastly increase the margin between costs and retail prices. Artists, he thought, would be well served by this development if they became willing to devote themselves to poster art since, cheap as it was to produce, industrialists would likely be willing to give genuine creative freedom to artists who lent their talents to such an enterprise. In short, the answer to the problem of art's survival in a world of commodities was advertising art.

There are a number of difficulties in this argument which cannot detain us here. I would only note in passing that Fry missed a significant analytical opportunity when he failed to perceive that commodities might be best understood as yet another sort of human product, one that effectively combines artifact and opifact into a single entity. What is most significant about the argument he did make is that he portrayed the activity of art and its history almost entirely within a narrow materialist

framework. Although he understood that the urge to create art is at some level part of human nature and, in that sense, that we are all artists, in his historical analysis Fry treated artists as a special social category functioning within the logic of economic development. Moreover, he thought that artists were largely at the mercy of that development. Societies, Fry made clear, do not need art but simply tolerate it. All artists can do is to take advantage of whatever openings economic development provides them in order to keep their creative activity alive.

Read proceeds quite differently. For him, a proper analysis of art in modern society departs not from materialist premises and the history of economic development but from the "spirit" of a nation as manifested in its artistic tradition.[23] Art is universal in the sense that it grows out of a "certain human need" deeply rooted in human nature—"the need to see our perceptions and ideals externalized in appealing form." Yet specific works of art must always be understood in relation to their roots in national traditions and, ultimately, in the local conditions of life that undergird those national traditions. Moreover, specific forms of art—in this case, the art of glass-painting in England—must always be understood in relation to the history of art in general, which in turn implies an aesthetic theory. Here Read's main guide is "Wilhelm Worringer, of whose ideas I confess myself an enthusiastic devotee."[24] What he finds useful in Worringer is primarily the idea that art involving abstract geometric design (such as that which prevailed in ancient Egypt) is not inferior to representational art but simply based on a different artistic volition. We must recognize that there are "two fundamental attitudes towards natural life" which must be differentiated: one, essentially sympathetic, takes aesthetic pleasure in identifying with the vitality of organic growth; the other, more suspicious of the "casualness of nature," retreats into the pursuit of "aesthetic rhythm and harmony" by creating formal geometric patterns. In Europe, the first attitude has its high points in the naturalism of Greek antiquity and the Italian Renaissance, while the second tends to characterize "the native art of the North" that flowered in the Romanesque and early Gothic styles.[25]

For Read, Worringer's insight that the roots of northern art lay in an experience of nature through which the abstract and geometric became exalted was fundamental to appreciating why the finest expressions of English art, and specifically of its stained glass, had come in the early Gothic period. Ruskin had made the mistake of depreciating this early period because of a failure to grasp the nature and sources of abstract art, and it led him to a contradictory aesthetic through which he tried to

appreciate the Gothic in terms of vitalism and mimesis rather than design and composition. In contrast, Read lays out a historical schema of three epochs—the "age of reason" (1150–1350), the "age of sentiment" (1350–1500), and the "age of fancy" (1500–1900), which represent a progressive decline that is fundamentally explained by periodic invasions of foreign ("southern") religious and cultural forces that alienate English art from its local rootedness. Early Gothic art is based on a holistic sense of design in which elements are integrated into a unified vision, one that is "impersonal," "devoid of sentimentality," and "universal." This art culminates in a style that is able to assimilate naturalism into abstraction in a way that parallels the greatest intellectual achievement of the epoch, Thomism, and its harmonious integration of faith and reason. Yet "in contrast with philosophy, art to a great extent . . . is confined to the place of its creation . . . , and therefore it is relatively local."[26] In particular, Read is keen to reject the thesis, held by some scholars, that English stained glass in this early period was significantly influenced by the French.

In the thirteenth century, however, the influence of St. Francis and his movement did spread throughout Europe. Culturally, this meant the celebration of anti-intellectual values, the simple life, and a sentimental approach to nature. In art, the "Franciscan spirit" translated itself into "a fidelity to the forms of nature divorced from all tendency towards abstraction"—an "art of sentiment, of human feeling seeking its ideal expression." The transmission process was gradual, of course, but Read concludes that by 1350 an alien naturalistic spirit had come to pervade English glass-making.[27] Moreover, it would intensify with Renaissance humanism, which leads after 1500 to an art of pure imitation that lacks any countervailing tendency toward idealization. In this new "age of fancy," the humanism of which St. Francis was already the carrier becomes linked to a "revival of learning," which—in combination with "the invention of paper and printing, the discovery of the compass and of gunpowder, the exploration of the seas and the scientific explanation of the universe"—promotes a secularizing spirit that shatters the harmony of the Thomistic synthesis. Moreover, a tendency toward artistic individuality, already evident in the fifteenth century, now becomes pronounced: "we see nothing but scattered individuals, each expressing his own wayward fancy, displaying some ingenuity, supplying some passing need, but achieving nothing of significance."[28] The age of fancy is the age of decadence, and the art of stained glass becomes entirely moribund for the two centuries that precede its revival by William Morris.

How was this revival possible? The short answer is that while the art had become moribund, the national spirit out of which it had initially sprung was merely dormant. "The spirit of the Renaissance, as expressed, for example, in the contemporary art of Italy, Germany, and France, never became grafted on to the English spirit. It remained in the land, but only as a foreign strand—denizened in course of time, but never absorbed into our native blood." When someone like Morris came back in touch with the native spirit through his love for the medieval world, "a second renaissance of the plastic arts"—this time genuinely English—became possible. However, the cultural forces Morris had to overcome were not simply foreign incrustations that had never penetrated national soil. Unlike the Renaissance, the Reformation "was a seed that fell on fertile ground." By the end of the fourteenth century, the Lollards—those "sober and unimaginative" followers of John Wycliffe who so hated "all images and costly vestments"—had implanted in England that "tenacious and obstinate philistinism which, in the course of little more than a century, was to expand under the impulse of the Reformation into the proportions of a national trait."[29] It is interesting that Read here refers to philistinism as a "national" trait, for it is certainly not an attitude to be associated with the national spirit that had produced early English art. The point is made only in passing in *English Stained Glass,* and in 1926 Read's primary explanation for the decadence of English art in the age of fancy remains foreign influence. But in the seven years that separate it from his essay entitled "English Art," Read became increasingly preoccupied with exploring the philosophical and psychological underpinnings of what we might call his second England— the England of puritanism, individualism, free markets, industrialism, commodity culture, and philistinism.

Read's answer to the problem of how art can survive in a world of commodities will not change: a modernist movement in English art must somehow get back in touch with the national spirit that prevailed when this tradition first flowered. Indeed, as we will see when we come to his writings of the mid-1930s, Read believed that the most avant-garde of modernisms—like surrealism—were really just latter-day rediscoveries of aesthetic and psychological principles already fully evident in "the native tradition of our [English] art and literature."[30] And since that tradition and its underlying spirit are clearly at odds with the second England that becomes dominant in the age of fancy, no accommodation with commodity culture would seem to be possible for Read, as it is for Fry. Yet, obviously, it is one thing for the critic to present a historical

analysis that justifies as necessary a certain cultural pathway and quite another to demonstrate how such a strategy is economically and politically viable. That is a question Read will not address until after 1933, although he is already reflecting upon the political role of intellectuals in relation to the ideas of Julien Benda then being heatedly debated.[31]

In *English Stained Glass,* we get only a cursory treatment of the age of fancy, and few details are added to that picture until 1933, when the essay on English art and *Art Now,* Read's first major effort to offer a framework for understanding contemporary art, both appear. Why the gap? Arguably, before he could offer a fuller appraisal of post-Renaissance art, Read needed to get clear about what the intellectual principles and practices were that underlay it and how they accounted for the degradation of art. The main explanatory variable he deploys in *English Stained Glass* is the rise of humanism and its culmination in secularism with the revival of learning. But Read is himself a secularist, and he certainly has no inclination to argue that we need somehow to retreat to a religious world. As he told a University of Edinburgh audience in 1931, "I am not suggesting that the way to recover our art, to bring beauty back to life, is to readopt a medieval religion, or a pre-Cartesian philosophy, and to ignore the logic of science altogether. All forms of sentimental medievalism are false to the spirit of the age."[32]

In June 1926, Read published a review of A. N. Whitehead's *Science and the Modern World,* which he opened by declaring that "this is perhaps the most important book published in the conjoint realms of science and philosophy since Descartes' *Discourse on Method.*"[33] Three years later he published an essay on Descartes.[34] Both texts cast Descartes in the now all-too-familiar role of the philosophical villain who first made explicit "the assumption of modern science," namely that "bodies and minds are independent substances, each existing in its own right apart from any necessary reference to each other."[35] In this modern worldview, science becomes an uncritical theory of material mechanism operating independently of philosophy, which is reduced to an idealist epistemology without material base or structure. Moreover, the worldview has "disastrous" consequences for art.[36] As Read had learned from Worringer, the abstractions of the artist must be understood as the aesthetic expression of what the philosopher does with conceptual abstractions.[37] Translated into art, Cartesian dualism represents a complete denial of aesthetic values ("beauty can only be a mechanical harmony, devoid of spiritual animation"), which is why "no great art has prevailed during the domination of the Cartesian spirit."[38] What passes for art in a ratio-

nalist world is best illustrated for England by Sir Joshua Reynolds, whose belief that "art consists . . . in being able to get above all singular forms, local customs, particularities, and details of every kind" put him at antipodes to the true national spirit.[39] For France, Read's typical example of Cartesian art is Nicolas Poussin, but in a general way the whole academic tradition since the Renaissance is found to be degraded.[40]

By building upon Bergson's concept of intuition, which brings us back in touch with the qualitative and time-permeated dimensions of lived experience beyond concepts and even fixed images, Whitehead was able to restore instinct and imagination to their rightful place in aesthetic creativity and to privilege intuition entirely over intellect within the creative process. Read was actually somewhat slow to seize upon this insight, for reasons having to do with his own preferences for classical art, which had been nurtured in the "return to order" atmosphere of the 1920s.[41] But by 1932, he had admitted that "all art originates in an act of intuition," and he had associated classical art with an inappropriate "disposition to inhibit instinctive impulses in accordance with a regulative principle."[42] Moreover, by 1933, Read had come to see in Giambattista Vico and his "genetic concept of art" a kind of early modern alternative to Descartes. Poetry, Vico had understood, is "primitive" in the sense that "it is the metaphysic of man whilst he is still living in a direct sensuous relation to his environment, before he has learned to form universals and to reflect." Following Vico's genetic method, we realize that art in general is not to be "conceived as a rational ideal, a painful striving toward an intellectual perfection, but . . . as a stage in the ideal history of mankind, as a pre-logical mode of expression." Still more important, the tradition of modern art itself achieves this realization in the era of post-1880 symbolism when an art based on the search for laws of nature's structure breaks down with the increasing recognition that even the most faithful mimesis is actually an artistic construction and that artistic vision is ultimately rooted in the artist's own inner subjectivity. Postimpressionist painters then pursue these insights, Read thought, in one of two ways. Either they use nature as a point of departure for their own constructions based on rules of form that proceed from a logic governed by artistic questioning rather than nature as it appears to the eye (as in abstract cubism). Or they take nature as a starting point for an art devoted to the observation of the artist's own subjectivity and unafraid to abandon the effort to reproduce the phenomenal character of the object (as in some expressionisms).[43]

By 1933, then, Read had arrived at a unitary theory of art based on

the primacy of intuition and an understanding of how art in the impressionist and, especially, postimpressionist era had rediscovered its intrinsic nature and purpose. But what practical difference had it made, or would it make, that contemporary art had thrown down the gauntlet to Descartes? In a despairing section of *Art Now* entitled "Social Significance of Abstract Art," Read presented the modern artist as someone who feels "himself no longer in any *vital* contact with society" and who "performs no *necessary* or *positive* function in the life of the community."[44] Yet if this is so, then the newly won self-understanding of modern art is not a genuine resuscitation of the national spirit, since it remains quite unclear what role in the national life artists are to play. Read's was a deeply serious notion of art, and he did not believe that the artist should become a futurist-style entertainer, still less that he or she should merely "give the public what it wants."[45] But he was also unable to posit an alternative. One might even say that Read in 1933 was not yet comfortable with his role as an engaged avant-garde modernist, even if he was a modernist by virtue of his own aesthetic activities and associations, as well as in terms of his view of modernity as a crisis for which modern art is an important aspect of the remedy. For while he had adopted an aggressive stance as a critic aiming to restore a properly aesthetic sense through the historical and theoretical analysis of art, he remained uneasy about any mixing of art with politics. The essay on Benda had suggested that intellectuals do right by society when they concentrate on their work, which means staying out of politics and pursuing "universal" intellectual values.[46] Indeed, even in his cultural nationalism, Read was something of a universalist. In his introduction to a 1933 anthology called *The English Vision,* he made a claim for "the universal value of our tradition. Alone of national ideals, the English ideal transcends nationality."[47]

THE TURN TOWARD AVANT-GARDE ENGAGEMENT

The triumph of Nazism in Germany and Stalinist repression in Russia sent prominent exiles from these art worlds fleeing into Britain just as Read—newly freed from his university responsibilities at Edinburgh and becoming accustomed to the independent London life of an art critic and editor—was most prepared to receive them. Among the many new faces which appeared on the London art scene between 1933 and 1938 were Gropius, Moholy-Nagy, Marcel Breuer, and Naum Gabo. Some of them merely passed through London on their way to America, but those who

stayed for any length of time tended to cluster together with Read in the village of Hampstead, then a lively art scene which included Henry Moore, Barbara Hepworth, Ben Nicholson, Paul Nash, and other members of the Unit 1 group, as well as a base of operation for many other arts-oriented intellectuals including Freud, Spender, Nikolaus Pevsner, and George Orwell.[48] Read cultivated that scene out of pride in English art, but he was probably also beginning to see that modernism would be able to survive in Europe only in an English context. Certainly we already hear the heavy footsteps of the Nazi storm trooper when we read the preface to *Art Now* with its references to "recent events in Germany" and the "far-reaching vendetta" against "*Kulturbolschewismus.*"[49]

However, as Read acknowledged two years later, his intent in that preface had still been "to dissociate revolutionary art and revolutionary politics." In principle, he continued to share Benda's "desire to occupy a detached position," and he therefore made the argument that "revolutionary artists" (and presumably art critics) are "singularly devoid of ideologies of any kind." Yet he had soon come to see with Trotsky that "the intellectual cannot avoid the economic conditions of his time; he cannot ignore them—for they will not ignore him."[50] Indeed, already in 1933, Read seems to have concluded that the life of a properly detached intellectual is not possible in the present world, which was an "age of transition" in which "the structure of society" had been revealed as something that needed to be "mended" and in which "the position of the artist must to some extent be anomalous" until that mending takes place.[51] By 1936, he was writing more straightforwardly that "in normal circumstances the *detachment* of the artist from a party and therefore a partial point of view is a condition of his *attachment* to an integral view of life. But the conditions of the present time are not normal."[52]

Read's embrace of an avant-garde politics for an age of transition took a variety of forms. One of them was a Bauhaus-inspired design modernism, Read's formulation of which—in his manifesto-like *Art and Industry* (1934)—remains perhaps the single most important document in the twentieth-century history of this British movement. While we cannot review that history here, a few comments about it will help set the context for a consideration of Read's book.[53]

Frustrated with the failure of the Arts and Crafts movement to have much of an impact on industrial production in England, a few of its members attended the 1914 Cologne convention and then began the Design and Industries Association (DIA), modeled on the Werkbund, in 1915. An active organization that still exists, the DIA published a jour-

nal, mounted exhibitions, and showered industry with propaganda about the benefits of good design but, in the interests of diplomacy, rarely addressed art directly. Nor was the DIA necessarily committed in its early years to artistic modernism or even machine production, as was evident at the 1927 Leipzig fair, where its contribution was a display of English country crafts. Similarly, the Omega Workshops that Roger Fry had organized in 1912, while apparently more serious about a marriage of modernist art and design, never made an effort at an art-industry alliance or even at machine-based mass production, and they closed after the war just as Bauhaus and continental design modernism were getting under way.[54] But in the Depression atmosphere of the early 1930s, the British government, which had always been more interested than industry in using "industrial art" to boost competitiveness, launched a broad inquiry, which culminated in the Gorell Report of 1932.[55] Meanwhile, the Society of Industrial Artists was formed in 1930, and reform-minded members of the DIA gained the upper hand, sending a delegation to visit the Bauhaus in Dessau in 1931 and intensifying the campaign for the cooperation of art and industry. By 1934, the Council for Art and Industry had been created and a freshly arrived Gropius was lecturing to the DIA. But in Read's book of the same year, we find him still making the argument that "art" and "the machine" were compatible. Moreover, in a 1937 book, Pevsner, though heartened by the flurry of recent effort, remained pessimistic about the present artistic level as well as the aesthetic prospects of British industry and concluded with a number of "suggestions for improvement."[56]

Read's book posed two main problems: how to make English machine-made products reach the level of "art" and how to integrate the artist into the industrial process. In addressing the first, he was uncompromising: we must accept the machine age ("the cause of Ruskin and Morris may have been a good cause, but it is now a lost cause"), recognize that aesthetic values can be consistent with machine production, and strive to have industrial products reflect them, educating industrialists, consumers, and artists, each in appropriate ways, to raise the level of publicly expressed taste. Echoing the German notion of a "styleless style," Read argued further that those epochs (such as England's "age of reason") which excelled in design did not operate with a self-conscious aesthetic but simply allowed their technical know-how to be informed by their instinctive imaginations.[57] Unfortunately, however, modern industrialists have failed to understand the intrinsically aesthetic nature of production. Although he did not mention Fry, Read accused the indus-

trialists of holding "a fallacy about the nature of art" that was very much like Fry's view in *Art and Commerce:* that art was not rooted in human biology as a kind of aesthetic instinct but was a superfluity that could simply be produced and exchanged "like any other commodity" and then "applied" to their manufactures.[58] If, instead, industrialists will allow the aesthetic dimensions of the product to emerge naturally during production, even product standardization will not spell defeat. For while it is true that "certain aesthetic values are lost" in the modern world, new arts arise ("the novel replaces the drama, the cinema the music hall") and the "modern painter" can prove "a very good substitute" for the "peasant craftsman." There is no turning back. But if "the economic law is absolute," it is also "healthy" in that "it compels the human spirit to adapt itself to new conditions, and to be ever creating new forms."[59]

Yet if he exuded confidence about the prospects for machine production, Read was noticeably more measured in what he said about the role of artists within it. His message was no less direct: "the abstract artist . . . must be given a place in all industries in which he is not already established," "his decision on all questions of design must be final," and "the factory must adapt itself to the artist, not the artist to the factory." Yet his next paragraph began: "Naturally such a reorganization could not come about in the present industrial system."[60] For Read, then, unlike for Gropius when he was director of the Bauhaus, there can be no hope of an art-industry alliance developing in the near term. Rather the present task must be conceived as "primarily educational." To shore up this view, Read then cited some long passages from Gropius's speech at the DIA which suggest that the "Bauhaus experiment" had been essentially about education.[61] That this was a sharp reduction of the Bauhaus project, which had become its fate largely because of a German political trajectory that had culminated in Hitler's coming to power, was a point Read left unmentioned.

In important respects then, *Art and Industry* appears to be a failure of nerve: the book raised the prospect of an art-industry alliance only to back away from any activist agenda and to call for "education" in the way that governments which do not want to act on a policy issue often call for "more study." Yet it should be recognized how Read's cultural nationalism predisposed him to such a conclusion. Unlike Fry, whose materialist history led him to advocate for artists the art of the possible and who had done precisely that in an appendix he wrote for the Gorell Report, Read believed that a viable modernism would have to recover its connection with the English tradition.[62] Since capitalism and commodity

culture were bound up with a historical process full of foreign imposi-
tions and reflecting the false and superficial Englishness of the Puritans,
he could hardly avoid concluding that any alliance of modernist art with
actually existing industrialism must be refused.

Read's design modernism is very much crafted for an "age of transi-
tion," and the same is true for his other avant-garde allegiances of this
period: his promotion of Unit 1, of surrealism and British surrealism in
particular, and of abstract-constructivist art, particularly as connected
with the "Circle" manifesto of 1937.[63] They were all vehicles through
which he sought to champion a "revolutionary art" that he hoped would
help to define the nature of, and perhaps even aid in promoting, a fun-
damental transformation of modern society beyond capitalism. His own
intensified political activity was oriented to this end, although he was
generally leery of organizational allegiances. Thus, in 1935, he attended
a conference and contributed to a book sponsored by the Artists' Inter-
national Association—a group advocating "proletarian art" while also
remaining open to a variety of modernist styles—but privately expressed
suspicions about it.[64] He also wrote a number of pieces in 1935–1936 in
which he tried to reconcile his views with a non-economic-determinist
version of Marxism, in part because he feared that the anarchist sympa-
thies he had always held were impractical in a highly industrialized
world requiring big government.[65] His quasi-Marxist phase was short-
lived, however. After 1937, he embraced anarchism in a series of books
that continue into the postwar period.[66]

But what precisely did Read mean by "revolutionary art" and how
might such art help to define what came after the age of transition? Let
us first consider what revolutionary art is not: "bourgeois academic
art."[67] Read used this concept to refer to the art of "the classical-capi-
talist tradition of the last four hundred years," in other words, to the art
of the "age of fancy."[68] Such art is merely "a commercial commodity."[69]
It seeks to give us an accurate representation of reality. It seeks to enter-
tain. But it does not understand art as an activity through which one
learns about the world—as that form of cognition or "pre-logical mode
of expression" which is historically primary and thereby primal as a
mode of human experience. That is why it experiences the invention of
photography as a great challenge, and that is also why "practically all
artists and critics and intelligence" have defected from it.[70]

At the most fundamental level, revolutionary art is the belief that "no
satisfactory basis for art can be found within the existing form of soci-
ety."[71] Revolutionary artists therefore defect from the bourgeois aca-

demic tradition and aim to return us to art as a knowledge-seeking enterprise, that is, to what art, properly understood, always already is. Read treated Unit 1 in this light when he characterized its aim as that of forming "a point in the forward thrust of modernism," or of exercising "an instinct for possible extensions of human sensibility." Although they will pursue their "work" in their own individual ways (some, for example, are "surrealist" and others "abstract" in orientation), they understand that by banding together they can maintain the discipline and communal atmosphere that will restore a proper integrity to art. Such avant-gardism may even lead to reclaiming the word *academic,* for it "has become a term of abuse . . . but in so far as the functions of an academy are necessary, these may in future be fulfilled by groups of the type of Unit 1."[72] In Unit 1, then, Read saw an avant-garde pursuing revolutionary art very much on the model of the professional elite, as developed in fin de siècle France and furthered in recent years by Breton and his surrealist movement. Moreover, since avant-garde groups like Unit 1 pursued art seriously as a specialized knowledge that can extend human sensibility, Read believed that they had gained the right to play the role of professional "academic" arbiters of aesthetic value, one which "bourgeois academic art" had forfeited when it opted for commodity culture.

There are, however, at least three other more ambitious answers to the meaning of revolutionary art that Read pursued in this period and that help us grasp the full nature of his avant-garde politics. The first arises primarily in connection with his discussion of surrealism or "superrealism," as he generally preferred to call it. For Read, as for Breton, surrealism rejects an art that reproduces the world as the eye sees it (realism), as well as one that reproduces the world as it should be (idealism), in favor of an art that reflects inner subjectivity (or, in Breton's terms, an "inner model"). Yet, quite unlike Breton, Read treated surrealism as an art of emotional expression rather than as a steadfastly cognitive enterprise aiming to extend the mind's dominions beyond the narrowly intellectualistic. For him, the difference between expressionists and surrealists was that, while the former mostly confine themselves to the conscious level of emotional experience, the latter believe that we must transcend this limit by exploring the unconscious as revealed in "dreams, daydreams, trances, and hallucinations."[73] Only then is it possible to produce a dialectical art which synthesizes all aspects of our existence by transmuting, as Breton wrote in the First Manifesto, "those two seemingly contradictory states, dream and reality, into a sort of absolute reality, a super-reality, so to speak."[74] Yet such a dialectical aim in turn

implied, according to Read, that surrealism must pursue "a second characteristic of the Marxian dialectic—its capacity to pass from . . . a system of logic to a mode of action. . . . The notion of an art, then, divorced from the general process of social development, is an illusion; and since the artist cannot escape the transformation of life which is always in progress, he had better take stock of his position and play his part in the process."[75]

In his longest essay on surrealism, written to introduce the movement to a British audience when the 1936 International Surrealist Exhibition was opening in London, Read made plain that such a taking stock meant pursuing a strategy of political alliance: "to defend himself he [the surrealist artist] must ally himself with whatever political forces seem to him to promise the requisite intellectual liberty. That choice may be a difficult one. . . . Nevertheless, in a world of competing tyrannies, the artist can have only one allegiance: to . . . the dictatorship of the proletariat."[76] To make clear that the surrealist choice was also his choice, Read declared himself a surrealist in the essay, which may help explain why he was so accommodating to Marxism in this period despite his more deeply engrained anarchism. Still, there are many signs that he was never entirely comfortable with a political alliance strategy for modernism. As he wrote in his essay on Unit 1, surrealism was the best illustration of a revolutionary art that went beyond a mere defection from the bourgeois academic tradition by putting itself *"au service de la révolution."* Yet he did not seem to mind that Unit 1 had "no such pretensions."[77]

In another of its more ambitious senses, revolutionary art for Read meant facing up to the problem of the artist in modern society. We have seen that his only answer to this problem in *Art and Industry* was the idea of a long-term "education through art." But in the essay he wrote the following year for the Artists' International Association, he argued that revolutionary artists could use the artwork itself as a means not simply of expressing their distance from commodity culture but of actively discrediting "the bourgeois ideology in art."[78] To do this they would need to recognize (as defenders of socialist realism and most Marxist critics did not) that revolutionary art has nothing to do with its purely formal elements, which are largely the same from the world of primitive art to the present. Rather a revolutionary art is one that adopts a style and manner which aims either at the "negation and destruction" of what presently passes for art or, more positively, at keeping "inviolate, until such time as society will once more be ready to make use of them, the universal qualities of art." Surrealism is an exemplar of the first aim,

abstract art of the second. But both are "*intentionally* revolutionary" in the works of art they produce.[79]

Finally, and most important, a revolutionary art is one that seeks to bring us back in touch with the human capacity for intuition that has so withered under the domination of scientific rationalism. Thus, for Read, surrealism is not only, and perhaps not even primarily, an exemplar of a modernism of political alliance or of a revolutionary art of destruction; above all it is an art that stimulates us to remember that "the evidences on which we base the claims of surrealism are scattered throughout the centuries . . . and nowhere are these evidences so plentiful as in England."[80] To appreciate surrealist art is to understand that it is "a reaffirmation of the romantic principle." Here again Read's understanding of surrealism as an art of emotional expression is quite apparent. Indeed, he did not hesitate to count William Blake and Lewis Carroll as "superrealists," and English popular ballads, Shakespeare, Swift, Shelley, and Swinburne are all referred to in ways suggesting that they should be understood, at least in certain respects, as precursors of surrealism.[81] Yet, not only surrealism but also abstract art is fundamentally engaged in discovering "methods of circumventing the intellect—of releasing the compensatory images of the unconscious in plastic and poetic form."[82] In his essay on the "Circle" group, Read argued that "with the growth of rationality and a logical type of mind, art . . . was no longer, as in primitive times, an activity integral with life itself." The abstract artists of the Circle group have understood this and have moved "*beyond* the concept" in order to "construct a plastic object appealing immediately to the senses and in no way departing from the affective basis of art, which shall nevertheless be the plastic equivalent of the concept."[83] In this way, the pursuit by abstract art of "fresh syntheses" and "new paths" leads back, curiously enough, to the English "national spirit" in a kind of Vichian *corso-ricorso*.

Yet, after half a decade of avant-garde advocacy and political engagement, was Read really any nearer to a strategy for overcoming the degradation of modern art by commodity culture, or even to restoring the artist's "vital contact with society"? He would soon see that he was not. By 1939 he no longer counted himself a surrealist. Indeed, the British surrealist group expelled him that year when they sensed that he was more interested in his own theoretical ideas about their movement than he was in participating in it.[84] Moreover, Unit 1 was long dead, and Read regarded abstract constructivism as revolutionary only in the passive sense of keeping alive the "universal qualities of art . . . until such time as society will once more be ready to make use of them." Its revolutionary mes-

sage was something like a note in the bottle thrown out to sea—a revolutionary art of the sort Adorno saw in Beckett's plays. As such it certainly had value. Yet, by the time another world war was breaking out in Europe, Read knew that he needed a more concrete and politically plausible focus for his cultural nationalism.

CULTURAL DEMOCRACY AND UTOPIAN HOPE

As late as 1934, Read had expressed views quite incompatible with full-blown cultural democracy. In concluding passages of *Art and Industry,* which he omitted from later editions of the book, he argued that a strong distinction between aesthetic production and aesthetic appreciation ought to be applied to education: while "it is true that every child is a maker of something, and that making implies design . . . , it does not necessarily imply the designer. The designer, like the poet, is born not made." Every society has "a few who have original inventive talent" along with "a general body who will never be more than appreciative of art."[85] Moreover, nothing in his discussions of "revolutionary art" during the 1930s suggests that Read was thinking of a "popular art" or one that would eliminate the distinction between high and low. On the contrary, his 1937 book *Art and Society* clearly distinguished between "popular" and "elite" art and aligned "revolutionary art" with elite art (even a classless society "by no means involves the abolition of elites" when these derive from a "natural differentiation in the talents and abilities of men"). He also claimed that in all societies "the typical art of a period is the art of the elite," denied that popular art can ever be expected to "satisfy all the requirements of a full aesthetic sensibility," and dismissed as a "definite danger" the idea that "what is popular is therefore best." Revolutionary art aims to lead society to the optimal environment for great art—one in which the artist works "within some more or less restricted communal emotional unity"—but without necessarily making art "democratic" in terms of participants, modes of evaluation, or even audience.[86]

With the coming of the Second World War, however, Read's perception of political realities changed in ways that led him to hitch his wagon to the star of cultural democracy. There is a new apocalyptic tone in his writings of the early 1940s. He opened an essay entitled "Art in an Electric Atmosphere" with images of his thoughts on a long walk "picking his way among the ruins" of a bombed-out London.[87] His mood was nonetheless more one of hope than despair: "war will give place to social

revolution, to vast movements of spiritual revulsion and ardent, hopeful planning."[88] As he wrote two years later, "the world is waiting for a new faith," and the society that will emerge out of postwar reconstruction will be entirely new, since "the old institutions, the old parties, are dead at the roots."[89] And with the "new society" will come a new culture that has "no use for cultural *elites,* whether of Burlington House or Printing House Square." In fact, "it will have no use for any 'culture' that does not spring spontaneously from the progressive energy of the people, and from a people not debased by financial slavery and social subserviency, but a people confident and manly, and above all creative."[90] Moreover, it will be a society of "communal progress" and "mutual aid" linked to an art fully aware that "a process of 'disintellectualization' is necessary for our salvation."[91]

Captivated by the specter of wartime destruction and the potential for social regeneration based on a "new faith" that it seemed to promise, Read seized on the belief that commodity culture and the degradation of art it entailed were about to pass into history. The sort of society that revolutionary art demanded and required would arrive as a natural offspring of postwar reconstruction; the problem of avant-garde strategy had been resolved by the war. For "civilization" to survive, Read convinced himself, war would have to be eliminated, and the only means for its elimination was a revolution that would "alter the structure of society."[92]

In another of his provocative essays of the early 1940s, "To Hell with Culture," Read referred to the society that such a revolution would usher in with the reassuring phrase "the Democratic Order." Yet, as he emphasized in his subtitle—"democratic values are new values"—his concepts of democracy and of the culture that would underlie it were intended as a radical break with historical tradition.[93] Departing from Walt Whitman's observation that *democracy* was such a "great word" because its "history has yet to be enacted," Read argued that "in no country in the world has it ever, for more than a brief space of a few months, been put into practice." Moreover, democracy has "never existed in modern times" because it requires three conditions quite alien to what modernity has so far meant: that "all production should be for use, and not for profit"; that "each should give according to his ability, and each receive according to his needs"; and that "the workers in each industry should collectively own and control that industry." True democracy implies socialist forms of organization and the end of commodification—a worker-controlled industrial society producing beautifully designed high-

quality articles for general, perhaps even universal use.[94] Such a society would also require expanding personal liberty, maintaining the integrity of the family, and abolishing "parliament and centralized government"—the full enactment of Read's own anarchist convictions.[95]

The social and political organization of democracy would be underpinned, in Read's conception, by a "democratic culture." Such a culture would not entail, as Fry might have had it, "democracy plus culture," because "culture in the Democratic Order of the future will not be a separate and distinguishable thing" but will be so intimately bound up with everyday life as to be unconscious and invisible. Just as the ancient Greeks had no notion of culture as a "separate commodity . . . to be given a trademark by their academicians, something to be acquired by superior people with sufficient time and money," so too the democratic order of the future would renounce "opifacts" and similar notions in which culture amounts to a kind of "sauce" to be served over "otherwise unpalatable stale fish." Read envisioned the new "democratic order" as a reflection of "natural order," which is part of "the structure of the universe and of our consciousness of that structure." Indeed, in reprintings of the "To Hell with Culture" essay after his faith in a new democratic order had been dashed, Read routinely substituted the phrase "natural society" for "democratic order."[96]

In saying "to hell with culture" as a separate commodity, Read was also now happy to say "to hell with the artist. Art as a separate profession is merely a consequence of culture as a separate entity. In our Democratic Order there will be no precious or privileged beings called artists: there will only be workers." Or if you prefer, he quickly added, "there will be no despised and unprivileged beings called workers: there will only be artists."[97] So complete was Read's new faith in a democratic culture that he abandoned the categories of elite and popular art and the distinction between aesthetic production and appreciation that had so marked his analysis just four years before. The only apparent barrier to complete cultural equality was that some people would remain "lazy."[98] While Read did sometimes fall back, even in this period, upon the notion of a "life of art" pursued by someone called an "artist" who required some form of patronage to be able to make a living, he was mainly guided by the view that a democratic culture is "natural" in the sense that creativity is universal unless it is repressed by the unnatural conditions of commodity capitalism.[99]

For reasons connected with both his genetic theory of art and his championing of early "English art," Read embraced "nature" as a stan-

dard for judging aesthetic value, as well as for judging what he viewed as its social and political concomitants.[100] But what was nature? As one would expect from his embrace of nonrepresentational forms of art, Read did not accept Ruskin's standard of "truth to nature." Rather, as he explained in an essay on the abstract painting of Ben Nicholson, "nature" ought to be thought of not as "the sum of all organic things" but as "the principle of life which animates these things." Understood in this sense, an art that follows nature is one in which the artist tries to "sense" its "underlying spirit" and "to create works which embody this spirit in their form and culture."[101] The idea here is remarkably similar to Kandinsky's notion of "inner necessity," in which the artist seeks to hear the "inner sound" of the object and then to translate the "content" it has provoked into necessary "form."[102] Of course, like Kandinsky, Read saw that such intrinsic standards for assessing aesthetic value were under attack by commodity culture, which is why he tied his support for the concept of a democratic culture to the idea that artists would retain control over standards. Yet, unlike Kandinsky and most other modernists, Read believed—at least during the war years—that the "invitability of . . . [postwar] stabilization" will mean the imminent triumph of "a general tendency to substitute qualitative for quantitative standards" in aesthetics and in the social world generally.[103] From his vantage point in 1943, the modernist utopia appeared to be right around the corner.

Another clear sign of Read's newly won optimism is that he moved into the practical world of design modernism in a way he had not dared even to advocate in *Art and Industry*. On the first day of 1943, he opened the doors of the Design Research Unit (DRU) as its director. Planned the year before by Read and Marcus Brumwell, a left-leaning advertising executive, and backed by their friends in the Exhibitions Division of the Ministry of Information, the DRU was an effort to ensure that postwar reconstruction would be married to excellence in design. Yet, even in the last two years of war, Read moved to develop prototypes for what he hoped would be a postwar "marriage of art and industry."[104] Always suspicious of industrialists, he promoted the DRU as a design service for industry rather than simply assembling a team of design professionals and waiting for industry to call upon them. One of his early projects, for example, involved having the sculptor Naum Gabo do an automotive design for Jowett Cars, a task Gabo carried out with great artistic success, although Read, despite strenuous efforts, was never able to convince the company to use it.[105] Nonetheless, he was convinced that excel-

lence in design would be required "for competitive reasons" in the post-war world and thus that history was about to reverse the way "Industry" was usually cast in the role of "the bashful maiden and the Artist as the ardent suitor."[106]

In addition to providing design services for industry, Read aimed to have the DRU conduct research on consumer needs and "the potentialities of industry," bring designers into creative contact with scientists and engineers, serve as an archive for information on industrial design, and, ultimately, create a contemporary school of design.[107] Such an ambitious program was possible because the obstacles to it were not intellectual ("we know what good design is") but merely practical—mostly a matter of removing "defects in the existing economic system" so that "production is for use rather than profit, everything is made fit for the purpose it is to serve, and everyone has the necessary means to acquire the essentials of a decent life at the highest level of prevailing taste." Such a prospect might appear utopian, he argued, but "it is, let me emphasize, a very possible, and even a very probable, Utopia," since there are "many signs that the economic system is changing and will continue to change in this direction." The main practical challenge was not economic but aesthetic: "to prevent this search for quality and variety [from] degenerating into an avalanche of vulgarity." This is where "education for art" and "civilization from under" came into the picture. "We" may know what good design is, but "they" must also know if we are actually to achieve good design. "Good taste is always built up from a broad basis: it is a slow elaboration and refinement of instinctive activities natural to man." Aesthetic sensibility is natural so long as people grow up in a world in which their "fingers . . . feel the clay, the crisp substance of wood, the tension of molten metal."[108] If we educate our children properly so that they continue to have such experiences, the problem of vulgarity will never arise.

In *Education through Art* (1943), Read offered a detailed inquiry into aesthetic education which drew extensively on modern psychological theory and pedagogy. Its aim was to defend "a natural mode of education" with art as its "basis." Such an education would expose the young to the world of art and handicraft, but it would not be essentially an "art education." Instead, Read advocated "an integral approach to reality which should be called *aesthetic* education—the education of those senses upon which consciousness, and ultimately the intelligence and judgment of the individual are based." Such an aesthetic education would help to foster the individual growth, discipline, and morality

required for a democratic culture at the same time as it built the foundation for "good taste."[109] However, Read emphasized that this education was not aimed at increasing the individual's "understanding" either of his or her capacities or of what good design is. Like Apollinaire, he believed that an Enlightenment-oriented cultivation of intellectual understanding in aesthetic matters was part of the problem and not its solution.[110] What was needed was a reshaping of civilization as a whole through the "cultivation" of the "awareness of intrinsic value."[111] Properly understood, art was "not so much a subject to be taught as a method of teaching any and all subjects."[112]

In the world Read envisioned in 1943, young boys and girls would all learn a craft at a basic level but not in order that they might become craftsmen as adults (at least during the hours they spent at work). Like the Weimar Bauhaus in which students learned to appreciate pure aesthetic forms by studying with great artists and then mastered crafts in order to better participate in industry, Read had in mind an intricate educational program that would utilize various artistic means including the crafts to arrest the "atrophy of sensibility" and the "decay of civilization," but not in order to return to some pristine world we have lost. "We cannot, at this stage of development, oppose the machine: we must let it rip, and with confidence." At the same time, we must not "make the mistake of assuming that a civilization can be based on rationality and functionalism alone." Rather we must "create a movement in a parallel direction, and not in opposition [to those ideals]."[113]

The proper integration of aesthetic education into the age of industry, Read argued, would produce a "double-decker" or "duplex civilization" whose fundamental character was already illustrated by ancient Egypt. There, as in contemporary industrial society, two forms of art had developed—one high-classical, the other low-popular—that were largely unaware of one another. Citing Worringer's description of Egyptian architecture as a product of "that naked, abstract absoluteness of the constructive spirit in its cold grandeur, its terse decidedness, its renunciation of every superfluous articulation," he suggested that the same words could be used to describe "contemporary functional architecture." The art of the machine generally is one of geometric proportions and purely formal harmonies; it is an art of "objective rationality." Yet a proper aesthetic education might at the same time cultivate an art that is "naturalistic, lyrical, [and] even sentimental." In modern society, however, these two forms of art should not and will not be aligned with a hierarchical division between "a technological priesthood and a lower

order of handicraftsmen." Within art itself, they should and will appear as different forms of modern art, as the contrast, for example, between abstract art and surrealism. Within society more generally, they should and will appear "horizontally" as a division within the life spans of individuals and between their work and leisure activities. "If, between the ages of five and fifteen, we could give all our children a training of the senses through the constructive shaping of materials—if we could accustom their hands and eyes, indeed all their instruments of sensation, to a creative communion with sounds and colours, textures and consistencies, a communion with nature in all its substantial variety, then we need not fear the fate of those children in a wholly mechanized world. They would carry within their minds, within their bodies, the natural antidote to objective rationality, a spontaneous overflow of creative energies into their hours of leisure."[114]

By the time the European war ended in May 1945, Read had resigned as director of the DRU. Although his involvement in various practical-political activities including the promotion of design modernism and an "education through art" would continue into the postwar period, he certainly no longer understood such work as part of an emerging "probable utopia." Indeed, a definite disillusionment is visible already in April: "there was a time—back in 1940—when I thought that here too the war would inevitably lead to revolution—that it would be neither won nor lost without a social upheaval. I was wrong. We won the Battle of Britain, but lost the chance of a British revolution."[115] Nonetheless, he continued to believe, as he wrote in 1947, that "our civilization is in a state of crisis," that "the system of laissez-faire capitalism . . . has broken down," and that "various alternatives seem to present themselves," of which the main two were some form of state-planned capitalism or "the replacement of capitalist enterprise by some form of communal ownership of the means of production and distribution."[116]

The primary difference between Read's views of 1947 and those he had held during the war had to do with whether or not avant-garde modernists should attempt to move history in a direction that would improve the prospects for art. In a postwar world of disappointment, Read renounced activism in favor of the view that we have arrived at a "tragic situation . . . and it is not for the artist to resolve it by direct means." Rather "history"—"a vital cyclic process beyond human control"—will simply "take its course." In the meantime, "the duty of the artist" was essentially defensive: "to preserve art from the contamination of false values, political values and propagandist values, utilitarian values

and entertainment values—all the false values that destroy the integrity and the universality of the work of art."[117]

GENERATIONAL POLITICS AND THE CRISIS OF READ'S MODERNISM

Read's postwar circumstances appeared to cooperate rather well with these objectives. In June 1947 he realized a long-standing dream by becoming the founding director of the Institute of Contemporary Arts (ICA) in London.[118] Conceived by Read in quasi-anarchistic terms as a "hearth round which the artist and his audience can gather in unanimity, in fellowship," the ICA was not to be a museum in the conventional sense of an institution relying upon wealthy trustees to build a permanent collection.[119] Rather, it would devote itself to cutting-edge temporary exhibitions and to a "study department" concerned with historical research on art and, in particular, with understanding the influence of the sciences upon contemporary art.[120] Yet despite the radical aura Read sought to project, his efforts were supported from the beginning by the British political and cultural establishment, especially by the Arts Council, which had been founded by royal charter in 1946 and which, under the leadership of John Maynard Keynes, devoted itself to "high art" and excluded industrial art and design from its purview.[121] Beginning in 1947, Read sat on its governing board. From the Arts Council's point of view, the ICA was a convenient alter-ego which could sponsor the sort of avant-garde experimentalism that the council itself might not wish to embrace actively. With each passing year, however, it also tended to put more and more pressure upon the ICA to increase revenues by moving toward the mainstream, a policy also favored by several members of ICA's own board. Read was reluctant to surrender the ICA's independence in order to land major donations, but he also rejected the arguments of those who would break with the council, which rewarded him in 1950 with a permanent building for the ICA on Dover Street in the West End.

By the early 1950s, Read's life was deeply embedded in a world of established elites. As president of the ICA, he represented the nation on the juries of international art competitions. In 1953, he was honored by Buckingham Palace with a knighthood "for services to literature," and he spent the 1953–1954 academic year as Charles Eliot Norton Professor of Poetry at Harvard. Yet it would be simplistic and unfair to treat this rise to preeminence, which certainly shocked his many anarchist friends, as some sort of "selling out." Read's radical convictions would go with him to the grave in 1968. What was changing was the relationship of his

advocacy of modernist art to the views of the British and American cultural establishments. As many scholars have noted, while modernism may still have been considered subversive in the early postwar years, by the middle of the 1950s it was becoming increasingly "canonized" as a set of specifically aesthetic attitudes and styles, and thereby separated from its politically "revolutionary" aspirations. Having shed "its anti-bourgeois stance and achieved comfortable integration into the new international capitalism," *aesthetic* modernism came to be perceived as "*here* in this specific phase or period" and thus as a "safe" doctrine without transformative consequences for the future.[122] Indeed, by the 1960s, aesthetic modernism was widely perceived by artists and architects as an "orthodoxy" to be attacked.[123] Read of course was acutely sensitive to this changing context, and although it did not force him to alter his convictions, it did lead him to some drastic adjustments in his sense of the possible.

In 1951, Read published a short book entitled *Contemporary British Art,* which coincided with the Festival of Britain. As its recent students have stressed, the festival, which commemorated the 1851 Crystal Palace Exhibition, was designed to shore up national morale by celebrating British victory and postwar reconstruction, and its atmosphere was nationalistic and nostalgic, sometimes veering toward the xenophobic.[124] Yet, in principle at least, the festival was no problem for Read. After all, he had always championed "English art" as his fundamental aesthetic value, and he was now wholly receptive to the emerging interest among younger "neo-romantic" British artists in returning to their native roots. But, while the concept of English art had functioned in his earlier work as a way of referring to a cultural-political project that would do nothing less than roll back the "age of fancy," he was now so pessimistic about the historical context that this larger connection was almost entirely lost. To be sure, Read reminded his readers of his long-standing historical thesis: "Early in the sixteenth century a blight descended on our painting and sculpture . . . [and] this aesthetic blackout lasted for about three centuries—until, early in the nineteenth century, our slumbering sensibility was reawakened, and found expression in the geniuses of Constable, Bonington and Turner."[125] And he bravely suggested that the "present stage" of history remained one of "social transition." Nonetheless, he also conceded that to speak now of a "revival of culture" might be "imprecisely optimistic." For the "future . . . has never been so uncertain as it is today," and "the world . . . is in a sad state—civilization such as the nineteenth century conceived it is visibly disintegrating."

Moreover, no counterthrust from avant-garde modernism could be anticipated. The international surrealist movement was dead, and the British version of it had never "crystallized into an independent group of a distinct character."[126] It therefore comes as no surprise that the connections between "English art" and international avant-garde movements, so strongly asserted by Read in the 1930s, are absent from this text. Considered as a whole, it is difficult to see the book's presentation of contemporary British art as anything more than a narrow declaration of Read's aesthetic preferences and, therefore, as the appearance in his own work of precisely the sort of sundering of the aesthetic and political aspects of avant-garde modernism then beginning to be registered in the larger culture.

This retreat from avant-garde engagement to a narrower aesthetic interpretation of modernism, which marked much of Read's writing on art over his last two decades, is perhaps the most profound indication of the crisis in his outlook. But there are many others. Read no longer offered his readers an aggressive rhetoric of cultural democracy, based as it had been on the premise that workers would come to live in social conditions that would allow them to become artists. While he remained a cultural democrat in principle, he backed off from the view that there is no distinction between popular and elite art and even sometimes argued that "the values of art are essentially aristocratic."[127]

Nor did the postwar Read offer any hint of how he might conceive the repoliticized modernism that could move society beyond the present "age of transition." A political alliance strategy for art was now rejected as "dangerous," yet he offered nothing in its place.[128] Moreover, while he recognized the power of modern media and entertainment industries, he rejected any compromise that would, in his terms, "accept the taste of the masses as the expression of a new aesthetic, an art of the people," and thus offered no way to combat its values and practices except by reasserting his program for an "education through art."[129] Finally—and this was the source of crisis that Read seems to have found most personally irritating—he began to see, especially after 1951, that artists themselves were no longer sympathetic to him; indeed, that a younger generation of British artists and critics were strongly ill disposed toward his attitudes and values.

To find such artists and critics, Read did not have to look far: some of the brightest and most insistent of them were associated with the ICA, specifically, with what came to be known between 1952 and 1955 as the Independent Group.[130] As the primary locus for contemporary art in

London, the ICA naturally attracted up-and-coming artists such as Richard Hamilton, Nigel Henderson, and Eduardo Paolozzi, as well as young critics such as Reyner Banham and Lawrence Alloway, many of whom worked in the trenches of the ICA study department. They resented what they regarded as Read's tight control over the ICA's intellectual agenda, and in 1952 they began to meet independently and to demand the right to hold ICA lectures for themselves. Not surprisingly, they were especially assertive in 1953–1954, when Read was off at Harvard. As Hamilton later recalled, "if there was one binding spirit among the people of the Independent Group it was a distaste for Herbert Read's attitudes."[131] While the members of the group never promulgated a common intellectual position, it is important to stress that they were inspired by the modernist tradition no less than Read was. What they rejected was Read's positioning of that tradition as the inexorable outcome of the evolution of a single universal "art." In their view, such an account was less historical than metaphysical. What was needed was an empirical approach to art that accepted the notion of its multiplicity: societies must be expected to produce many equally valid forms of art, given that human creativity is mediated by widely various economic, political, and social circumstances and aesthetic visions. From this point of view, modernism too was multiple: the question was which of the modernist movements and traditions might be most helpful in inspiring an art truly adequate to the cultural realities of postwar society. Although they did not disagree with Read's glum assessment of postwar British politics, they were fascinated rather than repelled by the emergence of a "pop culture" based on American films, magazines, and consumer advertisements. It was a culture they had all imbibed while growing up in the 1930s, and even as they understood its nature as ephemeral fashion, they did not regard what was, in Banham's vocabulary, "expendable" or "throw-away" as necessarily less valuable than what others saw as "eternal."[132]

Of the critics in the Independent Group, Banham was the most trenchant, and a brief consideration of some of his attitudes will serve to illustrate the sort of challenge that the Independent Group presented to Read.[133] In the 1950s, Banham was writing a doctoral dissertation under Nikolaus Pevsner that would later become the heart of *Theory and Design in the First Machine Age* (1960). The project led him into a wide-ranging review of the various European modernisms through which he sought to cast off the soft and comfortable attitudes that were then being associated with modernism and to rediscover the explosive power that

these movements had possessed as they emerged out of the dynamic urban, industrial, technological environments of the early twentieth century. In his own accounting, the most important of these rediscoveries was Marinetti's prewar futurism, the dynamism and originality of which, he thought, had been willfully neglected in subsequent modernist criticism.[134] Futurism's achievement had been nothing less than "to identify, with some accuracy, how people were going to live in the twentieth century, and to indicate, with some authority, certain basic ways of responding to it" that had anticipated his own generation's concerns with "the machine aesthetic, motion-studies in art, a-formal composition (as in action-painting) and what we then termed non-art, but is now called anti-art." With its anti-art—its attack on sacralized bourgeois art or "Art with a capital A"—futurism had anticipated the "hipsterism" celebrated in Jack Kerouac's *On the Road* and, in general, had shown the way to that fusion of art and entertainment which the "café-chantant, gramophone, cinema, electric advertising, mechanistic architecture, skyscrapers . . . night-life . . . speed, automobiles, aeroplanes and so forth" were already making possible before the Great War.[135]

Banham also showed his debt to early futurism in what he specifically rejected: an art celebrating the local, provincial, or narrowly "English"; or one that retreated to the world of Ruskin and the Victorians; or one that in any way revered the past and called for its "conservation."[136] Banham playfully mocked "Sir Herbert" for his incomprehension of the ways in which futurism was "the true voice of twentieth-century feeling" and, thus, of how an embrace of its values might enable modernism to remain aesthetically vital and culturally alive.[137] Read was still stuck in the "nineteenth-century democratic dream of creating a universal elite, in which every literate voter was to be his own aristocratic connoisseur and arbiter of taste—the assumption being that the gap between the fine arts and the popular arts was due only to the inadequate education of the 'masses.' " But this view depended upon a "view of popular taste" which erroneously "assumed that because only well-designed and artist-decorated artifacts had survived from Gothic times, then all medieval men, from prince to peasant, must have possessed natural good taste." In fact, as the designs of those contemporary consumer products that are popularly acclaimed attest, "popular taste" is and always has been quite different from the taste of elites. Inevitably, "what is popularly recognized as good, desirable or exciting" will be much more closely linked to "the dreams that money can buy" than what elites recognize as possessing such qualities. For Banham, the critic attentive to this fact—and thus to

a view of cultural democracy that is actually democratic—must resist the impulse to "educate for art" and develop instead "the ability to sell the public to the manufacturer, the courage to speak out in the face of academic hostility, the knowledge to decide where, when and to what extent the standards of the popular arts are preferable to those of the fine arts."[138]

In defending this position, Banham was not denying that "there is commercial exploitation in pop culture." What he did deny was that popular culture could be reduced to commerce or "entertainment industry." However commercial, pop culture always involved "some substratum of genuine feeling" such that, "whatever the intentions of the entertainment industry, the public is not being, and apparently *cannot* be, manipulated to that extent."[139] For Read, on the other hand, to accept the notion that something called pop or popular culture could operate under "standards" that were not only independent of "art" but contrary to its values was a betrayal of art and, ultimately, of civilization itself. Banham was able to assert a culturally democratic position, in Read's view, only because he had surrendered the modernist commitment to artistic control over the definition of art and the standards by which its value could be assessed. Moreover, Banham had retreated from the moral imperative of the critic to transmit artistic value to the public and had accepted the counterfeit notion of a communication stream moving from audience or public to critic to artist and designer. In short, Banham had acquiesced in the prevailing fashion of "giving the public what it wants."[140]

However, as Read had been arguing ever since *English Stained Glass,* the tendency for artistic production to become merely a matter of "scattered individuals, each expressing his own wayward fancy" with a certain "ingenuity" was no temporary phenomenon but was deeply embedded in modern culture.[141] In the age of fancy, artists and critics are under great pressure not only to follow fashion but to submit as well to "foreign influences" and "bourgeois academic canons of taste." Indeed, they are encouraged to follow everything except what is most essential about art, namely, that it is humanity's most fundamental form of learning, a cognitive exercise at the intuitive level that reveals the most basic truths about the world. As Read memorably suggested in his Norton Lectures, to grasp aesthetic consciousness "one must imagine a constant force, a blind instinct, groping towards the light, discovering an opening in the veil of nothingness and becoming aware of significant shapes. The specifically aesthetic act is to take possession of a revealed segment of the real, to establish its dimensions, and to define its form. Reality is what we thus

articulate, and what we articulate is communicable only in virtue of its aesthetic form."[142]

Perhaps Read's most impassioned response to the arguments of younger critics such as Banham came in a lecture he delivered in 1964 at a contemporary art exhibition in Kassel, Germany.[143] Here his point of departure was "art's integrity," a value which is realized only when art is bound up with processes of human learning, processes that allow art to exhibit "vitality." Modernist movements have always understood this point. "The modern movement in art has been an immense effort, that has now lasted for more than a century, to restore to art its vital function, to make art once more an organic mode of perception and communication." Unfortunately, however, "the great enterprise that was initiated by Cézanne has gone astray and some of its outriders have been lost in the desert. . . . This great enterprise has been betrayed by the permissive art of today, the art which 'abandons the philosophic guides.'" Such contemporary art "is not art at all" but an "anti-art"—an art "without concentration . . . which boasts of its inconsequence and incoherence." It is nothing more than a mode of acting-out like that engaged in by "delinquent children who destroy a beautiful object shamelessly because they are not loved, because they resent the world they did not make . . . a world characterized, in Heidegger's words, by 'the flight of the gods, the destruction of the earth, the standardization of man, the pre-eminence of the mediocre.'" Read confessed his deep worries regarding these larger conditions of modern life, which had to do with commodification and effects of commodification such as standardization, cultural materialism, mass communication, and "mass values." These phenomena threatened art with "disintegration." Nonetheless, he remained unwilling to excuse the current generation of artists as victims of structural forces beyond their control. However embattled, "genuine arts" remain. "If they lose, then art, in any meaningful sense is dead. If art dies, then the spirit of man becomes impotent and the world relapses into barbarism."[144] If contemporary artists and critics do not wake up to these realities, then they will bear the ultimate responsibility for perpetuating them.

· · ·

Even if one sympathizes, as I do, with Read's account of aesthetic consciousness as the most fundamental form of learning, it is difficult to regard it as an adequate answer to Banham and the Independent Group,

let alone the theoretical basis for a viable postwar modernism. Read was clearly right when he argued that art "is not something which can be ladled out from a glorified soup-kitchen, even if that institution is presided over by a Minister of Fine Arts. Art . . . is not something which can be handed out on a plate of any kind. Art must be discovered, not received. It must be created, not conferred. It must arise spontaneously in persons and among groups, as an expression of their vitality."[145] Yet if art is discovered rather than received, by what logic can we claim that either it must correspond to what some artistic elite wants discovered or it is barbarous? What if what is being discovered is art's essential multiplicity? Must the fact that popular art is mostly commercial entertainment and not learning mean that art as learning has been defeated? Moreover, might not the popular and fine arts cross-fertilize one other? Might not an entertainment industry and a generally aestheticized capitalism stimulate the fine arts to become more "vital" and exciting? Might not Banham have been right to suggest that commercial infusions sometimes promoted a more aesthetically sophisticated public?[146] Similarly, might not modernist art tend to become tame and safe when it self-consciously cuts itself off from popular forms of art, including commercialized entertainment? Might not Marinetti have been right that a vital modernism learns from the culture industry—learns to "distract and amuse," to generate a "marvelous," while at the same time destroying art in the sense of something "solemn, sacred, serious, and sublime"?[147] Might he not also have been right that modernist art needed a popular audience to keep it vital, to keep it from becoming soft, predictable, and "religious"?

These were the kind of questions posed by a younger generation of British critics such as Banham, who, however enthralled they were by Marinetti's futurism, had come to regard present-day modernism as tired and passé. For them, Read was an engaging character who had presented a full and spirited but ultimately unsatisfactory defense of avant-garde modernism. I would tend to concur. Yet, as a lens through which to understand the evolution of modernism, his work remains extremely valuable. Although he was too young to have written much modernist criticism during the tumultuous early years of avant-garde and design modernism, his writing in the four decades between 1926 and his death took many of the turns exhibited by the modernist movement as a whole and even recouped some of the modernist practices that his birth date forced him to miss. As we have seen, modernist criticism meant something different for Read in each of his four main periods. In the 1920s

and early 1930s, he had laid out a historical argument regarding the way English art had been undermined by modern commodity culture, as well as how British modernists in art and criticism might repair the damage by reconnecting with the English tradition that had flowered in the early Gothic period. Here his analysis bore certain affinities with that of the Italian *strapaese* movement, although his more philosophically grounded analysis cut deeper, even as the consequences he drew from it were less political. Through his reading of Benda, he began to think through the issue of avant-garde modernist politics, but it did not move to the center of his work until 1933. Then, over the next half decade until the onset of the Second World War, Read moved resolutely into the world of politically aligned modernism by exploring the way European avant-garde movements such as Bauhaus, surrealism, and constructivism might point the way out of the current crisis. Although in the end he found all modernist movements relying on political alliances to be unsatisfactory, his optimism that a modernist politics based on the value of cultural democracy might lead modern art and culture out of its crisis continued to expand and even reached new heights during the war. After the war, however, Read underwent a precipitous disenchantment that led him into a new defensiveness and, ultimately, to a severing of the aesthetic and political dimensions of his modernism.

Even in these final years of disillusionment, however, Read continued to mount an impressive version of the argument, earlier put forward by Apollinaire and Kandinsky, that all great art grows from vibrant local cultures, "from roots that grow deep into a native soil."[148] For Read, the sustenance of what remained of local cultures was the necessary antidote to processes of commodification that undermined art in part by replacing the local with the faux-universal. Read believed that any true realization of an art of universal appeal would always be the result of the "fundamental paradox" that "local pressures yield universal values."[149] It is a paradox that remains worth pondering, even if Read himself failed to grasp how art could remain vital in a world that had largely moved beyond "the local" as he rather nostalgically conceived it.

Conclusion

"Each epoch dreams the one to follow," wrote Walter Benjamin, citing Jules Michelet, in connection with the Paris of the arcades, yet they also reminded him that in constructing "images of its successor" out of present "immaturity" and "inadequacies," an epoch's imagination is often deflected "back upon the primal past."[1] No better illustration of this phenomenon exists than the passage from Kandinsky with which this book began. In it we see how the fin de siècle cultural crisis summoned not only Kandinsky's anger but also his primal dream of a respiritualization of the world through art. Yet Kandinsky's dream was just one variant of a more general modernist dream of creating a vibrant democratic culture in which the knowledge and practices of an aesthetically informed elite would become universalized. In some versions of this dream, like that of Marinetti's futurism, Adorno's "gypsy wagons" would be harnessed so that aesthetic pleasure could be wheeled in without inducing the passivity associated with sacralized "mass" entertainment. In others, like that of Breton's surrealism, the masses would be encouraged not simply to consume but to become full participants in a cultural creativity whose pathways avant-garde research would open to view. Yet, however conceived, the modernist dream faded after 1935, and by the postwar period it appeared to be exhausted. The stage was set for

modernism's sad retreat into the tired orthodoxy and cultural aloofness that made it so vulnerable to the kind of critique that Read experienced following the Festival of Britain.

Several years before the deaths of Read and Breton, the German critic Hans Magnus Enzensberger wrote an acerbic critique of "the aporias of the avant-garde" in which he accused the futurists and surrealists of having been politically "confused," "doctrinaire," and inclined toward "obscure doctrines of salvation," as well as of having surrendered the concept of aesthetic experiment to the "consciousness industry."[2] The only artists made "productive" by the avant-garde, he argued, were "those who had freed themselves from its doctrine." Indeed, the avant-garde had become "its opposite: anachronism." More recently, much the same refrain has been sung by the sociologist and critic Zygmunt Bauman, who suggests that "in the present-day postmodern setting, speaking of an avant-garde does not make sense."[3] But Bauman goes one step further: not only is the avant-garde an anachronism but its form of aesthetic politics has become unintelligible in a postmodern world of "mobile stagnation." The notion of a "guard" that comes before, that is "advanced," depends upon an orderly notion of time flow; avant-gardes downstream help the rest of the culture navigate the river. Yet, he argues, we live today not on a river but in a "minefield—in which from time to time, here and there, explosions occur, but no one can say with certainty when and where the next mine will explode."[4] In such a world, the consequences of setting off new explosions are at best unpredictable, at worst dangerous, hence best avoided.

This book has been written in a very different spirit. I regard it as tendentious to reduce the idea of the avant-garde—hence the practices of avant-garde modernism—to a prolepsis through which aesthetic directions are demarcated so that the rest of a culture can somehow catch up with them.[5] As I hope this book has shown, avant-garde modernism was not merely an aesthetic but a broadly political endeavor in which a wide variety of practices were pursued. Such practices aimed to develop the artistic and political potential of new forms of mass entertainment; to demonstrate the capacity of the critic as taste professional to stimulate the public appetite for art while actively shaping art movements; to reconnect cutting-edge art with its roots in artisanship and national, regional, or local traditions; to open up pathways for the cooperation of art and industry as well as for developing artistic vocabularies to serve this purpose; to explore connections between aesthetics, commodity culture, and the state; and to critique existing paradigms of knowledge in

order to increase the legibility of modern experience and the potential for human creativity. The avant-garde involvement in modernism cannot be essentialized or in any way reduced to a single image. It was multivalent, continuously evolving, and never monolithic. It involved a wide variety of practices in many different national contexts and historical circumstances. Still, contemporary critics are justified in raising the question of what, if anything, we can learn from the experience of avant-garde modernism and how, if at all, the spirit of its practices, or even those practices themselves, continue to be relevant for contemporary public life.

This book has tried to show, first, that the discursive and practical field represented by avant-garde modernism involved many different positions which developed in response to one another as well as to the larger cultural and historical environment. Thus we have seen how Marinetti's early futurism reacted to symbolism and to the rise of entertainment industries; how Apollinaire appropriated symbolism and naturism; how he and Kandinsky both responded to futurism; how Kandinsky developed constructivism and then reacted to Russian constructivism as well as to Bauhaus; how Gropius went beyond his own expressionism and bent Kandinsky's creativity toward new ends; how van Doesburg appropriated Kandinsky and challenged Bauhaus; how purism appropriated cubism and reacted to both Bauhaus and De Stijl; how postwar design modernism in general viewed prewar avant-garde modernism; how Novecento responded to futurism and vice versa; how *strapaese* did the same and how it understood prewar modernist movements; how surrealism positioned itself in relation to futurism and purism; and how Read responded to both design modernism and surrealism.

Second, the book has tried to illuminate some of the many ways in which nationalism was bound up with avant-garde modernist movements. We have seen, for example, that the nation—variously conceived in terms of place, folkways, traditions, loyalties, ethical and political commitments, and future aspirations—was often taken by modernists to be a vital affective attachment in contrast to the impersonality of both marketplace and state institutions. Yet it also functioned in this way for many who attacked avant-garde modernists. If we imagine three axes— nationalism in relation to commodity culture, nationalism in relation to one's view of avant-garde art, and nationalism as exclusivist or as more cosmopolitan (as in Kandinsky's "nationalist universalism"), then at least six of the eight variants one might logically generate have played important roles in this book. Nationalism, we have seen, can function as an exclusivist mode of criticizing avant-garde art and commodity culture

(Duhamel, Vinnen); as a cosmopolitan mode of criticizing avant-garde art and commodity culture (French Communists critical of surrealism such as the post-1931 Aragon); as an exclusivist mode of advancing avant-garde art and attacking commodity culture (Soffici); as an exclusivist mode of advancing avant-garde art while being mostly receptive to commodity culture (Apollinaire); as a cosmopolitan mode of advancing avant-garde art and attacking commodity culture (Kandinsky, Read); or as a cosmopolitan mode of advancing avant-garde art while upholding commodity culture (early Marinetti).

Third, we have seen that the First World War opened an enormous breach in the history of modernism. One can approach this issue from many angles. Some historians of the avant-garde, thinking mostly of dada and surrealism, have stressed the way the war undercut "official bourgeois culture," confirmed the modernist obsession with cultural crisis, and thereby created conditions that allowed modernism to flourish in the 1920s.[6] While I do not disagree with this assessment, my emphasis has been more on the way the war reconfigured the environment for, and therefore the strategic outlooks adopted by, avant-garde modernists, who turned away from avant-garde conceptions based on self-supporting movements to those involving notions of alliance either with industry, as in design modernism, or with revolutionary political movements or regimes antagonistic to prevailing capitalism and commodity culture. From this point of view, the war can hardly be seen as having allowed modernism to flourish: the major movements of design modernism were largely defeated by the mid-1920s, it failed thereafter to become deeply rooted even in hospitable environments such as Britain, and political-alliance modernism—based at least on the movements in France and Italy considered here—was a disaster.

Finally, this book has sought to make the case that what held all the various modernist movements together was their effort to resist commodity culture either by defeating it outright or, more typically, by transforming it in ways that would position art in its rightful place at the center of modern public life and prevent it from being reduced to a commodity to be judged merely in terms of exchange value. Admittedly, such an approach makes it difficult to tell the story of a flourishing modernism, especially given that virtually no one living in its postmodern wake seems any longer to believe that it is possible to create a society fundamentally different from the materialistic and consumption-driven one that currently prevails not only in the West but in most of the rest of the world as well. Avant-garde modernism's defeats are easily recognized.

Gropius, van Doesburg, Le Corbusier, Kandinsky, and Marinetti all suffered major defeats in the 1920s. Marinetti's futurism then went on to another kind of defeat in the 1930s, as did Sarfatti's Novecento and *strapaese*. Breton experienced his major defeat in the same decade; Read's defeat would not fully arrive until the postwar period, but when it came there was no mistaking it. Nonetheless, I resist the conclusion that the experience of avant-garde modernism lies before us merely as a clump of ruins on a devastated landscape from which we ought to bid "farewell."[7] Although the experience of writing this book did not lead me to any more inviting place that I anticipated, now that it is nearly concluded I am inclined to offer a limited but nonetheless vigorous defense of avant-garde modernism—above all, in its prewar manifestations.[8]

Prewar modernist movements, I want to argue, generally got the problem right: modern life is ineluctably bound up with a commodity culture that derives from capitalist markets—a fact that, for art, constitutes a definite threat but also opportunities for vital engagement with the public. The problem is to mitigate the imperializing tendencies of commodity culture, to keep open a space for the life of art, to widen art's popular appeal, to expand opportunities for creative work generally as well as for popular participation in the arts, and above all, to "rescue art" in Adorno's sense of avoiding "the thoughtless . . . reproduction of what is" by encouraging creative experiment and the utopian vistas always at least potentially connected with such experiment.[9] In other words, broadly speaking, the problem is to continually revitalize the relationships among art, commodity culture, and both the expansion and deepening of cultural democracy. We will return to this point.

Yet early modernists, like their postwar successors, also took some wrong turns. One of them was on the question of standards for judging art. Provocative as Kandinsky's account of internal necessity is—and helpful as it is in its dynamic aspects—it seems unduly limiting and even wrongheaded to insist that the evaluation of art be conceived entirely on the basis of a unidirectional model that proceeds from artist to spectator or reader and, therefore, that any influence of the latter on the content or form of art must be based on "external necessity." Nor are most of us today comfortable with the notion of objective standards in art, however construed. For we have become more attentive not only to processes of cultural construction but also to the postmetaphysical situation left by the erosion of foundational philosophy. Modernists were right to insist on standards for art that cannot be reduced to exchange value or its effective equivalents such as popularity or "box office," but such stan-

dards must be conceived as a matter for continuous negotiation. Certainly arts professionals, including artists, ought to play a central role in this negotiation, yet the larger public—as well as the particular local publics within it, as constituted by cultural traditions, languages, class, race, gender, sexual orientations, and other markers of difference— must also be included in any viable, culturally democratic notion of an "interpretative community."[10] Moreover, what matters for democratic cultures, I think we now recognize, has less to do with the continued existence of avant-garde art or objective standards for judging such art than with the vigor of cultural expression that comes from "every man" as "a special kind of artist," to recall a phrase from Read.[11] Certainly if this vigor is lacking, there will be little hope that some professional arts elite can stimulate it or compensate for it.

Modernist movements also took a wrong turn when they entertained fantasies of destroying commodity culture and entered into Faustian bargains with political movements or regimes that seemed to promise such an outcome. Such alliances were certainly understandable given the new political and economic constellation of the interwar years. Indeed, in some cases such as fascist Italy, one might have thought them unavoidable had not a movement such as *strapaese* shown otherwise. Yet futurism and surrealism gained nothing from their alliances and were often humiliated by them. In Breton's case, it seems especially obvious (admittedly, with the aid of hindsight) that the pursuit of a communist alliance produced no benefits at all that justified the enormous time and energy he spent on it. Yet, of course, avant-gardes are not about careful calculation, least of all Breton's surrealism. Poggioli was right to see the centrality for avant-gardes of an "agonistic attitude," a proclivity for the apocalyptic in which they strive to "transform the catastrophe into a miracle."[12] Far from acting as "advanced guards" who scout downstream so that others may navigate the river more easily, avant-gardes often venture where few others are ever likely to follow. The fearless, sometimes reckless pursuit of grand visions is what avant-gardes are all about; if it is their curse, it is also their charm.

One might counter that for every Breton, there was a Gropius, and it is true that the Bauhaus under Gropius's leadership pursued a grand vision that was also carefully and even brilliantly calculated. Yet—again with the aid of hindsight—it seems clear that Bauhaus was far better as political strategy than as vision. Given the conservatism of mainstream German society and the power of its elites in the era of postwar recon-

struction, Gropius was right to adopt a strategy of elite collaboration and prescient to understand that modern machine technology, however temporarily discredited by the war, was destined to play an ever-increasing role in modern life. From this point of view, the use of powerfully original artistic intelligences such as Kandinsky and Klee to guide budding artistic virtuosi to a "styleless style" that could underpin a genuine aestheticization of a reemerging capitalism was an adroitly conceived and resourceful avant-garde strategy. Yet even leaving aside the short-term failures of this project, which were probably unavoidable, the enduring result of "Bauhaus style" was the establishment of a luxury-market niche, a result that not only fell far short of the movement's aims but one that might have been anticipated from the fate of William Morris a few decades before. Moreover, this result was by no means limited to Bauhaus. Whether we take our foremost exemplar of design modernism to be Bauhaus or its competitors such as Dutch De Stijl or French purism, or even Marinetti's "second futurism," the strategy offers far less inspiration to those of us who reside in postmodern commodity cultures than it must have to its creators.

To my mind, it is the constructivist spirit of prewar avant-garde modernism that we have the most to learn from today. Yet before pursuing this point, let me introduce a few images from a contemporary art critic regarding the current aesthetic-political landscape. "The art world has become a variety show," writes Jed Perl, by which he means nothing specific like a Marinettian variety theater but simply a pell-mell world in which "everything is possible"—and available.[13] This world celebrates freedom of choice, which is good since it is "both a democratic value and an artistic value," yet no one can assimilate the results, which are simply too various and vast. "The artist has come to be regarded as the ultimate free-wheeling citizen, who wakes up in the morning and decides what he or she will be today." As a dance partner, this artist has "a public that does not know what it wants but does know that it wants *more*. The art world is full of any-aesthetic-will-do consumers." As a result we have "a kind of equalization of everything for everybody." But if this sounds like cultural democracy fully realized, think again. In Perl's view, "you can argue that there is something highly undemocratic about an art world in which fixed standards are irrelevant and creativity, totally divorced from any generally agreed-upon idea of craft or technique, is just another word for getting ahead." This world has also lost any sense of place as well as any "collective memory of an artisanal past." Without a clear

sense of standards or of rootedness in place and time, and having undergone the surrealist divorce of creativity from craft, today's art world is one of cacophony and mindless drift rather than creative liberation.

Anyone who has been to a recent Venice Biennale or made a tour of the Chelsea gallery scene in Manhattan is likely to see some truth in this picture. Yet whether one wholly agrees with it or not, it does lend credence to the modernist fear of a loss of cultural creativity in modern societies not so much (or not merely) because new entertainment industries suppress it but because art itself becomes so easily unglued in a culturally democratic world that is no longer subject at least to some avant-garde direction. While I am too mindful of Kandinsky's analysis of internal necessity to call for a restoration of avant-gardism in its modernist forms (impossible in any case), it is worth reminding ourselves of some of its virtues as we think about what a more vibrant embrace of art for the public (including public art) might mean for us.

Marinetti was unequaled in his ability to create a dynamic public art that could draw large new audiences by utilizing the modes and styles of communication opened up by the modern world of technology and mass culture—what today might be called his ability to learn from Las Vegas. Moreover, his audiences were never in the dark about what he thought futurist style and futurism's vision for a reconstructed modern culture were. As his Blaue Reiter project showed, Kandinsky was unequaled among modernists in his ability to link experimental modern art with its roots in artisanship and cultural traditions—without falling into traditionalism and while projecting a sense of hope about the future which Stephen Spender, writing in the age of modernist decline, called "touching, innocent, mysteriously exciting."[14] Yet it is Apollinaire who strikes me as the avant-garde modernist from whom we have the most to learn. As a critic, he showed how to stimulate the public imagination and its appetite for aesthetic experience by being an entertaining writer and public presence, even as the values he upheld were deeply serious. He knew how to use allusive and suggestive writing to transmit the voice of the artist to the public without dictating how the art should be experienced and while remaining attentive to public responses. As an avant-garde promoter, he championed modernist art as a whole rather than this or that movement. Overall the result of his work was to strike some intricate balances: between the values of entertainment and art, between leadership and responsiveness, and between a desire to democratize the experience of art and a firm opposition to any "industrialization of art" that would eradicate its qualitative dimensions.

In the boldness with which they asserted the values of art, creativity, and qualitative experience, as well as in the redemptive hopes they had for a revivified public sphere, the early avant-garde modernists exemplified the sort of leadership that an aesthetically engaged democratic culture needs if it is to avoid the dystopia of an "equalization of everything for everybody." One did not have to become a futurist in order to appreciate the infectious enthusiasm of the early futurist movement, or accept Apollinaire's judgments about specific artists or works of art to grasp the fertility of the cultural world about which he was writing, or be firmly rooted in the various traditions of Christian art to sense the "mysterious excitement" in the way spiritual knights such as St. George moved through the pages of the *Blaue Reiter Almanac*. Yet the continuing importance of early avant-garde modernists lies not only in the qualities of leadership and public engagement they brought to their cultural environments. In at least two respects, their most fundamental intellectual preoccupations remain no less engaging for us today.

One of these is the issue of cultural democracy that has loomed so large in these pages. As suggested in chapter 1, the late eighteenth-century era of democratic revolutions brought with it a collapse of social hierarchies in which the normative basis of social structure and organization moved from the vertical to the horizontal, from rank and honor to dignity and rights, the repository for which became the human individual. Among those who took advantage of this development to assert claims to recognition on the basis of individual uniqueness, avant-garde modernists were prominent. Whether out of high regard for their creative talents or because of their sense of themselves as a legitimate profession, modernists invariably attached their advocacy of a democratic culture to the notion that art would not be reduced to a commodity because they would remain in important respects its custodians. Their stubborn insistence on this point not infrequently brought them into antagonistic relations with the public or involved them in conflicts between their democratizing goals and their determination not to surrender control. Undoubtedly, it must have appeared to many of their observers that modernist movements were out of tune with democratic norms, that, in plain words, they remained unjustifiably "elitist." But were they guilty as charged, or might there be some persuasive justification for the stance they took?

Without in any way seeking to defend the behavior of either individual avant-garde modernists or the groups they represented, behavior which was often annoying, patronizing, ridiculous, or worse, I would

nonetheless offer at least the beginnings of a theoretical justification for the role avant-gardes seek to play in a democratic culture in the following terms. Assume for a moment that in a democratic culture, people will demand the right to judge artists—and self-appointed custodians of the arts—in the same way that they judge politicians. If we think that you are doing a bad job, we vote you out. To avant-gardists who say we alone really understand art and thus must be allowed to set its agenda and judge its results, the people reply: that would be like allowing politicians to judge politicians. To this the avant-gardist might then reply: but if you don't allow me my independent voice, which implies the possibility that I will produce something highly unpopular or even reprehensible, your existence might become complacent, unreflective, conventional, corrupt, humdrum, standardized, or in some other similar way inadequate. Democratic cultures need mechanisms that allow them to be disturbed, provoked, probed, critiqued, even opposed. They need a Socratic element—a mode of questioning designed to uproot mediocrity and complacency. They need Kierkegaardian irony in the sense that Jonathan Lear has defended (in a very different context) in a recent book.[15] "What did Socrates's irony actually consist of," Lear reports Kierkegaard asking himself in his diary. "While the whole contemporary population of farm-stewards, trades people etc., in brief, these thousands, while all of them were absolutely sure that they were human beings and knew what it meant to be a human being, Socrates probed in depth (ironically) and busied himself with the problem: *what does it mean to be a human being?* By doing so he really expressed that all the bustle of these thousands was an illusion, a phantasmagoria, a tumult."[16]

In short, the defense of the avant-gardist—to my mind legitimate—is that he or she represents the liberal element in cultural democracy. In the terms set forth by Jacques Derrida in a late work, avant-gardes represent the singularity that keeps the system open, that prevents "closure." "There is no democracy without respect for irreducible singularity or alterity," wrote Derrida, "but there is no democracy without the 'community of friends' (*koina ta philon*), without the calculation of majorities, without identifiable, stabilizable, representable subjects, all equal. These two laws are irreducible to one another."[17] But both, he argued, were necessary. The community of friends is demanded by equality, but the openness to singularity and otherness is necessary because democracy is an ideal that is never achieved in practice. It is a telos; democracy implies what Derrida called a "democracy to come."[18] A fully adequate conception of cultural democracy must therefore involve not simply a

practice of art that responds to popular taste but, at least as important, one that examines, challenges, contests, and seeks to shape and reshape that taste. By the same token, what is true for democratic majorities is also true for individualistic avant-gardes: they must remain open to contestation from others in the arts community as well as from the broader public. Avant-gardes may help to combat the standardization we associate with entertainment industries—one that spills over, for example, into the blockbuster shows of the contemporary art world—but they are themselves not immune from being afflicted by complacency or current fashion, nor are they necessarily representative of the various particular communities that exist in multicultural societies and a globalizing world.

This observation brings me to a second modernist preoccupation that continues to engage us: the connection between cultural creativity and locality, place, and community.[19] This was also a very contested issue within modernism. As we have seen, many of those who most insisted on the rootedness of genuine creativity in folk traditions, specific locales, and the life circumstances of particular human communities—places in which the qualitative seemed to find secure anchorage—were men who had themselves been uprooted. One thinks not only of Apollinaire and Kandinsky but also of Read, for whom the farm at Muscoates Grange in Yorkshire where he was born seems to have played an imaginative role akin to Moscow sunsets for Kandinsky. Yet there were exceptions. One thinks immediately of Le Corbusier, a Swiss living in France who nonetheless dismissed appeals to "local cultures" or "folk cultures of the past" as so much "Ruskinian baggage" to be discarded.[20] Today it seems difficult not to agree with him, at least in the sense that appeals like that of Apollinaire to the "nation" as a privileged source of a properly rooted art seem antiquated, nostalgic, liable to unfortunate forms of prejudice, and even perhaps nonsensical given the complexities of globalized cultures.

So let us consider the claim in the more sophisticated form in which Kandinsky put it forward: that genuine art is rooted in local conditions of time and place but in a dynamic way that neither reproduces convention or tradition nor appeals to particularistic prejudices. Was Kandinsky right to think that the withering of the localized sustenance of artisanal and artistic traditions condemns art to becoming external and spiritually lifeless? Might it be that the objective conditions for singularity or alterity are necessarily found in a cultural "neighborhood" and that the loss of such moorings in contemporary globalizing societies (often referred to as "de-localization") undermines the conditions for true aesthetic expe-

rience? While I cannot hope to answer such questions here, one promising direction for an answer seems to me to lie in the work of Arjun Appadurai.[21] Particularly fruitful is his distinction between "neighborhood"—"situated communities characterized by their actuality, whether spatial or virtual, and their potential for social reproduction"—and "locality" in the sense of a "complex phenomenological quality" which is "primarily relational and contextual rather than scalar or spatial" and "which expresses itself in certain kinds of agency, sociality, and reproducibility."[22] Such a distinction between the physical or actual and the phenomenological, affective, and symbolic aspects of place seems to me to make possible a rethinking of the conditions of the structure of feeling that "locality" continues to represent for a world in which "neighborhoods" have become so much more complex and no longer correspond in any simple way with modes of daily cultural interaction. In this sense, even if Kandinsky is right that art is enabled by feelings of locality ultimately rooted in neighborhoods, one has the tools to consider how such neighborhoods might operate in virtual ways (as with diasporic communities) or whether, even as spatial or material, they may be "imagined" on a wider and more fluid basis than was the case in the world Kandinsky knew. In the contemporary world in which eclecticism rules not simply in the way postmodernists such as Jean François Lyotard imagined it two decades ago ("one listens to reggae, watches a western, eats McDonald's food for lunch and local cuisine for dinner, wears Paris perfume in Tokyo and 'retro' clothes in Hong Kong") but as part of the new postcolonial space-time-compressed world of transnational migrations, borderland exchanges, and hybridized cultural concoctions fed by electronic mail and Internet connections, one might venture the speculation that, however much locality has been freed from neighborhood in the "real" sense, it remains very much allied with neighborhood in increasingly complex "imagined" senses.[23]

Whether or not this is so, it is clear that what the critic Lucy R. Lippard has called "the lure of the local" has not lost its fascination in contemporary cultural life.[24] Indeed, she argues that "the cult of the 'new' is a virus that has done public art little good" and that, in contrast, "a place-specific art offers tantalizing glimpses of new ways to enter everyday life" as well as a source of "bonds radiating out from the art 'community'—to marginalized artists, to participant communities and audiences, allowing the idea of art to become, finally, part of the social multicenter rather than an elite enclave."[25] Yet, far from being a dream that takes us beyond the modernist "cult of the new," I believe most of

the avant-garde modernists considered in this book would have recognized themselves in this way of picturing a democratic culture. For while their dream may have been one of extending "elite enclaves" out to a "social multicenter" rather than using the latter to sublate the former, they certainly hoped to give new life to marginalized artists by bringing them into vital contact with particular communities and audiences, thereby positioning the idea and practice of art as the omphalos of modern public life.

Modernists lived their passion for art and their dreams of remaking modern culture within some of the darkest years of what the historian Eric Hobsbawm has called the "age of extremes."[26] Amid the catastrophe of two world wars, the rise of Hitler and Stalin, the Holocaust, the Gulag Archipelago, Hiroshima and Nagasaki, the Depression, the Spanish Civil War, and all the other smaller calamities of the interwar and early postwar eras, it is easy for the historian to lose sight of the idiosyncratic and sometimes perverse perambulations of Europe's avant-garde modernists. Yet as the late critic Edward W. Said reminded us in a review of Hobsbawm's book, "the Short Twentieth Century is, more strikingly and jarringly than any before it, an age of warring interpretations, of competing ideologies, methods, crises. The disciples of Nietzsche, Marx, Freud, the apologists for culture and counter-culture, for tradition, modernity, and consciousness, have filled the air, and indeed space itself, with contestation, diatribe, competing viewpoints."[27] Thus, while we may locate the origins of the century's manifold tragedies mostly in the machinations of heads of state and those who took orders from them, the workings of the European intellectual and cultural world ought not to be downgraded to the status of a mere "superstructural phenomenon." As Said quite correctly observed, "the twentieth century saw, along with the appearance of genocide and total war, a massive transformation of intellectual and cultural terrain." Human life, we have begun to understand, works differently in an age when "Newspeak, propaganda, media hype, and advertising" come to control the way in which reality is encountered and processed.[28] In telling the story of how some embattled avant-gardes resisted commodity culture and dared to hope that they could help redeem the promise of modernity by bringing experiences of art to the center of public life, this book has, I hope, contributed at least modestly to our understanding of how that "massive transformation of intellectual and cultural terrain" was actually lived.

Notes

INTRODUCTION

1. Wassily Kandinsky, *On the Spiritual in Art* (1912), now in *Kandinsky: Complete Writings on Art,* ed. Kenneth C. Lindsay and Peter Vergo (New York: Da Capo, 1994), 128, 139, 135.

2. On the older literate culture and the transition away from it, see George Steiner, "In a Post-Culture," in *Extraterritorial* (New York: Atheneum, 1971), 155–171; and Walter Benjamin, "One-Way Street," in *Selected Writings, Volume 1: 1913–1926,* ed. Marcus Bullock and Michael W. Jennings (Cambridge, Mass.: Harvard University Press, 1996), especially 456–457.

3. On space-time compressions after 1880, see Stephen Kern, *The Culture of Time and Space, 1880–1918* (Cambridge, Mass.: Harvard University Press, 1983).

4. For complementary histories from the perspectives of literary modernism and architecture/decorative arts respectively, see Peter Nicholls, *Modernisms: A Literary Guide* (Berkeley: University of California Press, 1995); and Richard Weston, *Modernism* (London: Phaidon, 1996). For the visual arts, see Bernard Smith, *Modernism's History: A Study in Twentieth-Century Art and Ideas* (New Haven, Conn.: Yale University Press, 1998); and T. J. Clark, *Farewell to an Idea: Episodes from a History of Modernism* (New Haven, Conn.: Yale University Press, 1999). For some comprehensive historical views, see Christopher Butler, *Early Modernism: Literature, Music and Painting in Europe, 1900–1916* (Oxford: Oxford University Press, 1994); Richard Sheppard, *Modernism — Dada — Postmodernism* (Evanston, Ill.: Northwestern University Press, 2000); Martin Jay, "From Modernism to Postmodernism," in *The Oxford Illustrated*

History of Modern Europe, ed. T. C. W. Blanning (Oxford: Oxford University Press, 1996), 255–279; and Robert Wohl, "Heart of Darkness: Modernism and Its Historians," *Journal of Modern History* 74 (September 2002): 573–621.

5. Some exemplary recent works are Cinzia Sartini Blum, *The Other Modernism: F. T. Marinetti's Futurist Fiction of Power* (Berkeley: University of California Press, 1996); David Cottington, *Cubism in the Shadow of War: The Avant-Garde and Politics in Paris, 1905–1914* (New Haven, Conn.: Yale University Press, 1998); Steven Harris, *Surrealist Art and Thought in the 1930s: Art, Politics, and the Psyche* (Cambridge: Cambridge University Press, 2004); Christopher Green, *Art in France, 1900–1940* (New Haven, Conn.: Yale University Press, 2000); Peter Fritzsche, *Reading Berlin, 1900* (Cambridge, Mass.: Harvard University Press, 1996); and Michael T. Saler, *The Avant-Garde in Interwar England: Medieval Modernism and the London Underground* (Oxford: Oxford University Press, 1999).

6. My concept of an institution of art is most strongly influenced by the formulations of Peter Bürger and Stanley Fish. See Bürger, *Theory of the Avant-Garde,* trans. Michael Shaw (Minneapolis: University of Minnesota Press, 1984), 22; Peter Bürger and Christa Bürger, *The Institutions of Art,* trans. Loren Kruger (Lincoln: University of Nebraska Press, 1992), 3–29; and Fish, *Is There a Text in This Class? The Authority of Interpretative Communities* (Cambridge, Mass.: Harvard University Press, 1980), 1–17, 338–355. For a recent work on modernism from this point of view, see Lawrence Rainey, *Institutions of Modernism: Literary Elites and Public Culture* (New Haven, Conn.: Yale University Press, 1998).

7. My method here is inspired by Pierre Bourdieu, *The Field of Cultural Production: Essays on Art and Literature* (New York: Columbia University Press, 1993). For my understanding of Bourdieu's method, see my *Avant-Garde Florence: From Modernism to Fascism* (Cambridge, Mass.: Harvard University Press, 1993), 4–6.

8. On this transition, see Benedict Anderson, *Imagined Communities: Reflections on the Origin and Spread of Nationalism,* rev. ed. (London: Verso, 1991), 9–36; and Karl Mannheim, "The Democratization of Culture," in *Essays on the Sociology of Culture,* trans. Paul Kecskemeti (London: Routledge and Kegan Paul, 1956), 171–246.

9. Jean-Marie Schaeffer, *Art of the Modern Age: Philosophy of Art from Kant to Heidegger,* trans. Steven Randall (Princeton, N.J.: Princeton University Press, 2000).

10. Eugen Weber, *Peasants into Frenchmen: The Modernization of Rural France, 1870–1914* (Stanford, Calif.: Stanford University Press, 1976), 495–496.

11. For examples of this view, see Rainey, *Institutions of Modernism;* Pierre Bourdieu, *The Rules of Art: Genesis and Structure of the Literary Field,* trans. Susan Emanuel (Stanford, Calif.: Stanford University Press, 1995); D. L. LeMahieu, *A Culture for Democracy: Mass Communication and the Cultivated Mind in Britain Between the Wars* (Oxford: Clarendon Press, 1988); and Lawrence W. Levine, *Highbrow/Lowbrow: The Emergence of Cultural Hierarchy in America* (Cambridge, Mass.: Harvard University Press, 1988).

12. See Judith R. Walkowitz, *City of Dreadful Delight: Narratives of Sexual Danger in Late-Victorian London* (Chicago: University of Chicago Press, 1992);

Bram Dijkstra, *Idols of Perversity: Fantasies of Feminine Evil in Turn-of-the-Century Culture* (Oxford: Oxford University Press, 1986); and Rita Felski, *The Gender of Modernity* (Cambridge, Mass.: Harvard University Press, 1995), especially 74–79.

13. See Schaeffer, *Art of the Modern Age,* 8.

14. See Felski, *Gender of Modernity;* and Andreas Huyssen, *After the Great Divide: Modernism, Mass Culture, Postmodernism* (Bloomington: Indiana University Press, 1986), x and passim.

15. Nonetheless, even as late as the 1970s, one important critic of modernism—Daniel Bell—failed to understand it because he left the rise of commodity culture out of his account. Indeed, in *The Cultural Contradictions of Capitalism* (New York: Basic Books, 1976), Bell went so far as to blame modernists for the rise of a culture of hedonist consumption because he identified the "techno-economic realm" of capitalism entirely with production.

16. See Theodor W. Adorno, *Aesthetic Theory,* trans. Robert Hullot-Kentor (Minneapolis: University of Minnesota Press, 1997), especially 1–26 and 236–237.

17. See Fredric Jameson, "Reification and Utopia in Mass Culture," *Social Text* 1 (Winter 1979): 130–148, which treats modernism explicitly as "resistance to the commodity form"; and Terry Eagleton, "Capitalism, Modernism and Postmodernism," in *Against the Grain* (London: Verso, 1986), 140.

18. Rainey, *Institutions of Modernism,* 3.

19. See Robert Jensen, *Marketing Modernism in Fin-de-Siècle Europe* (Princeton, N.J.: Princeton University Press, 1994).

20. See Green, *Art in France,* 52.

21. Schaeffer (*Art of the Modern Age,* 7–8) forgets about futurism when he writes that the "speculative theory of Art . . . a theory of Art with a capital A . . . played a legitimating role for . . . 'modernism.'"

22. See Thomas Crow, "The Birth and Death of the Viewer: On the Public Function of Art," in *Discussions in Contemporary Culture: Number One,* ed. Hal Foster (Seattle: Bay Press, 1987), 1–8; and *Painters and Public Life in Eighteenth-Century Paris* (New Haven, Conn.: Yale University Press, 1985).

23. See Stanley Sultan, *Eliot, Joyce and Company* (Oxford: Oxford University Press, 1987), 97.

24. See Matei Calinescu, *Five Faces of Modernity: Modernism, Avant-Garde, Decadence, Kitsch, Postmodernism* (Durham, N.C.: Duke University Press, 1987), 279.

25. See Rainey, *Institutions of Modernism,* 3.

26. See David Weir, *Anarchy and Culture: The Aesthetic Politics of Modernism* (Amherst: University of Massachusetts Press, 1997); Weir, *Decadence and the Making of Modernism* (Amherst: University of Massachusetts Press, 1995); and Clark, *Farewell to an Idea.* See also Seth Taylor, *Left-wing Nietzscheans: The Politics of German Expressionism, 1910–1920* (Berlin: Walter de Gruyter, 1990) for Germany; and Green, *Art in France,* 36, for France. For the contrary argument, that avant-garde modernism is always reactionary, see John Carey, *The Intellectuals and the Masses* (London: Faber and Faber, 1992).

27. See Thomas Crow, "Modernism and Mass Culture in the Visual Arts," in *Modern Art in the Common Culture* (New Haven, Conn.: Yale University Press,

1996), 3–37, a paper originally written in response to Clement Greenberg. For that exchange, see Benjamin H. D. Buchloh, Serge Guilbaut, and David Solkin, eds., *Modernism and Modernity: The Vancouver Conference Papers* (Halifax: Press of Nova Scotia College of Art and Design, 1983), 161–168, 215–264.

28. See Peter Jelavich, "Popular Dimensions of Modernist Elite Culture: The Case of Theater in Fin-de-Siècle Munich," in *Modern European Intellectual History: Reappraisals and New Perspectives* , ed. Dominick LaCapra and Steven L. Kaplan (Ithaca, N.Y.: Cornell University Press, 1982), 220–250; and Jeffrey Weiss, *The Popular Culture of Modern Art: Picasso, Duchamp, and Avant-Gardism* (New Haven, Conn.: Yale University Press, 1994).

29. See George Mosse, *The Nationalization of the Masses* (New York: Howard Fertig, 1975).

30. See Eric Hobsbawm, *Nations and Nationalism since 1780: Programme, Myth, Reality* (Cambridge: Cambridge University Press, 1990), 92.

31. A similar point is made by Hal Foster, *The Return of the Real: The Avant-Garde at the End of the Century* (Cambridge, Mass.: MIT Press, 1996), 206.

32. See Renato Poggioli, *The Theory of the Avant-Garde,* trans. Gerald Fitzgerald (Cambridge, Mass.: Harvard University Press, 1968); and Bürger, *Theory of the Avant-Garde,* especially 15–27, 109.

33. The most incisive early critique of Bürger is Benjamin Buchloh's "Theorizing the Avant-Garde" (*Art in America* 72 [November 1984]: 19–21), which raised the important point that focusing avant-garde practices exclusively on the dismantling of the false autonomy of the bourgeois institution of art is too reductionist and cannot explain many practices that have no less of a claim to being regarded as avant-garde.

34. In this way, Bürger's avant-garde institution of art seems to be a sublation of the institution of art altogether, but, at least in *Theory of the Avant-Garde,* 55–82, he continues to speak of the avant-garde as producing works of art, albeit of a new "non-organic" type.

35. Similar reservations are expressed in Green, *Art in France,* 36, and Saler, *Avant-Garde in Interwar England,* 7.

36. On dada in this regard, see José Pierre, *Futurism and Dadaism,* trans. Joan White (Geneva: Edito-service SA, 1969), 52–56; Dawn Ades, "Dada-Constructivism," in *Dada-Constructivism* (London: Annely Juda Fine Art, 1984), 33–46; and Sheppard, *Modernism — Dada — Postmodernism,* 171–265.

37. See Harris, *Surrealist Art and Thought in the 1930s,* 1–18, 219–223; and Kim Grant, *Surrealism and the Visual Arts* (Cambridge: Cambridge University Press, 2005), 1–10 and passim. These books approach modernism as a politics in ways similar to my own; see especially Harris's discussion, 1–2.

38. My approach to the avant-garde as a set of practices is influenced by Paul Veyne, "Foucault Revolutionizes History," in *Foucault and His Interlocutors,* ed. Arnold Davidson (Chicago: University of Chicago Press, 1997), 146–182. However, my concept of practice is not specifically Foucauldian.

39. For examples of these approaches, see, respectively, Bürger, *Theory of the Avant-Garde,* 60–62; Poggioli, *Theory of the Avant-Garde,* 25–40, 149; and Cottington, *Cubism in the Shadow of War,* 3.

40. In excluding non-avant-garde modernists and their works from this study,

I recognize that I am dealing with only a subset of the whole of modernism and that I may therefore be accused of tendentiousness in my claim regarding the inherently political character of modernism. In my defense I can only say that studies of non-avant-garde or less avant-garde modernists (e.g., Kafka, Woolf, or Picasso) frequently show them to be no less political than their more activist colleagues.

41. The editor of *Il Bargello* (1929–1943), Alessandro Pavolini, served as Mussolini's minister of popular culture (1939–1943). On Pavolini's circle, see Arrigo Petaco, *Il superfascista: Vita e morte di Alessandro Pavolini* (Milan: Mondadori, 1998), 37–47.

42. Some interwar modernist movements, such as Breton's surrealism and Italian *strapaese,* would prove to be exceptions here.

1. INTELLECTUALS, COMMODITY CULTURE, AND RELIGIONS OF ART IN THE NINETEENTH CENTURY

1. Walter Benjamin, "A Child's View of Color," in *Selected Writings, Volume 1: 1913–1926,* ed. Marcus Bullock and Michael W. Jennings (Cambridge, Mass.: Harvard University Press, 1996), 50–51.

2. Wassily Kandinsky, "Reminiscences," now in *Kandinsky: Complete Writings on Art,* ed. Kenneth C. Lindsay and Peter Vergo (New York: Da Capo, 1994), 357, 360.

3. For Benjamin's early program for a post-Kantian philosophy, see Howard Caygill, *Walter Benjamin: The Colour of Experience* (London: Routledge, 1998), 1–33.

4. See Jürgen Habermas, *The Theory of Communicative Action, Volume 1: Reason and the Rationalization of Society,* trans. Thomas McCarthy (Boston: Beacon Press, 1984), 163–164 and passim.

5. Hannah Arendt, *The Human Condition* (Chicago: University of Chicago Press, 1958), 3.

6. G. W. F. Hegel, *Jenaer Realphilosophie: Vorlesungsmanuskripte zur Philosophie der Natur und des Geistes von 1805–1806,* ed. Johannes Hoffmeister (Hamburg: Felix Meiner, 1967), 255.

7. Karl Mannheim, "The Democratization of Culture," in *Essays on the Sociology of Culture,* trans. Paul Kecskemeti (London: Routledge and Kegan Paul, 1956), 171. In addition to Mannheim's essay, the conception of cultural democratization most influential on the brief account which follows here is that of Charles Taylor. See Taylor, *Sources of the Self: The Making of Modern Identity* (Cambridge, Mass.: Harvard University Press, 1989); and Taylor, "The Politics of Recognition," in *Multiculturalism: Examining the Politics of Recognition,* ed. Amy Gutmann (Princeton, N.J.: Princeton University Press, 1994), 25–73.

8. Mannheim, "Democratization of Culture," 176.

9. Walter Benjamin, "The Work of Art in the Age of Its Technological Reproducibility," in *Selected Writings, Volume 4: 1938–1940,* trans. Edmund Jephcott, ed. Howard Eiland and Michael W. Jennings (Cambridge, Mass.: Harvard University Press, 2003), 262.

10. K. Anthony Appiah, "Identity, Authenticity, Survival: Multicultural Societies and Social Reproduction," in Gutmann, *Multiculturalism,* 149.

11. Walter Benjamin, "Paris, the Capital of the Nineteenth Century," in *The Arcades Project,* trans. Howard Eiland and Kevin McLaughlin (Cambridge, Mass.: Harvard University Press, 1999), 7.

12. Ibid., 11.

13. Ibid., 13.

14. Among other important sources of this reconstitution that also figure in the present study is the rise of nationalism, both in the sense of popular movements from below and of efforts by political authorities to control the populations over which they rule.

15. See also Benjamin, "Work of Art," 256–257, in which the latter two possibilities appear as "a negative theology, in the form of the idea of 'pure' art" and "artistic production . . . based on a different practice: politics."

16. See Jean Baudrillard, *For a Critique of the Political Economy of the Sign,* trans. Charles Levin (St. Louis: Telos Press, 1981); Arjun Appadurai, *The Social Life of Things: Commodities in Cultural Perspective* (Cambridge: Cambridge University Press, 1986), 8–9; and John Frow, *Time and Commodity Culture: Essays in Cultural Theory and Postmodernity* (Oxford: Clarendon Press, 1997), 140–143.

17. See *Capital,* in *The Marx-Engels Reader,* 2nd ed., ed. Robert C. Tucker (New York: W. W. Norton, 1978), 319–320.

18. The final phrase is taken from Adorno's letter to Benjamin (2–4 August 1935), now in Benjamin, *Selected Writings, Volume 3: 1935–1938,* trans. Edmund Jephcott, ed. Howard Eiland and Michael W. Jennings (Cambridge, Mass.: Harvard University Press, 1996), 56.

19. *Capital,* in *Marx-Engels Reader,* 321–322.

20. See, for example, his discussion of consumption in Marx, *Grundrisse: Foundations of the Critique of Political Economy,* trans. Martin Nicolaus (New York: Vintage Books, 1973), 90–94.

21. See Marx, "The Power of Money in Bourgeois Society," in *Marx-Engels Reader,* 101–105.

22. See, for example, Marx's discussion of "production in a human manner" in *Selected Writings,* ed. David McLellan (Oxford: Oxford University Press, 1977), 121–122.

23. See *Capital,* in *Marx-Engels Reader,* 328. This passage is one Benjamin chose to copy into his notes; see *Arcades Project,* 656.

24. On this distinction, see especially Appadurai, *Social Life of Things,* 73.

25. *Communist Manifesto,* in *Marx-Engels Reader,* 475–476.

26. Those who have approached the dating of commodity culture from the vantage point of the visual arts have reached similar conclusions. See, for example, T. J. Clark, *The Painting of Modern Life: Paris in the Art of Manet and His Followers* (Princeton, N.J.: Princeton University Press, 1984), 9–10; and Anne Higonnet, *Berthe Morisot's Images of Women* (Cambridge, Mass.: Harvard University Press, 1992), 84–98.

27. See Pierre Bourdieu, *Distinction: A Social Critique of the Judgment of Taste,* trans. Richard Nice (Cambridge, Mass.: Harvard University Press, 1984), 2–3.

28. Émile Zola, *The Ladies' Paradise*, trans. Brian Nelson (Oxford: Oxford University Press, 1995), 208, 35.

29. Joris-Karl Huysmans, *Against Nature*, trans. Robert Baldick (Harmondsworth, UK: Penguin Books, 1986), 55.

30. On the aestheticization of capitalism, see Frow, *Time and Commodity Culture*, 48–49; Terry Eagleton, "Capitalism, Modernism and Postmodernism," in *Against the Grain* (London: Verso, 1986), 133; Fredric Jameson, "Reification and Utopia in Mass Culture," *Social Text* 1 (Winter 1979): 132, 139; and Scott Lash and John Urry, *Economies of Signs and Space* (London: Sage, 1994), 123.

31. Although neither Zola nor Huysmans explicitly discusses brand names and trademarks, their respective descriptions of the department store and of the interior decoration of decadence show an awareness of the role this visual language was beginning to assume. For a discussion of brand names and trademarks in a slightly later period of German commodity culture, see Frederic J. Schwartz, *The Werkbund: Design Theory and Mass Culture before the First World War* (New Haven, Conn.: Yale University Press, 1996), 121–212.

32. Studies of commodity culture in the English tradition have been particularly numerous. See, for example, Guinn Batten, *The Orphaned Imagination: Melancholy and Commodity Culture in English Romanticism* (Durham, N.C.: Duke University Press, 1998); Andrew H. Miller, *Novels behind Glass: Commodity Culture and Victorian Narrative* (Cambridge: Cambridge University Press, 1995); Thomas Richards, *The Commodity Culture of Victorian England: Advertising and Spectacle, 1851–1914* (Stanford, Calif.: Stanford University Press, 1990); Jonathan Freedman, *Professions of Taste: Henry James, British Aestheticism, and Commodity Culture* (Stanford, Calif.: Stanford University Press, 1990); and Garry Leonard, *Advertising and Commodity Culture in Joyce* (Gainesville: University Press of Florida, 1998). None of these works, however, defines commodity culture in relation to commodification; they simply use it to refer to the consumer culture of the era under review.

33. This formulation is indebted to Leora Auslander, *Taste and Power: Furnishing Modern France* (Berkeley: University of California Press, 1996). Although Auslander speaks of the "bourgeois stylistic regime" in lieu of commodity culture, her discussion of the relation of this "regime" to the productivism of prerevolutionary France as well as to the "transitional" regime that she locates in the first seven decades of nineteenth-century France is most instructive.

34. Ibid., 144, 190–224.

35. For an illuminating discussion of the appearance of pressures for decommodification within the history of commodification, see Frow, *Time and Commodity Culture*, 144–148.

36. David Harvey (*Paris, Capital of Modernity* [London: Routledge, 2003], 3) treats 1848 as a "radical break" which pushed "the city into modernity," but he also finds important anticipations of modernity in "Balzac's Paris," an argument made more forcibly in Jennifer Terni, "Elements of Mass Society: Spectacular Identity and Consumer Logic in Paris, 1830–1848" (Ph.D. diss., Duke University, 2002).

37. See Asa Briggs, *Mass Entertainment: The Origins of a Modern Industry* (Adelaide, Australia: Griffin Press, 1960), 6.

38. See Auslander, *Taste and Power*, 256; and Lawrence Rainey, *Institutions of Modernism: Literary Elites and Public Culture* (New Haven, Conn.: Yale University Press, 1998), 37.

39. See Pierre Bourdieu, *The Rules of Art: Genesis and Structure of the Literary Field*, trans. Susan Emanuel (Stanford, Calif.: Stanford University Press, 1995).

40. In his analysis of the French symbolists, Richard Cándida Smith makes a similar point; see his *Mallarmé's Children: Symbolism and the Renewal of Experience* (Berkeley: University of California Press, 1999), 52.

41. This dating reflects the English experience; see Alan Macfarlane, *The Culture of Capitalism* (Oxford: Basil Blackwell, 1987), 144–169.

42. Such was Marx's view (*Marx-Engels Reader*, 328), as well as that of Georg Lukács in *History and Class Consciousness*, trans. Rodney Livingstone (Cambridge, Mass.: MIT Press, 1971), 84–85; and Adorno in his 2 August 1935 letter to Benjamin (Benjamin, *Selected Writings, Volume 3*, 57).

43. The classic study is Karl Polanyi, *The Great Transformation* (New York: Farrar and Rinehart, 1944). For an allied study in which the extension of commodity production and exchange is brought to bear on the rise of modern civil society, see Jürgen Habermas, *The Structural Transformation of the Public Sphere: An Inquiry into a Category of Bourgeois Society*, trans. Thomas Burger (Cambridge, Mass.: MIT Press, 1989).

44. For a legal perspective on the history of commodification in early modern England, see E. P. Thompson, "Custom, Law and Common Right," in *Customs in Common* (New York: New Press, 1991), 97–184.

45. A few key works in this domain are Daniel Roche, *A History of Everyday Things: The Birth of Consumption in France, 1600–1800*, trans. Brian Pearce (Cambridge: Cambridge University Press, 2000); John Brewer and Roy Porter, eds., *Consumption and the World of Goods* (London: Routledge, 1993); Chandra Mukerji, *From Graven Images: Patterns of Modern Materialism* (New York: Columbia University Press , 1983); and Auslander, *Taste and Power*.

46. Important examples include Jean-Christophe Agnew, *Worlds Apart: The Market and the Theater in Anglo-American Thought, 1550–1750* (Cambridge: Cambridge University Press, 1986); Arnold Hauser, *The Social History of Art*, 4 vols., trans. Stanley Godman (New York: Vintage Books, n.d); Theodor W. Adorno, "Lyric Poetry and Society," in *The Adorno Reader*, ed. Brian O'Connor (Oxford: Basil Blackwell, 2000), 211–229; and William Weber, *Music and the Middle Class: The Social Structure of Concert Life in London, Paris and Vienna* (New York: Holmes and Meier, 1975).

47. See Briggs, *Mass Entertainment*, 5–8.

48. See Habermas, *Structural Transformation*, 164–165; original emphasis.

49. See Christophe Charle, *Naissance des "intellectuels" 1880–1900* (Paris: Les Éditions de Minuit, 1990) and *Les Intellectuels en Europe au XIXe siècle: Essai d'histoire comparée* (Paris: Édition du Seuil, 1996).

50. Habermas, *Structural Transformation*, 174.

51. Theodor W. Adorno, *Aesthetic Theory*, trans. Robert Hullot-Kentor (Minneapolis: University of Minnesota Press, 1997), 225.

52. Renato Poggioli, *The Theory of the Avant-Garde*, trans. Gerald Fitzgerald (Cambridge, Mass.: Harvard University Press, 1968), 115.

53. One document from the 1840s that illustrates the social side of the alienation of artists in Paris is Honoré de Balzac's *Lost Illusions,* trans. Kathleen Raine (New York: Modern Library, 1985).

54. On the religion of art in the nineteenth century, see Jean-Marie Schaeffer, *Art of the Modern Age: Philosophy of Art from Kant to Heidegger,* trans. Steven Randall (Princeton, N.J.: Princeton University Press, 2000), 67–236; Jacques Barzun, *The Use and Abuse of Art* (Princeton, N.J.: Princeton University Press, 1974), 24–57; and, most succinctly, Nicholas Pevsner, *Pioneers of Modern Design: From William Morris to Walter Gropius* (Harmondsworth, UK: Penguin, 1968 [1936]), 21.

55. For a latter-day Italian apostle, see chapter 6 of this volume and my "Ardengo Soffici and the Religion of Art," in *Fascist Visions: Art and Ideology in France and Italy,* ed. Matthew Affron and Mark Antliff (Princeton, N.J.: Princeton University Press, 1997), 46–72. A "religion-of-art" orientation remained strongest among those modernists who continued to be influenced by symbolist concepts of transcendence such as Wassily Kandinsky and Theo van Doesburg.

56. See, for example, the discussions in Meyer Schapiro, *Modern Art: 19th and 20th Centuries* (New York: George Braziller, 1978), 193–194; Bourdieu, *Rules of Art,* 117–119; and Peter Nicholls, *Modernisms: A Literary Guide* (Berkeley: University of California Press, 1995), 25, 34.

57. For an early and still illuminating discussion of the connection between William Morris and the notion of a religion of art, see Carl Schorske, "The Quest for the Grail: Wagner and Morris," in *The Critical Spirit: Essays in Honor of Herbert Marcuse,* ed. Kurt H. Wolff and Barrington Moore Jr. (Boston: Beacon Press, 1967), 216–232. For the religious language of the Arts and Crafts Movement, see S. K. Tillyard, *The Impact of Modernism, 1900–1920: Early Modernism and the Arts and Crafts Movement in Edwardian England* (London: Routledge, 1988), xvii, 52.

58. For the prewar modernist connection, see, for example, F. T. Marinetti's "Ce deplorable Ruskin," in *Le Futurisme* (Paris: E. Sansot, 1911), 33–48.

59. On English Arts and Crafts, see Peter Stansky, *Redesigning the World: William Morris, the 1880s, and the Arts and Crafts* (Princeton, N.J.: Princeton University Press, 1985); Christopher Crouch, *Modernism in Art, Design, and Architecture* (New York: St. Martin's, 1999), 29–45; Tillyard, *Impact of Modernism,* 1–80; Pevsner, *Pioneers of Modern Design,* 19–67; and Raymond Williams, *Culture and Society, 1780–1950* (New York: Harper and Row, 1958), 130–158.

60. William Morris, "The Revival of Handicraft," in *The Collected Works of William Morris* (London: Routledge, 1992), 22: 334.

61. The classic discussion of this tradition is Williams, *Culture and Society.*

62. For this reaction, see Jeffrey A. Auerbach, *The Great Exhibition of 1851: A Nation on Display* (New Haven, Conn.: Yale University Press, 1999), 207 and passim; and Lawrence Alloway, *The Venice Biennale, 1895–1968: From Salon to Goldfish Bowl* (Greenwich, Conn.: New York Graphic Society, 1968), 36.

63. Herbert Read, *The Contrary Experience: Autobiographies* (London: Secker and Warburg, 1973), 276.

64. John Ruskin, *The Two Paths,* in *The Works of John Ruskin,* ed. E. T. Cook and Alexander Wedderburn (London: George Allen, 1905), 16: 245–411.

65. Ibid., 16: 262–269.

66. Ibid., 16: 344, 342.

67. Stansky, *Redesigning the World,* 6.

68. Schorske, "Quest for the Grail," 220.

69. Morris, "Art, Wealth, and Riches," in *Collected Works of William Morris,* 23: 147.

70. Morris, "Revival of Handicraft," 22: 340.

71. Morris, "The Beauty of Life," in *Collected Works of William Morris,* 22: 56.

72. See, for example, Pevsner, *Pioneers of Modern Design,* 24; and Crouch, *Modernism in Art, Design, and Architecture,* 35.

73. Morris, "The Socialist Ideal. I. Art," in *Collected Works of William Morris,* 23: 255–263.

74. Pevsner, *Pioneers of Modern Design,* 22–23.

75. Morris, "Art under Plutocracy," in *Collected Works of William Morris,* 23: 173.

76. Charles Baudelaire, "The Salon of 1846," in *Selected Writings on Art and Literature,* trans. P. E. Charvet (London: Penguin, 1972), 54–56.

77. On Baudelaire's treatment of the convalescent, see Barbara Spackman, *Decadent Genealogies: The Rhetoric of Sickness from Baudelaire to D'Annunzio* (Ithaca, N.Y.: Cornell University Press, 1989), 42–53.

78. Baudelaire, *Selected Writings,* 398–399.

79. On Baudelaire's "surnaturalism," see David Carrier, *High Art: Charles Baudelaire and the Origins of Modernist Painting* (University Park: Pennsylvania State University Press, 1996); and Celia Rabinovitch, *Surrealism and the Sacred: Power, Eros, and the Occult in Modern Art* (Boulder, Colo.: Westview Press, 2002), 38–39, 86–87.

80. "Richard Wagner and *Tannhäuser* in Paris," in *Selected Writings,* 340.

81. *Selected Writings,* 265, 267.

82. *Selected Writings,* 294.

83. "The Salon of 1846," in *Selected Writings,* 63–64.

84. "The Salon of 1859," in *Selected Writings,* 296.

85. Baudelaire's more individualistic, spiritualist, and amoral attitudes are not without their parallels in the England of the pre-Raphaelites, Walter Pater, James Abbott McNeill Whistler, and Oscar Wilde, which arose during Ruskin's later years. On this tradition and its relation to Ruskin and Morris, see Linda Dowling, *The Vulgarization of Art: The Victorians and Aesthetic Democracy* (Charlottesville: University of Virginia Press, 1996), 25–100.

86. Théophile Gautier, preface to *Mademoiselle de Maupin,* trans. Joanna Richardson (Harmondsworth, UK: Penguin, 1981 [1834]), 39.

87. "Pierre Dupont," in *Baudelaire as a Literary Critic: Selected Essays,* ed. Hyslop, Lois Boe and Francis E. Hyslop Jr. (University Park: Pennsylvania State University Press, 1964), 52.

88. "Of Virtuous Plays and Novels," in *Selected Writings,* 111–112.

89. Bourdieu, *Rules of Art,* 77.

90. On Baudelaire's bohemianism and his association with the Brasserie Andler in contrast to his more aristocratic "dandyism," see Jerrold Seigel, *Bohemian Paris: Culture, Politics, and the Boundaries of Bourgeois Life, 1830–1930* (New York: Viking, 1986), 97–124.

91. Bourdieu, *Rules of Art*, 77. See also Nicholls, *Modernisms*, 8–9.

92. See M. A. Ruff, *Baudelaire*, trans. Agnes Kertesz (New York: New York University Press, 1966), 60; Nicholls, *Modernisms*, 15; and Baudelaire, *My Heart Laid Bare and Other Prose Writings*, trans. Norman Cameron (New York: Vanguard Press, 1951), 185.

93. "The Salon of 1859," in *Selected Writings*, 311.

94. Ibid., 303.

95. On the reforms of 1881, see Michael R. Orwicz, "Anti-academicism and State Power in the Early Third Republic," *Art History* 14 (1991): 571–592. On the privatizing atmosphere of the Second Empire, see Patricia Mainardi, *Art and Politics of the Second Empire: The Universal Expositions of 1855 and 1867* (New Haven, Conn.: Yale University Press, 1987).

96. Letter of 21 March 1847, to his parents, in *Letters of Gustave Courbet*, ed. Petra ten-Doesschate Chu (Chicago: University of Chicago Press, 1992), 70.

97. "The Universal Exhibition of 1855," in *Selected Writings*, 127.

98. See Beatrice Farwell, *The Cult of Images: Baudelaire and the 19th-Century Media Explosion* (Santa Barbara, Calif.: UCSB Art Museum, 1977), 7; and Baudelaire, *My Heart Laid Bare*, 198.

99. Benjamin, "Work of Art," 252.

100. On these journals, see Ralph E. Shikes, *The Indignant Eye: The Artist as Social Critic in Prints and Drawings from the Fifteenth Century to Picasso* (Boston: Beacon Press, 1969), 148–150.

101. On Daumier's print making, see Shikes, *Indignant Eye*, 157–178.

102. Joanna Richardson, *Baudelaire* (London: John Murray, 1994), 242.

103. *Selected Writings*, 391, 392, 395.

104. Michel Foucault, "What Is Enlightenment," in *The Foucault Reader*, ed. Paul Rabinow (New York: Pantheon, 1984), 40–41. The words quoted are from Charles Baudelaire, *The Painter of Modern Life and Other Essays*, ed. and trans. Jonathan Mayne (New York: Da Capo, 1986), 12.

105. *Selected Writings*, 402.

106. For example, see Martin Jay, *Downcast Eyes: The Denigration of Vision in Twentieth-Century French Thought* (Berkeley: University of California Press, 1993), 121.

107. *Selected Writings*, 391.

108. *Foucault Reader*, 42.

109. *Selected Writings*, 420, 421.

110. *Foucault Reader*, 41; Bourdieu, *Rules of Art*, 111.

111. *Selected Writings*, 287, 289.

112. For a fuller reading of Baudelaire along these lines, see Susan Blood, *Baudelaire and the Aesthetics of Bad Faith* (Stanford, Calif.: Stanford University Press, 1997), 150–172.

113. *Selected Writings*, 297.

114. *Selected Writings*, 35. The role of the artist-critic in France went back to

the eighteenth century, its most famous early practitioner having been Denis Diderot.

115. This passage, omitted from *Selected Writings,* may be found in Baudelaire, *Art in Paris, 1845–1862: Salons and Other Exhibitions,* ed. and trans. Jonathan Mayne (London: Phaidon, 1965), 9.

116. For a sensible guide to the controversies, see Richard D. E. Burton, *Baudelaire and the Second Republic: Writing and Revolution* (Oxford: Clarendon Press, 1991), v–x.

117. According to Baudelaire's friend Charles Asselineau, the *"accapareurs"* Baudelaire had in mind were the "demi-bourgeois and false artists" who were out to profit from the new art market. See Jacques Crépet and Claude Pichois, eds., *Baudelaire et Asselineau* (Paris: Nizet, 1953), 76.

118. *Selected Writings,* 47–49. Baudelaire was scathing in his treatment of "newspaper criticism"; see, for example, *Selected Writings, 33.*

119. "Richard Wagner and *Tännhauser* in Paris," in *Selected Writings,* 340.

120. Burton, *Baudelaire and the Second Republic,* 37.

121. Clement Greenberg, "Avant-Garde and Kitsch," in *Art and Culture: Critical Essays* (Boston: Beacon, 1961), 8.

122. See Josef Chytry, *The Aesthetic State: A Quest in Modern German Thought* (Berkeley: University of California Press, 1989), 274; and William Weber, "Wagner, Wagnerism, and Musical Idealism," in *Wagnerism in European Culture and Politics,* ed. David C. Large and William Weber (Ithaca, N.Y.: Cornell University Press, 1984), 45.

123. Letter to Theodor Uhlig, 12 November 1851, now in *Selected Letters of Richard Wagner,* ed. Stewart Spencer and Barry Millington (London: J. M. Dent & Sons, 1987), 234; original emphasis.

124. Letter to Theodor Uhlig, 18 December 1851, in *Selected Letters of Richard Wagner,* 241.

125. Wagner, *Dichtungen und Schriften* (Frankfurt: Insel, 1983), 5: 284; translation amended from *The Art-Work of the Future and Other Works,* ed. William Ashton Ellis (Lincoln: University of Nebraska Press, 1993), 42.

126. *Dichtungen und Schriften,* 5: 284, 291; *Art-Work of the Future,* 42, 48.

127. *Dichtungen und Schriften,* 5: 295, 6:31; *Art-Work of the Future,* 51, 90.

128. For a comparison of the religion of art in Wagner and Morris, see Schorske, "Quest for the Grail."

129. See also *Dichtungen und Schriften,* 6: 48; *Art-Work of the Future, 205.*

130. See Weber, "Wagner, Wagnerism, and Musical Idealism," 51.

131. In "Art and Revolution," Wagner contrasts the "true artist" with what he has become in the modern world, a *"Handwerker."* See *Dichtungen und Schriften,* 5: 291; *Art-Work of the Future,* 48.

132. See this and related phrasings in *Dichtungen und Schriften,* 6: 139–145; *Art-Work of the Future,* 195–201. See also the discussion of Wagner's related concept of *Künstlertum* in Chytry, *Aesthetic State,* 285–287.

133. See Frederic Spotts, *Bayreuth: A History of the Wagner Festival* (New Haven, Conn.: Yale University Press, 1994); Hans Mayer, *Richard Wagner in Bayreuth, 1876–1976,* trans. Jack Zipes (New York: Rizzoli, 1976); and David C.

Large, "Wagner's Bayreuth Disciples," in *Wagnerism in European Culture and Politics*, 72–133.

134. Weber, "Wagner, Wagnerism, and Musical Idealism."

135. Theodor W. Adorno, *In Search of Wagner,* trans. Rodney Livingstone (London: Verso, 1984), 31. For a recent discussion which extends Adorno's view and contextualizes it in relation to late nineteenth-century spectacle, see Jonathan Crary, *Suspensions of Perception: Attention, Spectacle, and Modern Culture* (Cambridge, Mass.: MIT Press, 1999), 247–258.

136. For a view emphasizing Wagner's continuity with the romantics, see Jack M. Stein, *Richard Wagner and the Synthesis of the Arts* (Westport, Conn.: Greenwood, 1973), 3–9 and passim. For the opposite view, see Adorno, *In Search of Wagner,* 97.

137. Friedrich Nietzsche, *The Birth of Tragedy and The Case of Wagner,* trans. Walter Kaufmann (New York: Vintage Books, 1967).

138. On the relation of these two aspects of Wagner's ideal of *Gesamtkunstwerk,* see Dieter Borchmeyer, *Richard Wagner: Theory and Theatre,* trans. Stewart Spencer (Oxford: Clarendon Press, 1991), 59–72.

139. On futurist *Gesamtkunstwerk* in relation to Wagner and performance, see Daniel Albright, *Untwisting the Serpent: Modernism in Music, Literature, and Other Arts* (Chicago: University of Chicago Press, 2000), 209–215; for Kandinsky's view, see Lindsay and Vergo, *Kandinsky: Complete Writings,* 259–260, 708. Adorno's critique of Wagner did not fail to consider the ideal of *Gesamtkunstwerk,* which he understood in Kandinsky's manner as an effort to overcome specialization. But for him this was hopeless: Wagner's version was "dilettantish" because "a valid *Gesamtkunstwerk* . . . would have required a collective of specialist planners." See Adorno, *In Search of Wagner,* 29, 111.

140. On Wagner's influence, see Jacques Barzun, *Berlioz and the Romantic Century,* (Boston: Little, Brown, and Company, 1950), 2: 201.

141. Wagner is discussed in the novel but mostly just to emphasize the reluctance of the protagonist to venture into the public realm where Wagner was performed; see Huysmans, *Against Nature,* 204–205.

142. On these points, see Large and Weber, *Wagnerism in European Culture,* 15–17, 283–286.

143. On the *Revue wagnérienne,* see Gerald D. Turbow, "Art and Politics: Wagnerism and France," in *Wagnerism in European Culture and Politics,* 159–164.

144. Huysmans, *Against Nature,* 204–205.

145. Rosemary Lloyd, *Mallarmé: The Poet and His Circle* (Ithaca, N.Y.: Cornell University Press, 1999), 180. Lloyd cites evidence (206) to show that Mallarmé reacted strongly to the French defeat in 1870 and claims that he maintained some interest thereafter in the politics of the French republican left despite his determination to live primarily for art.

146. A. G. Lehmann, *The Symbolist Aesthetic in France, 1885–1895* (Oxford: Basil Blackwell, 1968), 195–197.

147. Mallarmé, "Rêverie d'un poëte français," *Revue wagnérienne* (8 August 1885), now in *Oeuvres complètes* (Paris: Gallimard, 1945), 541–546; translated

in *Mallarmé: Selected Prose Poems, Essays, and Letters,* trans. Bradford Cook (Baltimore: Johns Hopkins University Press, 1956), 72–78.

148. Notes by André Fontainas, from a Rue de Rome gathering of 15 January 1895, cited in Lloyd, *Mallarmé,* 152.

149. On Wagner's turn to Schopenhauer and its implications for his view of music, see Bryan Magee, *The Tristan Chord: Wagner and Philosophy* (New York: Henry Holt, 2000), 126–227.

150. This nationalist challenge was implicit in the article's subtitle, "Reverie of a French Poet." See Gordon Millan, *Mallarmé: A Throw of the Dice, The Life of Stéphane Mallarmé* (London: Secker and Warburg, 1994), 249. Millan also cites a letter from Mallarmé to Maurice Barrès (250), in which he suggests that his real view of Wagner was even more critical than the article allowed.

151. The best recent study of these matters, especially their political dimensions, is Cándida Smith, *Mallarmé's Children.* For Mallarmé's view of language, see also Lehmann, *Symbolist Aesthetic in France,* 129–193.

152. "Crise de vers," in *Oeuvres complètes,* 368; *Mallarmé: Selected Prose Poems,* 42.

153. "La musique et les lettres," in *Oeuvres complètes,* 647, 649; *Mallarmé: Selected Prose Poems,* 48, 50.

154. See Adorno's letter to Benjamin, 18 March 1936, now in Theodor W. Adorno and Walter Benjamin, *The Complete Correspondence, 1928–1940,* ed. Henri Lonitz, trans. Nicholas Walker (Cambridge, Mass.: Harvard University Press, 1999), 128–129.

155. "L'art pour tous," in *Oeuvres complètes,* 259; *Mallarmé: Selected Prose Poems,* 11. For the letter to Verlaine (16 November 1885), see *Oeuvres complètes,* 664; translated in *Selected Letters of Stéphane Mallarmé,* ed. Rosemary Lloyd (Chicago: University of Chicago Press, 1988), 144. For a reading of Mallarmé that tries to square his aristocratic and democratic tendencies, see Cándida Smith, *Mallarmé's Children,* 199–201.

156. For the letter to Verlaine and on the point more generally, see Yves Bonnefoy, "Igitur et le photograph," in *Mallarmé 1842–1898: Un destin d'écriture,* ed. Yves Peyré (Paris: Gallimard, 1998), 59–85.

157. For a literalist reading of *La Dernière Mode* and the most comprehensive, see Jean-Pierre Lecercle, *Mallarmé et la mode* (Paris: Séguier, 1989); for a reading of it as a kind of symbolist poem, see Roger Dragonetti, *Un fantôme dans le kiosque: Mallarmé et l'esthétique du quotidien* (Paris: Seuil, 1992), 87–147; and for readings stressing the relation to the commodity world either as "self-reflexive exploration" or as a "proto-camp document" of "decadent-dandyism," see, respectively, Crary, *Suspensions of Perception,* 119–125; and Rhonda K. Garelick, *Rising Star: Dandyism, Gender, and Performance in the Fin de Siècle* (Princeton, N.J.: Princeton University Press, 1998), 47–77. In addition, Mallarmé's debt to shopping advertisements is shown in Rachel Bowlby, "Modes of Modern Shopping: Mallarmé at the Bon Marché," in *The Ideology of Conduct: Essays on Literature and the History of Sexuality,* ed. Nancy Armstrong and Leonard Tennenhouse (London: Methuen, 1987), 185–205. For a facsimile reproduction, see *La Dernière Mode: Gazette du monde et de la famille* (Paris: Ramsey, 1978); Mallarmé's text is also available in *Oeuvres complètes,* 705–847.

158. Crary, *Suspensions of Perception,* 121; for the articles, see *Oeuvres complètes,* 666–686.

159. "Première lettre," in *Oeuvres complètes,* 666–667.

160. See *Oeuvres complètes,* 664; *Selected Letters of Stéphane Mallarmé,* 144.

161. For a provocative analysis of this connection, see Johanna Drucker, *The Visible Word: Experimental Typography and Modern Art, 1909–1923* (Chicago: University of Chicago Press, 1994), 50–60.

162. See Benjamin, "One-Way Street," in *Selected Writings, Volume 1: 1913–1926,* 456, 444.

163. See Cándida Smith, *Mallarmé's Children,* 200–225, whose argument that professionalism within avant-garde art arrives in the mid-1890s as part of the broader social and cultural transformations of that decade seems superior to the suggestion of Bourdieu, in *Rules of Art,* 111, that professionalism was a direct (and therefore earlier) outgrowth of a commitment to art-for-art's-sake.

164. For the Gide reference, see Henri Peyre, *What Is Symbolism?* trans. Emmett Parker (Tuscaloosa: University of Alabama Press, 1979), 90. On Gourmont generally, see Glenn S. Burne, *Rémy de Gourmont: His Ideas and Influence in England and America* (Carbondale: Southern Illinois University Press, 1963); and Garnet Rees, *Rémy de Gourmont: Essai de biographie intellectuelle* (Paris: Boivin, 1939). For an early appreciation of Gourmont that details his friendship with Apollinaire and claims Gourmont was already unknown in 1910, see Guillaume Apollinaire, "À propos des croques de Raoul Dufy d'après Rémy de Gourmont," *Oeuvres en prose complètes,* ed. P. Caizergues and M. Décaudin (Paris: Gallimard, 1991), 2: 1044–1049.

165. See *Rémy de Gourmont: Selected Writings,* ed. Glenn S. Burne (Ann Arbor: University of Michigan Press, 1966), 121.

166. On Mallarmé's support for Boulanger, see Lloyd, *Mallarmé,* 210.

167. On Fénéon, see Joan Ungersma Halperin, *Félix Fénéon: Aesthete and Anarchist in Fin-de-Siècle Paris* (New Haven, Conn.: Yale University Press, 1988).

168. See Norman J. Kleeblatt, ed., *The Dreyfus Affair: Art, Truth, and Justice* (Berkeley: University of California Press, 1987).

169. "Le joujou patriotisme," *Mercure de France* (April 1891): 197.

170. "Petites chroniques," *Mercure de France* (November 1895): 250–251.

171. On the article by Maurras and the theme of "Latinity," see Michael Marlais, *Conservative Echoes in Fin-de-Siècle Parisian Art Criticism* (University Park: Pennsylvania State University Press, 1992), 182.

172. See Sanford Schwartz, *The Matrix of Modernism: Pound, Eliot, and Early Twentieth-Century Thought* (Princeton, N.J.: Princeton University Press, 1985), 82.

173. Debora L. Silverman, *Art Nouveau in Fin-de-Siècle France: Politics, Psychology, and Style* (Berkeley: University of California Press, 1989), 12.

174. This 1895 turn figures centrally in Cándida Smith, *Mallarmé's Children,* and in Michel Décaudin, *La Crise des valeurs symbolistes: Vingt ans de poésie française 1895–1914* (Geneva: Slatkine, 1981).

175. See Kenneth Burke, *A Rhetoric of Motives* (Berkeley: University of California Press, 1969), 149–154; and Giovanni Papini, *Four and Twenty Minds,* trans. Ernest Hatch Wilkins (New York: Benjamin Blom, 1971), 203–205.

176. "The Dissociation of Ideas," in *Rémy de Gourmont: Selected Writings*, 11, 15.

177. "Women and Language" and "Art and Science," in *Rémy de Gourmont: Selected Writings*, 136, 172.

178. "La mort de Nietzsche," *Mercure de France* (October 1900): 166.

179. Similar views were expressed at about the same time by Benedetto Croce, who was also partly in Nietzsche's debt, though probably less so than Gourmont; see Walter L. Adamson, "Benedetto Croce and the Death of Ideology," *Journal of Modern History* 55 (June 1983): 208–236.

180. "Women and Language," in *Rémy de Gourmont: Selected Writings*, 138.

181. "Preface to *Le Livre des masques*," in *Rémy de Gourmont: Selected Writings*, 181–182.

182. "Success and the Idea of Beauty," in *Rémy de Gourmont: Selected Writings*, 35. See also his "Sur la hiérarchie intellectuelle," *La Plume* (June 15–30, 1894): 251.

183. See Gourmont, "Sur l'art nouveau," in *Le Problème du style* (Paris: Mercure de France, 1924), 203–215; and "La 'Dernière Mode' de Stéphane Mallarmé," in *Promenades littéraires*, 2nd series (Paris: Mercure de France, 1913), 33–48.

184. Natasha Staller, "Méliès' 'Fantastic' Cinema and the Origins of Cubism," *Art History* 12 (June 1989): 205.

2. F. T. MARINETTI

1. For an early appreciation of futurism as an effort to transform art into a program of aesthetic reorientation for modern life, see Reyner Banham, *Theory and Design in the First Machine Age* (London: Architectural Press, 1960), 99–137.

2. According to his later autobiographical reflections, Marinetti was an early devotee of Wagner, before coming to and accepting Nietzsche's critique of him. See Marinetti, *La grande Milano tradizionale e futurista / Una sensibilità italiana nata in Egitto* (Milan: Mondadori, 1969), 21. For a futurist conception of *Gesamtkunstwerk* as applied to urban life, see Giacomo Balla and Fortunato Depero, "Ricostruzione futurista dell'universo" (11 March 1915), now in *Marinetti e il futurismo*, ed. Luciano de Maria (Milan: Mondadori, 1973), 171–176; translated in Umbro Apollonio, ed., *Futurist Manifestos* (New York: Viking, 1973), 197–200.

3. On the early Marinetti, see Claudia Salaris, *Marinetti: Arte e vita futurista* (Rome: Riuniti, 1997), 3–159; Giovanni Lista, *Futurism*, trans. Susan Wise (Paris: Éditions Pierre Terrail, 2001), 19–123; Lista, *F. T. Marinetti: L'Anarchiste du futurisme* (Paris: Séguier, 1995); and Lista, "Poeta simbolista: Il 'complesso di Swinburne,'" in *F. T. Marinetti: Arte-vita*, ed. Claudia Salaris (Rome: Fahrenheit 451, 2000), 87–107; Günter Berghaus, *The Genesis of Futurism: Marinetti's Early Career and Writings, 1899–1909* (Leeds: Society for Italian Studies, 1995); Gino Agnese, *Marinetti: Una vita esplosiva* (Milan: Camunia, 1990), 5–164; and Gaetano Mariani, *Il primo Marinetti* (Florence: Le Monnier, 1970).

4. According to Agnese, *Marinetti*, 14, the young poet had read Rémy de

Gourmont, "Le symbolisme," *Revue blanche* 2 (June 1892): 321–325, while still in Alexandria. Salaris, *Marinetti,* 5, suggests that his decision to change his name to F. T. Marinetti was "almost a sort of predestination" in that his initials now reflected the major consonants of *FuTurisMo.*

5. Michel Décaudin, *La Crise des valeurs symbolistes: Vingt ans de poésie française 1895–1914* (Geneva: Slatkine, 1981), 243.

6. See Lista, "Poeta simbolista," 89.

7. On Marinetti's early leftist politics, see Agnese, *Marinetti,* 34–36.

8. See James Joll, *Three Intellectuals in Politics* (New York: Pantheon, 1960), 138.

9. Carlo Linati, *Sulle orme di Renzo: Pagine di fedeltà lombarda* (Rome: Quaderni della Voce, 1919), 30.

10. Tullio Panteo, *Il poeta Marinetti* (Milan: Società Editrice Milanese, 1908), 213–214. It has been plausibly alleged that, while Panteo wrote the brief biographical sketch quoted here, much of this early "biography" was actually written by Marinetti. See Domenico Cammarota, *Filippo Tommaso Marinetti, bibliografia* (Milan: Skira, 2002), 49–50.

11. Soffici, *Fine di un mondo* (Florence: Vallecchi, 1955), 308.

12. Marinetti was so dubbed by a Paris newspaper; see Walter Vaccari, *Vita e tumulti di F. T. Marinetti* (Milan: Omnia, 1959), 218.

13. There is as yet no comprehensive history of these early entertainment industries, but see Leo Charney and Vanessa R. Schwartz, eds., *Cinema and the Invention of Modern Life* (Berkeley: University of California Press, 1995); Richard Maltby, *Passing Parade: A History of Popular Culture in the Twentieth Century* (Oxford: Oxford University Press, 1989); Elizabeth Wilson, *Adorned in Dreams: Fashion and Modernity* (London: Virago, 1985); Arno Mayer, *The Persistence of the Old Regime: Europe to the Great War* (New York: Pantheon, 1981), chapter 4; Richard D. Mandell, *Sport: A Cultural History* (New York: Columbia University Press, 1984), chapters 7–10; and Jürgen Habermas, *The Structural Transformation of the Public Sphere: An Inquiry into a Category of Bourgeois Society,* trans. Thomas Burger (Cambridge, Mass.: MIT Press, 1989), 159–195.

14. In addition to works by Salaris already cited, see Salaris, "Marketing Modernism: Marinetti as Publisher," *Modernism/Modernity* 1 (September 1994): 109–127; Salaris, *Marinetti editore* (Bologna: Il Mulino, 1990); Salaris, *Filippo Tommaso Marinetti* (Scandicci: La Nuova Italia, 1988); Salaris, *Il futurismo e la pubblicità: Dalla pubblicità del arte all'arte della pubblicità* (Milan: Lupetti, 1986); Salaris, *Storia del futurismo: Libri giornali manifesti* (Rome: Editori Riuniti, 1985); and Salaris, *Le futuriste: Donne e letteratura d'avanguardia in Italia (1909–1944)* (Milan: Edizioni delle Donne, 1982).

15. For fuller discussions of earlier twentieth-century Milan, upon which my discussion draws, see Franco Della Peruta, ed., *Storia illustrata di Milano,* vol. 3 (Milan: E. Sellino, 1993); Marco Meriggi, *Milano borghese: Circolo ed élites nell'Ottocento* (Venice: Marsilio, 1992); Indro Montanelli and Mario Cervi, *Milano Ventesimo secolo* (Milan: Rizzoli, 1990); Rosita Levi Pisetzky, "La vita e le vesti dei milanesi all'inizio del nuovo secolo," in *Storia di Milano* (Milan: Fondazione Treccani degli Alfieri, 1962), 16: 125–186; Folco Portinari, "Milano," in *Letter-*

atura italiana: Storia e geografia, ed. Alberto Asor Rosa (Turin: Einaudi, 1989), 3: 221–288; and Alberto Lorenzi, *Milano, il nostro secolo: Letteratura, teatro, divertimenti e personagi del '900 milanese* (Milan: Bramante, 1969).

16. On the fair, see John Findling, ed., *Historical Dictionary of World's Fairs and Exhibitions, 1851–1988* (Westport, Conn.: Greenwood, 1990), 193–194.

17. On the changing social status of opera audiences, see John Rosselli, *The Opera Industry in Italy from Cimarosa to Verdi: The Role of the Impressario* (Cambridge: Cambridge University Press, 1984).

18. David Forgacs, *Italian Culture in the Industrial Era, 1880–1980: Culture Industries, Politics and the Public* (Manchester, UK: Manchester University Press, 1990), 35.

19. On Marinetti's working-class audience in the prewar years, see Antonio Gramsci, ["A Letter to Trotsky on Futurism"], in *Selections from Cultural Writings,* ed. David Forgacs and Geoffrey Nowell-Smith, trans. William Boelhower (Cambridge, Mass.: Harvard University Press, 1985), 53.

20. "Abbasso il tango e Parsifal" (1914), now in Marinetti, *Teoria e invenzione futurista,* ed. Luciano de Maria (Milan: Mondadori, 1968), 95–97 (hereafter abbreviated *TIF*); translated in *Selected Writings,* ed. R. W. Flint (New York: Farrar, Straus, and Giroux, 1972), 69–71.

21. Marinetti, *Les Dieux s'en vont, D'Annunzio reste* (Paris: Sansot, 1908), 14.

22. Marinetti's poem "À l'automobile" appeared in the August 1905 issue of *Poesia* and was reprinted under the title of "À mon Pégase" in *La Ville charnelle.*

23. See "Ce deplorable Ruskin" and "Ce qui nous sépare de Nietzsche," in Marinetti, *Le Futurisme* (Paris: E. Sansot, 1911), 33–48, 93–102. Nonetheless, Marinetti was influenced by Nietzsche. For a good assessment of this relationship, see Luca Somigli, *Legitimizing the Artist: Manifesto Writing and European Modernism, 1885–1915* (Toronto: University of Toronto Press, 2003), 104–127.

24. Marinetti, "Fondazione e Manifesto del Futurismo," in *TIF,* 13; Apollonio, *Futurist Manifestos,* 23.

25. So Marinetti himself claimed; see Salaris, "Marketing Modernism," 115.

26. On the accident and its relation to the founding manifesto, see Jean-Pierre Andreoli de Villers, "Ancora sul Manifesto," *Futurismo-oggi* 20 (January-April 1988): 3–5; and Lista, "Poeta simbolista," 105–106.

27. See Marinetti, *Una sensibilità italiana nata in Egitto,* 278; and Agnese, *Marinetti,* 73. The symbolist and naturist manifestos had appeared in *Le Figaro* on 18 September 1886 and 10 January 1897 respectively.

28. A negative reply by André Gide to one such letter may be found in the Marinetti Archive at Yale University's Beinecke Library, box 11, folder 526 (hereafter cited as Beinecke).

29. On the Marinetti-Notari friendship, see Vaccari, *Vita e tumulti,* 58.

30. *Verde e Azzurro* began as a weekly on 19 April 1903 but became a daily with its 14 February 1904 issue, when it began to bear the subtitle "*Quotidiano sportivo, mondano, teatrale*"—a Sports, Fashion, and Theater Daily.

31. They were *Gabriele D'Annunzio intime* (1903) and *La Momie sanglante* (1904). Both appeared in French, although the former had *D'Annunzio intimo* as its cover title.

32. Four years after publication, *Quelle signore* had sold 209,000 copies, and

by 1920 it had sold 300,000—figures that were extraordinary for its era. For more on Notari's early successes and style, see Bruno Wanrooij, "Umberto Notari, o dell'ambigua modernità," *Belfagor* 44 (1989): 181–193; Ugo Piscopo, "Umberto Notari: A 80 anni dalla fondazione dell' 'Associazione italiana di avanguardia,'" appendix to Umberto Notari, *"Noi,"* now in *Dossier futurista,* 2 vols., ed. Luciano Caruso (Florence: S.P.E.S., 1995), vol. 1, document 1; and the appendices to Gian Pietro Lucini, *Libri e cose scritte,* ed. Glauco Viazzi (Naples: Guida, 1971), 220–233.

33. The original translation with Marinetti's introduction may be found in Beinecke 28: 1426.

34. In the early years, he went so far as to ban political discussion from the pages of his journal; see his editorial in *Verde e Azzurro* (6 December 1903). However, by the end of the decade he had changed his mind. His next journal, *La Giovane Italia* (1909–1911), was in fact primarily political and was connected with his efforts to develop an "avant-garde" association. Its successor, *Gli Avvenimenti,* was involved in the interventionist movement that preceded Italian participation in World War I and was even subtitled "illustrated political daily" during the first months of the Italian war effort.

35. Umberto Notari, *"Noi": Etica e dinamica della Associazione italiana di avanguardia* (Milan: Casa Editrice di Avanguardia, 1910); also now available in Caruso, *Dossier futurista.* The volume was self-published, as were all of Notari's books, about fifty in number by the end of his life. For Marinetti's endorsement of Notari's proposal to expel the Vatican, see Beinecke 1: 11. The proposal was first made in *Verde e Azzurro*; see, for example, "Lo sport in Vaticano" (14–15 March 1904).

36. In the very first issue of 19 April 1903, Notari's cover editorial called for a "new Italian renaissance" based on "the bathing and climate industry." See also his "Il miglioramento degli alberghi," *Verde e Azzurro* (19 July 1903).

37. The modernist aesthetic was evident in the journal's coverage of the arts; it became reflected in the new subtitle of the journal—*"Giornale quotidiano della modernità, della forza, e dell'ingegno"* [A Daily Journal of Modernity, Force, and Wit]—adopted 14 March 1904.

38. Marinetti's description is taken from an article he wrote for the *Gazzetta del Popolo* and reprinted as a self-promotion by Notari at the conclusion of his *Dichiarazione alle più belle donne del mondo* (Milan: Istituto Editoriale Italiano, 1933). For the details of the marathon, which was held on 12 May 1904, see "La maratona italiana," *Verde e Azzurro* (31 March–1 April, 2–3 April, 4–5 April, 5–6 April, 11–12 May, and 14–15 May 1904). See also Wanrooij, "Umberto Notari," which notes that participants were clad in green and blue to match the name of the journal, which was printed on blue paper with green ink.

39. For Bontempelli's essay, which also originally appeared in the *Gazzetta del Popolo,* see Notari's appendices to *Dichiarazione alle più belle donne del mondo.*

40. Carlo Linati, *Milano d'allora: Memorie e vignette principio di secolo* (Milan: Longanesi, 1975), 106.

41. See the preface by Bruno Corra and Emilio Settimelli to F. T. Marinetti, *Come si seducono le donne,* 2nd ed. (Rocca San Casciano: Cappelli, 1918), 13.

42. For Notari's appreciation of such matters, see his references to the need

for *Verde e Azzurro* to be "a great shopwindow in which all the profound and suggestive beauties of the Italian landscape" are portrayed, to be a very visual journal "sumptuously and prodigally illustrated," and to be "cinematographic" (19 April 1903).

43. Beinecke 1: 1. Addressed to an *"illustre e gentile Signora,"* the letter is undated but is very likely from 1909 or 1910, given the *Poesia* letterhead and the thanks he bestows upon her for adhering to *"nostro manifesto."*

44. Salaris, *Marinetti*, 75–76; and Lista, *Futurism*, 66.

45. George Steiner, "In a Post-culture," in *Extraterritorial* (New York: Atheneum, 1971), 155–171.

46. Marinetti, *Les Dieux s'en vont, D'Annunzio reste*, 87–89.

47. For descriptions of the *serate*, see Michael Kirby and Victoria Nes Kirby, *Futurist Performance* (New York: PAJ Publications, 1986), 12–18; Agnese, *Marinetti*, 25–35; Vaccari, *Vita e tumulti*, 226–238; Giovanni Lista, *La Scène futuriste* (Paris: Editions du Centre National de la Recherche Scientifique, 1989), 106–111; Gloria Manghetti, ed., *Futurismo a Firenze 1910–1920* (Verona: Bi & Gi, 1984), 167–172; Walter L. Adamson, *Avant-Garde Florence: From Modernism to Fascism* (Cambridge, Mass.: Harvard University Press, 1993), 153–155; Sebastiano Vassalli, *L'alcova elettrica* (Turin: Einaudi, 1986), 140; and, above all, Francesco Cangiullo, *Le serate futuriste: Romanzo storico vissuto* (Milan: Ceschina, 1961).

48. Marinetti, "Il teatro di varietà," *TIF*, 80–81; Apollonio, *Futurist Manifestos*, 126.

49. Peter Nicholls, *Modernisms: A Literary Guide* (Berkeley: University of California Press, 1995), 2.

50. "Discorso ai Triestini," now in *TIF*, 247–253, which gives an account of the occasion as well as the speech itself.

51. See Vaccari, *Vita e tumulti*, 226–231.

52. Two of these, designed for the 1909 and 1913 elections, plus one that accompanied the beginning of the Italian campaign in Libya (October 1911), appear in *TIF*, 336–341; facsimile copies of the originals may be found in Luciano Caruso, ed., *Manifesti, proclami, interventi, e documenti teorici del futurismo, 1909–1944*, 4 boxes (Florence: Coedizioni SPES-Salimbeni, 1990), box 1, folders 4, 21, and 45. The 1913 manifesto originally appeared in *Lacerba* (October 15).

53. "Programma politico futurista" (October 1913).

54. "Contro la Spagna passatista," "Proclama futurista agli Spagnuoli," and "Discorso futurista agli Inglesi," in *TIF*, 38–45, 272–286.

55. Cited in Panteo, *Il poeta Marinetti*, 186–187.

56. Marinetti, "Democrazia futurista" (1919), in *TIF*, 449.

57. Marinetti, "Al di là del comunismo" (1920), in *TIF*, 471–572. Although published in 1920, the essay was written while Marinetti was briefly in prison in December 1919.

58. For Marinetti's theory of poetic language, largely developed between 1912 and 1914, see especially "Distruzione della sintassi—Immaginazione senza fili—Parole in libertà," in *TIF* 65–80; Apollonio, *Futurist Manifestos*, 95–106.

59. On futurism and typography, see Johanna Drucker, *The Visible Word: Experimental Typography and Modern Art, 1909–1923* (Chicago: University of

Chicago Press, 1994), 105–140; and John J. White, *Literary Futurism: Aspects of the First Avant-Garde* (Oxford: Clarendon Press, 1990), 8–72.

60. The *locus classicus* in this regard is Marinetti, "Democrazia futurista," in *TIF,* 343–469.

61. For an example of such a failure that occurred during one of Marinetti's appearances in England, see Lawrence Rainey, "The Creation of the Avant-Garde: F. T. Marinetti and Ezra Pound," *Modernism/Modernity* 1 (September 1994), 208–209.

62. Nicholls, *Modernisms,* 99–100.

63. See Pablo Echaurren, *Le edizioni futuriste di "Poesia"* (Rome: Quaderni di Futilità, 1981); and Salaris, *Marinetti editore,* 95–133.

64. *TIF,* 81–91; Apollonio, *Futurist Manifestos,* 126–131.

65. "Pesi, Misure e Prezzi del Genio Artistico" (11 March 1914), now in Caruso, *Manifesti,* 1: 60; Apollonio, *Futurist Manifestos,* 135–150.

66. See, for example, "Democrazia futurista," in *TIF,* 377–378.

67. These numbers are based on my own analysis of the journal using data presented in François Livi, ed., *Poesia (1905–1909)* (Naples: Edizioni Scientifiche Italiane, 1992).

68. For such an argument, see Barbara Spackman, "Mafarka and Son: Marinetti's Homophobic Economics," *Modernism/Modernity* 1 (September 1994): 89–107; and Ty E. Geltmaker, "Masquerade and Sacrifice: Honor in Italy from National Unification to World War" (Ph.D. diss., University of Southern California, 1994).

69. See the "Dedica" to F. T. Marinetti, *Mafarka il futurista: Romanzo,* trans. Decio Cinti (Milan: Edizioni Futuriste di "Poesia," 1910).

70. Marinetti, "Contro l'amore e il parliamentarismo" (1915), in *TIF,* 292–297.

71. Magamal, "Il Futurismo—la nuova religione dell'umanità," unpublished essay dated 20–24 December 1913, in Beinecke 47: 1884. Kühn Amendola took her pen name, Magamal, from Marinetti's novel *Mafarka il futurista,* in which Magamal, the protagonist's brother, is depicted as having a "feminine sensibility." In a letter to Giovanni Papini of 6 December 1913, held at the Fondazione Primo Conti in Fiesole, Kühn Amendola declares that she has just adhered to the futurist movement (although she "has always been a futurist") but must use a pen name in order to keep her identity concealed from family and friends.

72. On Saint-Point, see Vassalli, *Alcova elettrica,* 23–28; Leslie Satin, "Valentine de Saint-Point," *Dance Journal Research* 22 (Spring 1990): 1–12; Lista, *La Scène futuriste,* 92–96; and Günter Berghaus, "Dance and the Futurist Woman: The Work of Valentine de Saint-Point (1875–1953)," *Dance Research* 11 (Autumn 1993): 27–42.

73. Valentine de Saint-Point, "Manifesto of the Futurist Woman," reprinted in Pontus Hulten, *Futurism and Futurisms* (New York: Abbeville Press, 1986), 603.

74. Rosa Rosà, "Le donne del posdomani," *L'Italia futurista* (17 June 1917).

75. Rosa Rosà, "Risposta a Jean-Jacques," *L'Italia futurista* (1 July 1917).

76. See, for example, Domenico Guarricino, "Amore ed intelligenza," and Giovanni Fiorentino, "Variazioni sul tema 'donna,' Salvare la donna??!!," *L'Italia futurista* (26 August 1917).

77. Rosa Rosà, "Le donne del posdomani," *L'Italia futurista* (7 October 1917); and Enif Robert, "Lettera aperta a F. T. Marinetti," *L'Italia futurista* (31 December 1917).

78. See Marinetti, "Saluto di un bombardiere futurista alla donna italiana," *L'Italia futurista* (15 January 1918); and Marinetti, "Manifesto del Partito Politica Futurista," *L'Italia futurista* (11 February 1918).

79. F. T. Marinetti, "Assemblea di donne," *La Gazzetta del Popolo* (13 October 1940), now in Beinecke 54: 2000. The article is supertitled, "1926 in Francia."

80. Fortunato Depero, *Futurism and Advertising,* ed. and trans. Pasquale Verdicchio (La Jolla, Calif.: Parentheses Writing Series, 1990), 6–7; translation slightly altered on the basis of the original also reprinted in this volume. The text was first published in 1931 by the Campari company, for which Depero worked.

3. GUILLAUME APOLLINAIRE

1. On Apollinaire's friendship with Canudo, see Ricciotto Canudo, *Lettres à Guillaume Apollinaire 1904–1918,* ed. Giovanni Dotoli (Clamecy: Klincksieck, 1999); and Giovanni Dotoli, ed., *Canudo e Apollinaire: Giornalisti e scrittori del nostro tempo* (Fasano: Schiena, 1984).

2. See Leroy C. Breunig's introduction to his edited volume *Apollinaire on Art: Essays and Reviews, 1902–1918,* trans. Susan Suleiman (New York: Da Capo, 1972), xvii (henceforth abbreviated *AA*).

3. For Apollinaire's reflections on Stavelot and the symbolist ambience of that era, see his letter of July 1902 to his former school friend James Onimus, now in *Oeuvres complètes de Guillaume Apollinaire,* 4 vols., ed. M. Décaudin (Paris: André Balland and Jacques Lecat, 1966), 4: 714–716 (hereafter abbreviated *OC*). For documents on the Stavelot story and Apollinaire's commitment to symbolism in this period, see Francis Steegmuller, *Apollinaire: Poet Among the Painters* (New York: Farrar, Straus, and Company, 1963), 43–53.

4. See Daniel Pope, "French Advertising Men and the American 'Promised Land,'" *Historical Reflections* 5 (1978): 125.

5. Apollinaire wrote such a column himself ("Notes du moi") in *Le Festin d'Ésope: Revue des Belles Lettres,* the journal he edited from November 1903 to August 1904, which was reprinted by Slatkine in 1971.

6. See, for example, Sergio Zoppi, *Apollinaire teorico* (Naples: Edizioni Scientifiche Italiane, 1970), 25, 45, 94.

7. On the Abbaye de Créteil, see David Cottington, *Cubism in the Shadow of War: The Avant-Garde and Politics in Paris, 1905–1914* (New Haven, Conn.: Yale University Press, 1998), 52, 73–74.

8. See Jeffrey Weiss, *The Popular Culture of Modern Art: Picasso, Duchamp, and Avant-Gardism* (New Haven, Conn.: Yale University Press, 1994), 146–148.

9. Letter of 1918 to Roland Chavenon, now in *OC* 4: 897.

10. An exception is Patricia Leighton, *Re-Ordering the Universe: Picasso and Anarchism, 1897–1914* (Princeton, N.J.: Princeton University Press, 1989), 53–62, who sees the anarchist sympathies that Apollinaire's biographers have found in his late teens as underlying his entire opus and neglects his more conservative and nationalist dimensions.

11. Letter to Karl Boès (27 April 1902), in *OC* 4: 712.

12. "Le gouvernement," in *OC* 2: 652–656; originally in *La Revue immoraliste* (April 1905).

13. Ibid., 2: 655.

14. "Les jeunes: Picasso, peintre," *La Plume* 372 (15 May 1905), now in *AA*, 14.

15. On this milieu, see Maurice Agulhon, *The French Republic: 1879–1992*, trans. Antonia Nevill (Oxford: Blackwell, 1993), 82–129; and Robert Gildea, *France, 1870–1914*, 2nd ed. (New York: Longman, 1996), 60–79.

16. On this mood shift among intellectuals, see Robert Wohl, *The Generation of 1914* (Cambridge, Mass.: Harvard University Press, 1979), 5–18.

17. See Charles Péguy, "Notre patrie," *Cahiers de la Quinzaine* (17 October 1905), now in *Oeuvres en prose, 1898–1908* (Paris: Gallimard, 1959), 801–853.

18. See Eugen Weber, *Action Française: Royalism and Reaction in Twentieth-Century France* (Stanford, Calif.: Stanford University Press, 1962), 44–67.

19. In addition to works by Cottington, Pope, and Weiss already cited, two especially engaging studies are Charles Rearick, *Pleasures of the Belle Époque: Entertainment and Festivity in Turn-of-the-Century France* (New Haven, Conn.: Yale University Press, 1985); and Vanessa Schwartz, *Spectacular Realities: Early Mass Culture in Fin-de-siècle Paris* (Berkeley: University of California Press, 1998).

20. See the discussion of the reaction of the Catholic journalist Maurice Talmeyr in Rosalind H. Williams, *Dream Worlds: Mass Consumption in Late Nineteenth-Century France* (Berkeley: University of California Press, 1982), 61–66.

21. On *La Publicité* and the wider context of early French advertising, see Marjorie A. Beale, *The Modernist Enterprise: French Elites and the Threat of Modernity 1900–1940* (Stanford, Calif.: Stanford University Press, 1999), 11–47.

22. For the estimate of Paris street traffic, see Rearick, *Pleasures of the Belle Époque*, 169.

23. See Natasha Staller, "Méliès' 'Fantastic' Cinema and the Origins of Cubism," *Art History* 12 (June 1989).

24. Rearick, *Pleasures of the Belle Époque*, 42–50.

25. See Giovanni Dotoli, *Lo scrittore totale: Saggi su Ricciotto Canudo* (Fasano: Schiena, 1984), 119–138; and François Albera, "Ricciotto Canudo, Manifeste des Sept Arts," *Ciné-regards* (4 February 2002).

26. Apollinaire, "Un beau film," *Messidor* (23 December 1907), now in *Oeuvres en prose complètes*, ed. Michel Décaudin, 3 vols. (Paris: Gallimard, 1977), 1: 198–201 (hereafter abbreviated *OPC*); see Staller, "Méliès' 'Fantastic' Cinema," 208.

27. Alan Seeger, "Le baseball aux États-Unis," *Les Soirées de Paris* 26/27 (July/August 1914).

28. On Apollinaire's interest in film, see Cecily Mackworth, *Guillaume Apollinaire and the Cubist Life* (London: John Murray, 1961), 144–145.

29. On post-1880 changes in the art market, see Malcolm Gee, *Dealers, Critics, and Collectors of Modern Painting: Aspects of the Parisian Art Market between 1910 and 1930* (New York: Garland, 1981); Michael Baxandall, *Patterns*

of Intention: On the Historical Explanation of Pictures (New Haven, Conn.: Yale University Press, 1985), 50–64; Michael Fitzgerald, *Making Modernism: Picasso and the Creation of the Market for Twentieth-Century Art* (New York: Farrar, Straus, and Giroux, 1995); and Cottington, *Cubism in the Shadow of War,* 41–49.

30. Christophe Charle, *Naissance des "intellectuels" 1880–1900* (Paris: Les Éditions de Minuit, 1990), 41, 237; and Michael R. Orwicz, "Anti-academicism and State Power in the Early Third Republic," *Art History* 14 (1991): 574.

31. Cottington, *Cubism in the Shadow of War,* 42–43.

32. *Mercure de France,* 16 June 1913.

33. Letter to Madeleine Pagès (30 July 1915), reprinted in *Tendre comme le souvenir,* OC, 4: 494.

34. See Apollinaire's account of his treatment by the editors of *La Grande France,* Marius and Ari Leblond, in his 1902 letter to James Onimus; OC 4: 715.

35. Raymond Jean, *La Poétique du désir: Nerval, Lautréamont, Apollinaire, Éluard* (Paris: Éditions du Seuill, 1974), 345.

36. Letter to Ardengo Soffici (23 July 1913), emphasis added; now in *Guillaume Apollinaire: Corrispondenza con Marinetti, Soffici, Boccioni, Severini, Brunelleschi, Papini, Aleramo, Carrà,* ed. Lucia Bonato (Rome: Bulzoni Editore, 1992), 70.

37. Among the best sources are two notebooks of 1897 and 1899, which have been carefully studied but provide only a fragmentary impression. See Michel Décaudin, *Le Dossier d'Alcools* (Geneva: Droz, 1960).

38. Apollinaire, "La phallenge nouvelle" (April 1908), OC 3: 760; see also 3: 769. Apollinaire refers to the importance of naturism again in his wartime essay "L'esprit nouveau et les poètes" (OC 3: 909–910). Unfortunately, readers of the English translation will miss this connection because *"naturisme"* is there mistranslated as "naturalism"; see *Selected Writings of Guillaume Apollinaire,* trans. Roger Shattuck (New York: New Directions, 1971), 237.

39. Letter published in *L'Echo de Paris* (15 October 1935) and cited in Michel Décaudin, *La Crise des valeurs symbolistes: Vingt ans de poésie française 1895–1914* (Geneva: Slatkine, 1981), 64.

40. The text is reprinted in Bonner Mitchell, *Les Manifestes littéraires de la Belle Époque, 1886–1914: Antologie critique* (Paris: Seghers, 1966), 55–61.

41. Bouhélier, "La Révolution comme origine et comme fin du naturisme," *La Plume* 205 (1 November 1897), 650–657.

42. Le Blond, "Documents sur la poésie contemporaine," *La Plume* 205 (1 November 1897), 657–664.

43. A remark of Le Blond's cited in Germana Orlandi Cerenza, *Poetiche d'avanguardia del primo Novecento francese* (Rome: Bulzoni, 1984), 31.

44. Phrases cited in P. A. Jannini, "Naturismo/Occitania/Francophonia," *Quaderni del Novecento francese* 5 (1981): 45, 39.

45. Décaudin, *Crise des valeurs symbolistes,* 82.

46. Ibid., 115–117.

47. Apollinaire, "Au sujet de l'humanisme," OPC 2: 957.

48. Décaudin, *Crise des valeurs symbolistes,* 180–183.

49. On relations between Delaunay and Kandinsky and their effect on Apol-

linaire, see Margaret Davies, *Apollinaire* (Edinburgh: Oliver and Boyd, 1964), 211–215.

50. Apollinaire, "Picasso, Painter and Draftsman," and "Young Artists: Picasso the Painter," *AA*, 13–16.

51. See Apollinaire, *Alcools*, trans. Anne Hyde Greet (Berkeley: University of California Press, 1965), 84–85; translation slightly amended.

52. On the ethnic nationalism of Maurice Barrès, see Susan Rubin Suleiman, "The Literary Significance of the Dreyfus Affair," in *The Dreyfus Affair: Art, Truth, and Justice,* ed. Norman J. Kleeblatt (Berkeley: University of California Press, 1987), 117–139.

53. Apollinaire, "Exhibition of Decorative Artists at the Pavillon de Marsan," *AA*, 60.

54. Apollinaire, "The Exhibition of Decorative Arts from Munich," *AA*, 119.

55. Apollinaire, "The Salon des Indépendants," *AA*, 42.

56. Apollinaire, "The Germanic Museum of Nuremburg," *AA*, 6; and his letter of 22 September 1917 to the *Mercure de France,* now in *AA*, 454.

57. Apollinaire, "La loi de renaissance," *La Démocratie sociale* (7 July 1912), reprinted in Pierre Caizergues, ed., *Apollinaire et La Démocratie sociale* (Paris: Lettres Modernes, 1969), 36–37. On "solidarism," see Cottington, *Cubism in the Shadow of War,* 28–30.

58. Apollinaire, "In Tiny Pots . . . ," *AA*, 425.

59. For his view of plasticity in Matisse, see "Watch Out for the Paint! The Salon des Indépendants 6,000 Paintings are Exhibited," *AA*, 65–66.

60. Timothy Mathews, *Reading Apollinaire: Theories of Poetic Language* (Manchester, UK: Manchester University Press, 1987), 1–44. For a similar view by a scholar in the visual arts, see Virginia Spate, *Orphism: The Evolution of Non-figurative Painting in Paris, 1910–1914* (Oxford: Clarendon Press, 1979), 60–67.

61. On materiality in Apollinaire's language and in modernism generally, see Johanna Drucker, *The Visible Word: Experimental Typography and Modern Art, 1909–1923* (Chicago: University of Chicago Press, 1994), especially 73–74 and 140–168.

62. Apollinaire, *The Cubist Painters: Aesthetic Meditations,* trans. Lionel Abel (New York: George Wittenborn, 1962), 14.

63. Ibid., 9.

64. Ibid., 10.

65. Ibid., 23, emphasis added.

66. Ibid., 11.

67. Ibid., 10.

68. Ibid., 14–15.

69. On his personal motives, see Mackworth, *Guillaume Apollinaire,* 128–129.

70. Ibid., 139.

71. On the relation of Duhamel's attack to Apollinaire's reorientation regarding futurism, see Steegmuller, *Apollinaire,* 263; and, more obliquely, Mackworth, *Guillaume Apollinaire,* 152–153.

72. See Cottington, *Cubism in the Shadow of War,* 3–5.

73. See Harry E. Buckley, *Guillaume Apollinaire as an Art Critic* (Ann Arbor, Mich.: UMI Research Press, 1969), 76.

74. See "Young Painters, Keep Calm!" and "The Section d'Or," *AA*, 252–255.

75. Apollinaire, "The Salon d'Automne," *AA*, 23, 25, 34; "Young Painters, Keep Calm!" *AA*, 253; and "The Salon des Indépendants," *AA*, 149.

76. Apollinaire, "The Salon d'Automne," *AA*, 113.

77. Apollinaire, "M. Bérard Opens the Salon d'Automne," *AA*, 324.

78. Apollinaire, "The Art World," *AA* 120.

79. Apollinaire, "Through the Salon des Indépendants," *AA*, 290; and "Georges Braque," *AA*, 50.

80. Apollinaire, "Bernheim-Wagram," *AA*, 18.

81. The revelations came in Eugène Montfort, "Marges," *Les Marges* 19 (15 January 1910), 78–79.

82. See Weiss, *Popular Culture of Modern Art,* 45.

83. Apollinaire, "The Vernissage," *AA*, 72; and "On Fakes," *AA*, 10; but see also "The Forgeries at the Bagatelle," *AA*, 170, in which Apollinaire is less sympathetic to such humorism.

84. Apollinaire, "Exhibition of Decorative Artists at the Pavillon de Marsan," *AA*, 60.

85. Apollinaire, "An Opening," *AA*, 221.

86. Apollinaire, "The Decorative Arts," *AA*, 149.

87. Apollinaire, "The Art World," *AA*, 129, and "Drawings of the Great Masters," *AA*, 175–6.

88. Apollinaire, "The Salon d'Automne," *AA*, 22.

89. Apollinaire, "A Lecture by Fernand Léger," *AA*, 382.

90. Apollinaire, "Les tendances nouvelles," *OPC* 2: 986–987.

91. Apollinaire, "Futurism," *AA*, 255, and "Chronique mensuelle," *Les Soirées de Paris* 18 (15 November 1913), reprinted in *OPC* 2: 969.

92. Apollinaire, "La renaissance des arts décoratifs," *OPC* 2: 466–467.

93. Apollinaire, "La loi de renaissance," 36.

94. Apollinaire, "In Tiny Pots . . . ," *AA*, 425.

95. Apollinaire, letter to Madeleine Pagès (3 August 1915), in *Tendre comme le souvenir,* *OC* 4: 499.

96. For the publication history of "L'antitradition futuriste" as well as a copy of the original handwritten manuscript, see Apollinaire, *OPC* 2: 1673–1682.

97. Apollinaire, "The Italian Futurist Painters," *AA*, 199.

98. See Marinetti's letter to Soffici of 1 January 1913, in Maria Drudi Gambillo and Teresa Fiori, eds., *Archivi del futurismo* (Rome: De Luca, 1958), 1: 257–258.

99. Carrà's recollections are included in P. A. Jannini, *La fortuna di Apollinaire in Italia* (Milan: Istituto Editoriale Cisalpino, 1965), 24–25. Jannini argues that the content of the manifesto was mostly derived from Marinetti and deserves to be thought of as "only in minimal measure" (22) a work by Apollinaire.

100. See Apollinaire, *Anecdotiques* (Paris: Gallimard, 1955), 218–223. On the Florentine reaction, see my *Avant-Garde Florence: From Modernism to Fascism* (Cambridge, Mass.: Harvard University Press, 1993), 179–181.

101. Apollinaire, "Nos amis les futuristes," *Les Soirées de Paris* 21 (15 February 1914), reprinted in *OC* 3: 884.

102. A particularly sharp version of this argument may be found in Jean, *La Poétique du désir*, 346–349.

103. Apollinaire, "L'adieu du cavalier," in *OC* 3: 238 ("Oh God! what a lovely war").

104. Mathews, *Reading Apollinaire*, 214–216.

105. Kenneth E. Silver, *Esprit de Corps: The Art of the Parisian Avant-Garde and the First World War, 1914–1925* (Princeton, N.J.: Princeton University Press, 1989), 3–27.

106. Apollinaire, "L'esprit nouveau et les poètes," *OC* 3: 900–910 (original emphasis), translated in Shattuck, *Selected Writings of Guillaume Apollinaire*, 227–237. All quotations cited in the text come from Shattuck's translation.

107. For a reading of Apollinaire's war poetry in light of a return to order, see Jay Winter, *Sites of Memory, Sites of Mourning: The Great War in European Cultural History* (Cambridge: Cambridge University Press, 1995), 214–217.

108. Silver, *Esprit de Corps*, 123.

109. Benjamin emphasizes this side of Apollinaire's view of the poetic in his essay "Surrealism: The Last Snapshot of the European Intelligentsia," in *Selected Writings, Volume 2: 1927–1934*, trans. Rodney Livingstone, ed. Michael Jennings, Howard Eiland, and Gary Smith (Cambridge, Mass.: Harvard University Press, 1999), 212.

110. For Breton's view of the event, see his *Conversations: The Autobiography of Surrealism with André Parinaud and Others*, trans. Mark Polizzotti (New York: Paragon House, 1993), 18–19. For the play itself, see *OC* 3: 607–650.

111. Apollinaire, letter to Tristan Tzara of 14 December 1916, reprinted in Michel Sanouillet, "Sur trois lettres de Guillaume Apollinaire à Tristan Tzara," *La Revue des Lettres modernes* 104 (1964), 7–8.

112. On Apollinaire's political writing in this period, see Pierre Caizergues, "Apollinaire et la politique pendant la guerre," in *Apollinaire et la guerre*, ed. Michel Décaudin (Paris: Lettres Modernes, 1974), 67–101. For his relations with Maurras, see his letter of 15 March 1918 in *OPC* 2: 996–1000. For a conservative interpretation of the play, see Scott Bates, *Guillaume Apollinaire*, revised ed. (Boston: Twayne, 1989), 122–124. See also *OC* 3: 927, where the notes point to the "apparent contradiction between the gravity of the theme, affirmed by Apollinaire himself, and the farcical style that he adopted to treat it."

113. See Buckley, *Guillaume Apollinaire*, 106; Mackworth, *Guillaume Apollinaire*, 206; and Christophe Prochasson, *Les Intellectuels, le socialisme et la guerre 1900–1938* (Paris: Seuil, 1993), 151–152.

114. Letter of 6 February 1918 in Sanouillet, "Sur trois lettres," 9.

115. André Breton, "Ombre non pas serpent mais d'arbre, en fleurs,' *Le Flâneur des Deux Rives* (March 1954): 5.

116. André Breton, *Conversations: The Autobiography of Surrealism*, trans. Mark Polizzotti (New York: Paragon House, 1993), 32; see also Mark Polizzotti, *Revolution of the Mind: The Life of André Breton* (New York: Farrar, Straus, and Giroux, 1995), 62.

117. Letters to Roland Chavelon (1918) and Albert Vallette (22 September 1917), in *OC* 4: 897, 819.

4. WASSILY KANDINSKY

1. Theodor W. Adorno, *Aesthetic Theory,* trans. Robert Hullot-Kentor (Minneapolis: University of Minnesota Press, 1997), 87, 94.

2. Ibid., 21, 26, 226.

3. Prominent examples of such work include Will Grohmann, *Wassily Kandinsky: Life and Work,* trans. Norbert Guterman (New York: Harry N. Abrams, 1958); Jelena Hahl-Koch, *Kandinsky,* trans. Karin Brown, Ralph Harratz, and Katharine Harrison (New York: Rizzoli, 1993); Rose-Carol Washton Long, *Kandinsky: The Development of an Abstract Style* (Oxford: Clarendon Press, 1980); Sixten Ringbom, *The Sounding Cosmos: A Study in the Spiritualism of Kandinsky and the Genesis of Abstract Painting* (Helsingfors: Abo Akademi, 1970); Peg Weiss, *Kandinsky in Munich: The Formative Jugendstil Years* (Princeton, N.J.: Princeton University Press, 1979); and Weiss, *Kandinsky and Old Russia: The Artist as Ethnographer and Shaman* (New Haven, Conn.: Yale University Press, 1995). See also the catalog of the exhibition held at Passariano, Italy, *Kandinsky e l'avventura astratta* (New York: Solomon R. Guggenheim Foundation, 2003).

4. For these views, see respectively Robin Lenman, *Artists and Society in Germany, 1850–1914* (Manchester, UK: Manchester University Press, 1997), 176–184; Robert Jensen, "Selling Martyrdom," *Art in America* 80 (April 1992): 139–175; and Itzhak Goldberg, "Kandinsky: La stratégie du succès," *Beaux Arts* 165 (February 1998): 52–61.

5. For these views, see respectively Yule F. Heibel, "'They Danced on Volcanoes': Kandinsky's Breakthrough to Abstraction, the German Avant-Garde and the Eve of the First World War," *Art History* 12 (September 1989): 342–361; Shulamith Behr, "Wassily Kandinsky and Dimitrije Mitrinovic: Pan-Christian Universalism and the Yearbook 'Toward the Mankind of the Future through Aryan Europe,'" *Oxford Art Journal* 15 (1992): 81–88; Richard Sheppard, "Kandinsky's *oeuvre,* 1900–1914: The Avant-Garde as Rear-Guard," *Word and Image* 6 (1990): 41–67, reprinted as chapter 6 of his *Modernism — Dada — Postmodernism* (Evanston, Ill.: Northwestern University Press, 2000); and Gerald N. Izenberg, *Modernism and Masculinity: Mann, Wedekind, Kandinsky through World War I* (Chicago: University of Chicago Press, 2000).

6. For discussions that touch on this point, see Irit Rogoff, "Modern German Art," in *The Cambridge Companion to Modern German Culture,* ed. Eva Kolinsky and Wilfried van der Will (Cambridge: Cambridge University Press, 1998), 256–281; Mark A. Cheetham, *The Rhetoric of Purity: Essentialist Theory and the Advent of Abstract Painting* (Cambridge: Cambridge University Press, 1991), 99; Helen Boorman, "Rethinking the Expressionist Era," *Oxford Art Journal* 9 (1986): 3–15; and Giulio Carlo Argan, "The First Modern Popular Art," in *Homage to Wassily Kandinsky,* ed. Gualtieri di San Lazzaro (New York: Leon Amiel, 1975), 110–111.

7. Kandinsky's idea of a color-language [*Farbensprache*] goes back to 1904; see Peg Weiss, "Kandinsky in Munich: Encounters and Transformations," in *Kandinsky in Munich, 1896–1914* (New York: Solomon R. Guggenheim Museum, 1982),

35; and Hans K. Roethel and Jean K. Benjamin, *Kandinsky* (New York: Hudson Hills Press, 1979), 13.

8. For Kandinsky's self-characterization as unpolitical and nonpartisan, see his letter of 11 August 1924 to Will Grohmann in Karl Gutbrod, *Lieber Freund: Künstler schreiben an Will Grohmann* (Cologne: M. DuMont Schauberg, 1968), 46. It should be noted that the context of the letter was the violent political atmosphere in Weimar in 1924 in which Kandinsky was being attacked as a communist.

9. Weiss, *Kandinsky and Old Russia.*

10. Kandinsky, "Vorwort zum Katalog der Kandinsky Kollektiv-Ausstellung, 1902–1912," *Der Sturm* (September 1912), now in *Kandinsky: Die Gesammelten Schriften, Band I,* ed. Hans K. Roethel and Jelena Hahl-Koch (Bern: Benteni Verlag, 1980), 22.

11. Annette and Luc Vezin, *Kandinsky and the Blue Rider* (Paris: Terrail, 1992), 41.

12. Lingering popular culture and new mass culture represent two of the four principal contextualizing factors cited by Peter Jelavich in his *Munich and Theatrical Modernism: Politics, Playwriting, and Performance, 1890–1914* (Cambridge, Mass.: Harvard University Press, 1985), 6–10.

13. See Frederic J. Schwartz, *The Werkbund: Design Theory and Mass Culture before the First World War* (New Haven, Conn.: Yale University Press, 1996); and Joan Campbell, *The German Werkbund: The Politics of Reform in the Applied Arts* (Princeton, N.J.: Princeton University Press, 1978).

14. See Peter Jelavich, "Munich as Cultural Center: Politics and the Arts," in *Kandinsky in Munich, 1896–1914,* 17–26.

15. Kandinsky's early feelings about Munich were recalled in "The Blaue Reiter (Recollection)," now in *Kandinsky: Complete Writings on Art,* ed. Kenneth C. Lindsay and Peter Vergo (New York: Da Capo, 1994), 745; hereafter abbreviated *CWA.* His dismissal came in "Letter from Munich," published in the St. Petersburg journal *Apollon* (9 October 1909), now in *CWA,* 56.

16. For Kandinsky's relations with Behrens, see Weiss, "Kandinsky in Munich: Encounters and Transformations," in *Kandinsky in Munich, 1896–1914,* 50; and Washton Long, *Kandinsky,* 17, 54. Washton Long also suggests (8) that Kandinsky was probably familiar with the ideas of another figure active in the Werkbund and important for the origins of Bauhaus, the Belgian Henry van de Velde, who came to Germany in 1900.

17. On the Russian symbolist world, see John E. Bowlt, *The Silver Age: Russian Art of the Early Twentieth Century and the "World of Art" Group* (Newtonville, Mass.: Oriental Research Partners, 1979); and Irina Paperno and Joan Delaney Grossman, eds., *Creating Life: The Aesthetic Utopia of Russian Modernism* (Stanford, Calif.: Stanford University Press, 1994).

18. As her subtitle indicates, Weiss sees Jugendstil as a major influence in *Kandinsky in Munich: The Formative Jugendstil Years.* Hahl-Koch, however, stresses the Russian influences on Kandinsky and claims he was uninterested in all forms of art nouveau, including Jugendstil; see her *Kandinsky,* 53. Washton Long, *Kandinsky,* 9, takes the intermediate view that he was interested in Jugendstil but also feared its potential for devolving into mere decoration.

19. For Kandinsky's expression of such attitudes, see his "Whither the 'New' Art?" *Odesskie novosti* (1911), in *CWA*, 98–104.

20. See Weiss, *Kandinsky in Munich, 1896–1914*, 57.

21. Kandinsky, "Critique of Critics," *Novosti dnia* (April 1901), now in *CWA*, 35–44.

22. *CWA*, 142.

23. Kandinsky, "Letter from Munich," *Apollon* (October-November 1910), now in *CWA*, 76–77.

24. Ibid., *CWA*, 60.

25. *CWA*, 128, 130.

26. In "Reflections on Abstract Art" (1931), now in *CWA*, 758, Kandinsky writes that "works of abstract painting spring from the source common to all the arts: intuition."

27. Kandinsky, "On Stage Composition" (1912), now in *CWA*, 258.

28. Reflecting on this need for an antidiscourse, Kandinsky closed a 1913 autobiographical essay with the words: "If it is somewhat against my will that I have written these few lines of 'explanation,' it is only out of a desire to remove from the path of the well-meaning spectator the two worst barriers that the 'connoisseurs' and 'aestheticians' have with light hearts and in so careless a way succeeded in putting in his way" (*CWA*, 346).

29. Kandinsky, "Whither the 'New' Art?" now in *CWA*, 103; translation slightly amended.

30. *CWA*, 237.

31. Kandinsky's idea that "the world sounds" is explicit in his essay "On the Question of Form" (1912), now in *CWA*, 250, but implicit throughout *On the Spiritual in Art*.

32. *CWA*, 166.

33. Kandinsky, "Painting as Pure Art," *Der Sturm* (1913), now in *CWA*, 349–354.

34. For a succinct statement of these premises, see "Painting as Pure Art," now in *CWA*, 349.

35. This equation is made in "On the Question of Form," *CWA*, 239. But the same thought—with the same phrase, "ambition and greed" [*des Ergheizes und der Habsucht*]—is expressed in *On the Spiritual in Art*, *CWA*, 130.

36. Kandinsky, "Content and Form," now in *CWA*, 87–88.

37. *CWA*, 173.

38. Kandinsky, "Reminiscences," now in *CWA*, 370. The phrase is reiterated in his "Cologne Lecture" of January 1914, now in *CWA*, 396.

39. *CWA*, 157, 160, 165, 169, 171.

40. *CWA*, 176. The full quote from Goethe is given its own page in *Der Blaue Reiter*. See Kandinsky and Franz Marc, eds., *The Blaue Reiter Almanac*, trans. Klaus Lankheit (New York: Da Capo, 1974), 112 (hereafter abbreviated *BRA*).

41. *CWA*, 151–152.

42. *CWA*, 152, 176.

43. *CWA*, 202, 214, 176, 208. That Schopenhauer's metaphysics were an important influence on Kandinsky is persuasively argued in Cheetham, *Rhetoric of Purity*, 83–85.

44. *CWA*, 174–175.

45. Sheppard, "Kandinsky's *oeuvre*."

46. *CWA*, 193.

47. *CWA*, 170, 204.

48. *CWA*, 219.

49. Carl Vinnen, *Ein Protest deutscher Kunstler* (Jena: E. Diederichs, 1911). The manifesto itself, "Quousque tandem," appears on pages 2–16 and is followed by sixty pages of signatures and statements from 140 supporters. For a partial translation, see Timothy O. Benson and Éva Forgács, eds., *Between Worlds: A Sourcebook of Central European Avant-Gardes, 1910–1930* (Cambridge, Mass.: MIT Press, 2002), 50–51.

50. On the chauvinistic atmosphere of the prewar German art world and the Vinnen controversy, see Peter Paret, *The Berlin Secession: Modernism and Its Enemies in Imperial Germany* (Cambridge, Mass.: Harvard University Press, 1980), 156–199.

51. The fullest of these accounts is Klaus Lankheit, "A History of the Almanac," *BRA*, 11–48.

52. The nationalistic overtones of the split with the Neue Künstler-Vereinigung München and its connection with the Vinnen controversy are noted in Weiss, "Kandinsky in Munich: Encounters and Transformations," 66.

53. Peter Paret, "The Tschudi Affair," *Journal of Modern History* 53 (December 1981): 589–618.

54. Alfred Heymel, ed., *Im Kampf um die Kunst: Die Antwort auf den "Protest Deutscher Künstler"* (Munich: R. Piper, 1911).

55. Kandinsky, "On the Question of Form," now in *BRA*, 150; see also *CWA*, 237, for a slightly different translation.

56. *CWA*, 382. On this point, the most important study is Weiss, *Kandinsky and Old Russia*.

57. See Behr, "Wassily Kandinsky and Dimitrije Mitrinovic."

58. Paret, *The Berlin Secession*, 184.

59. *CWA*, 106–108.

60. *CWA*, 173.

61. Kandinsky, "The Blaue Reiter (Recollection)," now in *CWA*, 745–746.

62. *BRA*, 81.

63. See Jelena Hahl-Koch, ed., *Arnold Schoenberg, Wassily Kandinsky: Letters, Pictures and Documents,* trans. John C. Crawford (London: Faber and Faber, 1984), 28–41.

64. *CWA*, 746.

65. *BRA*, 151–152.

66. Peter Vergo, *The Blue Rider* (Oxford: Phaidon, 1977), 3.

67. Kandinsky commented on Italian futurist art only in November 1913 in two letters to Walden, but he already knew of Marinetti's movement, which is mentioned in Roger Allard's article for the almanac as well as in a letter from Franz Marc to Kandinsky of 23 April 1912. For the letter, see Kandinsky and Marc, *Briefwechsel,* ed. K. Lankheit (Munich: R. Piper, 1983), 162. For Kandinsky's letters of 12 and 15 November 1913 to Walden, see Andreas Hüneke, ed., *Der Blaue Reiter: Dokumente einer geistigen Bewegung* (Leipzig: Reclam-Verlag, 1991), 211–

213. For a discussion of Kandinsky's view of Italian futurism, see Gerhard Kolberg, "Der Blaue Reiter und die italienischen Futuristen," in Magdalena M. Moeller, *Der Blaue Reiter und seine Künstler* (Munich: Hirmer Verlag, 1998), 175–187.

68. Kandinsky's statement, which appeared simultaneously in two Moscow journals, *Muzyka* and *Russkoe slovo* (4 May 1913), is quoted by Jelena Hahl-Koch, "Kandinsky's Role in the Avant-Garde," in *The Avant-Garde in Russia, 1910–1930,* ed. Stephenie Barron and Maurice Tuchman (Cambridge, Mass.: MIT Press, 1980), 87–88. A slightly different translation is presented in Troels Andersen, "Some Unpublished Letters by Kandinsky," *Artes* 2 (1966), 96–97.

69. *CWA,* 381.

70. Kandinsky, "On Understanding Art," *Der Sturm* (1912), now in *CWA,* 287–290. This is perhaps Kandinsky's single most important pedagogical statement.

71. Weiss, *Kandinsky and Old Russia,* 70.

72. Jensen, "Selling Martyrdom." A more balanced account of the "business side" of Blaue Reiter can be found in Lenman, *Artists and Society in Germany,* 176–184.

73. Kandinsky to Marc, 5 June 1913, in *Briefwechsel,* 174.

74. See Klaus Lankheit, "Bibel-Illustrationen des Blauen Reiters," in *Ludwig Grote zum 70. Geburtstag am 8 August 1963,* ed. Ludwig Grote (Nürnberg: Germanisches Nationalmuseum, 1963), 199–207.

75. On this episode, see Jelavich, *Munich and Theatrical Modernism,* 295–297; and Hugo Ball, *Flight Out of Time: A Dada Diary,* trans. Ann Raimes (New York: Viking, 1974), 7–10.

76. *CWA,* 373.

77. Compare "Painting as Pure Art," *Der Sturm* (September 1913), now in *CWA,* 353, with Kandinsky's reply to Vinnen, in *CWA,* 107, as well as *On the Spiritual in Art,* in *CWA,* 187 and 211.

78. Kandinsky, "Cologne Lecture" (January 1914), now in *CWA,* 393–400.

79. See Campbell, *The German Werkbund,* 57–81.

80. Letter of 11 July 1914, cited in Vivian Endicott Barnett, *Kandinsky and Sweden* (Malmö: Malmö Konsthall, 1989), 45.

81. Excerpted in Barnett, *Kandinsky and Sweden,* 62–63.

82. For his one prewar discussion of this distinction, see *CWA,* 378n; for the 1916 brochure "On the Artist," see *CWA,* 408–418.

83. In addition to works by Grohmann, Hahl-Koch, and Andersen already cited, see Clark V. Poling, "Kandinsky: Russian and Bauhaus Years, 1915–1933," in *Kandinsky: Russian and Bauhaus Years* (New York: Solomon R. Guggenheim Museum, 1983), 12–83. For the broader context, see Sheila Fitzpatrick, *The Commissariat of Enlightenment: Soviet Organization of Education and the Arts under Lunacharsky, October 1917–1921* (Cambridge: Cambridge University Press, 1970).

84. *CWA,* 437–444.

85. For continuing references to the coming "epoch of the great spiritual," see *CWA,* 409, 414, 479, 481, 518.

86. Kandinsky, "Program for the Institute of Artistic Culture," now in *CWA,* 457–472.

87. On Russian constructivism, see Christina Lodder, *Russian Constructivism* (New Haven, Conn.: Yale University Press, 1983); and Irina Gutkin, "The Legacy of the Symbolist Aesthetic Utopia: From Futurism to Socialist Realism," in Paperno and Grossman, *Creating Life,* 178–184.

88. Letters of 18 January 1911 and 22 August 1912, in Hahl-Koch, *Arnold Schoenberg, Wassily Kandinsky,* 21, 56–59.

89. See Stephen Bann, ed., *The Tradition of Constructivism* (New York: Viking, 1974), xxix; George Rickey, *Constructivism: Origins and Evolution,* rev. ed. (New York: George Brazillier, 1995), 21–22; and H. L. C. Jaffé, *De Stijl, 1917–1931: The Dutch Contribution to Modern Art* (Cambridge, Mass.: Harvard University Press, 1986), 47.

90. *CWA,* 476.

91. On Kandinsky's reasons for emigrating, see Poling, "Kandinsky," 28; and Hahl-Koch, *Kandinsky,* 265.

92. Letter to Will Grohmann of 23 November 1923, cited in Beeke Sell Tower, *Klee and Kandinsky in Munich and at the Bauhaus* (Ann Arbor, Mich.: UMI Research Press, 1981), 150.

93. See Klaus Lankheit, "A History of the Almanac," *BRA,* 46–47; Marcel Franciscono, *Walter Gropius and the Creation of the Bauhaus in Weimar: The Ideals and Artistic Theories of Its Founding Years* (Urbana: University of Illinois Press, 1971), 88; and Éva Forgács, *The Bauhaus Idea and Bauhaus Politics,* trans. John Bátki (Budapest: Central European University Press, 1991), 16–17.

94. On this exchange, see Andersen, "Some Unpublished Letters by Kandinsky," 101–103.

95. Ibid, 102.

96. Kandinsky, "A New Naturalism?" *Das Kunstblatt* (1922), now in *CWA,* 481–482.

97. Kandinsky, *Point and Line to Plane* (1926), now in *CWA,* 658.

98. Kandinsky, "On the Reform of Art Schools," *Iskusstvo* (1923), now in *CWA,* 490–497.

99. Kandinsky, "The Value of Theoretical Instruction in Painting" (1926), now in *CWA,* 702–705.

100. Kandinsky, "And, Some Remarks on Synthetic Art," *i10* (1927), now in *CWA,* 708–717.

5. THE RISE AND FALL OF DESIGN MODERNISM

1. G. F. Hartlaub, "Kunst als Werbung," *Das Kunstblatt* (June 1928), Kraus reprint (1978): 170–176; translated in Victor Margolin, "Typography, Book Design, and Advertising in the 1920s: A Collection of Documents," *Design Issues* 9 (Spring 1993): 72–76.

2. On the exhibit and the cultural context of Neue Sachlichkeit, see John Willett, *Art and Politics in the Weimar Period: The New Sobriety, 1917–1933* (New York: Pantheon, 1978), 111–113; and Irving Sandler and Amy Newman, eds., *Defining Modern Art: Selected Writings of Alfred H. Barr, Jr.* (New York: Harry Abrams, 1986), 261n65.

3. G. F. Hartlaub, "Zum Geleit," in *Ausstellung 'Neue Sachlichkeit':*

Deutsche Malerie seit dem Expressionismus (Mannheim: Städtische Kunsthalle, 1925), reprinted in Anton Kaes, Martin Jay, and Edward Dimendberg, eds., *The Weimar Republic Sourcebook* (Berkeley: University of California Press, 1994), 491–493; original emphasis.

4. For a memoir emphasizing the special cultural vitality and dynamism of the decade following the war, which had "spent its force" by 1930, see Sibyl Moholy-Nagy, *Experiment in Totality,* 2nd ed. (Cambridge, Mass.: MIT Press, 1969), 4 and passim.

5. The critique of fashion was relentlessly pursued by Hermann Muthesius, *Style-Architecture and Building-Art: Transformations in Architecture in the Nineteenth Century and Its Present Condition,* trans. Stanford Anderson (Santa Monica, Calif.: Getty Research Institute, 1994 [1902]), 86–90.

6. See Frederic J. Schwartz, *The Werkbund: Design Theory and Mass Culture before the First World War* (New Haven, Conn.: Yale University Press, 1996).

7. See Alois Riegl, *Late Roman Art Industry* [1901], trans. Rolf Winkes (Rome: Giorgio Bretschneider, 1985); and Margaret Iversen, *Alois Riegl: Art History and Theory* (Cambridge, Mass.: MIT Press, 1993).

8. See Schwartz, *Werkbund,* 121–163; and Stanford Anderson's introduction to Muthesius, *Style-Architecture and Building-Art,* 1–43.

9. For Muthesius's intervention in Cologne, which came in the form of ten theses, see Ulrich Conrads, ed., *Programs and Manifestoes on 20th-century Architecture,* trans. Michael Bullock (Cambridge, Mass.: MIT Press, 1964), 28–29. See also Stanford Anderson, "Deutscher Werkbund—the 1914 Debate: Hermann Muthesius versus Henry van de Velde," in *Companion to Contemporary Architectural Thought,* ed. Ben Farmer and Hentie Louw (London: Routledge, 1993), 462–467.

10. For van de Velde's response to Muthesius, see Conrads, *Programs and Manifestoes,* 29–31.

11. On the history and meaning of "advertising art" in early twentieth-century Germany, see Sherwin Simmons, "Kitsch oder Kunst? Kokoschka's *Der Sturm* and Commerce in Art," *Print Collector's Newsletter* 23 (November-December 1992): 161–167. For parallel developments in France, see Marjorie A. Beale, *The Modernist Enterprise: French Elites and the Threat of Modernity, 1900–1940* (Stanford, Calif.: Stanford University Press, 1999), 11–47.

12. Even this point can be exaggerated, as studies of the relation of dadaism and constructivism have shown. See especially Dawn Ades, "Dada—Constructivism," in *Dada — Constructivism* (London: Annely Juda Fine Art, 1984), 33–46.

13. Willett, *Art and Politics,* 11; Kenneth E. Silver, *Esprit de Corps: The Art of the Parisian Avant-Garde and the First World War, 1914–1925* (Princeton, N.J.: Princeton University Press, 1989), 229–237; and Michael T. Saler, *The Avant-Garde in Interwar England: Medieval Modernism and the London Underground* (Oxford: Oxford University Press, 1999), 61–62, 171, are among the most important of the many works that could be cited. For an effort to portray the mood of postwar modernist culture across Europe, see Richard Weston, *Modernism* (London: Phaidon, 1996), 91–139.

14. Some of the more important studies in these intersecting areas are Nicholas Pevsner, *Pioneers of Modern Design: From William Morris to Walter*

Gropius (Harmondsworth, UK: Penguin, 1968 [1936]); Reyner Banham, *Theory and Design in the First Machine Age* (London: Architectural Press, 1960); Christopher Crouch, *Modernism in Art, Design, and Architecture* (New York: St. Martin's, 1999); Weston, *Modernism;* Detlev Mertens, introduction to *The Victory of the New Building Style,* by Walter Curt Behrendt (Los Angeles: Getty Research Institute, 2000), 1–84; and Willy Rotzler, *Constructive Concepts: A History of Constructive Art from Cubism to the Present,* trans. Stanley Mason (New York: Rizzoli, 1989).

15. On this theme, see Charles S. Maier, *Recasting Bourgeois Europe: Stabilization in France, Germany, and Italy in the Decade after World War I* (Princeton, N.J.: Princeton University Press, 1975); and Beale, *Modernist Enterprise,* especially 61–68.

16. See Joan Campbell, *The German Werkbund: The Politics of Reform in the Applied Arts* (Princeton, N.J.: Princeton University Press, 1978), 104–140.

17. The following biographical remarks on Gropius draw upon Reginald Isaacs, *Gropius: An Illustrated Biography of the Creator of the Bauhaus,* trans. and abridged by Gerard van der Leun (Boston: Little, Brown and Company, 1991); Elaine Hochman, *Bauhaus: Crucible of Modernism* (New York: Fromm International, 1997); Éva Forgács, *The Bauhaus Idea and Bauhaus Politics,* trans. John Bátki (Budapest: Central European University Press, 1991); Frank Whitford, *Bauhaus* (London: Thames and Hudson, 1984); Hans M. Wingler, *The Bauhaus: Weimar Dessau Berlin Chicago,* trans. Wolfgang Jabs and Basil Gilbert (Cambridge, Mass.: MIT Press, 1969); Marcel Franciscono, *Walter Gropius and the Creation of the Bauhaus in Weimar: The Ideals and Artistic Theories of Its Founding Years* (Urbana: University of Illinois Press, 1971); and Walter Gropius, "To the Editors," *Architectural Review* 134 (July 1963): 6.

18. On this point, see Peter Gay, *Art and Act: On Causes in History — Manet, Gropius, Mondrian* (New York: Harper and Row, 1976), 114, where a 1974 letter from Gropius's wife, Ise, is cited to show that "the term functionalism . . . was taboo in the Bauhaus" when her husband was its director; and Gropius, "To the Editors," in which he maintains that "Hannes Meyer's inner downfall was his denying art as such." On the relationship of *Sachlichkeit* and functionalism, see Rosemarie Haag Bletter, "The Myths of Modernism," in *Craft in the Machine Age, 1920–1945,* ed. Janet Kardon (New York: Harry N. Abrams, 1995), 46–51.

19. See Franciscono, *Walter Gropius,* 30–31, 72–73; and Banham, *Theory and Design,* 84–86.

20. See Wingler, *Bauhaus,* xviii, 20–21.

21. Gropius, "To the Editors."

22. Letter of 11 April 1915, now in Wingler, *Bauhaus,* 21.

23. Ibid., 23–24.

24. On the politics that produced Bauhaus, see Forgács, *Bauhaus Idea,* 22–26; Hochman, *Bauhaus,* 58–90; and Karl-Heinz Hüter, *Das Bauhaus in Weimar: Studie zur gesellschaftspolitischen Geschichte einer deutschen Kunstschule* (Berlin: Akademie-Verlag, 1976), 11–23, 201–211.

25. Forgács, *Bauhaus Idea,* 22. No significant revenue came from student tuition, although modest fees were charged.

26. Forgács, *Bauhaus Idea,* 63, judges Itten to have had more power than Gropius in early 1921.

27. "Programm zur Gründung einer allgemeinen Hausbaugesellschaft auf künstlerisch einheitlicher Grundlage m.b.H.," in *Ausgewählte Schriften, Walter Gropius,* ed. Hartmut Probst and Christian Schädlich (Berlin: Ernst and Sohn, 1988), 3: 18–25, partially translated in Wingler, *Bauhaus,* 20–21.

28. "Monumentale Kunst und Industriebau," in Probst and Schädlich, *Ausgewählte Schriften,* 3: 28–51.

29. On the connection between Riegl and Gropius, see Karin Wilhelm, *Walter Gropius, Industriearchitekt* (Braunschwig: F. Vieweg, 1983), 30–33, in which the text of the 1911 lecture may also be found, 116–120.

30. Gropius, "Programm," in Probst and Schädlich, *Ausgewählte Schriften,* 3: 18–19.

31. "Die Entwicklung moderner Industriebaukunst," *Jahrbuch des Deutschen Werkbundes* (1913): 17–22, partially translated in Tim Benton and Charlotte Benton, eds., *Architecture and Design: 1890–1939* (New York: Whitney Library of Design, 1975), 53–55.

32. "Der stilbildende Wert industrieller Bauformen," *Jahrbuch des Deutschen Werkbundes* (1914): 29–32.

33. On Gropius's position at the Cologne convention, see Franciscono, *Walter Gropius,* 75; Schwartz, *Werkbund,* 180, 244n125; Isaacs, *Gropius,* 31–33; and Gropius, "To the Editors."

34. Isaacs, *Gropius,* 33 (the letter is from 1965).

35. See Gropius's "Letter to the Editor," *American Institute of Architects Journal* 39 (June 1963): 120–121, in which he was critical of van de Velde for failing to reconcile the "uniqueness of the creative individual" with the "spiritual coherence of the age."

36. On Gropius's pedagogy before and during Bauhaus, see Rainer K. Wick, *Teaching at the Bauhaus,* trans. Stephen Mason and Simon Lèbe (Ostfildern-Ruit: Hatje Cantz, 2000); and Giulio Carlo Argan, "La pedagogia formale della Bauhaus," in *Walter Gropius e la Bauhaus,* 2nd ed. (Turin: Einaudi, 1957), 31–84.

37. For example, see Gropius, "On the First Exhibition of Bauhaus Student Work" (1919), in *Between Worlds: A Sourcebook of Central European Avant-Gardes, 1910–1930,* ed. Timothy O. Benson and Éva Forgács (Cambridge, Mass.: MIT Press, 2002), 208–210; see also Isaacs, *Gropius,* 51–66; and Franciscono, *Walter Gropius,* 69, 88–152.

38. Scholars generally agree that the 1919–1922 period is to be distinguished from 1923–1928, but some believe that they should be treated as relatively continuous, since Gropius did not change his conception of design modernism but simply took a long time to implement it fully, while others read the periods as different because of the changing political context and the way he readapted his views in response. For the former view, see Franciscono, *Walter Gropius;* for the latter see Hochman, *Bauhaus;* Whitford, *Bauhaus,* and Wick, *Teaching at the Bauhaus.*

39. "Programm des Staatlichen Bauhauses in Weimar" (April 1919), now in Wingler, *Bauhaus,* 31–33, in both the original German and English translation.

40. Letter to Ernst Hardt of April 14, 1919, cited in Forgács, *Bauhaus Idea,* 26.

41. See Wick, *Teaching at the Bauhaus,* 34–38 and passim.

42. "The Viability of the Bauhaus Idea," a memo to the Bauhaus masters, in Wingler, *Bauhaus,* 52.

43. For Gropius's notion that the Bauhaus workshops should develop into "industrial laboratories," see his "Idee und Aufbau des Staatlichen Bauhauses," in *Ausgewählte Schriften,* 3: 83–92, and translated in *Bauhaus 1919–1928,* ed. Herbert Bayer, Walter Gropius, and Ise Gropius (Boston: Branford, 1959), 20–29. The notion is reiterated in his "Letter to the Editor" (June 1963), 121.

44. On what many saw as Gropius's "commercial conversion" bound up with that evaluation, see Hochman, *Bauhaus,* 136–145; on the exhibitions, see Forgács, *Bauhaus Idea,* 78–81, 98–102; and Hochman, *Bauhaus,* 159–162.

45. For the contrary view, see Forgács, *Bauhaus Idea,* 115.

46. For Gropius's view of van Doesburg, see his 1952 letter to Bruno Zevi, cited in Zevi, *Poetica dell'architettura neoplastica: Il linguaggio della scomposizione neoplastica* (Turin: Einaudi, 1974), 229.

47. Hochman, *Bauhaus,* 144, argues that "by the end of 1922 the Bauhaus was broke."

48. On Feininger's views in this regard, see Whitford, *Bauhaus,* 132–133.

49. The categories derive from Friedhelm Kröll, *Bauhaus 1919–1933: Künstler zwischen Isolation und Kollektiver Praxis* (Düsseldorf: Bertelsmann, 1974).

50. "Programm des Staatlichen Bauhauses in Weimar," in Wingler, *Bauhaus,* 31.

51. See, for example, the article by Bauhaus painter Georg Muche, "Bildende Kunst und Industriereform," *bauhaus* 1 (1926): 5, which argued that "the illusion that the fine arts could be absorbed in the creative act of technical design falls apart the moment it encounters concrete reality. . . . Art and technology are not a new unity; they remain fundamentally different in their creative worth."

52. Among the important works on van Doesburg, upon which I have drawn for his early life, are Joost Baljeu, *Theo van Doesburg* (New York: MacMillan, 1974); Carel Blotkamp, "Theo van Doesburg," in *De Stijl: The Formative Years, 1917–1922,* ed. Blotkamp, trans. Charlotte Loeb and Arthur Loeb (Cambridge, Mass.: MIT Press, 1982), 4–37; Allan Doig, *Theo van Doesburg: Painting into Architecture, Theory into Practice* (Cambridge: Cambridge University Press, 1986); Hans L. C. Jaffe, *De Stijl, 1917–1931: The Dutch Contribution to Modern Art* (Cambridge, Mass.: Harvard University Press, 1986); Donald Langmeade, *The Artists of De Stijl: A Guide to the Literature* (Westport, Conn.: Greenwood Press, 2000), 66–70; Paul Overy, *De Stijl* (London: Thames and Hudson, 1991); Evert van Straaten, *Theo van Doesburg: Painter and Architect* (The Hague: SDU, 1988); and van Straaten, *Theo van Doesburg: Constructor of the New Life* (Otterlo: Kröller-Müller Museum, 1994).

53. Available on microfiche, the Theo van Doesburg Archive, RBK (The Netherlands Office for Fine Arts, Donation van Moorsel), the Hague, has diary entries beginning in 1902, mostly in verse.

54. Schoenmaekers, whose neo-Platonic vision of universal order appeared in 1916 as *Beginselen der beeldende wiskunde* [Principles of Plastic Mathematics], strongly influenced both van Doesburg and Mondrian.

55. For an excellent bibliography of van Doesburg's work that includes his early writings, see Langmeade, *Artists of De Stijl*, 72–119. For Berlage's ideas, the influence of which in the Netherlands paralleled that of Peter Behrens and Herman Muthesius in Germany, see the introduction by Iain Boyd White to *Henrik Petrus Berlage: Thoughts on Style, 1886–1909*, trans. Iain Boyd White and Wim de Wit (Santa Monica, Calif.: Getty Center, 1996), 1–91. The volume contains Berlage's "Thoughts on Style in Architecture" (1905), 122–156.

56. Preface to Jaffe, *De Stijl, 1917–1931*, v.

57. An early indication of this activity was van Doesburg's collaboration on the Italian journal *Valori plastici*; see his "L'arte nuova in Olanda," 1 (April-May 1919): 18–19; and 1 (June-October 1919): 22–24.

58. Born as Christiaan Emil Marie Küpper, Theo van Doesburg, it is often suggested, was itself his first adopted role, but the point is disputed in Baljeu, *Theo van Doesburg*, 13.

59. For Oud's conception of monumental art, see his "Het Monumentale Stadsbeeld," *De Stijl* 1 (October 1917), now in reprint ed. (Amsterdam: Atheneum, 1968), 1: 12–13. The article is dated 9 July 1917. A translation, "The Monumental Townscape," can be found in Hans L. C. Jaffe, ed., *De Stijl* (New York: Harry Abrams, 1967), 95–96.

60. "De nieuwe beweging in de schilderkunst," *De Beweging* 12 (1916), 234, cited in Blotkamp, "Theo van Doesburg," 19.

61. Letter of 6 July 1919, cited in van Straaten, *Theo van Doesburg: Constructor of the New Life*, 11, original emphasis.

62. "Painting and its Environment," in van Straaten, *Theo van Doesburg: Painter and Architect*, 12–13; the article was previously unpublished.

63. For van Doesburg's reception of Worringer, see his 1916 lecture, "Het Aesthetisch Beginsel der Moderne Beeldende Kunst," in *Drie Voordrachten over de Nieuwe Beeldende Kunst: Haar Ontwickkeling, Aesthetisch Beginsel en Toekomstigen Stijl* (Amsterdam: Maatschappij voor Goede en Goedkoope Lectuur, 1919), 33–48, which develops arguments similar to those in Worringer's *Abstraction and Empathy: A Contribution to the Psychology of Style*, trans. Michael Bullock (London: Routledge and Kegan Paul, 1953 [1908]).

64. See *Drie Voordrachten*, 27 (the passage is dated 30 October 1915).

65. *De Nieuwe Beweging in de Schilderkunst* (Delft: J. Waltman, 1917), 42–43; the passage is dated May-August 1916. For the passage in Kandinsky, see Kenneth C. Lindsay and Peter Vergo, eds., *Kandinsky: Complete Writings on Art* (New York: Da Capo, 1994), 218–219.

66. The passage, from November 1915, is cited in Jane Beckett, "Discoursing on Dutch Modernism," *Oxford Art Journal* 6 (1983): 73–74.

67. "Fragmenten III," *De Stijl* 2 (February 1919), 48; translated in *De Stijl, Catalog 81* (Amsterdam: Stedelijk Museum, 1951), 23.

68. For a convincing argument to this effect, see Joop Joosten, "Painting and Sculpture in the Context of De Stijl," in *De Stijl: 1917–1931 Visions of Utopia*, ed. Mildred Friedman (Minneapolis: Walker Art Center, 1982), 50–67.

69. See van Doesburg, "Der Kampf um den neuen Stil," *Neue Schweizer Rundschau* 22 (1929): 45, now in the Theo van Doesburg Archive, RBK (The Netherlands Office for Fine Arts, Donation van Moorsel), The Hague, where he

claims that "a universal stylistic idea" was latent in 1917, although he and his De Stijl colleagues had not yet gone as far as "collective construction."

70. See Rotzler, *Constructive Concepts,* 10.

71. For Mondrian's concept of an abstract art as a "turning away from the natural," see his articles on "Neoplasticism in Painting," which appeared in the early issues of *De Stijl* and are translated in Jaffe, *De Stijl,* 36–93.

72. "Ter Inleiding," *De Stijl* 1 (October 1917): 1, translated in *De Stijl, Catalog 81,* 5.

73. Van Doesburg's objections to "newspaper criticism" are explicit in articles written in 1919; see their translations in *Principles of Neo-plastic Art,* trans. Janet Seligman (London: Percy Lund, Humphries, and Company, 1968), 9.

74. "Fragmenten II," *De Stijl* 1 (May 1918): 84; translated in *De Stijl, Catalog 81,* 23. For a discussion of van Doesburg's relation to Hegel, see Doig, *Theo van Doesburg,* 6–13.

75. For fuller and generally parallel discussions of this De Stijl project, see Doig, *Theo van Doesburg,* 1–6, 30–31, and passim; and Yve-Alain Bois, "The De Stijl Idea," *Art in America* 70 (Nov. 1982): 106–117.

76. See Nancy J. Troy, "The Abstract Environment of De Stijl," in Friedman, *De Stijl,* 165–189, as well as Troy, *The De Stijl Environment* (Cambridge, Mass.: MIT Press, 1983), especially 182–183. Because of these disputes, the participation of the nonpainters in De Stijl was brief; all of them except Rietveld had dropped out by the end of 1922.

77. The best discussion of this matter, upon which I largely rely here, is Doig, *Theo van Doesburg,* especially 47–51.

78. Ibid., 51.

79. See Theo van Doesburg, *On European Architecture: Complete Essays from Het Bouwbedrijf, 1924–1931,* trans. Charlotte I. Loeb and Arthur L. Loeb (Basel: Birkhäuser Verlag, 1990).

80. Van Doesburg, "Factory and Home," *Het Bouwbedrijf* 2 (May 1925), now in van Doesburg, *On European Architecture,* 57–63.

81. Thus he refers to potential associations with industry only when he is most confident that his theoretical program for art is about to be actualized. See, for example, his 1923 "Manifesto V," coauthored with Cornelius van Eesteren in Paris and translated in Conrads, *Programs and Manifestoes,* 66.

82. "From Copy to Experiment," *Het Bouwbedrijf* 2 (October 1925), now in *On European Architecture,* 70–74, original emphasis.

83. "Manifest I van 'De Stijl,'" *De Stijl* 2 (November 1918): 2; translations in Conrads, *Programs and Manifestoes,* 39–40; Overy, *De Stijl,* 47; and *De Stijl, Catalog 81,* 10.

84. On van Doesburg's internationalization, see Banham, *Theory and Design,* 186; and Bernd Finkeldey, "Hans Richter and the Constructivist International," in *Hans Richter: Activism, Modernism, and the Avant-Garde,* ed. Stephen C. Foster (Cambridge, Mass.: MIT Press, 1998), 92–121. For his relations with Marinetti and Italian futurism, see Giovanni Lista, "Van Doesburg et les futuristes," in *Theo van Doesburg,* ed. Serge Lemoine (Paris: Philippe Sers, 1990), 150–157.

85. See Victor Margolin, *The Struggle for Utopia: Rodchenko, Lissitzky,*

Moholy-Nagy, 1917–1946 (Chicago: University of Chicago Press, 1997), 45–79. Although El Lissitzky only arrived in Berlin in 1922, he and his fellow Russian Elie Ehrenburg produced three issues of a new journal, *Vesch-Objet-Gegenstand,* there that year. Written largely in Russian, it nonetheless enlisted support from many Western European intellectuals, including van Doesburg.

86. "Manifest II van 'De Stijl' 1920, De Literatuur," *De Stijl* 3 (April 1920): 49–50; translations in Baljeu, *Theo van Doesburg,* 110–112; and *De Stijl, Catalog 81,* 12. On van Doesburg as dadaist, see Hannah L. Hedrick, *Theo van Doesburg: Propagandist and Practitioner of the Avant-Garde, 1909–1923* (Ann Arbor, Mich.: UMI Research Press, 1980), 109–131.

87. On the critique of the Bauhaus, see especially van Doesburg, "Begrüsserung," *Mécano* 4/5 (1923): 16, in which he credited his own influence for its recent advances.

88. *Mécano* is available in a reprint edition (1979) from Quarto Press in Vaduz, Liechtenstein. For a portrait of van Doesburg in the *Mécano* years, see Kurt Schwitters, "Theo van Doesburg and Dada" (1931), reprinted in Robert Motherwell, ed., *The Dada Painters and Poets: An Anthology* (Cambridge, Mass.: Harvard University Press, 1988), 275–276.

89. On the congress, see Maria Müller, "Der Kongress der 'Union Internationaler Forschrittlicher Künstler' in Düsseldorf," in *Konstruktivistische internationale schöpferische Arbeitsgemeinschaft, 1922–1927: Utopien für eine europäische Kultur,* ed. Bernd Finkeldey (Düsseldorf: Kunstsammlujng Nordrhein-Westfallen, 1992), 17–22.

90. Signed by van Doesburg, Lissitzky, and Richter, the declaration is reprinted, along with van Doesburg's personal response to the congress, in Jaffe, *De Stijl,* 171–177.

91. *G: Material zur Elementaren Gestaltung* is available in a reprint, edited by Marion von Hofacker (Munich: Der Kern Verlag, 1986). It consists of five issues: two from 1923 of four pages in news format and three from 1924–1926, which are much lengthier.

92. The original De Stijl manifesto of 1918 was inserted by van Doesburg into his text; see Jaffe, *De Stijl,* 172–173.

93. On the exhibit, see van Straaten, *Theo van Doesburg: Constructor of the New Life,* 29–35; and Overy, *De Stijl,* 169–174.

94. "Manifest des Konstructivismus, Paris 1923," in van Straaten, *Theo van Doesburg: Constructor of the New Life,* 47.

95. See "Material zur elementaren Gestaltung," *G* 1 (July 1923), translated in Baljeu, *Theo van Doesburg,* 140–142; and in Stephen Bann, ed., *The Tradition of Constructivism* (New York: Viking, 1974), 91–93; and "De Beteekenis van de Kleur in Binnen-en Buitenarchitectuur," *Bouwkundig Weekblad* 44 (1923): 232–234, translated in Baljeu, *Theo van Doesburg,* 137–140. For the contrast with earlier work, see van Straaten, *Theo van Doesburg: Constructor of the New Life,* 45–46. For construction in relation to his work with van Eesteren, see "Vers une Construction Collective" and "- ? + = R4," *De Stijl* 6 (1924): 90–92, translated in Conrads, ed., *Programs and Manifestoes,* 66–67, and in Baljeu, *Theo van Doesburg,* 147–149.

96. Compare "Der Wille zum Stil," *De Stijl* 5 (1922): 23–41 (translated in

Jaffe, *De Stijl*, 148–163) with "Vers une construction collective," 90. The change of heart probably reflects the fact that the latter is in part an attack on Le Corbusier.

97. See, for example, "Der Wille zum Stil," 31–32.

98. Van Doesburg, "Wat is dada?" (The Hague: De Stijl, 1923), 3–14; translated in Baljeu, *Theo van Doesburg*, 131–135.

99. "Von der Neuen Ästhetik zur Materiellen Verwirklichung," *De Stijl* 6 (1923): 10–14, translated in Jaffe, *De Stijl*, 180–183. Many other examples of this sort of thinking could be cited. See the discussion in Jaffe, *De Stijl, 1917–1931*, 69, 93, 110.

100. See van Doesburg's letter to van Eesteren of 12 August 1924, cited in van Straaten, *Theo van Doesburg: Constructor of the New Life*, 38–39.

101. See the analysis in Doig, *Theo van Doesburg*, 166–168. Van Doesburg published "Appel de Protestation," *De Stijl* 6 (1925): 149–150, signed by twenty-five mostly foreign members of the art world, but to no avail.

102. See van Straaten, *Theo van Doesburg: Constructor of the New Life*, 53–55.

103. Letter of 26 December 1926, cited in Doig, *Theo van Doesburg*, 164.

104. Letter of November 1928 to Adolf Behne, cited in Troy, "The Abstract Environment of De Stijl," 189.

105. Among the first *De Stijl* articles showing a critical awareness of functionalism is "Von der Neuen Ästhetik zur Materiellen Verwirklichung," which refers to it as the "exclusively constructive" view. In his last years, van Doesburg contrasted functionalism with his own approach called "concrete art." See Baljeu, *Theo van Doesburg*, 97–100, 180–182.

106. Van Doesburg, "The Rebirth of Art and Architecture in Europe" (February 1931), now in van Straaten, *Theo van Doesburg: Painter and Architect*, 14–20.

107. On the young Le Corbusier, see H. Allen Brooks, *Le Corbusier's Formative Years: Charles-Edouard Jeanneret at La Chaux-de-Fonds* (Chicago: University of Chicago Press, 1997); Kenneth Frampton, *Le Corbusier* (London: Thames and Hudson, 2001); Eleanor Gregh, "The Dom-ino Idea," *Oppositions* 15–16 (Winter-Spring 1979): 61–87; Stanislaus von Moos, *Le Corbusier: Elements of a Synthesis* (Cambridge, Mass.: MIT Press, 1979); Nancy J. Troy, *Modernism and the Decorative Arts in France: Art Nouveau to Le Corbusier* (New Haven, Conn.: Yale University Press, 1991); and Paul Venable Turner, *The Education of Le Corbusier* (New York: Garland, 1977).

108. See his letters of February 1908 cited in Beatriz Colomina, *Privacy and Publicity: Modern Architecture as Mass Media* (Cambridge, Mass.: MIT Press, 1994), 104, and in Gregh, "The Dom-ino Idea," 73.

109. Charles-Edouard Jeanneret, *Étude sur le mouvement d'art décoratif en Allemagne* (New York: Da Capo, 1968 [1912]).

110. See Troy, *Modernism and the Decorative Arts in France*, 103–112.

111. Jeanneret, *Étude sur le mouvement d'art décoratif en Allemagne*, 73–74.

112. See Gregh, "The Dom-ino Idea."

113. Letter of 22 May 1916 to William Ritter, cited in Gregh, "The Dom-ino Idea," 77.

114. See Troy, *Modernism and the Decorative Arts in France*, 150–155.

115. See Turner, *The Education of Le Corbusier*, 137.

116. See Susan L. Ball, *Ozenfant and Purism: The Evolution of a Style, 1915–1930* (Ann Arbor, Mich.: UMI Research Press, 1981), 22, 65–67; and Christopher Green, *Leger and the Avant-Garde* (New Haven, Conn.: Yale University Press, 1976), 131–136.

117. On *L'Élan*, see Silver, *Esprit de Corps*, 51–58; and Troy, *Modernism and the Decorative Arts in France*, 156–158.

118. "Notes sur le cubisme," *L'Élan* 10 (December 1916), reprinted in Ball, *Ozenfant and Purism*, 191–194; and translated in Charles Harrison and Paul Wood, *Art in Theory 1900–1990: An Anthology of Changing Ideas* (Oxford: Blackwell, 1992), 223–225.

119. See Frampton, *Le Corbusier*, 8–9.

120. *Après le cubisme* (Paris: Altamira, 1999 [1918]), translated by John Goodman in Carol S. Eliel, ed., *L'Esprit Nouveau: Purism in Paris, 1918–1925* (New York: Harry Abrams, 2001), 129–167.

121. See, for example, Ozenfant, "L'angle droit," *L'Esprit nouveau* 18 (the twenty-eight issues of the journal were undated, sometimes, as here, unpaginated, and irregular in their frequency, beginning in October 1920 and ending in January 1925). The journal is available in a reprint edition of eight volumes (New York: Da Capo, 1968). For a comparison of the approaches to architecture adopted by van Doesburg and Le Corbusier in this period, see Bruno Reichlin, "Le Corbusier vs. De Stijl," in Yve-Alain Bois and Bruno Reichlin, *De Stijl et l'architecture en France* (Liège: Mardaga, 1985), 91–108.

122. Eliel, *L'Esprit Nouveau*, 147, 138, 145, 135, 138, 156.

123. Ibid., 142–143.

124. Ibid., 147.

125. Ibid., 162.

126. Ibid., 147.

127. *L'Art social* (Paris: Charpentier, 1913). On this movement, see Cottington, *Cubism in the Shadow of War*, 24, 69–72; and Troy, *Modernism and the Decorative Arts in France*, 163–164.

128. *L'Art décoratif d'aujourd'hui* (Paris: G. Crès, 1925); and *The Decorative Art of Today*, trans. James I. Dunnett (Cambridge, Mass.: MIT Press, 1987).

129. *Étude sur le mouvement d'art décoratif en Allemagne*, 69–70.

130. See Francesco Passanti, "Jeanneret as a Businessman," in *Le Corbusier before Le Corbusier: Applied Arts, Architecture, Painting, Photography, 1907–1922*, ed. Stanislaus von Moos and Arthur Rüegg (New Haven, Conn.: Yale University Press, 2002), 226–227.

131. See von Moos, *Le Corbusier*, 44; and Silver, *Esprit de Corps*, 374; in which Ozenfant's later claim of a government subvention is cited.

132. See Colomina, *Privacy and Publicity*, 118 and passim.

133. The notion of "common effort" [*effort commun*] appears in the initial *L'Esprit nouveau* program and is a matter of continuous, explicit and implicit, appeal. See *L'Esprit nouveau* 1: 3.

134. Ibid.

135. "Purisme," *L'Esprit nouveau* 4: 369–386, translated in Robert L. Herbert, ed., *Modern Artists on Art: Ten Unabridged Essays* (Englewood Cliffs, N.J.: Prentice-Hall, 1964), 58–73.

136. *Decorative Art of Today,* 86.

137. Ball, *Ozenfant and Purism,* 168, original emphasis; a similar conclusion is reached in von Moos, *Le Corbusier,* 281.

138. On this cultural atmosphere, see Silver, *Esprit de Corps,* and, above all, Romy Golan, *Modernity and Nostalgia: Art and Politics in France between the Wars* (New Haven, Conn.: Yale University Press, 1995).

139. Beale, *Modernist Enterprise,* 32–33.

140. "Des yeux qui ne voient pas," *L'Esprit nouveau* 8: 850.

141. Le Corbusier and Ozenfant, "Ce que nous avons fait, ce que nous ferons," *L'Esprit nouveau* 11/12: 1213.

142. Intent as she is upon finding connections between modernism in advertising and modernism as advertising, even Beale does not draw this conclusion; see *The Modernist Enterprise,* 11–47.

143. On Le Corbusier's faking of ads, see Victoria de Grazia, "The Arts of Purchase," in *Remaking History,* ed. Barbara Kruger and Phil Mariani (Seattle: Bay Press, 1989), 227.

144. *Decorative Art of Today,* xxii, 92, 110, 113, 86.

145. See Troy, *Modernism and the Decorative Arts in France,* 159–226; Tag Gronberg, *Designs on Modernity: Exhibiting the City in 1920s Paris* (Manchester, UK: Manchester University Press, 1998); and Green, *Leger and the Avant-Garde,* 1–5, 286–291.

146. Le Corbusier's discussion of his pavilion may be found in his *Almanach d'architecture moderne* (Paris: G. Crès, 1925), originally intended as the final number of *L'Esprit nouveau.*

147. Troy, *Modernism and the Decorative Arts in France,* 196.

148. For Le Corbusier's critical appraisal of the Bauhaus project, see his "Pédagogie," *L'Esprit nouveau* 19; for his support of Bauhaus during its crisis of 1924–1925, see "l'esprit nouveau apporte son appui au 'bauhaus' de weimar," *L'Esprit nouveau* 27.

149. Ozenfant gave his account of the parting in his *Mémoires, 1886–1962* (Paris: Seghers 1968), 142–143.

150. See Mary McLeod, "'Architecture or Revolution': Taylorism, Technocracy, and Social Change," *Art Journal* 43 (1983): 132–147; and Mark Antliff, "*La Cité française:* Georges Valois, Le Corbusier, and Fascist Theories of Urbanism," in *Fascist Visions: Art and Ideology in France and Italy,* ed. Matthew Affron and Mark Antliff (Princeton, N.J.: Princeton University Press, 1997), 134–170.

151. Silver, *Esprit de Corps,* 390.

152. Hans Richter, "An den Konstruktivismus," *G* (June 1924): 72; translated in Benson and Forgács, *Between Worlds,* 483.

153. Behrendt, *Victory of the New Building Style.*

6. FUTURISM AND ITS MODERNIST RIVALS IN FASCIST ITALY

1. F. T. Marinetti, "The Founding and Manifesto of Futurism 1909," in *Futurist Manifestos,* ed. Umbro Apollonio (New York: Viking, 1973), 23.

2. On the former, see my *Avant-Garde Florence: From Modernism to Fascism* (Cambridge, Mass.: Harvard University Press, 1993), 166–181; and Massimo

Carrà, ed., *Il carteggio Carrà-Papini: Da 'Lacerba' al tempo di 'Valori plastici'* (Milan: Skira, 2001), 59. A major example of the latter is the rift between Umberto Boccioni and Carlo Carrà; see Caroline Tisdall and Angelo Bozzolla, *Futurism* (London: Thames and Hudson, 1977), 181–183; and Carrà, *Boccioni* (1917), now in *Manifesti, proclami, interventi, e documenti teorici del futurismo, 1909–1944,* ed. Luciano Caruso, 4 boxes (Florence: Coedizioni SPES-Salimbeni, 1990), box 3, folder 385.

3. On the beginnings of Roman futurism, see Maurizio Calvesi, *Il futurismo: La fusione della vita nell'arte* (Milan: Fabbri, 1977), 129–160; Enrico Crispolti, *Storia e critica del futurismo* (Bari: Laterza, 1986), 17–45; and Gianni Eugenio Viola, *L'utopia futurista: Contributo alla storia delle avanguardie* (Ravenna: Longo, 1994), 111–128.

4. Giacomo Balla and Fortunato Depero, "Ricostruzione futurista dell'universo," in Apollonio, *Futurist Manifestos,* 197–200. For "second futurism," see Crispolti, *Storia e critica del futurismo,* 36–45 and passim; Crispolti, *Il secondo futurismo* (Milan: Notizie, 1960); Crispolti, *Il secondo futurismo: Torino 1923–1938* (Turin: Fratelli Pozzo, 1961); and Crispolti, "Second Futurism," in *Italian Art in the 20th Century: Painting and Sculpture, 1900–1988,* ed. Emily Braun (Munich: Prestel, 1989), 165–171.

5. On the break, see Giovanni Lista, *Giacomo Balla* (Modena: Galleria Fonte d'Abisso, 1982), 88–91.

6. The regionalist futurisms have been the subject of many important studies and exhibitions in recent years. See, for example, Enrico Crispolti, ed., *Il futurismo attraverso la Toscana: Architettura, arti visive, letteratura, musica, cinema e teatro* (Livorno: Silvana, 2000); Enrico Crispolti and Anty Pansera, eds., *Cesare Andreoni e il futurismo a Milano tra le due guerre* (Bergamo: Bolis, 1992); Franco Ragazzi, ed., *Liguria futurista* (Milan: Mazzotta, 1997); and Willard Bohn, *The Other Futurism: Futurist Activity in Venice, Padua and Verona* (Toronto: University of Toronto Press, 2004).

7. A classicist aesthetic was commonly used in this period to suggest modern alienation via ironic contrast and, in the Italian context, to assert nationalist aspirations. See Emily Braun, *Mario Sironi and Italian Modernism* (Cambridge: Cambridge University Press, 2000), 68–70.

8. Marla Susan Stone, *The Patron State: Culture and Politics in Fascist Italy* (Princeton, N.J.: Princeton University Press, 1998), 5.

9. Jeffrey T. Schnapp, "Epic Demonstrations," in *Fascism, Aesthetics and Culture,* ed. Richard J. Golsan (Hanover, N.H.: University Press of New England, 1992), 3.

10. Stone, *Patron State,* 4.

11. For a fuller assessment, see Philip V. Cannistraro, "Fascism and Culture in Italy, 1919–1945," in Braun, *Italian Art in the 20th Century,* 147–154.

12. On totalitarian art, see Igor Golomshtok, *Totalitarian Art in the Soviet Union, the Third Reich, Fascist Italy and the People's Republic of China,* trans. Robert Chandler (New York: Harper Collins, 1990).

13. For Sarfatti, see Philip V. Cannistraro and Brian R. Sullivan, *Il Duce's Other Woman* (New York: William Morrow, 1993); and Rossana Bossaglia, *Il "Novecento italiano": Storia, documenti, iconografia* (Milan: Feltrinelli, 1979).

For Bontempelli, see Antonio Saccone, *Massimo Bontempelli: Il mito del '900* (Naples: Liguori, 1979); and Massimo Bontempelli, *L'avventura novecentista* (Florence: Vallecchi, 1938). For the relation of Sarfatti and Bontempelli, see Braun, *Mario Sironi,* 251n62. For Bottai, see Alexander De Grand, *Bottai e la cultura fascista* (Bari: Laterza, 1978); and Luisa Mangoni, *Primato: 1940–1943* (Bari: De Donato, 1977). For the Gruppo 7, see Richard A. Etlin, *Modernism in Italian Architecture, 1890–1940* (Cambridge, Mass.: MIT Press, 1991), 224–254; and Ellen R. Schapiro, "Il Gruppo 7," *Oppositions* 6 (1976): 86–102 and *Oppositions* 8 (1978): 88–105.

14. On this movement, see Anna Scarantino, *'L'Impero': Un quotidiano 'reazionario-futurista' degli anni venti* (Rome: Bonacci, 1981).

15. As late as 1977, the important study by Calvesi, *Il futurismo,* effectively stopped in 1916. Moreover, while Marinetti's political activism of the 1919–1920 period has been of long-standing interest, a close look at his later politics was not undertaken until recently; see Marja Härmänmaa, *Un patriota che sfidò la decadenza: F. T. Marinetti e l'idea dell'uomo nuovo fascista, 1929–1944* (Helsinki: Academia Scientiarum Fennica, 2000).

16. Enrico Crispolti, ed., *Ricostruzione futurista dell'universo* (Turin: Mole Antonelliana, 1980).

17. Pontus Hultén, ed., *Futurism and Futurisms* (New York: Abbeville Press, 1986).

18. Guido Giubbini, "Il futurismo tra avanguardia e stile," in *Futurismo: I grandi temi 1909–1944,* ed. Enrico Crispolti and Franco Sborgi (Milan: Mazzotta, 1997), 64–68.

19. See, for example, Braun, *Mario Sironi,* 7, which argues that the notion of "creating a total style of life" is what holds together prewar and postwar futurism; or Cinzia Sartori Blum, *The Other Modernism: F. T. Marinetti's Futurist Fiction of Power* (Berkeley: University of California Press, 1996), vii, which argues that the "overarching ideological construct" is a "futurist fiction of power."

20. On Italy's early twentieth-century exposure to international design generally and art nouveau in particular, see Vittorio Magnago Lampugnani, "Architecture, Painting and the Decorative Arts in Italy 1923–1940 from the First Biennale to the Seventh Triennale," in *Italian Art, 1900–1945,* ed. Pontus Hulten and Germano Celant (New York: Rizzoli, 1989), 69–76.

21. Lista, *Giacomo Balla,* 24–25.

22. Balla, "Manifesto del colore" (October 1918), in Lista, *Giacomo Balla,* 473.

23. Enrico Crispolti, "Futurism and Plastic Expression Between the Wars," in Hulten and Celant, *Italian Art,* 201.

24. The two documents are reprinted in Lista, *Giacomo Balla,* 230–231.

25. Ibid., 15.

26. Balla and Depero, "Futurist Reconstruction of the Universe," in Apollonio, *Futurist Manifestos,* 199.

27. Enrico Prampolini, Ivo Pannaggi, and Vinicio Paladini, "L'arte meccanica," *Noi* (May 1923): 1–2, now available in a reprint edition (Florence: Studio per Edizioni Scelte, 1981) or in Caruso, *Manifesti,* 2:159.

28. See Serge Fauchereau, "Futurism: A Temptation, a Reticence," in *The*

Hungarian Avant-Garde, 1914–1933, ed. John Kish (Storrs, Conn.: William Benton Museum of Art, 1987), 104.

29. On this context, see Giovanni Lista, *Arte e politica: Il futurismo di sinistra in Italia* (Milan: Multhipla, 1980), 54–114; Lista, *Vinicio Paladini: Dal futurismo all'imaginismo* (Bologna: Il Cavaliere Azzurro, 1988); and Umberto Carpi, *L'estrema avanguardia del Novecento* (Rome: Riuniti, 1985), 103–139.

30. Vinicio Paladini, "La rivolta intellettuale," *Avanguardia* (23 April 1922), reprinted in Lista, *Arte e politica,* 194–196. For Paladini and Pannaggi's "Manifesto dell'arte meccanica futurista" (June 1922), which appeared in the lone issue of a Roman attempt to revive the prewar Florentine journal *Lacerba,* see Enrico Crispolti, *Il mito della macchina e altri temi del futurismo* (Trapani: Celebes, 1969), 391–392 and plate 99.

31. See Reyner Banham, *Theory and Design in the First Machine Age* (London: Architectural Press, 1960), 188; and Enrico Prampolini, "L'estetica della macchina e l'introspezione meccanica nell'arte," *De Stijl* 5 (July 1922): 102–105.

32. See Anty Pansera, "Arte e industria a Monza: 1923–1943, Note e documenti," *Op. Cit.* (September 1985): 27–38; Braun, *Mario Sironi,* 169, 176; and, more generally, Anty Pansera, *Storia e cronaca della Triennale* (Milan: Longanesi, 1978).

33. On Italian participation at the exposition, see Crispolti, *Storia e critica del futurismo,* 86–90, which judges it to be part of its consumerist mainstream rather than "really avant-garde" like Le Corbusier's L'Esprit Nouveau pavilion.

34. Fortunato Depero, "Manifesti agli industriali" (1927), now in Caruso, *Manifesti,* 2: 188.

35. Lista, *Futurism,* trans. Susan Wise (Paris: Éditions Pierre Terrail, 2001), 128.

36. F. T. Marinetti, "Al di là del comunismo" (1920), now in Marinetti, *Teoria e invenzione futurista,* ed. Luciano de Maria (Milan: Mondadori, 1968), 95–97 (hereafter *TIF*), 487.

37. For an account of Marinetti's participation in the sacking of the socialist newspaper *Avanti!* in April 1919, which left four dead, see Cannistraro and Sullivan, *Il Duce's Other Woman,* 198–199.

38. Marinetti, "Il tattilismo," *TIF,* 160.

39. Marinetti, "Inegualismo e artecrazia," *TIF,* 551–552.

40. Marinetti, "I diritti artistici propugnati dai futuristi italiani: Manifesto al governo fascista," *TIF,* 562–569.

41. Marinetti, Carli, Settimelli, "L'Impero Italiano: A Benito Mussolini, Capo della nuova Italia," *TIF,* 569–572.

42. Claudia Salaris, *Marinetti: Arte e vita futurista* (Rome: Riuniti, 1997), 236.

43. Marinetti, *Futurismo e fascismo, TIF,* 491–498. The dedication is "to my dear and great friend, Benito Mussolini."

44. Giuseppe Prezzolini, "Fascismo e futurismo," *Il Secolo* (3 July 1923), original emphasis.

45. The best portrayal of this evolution is Härmänmaa, *Un patriota che sfidò la decadenza.*

46. See Antonio Gramsci, ["A Letter to Trotsky on Futurism"], in *Selections*

from Cultural Writings, ed. David Forgacs and Geoffrey Nowell-Smith, trans. William Boelhower (Cambridge, Mass.: Harvard University Press, 1985), 52, in which Marinetti is pictured as no longer an active futurist but as devoting "his energies to his wife." See also Giorgio Amendola, *Una scelta di vita* (Milan: Rizzoli, 2001), 61.

47. Salaris, *Marinetti,* 258.

48. See, for example, Marinetti's review *Il Futurismo* (11 February 1925), now in Caruso, *Manifesti,* 3: 381; and Marinetti, "Onoranze nazionali a Marinetti e Congresso futurista," *TIF,* 612.

49. This time the main announcement came in a 1925 issue of *L'Impero;* see Caruso, *Manifesti,* 3: 390. See also Marinetti, "Onoranze nazionali a Marinetti e Congresso futurista," *TIF,* 615.

50. See, for example, the unsigned account in *L'Impero* (8 August 1926), entitled "Marinetti 'camicia nera d'onore' ha portato nell'America del Sud—trionfalmente—la voce del'Italia d'oggi," in which he is hailed as the "Duce of Futurism."

51. Cited in Gino Agnese, *Marinetti: Una vita explosiva* (Milan: Camunia, 1990), 233.

52. Mussolini, "Arte e civiltà" (5 October 1926), now in his *Opera omnia* (Florence: La Fenice, 1951–1963), 22: 230.

53. See Marinetti's catalog for the *Mostra di trentatré artisti futuristi* (Milan and Rome: Edizione Bestetti-Tumminelli, 1929), which declared: "As we prepare to leap, we intervene in the polemics of *stracittà* and *strapaese* with the First Aerial Dictionary accompanied by shouts of *stracielo!*"

54. Marinetti, *Futurismo e novecentismo* (Milan: Galleria Pesaro, 1930), 6, anastatically reissued by Luciano Caruso and Stelio M. Martini, eds., *Futurismo e novecentismo* (Livorno: Belforte, 1984).

55. Fillia, "Rapporto tra futurismo e fascismo," originally in the catalog of the show, "Arte futurista," in Alessandria, 22–31 March 1930, now in Caruso, *Manifesti,* 2: 196.

56. The following account of Sarfatti's early life is based fundamentally on the magisterial biography by Cannistraro and Sullivan, *Il Duce's Other Woman,* secondarily on her own memoir, *Acqua passata* (Rocca San Casciano: Cappelli, 1955), and the extensive documentation in Bossaglia, *Il "Novecento italiano."*

57. Sarfatti, *Acqua passata,* 97–101.

58. See Cannistraro and Sullivan, *Il Duce's Other Woman,* 175.

59. Ibid., 138–139.

60. "Un critico di avanguardia: Guillaume Apollinaire," *Il Popolo d'Italia* (31 December 1918).

61. "Contro tutti i ritorni in pittura," Direzione del Movimento Futurista, Milan (11 January 1920), now in Caruso, *Manifesti,* 2: 142; also available in Ettore Camesasca, ed., *Mario Sironi: Scritti editi e inediti* (Milan: Feltrinelli, 1980), 13–17.

62. For the photo, see Braun, *Mario Sironi,* 35.

63. For the memoirs by Dudreville and Funi, see Bossaglia, *Il "Novecento italiano,"* 65–81.

64. Cannistraro and Sullivan, *Il Duce's Other Woman,* 265.

65. Achille Funi, "Il Novecento," in Bossaglia, *Il "Novecento italiano,"* 79.

66. Sarfatti, "Bottega di poesia e altre esposizioni," *Il Popolo d'Italia* (13 January 1922).

67. Sarfatti, "Mostra di 'Sei Pittori del '900,'" in Bossaglia, *Il "Novecento italiano,"* 84.

68. See the parallel argument in Braun, *Mario Sironi,* 90–92.

69. Sarfatti, "La mostra Funi," *Il Popolo d'Italia* (27 October 1920), cited in Braun, *Mario Sironi,* 92.

70. For Sarfatti's aesthetics, see her *Storia della pittura moderna* (Rome: P. Cremonese, 1930); and Elena Pontiggia, "Il miraggio della classicità: Cenni sulla poetica del Novecento," in *Italia anni trenta: Opere dalle collezioni d'arte del comune di Milano* (Milan: Vangelista, 1989), 23–36.

71. See Sarfatti, "Segni, colori e luci" (1925), in Bossaglia, *Il "Novecento italiano,"* 94.

72. See Sarfatti, *Storia della pittura moderna* (1930), in Bossaglia, *Il "Novecento italiano,"* 120–122.

73. For the argument that Sarfatti was responding to Mussolini's dictatorship, see Cannistraro and Sullivan, *Il Duce's Other Woman,* 309; for the circular letter, see Sarfatti, "Lettera circolare," in Bossaglia, *Il "Novecento italiano,"* 89–92.

74. Sarfatti, "Catalogo della prima mostra del Novecento italiano," in Bossaglia, *Il "Novecento italiano,"* 95.

75. Futurist participation was confined to the second-floor room designs by Prampolini and Gerardo Dottori. See Enrico Crispolti, *Prampolini: Dal futurismo all'informale* (Rome: Carte Secrete, 1992), 282.

76. See Sarfatti, "Architettura, arte e simbolo alla Mostra del fascismo," *Architettura* (January 1933): 1–5; cited in Schnapp, "Epic Demonstrations," 4; Stone, *Patron State,* 143–144; Claudio Fogu, *The Historic Imaginary: Politics of History in Fascist Italy* (Toronto: University of Toronto Press, 2003), 132–133; and Emilio Gentile, *The Sacralization of Politics in Fascist Italy,* trans. Keith Botsford (Cambridge, Mass.: Harvard University Press, 1996), 110, among other recent studies.

77. Ardengo Soffici, *Periplo dell'arte: Richiamo all'ordine* (Florence: Vallecchi, 1928).

78. Günter Berghaus, *Futurism and Politics: Between Anarchist Rebellion and Fascist Reaction, 1909–1944* (Providence, R.I.: Berghahn Books, 1996), 245.

79. Sarfatti, "Catalogo della seconda mostra da 'Il Novecento italiano,'" in Bossaglia, *Il "Novecento italiano,"* 110.

80. See the account of Marinetti's visit to Berlin in Sibyl Moholy-Nagy, *Experiment in Totality,* 2nd ed. (Cambridge, Mass.: MIT Press, 1969), 99–103; for the Kandinsky letter, see Salaris, *Marinetti,* 283.

81. See Lista, *Futurism,* 154–155; and Franco Ragazzi, "Futurismo e fascismo, parole e immagini dell'aeropittura," in *Parole e immagini futuriste dalla Collezione Wolfson,* ed. Silvia Barisione, Matteo Fochessati, and Gianni Franzone (Milan: Mazzotta, 2001), 15–30. On the dispersion of the "case d'arte," see Crispolti, *Storia e critica del futurismo,* 68; and Lista, *Arte e politica,* 19.

82. Lista, *Futurism,* 154.

83. F. T. Marinetti, Angiolo Mazzoni, and Mino Somenzi, "Manifesto futur-

ista dell'architettura aerea," *Sant'Elia* (1 February 1934). For the original "Manifesto della aeropittura," first published in 1929, see *TIF,* 197–201.

84. Farfa, *Noi miliardario della poesia* (Milan: La Prora, 1933), cited in Ragazzi, "Futurismo e fascismo," 21.

85. Ragazzi, "Futurismo e fascismo," 16. See also Tisdall and Bozzolla, *Futurism,* 198; and Lista, *Futurism,* 166–205.

86. Härmänmaa, *Un patriota che sfidò la decadenza.*

87. Braun, *Mario Sironi,* 114.

88. Sarfatti, "Lettera al Direttore del giornale *Il Regime fascista*" (19 July 1931), in Bossaglia, *Il "Novecento italiano,"* 139; Farinacci's reply is also reprinted here.

89. Roberto Farinacci, response to Sarfatti's letter of 27 May 1933, in Bossaglia, *Il "Novecento italiano,"* 146. See also the parallel analyses in Braun, *Mario Sironi,* 176–177; and Fernando Tempesti, *Arte dell'Italia fascista* (Milan: Feltrinelli, 1976), 159.

90. Enrico Prampolini, "Il futurismo, Hitler, e le nuove tendenze," *Stile futurista* (September 1934), reprinted in Nello Ponente, ed., *Continuità dell'avanguardia in Italia: Enrico Prampolini (1894–1956)* (Modena: Galleria Civica, 1978), 51–52; and in Crispolti, *Il secondo futurismo,* 271–272.

91. Mino Somenzi, "La politica dell'arte," *Sant'Elia* (15 February 1934), now in Caruso, *Manifesti,* 3: 271.

92. "L'ostracismo di Hitler alle opere di avanguardia: La risposta di F. T. Marinetti," *Cronaca prealpina* (4 August 1937), cited in Viola, *L'utopia futurista,* 130; see also the press release from 3 August, cited in Ragazzi, "Futurismo e fascismo," 28n9.

93. See Crispolti, "Futurism and Plastic Expression," 213; Viola, *L'utopia futurista,* 131; and Lista, *Futurism,* 197.

94. Marinetti, "Lettera aperta dei futuristi italiani a Hitler," now in the Getty Center, Los Angeles, and cited in Härmänmaa, *Un patriota che sfidò la decadenza,* 267.

95. On the regime dole, see Viola, *L'utopia futurista,* 138–139.

96. On the relation of *Il Selvaggio* and Morandi, see Emily Braun, "Speaking Volumes: Giorgio Morandi's Still Lifes and the Cultural Politics of *Strapaese,*" *Modernism/Modernity* 2 (September 1995), 89–116.

97. Ardengo Soffici, "Apologia del futurismo," *Rete mediterranea* (September 1920), 200; reprinted in Ardengo Soffici, *Estetica e politica: Scritti critici 1920–1940,* ed. Simonetta Bartolini (Chieti: Marino Solfanelli, 1994), 123.

98. *Strapaese*'s temporal conceptions correspond fully to the description of the politics of time in "reactionary modernism" and "conservative revolution," as given by Peter Osborne, *The Politics of Time: Modernity and Avant-Garde* (London: Verso, 1995), 164–165.

99. Mino Maccari, "Squadrismo," *Il Selvaggio* (13 July 1924). Three days earlier, Curzio Malaparte made a similar plea in the first issue of his new journal, *La Conquista dello Stato.* See the discussion in Renzo De Felice, *Mussolini* (Turin: Einaudi, 1966), vol. 2, part 1: 663–664.

100. L'Eremita, "La metropoli e la provincia," *Il Selvaggio* (2–8 August 1925); L'Eremita [The Hermit] is a Maccari pseudonym.

101. See Raffaelo Portigiani, "Ritorniamo alla terra!" *Il Selvaggio* (16 August 1925); Mino Maccari, "Selvaggi del fascismo," *Il Selvaggio* (9 November 1924); and Kurt Erich Suckert [Curzio Malaparte], "Il partito deve controllare la burocrazia," *Il Selvaggio* (8 April 1925).

102. Mino Maccari, "Addio del passato," *Il Selvaggio* (1–14 March 1926).

103. For Soffici's life, see Luigi Cavallo, *Soffici: Immagini e documenti (1879–1964)* (Florence: Vallecchi, 1986), and my *Avant-Garde Florence,* 58–64, 95–97, 147–151, 156–162, 166–172, 209–212, and 245–248.

104. On Soffici's postwar epiphany, see my "Ardengo Soffici and the Religion of Art," in *Fascist Visions: Art and Ideology in France and Italy,* ed. Mark Antliff and Matthew Affron (Princeton, N.J.: Princeton University Press, 1997), 58–61.

105. Soffici, "Allarme," *Il Selvaggio* (1–14 April 1926).

106. Soffici, "Afforismi a buon mercato," *Il Selvaggio* (7 October 1926).

107. Ibid.

108. Kurt Erich Suckert [Malaparte], "Commemorazione del Seicento," *Valori plastici* (1921): 80–87. Malaparte develops the argument at greater length in *L'Europa vivente* (1923) and *Italia barbara* (1925), now in *L'Europa vivente e altri saggi politici* (1921–1931), ed. E. Falqui (Florence: Vallecchi, 1961), 317–605.

109. Orco Bisorco, "Gazzettino ufficiale di strapaese," *Il Selvaggio* (15 February 1927). Orco Bisorco is another Maccari pen name.

110. Orco Bisorco, "Gazzettino ufficiale di strapaese," *Il Selvaggio* (16 September 1927).

111. Unsigned article, "Automobili marca americana," *Il Selvaggio* (15 June 1928).

112. Ardengo Soffici, "Moralizzare l'Italia," *Il Selvaggio* (15 July 1927).

113. L'Abbordatore [the boarder], "La 'standardizzazione,' l'originalità, e l'anima," *Il Selvaggio* (30 September 1927); Lorenzo Braccaloni, "Lavoro al modo italiano," *Il Selvaggio* (15 July 1928).

114. Orco Bisorco, "Gazzettino ufficiale di strapaese," *Il Selvaggio* (30 March 1928).

115. Ardengo Soffici, "Firenze," *Il Selvaggio* (29 February 1928); now also in Soffici, *Estetica e politica,* 220.

116. See, for example, Ardengo Soffici, "Afforismi a buon mercato," *Il Selvaggio* (7 October 1926); the unsigned "Spuntature," *Il Selvaggio* (15 May 1927); Soffici, "Noterella," *Il Selvaggio* (31 December 1928); the unsigned "Intelligenza degli ebrei," *Il Selvaggio* (15 May 1933); Mino Maccari, "L'agonia del modernismo," *Il Selvaggio* (20 April 1934); and the anti-Semitic excerpt from Dostoyevsky, "Gli ebrei—status in statu," reprinted in the issue of 30 November 1927.

117. Soffici, *Periplo dell'arte,* v, 1, 3, 6, 16, 12, 65–70.

118. Ibid., 15–19, 27–33, 81–83.

119. Soffici, *Periplo dell'arte,* 81.

120. Ibid., 55–57.

121. Orco Bisorco, "Gazzettino ufficiale di strapaese," *Il Selvaggio* (30 March 1928).

122. Mino Maccari, "Lettera a Marinetti," *Il Selvaggio* (15 January 1927); original emphasis.

123. Curzio Malaparte, "Strapaese e stracittà," *Il Selvaggio* (10 November 1927); Orco Bisorco, "Gazzettino ufficiale de strapaese," *Il Selvaggio* (10 November 1927); and Camille Mauclair, "Esperante e pittura," trans. from the French by Soffici, *Il Selvaggio* (15 July 1931).

124. Marinetti, *Futurismo e novecentismo*, 20.

125. Letter of 1 February 1940, now in the Getty Center, Los Angeles, and cited in Viola, *L'utopia futurista*, 134.

126. Ardengo Soffici, *Sull'orlo dell'abisso: Diario 1939–1943* (Milan: Luni, 2000), 44–45.

127. Claudia Salaris, *Artecrazia: L'avanguardia futurista negli anni del fascismo* (Florence: La Nuova Italia, 1992), 231, paraphrasing F. T. Marinetti, "Nord americani malinconico fallimento di un futurismo privo di geni," *Antinglese* (October 1941). On Marinetti's move to the right in the early 1940s, see Härmänmaa, *Un patriota che sfidò la decadenza*, 55–57, 273–278.

128. See Golomshtok, *Totalitarian Art*, 41–42.

129. See Ardengo Soffici, "Morti di fame," *Il Selvaggio* (15 May 1927); now also in Soffici, *Estetica e politica*, 208–212.

7. ANDRÉ BRETON'S SURREALISM

1. André Breton, "Distances," *Oeuvres complètes*, 3 vols. (Paris: Gallimard, 1988), 1: 287–290 (hereafter abbreviated *OC*); translated by Mark Polizzotti in Breton, *Lost Steps* (Lincoln: University of Nebraska Press, 1996), 103–106. The article originally appeared in *Paris-Journal* (23 March 1923). For the sources of Breton's anger in the war years, see his *Conversations: The Autobiography of Surrealism with André Parinaud and Others*, trans. Mark Polizzotti (New York: Paragon House, 1993), 37–38.

2. See Marguerite Bonnet, *André Breton: Naissance de l'aventure surréaliste* (Paris: José Corti, 1988), 67–114; and Bonnet, "Aux sources du surréalisme: Place d'Apollinaire," *La Revue des Lettres modernes* 104–107 (1964): 38–74.

3. See Christopher Green, *Art in France 1900–1940* (New Haven, Conn.: Yale University Press, 2000), 28; and Bonnet, *André Breton*, 269–275. The name derives in part from the fact that Breton himself thought of creating a "*mouvement flou*" (Vague Movement) in these years; see Mark Polizzotti, *Revolution of the Mind: The Life of André Breton* (New York: Farrar, Straus, and Giroux, 1995), 176, 205.

4. Breton adumbrated the art-as-research theme in other articles of this period as well; see especially his "Characteristics of the Modern Evolution and What It Consists Of," in *Lost Steps*, 107–125; and *OC*, 1: 291–308.

5. See Peter Bürger, "Surréalisme et engagement," *Avant-Garde: Interdisciplinary and International Review* (Amsterdam: Rodopi, 1987): 83.

6. Interestingly, one of the pieces of evidence Bürger depends upon most is an article, "The Disdainful Confession," which originally appeared in the February and March 1923 issues of *La Vie moderne*—that is, at almost exactly the same time as Breton was writing "Distances." See Breton, *Lost Steps*, 1–11; and *OC*, 1: 193–202.

7. Bürger, "Surréalisme et engagement," 84.

8. Ibid., 86.

9. On the plans for the abortive congress, see Michel Sanouillet, *Dada à Paris* (Paris: Jean-Jacques Pauvert, 1965), 319–347; Polizzotti, *Revolution of the Mind,* 169–172; Bonnet, *André Breton,* 251–256; Breton, "Appel du 3 Janvier 1922," in *OC,* 1: 434–435; Breton, *Conversations,* 54–55; and Breton, "Characteristics of the Modern Evolution," 110–111. Scheduled for late March, it would have taken place just before the International Congress of Progressive Artists mentioned in chapter 5 and held in Düsseldorf at the end of May 1922.

10. On the plans for the abortive salon, see the commentary by Marguerite Bonnet in *OC,* 1: 1315–1317; on the Marinetti connection, see Breton's letter of 5 December 1922 to Robert Desnos, cited in *OC,* 1: 1316n2.

11. On Breton's early collecting, see Polizzotti, *Revolution of the Mind,* 119; and René Gaffé, *À la verticale: Réflexions d'un collectionneur* (Brussels: André de Rache, 1963), 63–77. On the Doucet-Breton relationship, see François Chapon, *Mystère et splendeurs de Jacques Doucet* (Paris: J.C. Lattès, 1984), 262–307; Jean-François Revel, "J. Doucet, couturier et collectionneur," *L'Oeil* 84 (December 1961): 44–51; Breton, *Conversations,* 75–78; Polizzotti, *Revolution of the Mind,* 146; Malcolm Gee, *Dealers, Critics, and Collectors of Modern Painting: Aspects of the Parisian Art Market between 1910 and 1930* (New York: Garland, 1981), 200–204; and Gérard Durozoi, *History of the Surrealist Movement,* trans. Alison Anderson (Chicago: University of Chicago Press, 2002), 31.

12. Gee, *Dealers, Critics,* 201; and Polizzotti, *Revolution of the Mind,* 163–164.

13. Polizzotti, *Revolution of the Mind,* 159; for the sad story, see Daniel-Henry Kahnweiler, *My Galleries and Painters,* trans. Helen Weaver (New York: Viking Press, 1971), 67–70.

14. Gee, *Dealers, Critics,* 33, 94, 99.

15. Breton, *Second Manifesto of Surrealism,* in *Manifestoes of Surrealism,* trans. Richard Seaver and Helen R. Lane (Ann Arbor: University of Michigan Press, 1972), 174.

16. On Breton's "quest for a childhood denied," see Polizzotti, *Revolution of the Mind,* 8; and Breton, *Conversations,* 17. On the nature and impact of his Cartesian education, see Jack J. Spector, *Surrealist Art and Writing, 1919–1939: The Gold of Time* (Cambridge: Cambridge University Press, 1997), 15–17; see also Breton's comment regarding the "Cartesian world" in *Conversations,* 80.

17. Breton, *Conversations,* 4.

18. Letter to Théodore Fraenkel, 30 August 1914, cited in Bonnet, *André Breton,* 43.

19. Letter from Apollinaire to Breton of 21 December 1915, now in *La Revue des Lettres modernes* 104–107 (1964): 20.

20. See Breton's account in *Conversations,* 19–21.

21. Breton, *Conversations,* 13; and Breton, *Second Manifesto of Surrealism,* 125.

22. Breton, *Conversations,* 15; and the letter from Breton to André Paris (18 June 1916), cited in Polizzotti, *Revolution of the Mind,* 46.

23. Breton, *Conversations,* 32.

24. *Selected Writings of Guillaume Apollinaire,* trans. Roger Shattuck (New York: New Directions, 1971), 231, 234–235.

25. Breton, "Characteristics of the Modern Evolution," 120–121.

26. Several chapters of the book appeared late in 1919 in *Littérature,* the first journal edited by Breton and his friends; see Breton, *Conversations,* 43. With its ironic title (a spoof of high-artistic pretensions), *Littérature* appeared as twenty monthly issues from March 1919 through August 1921; a second series of thirteen issues appeared from March 1922 through June 1924.

27. Breton, *Conversations,* 55; and his "L'esprit nouveau," *Littérature,* new series, 1 (1 March 1922), later reprinted as "The New Spirit" in Breton, *Lost Steps,* 72–73. For an intriguing and resourceful interpretation of the essay upon which I rely for my characterization of it, see Kim Grant, *Surrealism and the Visual Arts* (Cambridge: Cambridge University Press, 2005), 58–60.

28. See the exchange between Dermée and Breton in *Le Journal littéraire* 19 (30 August 1924): 4, and 20 (6 September 1924): 10.

29. See, especially, Grant, *Surrealism and the Visual Arts,* 35–60. Walter Benjamin commented in his *Arcades Project,* trans. Howard Eiland and Kevin McLaughlin (Cambridge, Mass.: Harvard University Press, 1999), 459: "To encompass both Breton and Le Corbusier—that would mean drawing the spirit of contemporary France like a bow, with which knowledge shoots the moment in the heart."

30. See Polizzotti, *Revolution of the Mind,* 226; and Polizzotti, *La Révolution surréaliste: Collection complète* (Paris: Jean-Michel Place, 1975), an anastatic reproduction of the original journal, which first appeared in December 1924, a month before the last issue of *L'Esprit nouveau,* and continued with eleven further, irregularly spaced issues, the last of them in December 1929.

31. On Breton's reasoning regarding his advocacy of a representational art, see especially his "Max Ernst," in Breton, *Lost Steps,* 60–61; and Suzanne Guerlac, *Literary Polemics: Bataille, Sartre, Valéry, Breton* (Stanford, Calif.: Stanford University Press, 1997), 129–131.

32. See Breton's description of (and quote from) Tzara in Breton, *Conversations,* 40. On his relationship with Vaché and what he took from it, especially regarding his appreciation of Lautréamont and Rimbaud, see Polizzotti, *Revolution of the Mind,* 38–43, 75–76.

33. See Tristan Tzara, "Dada Manifesto 1918" in *The Dada Painters and Poets: An Anthology,* ed. Robert Motherwell (Cambridge, Mass.: Harvard University Press, 1988), 78; and Breton, *Conversations,* 40.

34. Letter from Breton to Louis Aragon (16 April 1919), cited in Aragon, *Lautréamont et Nous* (Pin-Balma: Sables, 1992), 80. Breton seems to have this letter in mind when, in the *Manifesto of Surrealism,* he recalls his dada days and their "search for an application of poetry to advertising," including the idea of a "beautiful advertisement for heaven or for hell." See Breton, *Manifestoes of Surrealism,* 20.

35. The statement appeared in *Comoedia* (7 February 1922) and is reprinted in Bonnet, *André Breton,* 253.

36. See, for example, Breton, *Lost Steps,* 78, 81–82.

37. The one occasion on which Breton and his friends defended Marinetti was during his brief imprisonment for threatening Italian state security; see their editorial "Un acte nécessaire," *Littérature* 10 (December 1919): 1.

38. See, for example, Maurizio Calvesi, "L'écriture médiumnique comme source de l'automatisme futuriste et surréaliste," *Europe: Revue littéraire mensuelle* 53 (March 1975): 44–48; and Noëmi Blumencranz-Onimus, "Le Pré-surréalisme des futuristes italiens," and Maria Carla Papini, "Aspects présurréalistes des futuristes florentins," both in Sandro Briosi and Henk Hillenaar, eds., *Vitalité et contradictions de l'avant-garde: Italie-France 1909–1924* (Paris: Corti, 1988), 27–37 and 105–115 respectively.

39. Marinetti, *Teoria e invenzione futurista,* ed. Luciano de Maria (Milan: Mondadori, 1968), 82.

40. Breton, "Characteristics of the Modern Evolution," 113.

41. See Breton, "Légitime défense," in *OC,* 2: 290, translated as "In Self-Defense," in *Break of Day,* trans. Mark Polizzotti and Mary Ann Caws (Lincoln: University of Nebraska Press, 1999), 31–32.

42. Ibid., 32.

43. See, for example, Breton's remarks in *Conversations,* 61 and 239; and in *Lost Steps,* 55. His skepticism about art is already reflected in *Littérature*'s "*enquête*" [inquiry] on "Why Do You Write?" published in the December 1919 and January 1920 issues; see Polizzotti, *Revolution of the Mind,* 116–117; and Breton's retrospective comments in Breton, *Lost Steps,* 4–5.

44. See especially Breton, "Le message automatique," in *OC,* 2: 375–392, translated as "The Automatic Message," in *Break of Day,* 125–143.

45. Ibid., 138.

46. Breton, *Manifesto of Surrealism* (1924), in *Manifestoes of Surrealism,* 29.

47. Ibid., 37.

48. Breton and other surrealists were interested in mass culture—for example, the "*faits divers*" sections of the popular press—because it offered material from everyday life of possible significance for surrealist research. See Robin Walz, *Pulp Surrealism: Insolent Popular Culture in Early Twentieth-Century Paris* (Berkeley: University of California Press, 2000); and David H. Walker, *Outrage and Insight: Modern French Writers and the 'Fait Divers'* (Oxford: Berg, 1995). But the post-dada Breton was uninterested in using surrealism to contribute to or reshape mass culture in the way both Marinetti and the dadaists had aimed to do through their performances.

49. For analyses of the manifesto and its theory of the surrealist image, see, especially, Anna Balakian, *Surrealism: The Road to the Absolute* (Chicago: University of Chicago Press, 1986), 140–169; Bonnet, *André Breton,* 314–407; Jacqueline Chéniux-Gendron, *Surrealism,* trans. Vivian Folkenflik (New York: Columbia University Press, 1990), 60–70, 121–126; and Guerlac, *Literary Polemics,* 125–193.

50. Breton, *Manifesto of Surrealism* (1924), in *Manifestoes of Surrealism,* 4, 9, 10, 5; original emphasis. See also Breton, *Conversations,* 202, where he refers to "the desiccation of his [the artist's] wellsprings of inspiration, which rationalism and utilitarianism have brought about."

51. Breton, *Manifesto of Surrealism* (1924), in *Manifestoes of Surrealism,* 6, 14 (translation slightly altered).

52. Ibid., 7, 6, 7, 18 (translation slightly altered).

53. Ibid., 36–37.

54. See Breton, *Manifesto of Surrealism* (1924), in *Manifestoes of Surrealism*, 38–39, for the less famous examples Breton presents in the manifesto, some of them also from Lautréamont, one of them self-generated: "On the bridge the dew with the head of a tabby cat lulls itself to sleep."

55. Ibid., 39.

56. Ibid., 44–47 (original emphasis), and Breton, *Second Manifesto of Surrealism*, 151.

57. Breton would be forced to confront these questions in 1932, when Aragon was accused of inciting military insubordination and murder by French authorities. For Breton's defense, in which he referred back to these passages of the *Manifesto of Surrealism*, see his "Misère de la poésie: 'L'Affair Aragon' devant l'opinion publique," in *OC*, 2: 3–7, partially translated as "The Poverty of Poetry" in André Breton, *What Is Surrealism? Selected Writings*, ed. Franklin Rosemont (New York: Pathfinder Press, 1978), 104–113. Here he suggests not only that "poetry and prose [are] . . . two distinct spheres of thought" (107), but that "each man must . . . participate in this struggle in the direction of his individual and particular qualification" (111), thus implying that poetic thought should be permitted to intervene actively in a political sphere otherwise dominated by instrumental reason.

58. Breton, *Manifestoes of Surrealism*, 35.

59. Breton himself articulated this problem only much later in *Les Vases communicants*, in *OC*, 2: 101–215, translated by Mary Ann Caws and Geoffrey T. Harris as *Communicating Vessels* (Lincoln: University of Nebraska Press, 1990), 19, 130–131, 135, 146–147; and in a 1934 lecture, "Qu'est-ce que le surréalisme?" in *OC*, 2: 231–233, translated as "What Is Surrealism?" in Breton, *What Is Surrealism?* 156–158. In both texts Breton distinguishes between "rational knowledge" and "intuitive knowledge," or two "phases" in the development of the surrealist movement (an "intuitive" one lasting into 1925 and a "reasoning phase" taking over around October of that year), but without clarifying their relationship or the dialectical means of their coordination.

60. Among the many accounts of these events, some of the most helpful are Carole Reynaud Paligot, *Parcours politique des surréalistes 1919–1969* (Paris: CNRS, 1995), 25–69; Helena Lewis, *The Politics of Surrealism* (New York: Paragon House, 1988), 27–76; Maurice Nadeau, *The History of Surrealism*, trans. Richard Howard (New York: MacMillan, 1965), 100–142; Polizzotti, *Revolution of the Mind*, 232–276; Sylvia Kantaziris, "Surrealism, Communism, and Love," *Essays in French Literature* 7 (November 1970): 1–17; Alan Rose, *Surrealism and Communism: The Early Years* (New York: Peter Lang, 1991), 49–282; and Robert Short, "The Politics of Surrealism, 1920–1936," *Journal of Contemporary History* 1 (September 1926): 3–25.

61. See "Une cadavre," in José Pierre, ed., *Tracts surréalistes et déclarations collectives 1922–1939* (Paris: CNRS, 1980), 1:19–25, partially translated in Nadeau, *History of Surrealism*, 233–237. The pamphlet appeared on 18 October 1924, six days after France's death and three days after the publication of the surrealist manifesto. Its six parts were written by, respectively, Philippe Soupault, Paul Éluard, Pierre Drieu la Rochelle, Joseph Delteil, André Breton, and Louis Aragon.

62. Breton, *Conversations,* 74. Breton later reprinted his own short contribution to the pamphlet in *Break of Day,* 21.

63. See Breton's remarks at the Bar Certà of 23 January 1925, reprinted in Paule Thénevin and Marguerite Bonnet, eds., *Archives du surréalisme* (Paris: Gallimard, 1988–1992), 1: 110–115. See also 1: 70 for Breton's December 1924 memo, internal to *La Révolution surréaliste,* calling for "unequivocal revolutionary action."

64. Breton, "La dernière greve," *La Révolution surréaliste* 2 (15 January 1925), now in *OC,* 1: 891; Breton, "La révolution d'abord et toujours," and Breton, "Léon Trotsky: *Lénine,*" *La Révolution surréaliste* 5 (October 15, 1925), now in Pierre, *Tracts surréalistes,* 1: 54–56, and *OC,* 1: 911–914 respectively. The jointly authored pamphlet appeared in *L'Humanité* on 21 September 1925. An English translation of Breton's review as well as an abridged translation of the pamphlet appear in Breton, *What Is Surrealism?* 42–45, 422–424.

65. Breton, "Pourquoi je prends la direction de La Révolution surréaliste," *La Révolution surréaliste* 4 (15 July 1925), now in *OC,* 1: 902–906. Also at stake in this seizure of control was Breton's desire to remove Pierre Naville as an editor because Naville had declared in the April issue that "surrealist art" did not exist since no new art could be created before the revolution. See Naville, "Beaux arts," *La Révolution surréaliste* 3 (15 April 1925).

66. Breton, *Conversations,* 71 and 93 ("until that moment [in mid-1925] we had barely given a thought to the *means* of effecting" a revolutionary transformation).

67. For detailed accounts of the banquet, see Raymond Spiteri and Donald LaCoss, eds., *Surrealism, Politics and Culture* (Aldershot, UK: Ashgate Publishing, 2003), 1–3; Polizzotti, *Revolution of the Mind,* 235–240; Nadeau, *History of Surrealism,* 112–116; and Breton, *Conversations,* 87–89.

68. Both the petition and the open letter are available in Pierre, *Tracts surréalistes,* 1: 49–53.

69. Breton, *Conversations,* 89.

70. Breton recognized the point retrospectively in *Conversations,* 98: "Like it or not, we had to take that path."

71. "Leon Trotsky's 'Lenin,' " in Breton, *What Is Surrealism?* 43.

72. Breton, "What Is Surrealism?" in *What Is Surrealism?* 157, original emphasis.

73. See Breton, "In Self-Defense," 25. The text appeared originally as a pamphlet on 30 September 1926. In a postwar interview, Breton answered a question about what he was "hoping for from communism in 1925" by saying that it alone "struck me as having the requisite *framework*" to end exploitative human relations, but he said nothing about why he had thought this was true. See his *Conversations,* 290.

74. See the surrealist declaration, "Les intellectuels et la révolution," *L'Humanité* (8 November 1925), reprinted in Pierre, *Tracts surréalistes,* 1: 63–64.

75. Breton, "La force d'attendre," *Clarté* 79 (December 1925–January 1926): 380–381, now in *OC,* 1: 917–921.

76. Breton explained the failure of *Guerre civile* straightforwardly: success would have required the surrealists "'to know only the orders' given by the

French [communist] party," and that the surrealists refused to do; see Breton, "In Self-Defense," 38.

77. Pierre Naville, "Que peuvent faire les surréalistes" [1926], in *La Révolution et les intellectuels* (Paris: Gallimard, 1927), 121–122.

78. Breton, "In Self-Defense," 33, 23, 25, 36, 23, 34.

79. Victor Crastre, *Le Drame du surréalisme* (Paris: Les Temps, 1963), 74. Interestingly, Breton endorsed the historical work by "our friend Victor Crastre" in *Conversations*, 94.

80. See André Breton and Louis Aragon, "Protestation," in Pierre, *Tracts surréalistes*, 1: 64–65, original emphasis, which they published in the 15 June 1926 issue of *La Révolution surréaliste*; see also the account in the memoir by Matthew Josephson, *Life Among the Surrealists* (New York: Holt, Rinehart and Winston, 1962), 329–330; and Polizzotti, *Revolution of the Mind*, 260.

81. Breton and Aragon, "Protestation," 64. Four years later, in a polemical pamphlet, Jacques Baron would accuse Breton of duplicity: "He sent his pals to the Ballets Russes to scream 'Vive les Soviets!' and then, the next day, received Sergei Diaghilev with open arms at the Galerie Surréaliste because he had come to buy paintings." See Philippe Soupault et al., "Un cadavre," in Pierre, *Tracts surréalistes*, 1: 147.

82. Breton, "Au grand jour," *OC*, 1: 928, original emphasis. Transcripts of the proceedings against Soupault and Artaud are available in Thénevin and Bonnet, *Archives du surréalisme*; see especially 3: 22, 26, 27, 60, 62, and 70.

83. See Elza Adamowicz, *Surrealist Collage in Text and Image: Dissecting the Exquisite Corpse* (Cambridge: Cambridge University Press, 1998); and Megan C. McShane, "Exquisite Corpse: The Surrealist Practice of Collective Drawing, 1925–1941" (Ph.D. diss., Emory University, 2004).

84. See Breton's long footnote in the *Second Manifesto of Surrealism*, 178–182, from which the quotations are taken.

85. Grant, *Surrealism and the Visual Arts*, 157.

86. Breton, *Le Surréalisme et la peinture* (New York: Brentano's, 1945), translated by Simon Watson Taylor as *Surrealism and Painting* (Boston: MFA, 2002); page citations below are from the translated text (original emphasis).

87. Breton, *Surrealism and Painting*, 3–5, original emphasis. Interestingly, however, Breton did not stress color in his depiction of the workings of an "internal model." Although, like the early Benjamin, he saw the rationally untutored "wild eye" tracing colors "back to the rainbow," he seemed to regard color as having been, in effect, co-opted by the "external model"; see *Surrealism and Painting*, 1–2.

88. Breton, *Manifestoes of Surrealism*, 29–30.

89. Breton, *Surrealism and Painting*, 5–6, 25, 35, 44.

90. Ibid., 9, 12, 19, 12, 16, 13, 20, 21, 6, 35, 33.

91. See Polizzotti, *Revolution of the Mind*, 345, where it is also noted that a "larger trade run" was put on sale on the following November.

92. Breton, "Preface for the New Edition of the Second Manifesto (1946)," in *Manifestoes of Surrealism*, 113–115.

93. Breton, *Second Manifesto of Surrealism*, 128, 139.

94. Ibid., 176, 129.

95. Ibid., 187.

96. See Breton, *Second Manifesto of Surrealism,* 177, where Breton remarks that "some of our friends . . . appear to me to be a trifle too preoccupied with placing and selling their paintings."

97. Ibid., 131; and Breton, "Le Surréalisme en 1929," *Variétés: Revue mensuelle illustrée de l'Esprit contemporaine* (June 1929). The magazine generally featured popular photography and heavy doses of commercial advertisement in its opening pages. In this special issue, the photography was surrealist, the advertisements came at the end, and they were largely restricted to art galleries, bookstores, and surrealist books.

98. Pierre Bourdieu, *The Rules of Art: Genesis and Structure of the Literary Field,* trans. Susan Emanuel (Stanford, Calif.: Stanford University Press, 1995), 121–123, 389n80, and passim.

99. Breton, *Second Manifesto of Surrealism,* 133, 162, 177.

100. Walter Benjamin, "Surrealism," in *Selected Writings, Volume 2,* trans. Rodney Livingstone, ed. Michael W. Jennings, Howard Eiland, and Gary Smith (Cambridge, Mass.: Harvard University Press, 1999), 217.

101. Ibid., 217–218.

102. See Walter Benjamin, "The Work of Art in the Age of Its Technological Reproducibility," in *Selected Writings, Volume 4: 1938–1940,* trans. Edmund Jephcott, ed. Howard Eiland and Michael W. Jennings (Cambridge, Mass.: Harvard University Press, 2003), 264–265. This passage, which appears as section 12 of this final version of the essay, had appeared as section 15 of the second version, now available in *Selected Writings, Volume 2,* 116–117. All quotations in this paragraph come from the essay's final version.

103. Ironically, Breton was a fan of Chaplin's movies as well as serial films; see Polizzotti, *Revolution of the Mind,* 69, 342.

104. Louis Aragon, "Le surréalisme et le devenir révolutionnaire," *Le Surréalisme au Service de la Révolution* 3 (December 1931): 3, original emphasis; reprint edition (New York: Arno, n.d.).

105. Adorno was quite aware of the applicability of his critique to Breton's surrealism, which is another of the examples he offered in that discussion; see Theodor Adorno, *Aesthetic Theory,* trans. Robert Hullot-Kentor (Minneapolis: University of Minnesota Press, 1997), 94.

106. Breton, *Second Manifesto of Surrealism,* 142–145.

107. Well-informed recent estimates range from "three or four weeks" in Rose, *Surrealism and Communism,* 272; to "two months" of attending meetings in Durozoi, *History of the Surrealist Movement,* 137; to "a few months" in Spiteri and LaCoss, *Surrealism, Politics and Culture,* 5.

108. See Breton, "Question/Réponse," *Le Surréalisme au Service de la Révolution* 1 (June 1930): 1; and Breton, *Conversations,* 120.

109. See the accounts in Durozoi, *History of the Surrealist Movement,* 218–221; and Steven Harris, *Surrealist Art and Thought in the 1930s: Art, Politics, and the Psyche* (Cambridge: Cambridge University Press, 2004), 53–54.

110. Their joint draft of an "inaugural manifesto" for the organization appears in André Thirion, *Revolutionaries Without Revolution,* trans. Joachim Neugroschel (New York: MacMillan, 1975), 263–264.

111. Polizzotti, *Revolution of the Mind,* 359–360.

112. Breton, *Conversations,* 103.

113. Nadeau, *History of Surrealism,* 175.

114. Polizzotti, *Revolution of the Mind,* 327.

115. Although Éluard did not formally join the PCF until 1942, his break with Breton occurred upon Breton's return from Mexico in May 1938, when Breton discovered that he had become a contributor to the journal of the AEAR; see Lewis, *Politics of Surrealism,* 150.

116. Breton, *Conversations,* 119.

117. Dalí was put on "trial" by the surrealists in 1934 for pro-Hitler sympathies; although he avoided excommunication then, he separated from the group in 1939 because of his support for Francisco Franco. On the trial, see Polizzotti, *Revolution of the Mind,* 392–397; and Breton, *Conversations,* 143.

118. Harris, *Surrealist Art and Thought,* 2–3 and passim. See also, Chéniux-Gendron, *Surrealism,* 79–93, 158–177; Grant, *Surrealism and the Visual Arts,* 288–341; Joanna Malt, *Obscure Objects of Desire: Surrealism, Fetishism, and Politics* (Oxford: Oxford University Press, 2004), 76–221; and Hal Foster, *Compulsive Beauty* (Cambridge, Mass.: MIT Press, 1993).

119. For his emphasis on discontinuity, see Harris, *Surrealist Art and Thought,* 20.

120. Breton, "Crise de l'object," *Cahiers d'Art* 11 (1936): 21–26, translated as "Crisis of the Object" and reprinted in Breton, *Surrealism and Painting,* 275–277.

121. Breton invoked Gaston Bachelard's then recent advocacy of "surrationalism." For Habermas's vocabulary, see his *Knowledge and Human Interests,* trans. Jeremy J. Schapiro (Boston: Beacon Press, 1971); for a passage in Breton that links surrealism to the "emancipation of man," see Breton, "The Political Position of Today's Art" (1935), in *Manifestoes of Surrealism,* 231.

122. See Breton, *Break of Day,* 64–66.

123. Here I take exception to Harris, *Surrealist Art and Thought,* 13, which suggests that the surrealist refusal of *métier* and the bourgeois institution of art also implied a "refusal of professionalization."

124. See, for example, Josephson, *Life Among the Surrealists,* 219; Thirion, *Revolutionaries Without Revolution,* 174; and Alfred H. Barr Jr., *Cubism and Abstract Art* (Cambridge, Mass.: Harvard University Press, Belknap Press, 1986 [1936]), 179.

125. See Louise Tythacott, *Surrealism and the Exotic* (London: Routledge, 2003), especially 22–32; Celia Rabinovitch, *Surrealism and the Sacred: Power, Eros, and the Occult in Modern Art* (Boulder, Colo.: Westview Press, 2002), especially 4–5, 44–48; David Sylvester, "Regarding the Exhibition," in *Dada and Surrealism Reviewed,* by Dawn Ades (London: Arts Council, 1978), 1; and Green, *Art in France 1900–1940,* 29–30.

126. See Breton, *Lost Steps,* 111, and the discussion of "literary types" as well as "action and dream" in "the poet to come," in Breton, *Communicating Vessels,* 7–8, 146–148.

127. Breton, "Le message automatique," *Minotaure* 3–4 (December 1933): 54–65, translated and reprinted in *Break of Day,* 125–143.

128. See Breton, *Conversations*, 142, and the declarations on the opening page of its first issue (1 June 1933). Twelve subsequent issues of *Minotaure* appeared until May 1939.

129. Breton, *Break of Day*, 138–142.

130. Lautréamont, "Poésies II," in *Oeuvres complètes*, ed. Pierre-Olivier Walzer (Paris: Gallimard, 1970), 285. Breton called the passage "one of surrealism's fundamental watchwords" in *Conversations*, 187, and also quoted it in the "Surrealist Situation of the Object" (1935), in Breton, *Manifestoes of Surrealism*, 262. Éluard would misquote it in 1925 as "poetry can be made by everyone, not by one"—see Bürger, "Surréalisme et engagement," 86.

131. Benjamin, "The Author as Producer," in *Selected Writings, Volume 2*, 777.

132. See Polizzotti, *Revolution of the Mind*, 388–389; and Lewis, *Politics of Surrealism*, 121.

133. See Breton, "'M. Renault est très affecté,'" *OC*, 2: 525–526, translated in Breton, *What Is Surrealism?* 148–150; and Breton, "À propos du concours de littérature prolétarienne organisé par 'L'Humanité," in *OC*, 2: 332–340, translated in *Break of Day*, 78–87.

134. Letter of 11 March 1933, cited in *OC*, 2: xxxviii.

135. See Ferdinand Alquié, letter to Breton of 7 March 1933, in *Le Surréalisme au Service de la Révolution* 5 (May 1933): 43.

136. For the precise sequence of events, see *OC*, 2: xxxix.

137. Among such accounts, two especially interesting ones are Paligot, *Parcours politique des surréalistes 1919–1969*, which sees Breton pursuing such a tactic relentlessly for the rest of his life; and Elena Filipovic, "Surrealism in 1938: The Exhibition at War," in Spiteri and LaCoss, *Surrealism, Politics and Culture*, 179–203, which attacks Suleiman's view (see reference below) that Breton retreated to the salon in the late 1930s.

138. Susan Rubin Suleiman, "Between the Street and the Salon: The Dilemma of Surrealist Politics in the 1930s," in *Visualizing Theory: Selected Essays from V.A.R., 1990–1994*, ed. Lucien Taylor (London: Routledge, 1994), 149.

139. For a similarly calibrated but more detailed view than I can present here, see Harris, *Surrealist Art and Thought*, 137–152, 173–177, 219–229.

140. Breton, *Conversations*, 152.

141. Breton, "La planète sans visa" (24 April 1934), now in Pierre, *Tracts surréalistes*, 1: 268–269.

142. Breton, "What Is Surrealism?" in *What Is Surrealism?* especially 154 and 187.

143. On his strategy of internationalism, see Breton, *Position politique du surréalisme* (1935), in *OC*, 2: 473, translated as *Political Position of Surrealism*, in *Manifestoes of Surrealism*, 256; Breton, *Conversations*, 142–143; and Durozoi, *History of the Surrealist Movement*, 286–296.

144. Nadeau, *History of Surrealism*, 199. As always, however, Breton took his activity very seriously; see *Conversations*, 143, and, for his view of Nadeau, 165–166.

145. Breton, *Conversations*, 139.

146. Breton, "Du temps que les surréalistes avaient raison" (August 1935), in

Position politique du surréalisme, OC, 2: 471, translated as "When the Surrealists Were Right," in *Manifestoes of Surrealism,* 253, original emphasis.

147. Breton, "Position politique de l'art d'aujourd'hui" (1 April 1935), in *OC,* 2: 417–419; translated as "Political Position of Today's Art," in *Political Position of Surrealism,* in *Manifestoes of Surrealism,* 213–215.

148. *Political Position of Surrealism,* in *Manifestoes of Surrealism,* 230. In the passage, Breton is defending himself against an accusation by Tzara at the time of his break with surrealism that Breton's "common front" implied an overly defensive posture in which art was being "considered an end in itself." See Tzara's letter to *Cahiers du Sud* (March 1935), now in Tristan Tzara, *Grains et issues,* ed. Henri Béhar (Paris: Garnier-Flammarian, 1981), 254.

149. Ibid., 233, 231, 227.

150. See René Char, letter of 8 December 1935 to Benjamin Péret, in Pierre, *Tracts surréalistes,* 1: 291.

151. See "Contre-Attaque: Union de lutte des intellectuels révolutionnaires" (October 7, 1935), in Pierre, *Tracts surréalistes,"* 1: 281–284, reprinted by Breton in his *Position politique du surréalisme, OC,* 2: 496–500.

152. Georges Bataille, "Front Populaire dans la rue," and "Vers la révolution réele," *Les Cahiers de 'Contre-Attaque' 1* (May 1936), now in Bataille, *Oeuvres complètes,* ed. Michel Foucault (Paris: Gallimard, 1970), 1: 402, 413, 428.

153. "Contre-Attaque," in Pierre, *Tracts surréalistes,* 1: 283.

154. Ibid., 1: 282.

155. ["La rupture avec 'Contre-Attaque' "], in Pierre, *Tracts surréalistes,* 1: 301.

156. Breton, "Limits Not Frontiers of Surrealism," in *Surrealism,* ed. Herbert Read (London: Faber and Faber, 1936), 93–116. These remarks have their origins in a gallery talk Breton gave on 16 June; see *OC,* 3: 1338.

157. Ibid., 96. The text did not actually mention Trotsky by name but referred obliquely to a "clear-eyed observer." However, contextual information shows that the reference is to Trotsky; see *OC,* 3: 1341.

158. Ibid., 97–98, 99, 95; original emphasis.

159. Suleiman, "Between the Street and the Salon," 149.

160. This is the thesis of Steven Harris in *Surrealist Art and Thought,* 10, 15—in my view, an aptly formulated rejoinder to the claim in Peter Bürger, *Theory of the Avant-Garde,* trans. Michael Shaw (Minneapolis: University of Minnesota Press, 1984), that surrealism was an "avant-garde" and not a "modernist" movement because it rejected autonomous art in favor of the goal of reconciling art and life.

161. Bertrand de Jouvenel, *On Power: Its Nature and the History of Its Growth,* trans. J. F. Huntington (Boston: Beacon Press, 1962 [1945]), 220.

162. See the protest statements, "Neutralité? Non-Sens, crime et trahison!" (20 August 1936), "Appel aux hommes" (end of August, beginning of September 1936), and "Déclaration lue par André Breton le 3 Septembre 1936 au meeting: 'La vérité sur le Procès de Moscou,'" all signed by Breton, as well as his speech ["Discours d'André Breton à propos du Second Procès de Moscou"] of 16 January 1937, in Pierre, *Tracts surréalistes,* 1: 302–311.

163. See "Pour un art révolutionnaire indépendant," in Pierre, *Tracts surréalistes,* 1: 337, translated in Breton, *What Is Surrealism?* 245.

164. On the 1938 exhibition at the Galerie Beaux-Arts and its context, see Lewis Kachur, *Displaying the Marvelous: Marcel Duchamp, Salvador Dalí, and Surrealist Exhibition Installations* (Cambridge, Mass.: MIT Press, 2001), 3–101.

165. See, for example, Foster, *Compulsive Beauty,* 149; Lewis, *Politics of Surrealism,* 161; and Nadeau, *History of Surrealism,* 202. Among those who insist on the importance of the postwar period as well are Paligot, *Parcours politique des surréalistes 1919–1969,* and many of the contributors to Spiteri and LaCoss, *Surrealism, Politics and Culture.*

166. See Bessac, "Les dessins préhistoriques de Cabrerets sont-ils authentiques?" *Arts* 372 (15 August 1952): 1 and 8 (the first name of the author and official, Bessac, is not apparent from the article).

167. Breton, "Comète surréaliste" (June 1947), now in *OC,* 3: 752.

168. See Maurice Blanchot, "Reflections on Surrealism," in his *The Work of Fire,* trans. Charlotte Mandell (Stanford, Calif.: Stanford University Press, 1995), 96, which notes that "the service that surrealism expects from Marxism is to prepare for it a society in which everyone could be a surrealist."

169. In this regard, see Kachur, *Displaying the Marvelous,* 98, which argues that in practice Breton held fast to "surrealism as 'high' art."

8. THE CRITICAL MODERNISM OF HERBERT READ

1. Herbert Read, "English Art," *Burlington Magazine* 63 (December 1933): 276.

2. For a dated but still useful summation of one major aspect of British commodity culture, see Asa Briggs, *Mass Entertainment: The Origins of a Modern Industry* (Adelaide, AUS: Griffin Press, 1960). See also D. L. LeMahieu, *A Culture for Democracy: Mass Communication and the Cultivated Mind in Britain Between the Wars* (Oxford: Clarendon Press, 1988), 5–99; and the works cited in chapter 1, note 32.

3. On the persistence through World War I of a religion-of-art tradition within British Arts and Crafts, see S. K. Tillyard, *The Impact of Modernism, 1900–1920: Early Modernism and the Arts and Crafts Movement in Edwardian England* (London: Routledge, 1988). The undercurrent of a religion of art within Bloomsbury is especially evident in Clive Bell, *Art* (London: Chatto and Windus, 1920 [1913]), 75–94.

4. The most comprehensive study of this tradition remains Solomon Fishman, *The Interpretation of Art: Essays in the Art Criticism of John Ruskin, Walter Pater, Clive Bell, Roger Fry, and Herbert Read* (Berkeley: University of California Press, 1963). See also Raymond Williams, *Culture and Society, 1780–1950* (New York: Harper and Row, 1958).

5. For Read on this point, see his *English Stained Glass* (London and New York: G. P. Putnam's Sons, 1926), 184; and his "Why the English Have No Taste," *Minotaure* 7 (June 1935): 67–68. See also Michael T. Saler, *The Avant-Garde in Interwar England: Medieval Modernism and the London Underground* (Oxford: Oxford University Press, 1999), 11–12.

6. LeMahieu, *A Culture for Democracy,* 204.

7. Read, "What Is There Left to Say?" *Encounter* 19 (October 1962): 30, reprinted in Read, *The Cult of Sincerity* (London: Faber and Faber, 1968), 50–59.

8. For biographical information on Read, see James King, *The Last Modern: A Life of Herbert Read* (London: Weidenfeld and Nicolson, 1990); George Woodcock, *Herbert Read: The Stream and the Source* (London: Faber and Faber, 1972); and David Thistlewood, *Herbert Read: Formlessness and Form, An Introduction to His Aesthetics* (London: Routledge and Kegan Paul, 1984). Other helpful studies on Read include David Goodway, ed., *Herbert Read Reassessed* (Liverpool: Liverpool University Press, 1998); and Benedict Read and David Thistlewood, eds., *Herbert Read: A British Vision of World Art* (Leeds, UK: Leeds City Art Gallery, 1993).

9. King, *Last Modern*, xv, argues that "Read in 1964 was still the best-known promoter of modernism in the English-speaking world."

10. Read, *To Hell with Culture and Other Essays on Art and Society* (New York: Schocken Books, 1963), 78. The passage originally appeared in Read, *The Politics of the Unpolitical* (London: Routledge, 1943), 139.

11. See Read, *The Innocent Eye* (New York: Henry Holt, 1947 [1933]).

12. Read has also left us autobiographical reflections on the years in Leeds; see his *The Falcon and the Dove*, in *The Contrary Experience: Autobiographies* (London: Secker and Warburg, 1963), 149–281.

13. On Orage, see Tom Steele, *Alfred Orage and the Leeds Art Club, 1893–1923* (Aldershot, UK: Scolar Press, 1990), who devotes a chapter to Orage's mentorship of Read.

14. Read's war diary and two memoirs are included in *The Contrary Experience*, 59–146, 220–254. For the story behind the diary, see King, *Last Modern*, 44.

15. See Woodcock, *Herbert Read*, 22–23.

16. Read, *Falcon and the Dove*, 203–205, including a transcript of the original letter.

17. Read, "Definitions Towards a Modern Theory of Poetry," *Art and Letters* 1 (January 1918): 73–78. For Read's reflections on the *Art and Letters* experience, see *Falcon and the Dove*, 257.

18. See King, *Last Modern*, 56–57; Thistlewood, *Herbert Read*, 4, 176n11.

19. Read, *Falcon and the Dove*, 277.

20. The essay seems to have been the main source of Read's interest in Worringer; see Read, *The Philosophy of Modern Art: Collected Essays* (London: Faber and Faber, 1952), 217.

21. Read was technically a coauthor with Bernard Rackham of *English Pottery: Its Development from Early Times to the End of the Eighteenth Century* (London: Ernest Benn, 1924), but the book is a historical catalog largely written, it appears, by Rackham, a senior colleague and pottery expert at the Victoria and Albert Museum.

22. Roger Fry, *Art and Commerce* (London: Hogarth Press, 1926), reprinted in Crauford D. Goodwin, ed., *Art and the Market: Roger Fry on Commerce in Art* (Ann Arbor: University of Michigan Press, 1998), 111–123.

23. Read comes much closer to Fry in his later, quasi-Marxist period of 1935–

1936, when he acknowledges "the material organization of life" as "the basic fact." Even then, however, when he turns to history he writes that "culture, and not material civilization, is the continuing force in a society." See Read, *Essential Communism* (London: Stanley Nott, 1935), 10–15.

24. Read, *English Stained Glass*, 1, ix.

25. Ibid., 5, 15–16.

26. Here too Read built on Worringer's work, in this case on his *Form in Gothic*, which Read was translating as he wrote *English Stained Glass* (it appeared in 1927).

27. Read, *English Stained Glass*, 22–27, 89–90, 97.

28. Ibid., 179–181, 193–196.

29. Ibid., 183–184, 221, 184.

30. Read, *Surrealism* (London: Faber and Faber, 1936), 20.

31. See Read, *Julien Benda and the New Humanism* (Seattle: University of Washington Book Store, 1930).

32. Read, *The Place of Art in a University* (Edinburgh: Oliver and Boyd, 1931), 27, later reprinted in his *Education through Art* (London: Faber and Faber, 1943), 263. This was Read's Inaugural Lecture for a post he would hold for two years.

33. Read, review of A. N. Whitehead, *Science and the Modern World*, in *The New Criterion* 4 (June 1926): 581.

34. Read, "Descartes," in *The Sense of Glory: Essays in Criticism* (Cambridge: Cambridge University Press, 1929), 58–77.

35. Whitehead review, 585.

36. Ibid.

37. Read, *English Stained Glass*, 18.

38. "Descartes," 72.

39. Reynolds, as cited in Read, *Art Now: An Introduction to the Theory of Modern Painting and Sculpture* (London: Faber and Faber, 1933), 31.

40. See Read, "Descartes," 72–73; and *Art Now*, 61–63.

41. As late as 16 April 1930—and, ironically, in one of his first writings about surrealism—Read identified his own artistic preferences as "classical" and therefore in favor of an art "in which expression is achieved with some degree of formal precision." See his "Beyond Realism," *The Listener* 3 (1930): 679, reprinted in Goodway, *Herbert Read Reassessed*, 128.

42. Read, *Form in Modern Poetry* (London: Sheed and Ward, 1932), 44, 10–39.

43. Read, *Art Now*, 32–34, 99–100. In one of his last writings, Roger Fry attacked the book for being so enamored of Vico's "supposed pre-logical period of the social organism" and the "intuitive unreason" of the artists, mostly German expressionists, whose art it validates. See his review of *Art Now* in *Burlington Magazine* 64 (May 1934): 242–245.

44. Read, *Art Now*, 117–118; original emphasis.

45. Read rejects this route in his review of Stanley Unwin, *The Truth About Publishing*, in *Monthly Criterion* 6 (1927): 81–83. See also Read, *Art and Industry: The Principles of Industrial Design* (Bloomington: Indiana University Press, 1961 [1934]), 4, 103–104.

46. See Read, *Julien Benda,* and the clarification of that somewhat muddy essay in Read, *Essential Communism,* 9.

47. Read, *The English Vision: An Anthology* (London: Eyre and Spottiswoode, 1933), vii.

48. For Read's own reminiscences about Hampstead, see his "A Nest of Gentle Artists," *Apollo* 77 (September 1962): 536–540. See also Corin Hughes Stanton, "Microcosm of a Committed Decade: Hampstead in the 1930s," *Country Life* (11 November 1976): 1420–1422; and King, *Last Modern,* 119–121, 153–172.

49. Read, *Art Now,* 12–13.

50. Read, *Essential Communism,* 9–11.

51. Read, "Introduction to *Unit 1,*" in *Unit 1: The Modern Movement in English Architecture, Painting and Sculpture,* ed. Herbert Read (London: Cassell, 1934), reprinted in *A Tribute to Herbert Read, 1893–1968* (Bradford, UK: Bradford Art Galleries, 1975), 39. The article originally appeared in *Architectural Review* 74 (1933): 125–128.

52. Read, *Surrealism,* 89.

53. Among the important historical studies of British design modernism, upon which I rely for the brief account here, are Fiona MacCarthy, *A History of British Design, 1830–1970* (London: George Allen & Unwin, 1979); John and Avril Blake, *The Practical Idealists: Twenty-Five Years of Designing for Industry* (London: Lund Humphries, 1969); Nikolaus Pevsner, *An Inquiry into Industrial Art in England* (New York: MacMillan, 1937); and Saler, *The Avant-Garde in Interwar England,* chapters 4 and 6.

54. See Judith Collins, *The Omega Workshops* (Chicago: University of Chicago Press, 1984); and Isabelle Anscombe, *Omega and After: Bloomsbury and the Decorative Arts* (London: Thames and Hudson, 1981). Fry did make a serious effort in these years to redefine art as design; see his *Vision and Design* (New York: Cowan-McCann, 1930 [1920]). For Read's view of Omega, see his "Roger Fry," in *A Coat of Many Colours* (London: Routledge and Kegan Paul, 1945), 283.

55. Report of Lord Gorell, *Art and Industry* (London: His Majesty's Stationery Office, 1932). See also Read's appendix analyzing the report in his *Art and Industry,* 219–225.

56. Pevsner, *Inquiry into Industrial Art,* 1–12, 215–234.

57. Read, *Art and Industry,* 35, xiv, and passim.

58. Ibid., 7. Fry had denied a "biological" basis for art such as an inborn aesthetic sense in *Vision and Design,* 47.

59. Read, *Art and Industry,* 37–38, 98–99.

60. Ibid., 41.

61. Ibid., 42–44. For the private suspicions, see King, *Last Modern,* 158–160.

62. See "Memorandum by Mr. Roger Fry," in Gorell, *Art and Industry,* 44–49.

63. For Read's relations with the British surrealists, which I cannot consider here, see Paul C. Ray, *The Surrealist Movement in England* (Ithaca, N.Y.: Cornell University Press, 1971), especially 86–133.

64. See Read, "What Is Revolutionary Art?" in *5 on Revolutionary Art,* ed. Betty Rea (London: Wishart, 1935), 11–22.

65. See Read, *Essential Communism,* 19. Despite this passage, however, a fel-

low anarchist who knew Read well interprets this text as anarchist overall, and therefore as a foreshadowing of his many anarchist writings after 1937. See Woodcock, *Herbert Read,* 26–27.

66. For Read's own declaration of his lifelong anarchist beliefs, see *The Falcon and the Dove,* 202.

67. Read, *Art and Society* (London: William Heinemann, 1937), 115–117.

68. Read, *Surrealism,* 45.

69. Read, *Art and Society,* 115.

70. Ibid., 116.

71. Ibid., 120.

72. Read, "Introduction to *Unit 1,*" 37.

73. Read, *Art and Society,* 120.

74. See citation in Read, *Art and Society,* 120–121.

75. Ibid., 121–122. Read was fond of stressing the "dialectical" qualities of surrealism. See also his "Surrealism—the Dialectic of Art," *Left Review* 2 (1936): ii–iii; and his "A Primer of Dialectics" (review of T. A. Jackson, *Dialectics: The Logic of Marxism and its Critics — An Essay in Exploration*), *Left Review* 2 (1936): 518–520.

76. Read, *Surrealism,* 89–90. Read's reference to difficulty here may reflect his awareness that Breton's surrealism was no longer seeking a communist alliance by 1936 and was in search of some alternative.

77. Read, "Introduction to *Unit 1,*" 36.

78. Read, "What Is Revolutionary Art?" 20.

79. Ibid., 21, 18; original emphasis.

80. Read, *Surrealism,* 20–21.

81. For the precursors, see Read, *Surrealism,* 46–56; on Blake and Carroll as superrealists, see Read, introduction to *The International Surrealist Exhibition, Catalogue* (London: New Burlington Galleries, 1936), 13. In contrast, Breton took a much dimmer view of romanticism, as in a letter to Jacques Doucet of February 1922, in which he and Aragon called romanticism an "adventure that has run its course"; see Breton, *Oeuvres Complètes* (Paris: Gallimard, 1988), 1: 635.

82. Read, "The Faculty of Abstraction," in *Circle: International Survey of Constructive Art,* ed. Leslie Martin, Ben Nicholson, and Naum Gabo (New York: Praeger, 1971 [1937]), 61–66.

83. Ibid., 64–65; original emphasis.

84. Woodcock, *Herbert Read,* 26.

85. Read, *Art and Industry: The Principles of Industrial Design* (London: Faber and Faber, 1934), 127, 129.

86. Read, *Art and Society,* 70–71, 73.

87. Read, "Art in an Electric Atmosphere," *Horizon* 3 (1941): 308–313.

88. Ibid., 311.

89. Read, *Politics of the Unpolitical,* 12; the passage was omitted when Read later reprinted the essay in *To Hell with Culture,* 38–48.

90. Read, "Art in an Electric Atmosphere," 311–312; original emphasis.

91. Read, "Vulgarity and Impotence," *Horizon* 5 (1942): 272–273.

92. Read, *Freedom, Is It a Crime?: The Strange Case of the Three Anarchists Jailed at the Old Bailey, April 1945* (London: Freedom Press, 1945), 10.

93. Read, *To Hell with Culture: Democratic Values Are New Values* (London: Kegan Paul, Trench, and Trubner, 1941). A revised version of this essay became the centerpiece of Read's later collected essays bearing the same title.

94. Ibid., 18–29.

95. Read, *Politics of the Unpolitical*, 11.

96. Read, *To Hell with Culture: Democratic Values Are New Values*, 14–15, 7–8, 15–17.

97. Ibid., 36–37.

98. Read, "Art in an Electric Atmosphere," 312.

99. For Read's discussion of the "life of art" in relation to patronage, see his "The Collective Patron," in *Politics of the Unpolitical*, 106–111, later reprinted in *To Hell with Culture and Other Essays*, 93–99.

100. See Read, *The Grass Roots of Art: Lectures on the Social Aspects of Art in an Industrial Age* (New York: Meridian, 1961 [1947]), 19.

101. Read, "Ben Nicholson," in *A Coat of Many Colours*, 80–81.

102. Read was familiar with and sympathetic toward Kandinsky's analysis, although he found it ultimately unclear; see Read, *Kandinsky* (New York: Faber and Faber, 1959), 6.

103. Read, *The Future of Industrial Design*, Leaflet No. One (London: Design and Industries Association, 1943), 5.

104. See Read, "The Design Research Unit," *Architects' Journal* (15 April 1943): 252.

105. See Robin Kinross, "Herbert Read and Design," in Goodway, *Herbert Read Reassessed*, 151–152, which includes a photo of the clay model Gabo built. See also King, *Last Modern*, 215–216.

106. Read, "The Design Research Unit," 252.

107. Ibid.

108. Read, *Future of Industrial Design*, 3–6. See also Read, ed., *The Practice of Design* (London: Lund Humphries, 1946).

109. Read, *Education through Art*, 299–300, 1, 7, 265. On the democratic value of aesthetic education, see also Read, "Threshold of a New Age; Renaissance or Decadence?" in J. R. M. Brumwell (London: Scientific Book Club, 1945), 13.

110. Read liked Picasso's statement: "Everybody wants to understand painting. Why don't they try to understand the songs of birds? . . . Those who try to explain a picture are most of the time on the wrong track." See Read, "Epilogue 1947," in *Art Now*, 3rd ed. (London: Faber and Faber, 1948), 133–134. He also later recalled Picasso's reaction to an exhibit of children's art. "When I was the age of these children," Picasso had hold told him, "I could paint like Raphael. It took me many years to learn how to paint like these children." See Read, *The Cult of Sincerity*, 44.

111. Read, *Education through Art*, 305.

112. Read, *The Education of Free Men* (London: Freedom Press, 1944), 7.

113. Read, *Future of Industrial Design*, 7–8.

114. Ibid. Read reused this passage on "double-decker civilization" in his *Grass Roots of Art*, 153–157.

115. Read, *Freedom, Is It a Crime?*, 6.

116. Read, *Grass Roots of Art*, 21.

117. Ibid., 84.

118. In the spring of 1939, Read had worked unsuccessfully with his friend heiress Peggy Guggenheim on founding a museum for modern art in London; see her memoir *Out of this Century: Confessions of an Art Addict* (London: Andre Deutsch, 1979), 196–200. On the ICA, see King, *Last Modern*, 235–272; and Anne Massey, *The Independent Group: Modernism and Mass Culture in Britain, 1945–59* (Manchester, UK: Manchester University Press, 1995), 19–31.

119. Read, as recorded in ICA minutes cited in King, *Last Modern*, 235.

120. See J. P. Hodin, "The London Institute of Contemporary Arts," *Journal of Aesthetics and Art Criticism* 12 (December 1953): 278–282.

121. On the Arts Council, see Saler, *The Avant-Garde in Interwar England*, 168–170; and Raymond Williams, *The Politics of Modernism: Against the New Conformists* (London and New York: Verso, 1989), 141–150.

122. Williams, *Politics of Modernism*, 34–35. It should be noted that the quotation is drawn from a lecture Williams gave in 1987, the published text of which is based on his notes as well as those of a member of the audience.

123. Charles Jencks, *Post-Modernism: The New Classicism in Art and Architecture* (London: Academy Editions, 1987), 17.

124. See Becky E. Conekin, *"The Autobiography of a Nation": The 1951 Festival of Britain* (Manchester, UK: Manchester University Press, 2003); Massey, *Independent Group*, 1–18; and Nigel Whiteley, *Reyner Banham, Historian of the Immediate Future* (Cambridge, Mass.: MIT Press, 2002), 13–15.

125. Read, *Contemporary British Art* (Harmondsworth, UK: Penguin Books, 1951), 21.

126. Ibid., 38, 37, 34.

127. On Read's cultural democracy in this period, see Read, *Grass Roots of Art*, 100–101; and Read, *Art and Society*, 3rd ed. (New York: Schocken Books, 1966), vi; on his reversion to hierarchy in art, see *Grass Roots of Art*, 82–85, and his *Art and Alienation: The Role of the Artist in Society* (London: Thames and Hudson, 1967), 22.

128. See Read, *Grass Roots of Art*, 84.

129. See *Art and Alienation*, 23; and *Art and Industry*, 5th ed. (London: Faber, 1966), 17.

130. On the Independent Group, see Massey, *Independent Group*; Whiteley, *Reyner Banham*, 81–116; Lynne Cooke, "The Independent Group: British and American Pop Art, A 'Palimpcestuous Ancestry,'" in *Modern Art and Popular Culture: Readings in High and Low*, ed. Kirk Varnedoe and Adam Gopnik (New York: Museum of Modern Art, 1990), 192–216; and David Robbins, ed., *The Independent Group: Postwar Britain and the Aesthetics of Plenty* (Cambridge, Mass.: MIT Press, 1990).

131. See the 25 May 1977 discussion among Hamilton, Banham, and Alloway as recorded in the videocassette *Fathers of Pop* (Houston: White Horse Productions, 1979). See also Banham's view of Read, as cited in Whiteley, *Reyner Banham*, 84.

132. See Massey, *Independent Group*, 72–94.

133. For a full presentation of Banham's ideas, see Whiteley, *Reyner Banham*.

134. See Reyner Banham, "Primitives of a Mechanized Art," *The Listener* 62 (3 December 1959): 974–976, now reprinted in *A Critic Writes: Essays by Reyner Banham,* ed. Mary Banham (Berkeley: University of California Press, 1996), 39–45; and his discussion of futurism in Reyner Banham, *Theory and Design in the First Machine Age* (London: Architectural Press, 1960), 99–137.

135. Banham, "Primitives of a Mechanized Art," in Banham, *A Critic Writes,* 42, 40, 45.

136. See *Theory and Design in the First Machine Age,* 47, and the discussion in Whiteley, *Reyner Banham,* 11–16.

137. Banham, "Primitives of a Mechanized Art," 43–44. Read would have been appalled by a modernism recast in the mold of Kerouac; in "What Is There Left to Say?" 30, he confessed that "beatniks and bohemians give me the creeps."

138. See Banham, "A Throw-away Aesthetic," in *Reyner Banham: Design by Choice,* ed. Penny Sparke (New York: Rizzoli, 1981), 90–93.

139. Banham, "The Atavism of the Short-Distance Mini-Cyclist," *Living Arts* 3 (1964): 92–93; original emphasis.

140. See Read, "The Disintegration of Form in Modern Art," in *The Origins of Form in Art* (New York: Horizon Press, 1965), 185.

141. Read, *English Stained Glass,* 195.

142. Read, *Icon and Idea: The Function of Art in the Development of Human Consciousness* (Cambridge, Mass.: Harvard University Press, 1955), 20.

143. The lecture was published as "The Disintegration of Form in Modern Art."

144. Read, "Disintegration of Form in Modern Art," 176, 186, 187.

145. Read, *Grass Roots of Art,* 120.

146. See Whiteley, *Reyner Banham,* 138.

147. Marinetti, "Il teatro di varietà," in *Teoria e invenzione futurista,* ed. Luciano de Maria (Milan: Mondadori, 1968), 81, 82, 86; translated in *Futurist Manifestos,* ed. Umbro Apollonio (New York: Viking, 1973), 126, 129.

148. Read, *Contemporary British Art,* 39.

149. Read, *Grass Roots of Art,* 74.

CONCLUSION

1. Walter Benjamin, "Paris, the Capital of the Nineteenth Century," in *The Arcades Project,* trans. Howard Eiland and Kevin McLaughlin (Cambridge, Mass.: Harvard University Press, 1999), 4.

2. Hans Magnus Enzensberger, "The Aporias of the Avant-Garde" [1962], in *The Consciousness Industry: On Literature, Politics and the Media* (New York: Seabury Press, 1974), 16–41.

3. Zygmunt Bauman, "Postmodern Art, or the Impossibility of the Avant-Garde, in *Postmodernity and Its Discontents* (New York: New York University Press, 1997), 95–102.

4. Ibid., 96.

5. For a similar appraisal of this sort of reductionism, see Krzysztof Ziarek, *The Historicity of Experience: Modernity, the Avant-Garde, and the Event* (Evanston, Ill.: Northwestern University Press, 2001), 19.

6. See, for example, Robert Wohl, "Heart of Darkness: Modernism and Its Historians," *Journal of Modern History* 74 (September 2002): 613–615.

7. The opposing case is argued in T. J. Clark, *Farewell to an Idea: Episodes from a History of Modernism* (New Haven, Conn.: Yale University Press, 1999).

8. I share this enthusiasm with Christopher Butler, *Early Modernism: Literature, Music, and Painting in Europe, 1900–1916* (Oxford: Oxford University Press, 1994), 276–279, although I think Butler puts undue emphasis on the "left-right" continuum in evaluating the politics of early modernism. In a narrow sense, Marinetti, Kandinsky, and Apollinaire may have been men of the right—they certainly all ended up on the right—but their modernist visions embraced many values associated with the left and were in any case too comprehensive to be adequately treated in these terms.

9. See Theodor Adorno, *Aesthetic Theory,* trans. Robert Hullot-Kentor (Minneapolis: University of Minnesota Press, 1997), 94.

10. For the notion of an interpretative community to which I appeal here, see Stanley Fish, *Is There a Text in This Class? The Authority of Interpretative Communities* (Cambridge, Mass.: Harvard University Press, 1980), 10–11, 15–16.

11. Read, *To Hell with Culture: Democratic Values Are New Values* (London: Kegan Paul, Trench, and Trubner, 1941), 37.

12. Renato Poggioli, *The Theory of the Avant-Garde,* trans. Gerald Fitzgerald (Cambridge, Mass.: Harvard University Press, 1968), 65–66.

13. Jed Perl, "The Variety Show," *The New Republic* (23 July 2001): 27–32, original emphasis. See also Murray Krieger, "Art and Artifact in a Commodity Society," in *Arts on the Level: The Fall of the Elite Object* (Knoxville: University of Tennessee Press, 1981), 51–71.

14. Stephen Spender, *The Struggle of the Modern* (London: Hamish Hamilton, 1963), 85.

15. Jonathan Lear, *Therapeutic Action: An Earnest Plea for Irony* (New York: Other Press, 2003), 31–88.

16. Ibid., 69–70, original emphasis.

17. Jacques Derrida, *The Politics of Friendship,* trans. George Collins (London: Verso, 1997), 22.

18. Ibid., 104.

19. The issue engages not only artists and intellectuals but the broader public, including international organizations like UNESCO. For their "Cultural Diversity in the Era of Globalization" and "Towards a Convention on the Protection of the Diversity of Cultural Contents and Artistic Expressions," see the UNESCO website at portal.unesco.org/culture/en/ev.php (accessed 28 July 2006).

20. Le Corbusier, *The Decorative Art of Today,* trans. James I. Dunnett (Cambridge, Mass.: MIT Press, 1987), xxii, 92.

21. See especially Arjun Appadurai, *Modernity at Large: Cultural Dimensions of Globalization* (Minneapolis: University of Minnesota Press, 1996), chapters 7–9.

22. Ibid., 178–179.

23. See Jean François Lyotard, *The Postmodern Condition: A Report on Knowledge,* trans. Geoff Bennington and Brian Massumi (Minneapolis: University of Minnesota Press, 1984), 76.

24. Lucy R. Lippard, *The Lure of the Local: Senses of Place in a Multi-centered Society* (New York: New Press, 1997).

25. Ibid., 269, 286.

26. Eric Hobsbawm, *The Age of Extremes: A History of the World, 1914–1991* (New York: Pantheon, 1994).

27. Edward W. Said, "Contra Mundum," in *Reflections on Exile and Other Essays* (Cambridge, Mass.: Harvard University Press, 2000), 482.

28. Ibid., 482–483.

Index

Text: 10/13 Sabon
Display: Akzidenz Grotesk Condensed
Compositor: BookMatters, Berkeley
Printer and binder: Maple-Vail Manufacturing Group